When Harlem Was in Vogue

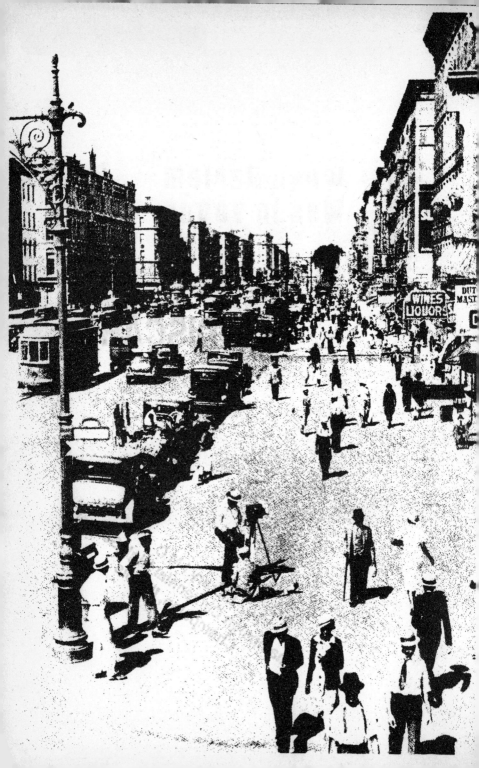

When Harlem Was in Vogue

by

David Levering Lewis

Oxford University Press
New York Oxford

1981

Oxford University Press
Oxford New York Toronto
Delhi Bombay Calcutta Madras Karachi
Petaling Jaya Singapore Hong Kong Tokyo
Nairobi Dar es Salaam Cape Town
Melbourne Auckland

and associated companies in
Berlin Ibadan

First published in the United States by Alfred A. Knopf, Inc.,
New York, and simultaneously in Canada by Random House of Canada
Limited, Toronto, in 1981. First published in paperback by Vintage
Books in 1982.

First issued as an Oxford University Press paperback, 1989

Oxford is a registered trademark of Oxford University Press

A portion of this book appeared in *Prospects: An Annual
Journal of American Cultural Studies* under the title
"The Politics of Art: The New Negro."

Another portion appeared in the *Massachusetts Review.*

Acknowledgment for permission to print previously
published, and unpublished, material, is on page 362.

Library of Congress Cataloging in Publication Data

Lewis, David Levering
When Harlem was in vogue.

Bibliography: p.
Includes index.
1. Afro-American arts New York (City)
2. Arts, Modern 20th century New York (City)
3. Harlem, New York (City)
4. Harlem Renaissance.
I. Title.
NX511.N4L48 700'.899607307471 80-2704
ISBN 0-19-505969-7

8 10 9 7

Printed in the United States of America

To my parents

"Harlem has the same role to play for the New Negro as Dublin has had for the New Ireland or Prague for the New Czechoslovakia."
—Alain Leroy Locke in 1925

"But who is going to write the intimate . . . tale of the New Negro, the years of plenty? The golden legend of the amazing young crowd who gathered in Harlem and almost succeeded in doing for New York what the pre-Raphaelites did for London . . . ?"
—Arna Bontemps to Countee Cullen in 1935

Contents

Acknowledgments

It is impossible to thank every person who made this book possible. There were simply too many. People in diners and night clubs, taxi drivers and street-corner veterans, academics and archivists, students (my own and others) and senior citizens—the categories run on. Inevitably, regrettably, there must be omissions, but those who look for themselves in vain here must believe that I will always be grateful for the help they gave.

Then there are survivors from Harlem's Golden Age who, in the interests of equity and space, must be listed alphabetically and without comment elsewhere. This was not an easy solution, for, while a few of the participants in the Harlem Renaissance were merely polite and several were even hostile witnesses, the great majority extended a collaboration so cordial and forthcoming as to make research uniquely rewarding and pleasurable. The warmth and the trust of these genteel men and women, the lengths to which they went to show me their past as they had truly lived it, have made this book more than an ambitious undertaking in intellectual and social history. It is, in part, their testament. I hope I have succeeded in transmitting it in a manner both worthy of them and responsible to their successors.

Because Richard and Carolyn Thornell extended their hospitality while most of the research was under way, I was able to live in Harlem. Without the affectionate understanding and patience awaiting me in their comfortable town house, writing this book would have been a much longer and harder task. When the Thornells were unavailable to share nocturnal enthusiasms born of a day's interviewing and research, George and Alison Bond often offered that pleasure in their Columbia

University faculty apartment. Ruth Ann Stewart, then assistant head of the Schomburg Center for Research in Black Culture, became involved in the life of this book, and enhanced it in a special way. The same was true of Charles Cooney, formerly of the manuscript division of the Library of Congress, whose knowledge of Afro-American and civil rights special collections probably has no equal anywhere. More than that, as I discovered when he read the major portion of the manuscript, he has the expert archivist's inductive restraint, invaluable for detection of convenient conclusions not quite supported by the documents.

John Higham of The Johns Hopkins University read an early segment of Chapter One, offering several improving suggestions. Hollis Lynch of Columbia University, occupant of another much-used faculty apartment, encouraged my writing of the second chapter and made available a useful unpublished monograph. Arthur Davis of Howard University probably knows more about my subject than any living scholar. Since I have made many of his judgments my own, his enthusiasm for the first draft of the manuscript was decisively encouraging. August Meier of Kent State University subjected the second draft to his well-known critical scrutiny, returning it with qualified enthusiasm and a small volume of objections and corrections. Music is certainly not my mistress, but there must be considerably fewer egregious errors on jazz and the blues thanks to Leslie Rout of Michigan State University.

Somewhere in Hoboken, New Jersey, Richard Bruce Nugent lives. To him, above all, this book owes whatever quality it may have of being written from the inside of its subject, for many portraits of personality and unravellings of complex relationships were possible largely because of his astonishingly accurate memory and the objective perceptions of the past which he helped to create. I regret that Aaron Douglas and George Schuyler died during the early writing and so escaped being importuned to read and react to what is said here about themselves and their contemporaries.

There are a number of persons who must be specially thanked for deeds far above and beyond the expectations of professional courtesy. Among them are Lee Alexander, university archivist, and Lillian Lewis, former head, special collections, Trevor Arnett Library, both of Atlanta University, who suspended normal research hours to permit me to accomplish twice as much as would otherwise have been possible in the short time available. At Dillard University's Amistad Research Center, Hattie Terry, administrative secretary, and Florence Borders,

senior manuscript librarian, extended similar unprecedented privileges
—even over a weekend. As an alumnus, I expected special treatment
at Fisk University; Ann Allen Shockley, head of special collections,
and her assistant, Beth Howse, certainly did not disappoint those ex-
pectations. Director Michael Winston's timely compliance with the re-
quest for unrestricted access to the invaluable Alain Leroy Locke
collection at Howard University's Moorland-Spingarn Research Center
was gracious and indispensable; and the unflagging efficiency of an
overworked Denise Harbin, manuscript librarian, lopped weeks from
the book's completion time. Jean Blackwell Hutson, head, Schomburg
Center for Research in Black Culture, The New York Public Library,
and Ernest Kaiser, library technician, patiently guided me time and
again to sources in and beyond their rich repository that would other-
wise have eluded me and which, invariably, provided crucial pieces of
the large Harlem puzzle. Through the years, Donald Gallup, curator of
the Beinecke Rare Book and Manuscript Library's collection of Amer-
ican literature, Yale University, has patiently responded to a barrage of
requests. Charles Davis, master of Yale's Calhoun College, presented
the keys to the college guest suite one summer as he headed for Bel-
lagio, Italy, thereby facilitating ideal access to the vast James Weldon
Johnson Memorial Collection.

At other institutions, there was Helen Armstead-Johnson of the
Helen Armstead-Johnson Foundation for Theatre Research; James
Kraft, executive director, The Witter Bynner Foundation, Inc.;
Elizabeth Mason, director, Oral History Research Office, and Bernard
Crystal, assistant librarian for rare books and manuscripts, Nicholas
Murray Butler Library, Columbia University; Laura V. Monti, chair-
person, rare books and manuscripts, The University of Florida; Wil-
liam Greaves of William Greaves Productions, Inc.; Martha Eliza
Shaw, former reading room curator, The Houghton Library, Harvard
University; the staffs of The Library of Congress; Roland Grayson, Jr.,
library technician, Music Division, The Library of Congress; Kenneth
Clark, director, and Betty L. Jenkins, librarian, The Metropolitan
Applied Research Center, Inc. (MARC, now defunct); Carl Cowl,
Claude McKay's literary executor; Charles Baragwanath, former se-
nior curator, Museum of the City of New York; Joseph Stinson, re-
search librarian, The New York Public Library; Neda Westlake,
curator of special collections, The Van Pelt Library, University of
Pennsylvania; Cathy Connor, curator, The Studio Museum in Harlem;
Carolyn Davis, manuscript librarian, The George Arents Research Li-

brary, Syracuse University; Elizabeth Parry Catenaccio of the house of
Knopf; and the staff and fellow fellows of the Woodrow Wilson Inter-
national Center for Scholars, where (with assistance from the National
Endowment for the Humanities) parts of this book were written and
defended.

There are others, the friends and colleagues whose comments, casual
and critical, and generously volunteered data were always revelatory
and, frequently, seminal: Faith Berry, Joseph Brent, Anne Chisholm,
Oscar Cohen, Leslie Collins, Maceo Dailey, Hasia Diner, Laurence
Glasco, Sadie Harlan, Jim Haskins, Nathan Huggins, Gary Imhoff,
Abby and Ronald Johnson, Bruce Kellner, Phyllis Klotman, Harold
Marcus, Stanley Nelson, Elliott Rudwick, Jack Schiffman, Charles
Scruggs, James Spady, Hortense Thornton, and Raymond Wolters.

To my wife, Sharon, and my editor, Charles Elliott, I am indebted
for abiding encouragement, wise counsel, and surplus labor, without
which this difficult book might have remained an inspiration in search
of a final draft. Whatever errors and insufficiencies this manuscript
contains are not my fault alone, for them I also blame my wife.

Preface

The New Negro Movement in the arts and letters, centered in Harlem, has been celebrated in song, commemorated in anthologies, captured in exhibitions, and talked about endlessly. Much has been written about its fiction and poetry by literary critics. Hence the widespread belief that what is usually called the Harlem Renaissance has also been extensively written about by students of social movements. This is not at all the case, and that is one of the two compelling reasons why I took on the topic.

The other reason—the more significant one—is that the large why, who, and how of the Harlem Renaissance had never been sufficiently understood. It was appreciated as a glorious necklace of anecdotes and *tours de force*, on which Zora Neale Hurston capers and Civic Club galas, proud Van Der Zee families and Florence Mills revues were spun between the brilliant bobbin of Jean Toomer's *Cane* and that of Wallace Thurman's *Infants of the Spring*. Social analysis, whenever it ventured beyond the Cotton Club, pretty much contented itself with the fabled Dark Tower and the rent party as sufficient paradigms.

So much energy and variety and dazzle have obscured something obvious about the Harlem Renaissance—although its most effective publicist, Alain Leroy Locke, was never unclear about its fundamental premise for a moment. Neither racial militancy nor socialist nostrums could improve the current conditions of Afro-Americans, Locke's *The New Negro* crisply explained; rather, "the more immediate hope rests in the revaluation by white and black alike of the Negro in terms of his artistic endowments and cultural contributions, past and prospective." "Nothing," civil rights elder statesman James Weldon Johnson agreed, in his bestselling anthology *The Book of American Negro Poetry*, "nothing will do more to

change the mental attitude and raise his status than a demonstration of intellectual parity by the Negro through his production of literature and art."

In such statements as these and so many more, the Harlem Renaissance reveals itself to be an elitist response on the part of a tiny group of mostly second-generation, college-educated, and generally affluent Afro-Americans—a response, first, to the increasingly raw racism of the times, second, to the frightening Black Zionism of the Garveyites, and, finally, to the remote, but no less frightening, appeal of Marxism.

The Harlem Renaissance, then, began as a somewhat forced phenomenon, a cultural nationalism of the parlor, institutionally encouraged and constrained by the leaders of the civil rights establishment for the paramount purpose of improving "race relations" in a time of extreme national reaction to and annulment of economic gains won by Afro-Americans during the Great War. Neither vulgar propagandists nor cruel cynics, the men and women who set the goals, made the philanthropic connections, recruited the writers, artists, and musicians, and staged the grand interracial dinners and banquets where prizes were bestowed truly wanted to believe that they were promoting a culture of comity and understanding that would transform a racist nation. Zora Neale Hurston described this arts-cum-civil-rights initiative, pungently, as an alliance of "Niggerati" and "Negrotarians."

From its authentic beginnings in 1919, with soldiers returning from the Great War, to its sputtering end in 1934, with the Great Depression deaths of two principals, the racial goals of the Renaissance remained constant. Notwithstanding Langston Hughes's famous manifesto on artistic independence or the strenuously outrageous literary behavior of Wallace Thurman and his friends, there was always, between seniors and Young Turks, the ultimate solidarity of conviction that a critical mass of exemplary talent could make things better. If *When Harlem Was in Vogue* were to be given a belated subtitle, it might be "Civil Rights by Copyright."

Aside from several corrections, indicated by asterisks, the original 1981 hardcover text remains unchanged.

<div style="text-align: right">

David Levering Lewis
The Schomburg Center,
New York City, 1988

</div>

When Harlem
Was in Vogue

1
We Return Fighting

On a clear, sharp February morning in 1919, on New York's Fifth Avenue, the men of the Fifteenth Regiment of New York's National Guard marched home to Harlem. Their valor under fire (191 unbroken days in the trenches) was legendary. Almost as acclaimed were the triumphs of their regimental band, under the command of Lieutenant James Reese Europe. Big Jim Europe's band, its instruments bought through a tin can millionaire's generosity, had conquered French, Belgian, and British audiences as utterly as his regiment had overwhelmed Germans in battle, leaving crowds delighted and critics mystified by the wail and wah-wah of the "talking trumpet." (So much so that when the proud, skilled musicians of France's Garde Républicaine failed to reproduce these unique sounds, suspicious experts examined one of Europe's horns for some hidden valve or chamber. The logic-bound French concluded that the talking trumpet was a Negro anomaly, musical magic beyond their ken.) European fascination with jazz had started with Jim Europe's band. White America already remembered the band from times before the war, when it had teamed up with Vernon and Irene—the dancing Castles—to make dancing a national pastime and help, as preachers vainly fumed and Puritan parishioners unlimbered, to revolutionize the nation's mores.

But today, February 17, was no occasion for the syncopated beat of ragtime. Lieutenant Europe's men, with Bill "Bojangles" Robinson as regimental drum major, were playing martial music for a victory march, for a heroes' ascent through Manhattan to Harlem. Thirteen hundred black men and eighteen white officers moved in metronome step behind Colonel William Hayward, still limping from a wound

suffered at Belleau Wood, out of Thirty-fourth Street into Fifth Avenue. They marched in the tight formation preferred by the French Army, a solid thirty-five-foot square of massed men, sergeants two paces in front of their platoons, lieutenants three paces ahead of sergeants, captains five paces ahead. They had been called "Hell Fighters" by the admiring French in whose 16th and 161st divisions they had served for almost ten months. Officially, they were still the United States 369th Infantry Regiment, the only unit of the war allowed to fly a state flag, the only American unit awarded the Croix de Guerre, and, as the French High Command's supreme mark of honor, the regiment chosen among all Allied forces to lead the march to the Rhine.

New York Mayor John F. Hylan was enjoying the sun in Palm Beach that day and the city fathers had declined to proclaim an official holiday; but high-ranking dignitaries were present and most New Yorkers gave themselves the day off. "I just had to see these boys," one middle-aged white spectator told a reporter. "I never will get another opportunity to see such a sight, and I can get another job."

"Swinging up the Avenue," *The New York Times* front page reported, the men of the 369th "made a spectacle that . . . might explain why the Boches gave them the title of *Blutlustige Schwarze Männer*"— "bloodthirsty black men." Colonel Hayward and Lieutenant Europe (the sole Afro-American officer) were objects of special attention by the crowds, but the hero of the moment was a coal dealer from Albany, Sergeant Henry Johnson, the first American to win the Croix de Guerre. Running out of ammunition, Johnson had killed four of the enemy with a bolo knife and captured twenty-two. The Croix de Guerre (with star and palm) gleamed from the sergeant's tunic as he stood, waving graciously, in the open limousine provided by the city. "New Yorkers," the *Times* continued, "were mightily impressed by the magnificent appearance of these fighting men."

The staccato of leather on Fifth Avenue macadam rose and fell to the deafening counterpoint of applause. At Sixtieth Street, the command of "eyes right" was given as the regiment passed the official reviewing stand. Governor and Mrs. Alfred E. Smith received the salute with appropriate expressions of gravity and pleasure, as did the secretary of state for New York, Francis Hugo, and Acting Mayor Moran. Representing Newton D. Baker, President Wilson's secretary of war, was Emmett Scott, special adviser on Afro-American affairs and the deceased Booker T. Washington's protégé. Rear Admiral Albert Gleaves and General Thomas Barry saluted briskly. Mr. and Mrs.

William Randolph Hearst and department store tycoon John Wana-maker applauded. That doyen of plutocrats, Henry Clay Frick, could be seen waving a flag from the window of his Seventy-third Street palace. From another window close by, Mrs. Vincent Astor and several society ladies waved these brave men along to their Harlem neighborhoods.

It was James Weldon Johnson, an official of the National Association for the Advancement of Colored People (NAACP), whose eye and pen gave the parade its best measure in the New York *Age,* one of Afro-America's leading newspapers:

The Fifteenth furnished the first sight that New York has had of seasoned soldiers in marching order. There was no militia smartness about their appearance; their "tin hats" were battered and rusty and the shiny newness worn off their bayonets, but they were men who had gone through the terrible hell of war and come back.

The tide of khaki and black turned west on 110th Street to Lenox Avenue, then north again into the heart of Harlem. At 125th Street, the coiled, white rattlesnake insignia of the regiment hissed from thousands of lapels, bonnets, and windows. A field of pennants, flags, banners, and scarves thrashed about the soldiers like elephant grass in a gale, threatening to engulf them. In front of the unofficial reviewing stand at 130th Street, Europe's sixty-piece band broke into "Here Comes My Daddy" to the extravagant delight of the crowd. At this second platform, Harlem notables and returning heroes beheld each other with almost palpable elation and pride. No longer now in the dense, rapid-stepping formation learned from the French, ranks opened, gait loosened. "For the final mile or more of our parade," Major Arthur Little recalled, "about every fourth soldier of the ranks had a girl upon his arm—and we marched through Harlem singing and laughing."

Colonel Hayward shouted a command: the march halted. The Hell Fighters were home. They had come, as thousands of other returning Afro-American soldiers came, with a music, a lifestyle, and a dignity new to the nation—and soon to pervade it.

More than any other Afro-American leader, Massachusetts-born William Edward Burghardt Du Bois had reason to weigh carefully the full significance of the victory march, knowing that his moral re-

sponsibility for the regiment's seven hundred dead and wounded was great. The years of pioneering scholarship in history, sociology, and urban studies now well behind him, Du Bois was at the close of his fiftieth year and at the summit of his career as propagandist for his race. A short man who seemed to tower over other men, defiant, uncompromising (but also maddeningly inconsistent), Du Bois was in every respect truly remarkable—and in some unique.

His was a tangle of colonial New England lineages—Dutch Burghardts on his mother's side, French Huguenots on his father's, a "flood of Negro blood" from a forebear who sang her songs in Bantu—but, Du Bois often rejoiced, "thank God! no 'Anglo-Saxon.' " But for the light brown skin inherited from Africa, the prodigy from Great Barrington would have made his distinguished way in the world as the white lad he at first thought himself to be ("I remember well when the shadow swept across me"). Instead of entering Harvard College in 1884, though, he was required first to attend "colored" Fisk University in Nashville, Tennessee, finally reaching Cambridge to matriculate in the class of 1890 for a second distinguished bachelor's degree. Instead of merit graciously acknowledged, he had had to lay siege to the John F. Slater Fund with eloquent public statements and outstanding Harvard testimonials before the philanthropy (established to promote Afro-American education) surrendered a fellowship permitting graduate study in Germany. He had come within a term of winning the doctorate in economics from the University of Berlin, but his fellowship was not reëxtended. He had solaced himself with the doctorate in history from Harvard, where his imposing dissertation on the African slave trade to the United States was selected in 1896 as the first volume in *Harvard Historical Studies.*

Du Bois was now the senior intellectual militant of his people, a symbol of brainy, complex, arrogant rectitude widely respected by the common people. He was one of the first Afro-American leaders ever to preach solidarity with the darker peoples of the globe and to foretell the awakening of Mother Africa. North and South, there were few young people who had not been catechized in school or home by Du Bois's prophetic words from *The Souls of Black Folk,* his stirring 1903 book of essays: "The problem of the twentieth century is the problem of the color-line—the relation of the darker to the lighter races of men in Asia and Africa, in America and the islands of the sea." But Du Bois's twentieth-century prescience was long flawed by a belief in "pride of race

and lineage and self," which led this warrior against tyrannies of race and class to embrace a patently nineteenth-century theory of race and leadership. Mankind was divided into distinct races by subtle psychic differences. "The history of the world is the history not of individuals, but of groups, not of nations but of races," he thundered in a famous paper read before the American Negro Academy, "and he who ignores or seeks to override the race idea in human history ignores or overrides the central thought of all history." A Brahmin who lacked the common touch, he had formulated while at Harvard a concept of race leadership that was unabashedly elitist and in striking contrast to the prevailing populist ideas of his future nemesis, Alabama educator Booker T. Washington. "I believed in the higher education of a Talented Tenth who through their knowledge of modern culture could guide the American Negro into a higher civilization," Du Bois explained—a numerically insignificant class imposing itself by education and "character" on the masses.

This mesmerizing essayist had been editor of *The Crisis*, official monthly of the NAACP, since 1910. Du Bois had not founded the NAACP—that was largely the achievement of a small group of wealthy whites in May 1909—but his Niagara Movement, a loose-knit band of Talented Tenth men and women meeting for the first time in 1905 on the Canadian side of the falls, was its precursor. Such details were of moment only to historians. In the eyes of Afro-America, William Edward Burghardt Du Bois *was* the NAACP, a perception carefully weighed by the Association's other directors and officers, who accepted his unique dual position as member of the board of directors and editor of *The Crisis* with varying degrees of enthusiasm. As an orator he usually left audiences more informed than inspired, yet he had but to publish an article or essay to sway vast segments of Afro-American opinion. His editorship of *The Crisis* was so successful that, by 1919, the magazine was selling nearly one hundred thousand copies monthly. In an era of rampant illiteracy, when hard labor left Afro-Americans little time or inclination for reading Harvard-accented editorials, the magazine found its way into kerosene-lit sharecroppers' cabins and cramped factory workers' tenements. In middle-class families it lay next to the Bible. J. Saunders Redding, a teacher and literary critic, remembered that *The Crisis* "was strictly inviolate until my father himself had unwrapped and read it—often . . . aloud."

Now, as the troops were returning, Du Bois was in France, the

driving force behind the first (really the second) Pan-African Congress, a conclave of African, Afro-American, and West Indian notables vainly striving to influence the deliberations of the peacemakers at Versailles. But his ringing words about the war for democracy and the democracy that must come out of war still resounded in millions of memories. In the summer of 1918, after news of the first triumphs of black troops on French battlefields, he had written "Close Ranks," an editorial vibrating with that majestically portentous prose Du Bois manufactured for his most special pronouncements:

This is the crisis of the world. For all the long years to come men will point to the year 1918 as the great day of decision, the day when the world decided whether it would submit to military despotism and endless armed peace . . . or whether they would put down the menace of German militarism and inaugurate a United States of Europe.

Summoning his people to a supreme challenge, Du Bois had concluded, "We make no ordinary sacrifice." It was a vast understatement for a man whose rhetoric, like his life, ran to superlatives. And it had angered and bewildered many of the men and women who, until then, found nourishment in his heroic indignation before social injustice and his searing contempt for political compromise.

There was never any likelihood that the ten million Americans upon whom the duties of citizenship fell with greater weight than upon any others would refuse to fight for their country. Patriotism was as Afro-American as religion. Nor was it even possible for a people taken for granted by one political party and despised by the other, poor and overwhelmingly rural, frightened and disunited, to dig in its heels and call for a clean sweep of racial inequities before donning uniforms. But in the weeks before the country went to war, there had been firm demands from some Afro-American leaders for certain reasonable, minimal steps toward social equality. Their people had fought in the Revolution and every war since then. Their four congressionally authorized regiments, the "Buffaloes" (two of cavalry and two of infantry), had been cited for valor in Cuba, the Philippines, and Mexico by the War Department. The Afro-American leaders were determined that this time, when the cheering stopped and the bemedalled tunics were put away, their people would come home to more than pensions and broken promises. This time, the lynching must cease, the ballot booth open, and the jobs go to anyone who could work. And this time, black men must be led into battle by black officers.

How to achieve this was a matter of furious debate. Socialists like Asa Philip Randolph and Chandler Owen denounced the war as capitalist fratricide and pleaded for total abstention, but their publication, *The Messenger* ("The Only Magazine of Scientific Radicalism in the World Published by Negroes"), had an extremely modest impact in the Afro-American community. Independent race spokesmen like Boston's Harvard-educated William Monroe Trotter and Washington's Harvard-educated Archibald Grimké clamored for a reversal of segregationist policies by the federal government before Afro-Americans marched off to war. "We believe in democracy," Trotter's Boston *Globe* proclaimed, "but we hold that this nation should enter the lists with clean hands." Still, racial mainstream leadership was inclined to argue for patriotism now and justice later. "When the storm is past," Lieutenant Colonel Charles Young, the army's ranking Afro-American officer, urged, "we can take up the idealism of the cause." Major Charles Douglass, son of the great Frederick, agreed; now was the time for a moratorium on racial issues.

Yet the first reaction of all but the most acccommodating Afro-American leaders was one of open outrage at the War Department's announcement that officers of their race would be trained at a segregated facility, Camp Des Moines, in remote Iowa. None had really imagined that white troops would be commanded by black officers. But they had supposed that the dignity of a commission demanded training alongside whites, even if the races ate and slept apart. More than dignity was at stake: a "colored" camp in the hinterlands was very likely to be a sleazy operation, turning out incompetents whose performance would simply support the racist claims of "authorities" arguing the intellectual and psychological unfitness of the Afro-American to command. Instead of being the long-awaited opportunity for the best and brightest to demonstrate the worth and promise of the rest of the race, the commissioning of Afro-American officers had every appearance of racial fraud.

On July 2, 1917, little more than twelve weeks after the declaration of war and as Afro-Americans wondered aloud what the war would mean for democracy at home, the worst race riot in American history swept through the industrial city of East Saint Louis, Illinois. Thousands of Afro-American laborers had poured into the city from the South in less than two years, most of them imported by industrialists determined to squelch attempts at unionizing the white aluminum ore workers. Nearly two hundred Afro-Americans perished and six

thousand were burned out of their houses. "No land that loves to lynch 'niggers' can lead the hosts of Almighty God," Du Bois cried out in *The Crisis*, and for a time it seemed possible that the Afro-American's deep and dogged patience had been strained too far. Three weeks after East Saint Louis, with Du Bois and James Weldon Johnson in the front rank, officers of the NAACP led nearly ten thousand people down the same avenue that the 369th Infantry would mount to Harlem on its victorious return. Not one marcher uttered a sound, not even the children clad in white at the head of the silent parade of women in white and men in mourning colors. Signs proclaiming Biblical passages such as "Thou Shalt Not Kill," poignant contemporary injunctions—MR PRESIDENT, WHY NOT MAKE AMERICA SAFE FOR DE-MOCRACY—and the giant streamer behind the national flag crying YOUR HANDS ARE FULL OF BLOOD, spoke for them.

Barely a month after the silent Protest Parade came the Houston riot. Men of the Twenty-fourth Infantry Battalion, brutally treated by white officers and regularly arrested whenever they ventured into town from their camp outside Houston, charged through the streets on the night of August 23, killing seventeen whites. Sixty-three Afro-American soldiers were court-martialled and thirteen hanged without right of appeal. Forty-one were sent to prison for life, and a second court-martial, to appease southern senators, would have consigned six more to the gallows but for a presidential reprieve. Once again, Du Bois staggered under the twin burden of rage and shame, pausing only to renew his purpose. By then he was committed to supporting the war effort, whatever the humiliations visited upon his people, firmly convinced that history, if not recent events, was on his side.

It was also true that the War Department was, by now, concerned enough to court the civil rights leadership. It had a superb ally in the white chairman of the board of the NAACP, elegant, aloof Joel Elias Spingarn, scholar, partisan of neighbor Theodore Roosevelt's "strenuous life" ideal, and soon to be a major in army intelligence. Lean and dark, with a long face and probing eyes that suggested both chivalry and calculation, this descendant of a wealthy German Jewish family lived in semiretirement at Troutbeck, his country estate near Amenia, New York. Retirement was, perhaps, inaccurate, for he had not retired from his profession of university academic; he had risen above it. Spingarn had been an inspired teacher of literature at Columbia University, renowned for his lectures on "The New Criticism." Yet his proudest hour had come in 1911 when he was fired for opposing

the arbitrary dismissal of a famous colleague by Columbia's autocratic
president, Nicholas Murray Butler. Spingarn would celebrate the anni-
versary of his own departure until his death, on one occasion sending
cards to friends with his poem "Héloise sans Abélard." It ended:

> O passionate Héloise,
> I too have lived under the ban,
> With seven hundred professors,
> And not a single man.

Spingarn and Du Bois had recognized a New England kinship of
patrician combativeness and superior culture almost immediately and
were as close as two aloof intellectuals could be. Spingarn was prob-
ably the only white man Du Bois regarded as a true friend and, with
James Weldon Johnson, one of the few people occasionally able to
influence *The Crisis* editor. Not many men or women ever ventured to
upbraid William Edward Burghardt Du Bois; Spingarn could pull it
off. In an October 1914 letter, he had gone on for paragraph after
paragraph spelling out the editor's faults, telling Du Bois that he had
"an extraordinary unwillingness to acknowledge that you have made a
mistake, even in trifles, and if accused of one, your mind will find or
invent reasons and quibbles of any kind to prove that you were never
mistaken." In the matter of the segregated officers' camp, Spingarn was
able, once again, to influence his friend. Segregation was abhorrent to
the NAACP board chairman, but qualified patriotism was even more
so.

Three months before the declaration of war, General Leonard
Wood, former army chief of staff, had let it be known that a few
hundred Afro-Americans might be commissioned if his friend Spingarn
could help recruit volunteers for Camp Des Moines. Dismissing the
philosophical and racial objections of fellow board members and prom-
inent chapter presidents, Spingarn wrote pamphlets and went on the
lecture circuit to win support for the camp. There was "only one thing
for you to do at this juncture," his open letter to "Educated Colored
Men of the United States" declared, "and that is to get the training that
will fit you to be officers, however and wherever this training may be
obtained." By June 1917, *The Crisis* sounded like Spingarn. What had
been a humiliating expediency at best was now being described as a
shining triumph. "We have won!" Du Bois cheered after the War De-
partment's official announcement. "The camp is granted. We shall have

1,000 Negro officers in the United States Army! Write us for informa-
tion."

Thirteen months later, when Du Bois wrote, "We make no ordinary
sacrifice," in his "Close Ranks" editorial, the reality was all too clear.
There was still lynching in the South. President Wilson had acted with-
out an iota of compassion in the Houston affair. Hundreds of thou-
sands of Afro-American draftees were being sent, over strenuous
NAACP protest, to army labor and quartermaster units rather than to
combat units. And despite the press abuse hurled at the War Depart-
ment and hundreds of letters and telegrams to the White House plead-
ing for just this one gesture of presidential fair play, the highest-ranking
Afro-American officer, Lieutenant Colonel Charles Young, was or-
dered into retirement on spurious medical grounds. Publicly, West
Pointer Young wrote the Pittsburgh *Courier* to defend the fairness of
his examining physicians. Privately, the cavalry officer with outstand-
ing combat experience in Mexico poured out his anguish to Du Bois
from Letterman General Hospital: "No one in the regiment, either
officer or man, believes me sick and no one save the doctors here
at the hospital; not even the nurses. Without one ache or pain, here I
sit twirling my thumbs, when . . . I should this minute be at Des Moines
helping to beat those colored officers into shape." Young rode horse-
back from his Ohio National Guard assignment to Washington to
demonstrate his fitness. It was hopeless.

Stunned and bitter, many veteran race leaders saw a historic oppor-
tunity slipping away. "Now, 'while the war lasts,' is the most opportune
time for us to push and keep our 'special grievances' to the fore," one
of them wrote Du Bois. Monroe Trotter's year-old charge that Du Bois
had "betrayed the cause of his race" and was a "rank quitter of the
fight for our rights" seemed confirmed. By late summer of 1918,
though, critics of *The Crisis* editor were a defeated minority. Ironi-
cally, Du Bois's war propaganda had succeeded so well in rallying the
Afro-American community to the national cause that the War Depart-
ment felt secure in reneging on its offer of a captaincy in army intelli-
gence. (Perhaps he was even relieved, as leave from the NAACP with
pay had become highly problematical and Archibald Grimké had
threatened to lead the Washington chapter out of the Association if Du
Bois accepted the commission.) Yet it was clear that for Afro-Ameri-
ca's greatest mind and most eloquent pen, the thrilling vision of black
troops fighting and dying across Flanders fields, led by Des Moines
officers, promised compensation for three centuries of appalling hu-

miliations and brutality. Du Bois had embraced the hope of full citizenship through carnage.

When the finely drilled 371st Infantry Regiment marched out of Camp Jackson, South Carolina, bound for France, a gangling Mississippi sergeant had cursed and said in a voice thick with emotion, "I'm done talking about niggers. These boys have been fine soldiers here, and if they ever get back from France, I'm big enough to lick any man who don't give 'em a square deal." Two hundred thousand Afro-Americans were sent to France, most into service and labor units, but nearly thirty thousand to the front lines. Before the army closed Camp Des Moines in late October 1917, 622 officer candidates had been commissioned. By war's end, almost four hundred thousand Afro-Americans had left the farm and the city for army camps. Their tragedy, and the nation's, was to be that reformed racists were very much a minority. Far more typical than the emotions of the Mississippi sergeant was the drawling threat of a New Orleans white man. "You niggers are wondering how you are going to be treated after the war. Well, I'll tell you, you are going to be treated exactly like you were before the war."

The creation of Afro-American combat soldiers and officers "was regarded by practically all regular Army officers as one of the greatest mistakes ever made by the War Department," a white civilian observer stationed abroad wrote. Sergeant George Schuyler, then a career soldier and later on the staff of Asa Philip Randolph's *Messenger*, was sent to Camp Des Moines to train the cadet officers. "When none of the prescribed courses of study given at other (white) camps were given to the colored candidates," he decided that the segregated camp "had every appearance of sabotage." Two hundred fifty candidates were drawn from the army's four regiments of Afro-American regulars, most of them with no more than eighth-grade educations. Not only were they commissioned in large numbers, they received most of the higher commissions. One major had been a War Department messenger. Ivy League graduates were treated like pariahs, and those from Afro-American liberal arts colleges were only slightly less detested. There was a decided preference for graduates of schools noted for industrial training.

Racism or not, the war demanded men. General Pershing was desperate for reinforcements. Only two months after the Houston riot, the War Department reluctantly ordered the cocky New Yorkers of the 369th Infantry Regiment abroad. It had been unavoidable. A sergeant

in the 369th, Noble Sissle, had been cursed and his cap knocked off when he and Sergeant James Europe tried to buy a newspaper in the whites-only lobby of a Spartanburg, South Carolina, hotel. The troops had started to march on the town the next night, and Colonel Hayward stopped them only by means of much desperate eloquence. There had been danger of another Houston. Within weeks the regiment sailed for France, where, after delays caused by suspicious engine troubles, a fire, and a damaged hull, it finally disembarked at Brest, on December 27, 1917. The French High Command called for rapid amalgamation of American troops with French units.

Soon, the War Department was being warned of other potential flash points in the South and Southwest. The Eighth Illinois, now the 370th Infantry Regiment, encamped outside Houston and commanded by Franklin Dennison, the sole Afro-American colonel since the enforced retirement of Charles Young, and officered entirely by Afro-Americans, was an anomaly that daily flabbergasted and infuriated local whites. In May 1918, it was dispatched to France, like the 369th, in advance of its division. By August 1918, one full-strength Afro-American division, the Ninety-second, had arrived; while the separately trained National Guard regiments of the "provisional" Ninety-third (comprised of the 369th, 370th, 371st, and 372nd regiments) had been placed under French command by General Pershing.

For what it was worth, President Wilson assured a delegation of Afro-American clergymen, "Your people have exhibited a degree of loyalty and patriotism that should command the admiration of the whole nation." But signs of the old order vigorously reasserting itself were too numerous to allow informed men and women to expect fair play, let alone generosity. In 1918, seventy-eight Afro-Americans had been lynched. Southern newspapers editorialized ghoulishly about the fate awaiting any Afro-American veteran daring to come home uniformed, bemedalled, and striding up main street like a white man. Southern congressmen informed the War Department of their extreme displeasure at the generous publicity given by the French press to Afro-American fighting units. A secret United States Army communiqué to French forces in early August advised the French "not to commend too highly the American troops, particularly in the presence of [white] Americans." To prevent "the presence of colored troops from being a menace to women," the Ninety-second Division was confined to camp and subjected to hourly checks. If it could not get rid of them, the army was determined to do its best to hide them from history. No Afro-

American troops participated in the glorious victory parade down the Champs-Elysées, although the blacks and browns of the British and French forces were prominently represented. The ultimate injustice was the War Department's insistence that Afro-American soldiers not be depicted in the heroic frieze displayed in France's Panthéon de la Guerre.

It was not surprising that a Williams College Phi Beta Kappa, Lieutenant Rayford Logan, came to loathe his country so much that he managed to be demobilized in France, intending to remain abroad indefinitely. Men like Lieutenant George Schuyler and Sergeant-Major Charles Spurgeon Johnson elected to return, but war experiences had fired them, each in his own significant way, with plans to bring about decisive changes. Boston's venerable Moorfield Storey, former president of the American Bar Association and president of the NAACP, fully comprehended the new sense of dignity and defiance spawned by the war. "The Negroes will come back feeling like men," he predicted, "and not disposed to accept the treatment to which they have been subjected." But it was left to Du Bois, returning from the Pan-African Congress, to chant the fighting spirit of the race most memorably. Two and a half months after the victory parades of New York's 369th and Chicago's 370th regiments, "Returning Soldiers" appeared in *The Crisis*, a long, stirring message which concluded:

The faults of *our* country are *our* faults. Under similar circumstances, we would fight again. But by the God of heaven, we are cowards and jackasses if now that the war is over we do not marshal every ounce of our brain and brawn to fight a sterner, longer, more unbending battle against the forces of hell in our own land.

We *return*.
We *return from fighting*.
We *return fighting*.

Make way for democracy! We saved it in France, and by the Great Jehovah, we will save it in the United States of America, or know the reason why.

Religious and racial intolerance, political and judicial heavy-handedness, and moralistic excess were the immediate legacies of the war. Prohibition was one result; the war for world democracy had also been a war to preserve and revivify native virtues, and it was easy for many to believe that "John Barleycorn" was an enemy even more insidious

than German spies. And there appeared to be poisons even more toxic
than those from a bottle. Bomb-throwing anarchists, antiwar socialists,
and plotting communists, harboring social visions as weird as their un-
American names, were, many Americans truly feared, about to rip
apart the fabric of a society already badly strained by economic unrest
—by strikes involving shipyard workers, coal miners, and steelworkers,
and even the Boston police force. Revolution in Russia and the rapid
spread of soviets in Germany and Hungary no longer encouraged dis-
crimination between parliamentary socialists and those true com-
munists (few in number) obedient to the Third International, or even
consideration of obvious differences between a romantic Marxist like
John Reed and an anarchist terrorist like Alexander Berkman.

Woodrow Wilson lay paralyzed, though mentally unimpaired, in his
White House sickbed. Law was in the hands of A. Mitchell Palmer, his
attorney-general. Palmer (the "Fighting Quaker," as he liked to be
called) had a simple solution for the national crisis: terrorize those he
could not deport and deport those who, because they were aliens, were
ipso facto terrorists. "Not for at least a half century, perhaps at no time
in our history, had there been such wholesale violation of civil liber-
ties," a historian of the period writes. In August 1919, the attorney-
general created the antiradical division of the Justice Department,
headed by J. Edgar Hoover. During the next four months federal and
state agents engaged in an orgy of searches, roundups, and jailings of
thousands of "subversives." Eugene Debs, the socialist leader, was al-
ready confined to an Atlanta prison cell; Victor Berger, the party's
other major leader, was jailed and denied his seat in the U.S. House of
Representatives. The New York State legislature, lathered up by its
Committee on Seditious Activities, expelled its five socialist members.
Under cover of the Alien Act of 1918, Palmer planned the deportation
of more than a thousand men and women against whom the only
proven reproach was foreign birth. Objections within the cabinet and
from the judiciary forced him to reduce the number to 249; all of them
were dispatched aboard the S.S. *Buford* to Russia by way of Finland,
in late December.

For nearly six months, Palmer, well served by the Senate Judiciary
Subcommittee and New York State's Committee on Seditious Activi-
ties, was America's strong man. According to the attorney-general's
alarming report on subversion, released in November, the country was
honeycombed with anarchists and Bolsheviks. He predicted there
would be an attempt to overthrow the government on May Day 1920.

In fact, by the end of January, the public was sated with raids and the rhetoric of imminent revolution. The strikes were ending, the economy improving rapidly, and the bombings subsiding. Even though the bombers were to go out with a terrific bang—thirty people killed on September 16, 1920, at the junction of Broad and Wall streets where the House of Morgan, the New York Stock Exchange, and the Sub-Treasury faced each other—the panic was over. A. Mitchell Palmer had in the end failed to convince the country that it was in immediate peril and, by implication, desperately in need of a man of his no-non-sense abilities as president: one who could build the alcohol-free, Bolshevik-less, immigrant-purged New Jerusalem.

To the average Afro-American, the "Red Scare" of 1919 was a white phenomenon that meant little or nothing. If he gave it any thought at all, he might even have been inclined to favor harsh mea-sures against political malcontents and labor troublemakers. Governed by the law of last-hired-first-fired, he tended to applaud bills in Con-gress aimed at staunching the flow of immigrants from Europe. "Just hold that door [shut] a few years longer, Uncle, and you'll be s'prised" was the caption to a Pittsburgh *Courier* cartoon. It portrayed a brawny black worker standing with back to a padlocked door marked "Ellis Island." This average Afro-American remained remarkably ignorant of and untouched by the socialisms of the day. Almost alone *The Messenger* had continued to oppose the war, while espousing the eco-nomic program of the Industrial Workers of the World. Its editors Chandler Owen and Asa Randolph were the only Afro-Americans to be arrested and tried for violating the Espionage Act, in early August 1918. A year after their trial, J. Edgar Hoover would conclude that Owen and Randolph were among the most dangerous radicals in America (the postmaster-general concurred, banning *The Messenger*), but the magistrate in Cleveland had not believed that the two young black men before him were capable of writing the articles charged against them. Whites also believed that the Red Scare was exclusively white men's business.

Yet it was evident to astute observers that hysteria and repression could not be racially segregated. A great and growing number of white victims of postwar economic hardship would demand a more obvious scapegoat for their woes, and Afro-Americans had served in this sorry role before. It was in the summer of 1919 that the violence came. For Afro-Americans, that "Red Summer" was a Gehenna, compared to which the ordeal of anarchists, communists, socialists, immigrants, and

white workers was merely scarifying. On May 10—a Saturday night—
a white sailor shot to death an Afro-American civilian in Charleston,
South Carolina. Unlike authorities in most of the twenty-five subse-
quent race riots that year, Charleston officials took firm measures im-
mediately to restore order. When police were overwhelmed by
marauding sailors, the mayor demanded that naval authorities send in
the marines. Shore leaves were cancelled and an uneasy calm was
restored by morning, with a total of two Afro-Americans dead and
seventeen wounded; seven sailors and one policeman were injured.

Meanwhile, lynching was being pursued with a relish approaching
that of the 1890s. In Ellisville, Mississippi, in late June, overzealous
members of a posse fatally wounded an alleged rapist named John
Hartfield as he fled through a cane field. A local white physician kept
the victim alive for the ritual the following day. Local newspapers an-
nounced the time and place of Hartfield's lynching, while Governor
Theodore Bilbo abjured responsibility ("Nobody can keep the inevita-
ble from happening"). Three thousand farmers and townspeople
gathered at the appointed tree and, after debating the best means of
liquidation, Hartfield's executioners hanged, burned, and, for good mea-
sure, shot him.

A few weeks later, in Longview, Texas, there was another outbreak
of racial violence, this time with economic undertones. Longview was
already unsettled by the activities of a group called the National Negro
Business League, founded in 1900 by Booker T. Washington to spread
the gospel of race solidarity and economic self-improvement. The
League in Longview had successfully persuaded farmers to bypass the
local white cotton growers and negotiate directly with buyers in Gal-
veston. The sequence of events began when the nude, bullet-ridden
body of a young Afro-American turned up outside Longview. A day or
two afterwards, the weekly edition of the Chicago *Defender*, a widely
circulated Afro-American newspaper, arrived in Longview carrying a
detailed and bloody account of the murder. White townspeople soon
concluded that the author of the article was S. L. Jones, a high-school
teacher in Longview and, with a physician named C. P. Davis, co-
director of the local Business League branch. On July 10, Jones was
beaten and ordered out of town by sundown, along with Davis. The
two men were defiant. Armed League members assembled at Jones's
house that night, and when the whites attacked, Davis fired the first of
some one hundred fifty shots which killed four of the mob and left
several lying wounded in the darkness. Militia and rangers dispatched

by the governor enforced martial law in Longview after whites had burned a number of houses and savagely murdered Davis's father-in-law. Jones and Davis managed to escape.

One Saturday night later in July, Washington, D.C., erupted. A near-casualty of the riot was a Howard University professor named Carter G. Woodson, Harvard man, author, and founder of the *Journal of Negro History*. Abstractedly making his way home along Pennsylvania Avenue on Sunday evening, July 20, Woodson may have been thinking about his unfinished article "Relations of Negroes and Indians in Massachusetts," but probably not about the month-long inflammatory reportage in the local press. In any case, he was startled when "there ran by me a Negro yelling for mercy and the like pursued by hundreds of soldiers, sailors, and marines, assisted by men in civilian attire." Slipping into the entryway of a department store as shots were fired at the man, Woodson crouched with his back to the mob. Fortunately, two white women joined him in the entrance, pleading for protection ("I felt like appealing to them to save me") but also hiding him from view. Politely taking leave of the ladies after several minutes and moving stealthily past Kahn's department store, the professor stumbled upon a second mob and a gruesome scene that he recounted to a congressional committee: "... They had caught a Negro and deliberately held him as one would a beef for slaughter, and when they had conveniently adjusted him for lynching they shot him. I heard him groaning in his struggle as I hurried away as fast as I could without running, expecting every moment to be lynched myself."

Washington's riot raged for two days, criminally abetted by the Washington *Post*. On July 22, the newspaper went so far as to provide marching orders to the rioters, announcing that "a mobilization of every available service man . . . has been ordered for tomorrow evening. . . . The hour of assembly is nine o'clock and the purpose is a 'clean-up' that will cause the events of the last two evenings to pale into insignificance." Like those in Longview, the city's Afro-Americans fought back. Weapons were imported from Baltimore and light-skinned soldiers in uniform infiltrated the mobs in order to bring back valuable intelligence to their communities. The mobilization signalled by the *Post* was aborted when Secretary of War Newton Baker ordered two thousand infantry to police the city on the evening of the twenty-second and a driving rain sent rioters indoors. Although more than a hundred people were injured—many seriously—only six had been killed.

Five days later, it was Chicago's turn. A lone white man had thrown

rocks at five Afro-American boys swimming from a makeshift raft anchored in Lake Michigan. One of them, Eugene Williams, drowned after a blow on the forehead. By late afternoon, July 27, Chicago was at war with itself. For five days, Afro-Americans and whites fought back and forth across Wentworth Avenue, the frontier dividing the white, blue-collar stockyard neighborhoods from the Black Belt. Mayor William Thompson finally called for the state militia on the evening of July 30. When the hostilities ended, 15 whites and 23 Afro-Americans were dead, 537 people wounded, and more than 1,000 homeless.

What had occurred in Chicago involved much more than simple racism. The radical showdown there was the culmination of a classic conflict between labor and capital. Superficially, race relations were no worse in Chicago than elsewhere in the urban North. It was a long way from being the Eden painted by the Chicago *Defender*, but its reputation as a good place to find employment and to live without fear had attracted tens of thousands of Afro-Americans in recent years. Chicago's Afro-American population increased in the decade 1910 to 1920 by 148.2 percent, most of the migrants arriving after 1917. There was a similar increase in Detroit, where migrants from the South swelled the Afro-American population by no less than 611.3 percent; Indianapolis, 59 percent; Cincinnati, 53.2 percent; and Pittsburgh, 47.2 percent. Three hundred thousand, and possibly many more, Afro-American farmers, unskilled laborers, and domestics left the South before 1920.

Booker Washington's lieutenant, Emmett Scott (now treasurer of Howard University), thought they came in quest of education for their children. The head of the Chicago Urban League was certain that lynchings were the cause. "Every time a lynching takes place in a community down South," T. Arnold Hill explained, "you can depend on it that colored people will arrive in Chicago within two weeks." A small number of courageous white southern newspapers were also certain that rampaging brutality was causing the great exodus. Georgia's Tifton *Gazette* enumerated typical horrors that drove Afro-Americans out of the South:

They have allowed negroes to be lynched, five at a time, on nothing stronger than suspicion; they have allowed whole sections to be depopulated of them (notably in several north Georgia counties); they have allowed them to be white-capped and to be whipped, and their homes burned, with only

the weakest and most spasmodic efforts to apprehend or punish those guilty—when any efforts were made at all.

"It all gets back to a question of manhood," Ray Stannard Baker, a white student of racism, was told. Manhood was a factor but "whatever grievances of this nature the Negro may have against the South," one careful social historian rightly concluded, "he has at least no new complaint and, therefore, no stronger reason for migrating on this account in 1917 than he has had for several decades." The real reason for the mass migration was economic. The deadly blows to the South's economy from natural disasters during 1915 and 1916—drought and rain and the boll weevil—launched the evacuation.

> Boll-weevil in de cotton
> Cut worm in de cotton,
> Debil in de white man,
> Wah's goin' on.

There was one other development without which the Afro-American migration would have been considerably less—the wartime decline in European immigration at the very moment when American industry needed more cheap labor. In 1914, immigrants arriving from overseas numbered 1,218,480. The next year, the figure plunged to 326,700. Three years later, it was down to 110,618. Meanwhile, four million Americans were being conscripted for military service. From late 1915 onward, the South was full of agents recruiting labor for northern industry. Railroad tickets were dispensed gratis or advanced against forthcoming wages; trains backed into small towns and steamed away with most of the young and the fit; and the Chicago *Defender* bally-hooed the milk and honey up North. As many as 1,300,000 Afro-Americans were reading or having read to them the weekly national edition of the *Defender*. Its direct impact on migration statistics is debatable, but of its powerful reinforcement of the lure of high wages in the North there is no doubt. On the average, Afro-American work-ers earned between $3.00 and $3.60 per day; steelworkers could make as much as $4.50. In the South only 4 percent ever made more than $3.00 daily. The top pay for Afro-American steelworkers in Birming-ham, Alabama, was $2.50 for a nine-hour day.

And so they came by the ten thousands, pouring into Chicago to work in the stockyards, the iron and steel forges, the electrical machin-

ery and machine shop plants, and on the railroads. They also came as
potential strikebreakers. Most white locals throughout the nation rig-
idly excluded them either by charter or in practice; other unions were
segregated; and many enrolled them for the duration of a confronta-
tion with management, only to expel them later. Unionized Afro-
American carpenters, electricians, masons, and plumbers were almost
as rare in Chicago as Afro-American businessmen. With good reason,
then, whether skilled worker or diplomaed political activist, most Afro-
Americans looked upon organized labor with only slightly less hostility
than they did the Klan. "Fuck the union" was the mildest expletive
greeting white organizers in the summer of 1919, and Chicago's indus-
trial and meat magnates were confident of having created a pool of
eager scabs. Du Bois joyously shared their confidence, writing in *The
Crisis* that the Afro-American worker "will soon be in a position to
break any strike when he can gain economic advantage to himself."
With 250,000 workers locked out or on strike in Chicago in late July
1919, the city was primed for the race war touched off by the drowned
boy in Lake Michigan.

Next came serious racial disorders in Knoxville, Tennessee, at the
end of August, followed by even more bloody disturbances a month
later in Omaha, Nebraska, and intervention by army troops com-
manded by General Leonard Wood. The October pogrom in Arkansas
may have cost several hundred lives, as white posses combed rural
Phillips County tracking and murdering Afro-Americans. More than a
hundred so-called insurgents were rounded up with the help of troops
and marked for grand jury indictment by a special "Committee of
Seven" (the sheriff, deputy sheriff, county judge, town mayor, and
three businessmen) at Helena, Arkansas, the county seat. Indictments
of seventy-three men were returned on October 30. By November 18,
twelve were sentenced to death and the rest (with one acquittal or-
dered by the judge) rapidly convicted in batches to serve terms ranging
from five to twenty-one years. Their real crime had been to dare to
organize the Progressive Farmers and Household Union of America, a
grandiloquently named and potentially realistic means of breaking out
of the iron ring of peonage. They had made clear that they were not
only courageous but determined to avoid costly mistakes by hiring a
white Little Rock attorney whose maverick Confederate pedigree and
tough lawyering lived up to the resonantly brawling name of U. S.
Bratton. It had been the catalytic appearance of Bratton at church
meetings in and around the town of Elaine that drove the whites to

surround the little church at Hoop Spur at 2 a.m. on October 1. Their fusillade was returned by the church people, killing and wounding several white community leaders. Local officials, the Arkansas press, and even *The New York Times* reported that there had been an armed Afro-American conspiracy to seize control of Phillips County. It was left to a young light-skinned officer of the NAACP named Walter White, investigating the facts at considerable personal danger, to report in print the true story of the butchery of people whose only crime was defiance of their peonage, of the partisan role of the army, and of the travestied legal proceedings at Helena.

The year 1919 was less than seven weeks old when the 369th Infantry Regiment marched proudly up Fifth Avenue. By the end of 1919, there had been race riots in two dozen cities, towns, or counties, rampant lynchings and resurrection of the Ku Klux Klan, and a dismal falling off of jobs in the North for Afro-Americans. Professor Carter Woodson had foreseen disastrous consequences for the northward migration, warning that "the maltreatment of Negroes will be nationalized by this exodus. The poor whites of both sections will strike at this race long stigmatized by servitude but now demanding economic equality." Trapped in the doorway of that Washington department store, Woodson saw the beginning of a holocaust. In nine terrible months, the best of times had become the worst of times, driving a young Jamaican poet in New York to strike off a poem with defiant lines that Afro-Americans soon chanted in the manner of a battle oath. "If we must die, let it not be like hogs / Hunted and penned in an inglorious spot," Claude McKay exhorted.

> O kinsmen! we must meet the common foe!
> Though far outnumbered let us show us brave,
> And for their thousand blows deal one deathblow!
> What though before us lies the open grave?
> Like men we'll face the murderous, cowardly pack,
> Pressed to the wall, dying, but fighting back!

When the North abandoned the former slave to his southern fate forty-odd years earlier, he had found no better social gospel to embrace than that of the industry, humility, and patience preached by Booker T. Washington. The Red Summer and its aftermath forged a different leadership, however. Washington, D.C., and Chicago had shown how

little fear of white men there was among demobilized Afro-American
soldiers or peasants who had braved the unknowns of migration. Now,
from the lips of virtually every spokesman and the pages of every
publication there was suddenly not only a bold new rhetoric—there
was a "New Negro." "The Old Negro goes," Harlem's militant *Cru-
sader* announced. "His abject crawling and pleading have availed the
Cause nothing." "The NEW NEGRO, unlike the old time Negro 'does
not fear the face of day,' " proclaimed the Kansas City *Call*. "The time
for cringing is over." He would prefer to remain peaceful, to be patient
so long as his demands were negotiated with good will. He was philo-
sophical enough, said the Chicago *Whip*, to understand that the rioters
"really fear the Negro is breaking his shell and beginning to bask in the
sunlight of real manhood"; optimistic enough, said the *Christian Re-
corder*, to hope that these were "the dark hours before morning which
have always come just before the burst of a new civic light." But the
New Negro would counter violence with violence, if necessary. The
choice was white America's, thundered *The Challenge Magazine*:
"The 'German Hun' is beaten, but the world is made no safer for
Democracy. Humanity has been defended, but lifted no higher. De-
mocracy never will be safe in America until these occurrences are
made impossible either by the proper execution of the law or with
double-barrel shot guns."

Yet though the new mood of militancy was genuine and widespread,
there were leaders and thinkers who doubted both the necessity and the
desirability of death with dignity. They recalled that the ennobling
rhetoric of the New Negro had been heard long ago, decades before the
Civil War, in David Walker's insurrectionist *Appeal in Four Articles*
and Robert Young's defiant *Ethiopian Manifesto*. Then, the great ma-
jority of Afro-Americans had chosen not to provoke certain death by
rebelling against their masters. They had elected to survive while striv-
ing (most of them) to keep as much dignity as bondage allowed. Those
who harbored doubts about braving genocide in 1919 were already
searching for a less heroic role for the New Negro to play in defending
the rights of his people. These pragmatic New Negroes understood that
the strategy and means to accomplish this would be neither straight-
forward nor short-term. The Red Summer had shown that most white
Americans, North and South, were in no mood for generosity, and that
outright conflict was a course pointing to almost certain doom.

2
City of Refuge

In 1905, the New York *Herald* announced the beginning of the end of white Harlem. "An untoward circumstance has been injected into the private dwelling market in the vicinity of 133rd and 134th streets," the paper noted in its edition for Christmas Eve. At 31 West 133rd Street tenants were leaving: there had been a murder in one of the apartments.

The apartment house manager's problems could hardly have come at a worse time. The Lenox Avenue subway was a year old but it had failed to improve the housing market north of Central Park as expected, because of the 1904–1905 depression. Desperate, the manager agreed to meet with Philip A. Payton, Jr., a high-rolling young Afro-American realtor who had been on the alert for just such an opportunity. Payton filled the 133rd Street building with reliable tenants of his own race who were happy to pay a five-dollar premium per apartment. (Fifteen years before, the photographer and journalist of the down-and-outs, Jacob Riis, had discovered that landlords frequently preferred Afro-Americans as cleaner, more stable tenants than "lower grades of foreign white people"—and, Riis added, because they could charge the Afro-Americans much more.)

Hundreds, then thousands, of clean, stable, high-rent-paying families poured into the new corridor running through the mid-130s between Fifth and Seventh avenues, despite the furious opposition of the white Property Owners Protective Association of Harlem. Unfortunately for them, the property owners were divided. Most resident owners deplored the incursion, while many nonresident owners found the lure of higher rents so attractive that they encouraged their tenants to move out. Some feigned regret, as a 1916 owner's notice showed:

> We have endeavored for some time to
> avoid turning over this house to
> colored tenants, but as a result of . . .
> rapid changes in conditions . . . this
> issue has been forced upon us.

The richest Afro-American businessman in New York, undertaker James C. Thomas, stood behind Payton's company. When the Pennsylvania Railroad bought Thomas's property at 493 Seventh Avenue for $103,000 cash, Payton guided Thomas into Harlem real estate speculation. Over the next fifteen years, the former waiter and mortician invested a quarter of a million dollars in Harlem apartment buildings at prices that usually assuaged the bitterness of panicky white property owners. When Thomas died in 1922, his fortune had greatly increased. Unfortunately, Phil Payton spent money faster than he made it. "It is all gone," he told a friend a few days after a dazzling deal. Payton's company folded in 1908, but the new firm of Nail and Parker stepped into the breach. By 1920 Afro-American expansion in Harlem no longer depended entirely upon sharp realtors and their mulatto and white front men.

Around the World in New York, a brisk seller of 1924, quoted the wistful recollection of one of Harlem's vanishing Germans:

Gone the agreeable homes where the rows and rows of long-stemmed meerschaum pipes hanging from the wall gave to every home that manly quality so dear to the Teuton race. It used to be so pleasant to pass a Harlem Street on a summer evening. The young ladies were accompanying their *Lieder* with the twanging of the soft zither, and the stirring robust melodies from the Lutheran churches used to fill the air on a Sunday.

If *Turnsverein* and *Liederstube* were now as rare as Baptist churches on the Lower East Side, Harlem was by no means all black by the early twenties, and much of the 125th Street area would hold out until the end of the decade. Just how many Afro-Americans there were in New York, no one knew. An Urban League study cited 1923 federal census estimates of 183,428 for the entire city. A more likely figure of 300,000 was provided by the Information Bureau of the United Hospital Fund. Whatever the exact number, most—perhaps two-thirds of them—were in Harlem, but they still represented no more than 30 percent of the total Harlem population. Whites evacuated Harlem as reluctantly as Afro-Americans flocked to it. Slicing almost the full

length of the district, Eighth Avenue cleanly severed black from white. From Eighth to the Hudson River few Afro-Americans were to be found. East of Eighth to the Harlem River, from 130th to 145th streets, lay black Harlem, the largest, most exciting urban community in Afro-America—or anywhere else, for that matter.

Harlem had seemed to flash into being like a nova. The war ended, and there it was, with its amalgam of money and misery, values and vices, hope and futility. The development of black Harlem was, nevertheless, not really so swift and unheralded as it seemed. Its existence had been anticipated by the faithful of Manhattan, the sixty-odd thousand Afro-Americans who lived in midtown's vastly overcrowded Tenderloin and San Juan Hill districts. The Tenderloin, stretching roughly from West Twentieth to Fifty-third streets in Manhattan, had first become the city's home for nonwhites during the early nineteenth century, following migration from the old Five Points slums east of today's Foley Square. By the 1890s, Afro-Americans were pushing above Fifty-third Street into the congested area of San Juan Hill, where they fought the Irish for a portion of that pitiable turf. Midtown was a pressure cooker, as fertility and immigration strained against the invisible walls of the ghettoes and the construction of Pennsylvania Station further diminished crucial land space.

The thousands of new New Yorkers from Georgia, the Carolinas, Virginia, and elsewhere gave the area a decidedly southern overlay. Of Manhattan's 60,534 Afro-Americans in 1910, only 14,300 had been born in New York. Problems of overcrowding, assimilation, and friction within the group and with the Irish racked the Tenderloin (a bloody riot in 1900 had been one result), but on the positive side was the New York *Age* reminder that "the great influx of Afro-Americans into New York City from all parts of the South made . . . possible a great number and variety of business enterprises." Just as the Lower East Side Jews had accumulated money through hard work and group unity and had then stampeded to Lower Harlem in the 1890s (where apartment signs announcing *Keine Juden und Keine Hunde* greeted them), Afro-American families in mid-Manhattan with a prayer of meeting Payton's rents signed up with the Afro-American Realty Company. Somewhat later, many of Brooklyn's Afro-American bluebloods—clannish, long-established families with substantial incomes from preaching, retailing, and catering—began selling their neat homes and moving to the "Negro capital of the world."

For two varieties of Afro-American enterprises—churches and

cabarets—money was especially abundant. Saint Philip's Episcopal Church disposed of its Tenderloin property on West Twenty-fifth Street for $140,000 in 1909 and liquidated its cemetery two years later for $450,000. Unable to buy a white church in Harlem, the congregation hired Afro-American architect Vertner Tandy and erected an admirably restrained early Gothic building on West 134th Street. Saint Philip's also astounded the New York real estate market by purchasing $640,000 worth of apartment buildings, at the time one of the largest exclusively Afro-American transactions of the era. An African Methodist Episcopal congregation followed three years later, purchasing the Church of the Redeemer through a ruse and renaming it "Mother Zion." Mighty Abyssinian Baptist Church, founded shortly after the turn of the century along with Saint Philip's, also sold its holdings for a fortune and migrated to Harlem, as did one-hundred-year-old Bethel African Methodist Church. Little Salem Methodist, a basement operation organized in 1902 by Reverend Frederick Asbury Cullen, Countee Cullen's adoptive father, began in Harlem and quickly enriched itself and expanded into grander quarters.

Of the several cabarets in the Tenderloin destined to play a notorious Harlem role, three—Banks's, Barron's, and Edmond's—were particularly outstanding. Banks's Club was raunchy, boozy, ragtimey honky-tonk, slightly dangerous, and too raw for successful musicians and Tenderloin dignitaries but beloved of the masses. Barron's Little Savoy was high-toned, racially integrated, a place where James P. Johnson, "Jelly Roll" Morton, Willie "the Lion" Smith, or even occasionally Scott Joplin, came to dazzle patrons. Edmond's (officially, the Douglass Club) was run by an ex-prizefighter named Edmond Johnson, whose one-legged pianist, Willie Joseph, was a midtown institution. Banks's, Barron's, and Edmond's decamped for Harlem well before the country went to war. Barron Wilkins's brother—Leroy—also moved to Harlem and went into the cabaret business.

Farther uptown, along Fifty-third Street, was Jimmie Marshall's hotel (127–129 West Fifty-third). Here was the heart of what was called "Black Bohemia," the artistic cradle of the future, the nursery of talent and tradition without which the muses of Harlem would have had to study much harder. As blighted as the Tenderloin unquestionably was, there was at least this one block, plus a row or two of dwellings nearby, whose elegance and excitement dimmed from view and banished from memory the hovels, prostitutes, gin-soaked derelicts, and tubercular children. "It was an alluring world, a tempting

world," James Weldon Johnson recalled. Marshall's was two large
brownstones, gas-lit, red-plushy overfurnished in the style of the day,
an elegant boarding house, with just a touch of refined bordello, where
regulars Rosamond and James Weldon Johnson whiled away late eve-
nings with the likes of Harry T. Burleigh, "Diamond Jim" Brady, Bob
Cole, Will Marion Cook, and Paul Laurence Dunbar. Jim Europe was
a Marshall's fixture, and singers, musicians, vaudeville stars, and the-
atre entrepreneurs like Lillian Russell, Noble Sissle, and Bert Williams,
George Walker and his wife Ada Overton, Florenz Ziegfeld and his
wife Anna Held were also faithful to the place. In addition to its unbut-
toned professional congeniality, the hotel also served as forum for
serious racial palaver. "Our room, particularly at night, was the scene
of many discussions," James Weldon Johnson recalled. "The main
question talked about and wrangled over being the status of the Negro
as writer, composer, and performer in the New York theater and world
of music." They were to carry that preoccupation to Harlem, where it
gained a potency and direction few of them could have anticipated.

The music the Afro-American brought to Harlem had already con-
quered New York. Ragtime had cakewalked out of the minstrel shows
of the late 1880s into Brooklyn's Ambrose Park during the 1894 sum-
mer production of *Black America* (the first all-black show) long
before Scott Joplin's Missouri career was launched. From Sam T.
Jack's 1890 minstrel show, *Creole Show,* through John W. Isham's
Octoroons five years later to his watershed extravaganza *Oriental
America* the following year, Afro-Americans had moved in artistic and
financial triumph from vaudeville houses to Broadway. *Oriental Amer-
ica* offered the Broadway public at Palmer's Theatre an abundance of
voluptuous, high-yellow chorines and plenty of obligatory blackface
buffoonery, but it had a semblance of theme, a crush of talent (Inez
Clough, the actress, Rosamond Johnson, the composer, Sidney Wood-
ward, a tenor, and Maggie Scott, a singer, were enrolled), and it dared
to present opera, employing the extraordinary voice of Sissieretta Jones
("The Black Patti") to render arias. "The finale of the show consisted
of solos and choruses from *Faust, Martha, Rigoletto, Carmen,* and *Il
Trovatore,*" James Weldon Johnson wrote delightedly. When Will
Marion Cook and Paul Laurence Dunbar had teamed up to write *Clo-
rindy* in 1898, the second Afro-American production to reach and enrap-
ture Broadway, they made a giant advance in a new art form—the
Broadway musical—rivalled only by Bob Cole and William ("Billy")
Johnson's simultaneous *A Trip to Coontown* (the first musical farce

written, produced, and owned by Afro-Americans). *Clorindy* was not, as some believed, the origin of the cakewalk, any more than *Shuffle Along* created the Charleston a quarter-century later; these dances originated deep in the bone and muscle of the migrating southern peasantry. No matter where the cakewalk began, though, it became overnight a ballroom diversion from Newport to Nob Hill. Cook described his success ecstatically:

My chorus sang like Russians, dancing meanwhile like Negroes, and cake-walking like angels, black angels! When the last note sounded, the audience stood and cheered for at least ten minutes. . . . It was pandemonium, but never was pandemonium dearer to my heart. . . . Negroes were at last on Broadway, and there to stay. . . . Nothing could stop us, and nothing did for a decade.

They marched, in ragtime, onward. When the nation danced, it did the cakewalk; when it sang, it bellowed Ernest Hogan's atrocious "All Coons Look Alike to Me," or, later, James Weldon Johnson and Bob Cole's "Under the Bamboo Tree"; and when it listened, it heard the commercial strains of Ford Dabney, Will Vodery, and Bob Cole. Meanwhile, Will Marion Cook, trained at Oberlin Conservatory of Music and a student of violinist Joseph Joachim in Berlin, was demonstrating to Broadway how surely Afro-Americans were "there to stay." *Clorindy* was followed in 1899 by *Jes Lak White Folks* (with soprano Abbie Mitchell, Cook's future wife, in a principal role). *Policy Players, In Dahomey, In Abyssinia,* and *In Bandana Land* were next—all within a nine-year stretch and all in collaboration with Dunbar. Bob Cole and Rosamond Johnson teamed up to compete with Cook, writing and appearing in *The Shoo-Fly Regiment* in 1906 and, two seasons later, the beautifully crafted, sophisticated *Red Moon*—operettas rather than musical plays and both Broadway successes.

The career of big Jim Europe was a remarkable illustration of the fame and fortune then available to Afro-American performers. Europe had none of the originality of a Bob Cole or the technical sophistication of a Will Cook. He was a better manager of musicians than he was a musician. He was a genius at commercially repackaging what was good, innovative, or unusual. He gave his public (and increasingly his public was white) what it wanted—dazzling ballroom and dance floor

echoes of the pure specimen. As one of the most successful bandmasters of the era, he accomplished a great deal by popularizing the music that helped make the Jazz Age possible.

Brought from Alabama to Washington, D.C., Europe had learned his piano and violin in public school and had the usual knock-about apprenticeship before finding his way to the Tenderloin in 1904. From the beginning, firsts were his specialty. A year after arriving, he led his Nashville Students Orchestra (without students or Nashvillians) in the first concert of syncopated music in America, at Hammerstein's Victoria Theater on Broadway. After a tour abroad, he introduced the saxophone to American jazz bands. In 1910, Europe incorporated the Clef Club, a combination musicians' hangout, labor exchange, fraternity club, and concert hall, across the street from Marshall's Hotel. Admission was restricted, rules issued, elaborate uniforms prescribed. Braided musicians entertained white-tie-and-tailed guests assembled for dancing, concerts, and champagne. When Fifth Avenue and Long Island socialites required musicians or vaudeville houses needed men for orchestra pits, Europe made the arrangements. The Clef Club's annual take exceeded $100,000 during its best years.

There were more firsts. In March 1914, Europe's club performed at Carnegie Hall in one of the most memorable of that hall's numerous and memorable Afro-American evenings. Two church choirs, forty-seven mandolins, twenty-seven harp guitars, eleven banjos, eight violins, eight trombones, thirteen cellos, seven cornets, five trap drums, two double bass, two clarinets, one tuba, one timpano, and ten pianos crowded onto the Carnegie Hall stage and stunned the capacity audience. The proportions were sheer Berlioz, the chorale an imponderable of spirituals, Handy, and Handel, and the orchestra a whirlwind of ragtime. Nothing like it had ever been heard. Music critics rhapsodized over the unconventional instruments, the balalaika-like sounds produced by mandolins and guitars. The critics had no way of knowing that the choice of banjos, guitars, and mandolins was dictated by the folk traditions of Jim Europe's musicians and the scarcity among Afro-Americans of oboe, violin, and French horn players. Europe blandly explained to the New York *Sun*'s critic that the sound of balalaikas was intentional, and that he had made a number of inspired substitutions: "Other peculiarities are our use of two clarinets instead of an oboe. As a substitute for the French horn we use two baritone horns, and in place of the bassoon we employ the trombone. We have no less than

eight trombones and seven cornets. The result, of course, is that we have developed a kind of symphony music that . . . is different and distinctive."

Next came Europe's decisive role in a social revolution—dancing. "By the fall of 1913," Irene Castle remembered, "America had gone absolutely dance-mad. The whole nation seemed to be divided into two equal forces, those who were for it and those who were against it." Dancing was the Devil's work in prewar America. Proper contact with a partner was even regulated by law in most places. Still, America was rapidly changing, and the Castles, Vernon and Irene, were leading the way. She was reckless, lovely, and upper middle-class New York in background; he was crisp, thin, tall, and British. Together, they were a picture of irresistible litheness, charm, and elegance, a combination of assets allowing them to cultivate powerful and rich protectors.

A growing number of respectable opinions held, with Mrs. Elisabeth Marbury, Mrs. Stuyvesant Fish, Mrs. Oliver Harriman, and Mrs. William Randolph Hearst, that what the Castles did was "refined" and "purified." "The One Step as taught at Castle House," declared Mrs. Marbury, "eliminates all hoppings, all contortions of the body, all flouncing of the elbows, all twisting of the arms, and, above everything else, all fantastic dips." She was positive, as a Christian and a member of the Four Hundred, that dancing was good for the health, the spirits, and preservation of youth. Puritan America paused, listened, began to dance a bit the one step, maxixe, and Castle walk, but remained, with Edward Bok of the arbitral *Ladies' Home Journal*, unconvinced and guilt-ridden.

It was at this critical moment, sometime in mid-1913, that Jim Europe, assisted by Ford Dabney, joined forces with the Castles. (After the Carnegie Hall concert, he abandoned the Clef Club altogether.) At swank Castle House, the Forty-sixth Street building secured with the help of Mrs. Marbury, long lines of young and old, rich and struggling filed through to be served tea by a socialite, to bunny-hug or camel-walk to Europe's music, to watch the Castles trot and, with luck, even dance with one of them—all for two dollars (three on Friday). "We did a thumping business," Irene crowed. From steps Europe had learned from W. C. Handy, and a score thrown off by Europe, Vernon Castle confected his wildly popular fox trot. Just two years before, a girl had been brought into court in New Jersey for turkey-trotting home while singing "Everybody's Doing It Now." By 1914, everybody

did it and laughed about old-fashioned ordinances. People who be-
lieved that the new dancing was connected with the slow, dreaded rise
of black culture now found themselves on the defensive, and when *The
Ladies' Home Journal* at last gave the Castles a flattering spread, Irene
knew they had won: "The bitter outcry against dancing began to come
to an end."

What finished it totally was the "Whirlwind Tour" of April 1914,
when Europe, Dabney, their two-hundred-man orchestra, and the Cas-
tles with dancing staff traveled by their private train to thirty-two
major American and Canadian cities, returning to New York to hold a
climactic dance contest in Madison Square Garden. "One by one,"
Irene recalled, "as the Dabney-Europe orchestra played, couples were
eliminated, and finally there were only two couples left." When a dis-
tinguished, middle-aged white couple with the memorable name of Mr.
and Mrs. Sailing Baruch walked off with first prize, it was clear that
nothing short of a war could slow the coming Jazz Age.

And even a war could not slow it much. Nick La Rocca's Original
Dixieland Jazz Band made the first jazz recording in New York in
1917, "Dark Town Strutters' Ball." La Rocca's New Orleans band was
white, always a decided advantage even in an idiom where most of
the best were known to be black. What passed for jazz on these first
recordings was really ragtime, cacophonous stuff full of burps, squeals,
and squawks. But while Dabney, Europe, Vodery, and other estab-
lished Afro-American musician-composers became more slick and pat-
terned and found work in Flo Ziegfeld's cabaret world, up in Harlem
the real jazz and the low-down blues were being fueled by the southern
invasion. "Many of our patrons are originally from the South," Lin-
coln Theatre owner Mrs. Marie Downs explained, "and they relish the
entertainment these folks bring, New York cultivated tastes being laid
aside for a time." Manhattan "cultivated tastes" were abandoned at
the Crescent, Lafayette, and Lincoln theatres for the likes of Perry
Bradford, Johnny Dunn, Fats Waller, and especially Mamie Smith in
the 1919 Lincoln Theatre smash, *Maid of Harlem*. Whites also flocked
to the Lincoln and Lafayette, and behind them came Flo Ziegfeld to
buy the rights to several shows.

When he returned from the war, Lieutenant Europe took his regi-
mental band (greatly expanded) on tour. His music was more popular
than ever, but he would not live to see the changes his music and
many of his musicians would undergo in Harlem. On May 19, 1919, a

deranged snare drummer named Herbert Wright stabbed Jim Europe
to death in his dressing room.

King Solomon Gillis, the protagonist of "City of Refuge," a short
story by one of Harlem's most promising novelists, Rudolph Fisher,
was a southern peasant born to buy the Brooklyn Bridge twice. Exiting
from the Lenox Avenue subway stop at 135th Street, Gillis exclaimed,
"Done died an' woke up in Heaven." "In Harlem," he reflected, survey-
ing the Lenox Avenue scene, "black was white. You had rights that
could not be denied you; you had privileges, protected by law. And
you had money. Everybody in Harlem had money." If any one thing
symbolized the place, gave it palpable meaning for Gillis, it was the
sight of an Afro-American traffic cop bawling out a red-faced white
driver. "Black might be white, but it couldn't be that white!"

Yet it was clear to the articulate and civic-minded of Harlem that a
metropolis of New Negroes was not to be made with the thousands of
Gillises stumbling out of the 135th Street subway or swaying up Lenox
Avenue atop overloaded carts and trucks. It would have been a differ-
ent matter, perhaps, if New York's industries had been in a period of
high production and expansion. Instead, New York, like other urban
centers in the North and East, was at the end of a recession. An uphill
struggle was ahead for Afro-Americans just to maintain wartime gains
in the garment industry, building trades, and light manufacturing.
Readers of The Crisis might also have been more disposed to receive
the Gillises if Afro-American patriotism had earned tangible gratitude
from the white public, if those IOUs Du Bois had sworn could be
redeemed were not everywhere being discounted at a fraction of their
value.

There was one figure in Harlem, however, who fixed his sights on the
Gillises, who would soon gather the illiterate southern migrant and
impoverished Caribbean immigrant into an expanding movement of
phenomenal force and potential. On a spring morning in 1916, soon
after arriving in the city on March 23, someone shouted in the speak-
ers' corner crowd at Lenox Avenue and 135th, "There's a young man
here from Jamaica who wants to be presented to this group! He wants
to talk about a movement to develop a back-to-Africa sentiment in
America!" Sportingly, Asa Philip Randolph, then finishing his socialist
studies at the Rand School, yielded his ladder to a stocky West Indian
whom one blunt Harlemite memorably described later as "a little
sawed-off, hammered down black man, with determination written all

united and mightier than in the days of the great pharaohs, her ancient arts and sciences the envy of the planet. "One God, One Aim, One Destiny!" Garvey proclaimed when he incorporated the UNIA in New York on July 2, 1918. A month later, he launched the weekly newspaper *The Negro World*, published in French, Spanish, and English, and soon to achieve the distinction of being banned throughout most of the British and French empires. At year's end, he was presiding over rallies five thousand strong at Harlem's Palace Casino.

In 1919, the UNIA seemed to be on the verge of sweeping aside conservative civil rights organizations and absorbing like-minded ones. Socialists, Marxists, and black nationalists like Asa Randolph and Chandler Owen, Cyril Briggs and W. A. Domingo, Hubert Harrison and Richard B. Moore publicly applauded Garvey's program well into that year. Like them, he had opposed Afro-American participation in the war, and, when the 369th stepped proudly up Lenox Avenue, Garvey wept in public. He pulled himself together for the peace conference, appointing Asa Randolph and Ida Wells-Barnett, an intrepid antilynching veteran, as UNIA "delegates" to Versailles. When the State Department refused them passports and gave the nod only to Du Bois, Garvey lacerated Du Bois in a tirade before five thousand in the Palace Casino, accusing him of sabotaging the interests of Africa and the UNIA.

Du Bois, the civil rights leadership, and most of the educated middle class—what Du Bois called the "Talented Tenth"—added up to a considerable opposition for a vagrant thirty-two-year-old West Indian, already under surveillance by J. Edgar Hoover and New York Assistant District Attorney Edwin P. Kilroe. Upper-class Harlem regarded the pageantry of Liberty Hall and the global schemes of its owner with a mixture of chagrin and derision. In "respectable" circles, Garveyites were commonly referred to as "outlaws" and UNIA rendered as "ugliest Negroes in America." None of this disturbed Garvey. His watchword was never "caution," but "Up, you mighty race." The establishment of a Liberian Zion and the eventual liberation of the ancestral continent seemed to him within reach. He established his Black Star Line Steamship Corporation in June 1919 and raised almost $200,000 in less than four months, most of it from the working poor of the Caribbean—like the trusting Panamanian who wrote proudly to say that he already had $125 of Black Star Line shares: "Now I am sending thirty-five dollars for seven more shares. You might think I have money, but the truth, as I have stated before, is that I have no money now.

But if I'm to die of hunger it will be all right because I'm determined to do all that's in my power to better the conditions of my race."

Garvey leaped without looking into the purchase of his first ship, the thirty-three-year-old, decrepit *Yarmouth*. The broker boasted, "If this fellow has got so much money, we are going to sell this ship and make as much money out of it as we can." The price—$165,000—perfectly suited Charles Cockburn, Garvey's "colored" British captain, who pocketed his commission and certified the vessel as seaworthy. The Black Star Line was a fiasco from the beginning. Garvey tried to keep the books in order. He even hired two reputable firms to organize the company's accounts and make regular checks, but he found that his own people "could not make regular and proper entries." On the day the *Yarmouth* was to be rechristened S.S. *Frederick Douglass* and hoist its red, black, and green colors, the second installment payment— $83,500—was mysteriously unavailable, despite continuing sale of Black Star stock. Under a special arrangement with the owners and the United States Shipping Board, the S.S. *Frederick Douglass* nevertheless weighed anchor from the 135th Street pier on October 31, 1919, with five thousand Harlemites cheering and weeping and the UNIA band blaring. On that roisterous Friday morning, only the UNIA inner circle knew that because of insurance problems and tired boilers, the ship was being sailed no farther than the Twenty-third Street pier.

In late December, while Garvey was on a brief Canadian honeymoon with his first wife, two Black Star officers bound the line to sail for Cuba with a million-dollar cargo of liquor before the January 17 federal embargo and accept full liability in case of failure—for a transportation fee of eleven thousand dollars. Off Cape May, the *Frederick Douglass* ran into heavy weather, which taxed her wheezing boilers beyond endurance and shifted her freight starboard. Part of the valuable whiskey had to be jettisoned before Cockburn could coax his ship back to New York under a coast guard escort. Finally, on February 27, after explosive visits by Garvey and enforcement of crew discipline by Hugh Mulzac, a new first mate dedicated to the UNIA, the anemic flagship weighed anchor off the Statue of Liberty for Havana. But Black Star problems were far from over. Garvey fretted and thundered in bewilderment as stock sold and revenues evaporated. "I gave everybody a chance," he moaned, "and the story is that nearly everyone that I placed in responsible position fleeced the Black Star line." Garvey continued to hire and fire, futilely, while Du Bois watched and collected evidence, and even Randolph, Owen, and

Domingo began to have second thoughts. Finally, so did Garvey, concluding in his darkest hour, "The Negro has no method or system to his dishonesty."

Meanwhile, the *Frederick Douglass* was proving to be a simultaneous propaganda triumph and a business disaster. Arrival in Havana on March 3, 1920, had brought vast numbers of gift-bearing Cubans to the pier. Officers were lavishly entertained by the Cuban president, who promised his government's support of the UNIA. Unfortunately, Havana's striking longshoremen refused to mix pride with business, tying up the ship for thirty-two days. Docking in Jamaica with a single passenger and no cargo to load, the *Douglass* patched its boilers and steamed for the Canal Zone, where "literally thousands of Panamanians swarmed over the docks with baskets of fruit, vegetables, and other gifts." At Bocas del Toro, Panama, the annoyed United Fruit Company sensibly declared a holiday and freighted its workers by train down from the mountains. "The crowd . . . was so thick" that an incredulous Mulzac watched as peasants "seized the hawsers as they came out of the water and literally breasted us alongside the dock." Finally, Captain Cockburn found a cargo—coconuts from Jamaica, destined for New York. Sailing home, he received instructions from Garvey: UNIA celebrants in Philadelphia and Boston were to be shown the grand ship immediately. Cockburn finally brought the *Douglass* into New York on the eve of the UNIA International Convention. "The coconuts, of course, were rotten," Mulzac remarked; and, once again, the contract had omitted to limit the Black Star Line's liability.

From August 1 through September 1, 1920, America was treated to a rally-pageant of a sort never seen before. Twenty-five thousand delegates poured into Madison Square Garden and a much smaller number into the UNIA's Harlem headquarters, Liberty Hall, for the first International Convention of the Negro Peoples of the World. Hugh Mulzac of the Black Star navy marched in the procession from Harlem. "As far as I am aware," he recalled forty years later, "it was the greatest demonstration of colored solidarity in American history, before or since." Fantasy, escapism, and symbolism as well as substance enveloped the proceedings at Madison Square Garden. "Garvey," wrote Mary White Ovington, a white member of the NAACP's board of directors, "was the first Negro in the United States to capture the imagination of the masses. . . . The sweeper in the subway, the elevator boy eternally carrying fat office men and perky girls up and down a shaft, knew that when night came he might march with the African

army and bear a wonderful banner to be raised some day in a distant, beautiful land." Few men in the immaculate ranks of the African Rifle Corps had ever fired a weapon or, beyond marching drills, been given an elementary course in military science. Of the nurses marching in peaked cap and starched uniform like photonegative nuns—black faces, white habits—few possessed healing knowledge. As for the nobility raised by President-General Garvey for this occasion—Nile dukes, Ethiopian counts, and assorted knights—its merits, in the main, were less apparent than those of Napoleon's similarly ennobled soldiers and civil servants. Four million persons of African ancestry had sworn allegiance, Garvey proclaimed, though the actual numbers were considerably smaller—by how much, probably not even the president-general really knew. The convention's first act was Garvey's telegraphic message to Ireland's Eamon de Valera: "We believe Ireland should be free even as Africa shall be free for the Negroes of the world. Keep up the fight for a free Ireland." The "Declaration of Rights of the Negro Peoples of the World" was another mixture of symbolism and substance, going far beyond previous Pan-African demands that Africa be "administered *for* the Africans." Garvey's declaration called for imminent black dominion.

The convention closed on a note of exhilaration. Red, black, and green were decreed the colors of the "Negro nation." The elaborate, hierarchical African Orthodox Church was created under the pontificate of West Indian George Alexander McGuire. The president-general promised more ships and would soon claim to have a treasury of ten million dollars. The grocery chain, laundry, restaurant, publishing house, and real estate controlled by his Negro Factories Corporation were thriving. In February 1921, the UNIA's first mission to Liberia sailed, $137,458 being subscribed for its Liberian Construction Loan almost as quickly as the campaign began.

But less than three years later, Garvey's first allies were either denouncing him openly or standing carefully aloof. His call for a "Negro capitalism" and his declaration that capitalism was "necessary to the progress of the world" surprised his *Messenger* allies and exasperated those in the new African Blood Brotherhood, a small group of Marxist West Indians led by Cyril Briggs. UNIA losses on the left were not balanced by new support from moderates, for, despite his condemnation of trade unionism, Garvey's capitalism embraced a disconcerting element of state control. He preached that "all control, use, and investment of money should be the prerogative of the State with the con-

current authority of the people." The only thing wrong with capitalism was the capitalists, the UNIA leader believed. "Men like Morgan, Rockefeller, Firestone, Doheny, Sinclair, and Gary should not be allowed to entangle the nation in foreign disputes, leading to war." In Garvey's state, the creation and ownership of capital would be split off from the process of ultimate political decisions. But in the meantime, until Afro-America could accumulate a sufficiency of capital and the UNIA state came into existence, Garvey insisted that the Afro-American laborer work for less than the white to "keep the good will of the white employer and live a little longer under the present scheme of things." Small wonder Garvey would boast many years later, "We were the first fascists."

This farrago of Booker Washington and Mussolini proved increasingly unacceptable because Garvey was not merely abrasive, flamboyant, and dogmatic, but a West Indian. The Afro-American professional classes especially ridiculed the gorgeously uniformed, pompous "Provisional President-General of Africa" and his West Indian courtiers. Resentment against Harlem's growing West Indian community was already welling up. West Indians were reputed to work harder for less, to speak and write better English than the southern migrants, and were disliked for their considerable aggressiveness in small business affairs and ward politics. The saying was already current in Harlem that a revolutionary invariably turned out to be an overeducated West Indian out of work.

The president-general of Africa had also displayed an instinct for the political jugular that frightened the Talented Tenth. Soon after the first UNIA convention, he began to exploit race color taboos, greatly exaggerating the correspondence between position and pigment in Afro-America. This was partly a reflection of the reality of Garvey's Jamaican homeland; but it was also a canny overemphasis of a North American reality. For the first time outside the genteel sphere of literature, the concealed tensions and subconscious antipathies of dark and light Afro-Americans were furiously exposed and nurtured. The days of "subtle and underhand propaganda fostered by a few men of color in America, the West Indies, and Africa to destroy the pride of the Negro race by building up what is commonly known as a 'blue vein' aristocracy" were finished, he warned.

The charge of brown racism was devastating. Cyril Briggs, infuriated at being called a "white man," sued Garvey for libel and won. When Garvey ridiculed Du Bois's Pan-African Congress labors, the

editor avoided confrontation and tried instead to enlist the aid of the State Department. On the eve of the third Pan-African Congress in London, Brussels, and Paris, Du Bois wrote Secretary of State Charles Evans Hughes for classified information which could be used against the UNIA; he was refused. Finally, after more severe provocation, Du Bois struck back in *Century* magazine and then in *The Crisis* with a searing "Lunatic or Traitor" article, calling Garvey "the most dangerous threat to the Negro race." Well, replied the president-general, "Du Bois is speculating as to whether Garvey is a lunatic or a traitor. Garvey has no such speculation about Du Bois. He is positive he is a traitor." People like the "cross-breed, Dutch-French-Negro editor" should be given a "good horsewhipping." Du Bois represented a group "that hates the Negro blood in its veins, and has been working subtly to build up a caste aristocracy that would socially divide the race into two groups." Garvey meant what he said. Since the disastrous visit to NAACP national headquarters soon after arriving, his loathing for this distinguished man of letters had become visceral. Garvey's belief "in a pure black race, just as how [*sic*] all self-respecting whites believe in a pure white race" was genuine. So was his teaching that "all the beauties of creation are the black man's.".

For all this, much of Garvey's spleen was histrionic. He was too intelligent not to see the limits of color in politics. He knew that the real problem of racism was "not because there is a difference between us in religion or in color, but because there is a difference between us in power." The error of leaders like Du Bois transcended skin color; they were rebels in American society only to the degree and duration of their exclusion from it. As James Weldon Johnson stated in a 1924 press release, "Mr. Garvey apparently does not know that the American Negro considers himself, and is, as much an American as any one." It was this reflex to defend and preserve the system exploiting them that distressed the UNIA leader: "How can a Negro be conservative? What has he to conserve?" Much better the "honest prejudice of the South," its rigid racial separation and salutary terror burning into Afro-American minds and hearts the lesson of unyielding white supremacy. You had to admire this "white man who fixed the Bible to suit himself," Garvey mused once, "and who even fixed tradition itself, telling us that everything worthwhile and beautiful was made by the white man." But how could you admire the Afro-American leaders who desired nothing more, really, than to amend that tradition to include themselves? After one last symbolic parade from Harlem to

midtown—a UNIA march with the NAACP, YMCA, and other groups in support of Congressman Dyer's federal antilynching bill in June 1922—Garvey washed his hands of civil rights solidarity. Why, "he could not even get a soda served even by a dirty Greek who kept his so-called white soda fountain in a Negro section" in Congressman Dyer's Saint Louis district.

Whites were as troubled by Garvey as some Afro-Americans. Months before the *Frederick Douglass* sailed for Havana, the mighty United Fruit Company signalled the Post Office about copies of *Negro World* reaching the peons of Central America. In September 1919, the company's general counsel had written the secretary of state that Garvey "might repeat the French experience in Haiti" if "allowed to go on as he has been doing." J. Edgar Hoover regretted that, for the moment, Garvey "could not be proceeded against as an undesirable alien," but Hoover encouraged his superiors with the prospect of "some proceeding against him for fraud in connection with his Black Star Line propaganda." Until then, the FBI took the unusual step of appointing an Afro-American special agent to watch UNIA headquarters. In October of that year the Garvey "nuisance" was nearly removed when George Tyler fired two bullets at point-blank range; one creased Garvey's forehead, another pierced his leg. Tyler's motives may have been simple revenge for having been recently sacked by Garvey, but his convenient suicide while in police custody was highly suspicious. The National Civic Federation, a patriotic league supported by V. Everit Macy, August Belmont, Elbert Gary, and other plutocrats, showed further establishment curiosity by sending one of its officers to the headquarters of the NAACP and *Messenger* to find out more about the UNIA just before the 1920 Madison Square Garden convention.

When Garvey left the country in 1921 for a triumphal tour of Jamaica and Central America, the U.S. Immigration Service delayed his reentry for three months, allowing him to return just in time for the second international convention but preventing the years he had already spent in America from counting toward naturalization. The British Foreign Office also communicated its annoyance over UNIA presence in West Africa. On January 12, 1923, Garvey was arrested for mail fraud and imprisoned for three months before President Harding quietly engineered his release on bail. Assaulted on all sides now, Garvey made a fatal decision. Until then, some of the most influential West Indian Harlemites had remained loyal or sympathetic. Writers

Claude McKay and Eric Walrond, bibliophile Arthur Schomburg, numbers king Casper Holstein, and Marxist W. A. Domingo had over-looked his excesses because of his tremendous potential for success. For all its theatrics and Mardi Gras absurdities, many thinking Afro-Americans saw Garveyism as Booker Washington's message of uplift through economic self-reliance on an international level. A much larger number still clung to it because of its escapism. But when the president-general attended a June 1922 summit meeting of the Ku Klux Klan in Atlanta, conferred with Mississippi's Senator Theodore Bilbo, caucused with Virginia's Ernest Sevier Cox, and with John Powell, head of the Anglo-Saxon League, and took pains to insult Afro-Americans at a North Carolina rally sponsored by local white racists, he injured himself more seriously than his enemies ever could have.

To Afro-Americans it could not have mattered less that the UNIA-Klan entente cordiale was, arguably, a logical outgrowth of Garvey's philosophy. Had he not praised Warren Harding's Birmingham, Ala-bama, speech in which the president had asserted, "Racial amalgama-tion there cannot be," and bade the Afro-American to be "the best possible black man and not the best possible imitation of a white man"? Had he not publicly declared, "Between the Ku Klux Klan and the Moorfield Storey National Association for the Advancement of 'Certain' People, give me the Klan for their honesty of purpose toward the Negro"? No matter. The prospect of ships plying to Africa financed, in part, by the Klan was an outrage obliterating internal disputes. The Afro-American leadership united in a "Garvey Must Go Campaign." An NAACP official, Robert Bagnall, delivered the first cut in *The Mes-senger* when he reviled Garvey as "a Jamaican Negro of unmixed stock, squat, stocky, fat, and sleek," and on and on. W. A. Domingo, former editor of Garvey's *Negro World*, rejoiced that *The Messenger* had finally decided to rid "the race of this disgrace of Garveyism." The UNIA abolished dual NAACP membership, and pitched battles were fought in Harlem between Garveyites and integrationists. Then came the open letter from Afro-American leadership to the U.S. attorney-general asking that Washington use "full influences completely to dis-band and extirpate this vicious movement." Du Bois and Randolph chose not to sign, but the eight who did clearly represented the full spectrum of official opinion—Robert S. Abbott, owner-editor of the Chicago *Defender*; Robert Bagnall and William Pickens of the NAACP; Chandler Owen of *The Messenger*; John Nail, James Weldon Johnson's brother-in-law and Harlem's leading realtor; Harry H. Pace,

a distinguished businessman; Julia P. Coleman and George Harris, civic leaders. And while Garvey was readying the second mission to Liberia at the end of the year (1923), Liberian politics were changing. Newly inaugurated President Charles D. B. King was soon declaring that the UNIA was unwelcome. Garvey was far from finished, but the forces arrayed against him were overwhelming.

In Chicago, just as Garvey's first ship was sailing nowhere, a young scholar was taking exact measure of the crisis of his people, a scholar who not only knew what must be done but had the cold-blooded resolve and indispensable philanthropic connections to work his way among Afro-America's benumbed and groping general staff. Charles Spurgeon Johnson was then twenty-six. He had been a volunteer in the 103rd Pioneer Infantry Regiment and had risen to sergeant-major; now, just returned from France, he was resuming graduate studies in sociology at the University of Chicago. "On the way home from the war," Johnson's friend and future director of the Julius Rosenwald Fund, Edwin R. Embree, records, "he ran into a series of riots in Brest and Norfolk and Washington, and arrived at the University just a week before the worst of them all." Racial violence was not new to Charles Johnson. One of his most vivid adolescent memories was of his father, a preacher and "small in stature," placing himself in the path of a lynch mob in a Virginia town. He "hurled at them the maledictions of heaven. He was not molested, neither did his protests have any effect upon the mob except to set them laughing. A man of remarkably even temper, it humiliated him more that they paid no heed than it could have if they had made him share the punishment of the victim." Reverend Johnson's teenage son learned about the limitations of courage and moral outrage from that experience.

Charles Johnson had attended Virginia Union University in Richmond, a college supported by Baptists, and his father's alma mater. He earned his tuition as a steward aboard the steamships plying between Norfolk and New York during the summers, played varsity football until a kidney injury stopped him, edited the college journal, was elected student council president, and graduated with honors. During his senior year, Johnson had an experience which, as Embree records, he would never be able "to get out of his mind, nor to cease pondering the anger of people at human catastrophe while they calmly accept conditions that cause it." Canvassing Richmond's black neighborhoods to make a list of families eligible for Christmas baskets, he discovered,

in a side-street hovel deep in the ghetto, a girl covered in filth, alone, freezing, and already in labor. The doctor he located refused to follow him. Just in time, Johnson found a midwife, paid her fee, then ran to find the girl's parents. The parents listened impassively and when he finished told him icily that their daughter was a sinner, that they had "banished her" forever. Charles Johnson was bewildered.

At the University of Chicago, under Robert E. Park, the outstanding authority of the era, Johnson embraced a sociological positivism answering his need both for intellectual tidiness and for guarded optimism. Park had been one of Booker Washington's ghostwriters at Tuskegee. "I probably learned more about human nature and society, in the South under Booker Washington, than I learned elsewhere in all my previous studies," a posthumous note among Park's papers revealed. Alabama had confirmed his theory of a race relations cycle that ran through four sociological periods—contact, conflict, accommodation, and, finally, assimilation. It was ". . . apparently progressive and irreversible. Customs regulations, immigration restrictions, and racial barriers may slacken the tempo of the movement; may halt it altogether for a time; but it cannot change its direction; cannot at any rate reverse it." There was also a fifth, postcyclical, era in which the class struggle would supplant the racial, wrenching society along a path of varsity combat between the forces of Marx and Rockefeller.

Park also was certain that there was a Negro essence, an identifiable quantum of black identity distinct from the Anglo-Saxon's pioneering instincts, the Jew's intellectual and idealist nature, or the introspection of Eastern peoples. The real Negro, he determined, was an "artist, loving life for its own sake. . . . He is, so to speak, the lady of the races." Such distinctions would pass; for nothing was more potent for change, Park insisted, than interracial friendships, which "cut across and eventually undermine all barriers of racial segregation and caste." Marginal at first, the "great moral solvent" of amicable ties between the races slowly permeates society to the core. For his disciple, Johnson, the power and significance of interracial contacts was gospel, and much of his professional career would be devoted to monitoring "vectors of social change," by which he mostly meant signs of fellowship among the races.

The Chicago riot was Johnson's opportunity to play a pivotal role in countering racist beliefs, prejudices, deductions. After two months of political squirming, Governor Frank Lowden cautiously endorsed the race relations commission proposal of the NAACP's Joel Spingarn and merchant prince Julius Rosenwald. A blue-ribbon panel of six white

and six Afro-American civic leaders, businessmen, and politicians was assembled to study the disaster and compile a report, with Rosenwald, the Sears, Roebuck president, meeting the first staff payroll out of his own pocket. Charles Johnson had already sent the commission a carefully composed outline on how to go about its work within days of its formal creation. He was also highly recommended by Park, who was president of the Chicago Urban League, for which Johnson worked as research director. Johnson was chosen as associate executive secretary, sharing authority with the white executive secretary, Graham Romeyn Taylor, son of a prominent Chicagoan. They worked well together, and Taylor's contribution was significant. But the seven-hundred-page volume, appearing in September 1922, was unmistakably the work of the associate executive secretary.

The Negro in Chicago: A Study of Race Relations and a Race Riot was doggedly optimistic. It minimized or discounted evidence of intractable white racism as residue of a passing sociological age of conflict. White stockyard workers may have *thought* they hated the Afro-Americans across Wentworth Avenue, the report argued, but mutual contact and responsible conduct by authorities would reveal that, between the races, differences were so minimal as to make nonsense of sustained enmity. Afro-Americans had also been guilty of behaving as if they were a different people with different goals from the whites. "Thinking and talking too much in terms of . . . race pride . . . and race alone are calculated to promote separation of race interests and thereby to interfere with racial adjustment," *The Negro in Chicago* explained. As a source for specific public policy, Johnson's report had negligible value. Even its single specific recommendation—creation of a permanent commission on race relations—was deferred for almost two decades. *The Negro in Chicago*'s scholarly value, however, was considerable, though in the long run seriously weakened by the underlying assumption that economic conflict was neither fundamental nor permanent.

By the time the press and scholarly journals were acclaiming the commission's report, Johnson had moved to New York to become the Urban League's national director of research and investigations and editor of its new monthly, *Opportunity* magazine. He had in mind an editorial program far more ambitious than churning out impressive sociological monographs. Johnson believed that he could speed up the movement of the race relations cycle. Throughout childhood and even now as the century's second decade unrolled, he had listened to passionate disputes in the Afro-American community between partisans of

Booker Washington and W. E. B. Du Bois. The Alabama sage lay in
hallowed ground on the Tuskegee campus, but his spectre haunted
nearly every conclave, fraternal order, newspaper staff, college trustee
board, and dining table in Afro-America. Like most ideological
wrangles, the longer this one persisted, the more distinctions without
differences there were, and the more cant and shibboleths were gen-
erated to obscure reason. The whole debate had been steadily affected
by pigment, pedigree, and politics to the considerable detriment of fact
and logic. To Charles Johnson, superbly educated and privileged,
"elitist" Du Bois made more sense than "populist" Washington—but
not so much as to banish from his thoughts all elements of the Book-
erite creed. Like Washington, Johnson calmly accepted the prospect of
long-term Afro-American repression by and exclusion from the domi-
nant society; he was in favor of "developing the defense coating of a
sense of humor" and the "deliberate rationalizing" of the race's "in-
ferior position" in such a way as to make it bearable. But like Du Bois,
Johnson intended for the Afro-American elite to play an imaginative
and even aggressive part in opposing whites on terms of full equality.
The author of *The Negro in Chicago* gauged more accurately than
perhaps any other Afro-American intellectual the scope and depth of
the national drive to "put the nigger in his place" after the war, to keep
him out of the officer corps, out of labor unions and skilled jobs, out of
the North and quaking for his very existence in the South—and out of
politics everywhere. Johnson found that one area alone—probably be-
cause of its very implausibility—had not been proscribed. No exclu-
sionary rules had been laid down regarding a place in the arts. Here was
a small crack in the wall of racism, a fissure that was worth trying to
widen. Not only was this a tactic admirably suited to the ability and
temperament of educated Afro-Americans, it seemed to be the sole
battle plan affording both high visibility and low vulnerability. If the
road to the ballot box and jobs was blocked, Johnson saw that the door
to Carnegie Hall and New York publishers was ajar. Each book, play,
poem, or canvas by an Afro-American would become a weapon
against the old racial stereotypes. Johnson was certain that "if these
beliefs, prejudices, and faulty deductions can be made accessible for
examination, many of them will be corrected." For the present,
though, it was a waste of time to cry for full equality for ten million
people. Nothing would measurably improve the lot of the masses of
southern sharecroppers or northern laborers for decades, nor would
even the middle classes achieve more than episodic and minor political

or legal gains. In the bleakness of the present, it was left to the Afro-American elite to win what assimilation it could through copyrights, concerts, and exhibitions. Thus did the leading Afro-American sociologist prepare to modify Booker Washington to suit the tactics of the Talented Tenth.

3
Stars

"Speaking of aiming for the stars," one of poet Countee Cullen's admirers wrote from Paris, "you have virtually disarranged the entire solar system." From 1923 onward, the skies over Harlem shimmered with new stars, candidates for Charles Johnson's ambitious program to promote racial advancement through artistic creativity. Two writers—Claude McKay and Jean Toomer—had already won critical acclaim. Two others—Langston Hughes and Countee Cullen—needed only to shine upon the world beyond Harlem to be recognized for their brilliance.

Claude McKay and Jean Toomer were different in many ways from their somewhat younger colleagues. Their work and lives were more deeply immersed in the universe of the Lost Generation. To this they owed much of their success, and also their lack of it. Both men were deeply troubled escapists. In their contempt for propagandist literature and disdain for literary politics, and their dogged struggles simply to be themselves, they tested the outermost limits of what was possible for persons of African ancestry dedicated to the creative life. Still—for paradox was the essence of their being—an objective survey of their works reveals that McKay played literary politics shamelessly and Toomer became a turgid propagandist.

Festus Claudius McKay came from the same proud, prosperous, peasant Jamaican hill country family background as Marcus Garvey. He was born in Clarendon Parish on September 15, 1889. Twenty-three years later, he had written two volumes of dialect poetry, *Songs of Jamaica* and *Constab Ballads*, and was on his way to study agriculture at Tuskegee Institute. Rural Alabama turned out not to be the

place for a fiery, black islander whose soft, lyrical voice was easily provoked into shrill profanity. He moved on to Kansas State College almost immediately, more suitable for agriculture but not ideal for poetry, which, by 1914, McKay had discovered he wanted to make his career after all. New York beckoned, and money for the trip arrived from a white Jamaican patron. Once there, he married; the date was July 30 of that year. Then biographical information becomes scanty: an unsuccessful restaurant venture; the wife's return to Jamaica; the birth of a daughter. By the end of 1921, Claude McKay had arrived. His first American poems had been published under the pseudonym Eli Edwards in the pacifist *Seven Arts*, a magazine founded by Waldo Frank, James Oppenheim, Van Wyck Brooks, and other Lost Generation lights. McKay himself had become coeditor of the nation's outstanding avant-garde literary and political publication, *The Liberator* (Max Eastman, its debonair socialist founder, having retired to the sidelines), and a book of poetry, *Spring in New Hampshire*, published during a year's sojourn in England, was about to appear in expanded form in America as *Harlem Shadows*. Max Eastman had provided a preface to it which was singular both for enthusiasm and (for an enthusiastic Marxist) a fairly marked strain of racism; he described the poems as "sung by a pure blooded Negro" whose song enriched "our literature" with a voice "from this most alien race among us."

The racial burden afflicting McKay was of the cruelest duality—of being *in* but not *of* two cultures. To most whites outside Greenwich Village, he was just another black man. But McKay also found himself estranged from Afro-Americans. W. E. B. Du Bois's *Souls of Black Folk* had shaken him "like an earthquake" when he read it as an agricultural student at Kansas State College. But meeting the flesh-and-blood Du Bois was "something of a personal disappointment. He seemed possessed of a cold, acid hauteur of spirit." Others had felt this way about Du Bois on first meeting him, changing later, but it was typical of McKay to walk away confirmed in his hasty, harsh judgment. There was something deeply self-serving about these judgments, as if, unsure of Harlemites' feelings and the price demanded for their friendship, he chose deliberate provocation. Protesting that he "never had the slightest desire to insult Harlem society or Negro society anywhere," McKay succeeded without really trying.

Disdainful of most Afro-American intellectuals and not entirely at ease even in tolerant enclaves like the Village, McKay leaped at the offer of a subsidized trip to England in 1919. He still believed in the

special bonds of affection and tradition between Great Britain and her colonies. The poetry of his Jamaican youth resounded here and there, as in "Old England," with a black Briton's naive affection for the Mother Country:

> I've a longin' in me dept's of heart dat I can
> conquer not,
> Tis a wish dat I've been havin' from since I could
> form a t'o't,
> Just to view de homeland England, in de streets
> of London walk. . . .

He discovered quickly that the average Briton had not the remotest idea that he and they shared at least a common culture of school and court, let alone any notion of equality between them. There was no more talk of Homeland England. England annealed the hatred within McKay, sending him back to America to become "among all black poets, . . . par excellence the poet of hate."

> There is a searing hate within my soul,
> A hate that only kin can feel for kin,
> A hate that makes me vigorous and whole,
> And spurs me on increasingly to win.

McKay not only learned to hate in England, he found a vehicle to carry it, for he had delved into Marx and Lenin ("it wasn't entertaining reading"), got to know red trade unionists and colonial nationalists, struck up friendships with dockworkers in whom revolutionary fires raged. He joined the staff of Sylvia Pankhurst's doctrinaire communist newspaper, *The Workers' Dreadnought*, where he polished off his Marxist instruction and also learned something of real-world political compromise when Pankhurst threw out his article attacking a plutocratic socialist M.P., whose newspaper supplied sheets on which *Dreadnought* was printed. He became a qualified Marxist—qualified because, as a black Jamaican with bittersweet intimacies among Greenwich Village radicals and East End English communists, he saw clearly how little the ideology affected anthropology. Realizing that Marxists could also be racists brought McKay to Garvey. "Although an international Socialist," he declared in *Dreadnought*, "I am supporting the movement, for I believe that, for subject peoples, at least,

Nationalism is the open door to Communism. Furthermore, I will try to bring this great army of awakened workers over to the finer system of Socialism." He sent a few articles to Garvey's *Negro World* before sailing for America in spring of 1920.

Back in New York, McKay sounded out the NAACP circle and found it distinctly cool, although he and James Weldon Johnson became personal friends. And so he fell back on fellow West Indians like Hubert Harrison and Cyril Briggs, and an occasional Afro-American like the quirky Harvard-Yale graduate William H. Ferris, inviting them for strategy sessions at *The Liberator*. Max Eastman worried about Justice Department surveillance. Presenting the young coeditor as an *enfant terrible* who had been denounced in the *Congressional Record* was in keeping with Eastman's socialist chic; explaining frequent meetings of a Garveyite cell group was not. "Do you think I was playing when twice in 1921 you saw colored men and women at *The Liberator* discussing political and race problems with me?" McKay chastised his patron. The real problem, however, was Garvey, who never understood why a leader as clever and determined as Lenin wanted to experiment with communism. McKay was disappointed by Garveyism but he kept faith long after its reckless founder had returned, deported, to Jamaica. One of McKay's last *Liberator* articles summed up the flaws of the Black Moses handily: "His spirit is revolutionary, but his intellect does not understand the significance of modern revolutionary developments. Maybe he chose not to understand; he may have realized that a resolute facing of facts would make puerile his beautiful schemes for the redemption of the continent of Africa."

Claude McKay was the purest of that special breed that strives for success only to find it intolerable. His ingratitude was also notorious. (Even so large-spirited a man as Joel Spingarn found it annoying to be called a vain, bourgeois professor after having brought McKay to the attention of *Seven Arts* magazine and, later, arranged the publication of *Harlem Shadows*.) Yet, under McKay's and Michael Gold's direction, *The Liberator*'s circulation leaped to sixty thousand, its format became classier, and William Gropper's illustrations were often worth more than the copy for instantaneous impact. McKay did his job well. He published some of E. E. Cummings's early poetry, after Max Eastman adjudicated a sharp office spat in McKay's and Cummings's favor. He lost the fight for a racial quota for space in the magazine—10 percent of each issue was to be devoted to Afro-American and related topics. Eastman warned McKay that if they "published too much ma-

terial about the Negro, our white readers would dismiss the *magazine*, not the material. They would stop buying and reading it." "Such is your opinion," McKay bristled, "which gives me a picture of you as a nice opportunist always in search of a nice path and never striking out for the new if there are any signs of danger ahead."

By summer of 1922, McKay felt that he could cleanse the sour taste of success in the Soviet Union. Relations with his coeditor, rigidly Marxist Michael Gold, were at an impasse. Not only had he lost the battle for an Afro-American space quota, Gold and the others had won the dispute about whether proletarian protest literature would take precedence over good writing. McKay knew "it was much easier to talk about real proletarians writing masterpieces than to find such masterpieces." His sympathies were with them, but his "attitude was not mawkish." It was a hard choice for Eastman, "but on the basis of the magazines you each put out, in spite of the superior reliability and delicacy of yours," he felt compelled to side with Gold "because his magazine had more 'pep.'"

When it came to the "Negro problem," McKay found his Marxist collaborators inclined to be more conventional. During the absence of the magazine's drama critic, McKay decided to review a new Broadway play himself, a translation of a work by Leonid Andreyev. Arriving at the Fulton Theatre with *The Liberator's* artist William Gropper, and delighted about "a free front-row parquet seat along with 'The Press,' instead of buying a ticket for the second balcony," the poet found an amazed usher and a rattled manager determined to force them into the balcony. McKay wanted to refuse, "but Gropper, quite properly, urged compromise." The impact on McKay of this "quite proper" compromise was delayed. When he wrote about the incident seventeen years later, under the title "He Who Gets Slapped" (the title of the play), it still rankled:

Poor, painful black face, intruding into the holy places of the whites. How like a specter you haunt the pale devils! Always at their elbow, always darkly peering through the window, giving them no peace, no rest. . . . Damn it all! Goodnight, plays and players. The prison is vast, there is plenty of space and little time to sing and dance and laugh and love. There is little time to dream of the jungle. . . .

With the appearance of *Harlem Shadows* in 1922, McKay was the most famous poet in Afro-America and one of the most sought-after

celebrities in the Village. All in all, he was pretty miserable. "Must fifteen million blacks be gratified," he demanded in "The Negro's Friend," "That one of them can enter as a guest, / A fine white house —the rest of them denied / A place of decent sojourn and a rest?" His own apparent acceptance by whites heightened his sense of abstract solidarity with those excluded Afro-Americans in Harlem with whom he got along personally so uneasily. His "one brief golden moment rare like wine" when New York behaved humanely and "Oblivious to the color of my skin, / Forgetting that I was an alien guest" made an effort his "hostile heart to win" was gone as quickly as it came. His depression became extreme, as in "Outcast," where in lines redolent of Thomas Hardy he conceded the insuperable fatality of having been born "far from my native clime, / Under the white man's menace, and out of time." In one of his most ambitious efforts, "The Desolate City," reading much like stanzas from T. S. Eliot's *The Waste Land*, he wrote: "My spirit is a pestilential city, / With misery triumphant everywhere, / Glutted with baffled hopes and human pity." McKay's misery was evenhandedly distributed over both ends of Manhattan. "The Tropics in New York," an early *Liberator* contribution, conjured up "Bananas ripe and green, and ginger root, / Cocoa in pods and alligator pears," only to dash the mood as, "hungry for the old, familiar ways, / I turned aside and bowed my head and wept." He wept for Jamaica's old, familiar ways, but wept more because Harlem's tropical verdancy hid the spiritual decay and strangulation spreading through the lushness of a sealed, suffocating hothouse. In the glowing years of the late twenties, when Harlem nearly forgot there was more to its life than cabarets and concerts, cocktail parties and publishers' contracts, McKay's verse spoke of "The ugly corners of the Negro belt; / The miseries and pains of these harsh days." Like Langston Hughes, he heard, in "Harlem Shadows," "halting footsteps of a lass" driven to "bend and barter at desire's call." She was the symbol with her "sacred brown feet of my fallen race. /Ah, heart of me, the weary, weary feet / In Harlem wandering from street to street." Sometimes, as in "The Harlem Dancer," compression of mood and message yielded a crystal of superb poetry and sociology:

> Upon her swarthy neck black shiny curls
> Luxuriant fell; and tossing coins in praise,
> The wine-flushed, bold-eyed boys, and even the girls,
> Devoured her shape with eager, passionate gaze;

But looking at her falsely-smiling face,
I knew her self was not in that strange place.

One night McKay took Eastman and another white friend to Harlem
—to Ned's, one of his favorite cabarets, where the music and the cli-
ents were authentically funky. Ned's was off-limits to whites, but
McKay thought Ned "would waive his rule for me." Instead, Ned went
nearly berserk. "Ride back! Ride back," he bellowed, "or I'll sick mah
bouncers on you-all!" One Saturday, coffee importer Eugen Boissevain
fetched him for a ride into the New Jersey countryside with Eastman.
The outing was spoiled because the one place admitting them for lunch
insisted they eat in the kitchen. "I felt not only my own humiliation,"
McKay gritted, "but more keenly the humiliation that my presence had
forced upon my friends. . . . I did not want friends to make such sacri-
fices for me." Confronted with the bleakness of choosing between Ned's
and New Jersey, McKay chose Russia. James Weldon Johnson gave a
farewell party and helped to raise travel funds. McKay had to get
away, "escape from the pit of sex and poverty, from domestic death,
from the *cul-de-sac* of self-pity, from the hot syncopated fascination of
Harlem, from the suffocating ghetto of color consciousness."

McKay was exhilarated and fascinated by the Soviet Union, then
slowly disenchanted. He had come to observe and to write, and if
possible, to attend the Fourth Congress of the Third International in
Moscow. A few days later, the official American delegation arrived. Its
suspicions of McKay quickly turned into hostility. When Rose Pastor
Stokes, a rich Marxist who used to amuse McKay in New York by
darting into the Astor and Plaza hotels to evade the FBI, had asked
him whether he thought the American communist party should remain
underground or conduct open propaganda, McKay unknowingly gave
the wrong answer. The delegation's majority favored covert activity.
Besides, the Americans already had their Negro spokesman in Otto
Huiswood, "a light mulatto" whom the Russians squinted at bewil-
deredly when told of his race. Shut off from the congress, McKay
enjoyed himself. Never in his life had he felt "prouder of being an
African, a black, and no mistake about it." Wherever he went, admir-
ing crowds formed to cheer the black visitor and McKay may have
been the first to be bounced on a sea of Russian shoulders, as Paul
Robeson would be years later. While the American delegation feuded
and Otto Huiswood insisted he spoke for the black proletariat, the
people of Moscow made McKay a "black ikon in the flesh." "The

photograph of my black face was everywhere among the most highest
Soviet rulers, in the principal streets, adorning the walls of the city."
The Americans now had a change of heart, and agreed that McKay
was a loyal, capable party spokesman after all.

On January 4, 1923, McKay rose from his seat next to Eastman and
walked past a beaming Zinoviev to address the ecumenical council of
Marxism. "Zinoviev asked me to speak and I refused," McKay wrote in
A Long Way from Home. Whatever his reasons for lying about it later,
the speech is a matter of record. The nub of it was the failure of
socialist ideology to transcend racism in America. "The reformist
bourgeoisie have been carrying on the battle against discrimination and
racial prejudice in America." But speaking from firsthand experience,
he had to report that "the Socialists and Communists have fought very
shy of it because there is a great element of prejudice among the Social-
ists and Communists of America." Neither he nor Huiswood offered a
solution, but McKay's Comintern speech played a key part in Mos-
cow's decision to refer the "Negro question" to a special committee.

Moving into the palace of Grand Duke Alexander, addressing the
Comintern, reviewing army and navy units, dining with Trotsky, Zino-
viev, and Bukharin (Lenin was too ill to meet him), amazing readers
of *The Crisis* with accounts of his and Russia's achievements, McKay
must have been tempted to remain in the Soviet Union as an idolized
artist and respected Marxist theoretician. *Negry v. Amerike*, his un-
translated and now lost book on the American race problem, was re-
quired reading for the hierarchy. On May Day 1923, he was given the
place of honor beside Zinoviev on the Uritsky Square reviewing stand
in Petrograd as the longest march-past in the world filed by, hour after
intoxicating hour. Unable to sleep that night, McKay wrote until dawn.
The Russians proclaimed the resulting poem, "Petrograd: May Day
1923," a classic.

Once again, success began to irritate. Huiswood told him he could
never "make a disciplined party member." And if McKay was proud of
his blackness, he began to wonder whether the Russians really appreci-
ated the man behind the color. He began to wonder about a religion of
international brotherhood that had so many anti-Semitic Russian disci-
ples. And he was saddened by audiences that refused to applaud when
he expressed doubts about the imminence of an American revolution.
Perhaps Huiswood was right. "My destiny," McKay had told his fellow
West Indian, "is to travel a different road." After all, for him it was not
so much the iniquity of organizing societies for profit, nor the resulting

inequities of class, that rankled—it was color prejudice. The real McKay—the proud peasant of his *Songs of Jamaica*—revealed himself, long after Russia and self-imposed European exile, in an unpublished autobiography of his early years, "My Green Hills of Jamaica." He tells of an evening (as revealing as improbable) when the island's governor visited McKay's learned, upper-class English patron, Walter Jekyll. Surprised at how quickly time had passed in drink and literary chat, Sir Sydney Olivier asked to spend the night. No, said Jekyll. "But," pointing at McKay, "he stays here," Olivier protested. "But he is my special friend," replied Jekyll, showing the governor the door. The English middle classes "never know when to say the right thing," the irritated host remarked. Wide-eyed, young Claude stammered, "But Mr. Jekyll, how can you tolerate me? I am merely the son of a peasant." "Oh, English gentlemen have always liked their peasants," was the reply. Festus Claudius McKay recalled that evening without irony, with the pleasure of a serf secure in a noblesse oblige untainted by race.

In June 1923, after six months in Russia, McKay's different road led to Berlin (where he received treatment for venereal infection), and then to Paris in the fall. By now, he was aware of something new stirring in Harlem. It would be many years before he was ready to return to America, and he would never feel anything other than condescending affection for the established Afro-American community. Still, McKay admitted that a few Afro-Americans were beginning to show literary promise.

Jean Toomer's first attempt to make *The Liberator* notice him was rewarded with a kindly dismissal. From his lofty editorial perch, Claude McKay wrote that the staff found "Miss Toomer's point of view" interesting, but "her" short story was, unfortunately, "a little too long, not clear enough, and lacking unity." Toomer quickly corrected the gender mistake, though the editorial judgment stood. But *The Liberator* soon noticed that Toomer was being published elsewhere, in *Double-Dealer* and *S4N*. By September 1922, a Toomer poem appeared in *The Liberator*. A warm correspondence flowed between editor and the new contributor, McKay regretting not being able to join Toomer at Harpers Ferry, West Virginia, and urging him to come to New York before he, McKay, left for the Soviet Union. They met briefly.

Jean Toomer was twenty-nine when Boni & Liveright published *Cane* in September 1923. Harlem and Afro-America welcomed what

promised to be a major contender for the Great American Novel. T. M. Gregory, of Howard University's drama department, gave *Cane* a lyrical review in the new Urban League monthly, *Opportunity* magazine, and Boston anthologist William Stanley Braithwaite, one of Afro-America's severest critics, rhapsodized that it was "a book of gold and bronze, of dusk and flame, of ecstasy and pain, and Jean Toomer is a bright morning star of a new day of the race in literature." Only the young Harlem poet Countee Cullen, who had met Toomer in Washington at a Saturday night literary salon, seemed to have reservations. "I know when I like a thing, and," Cullen wrote with just a hint of equivocation, "on the whole, I like *Cane*." White critics, like Robert Littell, Gorham Munson, and Van Wyck Brooks, were enthusiastic. White writers agreed. Hart Crane, scrappy and self-absorbed, told Toomer he was special and repeatedly praised him in letters to his Vanderbilt University friend, Allen Tate. "I believe it's the genuine thing—your new technique applied to the material for the first time," Tate wrote Toomer. They needed to meet soon, he urged, either in Washington or New York.

Sherwood Anderson had stumbled across Toomer's work in the office of John McClure, editor of the New Orleans review, *Double-Dealer*. What the Washingtonian was writing struck "a note I have long been waiting to hear come from one of your race," Anderson wrote encouragingly. "More power to your elbow." They struck up an intense correspondence, Toomer writing of how he sensed in Anderson's work a "reaching for the beauty that the Negro has in him," Anderson replying that Toomer's writing was the "first negro work I have seen that strikes me as really new." In search of that primal something he would later offer up in *Dark Laughter*, Anderson expounded on American civilization's desperate need for the Negro's glistening, joyous looseness, transmuted by literature. Toomer had the talent for it, but what worried Anderson was his latent sophistication. "Thrilled to the toes" by his "stuff" in *Double-Dealer*, *Dial*, and *Broom*, he feared Toomer would "let the intense white men" get to him. They were "going to color his style, spoil him," he warned Toomer. Then *Cane* appeared. He "plunged into it and finished it" before going to bed. "It dances."

Nathan Eugene Toomer was born December 26, 1894, in the roomy, well-appointed Washington home of his maternal grandfather, Pinckney Benton Stewart Pinchback, former lieutenant governor of Louisiana and former United States senator. The Pinchbacks lived in a

wealthy white neighborhood, until the senator's excesses at the Sara-
toga race track and other eastern racing courses forced the steady liqui-
dation of extensive real estate holdings. But while it lasted, life on
Bacon Street was swaddled in an indolent luxury reminiscent of the
Old South. The family belonged, Toomer said, to "an aristocracy—
such as never existed before and perhaps never will exist again in
America—midway between the white and negro worlds." There were
fine wines at dinner, Afro-American domestics serving and clearing and
anticipating a cigar's flame or a thirst for more port. Faithful "Old
Willis," a former slave, tended the grounds and was hired out to the
neighbors. One day, "Pinchy" (Toomer's sobriquet) found himself
hoisted onto the horse ridden by a round, goateed gentleman who
cantered to the end of the block before carefully depositing the lad on
the curbstone. A few days later, "Pinchy" excitedly recognized Theo-
dore Roosevelt in his grandfather's newspaper. Ambiguously white,
temporarily affluent, and politically well connected, Toomer's early
years passed in a silver spoon.

But family relations were less than ideal. Over her father's objec-
tions, Nina Pinchback had married the illegitimate mulatto son of a
wealthy, white North Carolina landholder. Nathan Toomer passed as
white and owned, or once owned, a large farm in Georgia. His son,
whose memory of him derived from a single occasion when they spent
a few hours together, described Nathan Toomer as "a large, handsome,
upstanding man with warm outgoing feelings and a big heart." Grand-
father Pinchback was a far better judge of Nathan Toomer—probably
because they were so much alike. A year after the marriage and shortly
after his son's birth, Nathan Toomer left his wife and debts to the
Pinchbacks. In 1904, Pinchback's friends maneuvered his appointment
to a patronage slot in the New York Customs House and the family
settled in New Rochelle. The good life was better than ever now. The
"Governor" (Pinchback's customary title) cut a high-styled swath
through Manhattan and Saratoga Springs, his fine figure draped in silks
and tweeds, a shower of large bills falling in swank restaurants, on
gaming tables, and at the race tracks, and his sardonic smile and
demonic laughter memorably registering with everyone who met him.
But he overplayed his hand; debts sapped his fortune, reducing a
princely annual income of ten thousand dollars to barely enough for
living expenses. Nina had remarried in 1905, again over her father's
pleas, and moved to Brooklyn, nevertheless a lucky development be-
cause the family was able to take refuge with her.

Young Toomer felt himself trapped in a ménage of his father's en-
emies. His mysterious, poor white stepfather, known to posterity only
as Coombs, was squat and fat, an altogether distressing figure to an
eleven-year-old lad who fantasized about Nathan Toomer whenever
the striking contrast of Coombs and Nina became too much: "She
ascended. He spread out. She glided. He waddled. Never can a glide
and a waddle correspond or be harmonized." Believing himself mis-
understood by his grandfather and blaming him and his mother for
rejecting his father, Toomer stayed away from home as much as possi-
ble, reading in the public library and learning to sail. Four years after
remarrying, Nina died of complications following an appendectomy.
Down on their luck with only a small savings account and income
from several Washington properties, the Pinchbacks had already
moved back to Washington, to an Afro-American neighborhood, in the
thirteen-hundred block of U Street, not far from Howard University.
"For the first time, I live in a colored world," Toomer wrote.

Nina Pinchback Toomer's death ended her son's life as a white
youth. It placed him in Dunbar High School, a school for sons and
daughters of the Afro-American elite, although publicly financed,
among upper-class beauties like Mary Church and Victoria Terrell and
bright comrades like Henry Kennedy and Richard Bruce Nugent. Fif-
teen years later, Toomer would deny this race, claiming, inventively,
that his grandfather had been a white man who feigned African ances-
try in order to gain political office in Reconstruction Louisiana.
"Whereas others would have thought it to their disadvantage to claim
Negro blood," an autobiographical fragment explains, "Pinchback
thought it to his advantage. So he claimed it, and advertised the claim."
To his credit, the governor had remained faithful to the blacks. "With
me, however, there is neither reason nor motive for claiming to have
Negro blood." Toomer dissembled. His knowledge of his ancestry
was as minute as that of a Spanish nobleman, and it reached back to
Major William Pinchback, a Virginia planter who died in the late
1840s. Mixed and complicated racially as it was, there is no question
that his ancestry was in some part African. Yet, whatever Toomer in
fact was (by physical appearance, white; by race, mixed) matters far
less than his reasons for first affirming his African heritage and later
denying it.

He was more than a natural poet; his was a lyrical nature. He
thought in rhapsodies and felt in meter, merging his soul with the
present moment and place—and race. He did not so much abhor the

most obvious distinctions as fail consistently to see them as the rest of the world did. And whether or not it is a pardonable excess that genius sometimes mistakes itself for the world, Toomer never doubted that the most important thing about life was the way *he* lived it. As often happens with such personalities, when he was asked for a description of his friend and mentor, the photographer Alfred Stieglitz, Toomer unconsciously described himself:

He will sometimes tell you that he feels uprooted. From one point of view this is true. He has not had a fixed establishment. . . . Yet I do not feel that he is suspended or unplaced. Always I feel he is rooted *in himself* and to the *spirit* of the place. Not rooted to things; rooted in spirit. Not rooted to earth; rooted to air.

Being "colored" in Washington turned out to be a social carnival and an intellectual calamity for Toomer. Lean and handsome, with black eyes that commanded men and subdued women, he was a combination of Adonis and Svengali. He glided through Dunbar High School in three-and-a-half years, in spite of an "avalanche of sex indulgences" in his second year that undermined his health, causing him to withdraw from friends and spend hours brooding at home. Becoming "increasingly disgusted with most of the life about [him]," he began to wonder, "What are these people doing with their lives? Surely I do not want to be like them." His innate mysticism surfaced. "I am not like them. I see and feel more in life than they will if they live to be a thousand years old."

He would have chosen Yale, like his uncle Bismarck Pinchback, finances permitting. Instead, Toomer went off to the University of Wisconsin to major in agriculture. An interested professor of English alerted him to *The Nation, The New Republic,* and the *Manchester Guardian,* and the possibility of "such a thing as a literary life, as a literary career." Toomer had said nothing about his race, but he was unhappy with these admiring whites. "Lack of emotions and feelings and color in the people began to affect me. The men and girls I met were cruder and far less warm than those I had known in Washington." That Christmas, at home on vacation, he fell in love with Phyllis Terrell, a student in Vermont. He returned to Wisconsin, finished the semester, and withdrew. Back home, under Uncle Bismarck Pinchback's tutelage, he became an accomplished *bon vivant* in the slightly disreputable circle of Washington artists and theatre people. His uncle, a dropout

from Yale Medical School, took much better care of Toomer's mental health, teaching him how to read books critically. After a mysterious brief stint at the Massachusetts College of Agriculture, he was in Chicago in 1916, attending the American College of Physical Training, pumping iron and piling muscle on a tall, slim frame that seemed far more suited to the exertions of the tennis court and swimming pool.

But Chicago bored him, too. That winter, 1916–17, he was an unwelcome guest at Grandfather Pinchback's. But he was also (or so he thought) much changed. A Clarence Darrow lecture, volumes by Herbert Spencer, Chicago University sociology professors, and a liberated white coed named Eleanor Davis had destroyed his inherited Catholicism and Republicanism. Gripped by the plight of Hugo's Jean Valjean, he became convinced that God was working through evolution for the triumph of socialism. Toomer concluded that agriculture and body building were unimportant in comparison with sociology, and summer 1917 found him attending lectures at New York University. That autumn he enrolled in City College, majoring in history. History was obviously what he had been waiting for; he got his first A. It was also his last.

There was nothing settled in his existence. Reading psychology and Shaw, trying and failing to enlist in the army (rejected for bad eyesight and a hernia), giving up college for a purposeless return to Chicago— all this led only to more random activity. He sold Ford cars, taught physical education near Milwaukee, rode the rails home to Washington and hitchhiked to New York. There, for the first time, he started to write, and through a girl met in his rooming house visited the Rand School—"the beginning of my contact with radical, and later, with literary New York." But his wandering continued. He learned to play the piano, hoboed, spent more time body building and even joined the working classes for a time as a welder in a New Jersey shipyard, where he quickly deduced that the workers were not ready for socialism. "They had two main interests: playing craps and sleeping with women." In time his nervous system collapsed. He went to the Catskills in the dead of winter, settled down in a cabin and nursed himself back to health on a vegetarian diet of his own concoction.

A literary party in New York gave him the feeling that "here was the first gathering of people I had ever seen in my life—people who were of my kind. It was simply a matter of learning to speak their language." But he was still a long way from being secure in such company. Back in Washington, helping his uncle Walter Pinchback run the famous

Howard Theatre, Toomer "wrote and wrote, and put each thing aside, regarding it as simply one of the exercises of my apprenticeship." Except for "Natalie Mann," a skeletal play about the artist's spiritual agonies among Washington's unintellectual upper-class Afro-Americans, he destroyed the work of this period. He was now twenty-six, still unpublished, and his best prospects were for becoming manager of the Howard Theatre.

A friend of his grandfather's stopped in Washington on his way to raise funds in New England for the small agricultural and industrial academy of which he was principal. He needed someone to run the school during the fall semester of 1921. Toomer volunteered; sent his grandfather to a nursing home; hired a woman to look after his grandmother; and took the train to Sparta, Georgia. Sparta was his introduction to the sunset world of the Afro-American serf, a land of long shadows and loam-colored bodies laboring, singing, and dancing against the crimson backdrop of sun, fire, violence, and dying light. He reacted much as Du Bois had on his rural Tennessee teaching assignment after his freshman year at Fisk University, at once appalled and entranced by a crudeness that was "strangely rich and beautiful." They did not sing spirituals in Toomer's Washington circle; they were not sung even among Sparta's black townspeople. But from sharecroppers' cabins and weathered places of worship Toomer heard the folk songs and spirituals for the first time. "God, but they feel the thing. Sometimes too violently for sensitive nerves; always sincerely, powerfully, deeply. And when they overflow in song, there is no singing that has so touched me."

He felt himself "body and soul" a Negro. "My seed," he would write Sherwood Anderson a year later, "was planted in *myself* down there. Roots have grown and strengthened." In a cabin "whose floor boards permitted the soil to come up between them, listening to the old folk melodies that Negro women sang at sun-down," Jean Toomer came down to earth, into the cotton and cane fields, for the first time in his life. *Cane* partook of Whitman and Joyce, Sandburg and Anderson ("Just before I went down to Georgia I read *Winesburg, Ohio*"), and elements of Waldo Frank, but it was indisputably Toomer's own luminous creation—a prose oratorio of earth, blood, and sun, and genius. Nearly fifty years later, when *Cane* was rediscovered, it would be mistakenly argued that Toomer had written it as a black man on furlough from a tortuous racial ambiguity. The truth is that *Cane* was possible

only because its author had been able to resolve his racial duality by affirming it—just for an instant.

In the Georgia hinterland, peopled by peasants and rednecks, he had confronted his tangled ancestry. As a venerable black barber trimmed his hair, two laughing girls had passed, one blond and fair-skinned, the other slightly dark in skin tone. "Isn't that unusual?" Toomer enquired, taking the second one for a mulatto. The old barber averred it was, but the white girl—the dark one—was the blond girl's best friend, even though the *blond* girl was "colored." And for some reason, Toomer asked if Nathan Toomer had ever visited Sparta. The old barber casually nodded; Nathan Toomer had paid court to a widow owning a large plantation. "The leading white man in town is said to have colored blood," the young assistant barber blurted, for some reason. Too much had been said. The clip-clip of scissors replaced conversation while Nathan Toomer's son sat in a black barber's chair as a white man pondering the meaning of spirituals, whites who were black, and whites who were, probably, his relatives. For all his intensely lived experience there, Sparta did not convert him into an Afro-American. "When I live with the blacks, I'm a Negro," he insisted. "When I live with the whites, I'm white, or, better, a foreigner. I used to puzzle my own brain with the question. But now I'm done with it."

During 1922, fragments of what was to become *Cane* landed like shrapnel in *Broom*, *The Dial*, *Double-Dealer*, *The Liberator*, *Secession* *S4N*, and *The Crisis*. He was "delighted that the magazines are opening up so," white litterateur Waldo Frank wrote. "Where did you get a chance to work out your technique?" an admiring Jessie Fauset, literary editor of *The Crisis*, wanted to know. At a tea given by Lola Ridge in Greenwich Village, the critic Gorham Munson, and even the hypercritical Kenneth Burke, found only positive things to say after Ridge read aloud one of Toomer's latest passages. Toomer now began to think of himself as a coming major force in American letters, dashing off long critical letters to established writers with a brio far beyond the usual ego of a young writer. He lavished unsolicited opinions and suggestions upon Sherwood Anderson, Waldo Frank, Gorham Munson, Matthew Josephson, Kenneth Macgowan, and Lewis Mumford. His letters were written in a kind of intimate, florid Whitmanesque argot full of broad-gauged mysticism, then much in vogue. Mae Wright, the daughter of a prominent Afro-American Baltimore physician, was showered with them. She had met Toomer during the summer after his

return from Sparta. He was more than ten years older than she, studiedly intense and determined to impress her, and infatuated. They were as inseparable as the alert chaperonage on a "Y" retreat at Harpers Ferry permitted. "Anybody, I think, would have noticed him," Mae Wright recalled. But his long letters ("he outlined all the books I should read if I intended to be a writer") were frankly boring, and Dr. Wright's plans for his daughter had no place for the unemployed grandson of a bankrupt Reconstruction politician. In the fall, Mae went off to college in New England.

Toomer's acquaintance with Waldo Frank was generously requited. A thick folder of letters had followed a chance Central Park meeting, affectionate hyperboles coming from both men. Blond and handsome, Frank was then at the apogee of his fame, a rich, brilliant product of Swiss preparatory schools and Yale. He had left university with more literary promise than New Haven had seen in years and, in the judgment of Lewis Mumford, more egotism than anyone was likely to encounter in a decade. With James Oppenheim, Van Wyck Brooks, Floyd Dell, and others, he had founded *Seven Arts*, one of the most exciting magazines of the Lost Generation, helping to launch Sherwood Anderson; introducing the French avant-garde to America; offering a forum for Randolph Bourne's unyielding pacifism; and issuing one of the first manifestoes proclaiming the coming triumph of art and humanism over materialism. Mystical, sometimes tortured and opaque, books followed: *Our America* (1919), *Dark Mother* and *City Block* (1922). Frank was drawn to Spain and North Africa by a morbid fascination with dark, dynamic forces. With Hemingway, he shared a love for the rough edges of the natural and the masculine— for what he described as his "Waldean continent, with its male organ as its center." Narcissism and sublimated homosexuality mutually nourished a will to dominate and an aversion to unlike natures. "Waldo," Mumford regretted, "has drawn about himself . . . the circle that forbids anyone to be frank with him about his work, and that threatens everyone who dissents with excommunication."

Jean Toomer entered the circle willingly. Toomer was one of the "very very, pathetically rare, *real*," Frank wrote. "You are a master, Jean, have no doubt of that." Lapsed Jew and racial chameleon, they were "brothers indeed, and I know of none others with us." Both lived under the menace of "a god in one's brain, a dynamo in one's flesh, and a volcano in one's loins." Frank knew that, like himself, Toomer was "creating a new phase of American literature (O there's no doubt of

that, my friend)." Frank's letters confirmed Toomer's own lofty opinion of himself, as well as the genius of his admirer. There was "not another man in the world" he would "let touch" his manuscript, Toomer wrote. "You not only understand CANE; you are *in* it, specifically here and there, mystically because of the spiritual bond between us." In early September 1922, Frank joined Toomer in Washington to begin a voyage into the Deep South. Frank wanted to put the Afro-American in his new book, *Holiday*. Aided by Jesse Moorland of the "colored department" of the International YMCA, Toomer had arranged for them to stay together in Spartanburg, South Carolina. The visit was a success. Frank was one of the few of Toomer's friends Grandma Pinchback liked. Howard University professor Alain Locke and Georgia Douglas Johnson's literary club, the Saturday Nighters, made him feel at ease. However self-absorbed, Frank was a sensitive observer; he saw the hidden face of Washington's Afro-American upper class and stole a sidelong glance at the other Jean Toomer:

I got the feel of what was then (perhaps it still is) the most conscious community of American Negroes: the poets, the intellectuals, the scholars of such institutions as Howard University, the bureaucrats with government jobs. They were aware of their ghetto and their awareness corroded their instinctual relation with the Negro peasant and with the earth of the South. They were intelligent, sensitive, neurotic. Toomer's trauma was deeper than the others'.

By December 12, *Cane* was finished. "My brother! CANE is on its way to you!" Toomer wrote to Frank. "For two weeks I have worked steadily at it. The book is done." Boni & Liveright released it in September 1923. The best of *Cane*'s critics likens it to a Pissarro tableau and calls it "an impressionist symphony." Like its author, the work defies the conventional categories of essay and novel, poetry and prose. It has proven almost as difficult to interpret. Of its three sections, the first (six vignettes of rural Afro-American women) succeeds best in terms of craft and characterization, and the last (a play in free form set in Georgia) is, psychologically, the most interesting and ambitious. The middle section, sketches set in Washington and Chicago, is the most uneven.

"Song of the Sun" sets the Toomerian key in part one and unlocks the meaning of the composer's score:

> O land and soil, red soil and sweet-gum tree,
> So scant of grass, so profligate of pines,
> Now just before an epoch's sun declines
> Thy son, in time, I have returned to thee,
> Thy son, I have in time returned to thee.
>
> In time, for though the sun is setting on
> A song-lit race of slaves, it has not yet set;
> Though late, O soil, it is not too late yet
> To catch thy plaintive soul, leaving, soon gone,
> Leaving, to catch thy plaintive soul soon gone.

An abundance of psychological abstractions can be read into part one —into the meaning of "Karintha," "Becky," and "Carma," "Fern," Louisa in "Blood-Burning Moon," and "Esther." "Becky," the white woman with a Negro brood living in "A single room held down to earth . . . O fly away to Jesus . . . by a leaning chimney," is a tale of the tragedy of miscegenation. But it is more. Clattering by her forlorn hut at the edge of the railroad tracks (the secret South at the edge of industrial society), the unthrottled train's vibrations destroy Becky and her children. Becky flies away to heaven leaving an ageless rubble, silent save for the wind-snapped pages of a Bible—record without a reader of mankind's aspiration for brotherhood and salvation.

All these women play their own instruments, but the music is the same for each. "In my own stuff," Toomer wrote Frank, "in those pieces that come nearest to the old Negro, to the spirit saturate with folk-song: Karintha and Fern," the dominant emotion is a "sadness derived from a sense of fading. . . ." That was the meaning of *Cane*— "What they were, and what they are to me, / Caroling softly souls of slavery." It might have seemed that, as Anderson and Frank encouraged, Toomer was extolling the primitive over the civilized, the rural over the urban. Sketches in *Cane*'s second part (especially "Seventh Street" and "Rhobert") can and have been misconstrued to do so. The cadenced condemnation of the black bourgeoisie in "Rhobert" was hardly an estimable depiction of the Afro-American in the city:

> Rhobert wears a house, like a monstrous diver's helmet,
> on his head. His legs are banty-bowed and shaky because
> as a child he had rickets. He is way down. Rods of the
> house like antennae of a dead thing, stuffed, prop up in

the air. He is way down. He is sinking as a diver would
sink in mud should the water be drawn off. . . .
　　Brother, Rhobert is sinking.
　　Lets open our throats, brother,
　　Lets sing Deep River when he goes down.

But these images were not intended as a summons back to a Black Belt
Eden. In them, Toomer distilled the essence of a racial twilight in
which transplanted Africa was a dying rustle ("Cane leaves swaying,
rusty with talk") rather than a metereological forecast.

"The supreme fact of mechanical civilization," one of his Frank
letters stated,

is that you become a part of it, or get sloughed off (under). Negroes have
no culture to resist it with (and if they had, their position would be identical
to that of the Indian). . . . A few generations from now, the Negro will
still be dark, a portion of his psychology will spring from this fact, but in
all else he will be a conformist to the general outline of American civili-
zation, or American chaos.

The Afro-American was, as he often said, "in solution." "Seventh
Street" and "Rhobert" were grotesque evidence of the process. And
"Kabnis," the story of the culturally bleached northerner returned to
Georgia—"Kabnis is *Me*." At its most abstract, *Cane* was neither a
longing for cane fields rustling with the sex and song of barely free
black men and women, nor a turning away from Afro-America's Cad-
dillac strips and residential Gold Coasts; it was an imagistic lighting up
of the future. The culture of the cotton fields was doomed by industrial-
ism. More than that: the "song-lit race of slaves" must not maim itself
by clinging overlong to the exotica of a brutal, brutalizing past. "Blue
Meridian," his ambitious (and now forgotten) poem appearing six
years after *Cane*, would mock the professional primitivists:

　　But we must keep keep keep
　　　the watermelon—
　　He moaned, O Lord, Lord,
　　　This bale will break me—
　　But we must keep keep
　　　the watermelon

The future lay far beyond—in a new American race formed out of the totality of races and in a future where materialism will have been transcended. "I came back to tell you, to shake your hand, and tell you that you are wrong," Paul explains to the leering black doorman in "Bona and Paul," *Cane*'s piece set in Chicago: "I came back to tell you, brother, that white faces are petals of roses. That dark faces are petals of dusk. That I am going out and gather petals." Returning to the spot where they had been standing, Paul finds Bona gone—his chance gone because he took too long explaining to a part of himself the nobler motives of his conduct.

Writing a preface to *Cane*, Frank predicted that the book would have a limited market. So it did, but the critical response was outstanding. Most of it agreed with Allen Tate's comment in the Nashville *Tennessean* that parts of *Cane* "challenge some of the best modern writing" and that it was "highly important for literature." "Tennessee" Anderson (Sherwood's wife) and Kenneth Macgowan almost decided to stage "Kabnis," and Eugene O'Neill wanted something from Toomer for the Provincetown Players. *Cane*'s impact was such that Robert Coates paid it the compliment of a delightful parody in his Lost Generation underground classic, *The Eater of Darkness*, published in Paris in 1926. In *Men Seen*, Paul Rosenfeld's 1925 appreciation of twenty-four modern writers (Joyce, Lawrence, Apollinaire, Proust, Fitzgerald, Cummings, Claudel, and others), Toomer received his share of praise in distinguished company. Rosenfeld's concluding remarks also revealed an ulterior reason for welcoming Toomer to the literary mainstream—the absence of controversy prevalent in works on the South by other writers: "They have had axes to grind; sadisms to exhaust in whipping up passions for the whites; masochisms to release in waking resentment for the blacks. But Toomer comes to unlimber a soul, and give of its dance and music."

The house of Boni & Liveright was sanguine about recovering its investment with Toomer's next work. No one doubted there would be another, and soon. He was polishing two pieces "that approximate Kabnis in length and scope." He had another long story "forming in my mind." The work would be another novella or prose poem, or whatever *Cane* was. He was "not quite ready for a novel, but one is forming." His publishers would have it in good time, he wrote Liveright. But there were already ominous hints. Liveright had sinned grievously by referring to Toomer as a promising Negro writer. "If my relationship with you is to be what I'd like it to be," Toomer upbraided Live-

right, "I must insist that you never use such a word, such a thought again." In part, the touchiness was encouraged by Frank, who warned, "The day you write as a Negro, or as an American, or as anything but a human part of life, your work will lose a dimension." He also seemed to sense that *Cane* was a swan song. The death of Grandfather Pinchback, late in 1922, and the decline of his beloved grandmother represented the death of an epoch. She had been the source of his *Cane* women. "With her passing will go direct contact with America, with New Orleans, before the Civil War, during it and during Reconstruction."

There was to be from Toomer no sequel to *Cane*, nothing ever again of lyrical genius applied to the South and the Afro-American, except the long poem "Blue Meridian" in 1929. John McClure, editor of *Double-Dealer*, had worried about Waldo Frank's influence. Frank did turn out to be a disaster for Toomer, but not quite in the way McClure feared. In late summer 1923, Frank invited his friend to spend a few days at his Darien, Connecticut, home. There Toomer met and fell in love with his host's wife, Margaret Naumburg Frank, and with the ideas of Georgi Ivanovitch Gurdjieff. Toomer's life and his talent would never be the same. Margaret Naumburg was a feminist founder of the progressive Walden School for youngsters. She had just read *Cane*'s proofs; her husband had talked of practically no one else but Toomer for months; Greenwich Village was excited about this brilliant, racial sport from remote Washington. And, suddenly, there he was, lean, mysterious, and splendid; the strong, long fingers and low voice utterly beguiling. He was at that moment even more attractive to her because Frank, recovering from an intestinal disorder and in the dumps over his new manuscript, had been hard to live with. Waldo Frank left alone for Europe six weeks later. But Naumburg and Toomer were discreet. Greenwich Village suspected nothing more than a friendship based on shared affection for Frank and their growing interest in the Gurdjieff movement.

Gurdjieff was something of a disappointed *staretz*—a Russian holy man who was said to have lost out to Rasputin in the competition to minister to Tsar Nicholas II's hemophiliac heir. In 1922, Gurdjieff had purchased the Château de la Prieuré near Fontainebleau and established his Institute for the Harmonious Development of Man. For philosophical content, his movement used the obscurantist thought of P. D. Ouspensky, whose book *Tertium Organum* had been a sensation in America. There was no doubt that Ouspensky's was a principled and profound, if frustratingly unfathomable, mind. He broke with Gurdjieff

after 1924. Gurdjieff himself was given to baffling maxims: "If all men were to become too intelligent they would not want to be eaten by the moon." He demanded a regimen of "inner exercises" and "sacred gymnastics" of his disciples, promising them release from the "mechanical plane" and knowledge of the lost truths of the East. There had been a fearsome scandal in literary circles when tuberculosis-ridden short-story author Katherine Mansfield died in 1923, after lying on a platform erected over a pigsty and obediently following prescribed breathing exercises at Fontainebleau. The master also demanded unquestioning financial support, frequently testing his disciples' faith by filling in their blank checks for maximum amounts.

New York was not ready for Gurdjieff and his Fontainebleau followers when they arrived to perform their sacred dances in April 1924, but Toomer and Naumburg were. The shaven-headed, walrus-mustached little man with black-button eyes overwhelmed them. He was gone before they could arrange a meeting, but they read Ouspensky deeply, practiced the dances, discussed the doctrine with Gorham Munson and Muriel Draper, and ignored Hart Crane's sneer that it was all so much nonsense. By now Frank had become concerned about his close friend. "I know nothing in the way of news of you save an occasional mention by Gorham who says he sees you little, by Hart who says likewise and that you are meditating much, and by Margaret who mentioned your presence at a party of Paul's [Rosenfeld], and one evening at MacDougal Street to dinner," he wrote. "That is the exact sum of my knowledge of you. Do you think that is just?" Frank was right to be concerned; Naumburg soon wrote him of her determination to seek a divorce, telling him that he had driven himself "up a blind alley in placing your work before life." "Go to Vienna as I have urged and do urge again, see Freud and be analyzed." At this point, as in almost every all-or-nothing situation in his life, Toomer withdrew. They talked of marriage, as Naumburg headed for Reno for her divorce. In Reno, she wondered "day and night" about Toomer. In mid-July, Toomer left for France to study at the feet of the master. Years later, they were still friends.

The Jean Toomer who returned to Harlem in late 1924, at the very moment when his fame was fresh and his power to influence greatest, was not much interested in the Harlem literary ferment. He came as a novice *guru* to teach the creed of Gurdjieff. He proselytized for more than a year, putting into his odd ministry all the dynamism new causes invariably evoked. At first Harlemites came to listen reverently, then

appeared to be on his way to becoming a perfect poet. Harlemites who suspected or knew that the young poet was less than perfect were a distinct and whispering minority. A few nubile young ladies tittered that Cullen was uninterested in women and preferred the company of Harold Jackman, handsome West Indian man about town, and there were comrades who snickered about his adoration of his adoptive father (rumored to be a menace to choirboys and oddly fond of Mrs. Cullen's cosmetics). But, rumors aside, Harlem always ignored or forgave everything of its best and brightest.

Those who knew the poet personally insist that literary critics and doctoral drones have been unduly diverted by the dark aspects in his life. They remember Cullen as outgoing, bubbly, and too busy writing and teaching for eccentricity or despair. "He was always a perfect gentleman," is a refrain among the Harlem survivors of the period. The Cullen who entertained gaily at his father's parsonage, bounced along Lenox Avenue casting sunny salutes or laughed merrily in Smalls' night club was real enough. Of course, the other Cullen was also real. Impotence and death run through his poetry like dark threads, entangling his most affirmative lines, and mocking his early poem, "I Have a Rendezvous With Life." His book *Color* opens with a spiritual casualty report and closes with an epitaph about the fleet sprinter, racing like a "hunted doe," but knowing that the pace of time will surely "lay him low." After the ravages of time comes release in "Requiescam": "I would my life's cold sun were setting / To rise for me no more." And there was "Suicide Chant," one of the early poems sent to Langston Hughes on a freighter at Jones Point, which Hughes thought was as atrocious as it was morbid. The sense of spoiled pleasures and deferred hopes steadily enfeebles whatever small joys the poet sometimes finds, as in "Confession": "If for a day joy masters" him, his wounds are not healed, but, far deeper than the scars people see, he keeps their "roots concealed." Or "For a Poet," in which Cullen announces he has wrapped his dreams in silken cloth, "And laid them away in a box of gold."

He was not always declining, decaying, and dying in his poetry, but Cullen never seemed far—even in moments of strong affirmation—from being affronted by life. Beyond his sensitivity as a poet and pain as an Afro-American, there was a singular, corroding suspicion of life cursed from birth, of something gone wrong from the day of creation. During his life and until now, Cullen's parentage was never certain, and he seems to have thickened the mystery at every opportunity. The best reconstruction of the facts is that he was born Countee Leroy

quizzically, then only because it was Jean Toomer. Langston Hughes looked in—once. Arna Bontemps, another young Harlem poet, returned to enjoy the company. Aaron Douglas, the artist, became a convert for life, and Wallace Thurman, soon to be an important part of literary Harlem and then just arrived from California, was a regular. So was Dorothy Peterson, attractive, financially secure, and another of Harlem's aspiring young writers. But after a while, Harlemites failed to see the wonder of Toomer's work; finally, they stopped coming to hear him. To a man with a cosmic mission, indifference was a small disappointment. He was already beginning to drift away many months before the community's interest flagged. There were rumors of a hot love affair with Edna St. Vincent Millay. Hart Crane wrote his mother that he had seen Toomer (who had tried to interest Crane in Naumberg) in the thick of Village affairs during this period, hobnobbing with Edmund Wilson, Marianne Moore, Van Wyck Brooks, Paul Rosenfeld, Alfred Kreymborg, and others of the Lost Generation peerage. And through Alfred Stieglitz and Georgia O'Keeffe, Toomer had been introduced to one of the most extraordinary women of the period, America's version of Madame de Staël, Mabel Dodge. She was Mabel Dodge Luhan by then, married to her fourth husband, a bewildered Pueblo Indian named Tony Luhan.

Mabel Dodge Luhan was cagey about Toomer in the beginning. In the first place, her experiences with Afro-Americans had been unfortunate. Not long before she met Toomer, novelist Carl Van Vechten had invited her to an evening of blues singing. Van Vechten enjoyed himself immensely, giggling and clapping his "pretty little hands" while a large, black woman stomped and bellowed. Mabel Dodge left in disgust. She may also have suspected that Gurdjieff was a charlatan. But Jean Toomer was handsomer even than John Reed, her great love before the war. "The atoms of which we are composed shift and change position" (Dodge had helped invent the strange language of the twenties), "so that each time we meet our relation to each other has become modified." By the end of 1924, she was ready to become a Gurdjieffan. She was "committed to this new thing," she wrote from Manhattan's exclusive old Hotel Brevoort. "Everything has been a preparation for it." Dodge had very complicated ideas about sex. She saw in Toomer, because of his continuing affair with Naumberg, the ideal partner. "You see, a man who has a complete and fulfilling sex outlet is made free. It gives him control." She was able to "cool when I please." She did not want to "burn with passion" and deny it "because of Tony."

"Now something else has got to happen. Something marvelous. If it doesn't—then we are friends. We like each other."

Something did happen. After she left her suite in the Hotel Brevoort for her estate in Taos, New Mexico, Dodge began bombarding Toomer with love letters. It was "wonderful to find some one who seems manly where I've had nothing but sins in my life, and not sins of God either." She wanted Toomer there, and she always got what she wanted. She still loved Tony Luhan, but he broke her heart "by the things he says— he wears me down—he crushes me under boredom, for I am no longer interested." When Toomer came, they were going to have to be careful not to enrage poor Tony, for Mabel intended to do more than give her heart to Gurdjieff's disciple. She was offering her fortune and her estate. She only asked to be used. She could not know that local Gurdjieff representatives had cautioned Fontainebleau that she was impetuous and unstable. Even so, sensing a hesitation, she gave Toomer fourteen thousand dollars for "the work." Toomer sank deeper into Dodge's world and into the slightly lunatic universe of Chicago's Gurdjieff devouts, preaching and raising money for the cosmic cause and writing long, turgid treatises and wooden novels inspired by the creed of Fontainebleau, all of them rejected by publishers who frequently wrote letters containing friendly, sane advice.

But Toomer was too deeply committed to Gurdjieff's teachings to let go. Headquartered in France, staffed by cosmopolitan Russian émigrés, sustained by the offbeat wealthy, famous, and talented, fostering an ideal of human solidarity and salvation outside history, and demanding confidence in the Founder—the movement satisfied Toomer's yearning for racial transcendence, glamor, community, elitism, and a father figure. Its calisthenics even recharged the muscles dormant since leaving the Chicago College of Physical Training. It also accommodated a colossal ego, for, although the movement's published literature is utterly silent about his role, Toomer was once regarded by Gurdjieff himself as his most important American disciple. For a decade, Toomer would stride among mere mortals as the anointed figure beyond all parochialisms, vouchsafed eternal verities. "I am not sure that I have a soul," he ventured, "but if I have, then Gurdjieff has penetrated the shell and written upon the kernel indelibly." But what did it profit a man to believe he had found his soul, yet lose not only his own people but his gift? "So Jean Toomer shortly left his Harlem group and went downtown," Langston Hughes lamented. "They liked him downtown because he was better looking than Krishnamurti, some

said," but the "Negroes lost one of the most talented of all their writers."

Countee Cullen was Harlem's poet prodigy. Like McKay and Toomer, he possessed the artist's genius, and, as it did to Langston Hughes, the craft of poetry came naturally to Cullen. His first poem appeared in 1918; three years later, when he was eighteen, the DeWitt Clinton High School *Magpie* published "Life's Rendezvous," a version of one of his strongest early poems. At New York University he won a stream of poetry awards, and his work caught the eye of some important readers. "I see that a negro student in NYU has won a prize for a ballad," Harvard's renowned Shakespearean George Lyman Kittredge wrote a colleague. "May I have a copy?" That year, 1923, Cullen had won honorable mention in the Witter Bynner Undergraduate Poetry Contest, and Bynner himself had sent regrets that he had been outvoted in awarding Cullen first prize. *The Crisis* and the new *Opportunity* had already carried Cullen's verse, accompanied by cheers. *The Bookman* published his poem dedicated to Hughes, "To a Brown Boy," in the same month Bynner first wrote to him—Cullen's initial exposure in a national magazine. *Harper's* and *Century* quickly followed, and then the *American Mercury*. In 1924, his "The Ballad of the Brown Girl" placed second in the Witter Bynner competition and the next year he finally won first prize in the Witter Bynner, with Carl Sandburg as one of the three judges. He was elected to Phi Beta Kappa, accepted for graduate training at Harvard, and saw his first volume of poetry, *Color*, published by Harper & Brothers. "Yet Do I Marvel," which opens *Color* and is among his best-known poems, might have been dedicated to himself—the marvel, "To make a poet black, and bid him sing!"

Establishment Harlem had never been comfortable with Jamaican Claude McKay. It lost Jean Toomer, whom it admired without quite understanding. But Countee Porter Cullen was indisputably one of its own, a local product, a living exemplar of Talented Tenth values. His father, Reverend Frederick Asbury Cullen, pastor of Salem Methodist Episcopal Church, was a pillar of the community. Mrs. Carolyn Belle Cullen, his mother, though somewhat reclusive, belonged to the right clubs, supported the appropriate charities, and stood loyally beside her husband. Mothers, teachers, and deacons vouched for young Cullen's good behavior, studious brilliance, and filial piety. He was said to be perfect companion, perfect student, and perfect son. In May 192

Porter in Louisville, Kentucky, on Saturday, May 30, 1903, that his father disappeared, and his mother took him to Baltimore to be reared by her husband's mother. Later, Cullen's grandmother moved to New York and ran a home for abandoned children. When the grandmother died, a Mrs. Goins persuaded her pastor, the Reverend Cullen, to adopt Countee. The poet's natural mother lived on in Louisville until 1940, in contact with her son and receiving regular sums of money from him, although she "never did anything" for him. But although Cullen hid the facts, he revealed a great deal in his poetry. "Saturday's Child," which speaks of cutting his teeth "as the black raccoon," of limbs swathed in "a sackcloth gown," and of death cutting the "strings that gave me life," is one of the grimmer, self-demeaning statements to be found. Furthermore he felt himself heir "Of some still sacred sin," a sin against women, against the race, and against God. Like his lowly birth and orphanage, Cullen's homosexuality was to be a source of shame he never fully succeeded in turning into a creative strength.

But Harlem—even *salon* Harlem—was too happy to indulge his genius and its own pride to agonize much over psychological shortcomings. Sometimes Cullen must have set even Harlem's teeth on edge with *Crisis* throwaways lisping of a "daisy-decked" Spring with her "flute and silver lute." If there was too much of that, a poem like "For a Lady I Know," projecting the lady's image of heaven as a place equipped with "poor black cherubs" doing "celestial chores," delighted the redcaps at Grand Central station. In another of his *Color* poems, the equally popular "Incident," he matched Hughes for straightforward economy. The awful insult "nigger" had been hurled at him in a southern city, and from "May until December" he remembered nothing else. Nor would Harlem and the Afro-American world beyond ever forget "Heritage," the long poem asking and answering in each hypnotic stanza, "What is Africa to me?" And even though he struggled increasingly against being typed a "Negro poet," Harlem (except for Du Bois, who reproached Cullen's parochialism) had cheered the 1923 interview in *The New York Times* quoting the Witter Bynner prizewinner as saying that race consciousness guided his muse, that "although I struggle against it, it colors my writing, I fear, in spite of everything that I can do."

Harlem loved Langston Hughes, Cullen's only serious rival (after the silence of Toomer and the expatriation of McKay), but it revered Countee Cullen. With his high-pitched voice, nervous courtliness, and large Phi Beta Kappa key gleaming on the chain across a vested, roly-poly middle, he was the proper poet with proper credentials. After his

Harvard master's degree and journey to the Holy Land with his father,
Harold Jackman, Du Bois's daughter Yolande, Arthur Huff Fauset,
Jessie's brother, and Dorothy Peterson, Harlemites celebrated his re-
turn in 1926 as though he came bearing a Nobel Prize.

James Mercer Langston Hughes's name alone advertised his distin-
guished origins. John Mercer Langston, Langston Hughes's mother's
uncle, had graduated from Oberlin before the Civil War, served as the
first dean of Howard University Law School, minister to Haiti, and
chargé d'affaires in Santo Domingo, and was elected to a term in the
U.S. House of Representatives from Virginia in 1888. In his flattering
autobiography, *From the Virginia Plantation to the National Capital*,
Langston advised Afro-American youth that only its own sloth could
prevent the full enjoyment of America's bounties. Like his great-uncle,
Hughes's maternal grandmother had also graduated from Oberlin, the
first Afro-American woman to do so. Her autobiography, had she
written one, would have been rather less joyous. Sheridan Leary, her
first husband, had died fighting with John Brown at Harpers Ferry.
Charles Langston, her second husband, was also a proud, assertive
man, traits his daughter, Hughes's mother, inherited. Living on and off
with Grandma Langston in Joplin, Missouri, young Langston was
given daily instruction in the Bible and *The Crisis* magazine—
exposure sufficient to explain his vivid imagination and command of
language. In Joplin, Hughes began to "believe in nothing but books,
and the wonderful world in books—where if people suffered, they
suffered in beautiful language, not in monosyllables, as we did in
Kansas."

Life with mother in Kansas had its lessons, too. Carrie Langston
Hughes charged into the principal's office one day, at Topeka's elemen-
tary school, and defied him to discriminate against her boy again.
Going to the opera with his mother to hear *Faust*, in Topeka, was one
of Hughes's earliest indelible memories. With his father, it was more a
matter of suppressing and forgetting. Nathaniel Hughes was a lawyer
who loathed the poor, despised Afro-Americans, and, according to his
son, "hated himself." He was also increasingly less fond of Mrs. Hughes.
In 1902, a few months after Langston Hughes was born in his grand-
mother's Joplin home, his father took the family to Mexico. Carrie and
Nathaniel Hughes did their best to make each other miserable, separat-
ing and tearfully reuniting until they divorced in about 1912 or 1913.
The real victim, of course, was their son, shunted back and forth be-

quizzically, then only because it was Jean Toomer. Langston Hughes looked in—once. Arna Bontemps, another young Harlem poet, returned to enjoy the company. Aaron Douglas, the artist, became a convert for life, and Wallace Thurman, soon to be an important part of literary Harlem and then just arrived from California, was a regular. So was Dorothy Peterson, attractive, financially secure, and another of Harlem's aspiring young writers. But after a while, Harlemites failed to see the wonder of Toomer's work; finally, they stopped coming to hear him. To a man with a cosmic mission, indifference was a small disappointment. He was already beginning to drift away many months before the community's interest flagged. There were rumors of a hot love affair with Edna St. Vincent Millay. Hart Crane wrote his mother that he had seen Toomer (who had tried to interest Crane in Naumberg) in the thick of Village affairs during this period, hobnobbing with Edmund Wilson, Marianne Moore, Van Wyck Brooks, Paul Rosenfeld, Alfred Kreymborg, and others of the Lost Generation peerage. And through Alfred Stieglitz and Georgia O'Keeffe, Toomer had been introduced to one of the most extraordinary women of the period, America's version of Madame de Staël, Mabel Dodge. She was Mabel Dodge Luhan by then, married to her fourth husband, a bewildered Pueblo Indian named Tony Luhan.

Mabel Dodge Luhan was cagey about Toomer in the beginning. In the first place, her experiences with Afro-Americans had been unfortunate. Not long before she met Toomer, novelist Carl Van Vechten had invited her to an evening of blues singing. Van Vechten enjoyed himself immensely, giggling and clapping his "pretty little hands" while a large, black woman stomped and bellowed. Mabel Dodge left in disgust. She may also have suspected that Gurdjieff was a charlatan. But Jean Toomer was handsomer even than John Reed, her great love before the war. "The atoms of which we are composed shift and change position" (Dodge had helped invent the strange language of the twenties), "so that each time we meet our relation to each other has become modified." By the end of 1924, she was ready to become a Gurdjieffan. She was "committed to this new thing," she wrote from Manhattan's exclusive old Hotel Brevoort. "Everything has been a preparation for it." Dodge had very complicated ideas about sex. She saw in Toomer, because of his continuing affair with Naumberg, the ideal partner. "You see, a man who has a complete and fulfilling sex outlet is made free. It gives him control." She was able to "cool when I please." She did not want to "burn with passion" and deny it "because of Tony."

"Now something else has got to happen. Something marvelous. If it doesn't—then we are friends. We like each other."

Something did happen. After she left her suite in the Hotel Brevoort for her estate in Taos, New Mexico, Dodge began bombarding Toomer with love letters. It was "wonderful to find some one who seems manly where I've had nothing but sins in my life, and not sins of God either." She wanted Toomer there, and she always got what she wanted. She still loved Tony Luhan, but he broke her heart "by the things he says— he wears me down—he crushes me under boredom, for I am no longer interested." When Toomer came, they were going to have to be careful not to enrage poor Tony, for Mabel intended to do more than give her heart to Gurdjieff's disciple. She was offering her fortune and her estate. She only asked to be used. She could not know that local Gurdjieff representatives had cautioned Fontainebleau that she was impetuous and unstable. Even so, sensing a hesitation, she gave Toomer fourteen thousand dollars for "the work." Toomer sank deeper into Dodge's world and into the slightly lunatic universe of Chicago's Gurdjieff devouts, preaching and raising money for the cosmic cause and writing long, turgid treatises and wooden novels inspired by the creed of Fontainebleau, all of them rejected by publishers who frequently wrote letters containing friendly, sane advice.

But Toomer was too deeply committed to Gurdjieff's teachings to let go. Headquartered in France, staffed by cosmopolitan Russian émigrés, sustained by the offbeat wealthy, famous, and talented, fostering an ideal of human solidarity and salvation outside history, and demanding confidence in the Founder—the movement satisfied Toomer's yearning for racial transcendence, glamor, community, elitism, and a father figure. Its calisthenics even recharged the muscles dormant since leaving the Chicago College of Physical Training. It also accommodated a colossal ego, for, although the movement's published literature is utterly silent about his role, Toomer was once regarded by Gurdjieff himself as his most important American disciple. For a decade, Toomer would stride among mere mortals as the anointed figure beyond all parochialisms, vouchsafed eternal verities. "I am not sure that I have a soul," he ventured, "but if I have, then Gurdjieff has penetrated the shell and written upon the kernel indelibly." But what did it profit a man to believe he had found his soul, yet lose not only his own people but his gift? "So Jean Toomer shortly left his Harlem group and went downtown," Langston Hughes lamented. "They liked him downtown because he was better looking than Krishnamurti, some

said," but the "Negroes lost one of the most talented of all their writers."

Countee Cullen was Harlem's poet prodigy. Like McKay and Toomer, he possessed the artist's genius, and, as it did to Langston Hughes, the craft of poetry came naturally to Cullen. His first poem appeared in 1918; three years later, when he was eighteen, the DeWitt Clinton High School *Magpie* published "Life's Rendezvous," a version of one of his strongest early poems. At New York University he won a stream of poetry awards, and his work caught the eye of some important readers. "I see that a negro student in NYU has won a prize for a ballad," Harvard's renowned Shakespearean George Lyman Kittredge wrote a colleague. "May I have a copy?" That year, 1923, Cullen had won honorable mention in the Witter Bynner Undergraduate Poetry Contest, and Bynner himself had sent regrets that he had been out-voted in awarding Cullen first prize. *The Crisis* and the new *Opportunity* had already carried Cullen's verse, accompanied by cheers. *The Bookman* published his poem dedicated to Hughes, "To a Brown Boy," in the same month Bynner first wrote to him—Cullen's initial exposure in a national magazine. *Harper's* and *Century* quickly followed, and then the *American Mercury*. In 1924, his "The Ballad of the Brown Girl" placed second in the Witter Bynner competition and the next year he finally won first prize in the Witter Bynner, with Carl Sandburg as one of the three judges. He was elected to Phi Beta Kappa, accepted for graduate training at Harvard, and saw his first volume of poetry, *Color*, published by Harper & Brothers. "Yet Do I Marvel," which opens *Color* and is among his best-known poems, might have been dedicated to himself—the marvel, "To make a poet black, and bid him sing!"

Establishment Harlem had never been comfortable with Jamaican Claude McKay. It lost Jean Toomer, whom it admired without quite understanding. But Countee Porter Cullen was indisputably one of its own, a local product, a living exemplar of Talented Tenth values. His father, Reverend Frederick Asbury Cullen, pastor of Salem Methodist Episcopal Church, was a pillar of the community. Mrs. Carolyn Belle Cullen, his mother, though somewhat reclusive, belonged to the right clubs, supported the appropriate charities, and stood loyally beside her husband. Mothers, teachers, and deacons vouched for young Cullen's good behavior, studious brilliance, and filial piety. He was said to be a perfect companion, perfect student, and perfect son. In May 1925, he

appeared to be on his way to becoming a perfect poet. Harlemites who suspected or knew that the young poet was less than perfect were a distinct and whispering minority. A few nubile young ladies tittered that Cullen was uninterested in women and preferred the company of Harold Jackman, handsome West Indian man about town, and there were comrades who snickered about his adoration of his adoptive father (rumored to be a menace to choirboys and oddly fond of Mrs. Cullen's cosmetics). But, rumors aside, Harlem always ignored or forgave everything of its best and brightest.

Those who knew the poet personally insist that literary critics and doctoral drones have been unduly diverted by the dark aspects in his life. They remember Cullen as outgoing, bubbly, and too busy writing and teaching for eccentricity or despair. "He was always a perfect gentleman," is a refrain among the Harlem survivors of the period. The Cullen who entertained gaily at his father's parsonage, bounced along Lenox Avenue casting sunny salutes or laughed merrily in Smalls' night club was real enough. Of course, the other Cullen was also real. Impotence and death run through his poetry like dark threads, entangling his most affirmative lines, and mocking his early poem, "I Have a Rendezvous With Life." His book *Color* opens with a spiritual casualty report and closes with an epitaph about the fleet sprinter, racing like a "hunted doe," but knowing that the pace of time will surely "lay him low." After the ravages of time comes release in "Requiescam": "I would my life's cold sun were setting / To rise for me no more." And there was "Suicide Chant," one of the early poems sent to Langston Hughes on a freighter at Jones Point, which Hughes thought was as atrocious as it was morbid. The sense of spoiled pleasures and deferred hopes steadily enfeebles whatever small joys the poet sometimes finds, as in "Confession": "If for a day joy masters" him, his wounds are not healed, but, far deeper than the scars people see, he keeps their "roots concealed." Or "For a Poet," in which Cullen announces he has wrapped his dreams in silken cloth, "And laid them away in a box of gold."

He was not always declining, decaying, and dying in his poetry, but Cullen never seemed far—even in moments of strong affirmation—from being affronted by life. Beyond his sensitivity as a poet and pain as an Afro-American, there was a singular, corroding suspicion of life cursed from birth, of something gone wrong from the day of creation. During his life and until now, Cullen's parentage was never certain, and he seems to have thickened the mystery at every opportunity. The best reconstruction of the facts is that he was born Countee Leroy

tween Mexico City, Missouri, Kansas, and Illinois—wherever his mother could place him. Throughout his life, whenever Hughes heard the complaint, " 'I can't sleep in a strange bed,' " he was puzzled. "Such a person I regard with wonder and amazement. . . . I figure I have slept in at least ten thousand strange beds." It was hard for him to believe during those hard years that "the good knight won, and the Alger boy triumphed." But that was mainly because he hated his father, whose success was vintage Horatio Alger. Nathaniel Hughes spoke Spanish fluently, prospered at law, and, when revolution swept Mexico, became the director of an expropriated American power and light company. While Carrie and her new husband struggled to make ends meet in Kansas and Illinois, Langston's father went to his office from a sumptuous town house and vacationed on his ranch.

Hughes accompanied his mother and her second husband to Cleveland. Grandma Langston was dead, but her grandson had learned to suffer in polysyllables. He had written his first poem in Lincoln, Illinois, and been elected class poet at its elementary school. At Cleveland's Central High, the daughter of Charles Waddell Chesnutt, Afro-America's first major novelist, polished his prose, and another teacher introduced him to Edgar Lee Masters, Amy Lowell, Vachel Lindsay, Sandburg, and Whitman. On his own, he discovered Maupassant, devoured him in French, and decided he had to be a writer. His Central High School classmates agreed. At least, they said they did, but Hughes, equable and sunny, was seldom naive; he saw that a political standoff between gentile and Jewish students aided his election to the *Belfry Owl*, in which his first published poetry appeared. The year after graduation, 1921, he was reading his verse in *The Brownies' Book*, a series for juveniles edited by Du Bois himself. That same year, *The Crisis* published one of his most enduringly popular poems, "The Negro Speaks of Rivers." Sandburgesque in cadence like so much of his early verse, it was distilled from one of the saddest moments in the exclusive sadness of a nineteen-year-old. Long afterward, Hughes said that he wrote "mostly because, when I felt bad, writing kept me from feeling worse." The poem was written on that same train to Mexico on which his father had once snarled something about the just deserts of worthless people and ordered him to look at a group of Afro-American laborers, trudging out of view into oblivion. "The Negro Speaks of Rivers" was Langston Hughes's defiant gesture of rejection of Nathaniel Hughes and an affirmation of the folk whose oblivion was a matter of perspective. He dedicated it to another autocratic patriarch, Du Bois:

I've known rivers:
I've known rivers ancient as the world and older
 than the flow of human blood in human veins.

My soul has grown deep like the rivers.
I bathed in the Euphrates when dawns were young.
I built my hut near the Congo and it lulled me to sleep.
I looked upon the Nile and raised the pyramids above it.
I heard the singing of the Mississippi when Abe Lincoln
 went down to New Orleans, and I've seen its muddy
 bosom turn all golden in the sunset.

I've known rivers:
Ancient, dusky rivers.

My soul has grown deep like the rivers.

A deep soul but an empty wallet was the problem. This was the summer his father would dictate the terms of his college education. What Nathaniel Hughes might say to majoring in literature was too unpleasant even to contemplate. But a mining engineering degree at a Swiss or a German university was even grimmer to his son. They compromised on engineering at Columbia University. Beyond Morningside Heights lay Harlem, on one side, and the Broadway smash, *Shuffle Along*, on the other, and utterly beyond Hughes was mining engineering. He stayed two semesters. After that he never saw his father again, never received another penny from him. But he never doubted the price was worth it. He was twenty, free, and a poet in Harlem, adored by Jessie Fauset, literary editor of *The Crisis*, and encouraged by Du Bois. He would have liked to meet McKay, but their circles never touched. Joel Spingarn, the NAACP's patrician former board chairman, took a liking to him; and his wife, Amy, a poet in her own right, was completely charmed by this talented, motherable young man.

Charming prodigies could starve as easily as unemployed domestics, however, and Langston Hughes's startling discovery while a high school student—a discovery that lay like quicksand beneath Harlem's solid achievement and frenetic optimism—was as true in New York as in Cleveland: ". . . kikes and spicks and the hunkies—scorned though they might be by the pure American—all had it on the niggers in one thing. Summer time came and they could get jobs quickly." Work on a Staten Island truck-garden farm came his way; later, he worked as a delivery boy for a florist. But this was hardly suitable for an aspiring poet, and he confided to Countee Cullen that he was in his "dullest

sensed he might be wasting irrecoverable months and years, confessing to Professor Locke how little Conrad, Nietzsche, Whitman, and Pío Baroja he had read since coming to the Point. The *Odyssey* ("a truly marvellous thing!") was now under his belt, at least. Maybe he was stupid, he wrote Locke—just a young kid "fascinated by his first glimpse of life." The professor had already warned that the dangerous age of creative puberty was upon Hughes and invited himself to Jones Point to guide the young poet—a prospect that "frightened me stiff," Hughes told Cullen. "How good of you to offer them to me"—help, friendship, and criticism—he replied by return post, lavishly enumerating the unthinkable inconveniences for Locke of such a visit, then telling Cullen he really "didn't want to see [Locke] anyway, being afraid of learned people in those days." In his own gentle way, Hughes was too full of rebellion against well-meant advice and proper conventions to follow the placid directions that Cullen was too good a friend to preach about and Locke too much a pedagogue not to.

The S.S. *Malone* was, at long last, ready to weigh anchor. It was time to follow his dreams to Africa and Europe. All his New York dreams had been realized: "college (horrible place, but I wanted to go), Broadway and the theatres—delightful memories, Riverside Drive in the mists, and Harlem. A whirling year in New York." Whatever the future held, he wrote of his June farewell to Locke, it had been nice to "come here and be simple and stupid" and experience a life that was a living thing with no "touch of books." And he really meant to be done with books and all they reminded him of. Hughes had raced back to Harlem to fetch his college library just before sailing, but that first night out, off Sandy Hook, he "leaned over the rail of the S.S. *Malone* and threw the books into the sea. . . .

It was like throwing a million bricks out of my heart—for it was not only the books that I wanted to throw away, but everything unpleasant and miserable out of my past: the memory of my father, the poverty and uncertainties of my mother's life, the stupidities of color-prejudice, black in a white world, the fear of not finding a job, the bewilderment of being controlled by others—by parents, by employers, by some outer necessity not your own.

A hundred Russian shoulders had uplifted McKay. For Hughes, it was to be the sea and Africa—what he saw of it during his six-month odyssey. After the Canaries, his excitement rose day by day. Then,

humor." By winter 1922–23, life was somewhat better. Hughes had signed on as messboys aboard the S.S. *Malone*,* a freighter plying between New York and the west coast of Africa. During the long wait at Jones Point before sailing, he learned that Cullen and Professor Alain Locke of Howard University were doing their utmost to foster his reputation. Cullen wrote regularly, passing along literary gossip and asking for new poems to read with his own at Harlem's 135th Street branch of The New York Public Library.

Cullen had taken a deep liking to Hughes, treasuring the autographed photo sent from Jones Point and dedicating "To a Brown Boy," a discreetly sensuous poem, to his friend. "I don't know what to say about the 'For L.H.,'" Hughes wrote coyly, "but I like the poem." Cullen's poetry reading at the 135th Street library was a considerable success, with Hughes delightedly learning that Hall Johnson, the Harlem violinist, wanted to "do a musical setting" for his "Mother to Son." Ridgely Torrence, one of the Provincetown playwrights, had already invited him to send his latest verse for a special edition of *World Tomorrow*, and Jessie Fauset followed with a letter urging him to pour himself into poems for *The Crisis*. He was beginning to miss New York's "little cellar places" that were "so interesting and very Harlemish," the opera, and the theatre. Paragraphs in letters to Cullen and Professor Locke fairly exploded in excited recall of the past Broadway season—seeing Chaliapin in *Boris Godunov*, Jane Cowl's *Romeo and Juliet*, Maugham's *Rain*, or O'Neill's *Anna Christie*, or the Moscow Art Players. When Cullen described a Washington weekend with Locke, Hughes crackled with curiosity, wanting to know about Howard, the city, and Locke. "Is Mr. Locke married?" he wondered, indicating how little he really knew about the professor who had initiated their correspondence after reading Hughes in *The Crisis*.

Marooned aboard his ship at Jones Point, among the freighters vanishing in the icy Hudson mists, Hughes's occasional yen for New York was quenched by sea chanty contests in a half-dozen languages and the camaraderie of the finest fellows he'd ever met, sailors you could "touch and know and be friends with." He worked hard at his poetry, and especially hard on "The Weary Blues," a poem the satisfactory ending to which eluded him—"something that seldom happens to any of my poems." It was a "glorious winter," but with his twenty-first birthday barely behind him and the Hudson beginning to thaw, he

* Cf., Arnold Rampersad, *The Life of Langston Hughes*, 2 vols. (1986, 1988), I, p. 71.

Dakar, the new Timbuktu—magnificent, riotously African, and impeccably French—where the crew was granted a few days' shore leave. From then on, though, most of what Hughes saw of Africa he saw from the deck of the *Malone*. In late July, he posted a letter to Cullen from Lagos, reporting that all he knew of the continent were the "orange-yellow sands" of its coast and the roofs of white houses hidden in coconut tree groves. Boma and Matadi on the Congo River were the next stops, then Luanda, Angola, before heading home after putting in at thirty-two ports. The people were "black and beautiful as the night," market women with "bare, pointed breasts," and cargo men loading palm oil, cocoa beans, and mahogany with "rippling muscles" sweat-glistening in the sun.

Ignorant of Africa beyond the shoreline, at least Hughes had seen Africans on their home ground, heard the drums and songs, smelled some of the continent's odors, wilted under scorching sun ("no hotter than a Chicago summer"), and lay awake enveloped by Africa's awesome nocturnal vibrations. It may have been because he was the only poet from Harlem ever to tack along the west coast (McKay never got beyond Morocco) that Hughes avoided romanticizing Africa excessively. Some of his African poems spoke of instantaneous affinity for the homeland, of yearning to be rid of the fetters of European civilization, of the primal appeal of the tom-toms.

> The low beating of the tom-toms,
> The slow beating of the tom-toms,
> Low . . . slow
> Slow . . . low—
> Stirs your blood.
> Dance!

Yet, even this poem, "*Danse Africaine*," was more remarkable as an early example of Hughes's experimenting with motion and mood than as a paean to Mother Africa. What he really thought of his kinship with Africa worked its way to the surface a year after returning, in "Liars":

> It is we who use words
> As screens for thoughts
> And weave dark garments
> To cover the naked body

Of the too white Truth.
It is we with the civilized souls.
We are liars.

In every port, Hughes heard Garvey's name "and the Africans did not laugh at Marcus Garvey, as so many people laughed in New York." He had never laughed at Garvey, either, but, unlike McKay, Hughes fully expected Garvey's program to end in debacle. The dock-workers of Sekondi and market people of Lagos did not "understand the terrific complications of the Colonial Problem." Something else they could not understand was the veil of culture separating the over-seas African from his homeland cousin. In "Fog," Gold Coast dockers were told, "You do not know the fog / We strange so-civilized ones / Sail in always." But the Africans understood Hughes's ambiguity be-cause, whenever he spoke of his and their similar problems, they "only laughed at me and shook their heads and said: 'You white man! You white man!'" In the short story "Burutu Moon," the narrator wants to see a Ju-Ju dance: "'No, him too awful! White man never go.' 'But I'm not a white man,' I objected. 'You no black man, neither.'"

In "Luani of the Jungles," one of the best of the early short stories (and bearing the clear imprint of Joseph Conrad), Hughes used the tragic marriage of a white Sorbonne student to an African *belle dame sans merci* as a multiple metaphor for cultural antipathy, primal affin-ity, the inexorability of being simply what we are, and, unwittingly, the tensions of intellectual Harlem. Years ago, at the Bal Bullier in Paris, a "little white man with the queer accent," a passenger bound for Lagos, had met Luani, educated in London and daughter of a wealthy Ni-gerian merchant. He tells the author-narrator, "'She seemed to me the most beautiful thing I had ever seen—dark and wild, exotic and strange.'" Suddenly, before he had known it, the man "leaned across the table and was saying, 'I love you.'" He renounced his studies; they married and left for her African village. "'You'll be the ebony goddess of my heart,'" he swears, "'the dark princess who saved me from the corrupt tangle of white civilization....'" But the jungle came between them even in Lagos where Luani donned tribal garb at the Liberty Hotel, sent her jewels "to the steel safe at the English bank . . . and seemed to put me away, too.'" In her village, she abandons French and English, hunts and fishes without her husband, and crushes him by loving the strong young son of the chief. Reproached, she says simply, "'I am sorry. A woman can have two lovers and love them both.'"

Four times the little man leaves Luani, only to turn back at Lagos. He is returning again. " 'Why I stay with her, I do not know any longer' " —Luani has borne a child by the chief's son—" 'Only one thing I do know—she drives me mad.' "

Six months at sea had given Hughes time to rough out many of the poems for *The Weary Blues*, the volume of collected works Carl Van Vechten would carry to publisher Alfred A. Knopf in late 1925. They had also given him the time and, probably, a number of experiences that decided him impetuously to take Locke up on his repeated offers of a special relationship. Perhaps, Countee Cullen, with whom Hughes stayed after returning, urged him to go to Locke. "May I come now?" he telegraphed in early February. But Locke had another friend at the moment. Two days later, the African explorer apologized. He should have realized the middle of the semester was a poor time, but he had been reading Locke's letter that day and was possessed of a sudden desire to go to Locke immediately, "right then, to stay with you and know you." He was, he sighed, "so stupid sometimes." A few days later, Hughes sailed on another freighter for Rotterdam. He crossed the Atlantic twice on the same ship. The second time, he drew his pay, twenty-five dollars, and headed for Paris. That first moment on French soil was enchanting, but there was nothing enchanting about Paris on March 11, about three weeks later, with seven dollars left. He wrote Cullen, "Kid, stay in Harlem!" The French were a nation of miserly, *sou*-grubbing pikers, "hard-faced, hard-worked, cold, and half-starved." You paid for even a smile in Paris. "And do they like Americans of *any color*? They do not! ! !"

Montmartre, in 1924, was an Afro-American colony. But Hughes was not the sort of Afro-American who belonged. Montmartre's Afro-Americans sang, danced, and played musical instruments for a living. " 'You must be crazy, boy,' " a veteran of the quarter snorted. " ' 'Less you can play jazz or tap dance, you'd just as well go back home.' " He starved a little, got a letter from his mother with no money but "containing the longest list of calamities" ever seen on a sheet of paper, was rescued by a dancer named Sonya, and finally found work at a little cabaret in Rue Fontaine. But the clientele had the habit of firing wine bottles at each other. "For such a job, five francs was not enough." Then, when circumstances were foulest, Hughes met Rayford Logan, a former Afro-American army officer, still bitter about the racism of Woodrow Wilson's war and making a hefty living in currency speculation. Logan took him to an Afro-American–run night club, the Grand

Duc, and got him a job washing dishes. The Grand Duc's star attraction was Florence Embry, brown, beautiful, Harlem-reared, and bitchy. *Le tout monde*—the Dolly sisters, Nancy Cunard, Anita Loos, Robert McAlmon, the Chicago McCormicks, Louis Aragon, Prince Touvalou of Dahomey, and more—scrimmaged for tables in the living room–sized club to hear her. The swells enjoyed her constant refusal to accept champagne from their tables. Important names meant nothing to Florence—money did, sometimes. After the last guests had lurched into taxis and limousines, the Grand Duc would become a Harlem cabaret, with the band, doubled by Afro-American musicians from nearby clubs, playing till dawn—jam sessions, "only in 1924 they had no such name for it." Some of Hughes's best jazz poetry would come from those bleary mornings: "Blues in the rue Pigalle. Black and laughing, heart-breaking blues in the Paris dawn, pounding like a pulsebeat, moving like the Mississippi!"

The Grand Duc's fortunes took a sour turn when its star stalked off to start her own place, Chez Florence, the cabaret sensation of the mid-twenties. Not even the appearance of a flame-haired, rough-voiced woman from Chicago helped the Grand Duc. In Paris, no one knew Bricktop, whose coming success would eclipse all rivals, and the Grand Duc was often quieter than New York's Civic Club before lunch. But Hughes's fortunes had never been better. He had just missed McKay, who was nursing himself back to health on the Riviera, but the famous singer Roland Hayes was expected at any moment, and the companionship of West African Prince Kojo Touvalou Houénou and René Maran, the Caribbean novelist, was good for the mind and for his French. "I don't get a third of what he says," he wrote Cullen of his visits to Maran, but he was terribly impressed and planned to see him often. Much more often, he saw Paris by night, Montmartre, where no one got up before seven or eight in the evening, "breakfast at nine, and nothing starts before midnight."

In April, he fell in love. The girl's name was Mary, a "soft, doe-skin brown" Anglo-African, whose wealthy African father lived in London. They walked in the rain in the gardens at Versailles, went to the museums and monuments, read McKay's *Spring in New Hampshire* to each other, and danced until morning at Le Rat Mort and Moulin Rouge. Her money paid for the theatre and the night life. "That embarrassed me at first," her lover said, "but then that was the only way we could go around much together, at all." There was talk of marriage —at least, Mary proposed it—but while Hughes weighed the pros and

cons of a patroness for a wife, an emissary from Mary's father arrived, ordered her trunks packed, and shepherded her to London. He "thought a lot about Mary after she went away," wrote a conventional poem for her in his attic, "The Breath of a Rose," then, after a while, he "didn't think about her so much." Alain Locke reentered his life.

Who was this man Locke who so fascinated and drew the young Langston Hughes? A brown, delicate academic, Alain Leroy Locke possessed unique credentials. At Harvard he had been a junior Phi Beta Kappa, and at Oxford the first Afro-American Rhodes scholar. His Harvard doctorate was in philosophy. He was a person of truly exquisite, if somewhat eccentric, culture. His Howard University colleagues never forgot the wake Locke held in his apartment in the early twenties. He had served them tea while the embalmed remains of his mother sat in her favorite armchair. Professor Locke had a weakness for his male students—and for intelligent males in general. He had done a great deal of thinking about Langston Hughes during the spring semester of 1923. Their will-o'-the-wisp relationship was annoying to him. That summer, given a League of Nations commission to report on French use of African troops in the occupied Ruhr, Locke had gone to considerable trouble to arrange to take Cullen and Hughes along to Europe with him. "Naturally, I am depressed," he grumbled to Cullen when the plans aborted. "As to Langston—he is a fool—never again— I mean it. For example, I had an invitation to the Bahai center at Haifa so worded as to include him." The fool had sailed for Africa instead. Now, in the summer of 1924, Locke was determined to find Hughes in Paris. Promising to bring him details of a possible Howard scholarship, offering to introduce him to famous Parisians, he forwarded his sailing schedule well in advance. Hughes replied warmly. He was working on his poetry again, and James Weldon Johnson of the NAACP had arranged for him to meet Albert Barnes, the Pennsylvania art collector, at Paul Guillaume's studio in mid-June. He was beginning to enjoy Paris, "now that the sun is shining and it is no longer so cold." One morning there was a polite tap at his door. *"Qui est-il?"* he asked sleepily. The "mild and gentle voice answered: 'Alain Locke.' "

Locke was as much in his element in Paris as on the Howard campus. He turned the Louvre and the Jeu de Paume into classrooms for Hughes. Seated in the Parc Monceau, his favorite, or strolling through the Luxembourg gardens, discoursing in French with hyper-

literate Frenchmen and Francophone colonials, the little professor mesmerized his long-pursued companion with what seemed an incomparable display of learning, urbanity, and empathy. They had a "glorious time," and later in the summer met again in Venice. There, Hughes gradually began feeling a surfeit of aestheticism. "I got a little tired of palaces and churches and famous paintings and English tourists. And I began to wonder if there were no back alleys in Venice and no poor people and no slums and nothing that looked like the districts down by the markets on Woodlawn Avenue in Cleveland, where the American Italians lived." Inspiration for Hughes's kind of poetry was not to be found in the Piazza San Marco.

At summer's end, Hughes left Locke and Venice, travelling by way of Toulon, where he intended to spend a few days with Claude McKay. He got as far as Genoa. A pickpocket in the third-class carriage lifted his wallet and passport, and he found himself living on the beach, just a few miles from the French border. The American consul was polite but unhelpful. Hughes's seaman's credentials saved him. A slow freighter, shambling down the Italian coast on the way to Spain, took him on as a deck hand. Perhaps it was that experience that inspired "Waterfront Streets":

> The spring is not so beautiful there—
> 　But lads put out to sea
> Who carry beauties in their hearts
> 　And dreams, like me.

Then he returned home—home to Harlem—arriving on November 24, just in time for the official commencement of the Harlem Renaissance.

4

Enter the New Negro

In mid-March 1924, Charles S. Johnson invited Jean Toomer and about a dozen other young and mostly unknown poets and writers to dine at the Civic Club on the evening of the twenty-first. The original idea had been an informal gathering to honor the publication of *There Is Confusion*, a novel by the literary editor of *The Crisis*, Jessie Fauset; Johnson had turned it into a well-advertised literary symposium. Cultural energies had been gathering. In the nineteen years since Charles Waddell Chesnutt's *The Colonel's Dream*, no more than five Afro-Americans had published significant books. In 1908, the fiery Baptist preacher Sutton Griggs had written his last novel, painfully flawed but fascinating, entitled *Pointing the Way*. Three years later came W. E. B. Du Bois's *The Quest of the Silver Fleece*, an economic treatise in the guise of a romance. The following year, the public had been offered the intriguing, well-crafted *Autobiography of an Ex-Colored Man*, James Weldon Johnson's anonymous novel. Then there was practically nothing (nothing except the curious folk novels of film-maker Oscar Micheaux, the heroic fantasies of Henry Downing and Etta Spencer, and the eccentric tour de force of Joel A. Rogers, *From Man to Superman*) until 1920, when Du Bois's coruscant, acid-dipped *Darkwater* was published by Harcourt, Brace. Claude McKay's *Harlem Shadows*, the first book of verse since Paul Laurence Dunbar, came in 1922, and in 1923 appeared Toomer's *Cane*.

"A group of the younger writers, which includes Eric Walrond, Jessie Fauset, Gwendolyn Bennett, Countee Cullen, Langston Hughes, Alain Locke, and some others," would be at the Civic Club, Johnson's letter of invitation to Toomer said. The club, on Twelfth Street near

Fifth Avenue, had been incorporated in 1917. It was the only upper-crust New York club without color or sex restrictions, where Afro-American intellectuals and prominent white liberals forgathered, more often than not around a table haloed by Benson and Hedges cigarette smoke exhaled by Du Bois. About fifty people would be at the dinner, Toomer read:

Eugene O'Neill, H. L. Mencken, Oswald Garrison Villard, Mary Johnston, Zona Gale, Robert Morse Lovett, Carl Van Doren, Ridgely Torrence, and about twenty more of this type. I think you might find this group interesting, at least enough to draw you away for a few hours from your work on your next book.

In fact, about one hundred ten came, but not Jean Toomer. He missed the dress rehearsal of what was soon to be known as the "Harlem Renaissance," just as he would choose to avoid the full production. *Cane* had marked the beginning of the end of Toomer the black man. But it was impossible for Johnson to know this in the fall of 1924. For him, Toomer still expressed "triumphantly the Negro artist, detached from propaganda, sensitive only to beauty."

For one of the most prolific sociologists of his generation, written evidence of Charles Johnson's vast influence on the Harlem of the New Negro is curiously spotty. This is not because he lived in Manhattan, where a telephone call or a stroll down an avenue could put him in touch with most of the people worth knowing, and letters did not need to be written. Other Harlem leaders of equal or greater distinction left entire libraries of official and unofficial correspondence. Even after allowance is made for the destruction by fire of Urban League archives and for the possibility of letters yet to surface, the record is still too skimpy not to have been planned that way by Johnson. It seems to have been his nature to work behind the scenes, recruiting and guiding others into the spotlight. His style was, nevertheless, more the pose of modesty than modesty itself, for Johnson had a considerable ego, re-flected in the British elegance of his suits and the businessman's gait. He was, moreover, a man whose passion for dominion expressed itself through secrecy and patient manipulation. Yet it was manipulation for a purpose: to redeem, through art, the standing of his people.

Nothing could have seemed to most Afro-Americans more extrava-gantly impractical as a means of improving racial standing than writing poetry or novels, or painting, but Charles Johnson and a few other

Harlem luminaries were keenly aware that some white writers had already found the Afro-American a salable commodity in the literary world. The times were obviously ripe. The old inflammatory themes of Thomas Nelson Page and Thomas Dixon were showing signs of obsolescence. *Birth of a Nation*, the film version of Dixon's *The Clansman*, had done its full and fearsome work. There was still a plethora of "coon" or "chicken thief" stories of the sort excelled in by Octavus Roy Cohen (*Highly Colored* and *Assorted Chocolates*, etc.), but other white writers were experimenting with more subtle and serious literature. From older writers like Lincoln Steffens and Van Wyck Brooks to young ones like Waldo Frank and Matthew Josephson, there existed a common conviction that Western civilization had been badly maimed by an omnivorous industrialism. The writer Harold Stearns and his fellow *révoltés* of Greenwich Village loudly advertised their loathing for "the people who actually run things" in America. "In literature alone," Van Wyck Brooks preached, could the regeneration of America "have a substantial beginning." From such convictions the rediscovery of the Afro-American followed logically and psychologically, for if the factory was dehumanizing, the campus and the office stultifying, and the great corporations predaceous, the Afro-American—excluded from factory, campus, office, and corporation—was the perfect symbol of cultural innocence and regeneration. "One heard it said," Malcolm Cowley remembered, "that the Negroes had retained a direct virility that the whites had lost through being overeducated."

The turning point had come in 1917, when Emily Hapgood produced Ridgely Torrence's three plays with black casts (*The Rider of Dreams, Simon the Cyrenian,* and *Granny Maumee*) at the old Garden Theatre on the fringes of Broadway. "Nobody who saw Opal Cooper —and heard him as the dreamer, Madison Sparrow—will ever forget the lift his performance gave," Edith Isaacs of *Theatre Magazine* wrote. When Eugene O'Neill's *Emperor Jones* followed three years later, the possibilities of black themes seemed greater than ever. Summer of 1921 brought the Flournoy Miller and Aubrey Lyles musical, *Shuffle Along*, to New York's rundown 63rd Street Theatre, the first postwar musical with music, lyrics, choreography, cast, and production entirely in Afro-American hands; it left the country singing Eubie Blake's "I'm Just Wild About Harry" and "Love Will Find a Way" long after it closed. The following year saw the theatrical debut of a Columbia University law student named Paul Robeson in Mary Hoyt

Wiborg's unstructured play, *Taboo*. Critic Alexander Woollcott said Robeson belonged anywhere but on the stage, and Robeson was inclined to agree. In May of 1923, Mrs. Sherwood Anderson produced Oscar Wilde's *Salomé*, using Raymond O'Neil's Ethiopian Art Players. And at the very moment Charles Johnson was sending invitations to the Civic Club, New Yorkers of both races were furiously debating the wisdom of exposing the public to Eugene O'Neill's play about miscegenation, *All God's Chillun Got Wings*, starring Robeson, who was now a law school graduate. Then there was a revival of *The Emperor Jones*, with Robeson interpreting the lead part originally performed to perfection by highstrung, alcoholic Patrick Gilpin.

Among themselves, Harlem's intellectuals had serious doubts about this new wave of white discovery. O'Neill's *The Dreamy Kid* was a vast improvement over Thomas Nelson Page's segregationist *Red Rock*, as was Clement Wood's 1922 novel *Nigger* over Dixon's *The Leopard's Spots*. Yet George Schuyler deplored the ever-present need of whites writing about the Afro-American to show that "even when he appears to be civilized, it is only necessary to beat a tom tom or wave a rabbit's foot and he is ready to strip off his Hart Schaffner & Marx suit, grab a spear and ride off wild-eyed on the back of a crocodile." A long road lay ahead before *their* Negro—the man or woman of sensibility and refinement—could find a serious place in the consciousness of white readers and theatregoers. When asked, of course, Harlem intellectuals pretended they were enthusiastic about the new dramatic and literary themes. After all, as the literary critic Benjamin Brawley confided to James Weldon Johnson, "we have a tremendous opportunity to boost the NAACP, letters, and art, and anything else that calls attention to our development along the higher lines." But those who understood that Freudian notions and the postwar quest for divertissement sweeping Europe and America were at the source of the new popularity of the Negro simmered indignantly over Gertrude Stein's *Three Lives*, E. E. Cummings's Jean Le Nègre in *The Enormous Room*, or Dreiser's *Nigger Jeff*. Talented Tenth lives, certainly, were not summed up by music, sex, primeval instincts, and an incapacity for logic. If Cummings's strapping extrovert was a potent literary metaphor of the forces of nature that a century of industrial culture had repressed in the white man, he was as undeniably alien to the parlors of Harlem's elegant Strivers' Row as a card-carrying Klansman.

Charles Johnson knew this better than most. For the present, never-

theless, he was satisfied to see the cultural spotlight shining on the Afro-American as never before, and he intended to secure this unique moment for an Afro-American effort at breakthrough. On March 21, the moment came, in a magic evening at the Civic Club. White railroad heir and Urban League board member William H. Baldwin III had been delighted to wield his considerable influence in the right places, especially with Frederick Lewis Allen, the Harper & Brothers editor. As Baldwin recalled, "Allen invited a 'small but representative group from his field,' and Charles S. Johnson 'supplied an equally representative group of Negroes.'" The master of ceremonies was dapper Alain Locke, habitually ceremonious to the point of prissiness. Charles Johnson spoke briefly about the need to encourage the creative writers of the race, then yielded the floor to Locke. Du Bois was there, just back from a Liberian mission as American plenipotentiary, and Locke presented him ("with soft seriousness") as a representative of "the older school" of Afro-American letters. His generation, Du Bois told the new generation of writers, had been denied its authentic voice. Racial conventions had imposed subject matter and style upon its artists. Modestly, he said nothing about the courageous exception of his own writing—of the thunder and lightning of *Darkwater*, the ultimate protest classic. He closed by predicting the end of the literature of apology. James Weldon Johnson followed, rising to respond briefly to praise as a precursor who had given "invaluable encouragement to the work of this younger group."

While Jessie Fauset, whose novel was the ostensible reason for the gathering, waited her turn, Locke presented Carl Van Doren, editor of *Century* magazine. Van Doren's address, "The Younger Generation of Negro Writers," would reverberate through middle-class Afro-America in a manner reminiscent of Ralph Waldo Emerson's Harvard declaration of American literary independence from Britain, eighty-seven years before. He had "a genuine faith in the future of imaginative writing among Negroes in the United States." He had "a feeling"—as Charles Johnson may have nodded imperceptibly—"that the Negroes of the country are in a remarkable strategic position with reference to the new literary age which seems to be impending." What was needed was a "happy balance between rage and complacency." Van Doren concluded on a note that seemed to make a brilliant run for Charles Johnson's artists as inevitable as the growth of the country itself: "What American literature decidedly needs at this moment is color,

music, gusto, the free expression of gay or desperate moods. If the Negroes are not in a position to contribute these items, I do not know what Americans are."

Horace Liveright, at his flamboyant best, made a compelling sales pitch for Toomer's *Cane* and Fauset's new novel, challenging his competitors to test the waters of black talent with a few publishing contracts. Alfred and Blanche Knopf were not present to boost *The Fire in the Flint*, Walter White's soon-to-be-published novel, so the NAACP's young assistant secretary spoke for himself, urging the new writers to put aside racial stereotypes. There was applause for T. Montgomery Gregory, chairman of Howard University's drama department, and for poet Georgia Douglas Johnson, both Washingtonians in the grip of genteel poverty, while at the other end of the spectrum, white Philadelphia pharmaceutical tycoon Albert Barnes spoke eloquently of his collection of African art. Jessie Fauset herself—literary mainstay of *The Crisis*, discoverer of Langston Hughes, and one of Du Bois's few confidantes—thanked the audience for honoring the publication of her new novel. Countee Porter Cullen, the twenty-one-year-old prodigy from DeWitt Clinton High School and New York University, read some of his prizewinning verse, and as a last offering of the evening, Gwendolyn Bennett presented "To Usward." Likening her fellow artists to "ginger jars . . . upon a Chinese shelf," she produced a fourth stanza at least more significantly bottled than the rest:

> And some of us have songs to sing
> Of jungle beast and fires;
> And some of us are solemn grown
> With pitiful desires;
> And there are those who feel the pull
> Of seas beneath the skies;
> And some there be who want to croon
> Of Negro lullabies.
> We claim no part with racial dearth,
> We want to sing the songs of birth!

As banal as it was, this apostrophe of the Talented Tenth, "To Usward," in no way dampened enthusiasm.

The dinner ended, Paul Kellogg, editor of the *Survey Graphic*, stayed on to talk with Countee Cullen, Eric Walrond, Jessie Fauset, and the others and then approached Charles Johnson with an unprece-

dented offer. He wanted to "devote an entire issue to the similar subjects as treated by representatives of the group," Johnson wrote excitedly to Ethel Ray Nance, a young Minnesota woman he wanted to come to New York as his secretary. "A big plug was bitten off. Now it's a question of living up to the reputation. Yes, I should have added, a stream of manuscripts has started into my office...."

In January 1923, when *Opportunity* had been launched, Urban League directors George Edmund Haynes and Eugene Kinckle Jones obviously had a different publication in mind than did Johnson, the new editor. "We shall try to set down interestingly but without sugarcoating or generalizations the findings of careful scientific surveys and the facts gathered from research," Jones's editorial proposed. Until late 1924, most of *Opportunity*'s articles had read like chapters from Johnson's *The Negro in Chicago*: Horace Mann Bond's analysis of wartime army intelligence testing; E. Franklin Frazier's discussion of Negro education; Melville Herskovits's statistical conclusions about racial variations in physiology; Joseph A. Hill's study of migration to the cities; and Monroe W. Work's study of rural and urban demography. Now, following the Civic Club affair, the magazine's literary content began to grow rapidly. The deal with Kellogg's *Survey Graphic* was struck and Johnson asked Alain Locke to assemble and edit materials for the project.

Once into the exciting labor of the *Survey* enterprise, pleading, reprimanding, rejecting, and revising against Kellogg's March 1925 deadline, Locke came to regard it as his own unique operation. Despite temperamental discordances, Locke and Johnson made a perfect team because, at bottom, both wanted the same art for the same purposes—highly polished stuff, preferably about polished people, but certainly untainted by racial stereotypes or embarrassing vulgarity. Too much blackness, too much streetgeist and folklore—nitty-gritty music, prose, and verse—were not welcome. Their interview with the German theatrical producer Max Reinhardt, published in *Opportunity* in May, dispelled any doubt. When Reinhardt rhapsodized about musicals like *Liza*, *Shuffle Along*, and *Runnin' Wild*, Johnson and Locke visibly cooled. "Ah yes," Reinhardt persisted, catching the interview's mood change, "I see—you view these plays for what they are, and you are right; I view them for what they will become, and I am more than right. I see their future." Despite a *Shuffle Along* cast that had included Josephine Baker, Catarina Jarbaro, Florence Mills, and Paul Robeson, and an orchestra conducted by Rosamond Johnson with William Grant

Still in the string section, "we did not enthuse," Johnson and Locke reported. Musical comedies, whatever the Afro-American countribution, were decidedly not the coming art form for the *Opportunity* muses.

While Locke labored with prose and verse and enragingly slow contributors, Johnson and his new secretary, Ethel Ray Nance, were creating a constituency. Dossiers on artists scattered across the country grew. Many artists were encouraged—even cajoled—to succumb to the risky promise of New York. Some needed little encouragement. Arna Bontemps and Wallace Thurman, neither California-born but finding no better niche for their California liberal arts degrees than the Los Angeles central post office, had followed the Harlem scene passionately ever since the appearance of McKay's *Harlem Shadows*. Bontemps's moment of truth came in August 1924, when *The Crisis* arrived containing his first published poem. "He resigned [his] job in the post office and packed [his] suitcase and bought a ticket for New York City." Thurman lingered for a few months longer. Zora Neale Hurston, a second-year student at Howard University, would have conned her way to China to find recognition. At Baltimore's Morgan College, where she completed most of her secondary training, Hurston had flattered the dean, William Pickens, shamelessly. "Greatest of all," she wrote him, "thirty or forty years hence, the world will look for some one that has really known you to write your biography. . . . I want to do that." Even a certified misogynist like Locke (customarily he dismissed female students on the first class day with the promise of an automatic grade of C) yielded to Hurston's extravagant flattery when she wrote for Howard's student publication, *Stylus*. Charles Johnson's enquiry about promising student writers at Howard was answered by an excited Locke before the close of the second semester. Zora Neale Hurston was the best and brightest in years, he wrote. "In the first week of January, 1925," her biographer records, "Zora Hurston arrived in New York City with one dollar and fifty cents in her purse, no job, no friends, but filled with hope."

Aaron Douglas, pretty well destined for a Kansas City, Kansas, high school principalship, had to be pushed. Johnson had been told that Douglas was one of the race's finest potential artists. The stable of promising novelists and poets was filling up, but, as yet, Harlem had no significant plastic artist. After her first polite letters failed, Johnson urged his secretary to try shaming Douglas out of his Kansas cocoon. "Better to be a dishwasher in New York than to be head of a high school

in Kansas City," she challenged. Douglas resigned, came to Harlem, and slept on Ethel Nance's couch for a longer time than either had anticipated, work for black painters being much harder to come by than Civic Club praise. Meanwhile, he squeezed in lessons from Winold Reiss, a white artist whose fascination with African themes was waning and who was anxious to train an Afro-American disciple.

Charles Johnson decided that what the arriving artists and writers needed was an established forum with its own standards, rules, and rewards. His September editorial announced the new *Opportunity* prizes for outstanding creative achievement to be presented with appropriate fanfare in May of the following year. His statement of purpose spoke of artistic creation, of "mining tremendously rich sources," of course, but the stress was clearly on the social utility of Afro-American arts and letters. The point was, Johnson wrote:

to encourage the reading of literature both by Negro authors and about Negro life, not merely because they are Negro authors but because what they write is literature and because the literature is interesting; to foster a market for Negro writers and for literature by and about Negroes; to bring these writers into contact with the general world of letters to which they have been for the most part timid and inarticulate strangers; to stimulate and foster a type of writing by Negroes which shakes itself free of deliberate propaganda and protest.

Markets, exposure, education, intercultural exchange—these were Johnson's goals, goals in which notions of art for its own sake hardly played a part. And neither was the spirit of organizational cooperation important to Johnson. Less than two months earlier, because of their "deep interest and faith in the contribution of the American Negro to American art and literature," the Joel Spingarns had sent Du Bois a three-hundred-dollar check to inaugurate an annual *Crisis* literary competition. The September announcement of the *Opportunity* prizes surprised and displeased NAACP officials. Du Bois wrote Joel Spingarn that it was more than curious that, although the *Crisis* prizes had been widely discussed in Harlem circles, "neither I nor you had any idea that they [the Urban League] were offering prizes until after your offer was made." It was an early example of Charles Johnson's gloved ruthlessness. For the pragmatic sociologist who believed that "literature has always been a great liaison between races," appropriation of a rival's idea was hardly even a misdemeanor if it promoted racial progress

through the arts. Two years earlier, in "Art for Nothing," Du Bois had movingly remonstrated in *The Crisis* that Afro-Americans could only get what they were willing to pay for in the arts. Johnson was undertaking, for the first time ever, to forge the conditions of compensation.

Harlem's cultural birth was not to be the single-handed creation of *Opportunity* magazine, however indispensable its organizing role. Nor was it to be entirely manufactured by white allies and sympathizers of the major civil rights movements. But white capital and influence were crucial, and the white presence, at least in the early years, hovered over the New Negro world of art and literature like a benevolent censor, politely but pervasively setting the outer limits of its creative boundaries. The motives of the whites, however, were as varied as those of the Afro-American intelligentsia were single-minded, and the whites' disunity provided room to play fast and loose along the borders of the arts or for raids even into the heartland of racism. Not being taken seriously—or taken seriously for the wrong reasons—had advantages, so long as leaders like Charles Johnson, James Weldon Johnson, and Du Bois knew what they were doing, were cautious about it, and adroitly manipulated their white patrons and allies.

Irrepressible Zora Neale Hurston, the Howard University coed, had a genius for coining terms like "Astorperious" and "Niggerati." "Negrotarians" was Hurston's word for whites who specialized in Afro-American uplift. They came in an almost infinite variety. There were Negrotarians who were earnest humanitarians, and those who were merely fascinated. Columnist Heywood Broun and his feminist wife, Ruth Hale, were loyal friends of James Weldon Johnson and Walter White, and earnest. Essayists and novelists like Pearl Buck, Fannie Hurst, Dorothy Parker, and T. S. Stribling believed themselves sincere, whatever the occasional controversy about what they wrote. Nor was there ever any serious controversy about the loyalty of Clarence Darrow or Sinclair Lewis. Carl Van Vechten, the former music critic of *The New York Times*, and his actress wife Fania Marinoff represented the fascinated—those drawn to these new artists, at first more or less as salon exotica, like Elisabeth Marbury, Rita Romilly, and Florine Stettheimer, and decadents or foreign sojourners like Robert Chanler and Cecil Beaton. "Jazz, the blues, Negro spirituals, all stimulate me enormously for the moment," Van Vechten tittered to H. L. Mencken in the summer of 1924. "Doubtless, I shall discard them too in time." This was the voice of the Salon Negrotarian—not always distinguishable

from that of professional primitivists of the Vachel Lindsay or Julia Peterkin variety.

There were many motives animating the Lost Generation Negrotarians. Some (Van Wyck Brooks, Hart Crane, Zona Gale, Waldo Frank) were drawn to Harlem on the way to Paris because it seemed to answer a need for personal nourishment and to confirm their vision of cultural salvation coming from the margins of civilization. Some expected the great renewal in the form of a political revolution and, like McKay's friends Muriel Draper, Louise Bryant, and Max Eastman, anticipated that the Afro-American would somehow play a major role in destroying the old order. For others, the new religion of Freudianism, with its sexual trapdoor under the ordered mind, transformed the Afro-American's perceived lack of cultural assimilation from a liability into a state of grace. DuBose Heyward, Frank Harris, Paul Green, Eugene O'Neill, and Alfred Stieglitz were possessed by that wistful urge Sherwood Anderson wrote of to Mencken: "Damn it, man, if I could really get inside the niggers and write about them with some intelligence, I'd be willing to be hanged later and perhaps would be." It was a standard white lament of the era—and not limited to writers.

Dollars-and-cents salon Negrotarians—business liberals like Albert Barnes, Otto Kahn, Horace Liveright, and Florenz Ziegfeld—combined noble sentiments with keen market analysis. While most Negrotarians were enormously pleased merely to socialize and patronize, the composers, critics, editors, impresarios, and publishers were more calculating and discerning in their Afro-American contacts. The Knopf New Year's party that Langston Hughes excitedly described to Locke ("Jascha Heifetz, Ethel Barrymore, Steffanson [*sic*], Fannie Hurst, and almost everybody was there") was, for all its interracial glow, an experiment in enlightened professional self-interest. It was the same for George Gershwin, Alexander Woollcott, V. F. Calverton, and H. L. Mencken, Carl and Irita Van Doren, Sol Hurok, and David Belasco. Afro-American material could yield handsome returns.

The motives of WASP philanthropy were an amalgam of inherited abolitionism, Christian charity and guilt, social manipulation, political eccentricity, and a certain amount of persiflage. Oswald Garrison Villard, for example, was abolitionist William Lloyd Garrison's grandson, a parlor socialist, a founding member of the NAACP board, and owner-editor of the lofty *Nation*. William English Walling and Jane Addams, also board members, were of a mold similar to Villard's.

Industrial princes like William H. Baldwin, Jr., Robert C. Ogden, and George Foster Peabody considered it their Christian duty to contribute to the training of Afro-Americans for alert if lowly service in the nation's economy and, on a limited basis where advisable, to the cultivation of unusual abilities among them. Christianity and social manipulation also guided the policies of the Baptist Rockefellers, who gave their money, carefully, to a variety of causes. Charles Johnson and his colleagues were to find the Rockefellers reluctant to support any causes less conservative than the deceased Booker Washington would have approved; they gave little or nothing directly to the literary efforts of the New Negro. For the foundations established by J. G. Phelps Stokes and William E. Harmon, men who gave the bulk of their respective copper and real estate millions to causes, the cultural growth of the Afro-American was as significant as the skills of his labor. Then there were eccentric benefactors like Charles Garland and wealthy socialist supporters like Mary White Ovington. Convinced that excessive wealth corrupts, Garland donated his inheritance to found the American Fund for Public Service, a major transfusion to civil rights organizations. Ovington, another founding board member of the NAACP, knew she lacked the "courage really to join the labor movement, to forsake father and mother and sister and brother and live the life of the working class." She rejoiced that at least she had lived "to hear Trotsky's cry," but instead of the proletariat she "went in for the Negro, where I could use what I had."

Being of use to the Negro was becoming virtually a specialty of the second most abused Americans of the early twentieth century. Jewish contributors to Afro-America went far beyond the philanthropy of the gentiles. Jacob Schiff's expense money for the NAACP in its first hours, or Amy and Joel Spingarn's unbroken flow of checks for official and personal needs at the Association, the contacts and guidance of Martha Gruening, Lillian Wald, and Herbert Lehman were typical examples of largesse many times repeated. When the NAACP drew up a list of major potential donors at about this time, Pierre Du Pont was included because his mother was Jewish. More than money, however, Jewish Negrotarians provided leadership, much of it highly visible. There were increasingly close ties between Charles Johnson and Urban League backers Julius Rosenwald and Paul Sachs. Moreover, the League's first board chairman had been Edwin R. A. Seligman, while the outstanding community leaders Felix Adler and Abraham Lefkowitz were active board members. At the NAACP, with Herbert Seligman as public relations director at its Fifth Avenue headquar-

ters, Arthur Spingarn as pro bono legal counsel (and soon assisted
by Louis Marshall, president of the American Jewish Committee), and
Joel Spingarn as key board member and, alternately, treasurer, chair-
man, and president, the Association's dependence on Jewish collabora-
tion was considerable. It was widely understood by the early twenties
that there was a special relationship between the leadership of the two
races.

And behind the slow, steady progress of Afro-American education,
the minimally successful civil rights lobbying, and the New Negro cre-
ativity in arts and letters stood the slight figure of modest, Illinois-born
Julius Rosenwald, chief stockholder in Sears, Roebuck & Company. He
always said his seemingly bottomless fortune was due to "ninety-five
percent luck and five percent ability." But he never expected many
others to have his luck; and he knew that the Afro-American needed a
great deal more than luck to survive. Clichés applied to Julius
Rosenwald—honor, the obligations of great wealth, abhorrence of
bigotry. When Jesse Moorland of the International YMCA told him
there were no "Y's" in the North open to his, Moorland's, race in
1910, Rosenwald saw to it that twenty-five were quickly built. The
Rockefellers, active in YMCA philanthropy, belatedly acted to correct
the oversight in New York as well. Upstaging Rockefellers in Afro-
American uplift was to be one of Rosenwald's indulgences. In 1910, he
read Booker Washington's *Up From Slavery* and was much moved.* He
made the philanthropist's obligatory pilgrimage to Tuskegee and built
his first elementary school for Afro-Americans there, in 1913. Between
1917 and 1924, he gave four million dollars in matching funds to build
5,000 elementary schools, 195 teachers' homes, 103 workshops, and 5
industrial high schools for Afro-Americans in the South.

By 1924, the year Charles Johnson formed plans for the New
Negro, Rosenwald's philanthropy was ready to venture beyond the
frame schoolhouses and primitive workshops of Bookerite uplift. When
the Standard Life Insurance Company, the richest and most powerful
corporate enterprise yet launched by Afro-Americans, began to crum-
ble at the end of the year, Rosenwald conditionally promised his
Tuskegee friends to rescue it, until his investigators revealed the extent
to which recklessly visionary management and southern white financial
manipulations had gutted the Atlanta venture. Within a few years, the
restructured Rosenwald Fund (modelled on the Rockefeller Founda-
tion, of which its founder was a trustee) would be committed to New
* Cf., Louis R. Harlan, *Booker T. Washington* (1972, 1983), 2 vols., II, p. 141.

Negro enterprises of university endowments, law and medical school construction, and graduate fellowships. Perhaps Julius Rosenwald was inspired by the singular fact of being born in the Springfield, Illinois, house lived in by Abraham Lincoln. More likely, as one of his biographers explains, his "large gifts to Negro causes were made because he was a Jew and the Jewish past had given him sympathetic understanding of other persecuted peoples." "If it is any consolation to you," Rosenwald once told an audience of admiring Afro-Americans, "I want to say to you that there are white people who suffer a great deal more. The Jewish race, which dates back thousands of years and like yours dates back to a time when they were known to be in slavery."

It was true that the Talmud prescribed charity as a social duty and that there was an abstract affinity among many American Jews for a race which, like themselves, had been torn from its homeland and systematically persecuted. Louis Marshall, distinguished member of the New York bar and president of Temple Emanu-El, admonished his people at the turn of the century that they would cut a "sorry figure" if they cried out against Czarist pogroms but failed to denounce persecution of the Afro-American. In his turn-of-the-century novel *Altneuland*, Theodor Herzl speaks through one of his characters to say, "The depths of that problem in all their horror, only a Jew can fathom. I mean the Negro problem." Jewish notables—scholars such as Franz Boas and Melville Herskovits, jurists such as Arthur Garfield Hays, Louis Marshall, and Arthur Spingarn, civic leaders such as Jacob Billikopf, Ernest Gruening, Belle Moskowitz, and Lillian Wald, and philanthropists such as Otto Kahn, the Seligmans, the Schiffs, and the Lehmans—were faithful to the commandments of religion and the lessons of a troubled history. But the Afro-American connection had a far more urgent reason for being—one which publishing notables such as the Knopfs and the Spingarns (Joel Spingarn was a founder of Harcourt, Brace) were especially able to promote. The genteel anti-Semitism of the late nineteenth century (residential covenants, club quotas, discrimination in the affluent professions) had given way to rawer and more obstreperous forms with the coming of the war. The lynching of Atlanta businessman Leo Frank in 1915 had stunned the Jewish community (and temporarily badly strained relations with Afro-Americans because the Adolph Ochs–owned *New York Times* accused a black witness at Frank's trial of the murder-rape). Madison Grant's popular book *The Passing of the Great Race* had warned against Negro seepage into the culture of white America but, like John Foster

Fraser's *The Conquering Jew* (another 1916 favorite), reserved its bitterest diatribes for the Jews. And Attorney-General A. Mitchell Palmer's witch hunt had seemed intentionally undiscriminating about lumping Jews with alleged political subversives. Henry Ford's Dearborn *Independent* ravings had followed.

It required no special acuity for Jews to comprehend the linkage between quotas and Jim Crow laws, to see that the rapid spread of the Ku Klux Klan out of the South into the Midwest and Southwest was as great a menace to them as to Afro-Americans. But fighting back openly risked exacerbating the peril. A worried Rosenwald confided to a Jewish politician at the time of Leo Frank's arrest that he was not "in the least anxious to see many Jews in politics or even on the bench." By establishing a presence at the center of the civil rights movement with intelligence, money, and influence, Jewish notables could fight against anti-Semitism by remote control. "By helping the colored people in this country," the *American Hebrew* candidly revealed, "Mr. Rosenwald doubtless also serves Judaism." Randolph's *Messenger* made a similar point even more bluntly: "Hitting the Jew is helping the Negro. Why? Negroes have large numbers and small money: Jews have small numbers and large money."

The stimulus of *Opportunity* magazine and *The Crisis*, the Negro-tarians, the Lost Generation, WASP and Jewish philanthropy, increasingly gave special form and purpose to much of the life of Harlem. But what these forces hoped to accomplish depended greatly upon the raw material at their command, upon Harlem itself, "the Negro Capital of the World." It was the existence of Harlem above all else—the translation into brick and asphalt of the New Negro's own special, cart-wheeling nationalism—that made the Golden Age possible. Almost everything seemed possible above 125th Street in the early twenties for these Americans who were determined to thrive separately to better proclaim the ideals of integration. You could be black and proud, politically assertive and economically independent, creative and disciplined—or so it seemed. Arna Bontemps and fellow literary migrants made a wonderful discovery. They found that, under certain conditions, it was "fun to be a Negro." "In some places the autumn of 1924 may have been an unremarkable season," Bontemps said. "In Harlem, it was like a foretaste of paradise. A blue haze descended at night and with it strings of fairy lights on the broad avenues." Harlem's air seemed to induce a high from which no one was immune. Standing on

"The Campus" (the intersection of 135th Street and Seventh Avenue), which was where English major Arthur Davis was more regularly found than on the campus of Columbia University, "one of the pleasures . . . was seeing celebrities. Just around the corner at 185 West 135th Street lived James Weldon Johnson. Next door to him lived Fats Waller." Florence Mills was two blocks away. "If we strolled down the Avenue to the Lafayette Theater at 132nd Street, we often found under the famous Tree of Hope such artists as Ethel Waters, Sissle and Blake, Fletcher Henderson, and Miller and Lyles." "It was truly bliss to be alive then."

There was almost too much to do and see. Columbia's John Dewey might be speaking at the 135th Street YMCA, at the invitation of Du Bois. More likely, though, it would be Hubert H. Harrison, the omniscient Danish West Indian who, as one Harlemite, himself a Yale man, said, "If he were white, he might be one of the most prominent professors of Columbia University, under the shadow of which he is passing today." Instructor of English and economics, Harlem School of Social Science; professor of embryology, Cosmopolitan College of Chiropracty; adjunct professor in comparative religion, the Modern School of New York; and tenured holder of a 135th Street soapbox, Hubert Harrison's Renaissance genius was ultimately legitimized by New York University, which made him a special lecturer, and the City's board of education, which in 1926 appointed him staff lecturer. His book *When Africa Awakes* was discussed in barbershops, where it was sold along with copies of *Voice*, official organ of Harrison's Liberty League, and the pros and cons of establishing his black state in the South spiritedly debated.

There were plays at the "Y," ambitious productions drawing on heavyweight selections from the Anglo-Saxon repertoire, with Du Bois's Krigwa Players valiantly stretching themselves into their parts. Attendance was excellent and an undertow of extra excitement flowed because of the probable presence of whites from the theatre world. Harlem remembered how, in 1920, when Paul Robeson had been a reluctant recruit for a part in the first revival of Torrence's *Simon the Cyrenian* at the "Y," Torrence, Robert Edmond Jones, and Kenneth Macgowan, founders of the experimental Provincetown Playhouse, had dashed backstage to offer him the lead in something called *The Emperor Jones*. "I went home," Robeson recalled, "forgot about the theatre, and went back next morning to the law school as if nothing

had happened." But Harlem's hungry young actors remembered the story.

Nearer Lenox Avenue, along 135th, was the neo-Classic Harlem branch of The New York Public Library (today's Schomburg Center), Miss Ernestine Rose's little world of poetry readings, book discussions, and general literary activity. It was Ernestine Rose whom George Schuyler praised for helping to make Harlem's cultural life more than the *arnchy* (Harlemese for "stuck up"), thin reality it often was elsewhere. But considering the qualifications of her assistant, Regina Anderson, and the exceptional staff of evening volunteers like Gwendolyn Bennett, Jessie Fauset, and Ethel Nance, Miss Rose could have failed only if she had been resolutely dim. What critics in the *Herald Tribune, The New York Times,* or *World* wrote about them was commercially crucial for Jean Toomer, Jessie Fauset, or Walter White, but whether they had really succeeded in portraying accurately the people they wrote about they only knew after acquitting themselves before Ernestine Rose's audiences. The intellectual pulse of Harlem throbbed at the 135th Street library.

The "Y" and the library were but two of the evening choices of a cultured Harlemite. Classical music concerts by the Harlem Symphony were well attended, with performers like Fletcher Henderson, Hall Johnson, James P. Johnson, and William Grant Still contributing to its mastery of Mendelssohn and Brahms. For rarer tastes, there was the Harlem String Quartet. As Bontemps's "blue haze descended at night," invitations to the Charles Johnsons' or James Weldon Johnsons', the Walter Whites' or the wealthy Enrique Cachemailles' or far wealthier A'Lelia Walker's were honored, anywhere from one to two hours late. There was likely to be a good deal of affectation and posturing at these evenings, the mode shifting from poetry to politics at the drop of a name or event. At the Reverend Frederick A. Cullen's fourteen-room Seventh Avenue brownstone, soirées were notably elevated. Who you were was important to Countee Cullen's adoptive father.

Whatever their affectations, though, most Harlemites had spent an evening at Arthur "Happy" Rhone's, an establishment that virtually invented the Harlem night club. Happy Rhone's was at 143rd and Lenox Avenue. The decor was black and white; it was the first upstairs club; and it was plush—the "millionaires' club." Rhone was the first to hire waitresses and the first to offer floor shows. Noble Sissle himself often served as impromptu master of ceremonies to a well-liquored clientele that frequently included John and Ethel Barrymore, Charlie

Chaplin, Jeanne Eagels, W. C. Handy, Ted Lewis, and Ethel Waters. What Texas Guinan—the lady credited with originating the American nightspot—had not learned in Paris *boîtes de nuit,* she probably lifted from Happy Rhone's, or else from Pod's & Jerry's (The Catagonia Club) in what was called "The Jungle" of 133rd Street. Banks's, "Basement Brownie's," "The Bucket of Blood," and Leroy's (where vaudevillian Bert Williams sometimes drank at a corner table) were usually beyond the pale for the literati. Barron's posh retreat for the sporting crowd was almost exclusively reserved for whites, apart from Jack Johnson, the prizefighter who had just sold his 131st Street club to Connie Immerman. Connie's Inn and the new Cotton Club barred Afro-Americans and were beyond the pocketbooks of most anyway. But there was Hayne's Oriental, a favorite of physician-writer Rudolph Fisher, Fritz Pollard, the All-American halfback, and Paul Robeson, and the haughty but fading Lybia, of which it was said that "people you saw at church in the morning you met at the Lybia at night." Even Alain Locke was known to end a hard day at the newly opened Smalls' (owned by a descendant of ex-slave Robert Smalls, Union Navy captain and South Carolina congressman), where the clientele, about equally divided between black and white, was served by roller-skating waiters.

And when they were not too busy being starchy symbols of the New Negro, they were known to dance, too. Mamie Smith's open-air "Garden of Joy" cabaret was no more, its corner lot at 138th Street having recently become the site for Reverend Adam Clayton Powell, Sr.'s Abyssinian Baptist Church, a garden of spiritual joy; but at the Renaissance Ballroom and sometimes to Fletcher Henderson's polished jazz at the aging but still majestic Rockland Palace (the old Manhattan Casino), the cream of Harlem would unlimber with the Charleston and Black Bottom. Annual galas sponsored by alumni of prestigious colleges like Fisk, Howard, and Lincoln, fraternity bashes hosted by Alphas, Kappas, and Omegas, fashion shows, club nights, and, at the pinnacle of posh, the yearly NAACP ball drew even dyspeptic types like George Schuyler. Schuyler's *Messenger* coverage of one such affair —the tenth annual fashion show of the Utopia Neighborhood Club at Madison Square Garden—was outstanding both for vintage Schuylerian satire and for its anatomy of Harlem society, already congealed by summer 1924:

As I glance around the vast assemblage of 10,000 well dressed, orderly, and apparently cultured Americans who crowded the boxes and balconies,

I could readily see that our group is making amazing progress—pigmentarily speaking. A genuine Negro was as conspicuous there as a clear window in the UNIA headquarters. . . . The show, staged very capably by Mrs. Daisy C. Reed, President of the Utopia Neighborhood Club, went off without a hitch. Of course, it didn't start on time, but what "Negro" affair does?

Not being a doctor, lawyer, real estate broker, bootlegger, undertaker, dentist, or a member of a college fraternity, and hence not being well acquainted with the "best" people of Harlem, I recognized very few of the manikins. So much comeliness passing in review prevented me from stealing the time to consult the well-printed program.

"Everybody," say the lyrics to a West African high life, "likes Saturday night." Saturday nights were terrific in Harlem, but rent parties every night were the special passion of the community. Their very existence was avoided or barely acknowledged by most Harlem writers, like that other rare and intriguing institution, the buffet flat, where varied and often perverse sexual pleasures were offered cafeteria-style. With the exception of Langston Hughes and Wallace Thurman, almost no one—at least no one who recited poetry and conversed in French at Jessie Fauset's—admitted attending a rent party. These were times, Willie "the Lion" Smith recalls, when "the average Negro family did not allow the blues, or even raggedy music, played in their homes." In fact, though, it frequently came about that after a sedate parlor gathering and after the cabarets closed, poets and writers (and even an NAACP official) would follow musicians to one of these nightly rent-paying rites. "If sweet mama is running wild, and you are looking for a Do-right child, just come around and linger"—crooned a printed invitation preserved by Langston Hughes to one of the more elaborate affairs. Or Cora Jones's at 187 West 148th Street: "Let your papa drink the whiskey / Let your mama drink the wine / But you come to Cora's and do the Georgia grind"—an invitation preserved by Arthur Davis.

Rent parties began anytime after midnight, howling and stomping sometimes well into dawn in a miasma of smoke, booze, collard greens, and hot music. Willie "the Lion" Smith called them "jumps," "shouts," or "struts," where, for a quarter, "you would see all kinds of people making the party scene; formally dressed society folks from downtown, policemen, painters, carpenters, mechanics, truckmen in their workingmen's clothes, gamblers, lesbians, and entertainers of all kinds. The parties were recommended to newly arrived single gals as the place to

go to get acquainted." At the more elaborate struts, along about 3 a.m.,
tempo would quicken when Willie the Lion, James P. Johnson, Claude
Hopkins, Fats Waller, or "Corky" Williams—and even Edward Ken-
nedy "Duke" Ellington—arrived palm-slapping and tuning up. Some
musicians hired booking agents to handle this after-hours volume. One
of these affairs has been recreated by Wallace Thurman, the young
novelist from Utah by way of California:

"Ahhh, sock it," . . . "Ummmm" . . . Piano playing—slow, loud, and
discordant, accompanied by the rhythmic sound of shuffling feet. Down a
long, dark hallway to an inside room, lit by a solitary red bulb. "Oh, play
it you dirty no-gooder."
 . . . A room full of dancing couples, scarcely moving their feet, arms
completely encircling one another's bodies . . . cheeks being warmed by
one another's breath . . . eyes closed . . . animal ecstasy agitating their
perspiring faces. There was much panting, much hip movement, much
shaking of the buttocks. . . . "Do it twice in the same place."

Looking back through a prism of census tracts, medical data, and
socioeconomic studies, the evidence that Harlem was becoming a slum,
even as Charles Johnson and Alain Locke arranged the coming-out
party of the arts, is persuasive. Rent parties were a function first of
economics, whatever their overlay of camaraderie, sex, and music. In
its 1927 report on 2,326 Harlem apartments, the Urban League found
that 48 percent of the renters spent more than twice as much of their
income on rent as comparable white New Yorkers. For a four-room
apartment (more than half the Urban League's sample), the average
monthly rent was $55.70; average family income was about $1,300.
The New York white equivalent was $32.43 in rent on a family income
of $1,570. That a fourth of Harlem's families had at least one lodger
(twice the white rate) and that an unknown number of householders
practiced a "hot bed" policy—the same mattress for two or more
lodgers on different work shifts—was as inevitable as the existence of
rent parties to relieve the fear and trembling of the first of the month. It
was true that Harlemites lived in cramped conditions. Many lived de-
plorably, in tenements so "unspeakable" and "incredible," the chair-
man of a 1927 city housing commission reported, "the State would not
allow cows to live in some of these apartments." Harlem's statistics
were dire. Dire enough to warrant the conclusion by a recent social
historian that "the most profound change that Harlem experienced in
the 1920's was its emergence as a slum."

What the statistics obscured was the mood of the universe north of Central Park. Whatever its contradictions, disparities between its reality and *Amsterdam News* fantasy, the one certainty almost all who lived there shared was that Harlem was no slum. Ghetto, maybe. Slum, never. Publications overflowed with Horatio Alger successes: frugal custodians who amassed hefty savings, invested in real estate, and sent their children to Lincoln or Syracuse universities; laundresses and barbers who parlayed modest revenues into service industry empires; graduates of Howard or Harvard who won brilliant recognition in their fields, despite repeated racist rebuffs; show people and racketeers whose unorthodox careers were capped by exemplary fortune and philanthropy. Not only newspapers like *Amsterdam News* and New York *Age* but critical organs like *The Crisis* and *Opportunity* joyously catalogued every known triumph over adversity as particular manifestations of universal Afro-American progress. The supposedly socialist *Messenger* (after 1924, "The World's Greatest Negro Monthly") sometimes read more like sleek, snobbish *Vanity Fair* than a protest periodical. Harlem ballyhoo even distorted the findings of Urban League researchers. "It has been estimated that 75 percent of the real estate in this community is under colored control," its 1927 report on "Living Conditions of Small Wage Earners" stated. If that was true for the 2,326 units in its report, the Urban League neglected to add that a 75 percent Afro-American real estate ownership was wholly atypical. Harlem remained a colony where absentee landlords and commercial barons hid behind Afro-American managers, where the largest department store, Blumstein's, even refused to hire black elevator operators until forced to, and where H. C. F. Koch's, another large department store, eventually chose liquidation over integration.

Jobs and rent money might be hard to come by, and whites might own more than 80 percent of the community's wealth, but the ordinary people of Harlem—not just civil rights grandees and exhilarated talents from the provinces—exuded a proud self-confidence that, once lost, would not reappear. It was the unlikely true story of "Pig Foot Mary's" success rather than the fictional but more typical tale of Rudolph Fisher's cruelly abused Solomon Gillis that gripped Harlemites. "Early in the fall of 1901 a huge Goliath of a woman," Lillian Harris, reached New York, the Federal Writers' Program monograph relates. Appropriating a segment of Sixtieth Street sidewalk over which she reigned with a baby carriage provisioned with chitterlings, corn, hogmaw, and pig's feet, and persuading the proprietor of nearby Ru-

dolph's saloon to share his stove, Pig Foot Mary plied a brisk trade. "A month passed and her pig's feet business boomed." Pig Foot Mary now presided "over a specially constructed portable steam table which she had designed herself." Moving to 135th Street and Lenox Avenue in 1917, at which corner she acquired both a husband and his thriving newsstand, Mrs. John Dean soon invested in Harlem real estate. A $44,000 Seventh Avenue apartment building, more buildings at 69–71 West 138th Street, still more at 2324 Seventh Avenue, and houses in Pasadena, California, until, by 1925, her holdings were conservatively valued at $375,000. It was said that when renters fell behind, she enjoined them by post, "Send it, and send it damn quick."

But Pig Foot Mary was by no means Harlem's greatest success story. That distinction went to Madame C. J. Walker, the richest self-made woman in America. Born of sharecropper parents in Delta, Louisiana, in 1869, Sarah Breedlove was married at fourteen and widowed at twenty when Charles J. Walker crossed into Mississippi one day and was never seen again; he was presumed dead. Taking her daughter, A'Lelia, Mrs. Walker headed north. For five hard years, from 1905 to 1910, she wandered from Saint Louis to Denver, Pittsburgh, and to Indianapolis, winning markets for her product, a secret formula for hair straightener. Shortly thereafter, as Madame C. J. Walker, she settled in New York. Now fabulously rich, she built a Harlem town house and an adjacent school of beauty culture on 136th Street and, within hailing distance of Jay Gould's Irvington-on-Hudson estate, built a $250,000 Italianate palace designed by Vertner Tandy, Harlem's most distinguished architect. She dabbled in politics and gave lavishly to charities. Indignant over the War Department's segregationist policies, Madame Walker led a delegation of women to see President Wilson. Proud of her African roots, she quietly encouraged some of the more intellectual Garveyite sympathizers. She had intended to represent William Monroe Trotter's National Race Congress at the Versailles Peace Conference. She was a gentle, good woman whose business credo reflected her humanity: "Lord, help me live from day to day / In such a self-forgetful way / That when I kneel to pray / My prayers shall ever be for others." Madame Walker died, much lamented, in May 1919. She left sums to civil rights and missionary organizations, a million dollars to her daughter, a mighty hair-straightening empire, and two-thirds of net corporate profits to charity. A'Lelia Walker Robinson, her headstrong daughter, who was known not to pray much for others, dazzled black and white Manhattan by

her lavish lifestyle. Her mother's Hudson River retreat, known as Villa Lewaro (an appellation devised by houseguest Ernico Caruso from the first syllables of A'Lelia's names) became the Xanadu of Harlem's artistic and intellectual elite.

Harlem had so many successful bootleggers and racketeers, and so many political, religious, and other characters, that it took most of them for granted: the barefoot seer, "Prophet Martin"; the mysterious herbalist-publisher, "Black Herman"; the Senegalese world boxing champion, "Battling Siki," and his lion mascot (both of whom died violently after wandering into an Irish neighborhood in 1924); "Black Jews"; and on and on. Of course, it could never take Marcus Garvey for granted, but his Harlem days were numbered. With the Afro-American establishment against him, the federal authorities prosecuting him for mail fraud, and the Liberian government denouncing him and impounding fifty thousand dollars of UNIA construction equipment, Marcus Garvey made a last-ditch stand with a spectacular 1924 international convention—then entered Atlanta federal penitentiary. With or without Garvey, Harlemites had good reason to believe that their ghetto was truly a vibrant microcosm of America, and that successes—even shady successes—were the rule rather than the exception.

They even had their own intercontinental aviator long before the rest of America discovered Lindbergh. "Lieutenant" (sometimes "colonel") Hubert Fauntleroy Julian, M.D. (for Mechanical Designer), was born in Port of Spain, Trinidad, in 1897, enlisted in the Canadian Air Corps during World War One, and descended on New York sometime in early 1922 to become Harlem's Saint-Exupéry, an erratic pilot whose exploits were more interesting in print than in the cockpit. Julian's debut is still remembered by aging Harlemites. WATCH THE CLOUDS THIS SUNDAY—JULIAN IS ARRIVING FROM THE SKY HERE, announced his sign before a vacant lot between 139th and 140th streets. With body-viewing rights sold to the highest-bidding mortician and lucrative contracts struck with two local businesses, Julian parachuted into Harlem on the morning of April 23, 1922, wearing a skintight scarlet outfit and a brown bandolier from which a banner unfurled fluttering the message, "Hoenig Optical Is Open Today," and landed on the post office roof. After that, he was more idolized than Bill "Bojangles" Robinson. He became an officer in the UNIA, and Liberty Hall was packed when he spoke. In late October 1923, blowing a gold-plated Martin saxophone on the way down, Julian jumped again, missed his target again (this time, it was the flagpole of the

123rd Street police precinct), and thrilled Harlem again. The New
York *Telegram* christened him "The Black Eagle."

The new year brought a new spectacular. After a newspaper adver-
tising blitz inviting donations, Julian announced he would fly to Africa
from New York by way of Florida, the West Indies, Central America,
Brazil, Saint Paul's Rock in mid-Atlantic, and Monrovia; returning by
way of Senegal, North Africa, Paris, London, Iceland, Greenland, and
Canada. When contributions lagged and James Weldon Johnson de-
clined to extend the NAACP's official blessings, Julian wavered. But
postal department agents insisted the Black Eagle keep to his July 4
departure, hinting strongly of prosecution for mail fraud. Dressed in
pale blue flight suit, matching leather helmet, cavalry boots, and ac-
companied by three large suitcases marked "tropical," "arctic," and
"any weather," Julian arrived at the appointed spot, the 139th Street
pier, waved to the crowd of thirty thousand, and approached *Ethiopia I*,
a Boeing hydroplane he had never flown. Three men surged from the
crowd with documents proving that fifteen hundred dollars was still
owed on the seaplane. "Guess we'll just have to call it off till I get that
money," Julian was saying just as a postal official appeared. UNIA
Lieutenant Saint William Grant sent his troops into the throng, promis-
ing Julian, "We can get that money in ten minutes." Finally, at 5 p.m.,
Julian roared away, skipped along the Harlem River, rose to two thou-
sand feet, jettisoned a bundle of handbills, and prepared to level off for
New Jersey. Instead, the plane dipped, the right pontoon ripped away,
and "Lieutenant" Hubert Julian nose-dived into Flushing Bay, mi-
raculously surviving with only a broken leg. "While more or less on his
course, Flushing Bay," *The New York Times* noted "had not been a
scheduled stop." Thus ended the intercontinental flight of the Black
Eagle, but not the flight of fancy of thousands of Harlemites who were
only moderately impressed by the triumph of the *Spirit of Saint Louis*
three years later.

With Bill "Bojangles" Robinson tapping up and down Lenox Ave-
nue and every actor and musician worth knowing palavering, at one
time or another, in the shadow of the Tree of Hope, Harlem's outdoor
labor exchange at 142nd and Lenox, the notion that they lived in a slum
would have been received by most Harlemites with puzzlement. Even
in the trough of the Great Depression, sociologist Myrtle Pollard would
find the people generally well dressed and happy. She saw the fatalists,
Harlem's "third class," too abused by circumstances to hope, but they
were overshadowed by the "strivers" and the professionals. Harlem was

far from a "slum or a fringe," James Weldon Johnson maintained in
1925. It occupied "one of the most beautiful and healthful sections of
the city," and there were three good reasons why it would maintain its
mainstream character, he said:

First, the language of Harlem is not alien; it is not Italian or Yiddish; it is
English. Harlem talks American, reads American, thinks American. Second,
Harlem is not physically a "quarter." It is not a section cut off. . . . Third,
the fact that there is little or no gang labor gives Harlem Negroes the
opportunity for individual contacts with the life and spirit of New York.

Anthropologist Melville Herskovits agreed after a few investigative vis-
its: "It occurred to me that I was seeing a community just like any
other American community. The same pattern, only a different shade!"

The new *Opportunity* prizes were to be awarded in May 1925 dur-
ing an elaborate banquet ceremony at The Fifth Avenue Restaurant.
From month to month, Charles Johnson heightened excitement with
announcements of distinguished whites agreeing to serve on the panel
of literary contest judges. Nineteen, then twenty-four, judges were em-
panelled: Carl Van Doren, Zona Gale, Fannie Hurst, Dorothy Can-
field Fisher, and Alain Locke among those for short stories; Witter
Bynner, John Farrar, Clement Wood, and James Weldon Johnson for
poetry; Eugene O'Neill, Montgomery Gregory, Alexander Woollcott,
and Robert Benchley for drama; Van Wyck Brooks, John Macy,
Henry Goddard Leach, and L. Hollingsworth Wood for essays; and for
personal experiences Eugene Kinckle Jones, Frank Lorimer, and Lil-
lian Alexander. The wife of Henry Goddard Leach, editor of *Forum*
magazine, contributed a well-publicized $470 for prizes in the five
categories.

Three hundred sixteen people came to the elegant dinner at The
Fifth Avenue Restaurant. Two of the prizewinners had already
achieved reputations beyond the circulation of *The Crisis* and *Oppor-
tunity* magazines. Countee Cullen's poem "Shroud of Color" had been
published in Mencken's *American Mercury*, and Langston Hughes had
engineered his "discovery" as a busboy poet in Washington, D.C., by
leaving Vachel Lindsay three poems in the Wardman Park Hotel din-
ing room. Others—Joseph Cotter, Jr., G. D. Lipscomb, Warren Mac-
Donald, Fidelia Ripley, and Laura Wheatley—would shine for a
moment, then recede beyond even the curiosity of future doctoral

candidates. Some, like John Matheus (first prize in short story writing) and Frank Horne (honorable mention there), never quite secured a place in the front ranks of the Harlem Renaissance. But the stalwarts of the future were there—Sterling Brown, taking second prize for his essay on Roland Hayes, E. Franklin Frazier, winning the first with an essay on social equality, Zora Hurston, awarded a second for her short story "Spunk," and Eric Walrond third, for "Voodoo's Revenge." Cullen and Hughes shared the third poetry prize, and Cullen took the second with a precious "To One Who Said Me Nay."

James Weldon Johnson read Langston Hughes's first-prize poem, "The Weary Blues." For the first time, something of the soul of the black migrant had combined with the art and spirit of a superior poet:

> Droning a drowsy syncopated tune,
> Rocking back and forth to a mellow croon,
> I heard a Negro play.
> Down on Lenox Avenue the other night
> By the pale dull pallor of an old gas light
> He did a lazy sway. . . .
> He did a lazy sway. . . .
> To the tune o' those Weary Blues.
> With his ebony hands on each ivory key
> He made that poor piano moan with melody.
> O Blues!
> Swaying to and fro on his rickety stool
> He played that sad raggy tune like a musical fool.
> Sweet Blues!
> Coming from a black man's soul.
> O Blues!

"The Weary Blues" sent Carl Van Vechten, that *dillettante extraordinaire*, rushing to Langston Hughes's side when the ceremonies closed. Four days later, he wrote publisher Alfred Knopf, who relied heavily on Van Vechten's advice, "I am promised the first look-in on this young Negro's first book . . . and shall be bringing it to you in a week or so, unless Harper's contract for it first."

Some of the judges' praise was fulsome (as Bontemps said later, "Both white and Negro critics paid more attention to the fact that a writer was Negro than to the literary merit of his work"). Much of it was sincere. All of it was significant. Playwright O'Neill and novelist Edna Worthley Underwood expressed the idea of what might be called

the primitive transfusion school. Underwood wrote Charles Johnson of her anticipation of a "new epoch in the history of American letters" wherein a "new race differently endowed" will be looked to increasingly for art "because joy—its mainspring—is dying so rapidly in the Great Caucasian Race." O'Neill's advice was straightforward—"Be yourselves! Don't reach out for our stuff which *we* call good!" Another novelist, Clement Wood, wrote Johnson that "the general standard of the contributors was higher than such contests usually bring out." Whatever their veiled motives or critical reservations, what mattered to Johnson was the upbeat consensus of these distinguished patrons and judges. As much as he wanted to foster the arts, what he really wanted was to cement an alliance between the movers and shakers of the white and black communities in New York and beyond. How well Johnson's strategy was succeeding was evident when he was able to announce, at the end of the flawless evening, that funds for a second annual *Opportunity* contest were already in hand, promised by Casper Holstein— "business man." (Casper Holstein's business was the numbers racket, over which the retiring Virgin Islander presided as undisputed king.) It was not a "spasm of emotion," Johnson said later. "It was intended as the beginning of something, and so it was. The meeting . . . ended with . . . announcements" binding this "initial effort to the future."

Three hundred sixteen people had attended Johnson's awards dinner; forty-two thousand—more than twice its regular circulation—had read the March *Survey Graphic*'s special edition, "Harlem: Mecca of the New Negro." On the magazine's cover was Winold Reiss's drawing of Roland Hayes, the Fisk-trained tenor who had won recognition in America only after a string of European triumphs; and, at the back, another, of one of Harlem's handsomer, more polished boulevardier bachelors, Harold Jackman, titled "A College Lad." Locke's opening essay, "Harlem," predicted that "without pretense to their political significance, Harlem had the same role to play for the New Negro as Dublin has had for the New Ireland or Prague for the New Czechoslovakia." Although he warned that the "migrating peasant" held the final answer to the success of the New Negro, Locke's second essay, "Enter the New Negro," made it clear that migrating peasants were expected to leave the immediate future to the upper crust—Du Bois's Talented Tenth. "The only safeguard for mass relations in the future must be provided in the carefully maintained contacts of the enlightened minorities of both race groups." There was nothing wrong with American society that interracial elitism could not cure. Time was running out, though,

because the "thinking Negro has shifted a little to the left with the world-trend, and there is an increasing group who affiliate with radical and liberal movements"—Garveyites and socialists. But Locke emphasized the underlying orthodoxy of Afro-American impatience—"The Negro mind reaches out as yet to nothing but American events, American ideas." If he was becoming slightly radicalized, the New Negro was above all a "forced radical"—a radical "on race matters, conservative on others." As for those who preached black separatism, "this," said Locke *ex cathedra*, "cannot be—even if it were desirable."

If American literature was not much enhanced by *Survey Graphic*'s offerings, thinking America was given new materials to ponder. There were the inevitable "serious" articles—George E. Haynes on the Negro church, W. A. Domingo on migrant West Indians, Charles Johnson on urban workers, Elise McDonald on women, Kelly Miller on prejudice. Melville Herskovits (apparently an honorary New Negro) detailed again the basic identity of black and white social patterns, obscured by a "different shade." Walter White, pursuing a favorite theme, revealed that, far more often than was suspected, even the shade was the same because of miscegenation. Du Bois's "The Black Man Brings His Gifts," a short story about an Indiana town's pageant of American contributions, was a throwaway piece of engaging irony. (On pageant day, it turns out that all contributions come from Afro-Americans.) A capsule history of Harlem was provided by James Weldon Johnson. Joel A. Rogers, the journalist, wrote divertingly on jazz, attempting to unearth the roots of that mysterious word. Puerto Rican bibliophile Arthur Schomburg contributed "The Negro Digs Up His Past," suggesting glorious surprises awaiting the excavators.

Any fair-minded reader would have conceded that these writers were as sensitive as any random pride of contributors to *American Mercury* or the *Atlantic Monthly*. A week after the ceremonies at The Fifth Avenue Restaurant, the *Herald Tribune* had not only praised their quality but given their movement its name. The Negro was finding his artistic voice, the article stated, and America was "on the edge, if not already in the midst, of what might not improperly be called a Negro renaissance." The point had been made—"We have poets and intellectuals, too, just like you"—and that alone would have satisfied Charles Johnson and Alain Locke for the moment. But there were also a few things in *Survey Graphic* of far more than average merit: physician Rudolph Fisher's short story "The South Lingers On"; Hughes's bittersweet poem "I, Too"; McKay's acid "White House" and euphonic

"The Tropics in New York"; and poetic snatches from Toomer's *Cane*. There were two poems of such perfect execution, evocation of mood, and metrical rhythm as to win durable fame: Hughes's "Jazzonia" and Cullen's "Heritage." That Harlem cabaret where "six long-headed jazzers play" while a bold-eyed dancing girl "lifts high a dress of silken gold" was so vividly described that Hughes's reader feels "silver rivers of the soul" lap at his ankles. Cullen's poem, if not his best, is one of his grandest efforts. If the too-familiar opening stanza seems now almost trite—"What is Africa to me: Copper sun or scarlet sea, . . ."—it is redeemed by other lines of lushness and mystery as true as the jungle canvases of the Douanier Rousseau.

Nineteen twenty-five—Year I of the Harlem Renaissance—ended with Albert and Charles Boni's publication of Locke's book *The New Negro*, an expanded and much polished presentation of poetry and prose spun off by the *Opportunity* contest and *Survey Graphic*. In addition to book decorations by Winold Reiss, there were the distinctive drawings of Egyptian silhouettes and geometric shapes by Aaron Douglas, henceforth the official artist of the Harlem Renaissance. With the notable omissions of Asa Randolph, George Schuyler, and Wallace Thurman, its thirty-four Afro-American contributors (four were white) included almost all the future Harlem Renaissance regulars— an incredibly small band of artists, poets, and writers upon which to base Locke's conviction that the race's "more immediate hope rests in the revaluation by white and black alike of the Negro in terms of his artistic endowments and cultural contributions, past and prospective." To suppose that a few superior people, who would not have filled a Liberty Hall quorum or Ernestine Rose's 135th Street library, were to lead ten million Afro-Americans into an era of opportunity and justice seemed irresponsibly delusional. Just the sort of fantasy expected from this "high priest of the intellectual snobbocracy," George Schuyler snorted, announcing that *The Messenger* was awarding Locke its monthly "elegantly embossed and beautifully lacquered dill pickle."

The New Negro was Locke's modest effort to create a work comparable in objective to Fichte's *Addresses to the German Nation*. Eurocentric to the tip of his cane, Locke sought to graft abstractions from German, Irish, Italian, Jewish, and Slovakian nationalisms to Afro-America. Like German university students after the Napoleonic defeat, his cell-group of thirty-four was given the titanic mandate of "acting as the advance guard of the African peoples in their contact with Twentieth Century civilization." It was heady stuff, but the times were intox-

icated with optimism. Harlem was turning its back on Garveyism and socialism to gawk in perplexed admiration at Phi Beta Kappa poets, university-trained painters, concertizing musicians, and novel-writing civil rights officials. "No sane observer, however sympathetic to the new trend, would contend that the great masses are articulate as yet," Locke's *Survey Graphic* preface read. "But they stir, they move, they are more than physically restless. The challenge of the new intellectuals among them is clear enough." As Bontemps said, everywhere they "heard the sighs of wonder, amazement and sometimes admiration when it was whispered or announced that here was one of the 'New Negroes.' " The Civic Club dinner had closed to stanzas from Gwendolyn Bennett's "To Usward." Locke's fifth page in *The New Negro* fittingly quoted the bracing lines of Langston Hughes:

> We have tomorrow
> Bright before us
> Like a flame.
>
> Yesterday, a night-gone thing
> A sun-down name.
>
> And dawn today
> Broad arch above the road we came.
>
> We march!

5

The Six

The time was coming when almost everybody above 125th Street seemed to be writing for *The Crisis, Opportunity,* or *American Mercury,* to be under contract to Boni & Liveright, Harper & Brothers, or Knopf, to be singing spirituals and lieder at Aeolian or Carnegie Hall, performing in sizzling Downtown reviews or significant dramatic roles, or heading for Paris to paint and sculpt. Langston Hughes recalled:

It was a period when, at almost every Harlem upper-crust dance or party, one would be introduced to various distinguished white celebrities there as guests. It was a period when almost any Harlem Negro of any social importance at all would be likely to say casually: "As I was remarking the other day to Heywood—" meaning Heywood Broun. Or: "As I said to George—" referring to George Gershwin. It was a period when local and visiting royalty were not at all uncommon in Harlem.

To outsiders—even to some participants—Harlem arts and letters seemed to be a natural consequence of the great folk migration begun during the war. Like foam over a robust beer, they were thought to have risen to the top under pressure from ten times ten thousand Afro-Americans pouring into the generous, well-cut glass handed them at the end of Manhattan Island. The Marxist newspaper *Independent* went so far as to yawn over Locke's *The New Negro,* its reviewer writing, "If I had supposed that all Negroes were illiterate brutes, I might be astonished to discover that they can write good third rate poetry, readable and unreadable magazine fiction, and that their real estate in Harlem is anything but dilapidated slum property." But even the whites who were

surprised that brutish illiteracy was not the universal state, as well as
those who knew of the existence of cultured Afro-Americans, reacted
to the Harlem Renaissance as no more than the latest creative bubble
in the American melting pot. The response was natural enough. Early
twentieth-century New York City had had its "Little Renaissance," just
as, earlier, there had been flowerings in New England, Knickerbocker,
Hoosier, and Yiddish literary traditions—and just as the South would
soon be heard from. "The Negro writers were caught up [in] the spirit
of the artistic yearnings of the time," says an authority on the subject,
"which is to say that their experience was part of the common experi-
ence."

But artistic and literary Harlem was not the natural phenomenon it
appeared to be. It was artifice imitating likelihood. "A few minor poets
and a few third-rate novelists are not a literature," Joel Spingarn confi-
dentially advised a foundation interested in Afro-American arts and
letters. The harshness of the judgment was debatable, but not its under-
lying truth: that in 1926 the volume and quality of the Harlem Renais-
sance was still far from evident. The other sectional and ethnic
literatures—modest as they may have been in comparison to the
mainstream—were robust when compared with the Afro-American.
Slavery and the heavy weight of segregation and discrimination had
made literacy a much sought-after but far from realized racial goal.
Yale and Princeton dropouts heading for writing seminars in Paris
cafés were invariably white. True, McKay, Toomer, and Hughes would
have written poetry even if Harlem had remained indifferent to them;
and Cullen's precocity would have sustained him for a time. Broadway
plays and musicals would have kept Charles Gilpin, Paul Robeson,
Rose McClendon, Bojangles Robinson, Florence Mills, and Ethel
Waters before the public, and well salaried. As always, Afro-American
musicians—the Fletcher Hendersons, Louis Armstrongs, and Fats
Wallers—would have found more work than their managers could
book.

For others, though—the scores of unknown painters, sculptors, and
writers pouring into Harlem—there would have been no emergency
loans and temporary beds, professional advice and Downtown con-
tacts, prizes and publicity without the patient assemblage and manage-
ment by a handful of Harlem notables of a substantial white patronage.
The artistic migration itself would not have occurred. Without that
handful of notables—six in number—the Harlem cultural scene would
have been little more than a larger version of Philadelphia or Washing-

ton, places where belles-lettres meant Saturday night adventures in tidy parlors, among mostly tidy-minded literati. Langston Hughes identified three of this key group in *The Big Sea*: "Jessie Fauset at *The Crisis*, Charles Johnson at *Opportunity*, and Alain Locke in Washington, were the three people who midwifed the so-called New Negro literature into being." There were three more—Walter White, Casper Holstein, and James Weldon Johnson. Without these six, the Harlem roster of twenty-six novels, ten volumes of poetry, five Broadway plays, innumerable essays and short stories, two or three performed ballets and concerti, and the large output of canvas and sculpture would have been a great deal shorter.

Jessie Redmon Fauset's influence upon the Harlem Renaissance was not as great as Charles Johnson's, or as well-advertised as Alain Locke's or Walter White's. Yet, for honesty and precocity, it was probably unequalled. With the exception of James Weldon Johnson, she knew a good deal more about the world of literature than the academics and civil libertarians in Harlem who were becoming overnight experts. Her 1905 Cornell University Phi Beta Kappa key had been earned in classical languages along with a firm grounding in French and German. She taught French for fourteen dutiful, unexciting years at Washington's Dunbar High School, the prestigious public institution which Jean Toomer and his upper-crust kind attended virtually by right of birth. Many of her students sensed that she was performing a service, just going through the motions, they said—though competently and to the letter, to be sure. Had she not been a "colored woman" she might have sought work with a New York publishing house (it was an ambition that reemerged after a few years at *The Crisis*). There is no telling what she would have done had she been a man, given her first-rate mind and formidable efficiency at any task. What she did in reality was to escape with fair regularity to Europe in the summers, and to apply herself to the master's degree in French, which the University of Pennsylvania awarded her in 1919.

Fauset's relationship with Du Bois dated from her senior year at Cornell. He had helped her obtain a summer teaching position at Fisk the year after her graduation. Occasional letters were exchanged as the years passed. There were visits. At some point, which it now seems unlikely that surviving letters will ever date, Jessie Fauset developed a profound emotional attachment to Du Bois. In her mind, he took the place of the strong father who died while she was at Cornell, and of the

grand physical passion she seems never to have had—unless that pas-
sion was, in reality, Du Bois himself. Two of her poems, "Enigma" and
"*La Vie C'est la Vie*," strongly suggest that that "man whose lightest
word / Can set my chilly blood afire" was the dark Brahmin of the
NAACP.

> But he will none of me, nor I
> Of you. Nor you of her, 'Tis said
> The world is full of jests like these—
> I wish that I were dead.

In any case, after 1919, she was constantly at his side as literary editor
of *The Crisis*, and busier in those years than she had ever been before
or would be afterward. These were years—1919 to 1924—when Du
Bois was caught up in the Pan-African Congress movement, attending
momentous gatherings in Brussels, Paris, Lisbon, and London. Fauset
made travel arrangements, did research, edited speeches, and, in the
editor's absence, ran *The Crisis*. Du Bois's major editorial effort of this
period, the *Brownie's Book* (a magazine for children), was almost
certainly put together by Fauset and Augustus Dill, another key assis-
tant. She also recognized the unknown talent of Toomer and Hughes
practically before anyone else, publishing the latter's verse as early as
1921. She wrote Arthur Spingarn early in 1923 that the lines she had
underscored by Toomer "were proof of an art and of a contribution to
literature which will be distinctly negroid [sic] and without propa-
ganda." To Toomer, she wrote clear-headed advice about over-
ripeness of prose and his need to stretch himself by reading in foreign
languages.

Had she been younger when she moved to New York, Jessie Fauset's
own capacity for reaching out to new ideas and new forms might have
been far greater. But she was already an unmarried, proper, thirty-
eight-year-old Washington schoolteacher in 1920. She was an active,
but hardly daring, force in the literary circles at Ernestine Rose's Har-
lem branch of The New York Public Library. Before Charles Johnson
arrived to take charge of arts and letters, Fauset had dreamt of prizes
and contracts for Harlem artists—dreams shared by her librarian
friends Regina Anderson and Gwendolyn Bennett. But her dreams
were of novels and poems about handsome people of breeding. Not that
she confused propaganda with art—intellectually, the distinction be-
tween the two was clear, and Fauset deplored propaganda repeatedly.

Emotionally, nevertheless, she recoiled violently from anything out of keeping with her prim upbringing and racial sensitivities. In early 1922 there had been a publisher's offer of a contract to translate into English the African masterpiece *Batouala* by the French West Indian writer René Maran. The novel had won France's Prix Goncourt the previous year. Joel Spingarn encouraged her. At first she thought she really might—until she reread the last half. "Alas, alack," she sighed to Spingarn, "I know my own milieu too well. If I should translate that book over my name, I'd never be considered 'respectable' again." Respectability, dignity, pride ("We're the old-fashioned 'poor but proud' sort") colored everything.

Her literary ideas hewed closely to her social code. Literary creation was both the highest measure of a race's achievement and the most effective present tactic to advance her own race. Both excited and disappointed by the flaws in white T. S. Stribling's race novel, the bestselling *Birthright*, she sensed clearly that the moment was ideal for a New Negro novel by a New Negro, pressing the idea on Walter White and others in her select circle of acquaintances: "We reasoned, 'Here is an audience waiting to hear the truth about us. Let us who are better qualified to present that truth than any white writer, try to do so.'" She set about doing so, softening, at least temporarily, Du Bois's deep suspicion about combining official civil rights activities with the arts. Her friends Gwendolyn Bennett and Regina Anderson gave Charles Johnson the idea for the Civic Club dinner. Her large apartment, shared with her sister, Helen Lanning Fauset, became, like those of Regina Anderson, Charles Johnson, James Weldon Johnson, and Walter White, a shelter for arriving talent, as well as a forum for cultural activity. Evenings at Jessie Fauset's were seldom relaxed. The hostess was disposed to discuss the latest French novel in French. She was a superb dancer, but there was almost never dancing at her apartment. Instead, guests were obliged to stretch themselves into large topics of discussion. Occasionally, Harold Jackman, the handsome bachelor, relieved an evening's formality by emptying a hip flask into the punch.

When Boni & Liveright released *There Is Confusion* in early 1924, the publisher expected the novel to sell much better than *Cane*. Sales were to be good, and reviews in the white press were generally favorable, although Fauset was mistakenly described as the first female writer of fiction of her race (an honor belonging to Frances E. W. Harper). Afro-American coverage was enthusiastic. It was the kind of novel socialists might have been expected to pan; yet, with only a

hint of surprise, George Schuyler's *Messenger* review stated, "I was never bored for an instant." Catching the spirit of an *Opportunity* banquet speaker, Schuyler called on his readers to buy, and buy again: "If it is a financial success, there will be a widening field of opportunity for our rising group of young writers, struggling to express the yearnings, hopes, and aspirations of the race." *There Is Confusion* was Stribling's *Birthright* rewritten to the approved literary canons of the Talented Tenth, a saga of the sophisticated in which French and occasionally German tripped from the protagonists' tongues as readily as precise English; a novel about people with good bloodlines whose presence in the Algonquin Hotel dining room—but for a telltale swarthiness—would have been *tout à fait comme il faut*. In her "Book Chat" column, syndicated to the Afro-American press, Mary White Ovington wondered if "this colored world that Miss Fauset draws" really existed. One rejecting publisher had sneered, "White readers just don't expect Negroes to be like this." Yet the world of *There Is Confusion* was real. A few hundred families strong, living (like the author's own ancient Philadelphia family) on the margin of affluence in a style of worn, fustian gentility, clinging to pedigree, color, and gracious manners, Fauset's characters have the straitened pretensions of aristocrats after a revolution. The sentiments of her figures—especially the women—are sometimes aristocratically farfetched or celestially elevated, but they are, nonetheless, authentic and saved from caricature because they reflect faithfully the attitudes of a class that was itself a caricature.

"Jessie is too prim school-marmish and stilted for me," Claude McKay wrote Walter White a few days before Christmas 1924. Savoring her success, Jessie Fauset had taken a few months' leave of absence from *The Crisis* for travel in Europe. The Spingarns provided letters of introduction to noted American expatriates, and Fauset expressed her delight from Paris at having met the literary agent William Aspenwall Bradley, but wrote with terse displeasure of Sylvia Beach of Shakespeare and Company—"Miss Beach has never acknowledged my note." There were few other such annoyances, although, to her surprise, Fauset discovered that she was not "as enthusiastic about the French as I once was." Poor dears, she decided that they had been "called on to bear too much." All in all, the tour of the Continent and North Africa—Carcassonne, Marseilles, Algiers, Nice, Genoa, Rome, Florence, Venice, and Vienna ("where I expect to have the best time of all, for I have several acquaintances there")—was a marvellous spiritual tonic. It was

the first time since her late teens, she wrote Arthur Spingarn, that she had been "comparatively free from fetters."

Arguably, Charles S. Johnson was the personality who did most to make the remarkable flowering of the arts possible—who was the most important of The Six. In Hughes's opinion, Charles Johnson "did more to encourage and develop Negro writers during the 1920's than anyone else in America." Zora Neale Hurston usually gave what she called the "Niggerati" short shrift, but no praise was ever too much for her Dr. Johnson. The Renaissance "was his work, and only his hushmouth nature has caused it to be attributed to many others," she wrote. The poet and novelist Arna Bontemps and the painter Aaron Douglas agreed. Bontemps understood Johnson perfectly when he explained his patron's role a generation later: "His subtle sort of scheming mind had arrived at the feeling that literature was a soft spot of the arts; it represented a soft spot in the armour of the nation, and he set out to exploit it." So did Douglas, who took for granted Johnson's "broad vision" but saw the operator who "understood how to make the way, how to get the next step, how to indicate the next step for many of these younger people." The ordinary Harlemite, added Douglas, "didn't put his hand on anything. He didn't mold anything." Strangely, though, this intellectual who did so much to launch the Harlem Renaissance allowed himself to appear to stand in Alain Locke's shadow, when in reality the situation was the opposite. In an uncharacteristically candid remark about Locke, Johnson once said as much—that the Howard professor had been "cast in the role merely of press agent" of the new artistic ferment.

Johnson was a masterful organizer and entrepreneur. In the Puerto Rican bank messenger and bibliophile Arthur Schomburg, he recognized a kindred spirit, involving him in the informal planning session for the first Civic Club affair in 1924. "Be prepared to enrich us with a mite of your immense knowledge of our subject," Eric Walrond, Johnson's go-between, wrote Schomburg. Schomburg's enormous amateur familiarity with the written record of the African past, his tact and common sense were also prized by James Weldon Johnson and Walter White, but Charles Johnson increasingly relied upon Schomburg to keep him informed about the Harlem community and, later, even represent him in foundation matters. Eventually, like Bontemps and Douglas, Schomburg would follow his patron to Fisk. Countee Cullen

also entered the fold. Within weeks after the poet's return from the
Holy Land, Johnson hired him as *Opportunity*'s assistant editor, where,
for two years, Cullen would survey Afro-American literature from
"The Dark Tower" column. Literary news began to be featured prom-
inently now, even in Afro-America's most frivolous newspaper, *The
Inter-State Tattler*, a sometimes viperous weekly hissing with gossip
about "sheiks" and "shebas" at play in Harlem, Chicago, and on the
West Coast. With a close friend from Chicago days, Geraldyn Major
(now Dismond), writing for the newspaper, Johnson could count on
bravura coverage of such highbrow affairs as the reception for the Span-
ish academician Salvador de Madariaga:

Mr. and Mrs. Charles S. Johnson had as their guest on Monday evening
at the home of Miss Jessie Fauset, a group of the younger writers and
artists, to meet Mr. Madariaga. . . . [The evening consisted of] a talk by
Mr. Madariaga, spirituals by the Utica Jubilee Singers, two solos by Alex-
ander Gatewood, and readings by the following poets from their works—
Countee Cullen, Langston Hughes, Arna Bontemps, Georgia Douglas John-
son, Jessie Fauset, and Richard Bruce [Nugent].

This was the rare occasion, however, when Johnson's impresario touch
had somehow faltered. The evening's program turned out to be much
too long, with a touch of the camp meeting, and when it finally ended,
Hughes, Johnson, and the guest of honor headed for Smalls' Paradise
and, as Hughes recalls, "had a ball."

Sooner or later the Harlem of Charles Johnson enveloped almost
every young artist or writer. "At times he could be quite ruthless," his
loyal secretary Ethel Nance conceded, "and maybe, as some people
say, . . . he maneuvered people like chess on a board." But if they
realized they were pawns, most of the artists were too delighted simply
to have an assigned square on the Harlem board to agonize over dan-
gers of official civil rights sponsorship versus unfettered aesthetic
expression. On Johnson's orders, Ethel Nance kept up-to-date dossiers
on any Afro-American whose talent won a newspaper squib. Flattered
and spellbound, often arriving from distant places where writing and
painting were regarded as freakish follies, they came blinking out of
the subway "A" train with Harlem telephone numbers and addresses
provided by Johnson's *Opportunity* network, willing to do almost any-
thing to be recognized.

Johnson was not only superb at organization and manipulation, he

was also a sensitive literary editor. "Perhaps I should wait until morning to allow myself to become unwrapt from its fascination," he wrote Angelina Grimké of Washington, D.C., Afro-American writer, poet, and acknowledged member of one of the South's most distinguished white families. "You have achieved a rare thing: that tragedy of life which escapes the melodramatic; characters which are real, unpretentious and lovable; that lurking shadow of the most interesting quirk the racial situation holds at present; good sound humor, no special pleading—all these with a delightfully competent touch—I salute you." (Nevertheless, he found the story too long.) Johnson also sent kind letters of rejection to Washington's Georgia Douglas Johnson about some of her overly sentimental poetry. She was a special case. In the living room of her S Street house behind the flourishing rose bushes, a freewheeling jumble of the gifted, famous, and odd came together on Saturday nights. There were the poets Waring Cuney, Mae Miller, Sterling Brown, Angelina Grimké, and Albert Rice. There were the artists Richard Bruce Nugent and Mae Howard Jackson. Writers like Jean Toomer and Alice Dunbar-Nelson (former wife of Paul Laurence Dunbar), and philosopher-critic Locke came regularly to enjoy the train of famous and to-be-famous visitors. Langston Hughes used to bring Vachel Lindsay; Edna St. Vincent Millay and Waldo Frank came because of Toomer; James Weldon Johnson and W. E. B. Du Bois enjoyed their senior sage role there; occasionally, Countee Cullen and, more often, the suave Eric Walrond accompanied Locke. Rebecca West came once to encourage Georgia Johnson's poetry. H. G. Wells went away from one of the Saturday nights saddened by so much talent straining to burst out of the ghetto of American arts and letters. "Someday I hope I may find a way to help your folk," was his parting note to Angelina Grimké.

In the Paris of the day, "Sank-Roo-Do-Noo" (5 rue Daunou, the address of Harry's Bar) was often the first French spoken by arriving American artists. In Harlem, Ethel Nance recalled, "all you had to say was 580 and they knew you meant 580 St. Nicholas [Avenue]." One of Harlem's swankiest apartment buildings, high on "Sugar Hill" (where affluent and prominent Afro-Americans were increasingly settling), 580 boasted Ethel Waters as a tenant, harbored fewer than a dozen nonwhites, and was home to Ethel Nance and her two flatmates, Regina Anderson and Louella Tucker. It served as a sort of Renaissance USO, offering a couch, a meal, sympathy, and proper introduction to wicked Harlem for newcomers on the Urban League approved list.

Countee Cullen's first visit to a night club was a gift of the 580 trio on his college graduation night. The little Fifth Avenue basement club, The Cat on the Saxophone (the trio's favorite nightspot), proved to be a daring adventure for the outwardly straitlaced poet. Melody, the sole waitress, catered to him as though he were one of the big spenders from the Cotton Club. Believing that "his education had been neglected," Nance said this was Cullen's night to begin catching up. "He was delighted; he was so impressed."

Five eighty was a casual billet only by appearances. For Toomer and Hughes, it was an evening furlough from the literary battlefront. For Eric Walrond, making his rounds with fascinated whites, it was a genteel waystop, a relaxed forum for contact between Uptown and Downtown New York. In reality, it functioned as a combination probation office and intelligence outpost for the Urban League. The artists who understood what was expected of them and who showed that they were not a flash in the pan from the provinces had a good chance in Harlem's literary competition and of being recommended to Alfred Knopf, Horace Liveright, and Carl Van Vechten. The 580 trio was excited by Walrond, his accented, rippling wit, his urbanity and fearless independence. "You would think of him as being tall; he may not have been six feet. He had flashing eyes; his face was very alert and very alive." Walrond also had a brooding side, and was given to bouts of paralyzing self-doubt. He belonged to one of the world's most uprooted species, the Anglo-African Caribbean *déraciné*—a British Guianan from a broken home, carted by a genteel mother to Barbados where Saint Stephen's Boys' School contoured his psyche to an English mold, and then to Panama where he completed secondary education in Spanish schools and under private tutors. Walrond had come to New York in 1918. He was twenty, already a journalist, destined to be a student at the City College of New York, a stenographer in the British Recruiting Mission, and to be hurt over and again by American race prejudice. In New York he began to write historical and political essays (some of them for Garvey's *Negro World*) and fiction. For Walrond, debonair and superior, to have flirted with Garveyism was a measure of the bitterness of those days. In September 1923, *The Smart Set* published "Miss Kenney's Marriage," a short story about the perils of cultural assimilation. Charles Johnson took notice and hired Walrond at *Opportunity*.

One of Nance's 580 duties was to alert Charles Johnson to anything amiss with a new arrival; her apartment-mate Regina Anderson's role

was to persuade her employer, librarian Ernestine Rose, that the community had a new talent whose works cried out for audition at the 135th Street library. Diffident and kindly Aaron Douglas was a pleasure and a perfect guest, as unlike the stereotype brooding or manic painter as Langston Hughes was unlike the delicate or high-strung poet. "Dear Dr. Du Bois" put Douglas to work in *The Crisis* stockroom, and the women were able to say farewell to Harlem's first painter after a week or so. Things were not always so easily managed, though. Zora Hurston put 580 to the test, as was her habit. In a rare flash of anger, Hughes would call her a "perfect darkie," an inapposite description of this handsome, brown-skinned Howard University transfer student with a sharp, independent mind and an urge to become an innovative anthropologist. Her reputation for being outrageous, unpredictable, and headstrong was widely known. When she appeared at the East Twenty-third Street headquarters of the National Urban League with less than two dollars and no job, Johnson turned her over to Nance with orders to keep her under strict surveillance. "We wanted to be sure that she was going to keep those appointments," said Nance—the meeting with Hurston's Barnard College benefactor, Annie Nathan Meyer, conferences with Barnard officials, and the rendezvous with Fannie Hurst—"because with her, if something else interesting came up, she was off." Somehow, the three women were successful; Hurston headed for Barnard, an *Opportunity* prize, and Fannie Hurst's apartment. Hurston had been introduced to Hurst at the first *Opportunity* awards dinner, and had made a very keen impression. After her stay at 580, Hurston became Hurst's secretary (although she barely typed), her driver, and travelling companion (usually turbaned to impersonate an Indian princess), and served as an inspiration for Hurst's novel *Imitation of Life*.

Casper Holstein, another of The Six, was never invited to 580. In the eyes of respectable Harlem, he was an unsavory operator, sufficiently repellent to respectable folk that, years later, Ethel Nance would refer to him as "another West Indian who was very prominent and his name escapes me right now . . . who gained a great deal of notoriety during the numbers game there." Casper Holstein was held almost single-handedly responsible for Harlem's most degrading excess —organized gambling. In an idle moment working as a Fifth Avenue porter shortly before the war, Holstein figured out the basis for a fine gambling enterprise. Bets could be taken on a three-digit number to be

drawn from the daily stock market sales reports. With odds against winning running at 600-to-1, the proprietor of the enterprise stood to do handsomely. Establishing headquarters at the Turf Club, 111 West 136th Street, Holstein soon presided over Harlem's busiest and most prosperous business. "In a year," one source records, "he owned three of the finest apartment buildings in Harlem, a fleet of expensive cars, a house on Long Island, and several thousand acres of farm land in Virginia." By 1926, he was almost a millionaire; he was benefactor of the West Indian community, sponsor of the annual Turf Club ball, a prominent Elk, and still a shadowy personality.

But there was nothing shadowy about Casper Holstein's West Indian nationalism. He and another highly successful West Indian business-man, P. M. H. Savory, served as bankers to the New York island community, quietly advancing promising businesses and careers. Hol-stein's sleepy homeland, the former Danish Virgin Islands, was now under the heavy hand of the United States Navy, the streets of quaint Charlotte Amalie patrolled by southern sailors whose contempt for the population was heartily returned. He was bitter about the suffering of his people (and sometimes wrote about it in Negro World), wise enough to see the linkage between their plight and that of the Afro-Americans, and ready to do whatever possible to help both. Invited by his young friend Walrond to use Opportunity as a sounding board for conditions in the Virgin Islands, Holstein wrote a detailed, carefully argued article for the October 1925 issue. From then on, the Oppor-tunity network had a generous friend at the Turf Club. Holstein's gift of a thousand dollars made the 1926 awards possible; yet even gener-ous patronage of the Harlem Renaissance would not win its mobster Medici more than tolerance.

For Charles Johnson, the social side of the Renaissance—the ban-quets, cocktail parties, salon gatherings—was a duty, although his friend Edwin Embree observed that Johnson "seemed to suffer no pain in doing his duty by the Harlem night clubs." For Walter White, it was an emotional necessity. Everything White did was done without brakes on, with a nervous single-mindedness that would have been abrasive but for a touch of style. No one ever denied he had class; just as no one ever denied his stupendous ego. And his ego was best served when it was front and center, charming or spellbinding important whites who went away in cheerful astonishment over meeting a blue-eyed, blond NAACP officer. At thirty-two, short, incomparably gregarious, White

was already a legend in Harlem, and on a first-name basis, it seemed, with virtually every important person in America. It was always an open question how many of these people knew him well. Some said he would have addressed the Pope by his given name, had they met. And the word was that when he called on President Roosevelt in the Oval Office a few years later, he was addressing him as Franklin within five minutes. Roosevelt didn't like that, and he told White so.

Walter Francis White was cocky. Harlem loved him for it, even if some folks wondered why he said he was an Afro-American. Physically, he was not only white, he was, as mordant George Schuyler wrote, one of the whitest white men ever to have an octoroon for a grandfather. With his eyes and hair, refined accent, and nervous energy, he looked and behaved far more the Wall Street broker than a man destined to be director of the nation's principal civil rights organization. But if the traits of his race were "nowhere visible upon me," an incident nearly twenty years past had irreversibly fixed his racial allegiance. It was the terrible Atlanta riot of 1906, when he, his brother George, and their father had armed themselves and joined their neighbors to repulse invading whites. "In that instant," White's autobiography records, "there opened within me a great awareness; I knew then who I was. I was a Negro, a human being with an invisible pigmentation which marked me a person to be hunted, hanged, abused, discriminated against, kept in poverty and ignorance. . . ." He would never be able to call himself white after that. Moreover, blue-eyed blonds were not at all unusual in Atlanta's upper-crust Afro-American community. Among the Bells, Caters, Pittses, and Westmorlands who grew up with him and were his classmates at Atlanta University, Walter was just another "white" colored lad. Unlike Jean Toomer, it had not been necessary for him to rediscover his roots.

Choosing to be Afro-American never prevented White from thoroughly enjoying masquerading as white. In his early days with the NAACP, shortly after fellow alumnus James Weldon Johnson recruited him and before his face became too well known in the South, his ability to "pass" had been a major asset to the organization. During the Red Summer of 1919, he had been fired on by blacks in Chicago and taken into the confidence of the governor of Arkansas. Four years later, he deceived Edward Y. Clarke, the Ku Klux Klan recruiter, into inviting him to Atlanta to advise about increasing membership. This time his identity was discovered before he had completed plans for the trip. During the 1923 push for congressional passage of the Dyer anti-

lynching bill, he went regularly to Washington with James Weldon
Johnson to lobby politicians who sometimes regretted their candor
after learning, too late, that White was not in fact white. In any case,
there was no doubt about his zest for his work. Originality was not his
strong point, but, like the Atlanta Life Insurance Company salesman
he had once been, White communicated electric excitement and was a
genius at pushing a good idea. Such an idea presented itself in the
spring of 1922, just as the campaign for the Dyer bill was getting under
way. Not long before, James Weldon Johnson had invited his assistant
along to an appointment with H. L. Mencken, then the editor of *The
Smart Set*, and the trio had discussed the merits of a controversial new
book by a white Tennessee novelist—*Birthright*, by T. S. Stribling.
Wholly unexpectedly, Mencken sent White a note asking "Why don't
you do the right kind of novel? You could do it, and it would create a
sensation."

 Birthright was the first major novel by a white to feature an Afro-
American protagonist since *Uncle Tom's Cabin*, presenting the hero, a
young Harvard graduate, sympathetically (if not altogether realisti-
cally) and in a realistic milieu. *Birthright* had a range of believable
types and a richness of plot. But the novel was not authentic enough
for those who, like White, Jessie Fauset, and James Weldon Johnson,
knew the mind and behavior of Afro-American university graduates
from the inside and were disappointed by the naiveté of Stribling's
hero, though they appreciated his goodness and courage. Mencken's
suggestion struck home. Mary White Ovington also thought it a fine
idea, offering White the use of her summer retreat in Great Barrington,
Massachusetts. He dove into writing as he did everything else—with
terrific concentration and not the slightest hesitation. Never in his life
(unless short stories in high school and a play which evoked Mencken's
scorn were counted) had he tried to write creatively. Two *Nation*
articles on race slaughter in Arkansas three years earlier had shown a
reporter's eye for facts but scarcely hinted of a novelist's imagination.
He and Gladys, his wife of less than a year, unpacked at "Riverbank,"
Ovington's cottage, and began to write.

 "I think I told you that when I started writing it," White's letter to
Claude McKay revealed, "the accumulation of experience and the in-
timate knowledge of what a colored man undergoes in a southern
community poured out of me like a veritable flood." His plot—the
struggles of a black physician in a small Georgia town: a fictionalized
version of a true situation—rang truer than *Birthright*. Kenneth

Harper, Atlanta University, northern medical school, and Bellevue intern, is a plausible character shaped by the granite faith that personal security and racial progress come through shining conduct and good works: "If he solved his problems and every other Negro did the same, he often thought, then the thing we call the race problem will be solved." Unhappily, the physician's good works are a source of danger from the whites and his shining conduct is misunderstood by some of his own people. The ways of Booker Washington, White makes clear, no longer work—if they ever had.

In the final chapters, cheered on by lovely Jane Phillips, Harper becomes a closet militant, helping to lead Center City's National Negro Farmer's Cooperative and Protective League. In the interplay of betrayal, ignorance, momentary interracial humanity, and ironic inevitability leading to Harper's lynching after an emergency night call to save a white girl, White exposed the barbarity of his South with better-than-average skill and scorching indignation. Then he collapsed in his wife's arms. He claimed to have written the entire novel in twelve days.

The Fire in the Flint should have been the second novel of the Harlem Renaissance, appearing soon after *Cane*. Fauset was just starting hers, and White, with his good luck and Algonquin contacts, bounded back from Massachusetts into the promise of a contract with Doran & Company. John Farrar, editor of *The Bookman*, had insisted on reading it as soon as White offhandedly mentioned his twelve-day creation. Farrar liked it so well he sent it to his friend Eugene Saxton, Doran's senior editor, who wrote White that, after minor revision, the firm would be pleased to publish *The Fire in the Flint*. Not long after, problems arose—worrisome, but not, it seemed, serious. A conference with George Doran and Eugene Saxton resulted in White's transforming one of his white characters, Judge Stevenson, into a paragon of old-fashioned, southern noblesse oblige in order to soften somewhat the novel's portrayal of white depravity and violence. By late July 1923, though, Saxton was worried about the reactions of the southern reading public. "On reading your story the second time, there are portions of the manuscript which, it seems to me, are bound to make bad matters worse." White was then unaware that George Doran had sought an outside opinion from a well-known Kentucky humorist. If Doran wanted "to have his books read in this part of the country as well as every other," Irvin Cobb warned him, "never put his [the Doran] name on the title page of that horrible book." The whole business was

obviously painful to Saxton, who not only still liked the novel but admitted to White, "So far as the facts go, your case is stated with much less horror than you might have used in setting it forth."

White sent the manuscript to Mencken, "disheartened and disillusioned," according to his autobiography, *A Man Called White*. In the meantime, he fought to change Doran's mind. Three days after Saxton's letter of rejection, White replied with a lengthy, tightly reasoned rebuttal. He recognized that his twelve-day wonder "lacked much in the way of artistic or finished treatment." But now that his decision was made, he challenged Saxton to reason along with him about the charge that the manuscript's " 'documentation is exclusively on one side of the case.' " Saxton had written, "Practically speaking, there is no one in court but the attorney for the prosecution." Well, why not? White demanded:

Is it not time that the prosecution should be heard? For fifty years or more the argument has been all on one side, i.e., for the defense. Thomas Nelson Page, George W. Cable, Thomas Dixon, Hugh Wiley, Octavus Roy Cohen, T. S. Stribling, H. S. Shands, Irvin Cobb—all have painted the Negro as a vicious brute, a rapist, a "good old nigger," or as a happy-go-lucky, irresponsible and shiftless type, with the exception of Stribling who tried to picture what an intelligent, educated Negro feels—*terra incognita* to him. . . . But here is an attempt . . . to depict the tragedy of color prejudice as seen by intelligent Negroes of high ideals—of which territory I am not wholly ignorant—and you object because an attempt is made to give the other side of the picture which has never been adequately given.

Saxton faltered, replying in a handwritten note that if a "white paper" (he resisted the obvious puns) on southern violence showed that well-known writers and authorities on race relations supported White, publication might still be possible. By late September 1923, White's testimonials were ready. Arthur Spingarn, the NAACP's volunteer counsel, offered the opinion that there was no basis for libel action against *The Fire in the Flint*; Joel Spingarn, writing on Harcourt, Brace stationery, spoke of the novel as "an overwhelming story" and of following the hero's career "breathlessly to his appointed destiny at the stake"; and Will Alexander and T. J. Woofter, two of the South's outstanding white authorities on race relations, said they "would be very glad if Doran decide[s] to publish it." Before submitting his testimonials, White wrote Saxton a final, vivid injunction to

give his race and his novel a fair hearing. The leaders of the South *"are* ineffectual. They *are* depraved. They *are* 'rotten.' " The truth was, "In seeking to oppress the Negro the white South has created a Franken-stein monster that is all but devouring the South. The tragedy lies in the fact that the South has so dehumanized and brutalized itself by its policy of oppression of the Negro that my white characters are true to life." Everything White said might be true—Saxton knew that it was—but, in the final letter of October 8, 1923, George Doran refused publication.

If one of the principal officers of the NAACP failed to find a pub-lisher for a surprisingly competent and accurate first novel about racism in a small southern town, what hope was there for Charles Johnson's program? Moving beyond the cloaked symbolism of *Cane* to a literature of exposure and denunciation, to a use of the arts to pro-mote social change, the Afro-American ran headlong into the politics of publishing. What was at stake was not entirely clear even to Mencken. Why bother with white publishers anyway? he asked White. "Aren't there some colored publishing firms already in existence?" So long as Afro-Americans insisted on dealing with white publishers, Mencken warned, they would "inevitably run into such difficulties as you encoun-tered with Doran." But it was not just an artistic and intellectual ques-tion of "freedom to write what you please," as Mencken understood it; there was the racial obligation to write as honestly as possible for hostile and indifferent readers under a nationally recognized and re-spected imprimatur. "Even if there were such a concern," White enlightened Mencken, it would not interest him to publish with it. It was not the Afro-American reader who had to be reached, but "the white man and woman who do not know the things you and I know. I mean the white person who has never suspected there are men like Kenneth Harper, who believes the ex-Confederates are right when they use every means, fair or foul, 'to keep the nigger in his place.' " That said, Mencken, who thought White had done a "good job," recom-mended the novel to Knopf, and to his surprise and White's delirious pleasure, a contract followed in mid-December. *The Fire in the Flint* appeared in early September 1924, about five months after Fauset's *There Is Confusion.*

The Fire in the Flint not only created an immediate and consider-able uproar, it was to sell steadily. Mencken, Joel Spingarn, T. S. Stribling, and other friendly critics told the author that his characters were more symbol than flesh, that the novel was more sermon than

plot, but they, like all who read it, were struck by the concentrated passion of the work. Hostile critics only helped sales. "The best way to get it talked of in the South," Mencken roguishly advised, "will be to send it to the worst Negrophobe papers for review"—a gambit that proved highly successful. "Knopf and I will be able to pay our bills for some time," White joked, telling Mencken that he was "being roasted to a turn" by the "professional Confederates." Outside the South, the public's natural curiosity was quickened by enthusiastic endorsements of the novel by such contemporary literary celebrities as Sinclair Lewis and Carl Van Vechten. "Neither my best friends nor my worst enemies have ever accused me of too great modesty," a confidently grateful White wrote Van Vechten; he had had no idea that Van Vechten would be "interested in a novel such as mine. . . . You saw exactly what I was driving at." White began to wonder if he were on the threshold of a new career, confiding in Mencken that, if he got the "writing disease," the fault would be that of the crusty Baltimore editor.

Walter White was a New York celebrity. The Sinclair Lewises came to dinner, and returned for drinks and talk with the James Weldon Johnsons and the Du Boises. "Red" Lewis and "Fuzzy" White (there was an immediate exchange of nicknames) liked each other instantly, White saying admiringly—"I had felt that I was a rather nervous and energetic individual, but compared to him, I felt rather anemic." With the blessings of James Weldon Johnson, White proceeded to turn his apartment at 90 Edgecombe Avenue into a stock exchange for cultural commodities, where interracial contacts and contracts were sealed over bootleg spirits and the verse or song of some Afro-American who was then the rage of New York. "We would very much like to have you come up some evening," Carl and Irita Van Doren were told. "Later on, we could have the Robesons and Julius Bledsoe, baritone, to come in for some music." "We had a few folks at the house," said the note to Roland Hayes—"Bledsoe, Paul Robeson, James Weldon Johnson, and Grace Johnson, Carl Van Vechten and Fania Marinoff, Covarrubias, the caricaturist, and George Gershwin. . . . We had a gorgeous time and the only thing lacking was your presence." "I still look back with pleasure at the delightful dinner at your house, and the agreeable reception I had afterwards," wrote Clement Wood, author of Nigger.

The Whites—Gladys, a poised beauty, and Walter, a superlative conversationalist—helped give Harlem cocktail gatherings a brilliant reputation. Heywood Broun, V. F. Calverton, and John Dewey, Horace Liveright, Sinclair Lewis, and George Jean Nathan, Dorothy Parker,

the Knopfs, the Van Vechtens, and other white regulars at Walter's and Gladys's were likely to be joined now by some of America's most distinguished visitors—Konrad Bercovici, Nancy Cunard, Georges Duhamel, Sergei Eisenstein, Prince Hikida, André Siegfried, Osbert Sitwell, Rebecca West, and others. "Everybody missed you and Gladys," Van Vechten's note told the indispensable couple, who missed a major Harlem evening. "We went on to A'Lelia Walker's, the YMCA dance, Bamville, and the Candy Club, which we left at 8:30, driving home through the sunlit, glowing park."

Ethel Ray Nance worshipped her boss, Charles Johnson, though not blindly. White's secretary, Richetta Randolph, was far less enchanted with hers. When he took over the NAACP in James Weldon Johnson's absence, Randolph complained that White tried to manage everything, "going over the time cards, checking up on the clerks," reading all the office mail. She saw the petty side of her employer's unique strength— his tendency to personalize everything and his manic attention to de- tail. He wanted to leave nothing to chance. Social encounters, profes- sional conduct—especially evenings at the theatre—were to be controlled to the maximum benefit of racial harmony. "The seats were perfectly situated, and the play is beyond anything anyone had led me to expect," Edwin Embree, president of the Julius Rosenwald Fund, wrote, thanking White for tickets to *The Green Pastures*. "Remember," a note from White said to Blanche Knopf, "you and Alfred are going with me to the opening of *Deep River* next Monday night." Artists who performed indifferently or unwisely set White's teeth on edge and were likely to get a note. It would be better, Florence Mills was advised, if the singer would be more careful in the future about roles with too much "vulgarity" and "stereotyping," as that in *Dixie to Broadway*. Marian Anderson's voice showed definite promise, but why, he groaned to Roland Hayes, had she spoiled her Town Hall debut with encores in such "bad taste"? "For example, she gave for an encore to a beautiful aria a banal thing like *My Lindy Lou*."

White never actually claimed responsibility for every positive hap- pening between the races, yet he invariably managed to invite that inference. A casual visit to International House occasioned a letter to its donor, John D. Rockefeller, Sr., bearing the glad tidings that Walter had overheard several residents praising the one-world spirit of the institution. He wondered if George Jean Nathan knew how frequently *American Mercury* was quoted in the Afro-American press. "This is having its effect, also, I have been glad to find, for, through personal

contact and correspondence, I find that the *Mercury* is beginning to be widely read among colored people all over the country." Although this was not very likely, assurances such as White's had much to do with regular advertisements for the *Mercury* and other Knopf publications in *The Crisis, The Messenger, Opportunity,* and even *The Inter-State Tattler.* "I spoke at The Plaza last Wednesday and devoted a good deal of time to you," White informed Cullen. "A number of the smug, fur-coated, well-fed ladies wrote down the title. I hope they spend some of their money for copies" of *Color.* Confidentially, White let it be known that Paul Robeson had abandoned a law career for the concert platform on his advice.

White knew how to make people grateful to him for their own gifts, enthusiastic to place success they believed they owed him in the service of racial advancement. Exhilarated by his second European tour, Roland Hayes sounded more like a civil rights official than a concert singer: "Walter, I am really doing my best! Nothing matters to me but *our goal,* and I shall give every ounce of energy, strength, and what-ever other powers I possess towards the end of progress—not only of our race, but also of the white race, too." Baritone Julius ("Jules") Bledsoe also caught the spirit, writing that when he became famous he would "always be able to look back on these days of sympathy and encouragement such as you and Mrs. White have given." White even made Charles Chesnutt, who had not published a novel since 1905, enthusiastic about writing again. "What you say," Chesnutt wrote ap-preciatively, "about the reception which a new book by me would receive encourages me to see what I can do." (When Chesnutt did write a new novel, he failed to find a publisher.)

Walter White was not all show business. Eighteen months before Charles Johnson announced the *Opportunity* literary competition, he had pushed for creation of a Negro art institute to support drama, dance, and music. Seed money would have come from the new Ameri-can Fund for Public Service (Garland Fund). Fund trustee James Weldon Johnson told White the art institute was an excellent idea. "Be motherly with it," Locke added, cooing to White, "I almost wish you were a hen." (The art institute idea would materialize two years later, but under white auspices and without Garland Fund support.) White's other original idea—one of the most remarkable of the many propa-ganda schemes of the Harlem Renaissance—was floated early in 1924. "There has never been a time when the United States was more un-

popular than today," he wrote a graduate student friend at Yale. England was bitter about being displaced by American financial power. Russia felt herself menaced. French, Germans, and Italians deeply resented the boorish arrogance of American tourists:

Unfortunately for them, America is, and for some time will be, the financial lord of them all. There cannot be any frontal attack made on America, but each of these countries would be glad to find some great moral issue on which they could attack, or at least criticize severely, the United States. . . . I am firmly convinced that if Negroes saw this opportunity in the broadest way in which it should be viewed, that with the expenditure of, say, a small sum like ten thousand dollars a year, we could put over the truth about the Negro in the United States in a way that would revolutionize conditions in the United States.

He had in mind some sort of bureau for dissemination of materials on American racism, to be located in a European capital. Apparently because of difficulties in raising funds exclusively from Afro-American sources, the idea was never realized.

Care and feeding of artists was becoming a round-the-clock matter for White. He may have been the best nursemaid of the Renaissance, giving invaluable assistance to Countee Cullen, Rudolph Fisher, Nella Larsen, Claude McKay, Dorothy West, and Hale Woodruff. When Fisher's "City of Refuge" appeared in the February 1925 *Atlantic Monthly*, White had just written the unknown young physician, then at Howard University: "I was talking with [Mencken] a few days ago," the letter began, "and he told me that he had more material . . . by and about Negroes and other non-Nordics than by Nordics." Fisher was assured that he had an advocate in court. Before signing his letter, though, White noticed "City of Refuge" in the *Atlantic*, and found it one of the finest short stories he had ever read. He plunged into the manuscript on his desk, Fisher's "High Yaller," becoming more excited. The letter received an ecstatic postscript:

You have very real ability as a writer, you handle your situation splendidly, and you have not only ability to express what you see but, what's more important, you have eyes that can and do see. . . . I am not only sending "High Yaller" to Mencken today, but I am calling the attention of Carl Van Vechten, Carl Van Doren, Sinclair Lewis, Zona Gale, and one or two other folks I know to your *Atlantic Monthly* story.

There were others White helped. His pressure on Sol Hurok was responsible for breaking the unfair contract binding baritone Jules Bledsoe. Nella Larsen Imes, wife of a young physicist, was one of his closest friends. She had shared from the outset Fauset's and White's determination to write about cultured Afro-America from the inside. White, and Carl Van Vechten (whom she met through White), urged her on. In October 1926, White had the first draft of the novel "Quicksand," had suggested revisions, and inveigled his reluctant secretary into typing Larsen's manuscript. Claude McKay and Hale Woodruff, the young Illinois painter, became White's special wards. Buttonholing wealthy white patrons of the arts and passing the collection plate among Harlem's affluent in order to send Woodruff to Paris for classes at l'Académie Scandinave became routine for White. He also approached the banker Otto Kahn, who, "without seeing any of Mr. Woodruff's work," agreed to give him two hundred fifty dollars a year for two years of European study.

Claude McKay needed an abundance of everything—money, moral support, editorial advice, publishers—and took everything for granted. The first collection plate for McKay had been passed in January 1924 —one hundred dollars that White sent to Paris so the ailing poet could go south and write at La Ciotat. McKay never mentioned that lovely, wilful Louise Bryant (John Reed's love and now Mrs. William Bullitt) had given him a large sum for the same purpose. Stop writing poetry, she told him. John Reed's best stuff had been stories about plain, simple people; McKay should do the same. Had McKay asked White, he would probably have got similar advice because, as the NAACP secretary agreed with Langston Hughes, most of the Jamaican's recent poetry was "distinctly second-rate." More than that, White wanted book-length fiction that would be snapped up by the public rather than critically acclaimed but barely read poetry.

When McKay mentioned he was about to start a novel, White determined to guide him by remote control. He enlisted Sinclair Lewis— one of the first things Lewis remembered, as he shook off the hangover from White's terrific farewell party ("It was quite mad!"), was that he had promised to "do whatever I can" for McKay. Lewis kept his promise, spending two nights drinking and talking about writing with McKay at Harry's Bar, and taking a careful look at the unfinished novel. McKay was so delighted by the camaraderie and professional tips he abandoned his usual churlishness. "You're lucky in making friends, you're altogether so charming and fine," he wrote White. "I'm

a son-of-a-bitch." Lewis's wife, Grace Hegger, worried about how the Jamaican would take "Hal's more than justified criticism" of "Color Scheme," the partially finished novel. When the blow fell, she saw McKay take it "in a manly way." He decided, she reported, "to scrap the whole thing."

Instead of scrapping his novel, however, McKay decided to revise it. It was a story about a Spanish West Indian girl who attends a Catholic seminary in the South, then comes to Harlem to live in both white and black worlds. "Color Scheme" became much raunchier as it was reworked, the characters "backbite and fuck like little people the world over," McKay wrote Arthur Schomburg, Harlem's bibliophile. Louise Bryant continued to open her purse. James Weldon Johnson and Walter White had arranged for a fifty-dollar monthly grant from the Garland Fund during most of 1924. "It was grand and romantic to have a grant to write, and I got going on a realistic lot of stuff," McKay recounted. Toward the end of April 1925, he was feeling better, psychologically, than he had in years. The novel was done, at the typist's, and he wanted Schomburg to find a publisher immediately, without even pausing to read it.

When White learned the novel was finished, he recommended sending it to Viking, a new firm with considerable capital and two highly competent men in charge, George Oppenheim and Harold Guinzburg. McKay was furious. Everybody knew "an older firm can always sell a book better than a very new one," he assured Schomburg a few days later. He still liked White, though, and he had no objections to Schomburg's showing him "Color Scheme"—"if my novel will not shock him." As weeks passed, McKay began to feel betrayed by "that NAACP crowd," especially Mary Ovington and Joel Spingarn, his "*bêtes noires.*" Black and white, he snarled to Schomburg, they were all the same, with their literary prizes, gold and bronze medals, and ridiculous ranking of Afro-American talent—"put any other race or national group in America in that position and see how ridiculous it looks." It amounted to aesthetic straitjacketing, really, for those artists "who believe in exercising freedom of thought and action that may run contrary to the aims of the NAACP." In mid-August, Knopf rejected "Color Scheme." Schomburg saw the conspiracy, did he not? Knopf's reader had kept the novel six weeks, probably only to insure itself a long lead to publish Carl Van Vechten's book on Harlem. Knopf's was prejudiced, and Walter White, an unreliable mulatto, was loyal to Van Vechten, McKay ranted. Schomburg should have known better than to

trust White. But McKay knew he still needed White, and when the dust settled, he addressed a long, apologetic letter to him full of complaints about illness, poverty (his New York patron had stopped his allowance), and worries.

While "Color Scheme" was dying of its own considerable defects and McKay was resigning himself to a fresh start, White was reading reviews of his own second novel. *Flight* took longer to write than *The Fire in the Flint*, yet it was composed during a period when NAACP executive secretary James Weldon Johnson was ill and White had full responsibility for running the organization. The first novel, well received by critics, was being translated into a dozen languages, including Japanese. Eugene O'Neill had liked it well enough to consider a dramatic adaptation, and George Gershwin had thought it had possibilities as a musical. Not only had Sinclair Lewis, now one of White's closest friends, staggered the unflappable author by praising it publicly as one of the two most significant novels of 1924 (E. M. Forster's A *Passage to India* being the other), but Somerset Maugham had written enthusiastically from Cap Ferrat—"It is a terrible book, but a very powerful one, and it gives one a tragic sense feeling of truth."

Flight was a much better book, White believed. Sinclair Lewis, back from Europe, had gone over the manuscript carefully, blue-pencilling parts that were too preachy, breathing life into the characters. The novel was in the Chesnutt tradition of mulatto adversity, offering much the same message as Fauset's *There Is Confusion*—that enormously cultured, very light Afro-Americans were proud, resourceful people who might sometimes succumb to the temptation of racial "passing," but only because of overwhelming hardship, discovering in the end that being black (or off-white)—whatever the handicaps—was far better. *Flight* was tighter and more attentive to the lives of its characters than *The Fire in the Flint*, but critics were lukewarm. Unlike the earlier book, it was not a story that had to be told. A high-strung, young newcomer to Harlem, Wallace Thurman, gave it a withering review in *The Messenger*. White tried to take his medicine gamely. But when another young writer, Frank Horne, surpassed Thurman in the July *Opportunity*, a letter marked "personal" arrived on Charles Johnson's desk. In substance, the NAACP demanded an apology from the Urban League. When Johnson regretted White's displeasure and hoped it would pass, White replied that he expected more than a "pleasant" letter. Johnson's next letter had about it the conciliatory formality suggesting conferences at the highest levels of civil rights officialdom:

"Really, I am inclined to go to the extreme in this instance—to be certain of being fair in a situation which can easily be misunderstood." *Opportunity* published a lively rebuttal of Frank Horne's penetrating review by White's protégée, Nella Larsen Imes.

Walter White was indefatigable as a one-man assault force in the arts. Yet without James Weldon Johnson's strong endorsement and guidance, he probably would never have ventured into the arts, and certainly would have faltered when Du Bois began arguing that the NAACP was wasting its resources. James Weldon Johnson had joined the NAACP in 1916, at the age of forty-five, first as field secretary and then, in 1920, as executive secretary, its ranking administrative officer. More than 80 percent of the NAACP's fifty-thousand-dollar annual budgets came from membership dues by 1926, much of the credit for which belonged to Johnson and the two field officers recruited by him, Robert Bagnall and William Pickens. He was a superb public speaker and an even better arbitrator and politician. His was the other NAACP voice, besides Joel Spingarn's, to which Du Bois usually listened with respect. Colleagues called Johnson "wise," "philosophical," "cosmopolitan," and possessed of "sweet reasonableness," all of which was true. By the mid-twenties, he was recognized, within the race and without, as Afro-America's senior statesman.

He was born in Jacksonville, Florida, where his father was making a fresh start, after losing much of his wealth in the Bahamas. Johnson's lineage placed him among the tiny elite of Afro-Americans whose families had been free, literate, and prosperous before the Civil War. His father was a freeborn Virginian from Richmond who learned the art of table-waiting in New York luxury hotels before moving on to the Bahamas where he married and prospered until the great hurricane of 1866 and the ensuing depression. Later, in Jacksonville, he became headwaiter at the Saint James, for many years Florida's finest hotel. His West Indian mother, the first "colored" female to teach in Florida's public schools, was a proud rebel, Johnson thought. She had refused to sing "America" in church when the congregation was told of West Point's rejection of a qualified candidate because he was Afro-American. Helen Dillet taught her son to be proud of his proud West Indian heritage: of her grandfather, Etienne Dillet, a Napoleonic officer stationed in Haiti; of her father, Stephen Dillet, freeborn, elected to the Bahama House of Assembly in the 1840s, postmaster general, and inspector of police. She had been too frail after his birth to nurse James

Weldon, but Mrs. McCleary, a white neighbor, took Helen Johnson's place. "In the land of black mammies," her son often joked, "I had a white one" (as did Walter White). He grew up in an immaculate, large frame house where there was a piano and a library. Frederick Douglass once paid a call while on a speaking tour, and Daniel Payne, the learned Methodist bishop, was an occasional guest. Johnson remembered the young mulatto lodger T. Thomas Fortune composing his sweeping manuscript, later published as *Black and White: Land, Labor and Politics in the South*. From another lodger, a young Cuban sent to learn English, Johnson learned to speak Spanish like a native. He was sent to Atlanta University's preparatory school, a major center of New England missionary zeal.

Formal education at Atlanta was good—for the South, outstanding —but it was by a Jacksonville physician's slightly Gothic tutelage in the classics, poetry, and agnosticism that Johnson's intellect was profoundly shaped. Yellow fever ravaged his hometown during the summer after his first year at Atlanta, and Johnson worked alongside a brooding, brilliant white doctor named T. O. Sumners. Sumners was drug-addicted and destined to be a suicide; "one of those mysterious forces that play close around us." Johnson called him "the model of all that a man and a gentleman should be." That fall, Johnson stayed out of school and travelled to Washington and New York with Sumners. When he returned to Atlanta, he knew what he wanted to make of himself. It was then that his favorite word became "cosmopolite." He abandoned organized religion, and in its place worshipped high culture. Atlanta University—"where the ideal constantly held up to us was of education as a means of living, not of making a living"—only reinforced the cosmopolitan ideal. He passed the last years of the nineteenth century in Jacksonville as proprietor of the first Afro-American daily newspaper in the nation, as first Afro-American lawyer admitted to the bar in his part of Florida, as founder of the first Florida public high school for Afro-Americans, and, very likely, as the first Floridian ever to compose an opera (with J. Rosamond, his New England conservatory-trained younger brother). Jacksonville's leading whites were so impressed by *Toloso* (about well-intentioned American imperialism), they gave the Johnson brothers an interracial party.

Then came New York. Even though critics there received *Toloso* with far less enthusiasm, Oscar Hammerstein came to the Johnson brothers' flat to hear it played, and encouraged them to persevere. In February of the following year, 1900, in honor of Lincoln's birthday

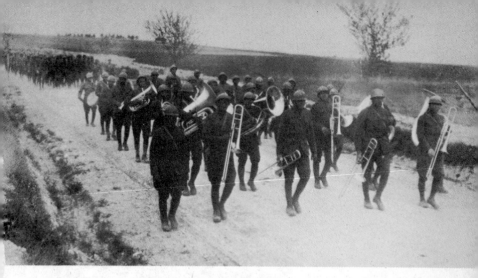

Lieutenant James Europe and his band in France. (National Archives)

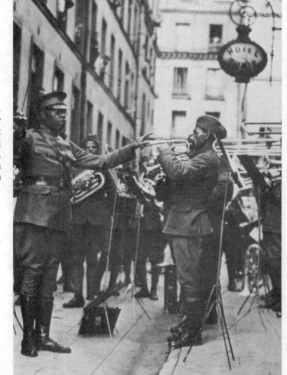

Europe conducts. (Schomburg Center for Research in Black Culture, The New York Public Library, Astor, Lenox and Tilden Foundations)

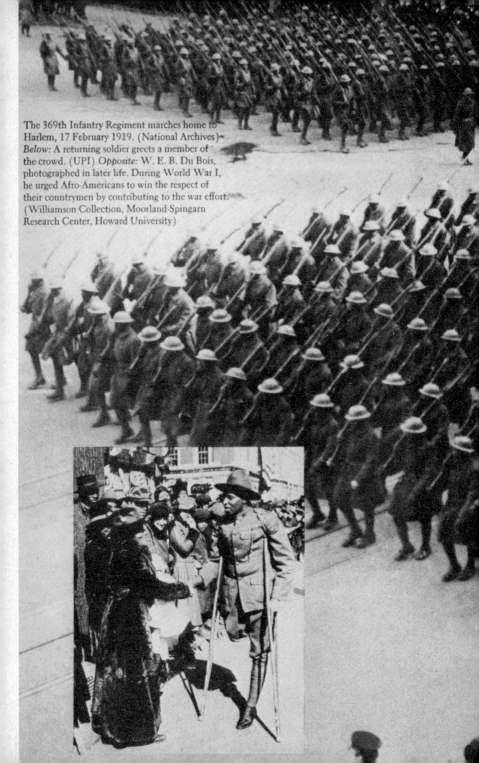

The 369th Infantry Regiment marches home to
Harlem, 17 February 1919. (National Archives)
Below: A returning soldier greets a member of
the crowd. (UPI) *Opposite:* W. E. B. Du Bois,
photographed in later life. During World War I,
he urged Afro-Americans to win the respect of
their countrymen by contributing to the war effort.
(Williamson Collection, Moorland-Spingarn
Research Center, Howard University)

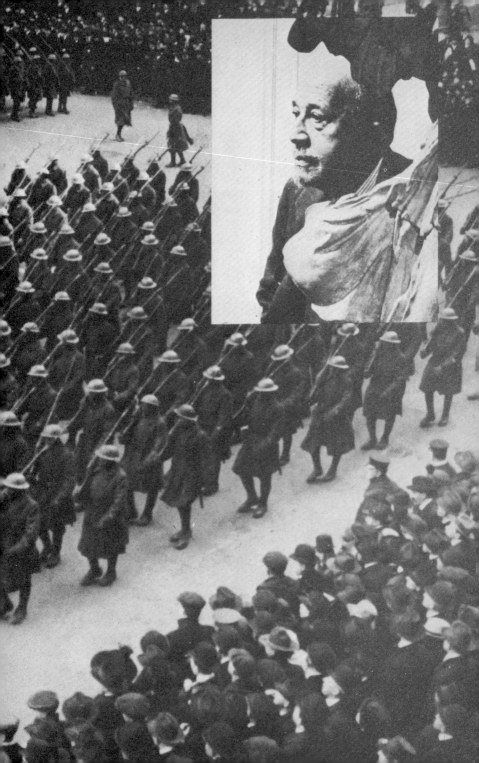

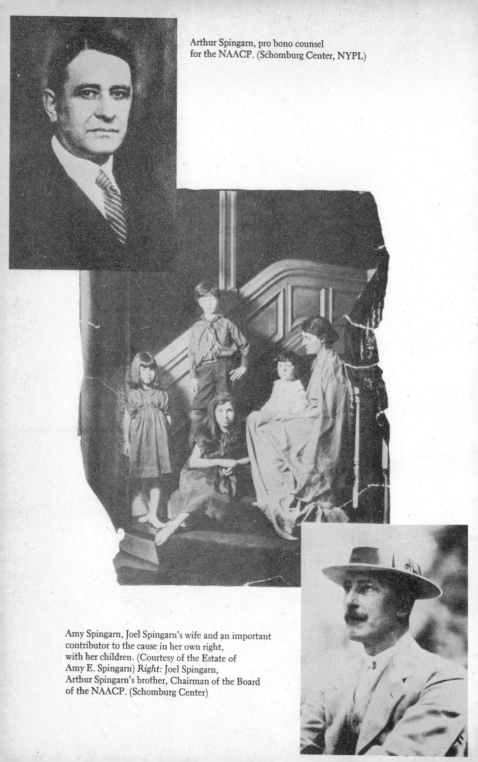

Arthur Spingarn, pro bono counsel
for the NAACP. (Schomburg Center, NYPL)

Amy Spingarn, Joel Spingarn's wife and an important
contributor to the cause in her own right,
with her children. (Courtesy of the Estate of
Amy E. Spingarn) *Right:* Joel Spingarn,
Arthur Spingarn's brother, Chairman of the Board
of the NAACP. (Schomburg Center)

Above: Palm Sunday at Mount Zion African Methodist Episcopal Church, 1920s. (Schomburg Center) *Right:* A portrait of four clerics, including Adam Clayton Powell (seated, center), pastor of the Abyssinian Baptist Church, and Frederick Asbury Cullen (right), pastor of Salem Methodist Episcopal Church and adoptive father of Countee Cullen. (Photographed by Van Der Zee)

Julius Rosenwald, a Sears, Roebuck tycoon and principal backer of the Urban League. (Department of Special Collections, University of Chicago Library)

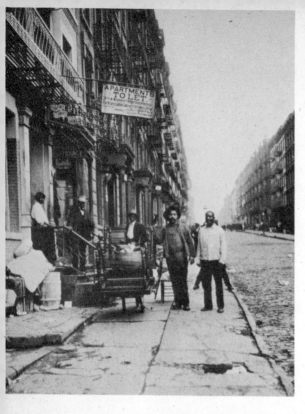

Left: A black family moves into Harlem, about 1905. The apartments in this building are already advertised as "For Respectable Colored Families Only." (Brown Brothers) *Below:* The most desirable of Harlem's neighborhoods—Sugar Hill. (Special Collections, Fisk University Library)

John Nail, of Nail & Parker
(brother-in-law to James Weldon
Johnson), was one of the few black
men to profit from the creation of
black Harlem. This ad appeared in
The Messenger in 1923. (Moorland-
Spingarn Research Center)

Strivers' Row (West 138th and 139th Streets),
designed by Stanford White. (Schomburg Center, NYPL)

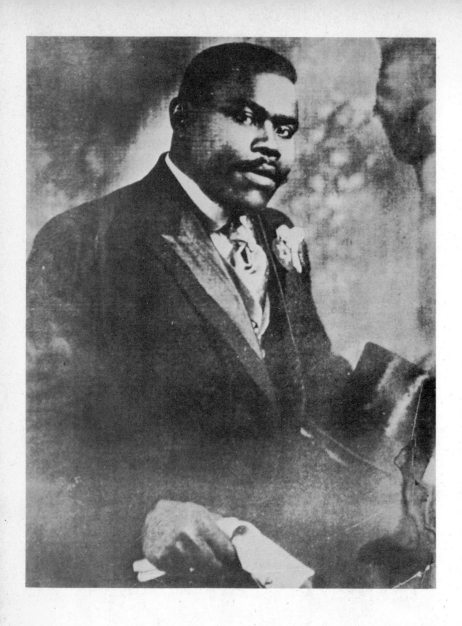

Marcus Garvey, the Jamaican founder of the
Universal Negro Improvement Association. (Schomburg Center, NYPL)
Opposite, above: A Garveyite and Family, 1924,
photographed by Van Der Zee. *Below: Garvey Parade, 1924,*
photographed by Van Der Zee.

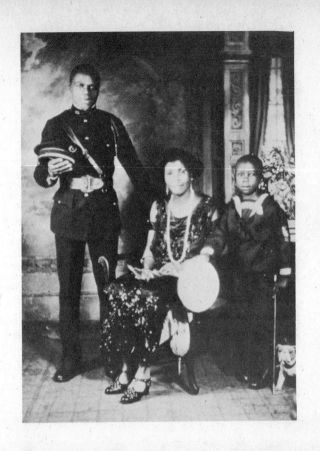

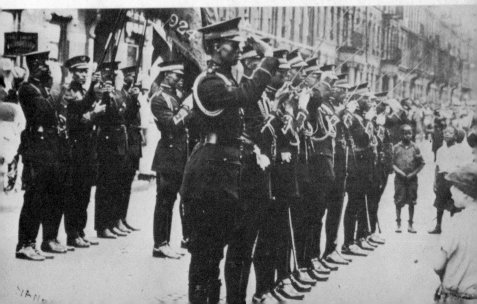

Left: Claude McKay, photographed
by Carl Van Vechten. (Estate of
Carl Van Vechten and McClendon–
Van Vechten Collection, Moorland-
Spingarn Research Center)
Below: "Mr. McKay Speaking
in the Throne Room of
the Kremlin." Photograph from
The Crisis, December 1923.
(Moorland-Spingarn Research Center)
Opposite, top left: Langston Hughes.
(Williamson Collection, Moorland-
Spingarn Research Center)
Top right: Jean Toomer.
(Special Collections, Fisk University Library)
Below right: Countee Cullen, photo by
Van Vechten. (Estate of
Carl Van Vechten and
McClendon–Van Vechten Collection)

A literary gathering at the 135th Street
branch of the New York Public Library.
Puerto Rican bibliophile Arthur Schomburg
may be seen in the back row, second from
the right. (Schomburg Center, NYPL)

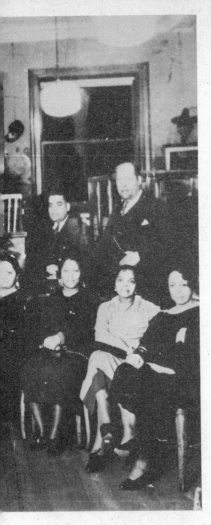

A party for Langston Hughes on the roof at 580 St. Nicholas Avenue, 1924. *From left:* Helen Lanning, Esther Popel, Pearl Fisher, Louella Tucker, Clarissa Scott Delany, Jessie Fauset, Regina Anderson, Mrs. Charles S. Johnson, Ethel Nance. The apartment shared by Nance, Anderson, and Tucker at 580 was a haven for artistic newcomers to Harlem.

At the Hughes party: Hughes, Charles S. Johnson, E. Franklin Frazier, Rudolph Fisher, Hubert Delany. (Both photographs courtesy of Mrs. Regina M. Andrews)

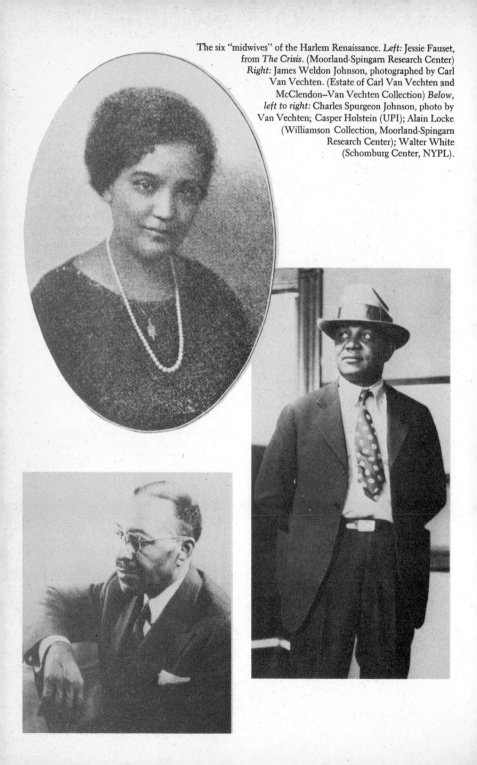

The six "midwives" of the Harlem Renaissance. *Left:* Jessie Fauset, from *The Crisis.* (Moorland-Spingarn Research Center) *Right:* James Weldon Johnson, photographed by Carl Van Vechten. (Estate of Carl Van Vechten and McClendon–Van Vechten Collection) *Below, left to right:* Charles Spurgeon Johnson, photo by Van Vechten; Casper Holstein (UPI); Alain Locke (Williamson Collection, Moorland-Spingarn Research Center); Walter White (Schomburg Center, NYPL).

Harlem belles, 1920s. (Schomburg Center, NYPL)

they wrote "Lift Every Voice and Sing," which came to be called the "Negro national anthem." In 1902, Johnson resigned his high-school principalship and went into writing songs and dialect poetry as a career with his brother and Bob Cole. In less than three years, so many of their tunes were being heard in Broadway's most successful shows that they were dubbed "Those Ebony Offenbachs." "The Congo Love Song," "Hello Ma Lulu," and a thick folio of other popular songs gave the team an income that made them the toast of Marshall's Hotel and all other Tenderloin watering holes. "Under the Bamboo Tree" became a generation's theme song:

> If you lak-a-me, I lak-a-you;
> and we lak-a-both the same,
> I lak-a-say, this very day,
> I lak-a-change your name;
> Cause I love-a-you and love-a-true
> And if you-a-love-a-me,
> One live as two, two live as one,
> Under the bamboo tree.

Meanwhile, James Weldon Johnson studied literature at Columbia under Brander Matthews, the university's most famous professor. Studies were interrupted for a triumphal six-week London theatre engagement, followed by a tour of the Continent, leaving them with a few dollars and their return tickets. *The Shoo-Fly Regiment*, another Broadway success, replenished bank accounts. But Columbia and Europe had made Johnson begin to reach out for more substantial artistic achievement. Poet Paul Laurence Dunbar had sensed Johnson's groping in Jacksonville when he heard him read some of his strange, Whitman-inspired verse. Now that Dunbar was dead of tuberculosis and drink, Johnson must have recalled the poet's words on that Jacksonville night: "I've kept on doing the same things, and doing them no better." Stability, reflection, marriage increasingly appealed to Johnson.

Charles W. Anderson, Booker Washington's ally and head of New York's Colored Republican Club, had taken Johnson under his protection, first as club treasurer and then as party lyricist. Johnson's 1904 campaign song, "You're All Right, Teddy," had delighted Roosevelt, and Johnson suddenly found himself "rewarded" (at a considerable loss in income) with admission to the consular service and appointment to duty in Puerto Cabello, Venezuela, in the spring of 1906.

Speaking Spanish fluently, and French almost as well, Consul Johnson found his social acceptance in Venezuela so complete that he worried about his failure to make an impact "as a Negro," for Johnson was a racial chauvinist of a special kind. He wanted his complete and natural assimilation of European culture to make such an impression that whites enjoying his cosmopolitan company would inevitably draw positive generalizations about Afro-Americans. Posted to Corinto, Nicaragua, in 1908, Johnson's racial ideas underwent much refinement. Corinto was Nicaragua's busiest Pacific port, eagerly possessed by whatever government was temporarily in power. He brought his new wife there, Grace Nail, sister of John Nail, former Tenderloin tavern owner from Brooklyn, who was now amassing a fortune in Harlem real estate. During the next five years, Johnson wrote a novel, directed U.S. Marines in aborting a Nicaraguan revolution, and saw his poem commemorating the fiftieth anniversary of the Emancipation Proclamation published on the editorial page of *The New York Times*. But he also saw his career in the consular service destroyed by the Wilson administration. Booker Washington, in ill health and soon to die, had an editorial position created for him on the New York *Age*, a weekly newspaper obedient to the Tuskegean's conservative racial philosophy.

Johnson had been christened James William. By 1925, the world knew him as James Weldon Johnson, the commonplace William having been dropped twelve years earlier—"you can see that Jim Bill Johnson will not do for a man who pretends to write poetry or anything else." His *The Book of American Negro Spirituals*, assembled with J. Rosamond, was among the year's ten best sellers. His three-year-old *The Book of American Negro Poetry* was the standard anthology. *Fifty Years and Other Poems* had not won the wide acclaim of its 1913 title poem, but its spirit of humble gratitude and untroubled patriotism was approvingly received:

> Far, far the way we have trod,
> From heathen kraal and jungle den,
> To freedmen, freemen, sons of God.
> Americans and Citizens.

His last flings with music had been in 1915, when he collaborated with his brother to compose "Treat Me Like a Baby Doll" and "You Go Your Way and I'll Go Mine"; he also undertook the prestigious job of translating Enrique Granados's opera *Goyescas* for presentation at the

Metropolitan Opera. *The Autobiography of an Ex-Colored Man*, written anonymously, had not sold well in 1912, but even now well-connected white friends were arranging for the novel's reissue. His period of active Republican Party politics was behind him: speechwriting for presidential candidate Charles Evans Hughes in 1916; a 1920 trip to Haiti for *The Nation* to expose the horrors of American occupation—a trip paid for by party stalwarts and yielding major campaign ammunition for Warren Harding. Mary White Ovington, uneasy about his ties to Booker Washington, had opposed Johnson's appointment as NAACP secretary at first. But by 1925 she found him admirable in every respect, describing the secretary almost romantically in her *Portraits in Color* as "a slender figure with long, delicate, musician's hands. A man of much dignity, who never shows a sense of inferiority either by shrinking back or by pushing himself forward."

There were ambivalences at the center of the New Negro Movement which found expression in James Weldon Johnson's thought and word. Mistakenly, many of Johnson's critics perceived the ambivalences as uniquely Johnson's own; in fact, they ran through the community. As Booker Washington's prize recruit, Johnson now headed the organization representing the antithesis of much of the Bookerite legacy. Exposer of American imperialism in Haiti, he had earlier defended the occupation as a benefit to the islanders (just as he would later justify his role in the Nicaraguan revolution as dictated not by "considerations of concessions and loans" but by the Japanese threat of a canal across the isthmus). Like Du Bois, he summoned his people to face the carnage of war stoically and seek justice afterward; unlike Du Bois, he had no faith in the League of Nations. Head of the major civil rights organization, he was opposed to socialism and labor unions, and a mellow convert to laissez-faire capitalism. He was the agnostic author of "The Creation," a 1918 poem of such simple, eloquent religious sentiment as to stir deeply even the most jaded Van Vechten party-goer. He believed, above all, in the power of high-minded men and women to alter events, yet he had deleted the most fiery stanzas from the original version of "Fifty Years" and had written lyrics and verse that capitalized on the "darky" tradition of American letters. The most modern of his *Fifty Years* poems, the symbolic "White Witch," deplored the loss of racial uniqueness through cultural assimilation, yet the hero of *The Autobiography of an Ex-Colored Man* decides to live as white, even though he fears he may have "chosen the lesser part."

But these inconsistencies existed not because Johnson was "root-

less," "marginal" (except in a statistical sense), a racial "hypocrite," or "among Negroes . . . the first modern." Indeed, from the viewpoint of class consciousness, the inconsistencies were either nonexistent or of minimal consequence. "Between people in like stations of life there is very little difference the world over," says the protagonist of Johnson's novel. This was the fundamental credo of his Talented Tenth brothers and sisters—of Fauset, and Charles Johnson, and White, and others—that the assimilated, cultured Afro-Saxon was every whit the equal of his "Nordic" counterpart. To fall away from orthodox religion, to mine the black folk tradition for its barely known riches, and to cheer the marines in the Caribbean and the capitalists at home were not aberrations but the reasonable reflections of genuine convictions of upper middle-class status. Yet the class was part of the race, and the generality of the race was not yet, they conceded, Civic Club material. Hence, the violent tensions in psychology and logic of Johnson and his class as they protested that if they matched the best whites, given the distance travelled and the roadblocks surmounted, it was because they were, in truth, superior human material. In an April 1917 New York *Age* editorial and in an address to the Bordentown, New Jersey, NAACP chapter three years later, Johnson claimed that although the white race excelled in organizing and applying knowledge, "it has never contributed one single element of what goes into modern civilization." For originality in American civilization, one had to look to the African—to his zest for life expressed in music.

Johnson looked to the recent history of the Jews for corroboration. He was awed and inspired by their accomplishments in America. Yet they were made to suffer because they claimed to be a chosen people. The Afro-American had made no such claim, yet he suffered even more because others insisted that he was alien. An alliance with Jews seemed obvious to Johnson, especially after the Leo Frank lynching, and his reasons were as clearheaded as Julius Rosenwald's. Rich and powerful, yet under attack, the Jew might, "in fighting for his own rights, in some degree fight for ours also." Johnson appreciated that American Jews were economically powerful enough to fight back. However, he consistently chose to ignore the economic impotence of Afro-Americans, arguing, as Charles Johnson had and Walter White did, that "the status of the Negro in the United States is more a question of mental attitude toward the race than of actual conditions." For economic power Johnson substituted artistic talent, as though they were independent and equally weighty attributes. His preface to *The*

Book of American Negro Poetry anticipated Locke's preface to *The New Negro* by nearly four years:

The final measure of the greatness of all peoples is the amount and standard of the literature and art they have produced. The world does not know that a people is great until that people produces great literature and art. No people that has produced great literature and art has ever been looked upon by the world as distinctly inferior. . . . And nothing will do more to change the mental attitude and raise his status than a demonstration of intellectual parity by the Negro through the production of literature and art.

Of all The Six, Alain Locke, the Proust of Lenox Avenue, was most controversial. The Howard University professor was fanatic on culture, and by "culture" he meant all that was not common, vulgar, or racially distasteful. "In my judgment," his favorite freshman lecture preached, "the highest intellectual duty is the duty to be cultured." Awed students were counselled to ignore "criticism of exclusiveness, over-selectness, perhaps even the extreme of snobbery. Culture," the professor feared, "will have to plead guilty to a certain degree of this." The Philadelphia Lockes were an old family—"O.P.s" (Old Philadelphians) like Jessie Fauset's. Pliny Locke, Alain's father, had received a law degree, in 1874, in the fourth class to graduate from Howard's law department. The elder Locke became a teacher at the Philadelphia School of Pedagogy and provided a materially adequate and exceedingly Victorian living for his family. One of Alain Locke's earliest memories was of his grandmother hanging clothes on the line in a broad bonnet and long white gloves, lest the summer sun darken her light skin, and turning to scold him for playing outdoors when he was already much too dark. Convinced that he had a bad heart and an unappealing physical appearance, there was little else left to Locke but to win the world's indulgence through intellectual excellence.

He was a brilliant student at Central High School and the School of Pedagogy. At Harvard, he graduated magna cum laude and Phi Beta Kappa in 1907. From Harvard, Locke went to Oxford as the first (and for nearly sixty years the only) Afro-American Rhodes scholar. Academically, he qualified handily, but as Rhodes scholars are also required to be competent athletes, the rules were stretched to allow him recognition as a coxswain. The physical demands of the scholarship were a good deal less heavy than the psychological. A friend from those Oxford days remembered Locke's warmth and ironic humor, his

zest for philosophical debate, but he also perceived that Locke's quick, light step, light laugh, and intense studiousness were part of the armor of a game brown man whose "quiet acceptance of his troubles" was admirable. Asian and African gentlemen of considerable means were regarded as scholastic adornments of empire, and the presence at the two great universities of America's future leaders was surplus confirmation of Great Britain's world primacy. But Alain Leroy Locke fit none of the special categories. White Americans spurned him; the British ignored him. "All this seared," Locke's closest colleague at Howard recalled almost a half century later, "the social discrimination which he suffered at Oxford—but it did not scar." The year at the University of Berlin and the year at the Collège de France were much less unkind. In those five years, this gentleman philosopher had come to see himself as one of the principal trustees of his people's destiny. It was hardly surprising that, as the orthodox Hegelian he prided himself to be, Locke was certain that, however deflected, different, or delayed, the dialectic of cultural progress for the Afro-American would duplicate the European pattern.

When Locke returned to America in 1912, he and Du Bois were among the most scrupulously educated Americans. Had it been possible for a black man to teach in a major university in those days, the twenty-six-year-old philosopher might have applied to his own school, yet, given the circumstances, Howard, Fisk, or Atlanta University was the most to be hoped for. Invariably, his summers were spent in Europe—in Paris and Berlin and the bathing spas. Yet he always seemed to be in Harlem, walking with his quick step and furled umbrella from Hotel Olga along Lenox and Seventh avenues, riding the subway to Downtown meetings and luncheons. He was, as Charles Johnson said, a natural "press agent" for the Harlem Renaissance, on the *qui vive* for talent, a superb disciplinarian, and an elegant and eloquent booster. Young artists and writers suffered fussy imperiousness far more readily from Locke than they would have from others, anecdotally relishing it as part of the professor's nervous but caring hauteur. With him, they were always undergraduates who were made to feel that they must do better than their best. Eric Walrond was typical of those who worried that they might have wasted Locke's time and who constantly apologized for an "inability to do justice to you whenever I am with you." Richard Bruce Nugent, an *enfant terrible* of Washington and Harlem, never lived up to Locke's classroom standards. Wallace Thurman, another literary dissident, never quite made the grade either. Locke knew

what was best for them—even for McKay, whose poem title "White House" the professor prudently altered to "White Houses" in *The New Negro* anthology, despite McKay's shrill protests.

For those deserving high marks, Locke had more to offer than any of The Six because of his position as chamberlain in the Park Avenue court of Charlotte Osgood Mason, an aged, well-preserved white dowager of enormous wealth and influence. So little is known today about Mrs. R. Osgood Mason, née Charlotte Vandervere Quick, that she seems almost a composite of some of the characters in Renaissance fiction—Rudolph Fisher's Agatha Cramp in *The Walls of Jericho* and Langston Hughes's Mrs. Dora Ellsworth in *The Ways of White Folks*. In fact, such was her influence upon those within her circle that several fictional characters were drawn from her formidable personality. Her husband had been a physician, but the origins of her compounded wealth reached back to the early days of the Republic. Chapins and Biddles bustled about the old lady like courtiers, and her penthouse at 399 Park Avenue was so vast as to match, in the imaginations of intimidated artists, the dimensions of an ocean liner. Langston Hughes's second autobiography anonymously described Charlotte Mason, with gentle irony, as "the kind lady who had been my patron." In *Dust Tracks on a Road*, Zora Hurston's autobiography, she was remembered affectionately as "Godmother," the title she insisted Harlem beneficiaries use when speaking of her in whispers. On pain of banishment, Godmother demanded that her subjects never mention her name to others without permission.

Guided by Locke, Harlem's striving artists, singers, and writers ascended to the Park Avenue penthouse, one after another, to be received as votive primitives by the regal husk seated in a large, ornate chair that may have—so bedazzled were they, they were never sure—rested on a platform. Some, like Zora Hurston, played the part of minion with fulsome abandon. The price could seem worth it: Godmother paid well when she was pleased. Langston Hughes was seduced immediately:

In the living room after dinner, high above Park Avenue with the lights of Manhattan shining below us, my hostess asked me about my plans for the future, my hopes, my ambitions, and my dreams. I told her I wanted to write a novel. She told me she would make it possible for me to write that novel. And she did by covering the expenses of my summer, so that I need do no other work during the vacation.

Painting murals at a Harlem club, Aaron Douglas remembered being ordered down from his scaffolding after his repeated refusals to appear at 399 Park Avenue compelled Godmother to motor to Harlem. To his later regret, Douglas became a retainer in Mason's court, frequently compelled to delay and even withdraw from major commissions offending his patron's sense of what was "proper Negro art"—until, at last, Douglas fled to Merion, Pennsylvania, on a fellowship at the new Barnes Foundation. Her power to command could be awesome, but the sense of her own power occasionally bordered on the delusional, as when she wrote Locke from her hospital bed about Marian Anderson: "If I were on my feet I would have obliterated the color line forever by having her asked to appear at the Metropolitan Opera House stage."

"Primitives" had always enchanted Charlotte Mason. At the beginning of the century, she had been fascinated by the American Indian, apparently trekking with Natalie Curtis to the Southwest to help gather materials for Curtis's *The Indians Book* (a treasure kept by Locke next to the urn containing his mother's ashes). Now it was the Afro-Americans' turn. Through her "precious Brown Boy," Rhodes scholar Locke, Godmother intended to discover and preserve all that remained unalloyed by Western civilization in the Afro-American tradition. "Ah, Alain," she urged upon him in her earliest surviving, nearly illegible letter, "live finely, your intelect [sic] is becoming the servant of your soul, and dear Boy, look at the wide doors that it is opening before you!" Great achievements awaited them, provided Locke obeyed her instructions. His "World Anthology of Negro Poetry" (contracted with Boni & Liveright but never completed) would awaken the literate world, she predicted. He need not worry about James Weldon Johnson's anthology plans. She was "determined he shall not make even a shadow across the path" of her Brown Boy. Soon, they would launch "our Harlem museum," a temple to the glories of Africa's past. Meanwhile, though, she wanted to add Jean Toomer to her collection, for Mason was convinced that she had to save Toomer from himself, perceptively alerting her chamberlain that a "flowing spirit like that can burn to ashes the things that push upon him and hide his miraculous power from his own vision." She lamented that Roland Hayes and Paul Robeson were probably already too successful to need her help, but Locke was ordered to offer it. Arthur Huff Fauset, Jessie's anthropologist brother, Hall Johnson, the musician and choirmaster, the young Philadelphians who launched the review *Black Opals*, and Miguel Covarrubias, the Mexican illustrator, accepted her summons. Hurston

eventually transferred her allegiance from Fannie Hurst to Mason, delighting the old lady with ethnic capers and "coon" stories that would have been the envy of Joel Chandler Harris. Louise Thompson, a pert, bright Californian recently arrived in Harlem, accepted employment as personal secretary and assistant to Mrs. Katherine Biddle and Miss Cornelia Chapin. Locke's prize recruits were Hughes and McKay.

Langston Hughes had spent most of 1925 working in Washington, D.C., to support himself, his mother, and his half-brother Gwyn Clark, while waiting vainly for a scholarship to Howard. He hated the humid city, where he contracted "malaria or something or other," and found its Afro-American elite to be pretentious and smugly anti-intellectual. When Amy Spingarn offered to help with tuition and Locke secured what amounted to a blank check from Godmother, the poet felt his life had been saved. Waring Cuney, a young Washington poet, suggested Lincoln University, in Pennsylvania, and Hughes enrolled there in autumn 1926, having in the meantime completed *The Weary Blues*. Mason money also defrayed expenses at a New England preparatory school for half-brother Gwyn, although Godmother was soon complaining, "All I started out to do, Alain, was to pay his board!" But what was money when Langston, her "most precious child," had given the world a volume of poetry, dutifully escorted her to the theatre during vacations, and was earnestly "nourishing flights of his beautiful spirit" in that nice academy in the Pennsylvania woods?

McKay, another "precious child," was one of Locke's stiffest challenges. From their first meeting in Berlin, in May 1923, the Jamaican poet had decided that the philosopher was "a charming, harmless fellow" and a "perfect symbol of the Aframerican rococo." Strolling together in the Tiergarten, McKay gritted his teeth as Locke extolled the statuary depicting Prussian kings and famous composers and philosophers as "the finest ideal and expression of the plastic arts in the world." Later, Locke's refusal to include the poem "Mulatto" in his *Survey Graphic* issue and his tampering with the title of another, changed McKay's opinion. "Jessie Fauset would have shown more courage than you have in this case," he taunted. "You are a dyed-in-the-wool, pussy-footing professor." In letter after blunt letter, Locke was told what a spineless disaster he was. No wonder the New Negro Movement was in such a bad way when "Negro intellectuals like you take such a weak line!" "No wonder Garvey remains strong despite his glaring defects." "I would much prefer if you dropped me out of your contemptible book." In January 1927, after McKay had brooded for

months over his poems in Locke's *The New Negro*, the professor re-
ceived the ultimate condemnation—"every vestige of intellectual and
fraternal understanding that may have existed between us [was de-
stroyed]." But after a few months of righteous silence, he and Locke
were corresponding again, for McKay was always careful not to break
irrevocably with people who could help him. As for Godmother, the
poet accepted her checks gratefully and wrote adoringly, thanking her
for news clippings and renewed magazine subscriptions, and in return
penning vivid descriptions of "primitive" life in North Africa.

Locke's bondage to Charlotte Mason, despite patronizing lectures
and occasional acts of rank tyranny, was more apparent than real. He
walked a tightrope between obsequious accommodation to the old lady
and nervous fidelity to his own beliefs, dissembling masterfully and
taking the cash. His stratagem was to use Mason's money to prove how
like well-bred, intelligent whites well-bred, intelligent Afro-Americans
were. Mason's expectations of her chamberlain were quite different.
"There are so many beautiful things, Alain, that I believe you are
going to be able to do," she predicted, once he was able to "slough off
white culture—using it only to clarify the thoughts that surge in your
being." Treading the sanctioned path, Godmother told him, Locke
would discover that there "is harmony flowing toward you from the
Souls of the Slaves from Africa that listen, quietly waiting in the Be-
yond." Writing learned articles on the influence of Africa in the works
of Picasso, conferring with collector Albert Barnes about Benin sculp-
ture, or searching for bargains for his African museum project brought
the cosmopolitan professor as close as he would come to the souls of
slaves. The last thing Locke could or would have done would have
been to "slough off white culture." One of his best gambits to turn his
patron's interests to his and the race's respectable advantage was the
plan for the Negro Art Institute, a more artistically oriented successor
to the defunct American Negro Academy founded in 1897. The idea
for the institute had been Walter White's, but Locke, as well as James
Weldon Johnson, enthusiastically embraced it, preparing most of the
paper work submitted to the Garland Fund for support. After rejection
by the foundation, however, Locke proposed it to Charlotte Mason,
rightly supposing that his patron would rejoice at the prospect of up-
staging Mrs. Payne Whitney, who promoted artists but was a disap-
pointment "when it comes to buying"; though Mason dropped the idea.

Mason's obsession with primitive purity constantly erupted in
remonstrances to her oldest child. The true Alain might never be born,

she feared. By the time he and other gifted Afro-Americans "finished running their inheritance on this slippery pond of civilization, there will not be any place where the white man has not divided the spoils of primitive African art, African music, all Africa's strengths." She was worried that Locke might not fully grasp that Western civilization was "already in the throes of death." If she and Locke failed in their mission, it would drag Africa down. Afro-Americans like Charles Johnson, James Weldon Johnson, and W. E. B. Du Bois were their own worst enemies, "holding so fast to the coat tails" of the moribund white world. Roland Hayes had ruined his gift by "whitening" his repertoire; the young sculptor Richmond Barthé had left his Chicago studio for the blandishments of Manhattan; Wallace Thurman had become a literary prostitute. Locke nodded agreement, yet managed to win a successful audience for Barthé. Barthé went on Godmother's payroll. " 'You don't know just how much I enjoyed my visit,' " Locke quoted the sculptor. " 'She told me such inspiring stories.' " The chamberlain was probably alternately amused and bored stiff by Mason's nostrums; and he was frankly irritated by the old lady's anti-Semitism, going so far as to remind her once that Afro-Americans suffered because of similar prejudices.

Worthwhile causes had a price. At Bad Nauheim, Germany, and in Carlsbad, Czechoslovakia, his expenses paid by Charlotte Mason, Alain Leroy Locke must have reflected on his pleasant servitude. Then he may have consoled himself with the thought that, with the exception of Casper Holstein, none of The Six could dispense the dollars he could.

6

Nigger Heaven

The mid-twenties solidified the Harlem Renaissance. Most of the signs of the times were enormously encouraging. Where arts and letters had been mainly supported by the Urban League and the NAACP, there now sprang up a number of prizes and fellowships officially sponsored by white benefactors, businesses, and foundations. Where Harlem had conducted its interracial activities sparingly and somewhat primly under the patronage of such socialites as A'Lelia Walker, Jessie Fauset, and others, the community now began to reciprocate the generosity of Downtown hosts and hostesses, party for wicked and bleary party. Where, only a few years before, Harlem's popular music had been held in low esteem by the established band leaders, its clubs were now rapidly becoming laboratories of a new type of jazz, attracting even the great jazz masters of New Orleans and Chicago as well as hordes of excited, uninstructed whites. And there was now an explosion of books, plays, and musicals about Afro-Americans.

Whatever the rival claims of Boston, Philadelphia, or Washington, Harlem took for granted that the intellectual center of Afro-America was located above Central Park. But the assertive dignity of the New Negro Movement was evident throughout America (its political and economic manifestations were probably greatest in Chicago). In just about every good-sized city, earnest little bands of part-time Afro-American culture-nurturers (usually, though not always, heavily represented by prim, light-complexioned wives of striving doctors, lawyers, preachers, and teachers) drew up bylaws, politely heard one another's book reports, and, if truly ambitious, tithed themselves to underwrite a literary publication. In Boston, the Quill Club launched the *Saturday*

Evening Quill. In Philadelphia, the literati published *Black Opals*, one of the most promising of the Afro-American little reviews of the early twenties. In Cleveland, the literary club benefitted from the presence of Charles Chesnutt and his daughter Helen. Many of these literary societies were far more social than literary, and about as exciting as a bridge club; a few, like Georgia Douglas Johnson's Saturday Nighters, were almost as lively as Mabel Dodge's early salon. Yet for guidance and goals, Afro-America now looked to Harlem. When Langston Hughes punctured the cultural pretension of Washington in *Opportunity*, the huffy rebuttal of one of the Washington intellectuals merely succeeded in making Harlem appear more attractive.

Overcrowded, vulgar, and wicked, Harlem was Afro-America's Paris. Beginning in 1925, the values of its intellectuals began to impose themselves in the citadels of Afro-American higher education. These were not the values of what had once been the dominant Booker Washington school; they represented a heady reassertion of the liberal arts ideal—updated. Men like Kelly Miller and Archibald Grimké of Washington and William Monroe Trotter of Boston had never abandoned deep beliefs in the superior value of liberal arts education—education for gentlemen leaders, with Greek, Latin, and modern languages, history, literature, and moral philosophy as indispensable elements. A quarter century earlier, Du Bois, their most powerful spokesman, had expatiated on the subject in *The Souls of Black Folk*:

And finally, beyond all this, it must develop men. Above our modern socialism, and out of the worship of the mass, must persist and evolve that higher individualism which the centres of culture protect; there must come a loftier respect for the sovereign human soul that seeks to know itself and the world about it; that seeks a freedom for expansion and self-development; that will love and hate and labor in its own way, untrammeled alike by old and new.

Education for progress was the ideal that united the Talented Tenth, transcending divisions of personality, politics, and ideology. All else failing—exercise of ballot, protection under the law, inclusion in labor unions and professional bodies—it was the rare Afro-American bourgeois who faltered in his faith in higher education.

For this small number of persons, conditions did seem to be improving. They were so few across the land that they could be numbered in the thousands. There were 2,132 Afro-Americans in college in 1917.

Ten years later, there were 13,580. Only 200 or 300 of these were in white schools. By 1927, 39 had won doctorates. In all, there had been 105 Phi Beta Kappas. When Carter Woodson wrote *The Negro Professional Man and the Community*, he placed the number of Afro-Americans in professions at 135,964, out of a total population of 11,891,000. But the cream of the professions—dentistry, medicine, law, college teaching and administration, banking, and commerce—populated the head of a pin along with statistically invisible architecture, engineering, and science. There were 1,748 Afro-American doctors, 1,230 lawyers, and 2,131 academics and administrators. In one way or another, most Harlem artists were products of the 10,000 privileged Afro-Americans—the miraculous .01 percent—who awoke every morning with the conviction that their particular reveries would merge with the national dream of ethnic advancement. Surely for them, the cachet of Harvard or Howard was not unattainable. Yet, now that the second generation born out of slavery stood ready to avail itself of the advantages of higher education, white schools were threatening to bar their doors, while Afro-America's own colleges were sliding into the bog of vocational training in either servile or obsolescent trades.

The first chairman of the Rockefeller-backed General Education Board had argued the necessity of protecting the Afro-American from "so-called higher education" so that he "should not be educated beyond his environment." Booker Washington had concurred, regretting that in the past "men have tried to use, with these simple people just freed from slavery and with no past, no inherited traditions of learning, the same methods of education which they have used in New England." Thus, while the endowments of vocational Hampton and Tuskegee institutes ballooned until they were among the richest schools in America (by 1925, Hampton ranked seventeenth in the country with an endowment of $8.5 million), the three outstanding Afro-American liberal arts colleges—Atlanta, Fisk, and Lincoln—were reduced to pittances by the Carnegie, Jeanes, Phelps-Stokes, and Slater foundations, and the General Education Board. Fisk limped along, but Atlanta University, defiantly maintaining integrated faculty and dining facilities, and Lincoln University in rural Pennsylvania (forfeiting a $200,000 bequest rather than water its curriculum with bricklaying, carpentry, and agriculture) suffered crippling poverty. When in 1916 the United States Bureau of Education and the Phelps-Stokes Fund issued a joint 724-page definitive report on Afro-American higher education, ordaining vocational instruction as paramount and deploring

the academic curricula disapproved of by the white South, matters seemed beyond hope. Booker Washington's death and the war slowed the implementation of this anti–liberal arts policy.

When the war was over, the Talented Tenth began its counterattack, led by Du Bois, the two Grimké brothers, Archibald and Francis, Alain Locke, Kelly Miller, and a few others. In 1922, when President Lawrence Lowell of Harvard imposed both a Jewish quota and a ban on Afro-American dormitory residency, he was compelled in short order by Negrotarian alumni to rescind the dormitory ban. *The New Republic* and *The Nation* supposed there might be good reasons to limit Jews at Harvard: "Ten Jews to the hundred might assimilate. But twenty or thirty—no." But Afro-Saxons like Edward Jordain, Jr., world champion broad jumper; Pritchett Klugh, son of a noted Boston clergyman; Edward Wilson, second-generation Harvard; and Roscoe Conkling Bruce, Jr., son of a Harvard honors graduate and grandson of a United States senator, were certified as honorary WASPs; 145 alumni signed a petition circulated by Moorfield Storey, Lewis Gannett, and Robert Benchley, friends of Harvard men Du Bois and Locke. (It was a poor reflection upon them that Afro-American leaders had little to say about the Jewish quota, which remained in place.) Several months later, Columbia University students burned a cross in front of Furnald Hall to force one Frederick Wells to move. *The Messenger* was relieved to report that Columbia's dean applauded Wells's decision to keep his room.

Harvard and Columbia having been secured, the battle for Atlanta, Fisk, Howard, and Lincoln was launched in the mid-twenties. Atlanta University was destined to be "saved" by the General Education Board plan to make it a graduate institution serviced by local colleges with academic and social programs more in tune with white southern philosophy. Year after year, the thirty-odd Afro-American private colleges had become more like Hampton and Tuskegee—academies, Du Bois complained, designed by "rich and intelligent people, and particularly . . . those who masquerade as the Negroes' friends . . . to educate a race of scullions and then complain of their lack of ability." When Paul Cravath, president of Fisk's board of trustees and head of New York's most prestigious law firm, declared "complete separation" as the "only solution to the Negro problem," the challenge had to be met. "Yesterday, Fisk had a president," Du Bois lamented in *The Crisis*, as his college compromised its principles to raise the largest endowment. "Tomorrow, she will have a million dollars." He attacked conditions at

Fisk in his 1924 alumni address and after the student strikes the following January wrote one of his most uncompromising editorials. It was intolerable, he said, that foundation money should make "intelligent, free, self-respecting manhood and frank honest criticism increasingly difficult among us." Anyone brave enough to speak the truth, expose incompetency, or rebel against injustice was greeted by a chorus of " 'Sh! You're opposing the General Education Board!' 'Hush! You're making enemies in the Rockefeller Foundation!' 'Keep still! or the Phelps-Stokes Fund will get you!' " As it turned out, it was the students who got Fisk's white president, forcing his resignation, abolition of the disciplinary code, ending of segregated concerts by the glee club and famous Jubilee Singers, restoration of student government, and return of the *Herald*, oldest of the Afro-American campus literary publications.

At Howard University—the only university with graduate professional schools—most of the faculty was Afro-American (unlike Atlanta, Fisk, and Lincoln) and the triumvirate of "black deans" formed a countervailing power to the unbroken succession of white presidents. Nevertheless, the margin of institutional independence was as narrow as the racial tolerance of a Mississippi congressman—the likes of whom annually held Howard's unique federal appropriation hostage to good behavior. With Fisk's example before them and Du Bois's editorials read in offices and dormitories, Howard faculty and student good behavior began to stray from accepted paths. President Stanley Durkee, after a good beginning, had grown arbitrary and haughty. His new master plan for the university reeked of power politics (its victims called it racist). Alain Locke, for his courage in representing the grievances of the faculty salary committee, was temporarily fired in spring 1925. Compulsory daily chapel, with an unvarying diet of psalm-reading and spirituals, and stiffening of ROTC requirements, finally caused a student boycott. In March 1926, Howard's trustees allowed the muscle-minded president to resign to take up a New England pastorate. Howard's first Afro-American president, Mordecai Johnson, succeeded him.

Lincoln, the oldest of the schools (it was founded in 1859), was next. President, administrators, faculty—all were white at this Presbyterian college. Some alumni, like trustee Reverend Francis Grimké, were weary of the arrangement, but undergraduate Langston Hughes discovered, as late as 1929, that "sixty-three percent of the members of the upper classes favor for their college a faculty on which there are no

Negro professors." But even Lincoln's comparatively well-to-do students objected when the presidency was offered to a Philadelphia minister who had defended the right of the Ku Klux Klan to assemble in the City of Brotherly Love. Throughout 1926, the college was in turmoil until, on the fourth try, a white faculty member was successfully chosen as the least divisive candidate.

When student unrest reached Hampton in the autumn of 1927, the foundations and trustee boards could no longer ignore the earthquake. Four times richer in endowment than William and Mary—richer even than Jefferson's University of Virginia—Hampton made its peace with the Old Dominion by creative obsequiousness. Its white trustees and principal were proud of a tradition by which, through example and text, Christian patience and Puritan industry had been faithfully inculcated. It was their special pride that Booker Washington had gone forth as the founder's star pupil, to spread the message that work makes free. Eventually, however, it was Hampton's overly strict rules to "protect" students from themselves that proved too painful—chaperonage on campus, spies in dormitories, a lighted cinema to prevent necking, compulsory Sunday evening chapel to serenade white visitors (housed in a segregated hostel) with plantation songs. On Sunday, October 9, while the governor of the Gold Coast and an official of the Jeanes Fund awaited Professor Nathaniel Dett's choir, the students launched a boycott that closed Hampton until the second semester. Supported by a majority of the parents and trustees, Principal Gregg and most of Hampton's policies survived. Its brightest and most combative students were expelled. The Hampton strike, incidentally, drove attractive, brilliant Louise Thompson from her faculty post to Harlem and a deep, lasting friendship with Langston Hughes.

Writing in *The Messenger*, Asa Randolph saluted the events at Fisk and Howard. "A new Negro student has arisen," he proclaimed. "He breathes the spirit of independence and revolt against oppression." As usual, Du Bois summed up best the meaning of the college turbulence. The foundations had the power and the wealth, "but, glory to God, we still own our own souls." Fighting for their souls, they won the battle for their minds. Overturning monastic regulations imposed to thwart the irrepressible sexuality by which white presidents and deans believed them possessed, reforming curricula designed to train them for menial or outmoded livelihoods and righteous suffering, and winning student government and press rights, Afro-America's young men and women created an institutional base and a reservoir for the Harlem Renais-

sance. If there was no direct connection between college rebellion and the young Afro-Americans who later became painters, poets, or writers in New York and Paris, there was, nonetheless, a definite connection of situation and psychology. Harlem's lure of glamor, success, and unconventionality had an increasing effect in the new campus environment of flourishing literary magazines and Langston Hughes poetry readings. At Fisk, where Du Bois was revered as a god, alumnus Roland Hayes was a superstar. At Howard, where Ernest Just (the future discoverer of plasma) was a figure larger than life, medical student Rudolph Fisher admired Locke and put his talent into medical studies and his genius into literature.

By contrast, as Afro-America captured its own centers of higher learning, Harlem's exciting reputation had sparked a white invasion. When the *Herald Tribune* announced the Harlem Renaissance a few days after the first *Opportunity* Literary Contest Awards Dinner in May 1925, the newspaper also speculated about what might happen to a " 'Nordic' stock, so bustling and busy" as sometimes to forget about feelings if touched by an African "love of color, warmth, rhythm, and the whole of sensuous life." It would be "one of fate's quaint but by no means impossible revenges if the Negro's real contribution to American life should be in the field of art." Sophisticated white fascination with the Afro-American would run wild in the summer of 1925—even in the Deep South. In South Carolina, two writers of purest antebellum lineage, Julia Peterkin and DuBose Heyward, were rediscovering their ancestors' bondsmen with empathetic power rarely achieved since the days of George Washington Cable. At the University of North Carolina, Paul Green was striking naturalist chords that would make him one of the most respected playwrights of the genre. In the North, the director Raymond O'Neil and Mrs. Sherwood Anderson had brought their Ethiopian Art Players first to Harlem and then to Broadway from Chicago. Despite the professionalism of the Players and inclusion in their repertoire of Willis Richardson's *The Chip Woman's Fortune*—the first serious drama by an Afro-American—neither Harlem nor Broadway was ready, in 1924, for Shakespeare in modern dress accompanied by jazz. But Afro-American unorthodoxy worked for Eugene O'Neill. While the Ethiopian Art Players were foundering, the Provincetown Players survived a raucous New York controversy to present Paul Robeson in *All God's Chillun Got Wings*. More remarkable, in summer of 1925, the Afro-American press could report Al Jolson's efforts to obtain

Broadway financing for Garland Anderson's *Appearances* ("the clean-
est play ever staged in New York"), the work of a San Francisco
bellhop.

Then came the breakthroughs in serious music. When tenor Roland
Hayes sang the final encore of his December 1923 Town Hall con-
cert of lieder and spirituals, Mary White Ovington saw it as a turn-
ing point comparable to the triumph of the Fisk Jubilee Singers fifty
years before: "There will never be another concert like that first one at
Town Hall. . . . The voice showed us the suffering of man's spirit upon
the cross." Herbert Seligman agreed, writing in *Opportunity*, "One
song of Roland Hayes makes all the world kin." Sixty-eight concerts
and fifty-four cities later, much of mankind concurred. On April 21,
1924, Jules Bledsoe, then still a Columbia medical student, sang Han-
del, Bach, Purcell, and Brahms in Aeolian Hall. The New York *Sun*
music critic admired Bledsoe's rich baritone but marvelled even more
at his delivery and multilingual prowess, "which did not betray any of
the idiosyncrasies usually associated with Afro-American singing."
Now that Roland Hayes had taken spirituals into the concert hall,
cultured Afro-Americans were suddenly as pleased as southern plant-
ers to hear them again. In 1925, Harlem violinist Hall Johnson or-
ganized his choir to "preserve the integrity of the Negro spiritual."
Like Hayes, Johnson's idea of "integrity" was so refined that his white
radio listeners generally believed the Hall Johnson Choir was white.
Then, in the midst of a New York Stravinsky imbroglio almost as fierce
as the Paris explosion eleven years earlier, the "First American Jazz
Concert" was performed at Aeolian Hall on February 12, 1924. With
tempers at hair-trigger because of *Le Sacre du Printemps*, New York
critics were unready for more innovation. Victor Herbert's *Four Ser-
enades* received an ovation, but Olin Downes of *The New York Times*,
in describing *Livery Stable Blues* as a "glorious piece of impudence,"
was thought exceedingly generous. And exceedingly kind to a young
pianist who "stepped upon the stage sheepishly" and exhibited "extraor-
dinary talent" in his struggle "with a form of which he is not yet
master." George Gershwin's *Rhapsody in Blue*, like Stravinsky's *Sacre
du Printemps*, was far ahead of its public.

Until the playhouse and concert hall guided white traffic above Cen-
tral Park, the New York and national press had deigned to mention
Harlem merely to insult, alarm, or ridicule—squibs about primitive
hygiene, grisly homicides, religious aberrations. Although about 30
percent of Harlem was still white, few alien whites ventured above

125th Street during the early twenties, and the overwhelming majority
of Afro-Americans were content to live without their company. Charles
Johnson wanted whites in the parlors of the Talented Tenth, of course,
and had been recruiting them for many months with the help of Eric
Walrond. A presence in Greenwich Village artistic circles, Walrond,
who called Harlem "a sociological El Dorado," was an ideal tour
guide. "He was always bringing someone to Harlem," Ethel Nance
recalled, "or if people wanted to come they would say, 'Get in touch
with Walrond and he'll see that you meet interesting people.'"

But Harlem would never have been on white New York's extra-
curricular itinerary had it not been for the Broadway musical. Middle-
class Afro-Americans were ambivalent about these almost exclusively
white-produced musicals of black life. After seeing *Dixie to Broadway*
in December 1924, Walter White lectured Florence Mills about its
excessive "vulgarity" and "stereotyping." Still, that Plantation Club
review was the first "integrated" musical in years, with Gershwin mel-
odies (including "Lady Be Good") and dancing by the Astaires in the
first half, and the second half featuring Florence Mills and dancing so
kinetic that *World* columnist Heywood Broun found "certain reserva-
tions in the theory of white supremacy." Sissle and Blake's winning
Chocolate Dandies, with Inez Clough, Johnny Hudgins, and Josephine
Baker, was indifferently reviewed for *Opportunity* by Walrond as "dull
and tiresome." "Setting out (it is obvious) to cater to the jaded desires
of the white comedy lovers," Sissle and Blake had created something
"that didn't seem like a colored show at all." Whatever their shortcom-
ings, the musicals sent more and more whites from the theatre Uptown
to Lenox and Seventh avenues.

Then came *Lulu Belle* in February of 1926, a melodrama of Harlem
street life produced by David Belasco, written by Edward Sheldon and
Charles MacArthur, and starring Lenore Ulric in blackface along with
several real Afro-Americans (Edna Thomas, as white as Ulric, made
her Broadway debut). If the sociology of vogues teaches that single
events have complex antecedents, it was, with this qualification, *Lulu
Belle* that sent whites straight to Harlem in unprecedented numbers for
a taste of the real thing. Their arrival was so sudden that Harlem had
to gallop in order to live up to expectations. As late as February 1926,
Variety's reporter was disappointed, writing that he knew "twenty
white night clubs within the Times Square precincts, any one of them
wilder at four in the morning than all the combined cabarets or black
and tans of Harlem." Demand would solve the supply problem in short

order. Soon Charles Johnson would share Walrond's lament that Harlem was becoming "a white man's house of assignation." Overnight, there was a real danger that in the stampede to the exotic and forbidden, Harlem's intellectual and artistic elite would be crushed by frantically stimulated whites. The transformation was so abrupt, so ubiquitous, that when the physician-novelist Rudolph Fisher returned to New York from Washington, he wandered among his old cabaret haunts exclaiming, "What a lot of fays [whites]!" Fisher was even moved to write an article about the changes for *American Mercury*, "The Caucasian Storms Harlem." "The best of Harlem's black cabarets have changed their names and turned white."

When Sir Osbert Sitwell arrived in New York, late in 1926, America was strenuously observing Prohibition by staying sempiternally and gloriously drunk. "Love of liberty made it almost a duty to drink more than was wise," he noted, and remarked that at some of the best addresses it was not unusual after a party to see young men "stacked in the hall ready for delivery at home by taxicab." No one was sober, and everybody seemed to be as rich as Croesus. "Never," he believed, "have so many rich people been crowded together in so minute a space." Riches without end, it seemed to the Englishman. "The torrent of prosperity swept on. Colored people offered hospitality as much as white," and, to Sitwell's astonishment, the ostentation of Park Avenue extended to Harlem. After high jinks at financier George Moore's penthouse and ducal diversions at Mrs. Cornelius Vanderbilt's Fifth Avenue château, Sir Osbert—probably escorted by Carl Van Vechten—found himself at A'Lelia Walker's. The mansion at 108–110 West 136th Street was only one of Harlem's imposing addresses. Stanford White's turn-of-the-century Italianate houses under the trees of 138th and 139th streets—Shrivers' Row—were architectural masterpieces and addresses of distinction. Afro-American bandleaders and dentists, prizefighters and surgeons had almost entirely displaced original white residents, but the new owners were not millionaires. A'Lelia Walker herself was, and the twin brownstones flaunted their mistress's wealth from the marble entrance hall and French rooms done in gold and buff to the Aubusson carpets beneath Louis XVI furniture.

A'Lelia—A'Lelia Walker Robinson Wilson, for she had acquired and rapidly shed two husbands—had been left by her mother the controlling interest in a hair-straightening empire, a palace—Villa Lewaro—at Irvington-on-Hudson, considerable amounts of rental property in

and outside New York, the 136th Street brownstones (with the Walker beauty culture salon at ground level), and nearly a million dollars in cash. Not long after her mother's death, in 1919, she had purchased an apartment at 80 Edgecombe Avenue, a combination retreat and pleasure lair, which she preferred to the 136th Street address or to the Hudson estate. A'Lelia was not beautiful—certainly not by the color-dominated standards of the day—but she managed, by carriage and dress (erect, tall, riding crop often in hand, and bejewelled turbans) to appear striking always. Her intellectual powers were slight. After seven minutes, conversation went precipitously downhill, but those first seven minutes were usually quite creditable. She was, testimony reveals, somewhat blunt (though never vulgar). She received most of the Harlem artists and sent them congratulatory notes, but spent the Renaissance playing bridge.

Not everybody pined for an invitation to her brownstones and her country place. Grace Nail Johnson, the wife of James Weldon Johnson and "social dictator" of Harlem, would as soon have done the Black Bottom on Lenox Avenue as cross A'Lelia's threshold. According to Richard Bruce Nugent, who knew her as well as he understood the rigidity of Afro-America's class lines, A'Lelia "had made her bid for space on the upper rungs of the sepia social ladder, a bid which had been cruelly rejected by the securely familied 'lily-whites' of Washington, Philadelphia, Boston, and points South, East, and North." Even those who came gladly to her Harlem soirées and Hudson weekends—Du Bois, Cullen, Hughes, White—were secretly amused by the "Mahogany Millionairess," the "dekink heiress," whose money came from a formula to make Negro hair more like Caucasian.

A'Lelia was the classic poor little rich girl, surrounded by parasites, jesters, and well-meaning courtiers, none of whom ever quite reconciled her fully either to what she did or did not have. Her parties were attended by English Rothschilds, French princesses, Russian grand dukes, members of New York's social register and the stock exchange, Harlem luminaries, Prohibition and gambling nobility, and a fair number of nattily attired employees of the U.S. Post Office and the Pullman Corporation. The party at which whites were seated apart and served chitterlings and bathtub gin and the blacks caviar and champagne was famous in New York society legend. On one notable occasion, a distinguished personage thrust through the mass of revellers to announce that the crown prince of Sweden, his master, was outside, unable to enter because of the press of celebrators. That was a shame, A'Lelia

agreed, and ordered one of her servants to give the equerry a bottle of champagne to take to the crown prince. The evening Osbert Sitwell arrived was equally frenetic. He shook hands with someone who may very likely have been Du Bois, admired the luxury of the room—"a tent room, carried out in the Parisian style of the Second Empire"— and was whisked upstairs to witness A'Lelia peeling off her shoes, groaning about the incompatibility of new shoes and new husbands, and commanding the uncorking of two bottles of champagne. Downstairs, one of her nieces grilled Sitwell's friend, Dick Wyndham, as they danced. "Excuse my asking, but are you high-class?" When Wyndham spluttered that he probably was, the niece explained that she was much relieved—she had no color prejudice, but she did "think the classes oughtn't to mingle."

It was an accurate reflection of changing priorities that when Madame C. J. Walker, A'Lelia's mother, found time to offer her wealth to the struggles of her race, it had been through politics and Christian philanthropy. Not A'Lelia. There were no prizes offered in her name at annual *Crisis* and *Opportunity* awards dinners, nor did the Madame C. J. Walker & Company, more competitive than ever with its new million-dollar Indianapolis plant, support such contests. Perhaps F. B. Ransome, Madame Walker's business manager and now the spirit of the company, thought it sufficient to advertise generously in the organs of the NAACP and the Urban League. A'Lelia spent lavishly at Manhattan couturiers and jewellers and motorcar dealerships. Her generosity was legendary: to the circle of handsome women attending her—Edna Thomas, Mayme White, Mae Fane, and others—to the effete men like Caska Bonds and Edward Perry who organized her socials, and to her retinue of domestics. But to the intellectuals and artists of Harlem she opened her houses and almost never her purse.

Yet if she gave infinitely less from her bank account than did Charlotte Osgood Mason, and seemed less than literate when compared to the women at 580, majestic A'Lelia turned in an impressive performance as Harlem's principal salon-keeper, doing for the Renaissance what Mabel Dodge had done before the war for the artists and intellectuals of Greenwich Village. For some reason, she was never comfortable at Villa Lewaro, but when the cause required it, she uncomplainingly repaired to Irvington-on-Hudson to act as hostess. Walter White handed visiting writers Rebecca West and Konrad Bercovici over to her for a weekend at Lewaro. Sometimes, however, when her patience or good will was taxed, there was a note of displea-

sure: she appreciated Bercovici's book and his "kind remarks in refer-
ence to me, still, I don't think he has been quite truthful, especially in
his article of Harlem. He drew a colorful description, but not truthful."
For the sake of interracial harmony and her own social whims, A'Lelia
passed years of weekends in the thirty-four-room palace with the Hep-
plewhite dining suite under frescoed dining room ceiling, the golden
grand piano and gold-plated organ (piping music throughout the man-
sion), the small wood-encased library (containing, among some six
hundred unread volumes, a fifteen-thousand-dollar, limited ten-volume
set of great operas with introduction by Verdi), the chapel, and the
large garden pool bordered by statuary.

Arriving by train or motorcar on a Friday evening or Saturday
morning, dressing to the nines and descending the white marble stair-
case to flow with the swirl of guests from Europe, Harlem, the Village,
and points west, conversing with noted celebrities in the marble ball-
room, drinking and dining on a gargantuan scale (A'Lelia loved doing
both)—a guest at a gala weekend could not have found the Villa
Lewaro easily excelled for luxury, variety, and stimulation by the great
mansions along the Hudson. Like Mabel Dodge, who had the good
sense to say no more than necessary at her Village Wednesday nights,
A'Lelia rarely imposed herself on the brilliant people who did so much
to enhance her fame and the enviable reputation of her parties. She
had the invitations sent, ordered the bottles uncapped and uncorked,
mingled briefly, then retreated to play bridge, leaving the chemistry of
the evening to work its way. In one subtle respect, though, her immedi-
ate influence was significant. She was especially fond of homosexuals,
and those Harlemites who might otherwise have voiced disapproval of
manners and pursuits considered strange or decadent learned to guard
their tongues if they desired A'Lelia's good will.

A'Lelia had decided to go in for culture in a big way in the fall of
1927. "She saw a real need for a place, a sufficiently sympathetic
place," Richard Bruce Nugent recalls, where artists "could meet and
discuss their plans and arts, to which they could bring their friends and
at which they could eat for prices within their very limited reach."
Gathering several of the artists and littérateurs at the Edgecombe Ave-
nue apartment, she proposed that her 136th Street address be con-
verted into such a place. After a few more cocktails and plates of
spaghetti, it was agreed that Aaron Douglas and Nugent would deco-
rate the room. Nugent suggested calling it "The Dark Tower," after

Cullen's column. To sustain the Dark Tower, a group of fifty affluent subscribers—lovers of the arts—was to be organized.

It was an absolutely thrilling idea to a "breed of chiselers," Nugent said. Neither he nor Douglas decorated the room, as it turned out. The artists' meetings were disrupted by a surcharge of temperament and muddled by too much of A'Lelia's bonded gin. Finally, their bene-factress lost patience and had the room done by Manhattan decorator Paul Frankel. The gold French wallpaper contrasted strikingly but not discordantly with the huge, modern bookcase and red chairs and ta-bles. On one wall hung the framed text of "The Dark Tower," on the opposite, Hughes's "The Weary Blues." But when it finally opened in early 1928, the heiress had modified her original idea. In place of squabbling, freeloading artists and writers, there were present mainly the rich, the prominent, and the striving. Nugent, the most bohemian of the lot (he arrived without tie or socks), recorded the shock of the occasion:

Those engraved invitations should have warned them. . . . The large house was lighted brilliantly. There was an air of formality which almost intimi-dated them as singly and in pairs they arrived. . . . The great room and hall was a seething picture of well-dressed people. Everyone had worn evening clothes. One of the artists was nearly refused admission because he had come with open collar and worn no cravat, but some one already inside fortunately recognized him and he was rescued. . . . Colored faces were at a premium, the place was filled to overflowing with whites from downtown who had come up expecting that this was a new and hot night club.

Prices were staggering, too: coffee ten cents, sandwiches fifty, and lemonade twenty-five. The artists "left hungry."

For all its vivid decor and myriad amusements, the Dark Tower was not a hot new nightspot, however much, on occasion, it resembled the new Savoy Ballroom at Lenox Avenue between 140th and 141st streets. Although the Dark Tower and the Savoy belonged to two different cultural universes, they were also two versions of the same phenomenon—the upsurge of Afro-American self-confidence and creativity. Quarrelling bitterly among themselves about the right road to deliverance, Garveyites, neo-Bookerites, socialists, utopian cultists, and all manner of integrationists shared in equal measure what might

be called Harlem nationalism—the emotional certainty that the very
dynamism of the "World's Greatest Negro Metropolis" was somehow a
guarantee of ultimate racial victory. To a remarkable degree that col-
lective optimism touched everyone—the humble cleaning woman, the
illiterate janitor, and even the criminal element. Nowhere else in
America were ordinary people as aware of the doings of their artists
and actors, composers and musicians, painters and poets, sculptors and
singers, and its literary and academic writers than in the Harlem of the
mid- and late twenties. Newspapers, periodicals, and civil rights month-
lies showered readers with every possible item of cultural gossip and
success, much of it as overblown as it was unanalytical. Street corner
orators interpolated political harangues with news of Claude McKay's
wanderings, Zora Hurston's anthropological junkets, or Walter White's
Guggenheim fellowship. Essentially, this amounted to mere scorekeep-
ing and partook of the same fascination experienced by countless
Harlemites over the weekly numbers jackpot. To many ordinary folk,
it was all the same—some people won fame and money by the magic of
letters and sounds, others by the magic of numbers.

A'Lelia's was the social forum for the elite; the Savoy was every-
body's forum. The March 12, 1926, opening of the Savoy shook Amer-
ica as profoundly in its own way as the 1913 Armory Show had turned
the world of mainstream art inside out. Architecturally, the Savoy
dazzled with a spacious lobby framing a huge, cut-glass chandelier and
marble staircase, an orange and blue dance hall with soda fountain,
tables, and heavy carpeting covering half its area, the remainder a
burnished dance floor 250 feet by 50 feet with two bandstands and a
disappearing stage at the end. Four thousand people could be enter-
tained at one showing—two thousand fewer than the Rockland Palace
(the old Manhattan Casino) but many more than the half-dozen other
competitors. Jay Fagan and the Gale (Galewski) brothers, the pro-
moters and backers, spent more than $200,000 on the block-long
building. It was worthy of Harlem, and neither the Alhambra nor the
Renaissance regularly evoked as much pure joy from Harlemites as
when "stompin' at the Savoy." Opening night was pandemonium.
"You will be bombarded with a barrage of the most electrifying spasms
of entertainment ever assembled under one roof," the publicity prom-
ised. The hour of delirium came after the crowd had been revved up by
Fess Williams's Royal Flushers, the Charleston Bearcats, and Eddie
Rector's band. At 1:30, Fletcher Henderson's Rainbow Orchestra ar-
rived to a standing ovation (its gig at the Manhattan Casino had just

ended) and when its wiry little conductor eventually led the men
through the finale, the brand-new building seemed to shift on its
foundations.

Fletcher Henderson was New York jazz in the flesh, and New York
jazz—however derivative, polished, commercialized—was soon to be
the dominant school as far as the record-buying, radio-listening public
was concerned. New York jazz was big-band music, with its roots in
the showy, fast-paced one-hundred- and even two-hundred-man or-
chestras of Jim Europe's Clef Club. Hundreds of Clef Club and 369th
Infantry Regiment musicians were now the leavening of any musical
effort. The dispute that once raged among aficionados and musicolo-
gists about whether Fletcher Henderson was a pioneer of "hot" jazz or
simply the most accomplished of the "sweet" jazzmen is now eased by
the balm of perspective. He was both. In the late twenties, when his
bands were among the most sought-after in the country and he was too
successful—or too unhinged from an automobile accident—to care
much, Henderson's arrangements became jumpier and just a bit
sticky. The line between his music and Paul Whiteman's (to whom he
lost some of his best players) grew thinner as Henderson began to imi-
tate himself, and Whiteman's imitations of the best of Henderson as-
sumed a life of their own. The best of Henderson, though, was just shy
of being truly innovative—as with his brilliant reworking of King
Oliver's "Dippermouth Blues" into "Sugar Foot Stomp," first recorded
in May 1925 and the classic model of the New York style. Whether he
was at his peak or simply stringing along on sound, the swing that would
become the trademark of Artie Shaw and Benny Goodman was there all
along in Henderson's arrangements.

The real jazz was still on Chicago's South Side, at places like the
Apex Club (where Maurice Ravel's mouth "dropped open" under
Mezz Mezzrow's all-seeing eye), the Deluxe Café and the Pekin Inn
(where King Oliver and Freddie Keppard's Original New Orleans
Creole Jazz Band performed), the Dreamland and the Lincoln, Schil-
ler's (where cornetist Bobby Williams "almost blew Satchmo out into
the street"), and the Vendôme (where Louis "Satchmo" Armstrong
tamed Freddie Keppard before every jazz musician in Chicago), and
other joints, clubs, and music halls where exiled New Orleans had
created a greater Storyville. Preparing his essay for the Carnegie-Myrdal
Study, the young poet Sterling Brown would write of the "great days
for jazz with pianists like Earl Hines, Weatherford, Lil Hardin, Jerome
Carrington, "Fats" Waller, and Luis Russell around; with clarinetists

like Jimmy Noone, Johnny Dodds, and Dixon; trumpeters like Oliver, Keppard, Armstrong; trombonists like Honoré Dutrey; and drummers like 'Zutty' Singleton, Baby Dodds, and Paul Barbarin." Beyond these, clarinetist Sidney Bechet, drummer "Tubby" Hall, trombonist Roy Palmer, and master of banjo and guitar Johnny St. Cyr were the models for the green but avid young white musicians around Chicago —Bix Beiderbecke, Eddie Condon, Gene Krupa, Jimmy MacPartland, Glenn Miller, Ben Pollack, and Benny Goodman. Years after, jazz-dom's roving memoirist Mezz Mezzrow wrote worshipfully of the moment he heard Bessie Smith for the first time: "That wasn't a voice she had, it was a flamethrower licking out across the room." What was true of the blues in Chicago was even truer of jazz. The kind of music played by bands led by Oliver and Ory and Don Redmond (of Detroit days) and others was hot, loud, improvised, and with more of the wail of the blues in it than its New York counterpart.

Instead of a flamethrower, Fletcher Henderson held a torch. It dazzled and warmed but it did not leave audiences blind and scorched. His music was not what Chicago jazzmen admired. Louis Armstrong had spent part of 1924 in Fletcher's orchestra and had been happy to return to Chicago when his pianist wife, Lil Hardin, wired about a long-term engagement. But the younger musicians saw that the future—jobs, recording opportunities, bigger and better-heeled audiences—was in New York. Satchmo knew that he would return. Older musicians tended to prefer the purer musical climate of Chicago. Why Freddie Keppard had failed to make the first jazz recording in December 1916 is still debated (the honor had gone to the white musicians of Nick La Rocca's Original Dixieland Jazz Band), but Sidney Bechet thought it had to do with philosophy: "These people who was coming to make records, they was going to turn it into a regular business, and after that it wouldn't be pleasure music. That's the way Freddie was." Bechet himself came to Harlem to play with James P. Johnson at the Kentucky Club and was fired because he held fast to his New Orleans style. "James P. was trying to make it almost like one of those big swing bands—hit parade stuff," the clarinetist sniffed long years afterward. "He was all for making these big arrangements, adding musicians, adding instruments—all that business that leaves a musician with nothing to say and no way to say it." King Oliver passed up a Cotton Club offer in 1927, and the contract went to a young Washingtonian, Edward Kennedy "Duke" Ellington, whose first impression upon veteran Harlem musicians had been less than remarkable.

On the memorable night of the Savoy's opening and in the many nights to follow, Fletcher Henderson's Rainbow Orchestra symbolized, purely and simply, the debut of jazz as a product for national consumption. Until the end of the twenties, the national jazz sound was the swinging syncopation of Henderson's orchestra—with the Cotton Club orchestra of Duke Ellington (even smoother and "whiter") placing a close second. The Savoy jam sessions broadcast over the radio, were to American popular music what Dearborn was to transportation. Fletcher Henderson himself represented in his culture and character another significant development—the sufferance if not the approval of jazz by some of the Talented Tenth. Afro-American music had always been a source of embarrassment to the Afro-American elite. The group continued to be more than a little annoyed by the singing of spirituals long after James Weldon Johnson and Alain Locke had proclaimed them America's most precious, beautiful, and original musical expression. Its feelings about urban spirituals—the blues—and about jazz sometimes verged on the unprintable. Ernest Ansermet might marvel over Bechet's clarinet in London ("Was I singing in my instrument to make it sound that way?") and Maurice Ravel sit for hours at the Apex Club listening to Jimmy Noone's band (" 'Amazing,' Ravel would say to his pal, and the guy would answer, 'incredible' "), but upper-crust Afro-Americans still mostly recoiled in disgust from music as vulgarly explosive as the outlaw speakeasies and cathouses that spawned it.

There had been no jazz in Henderson's background before he came to New York. His father was principal of a Cuthbert, Georgia, training school. His mother, Ozzie, a pianist of local distinction and a music instructor, began Fletcher's piano lessons at age six. Courteous, aloof, a bachelor of science in chemistry from crusty Atlanta University, he arrived in New York in 1920, twenty-two and in the employ of the Pace & Handy Music Company as a music demonstrator. When the unknown Ethel Waters met him in early 1921, "sitting behind a desk and looking very prissy and important," Henderson had never even heard a James P. Johnson piano roll.

The meeting between Waters and Henderson was one of the great "what ifs?" A few months earlier (July 1920), the failing Okeh Recording Company had released two songs by Mamie Smith, star of Perry Bradford's *Maid of Harlem*, a revue at Harlem's Lincoln Theatre. "That Thing Called Love" and "You Can't Keep a Good Man Down" sold briskly, even though Okeh had done almost nothing to

advertise the record. It was the first recording by an Afro-American vocalist. Four months later, after negotiations with Sophie Tucker fell through, Okeh reluctantly hired Mamie Smith again to record two songs by Bradford, her Harlem manager. This recording (Okeh 4169) by "Mamie Smith and Her Jazz Hounds," with Willie "the Lion" Smith on piano, was of much better quality. By word of mouth alone, "Crazy Blues" and "It's Right Here for You (If you don't come and get it, 'taint no fault o' mine)" sold seventy-five thousand copies in Harlem in less than one month. Okeh's worries were over. Almost every record company in America issued a version of Bradford's "Crazy Blues," and many found a vocalist named Smith. The era of the "race record"—the black record issued by the white company—was under way.

That was what brought Ethel Waters to the Pace Phonograph Company at 2289 Seventh Avenue in February 1921, where Fletcher Henderson was recording manager of the new firm founded by Harry Pace after dissolution of the Pace-Handy partnership. Pace's venturesome ambition was broadcast by the firm's motto swirling on every "Black Swan" disc and in advertising copy sent to the Afro-American press—"The Only Genuine Colored Record—Others Are Only Passing for Colored." With cash receipts of $674.64 at the end of the first month, Harry Pace was more than willing to audition the skinny, honey-voiced teenager from Chester, Pennsylvania. "There was much discussion," Waters remembered, "of whether I should sing popular or 'cultural' numbers." Black Swan records, after all, were intended to have class and reflect credit on the race. The directors did not want the company to appear too colored; and Bessie Smith, also auditioning in February, was rejected because of her unmistakable nitty-grittiness. William Grant Still, a member of the Harlem Symphony and future composer, was music director of Black Swan; Du Bois and John Nail, James Weldon Johnson's brother-in-law and Harlem's largest real estate broker, were on its board of directors. "They finally decided on popular," Waters said. It was the right decision.

"Down Home Blues," with "Oh, Daddy" on the other side, helped push the company's average monthly receipts to $20,000 by the end of the year. Income from record sales was $104,628.74 for the first year. The business manager, Lester Walton, future United States minister to Liberia, proposed that Black Swan advertise itself through a tour—Philadelphia, Chicago, and the South—with Waters as star and Henderson organizing a band around her. Waters never accepted Henderson's musical preferences, though. She made him listen to James P.

Johnson recordings. Finally, in New Orleans, she left the tour, ending a relationship that might easily have made the crucial difference in the life of the Pace Phonograph Company.

In January 1922, Black Swan recorded the winner of the 369th Infantry Regimental Band's first concert competition, Trixie Smith. Trixie was good, but she was no Ethel Waters. Moreover, the board of directors was increasingly uneasy about blues recordings. It felt the pressure from upper-class Afro-Americans to upgrade the catalogue. The May 1922 ad in *The Crisis* listed two "corking good Blues songs" by Trixie Smith, but the featured record carried two operatic numbers by Antoinette Garnes, "The Only Colored Member of the Chicago Grand Opera Company." Nineteen twenty-two was the last good year. The following year, Pace sold his catalogue to Paramount and struggled along for a while longer. Advertisements by "The Only Colored Phonograph Company in the World" were displaced in *The Crisis* and *Opportunity* by those of Okeh and Columbia, whose race sales soared with the discovery of Edith Wilson. Meanwhile, Fletcher Henderson had formed his own band and begun to develop his big-band style. No doubt Du Bois, who was an occasional celebrant at the Savoy, would have preferred that Henderson devote all his talents to the Harlem Symphony (Henderson was an active member). But since jazz was obviously not going to go away, those who felt responsible for Afro-American public behavior could comfort themselves with the fact that success could not have come to a more responsible middle-class musician. Somehow, under Henderson's baton, the funkiness and raucousness of jazz dissipated—not altogether, certainly, but enough so that an Afro-Saxon college-trained professional man might leave the Dark Tower and thoroughly enjoy himself at the Savoy without being downright savage about it.

It may have been about the time of the second *Opportunity* awards dinner in spring of 1926 that Claude McKay wrote "Negro Life and Negro Art," an unpublished fragment denouncing the prize-giving and official grooming of artists. The Negro intelligentsia was "actively and potentially propagandist," he wrote. "And in striving for professors' armchairs, Army and Navy shoulder chips, sacerdotal gaiters, big business fellowships, and high political preferences of the majority and ruling race, the growing army of the professional Negro class necessarily invokes the aid of the Negro propagandist intelligentsia." All this was inimical to true artistic expression, McKay argued, for the artist

was "a freak to the average intelligence," someone who was "fasci-
nated by life as it is." Even if McKay had published his concerns rather
than confining them to angry personal letters, he would almost cer-
tainly have been drowned out by the great majority faithful to the
official artistic and literary line. Ironically, though, but for opposite
reasons, McKay would have found an unexpected ally in haughty Dr.
Du Bois. If the poet was certain that true artistic impulse was being
corrupted by the propaganda of class uplift, the civil rights doyen was
becoming alarmed about the displacement of legitimate polemics and
propaganda by art devoid of political content. "I do not care a damn
for any art that is not used for propaganda," Du Bois shouted. Never-
theless, Du Bois had proudly presided over the first *Crisis* awards din-
ner at Harlem's Renaissance Casino in November 1925. A lustrous
panel of judges assembled by the editor and Jessie Fauset had included
Edward Bok of *Ladies' Home Journal* and William Stanley Braith-
waite, the Afro-American anthologist, Sinclair Lewis, Robert Morss
Lovett, Eugene O'Neill, Ridgely Torrence, and H. G. Wells (Willa
Cather and George Bernard Shaw declined). A few months later, how-
ever, the organizer of the awards program was uneasy.

In an attempt to allay his own doubts about the contests, the editor
invited John Farrar, Alfred Knopf, William Lyon Phelps, Joel Spingarn,
and Carl Van Vechten to participate in a March 1926 *Crisis* symposium,
"The Negro in Art." Du Bois's own aesthetic ideas were often incon-
sistent and subject to violent swings, but he concurred in James Weldon
Johnson's hypothesis that what was distinctly American in culture was,
in fact, Afro-American in origin. In *The Gift of Black Folk*, published
in 1924, Du Bois had spelled out the contribution of the race, writing
that the Negro was "primarily an artist," that, from the time of the
pharaohs to the present, "the blood of the Negro" had manifested itself
through the arts. The special gift of black folk ("hard to define or
characterize") Du Bois characterized much as Robert Park had:

a certain spiritual joyousness; a sensuous, tropical love of life, in vivid
contrast to the cool and cautious New England reason; a slow and dreamful
conception of the universe; a drawling and slurring of speech, an intense
sensitiveness to spiritual values—all these things and others like them tell
the imprint of Africa on Europe in America.

Van Vechten's symposium statement was inspired by kindred notions
of a special African imprint on Europe in America, yet it was greatly

troubling to Du Bois. Van Vechten rejoiced in "the squalor of Negro life, the vice of Negro life" and asked, "Are Negro writers going to write about this exotic material while it is still fresh or will they continue to make a free gift of it to white authors who will exploit it until not a drop of vitality remains?" If the Negro was primarily an artist, by early 1926 Du Bois was disenchanted with many of the artist's white patrons.

Du Bois's growing opposition to what seemed an excess of socially unredeeming art affected one of his deepest friendships. Jessie Fauset's departure from regular editorship of *The Crisis* in February was an indication of more than personal friction, although the friction was deeply personal. The embarrassment of a financial debt merely made Du Bois less chivalrous as he went about making his associate editor miserable enough to resign. Fauset and her sister had loaned Du Bois twenty-five hundred dollars in 1923, which they wanted repaid and which Du Bois coldly refused to do. This was the man who had inspired Fauset's love poems, who now treated "old and sympathetic friends" cruelly. In a long, moving letter to Joel Spingarn, she begged him to offer a large sum of money on the pretext of advancing Du Bois's sixtieth birthday gift by two years so that his "financial worries could be made less pressing and he thereby would have more time to devote to his real interests" (and, not incidentally, to repay the Fauset sisters). Du Bois's ungentlemanly behavior was more likely caused by Fauset's desire to turn the NAACP's monthly into an *Opportunity*, with the arts gradually achieving parity with politics and economics. Had he not announced the previous May that *The Crisis* intended to conduct a crusade "covering the next three years and taking up in succession the history and significance of the Labor Movement in the modern world"? Had he not been scandalized when he read Van Vechten's novel *Nigger Heaven*, released in spring 1926? Had he not proclaimed after his trip that year to the Soviet Union that if what he had seen "with my eyes and heard with my ears in Russia is Bolshevism, I am a Bolshevik"? The old warrior was not in the mood for art.

"How is it that an organization like this," Du Bois asked an NAACP conference in late 1926, "a group of radicals trying to bring new things into the world, a fighting organization which has come out of the blood and dust of battle, struggling for the right of black men to be ordinary human beings—how is it that an organization of this kind can turn aside to talk about art? After all, what have we who are slaves and black to do with art?" When the occasion demanded, Du Bois could

sound surprisingly like Marcus Garvey. He answered his question by telling the assembly that what Afro-Americans wanted was to be Americans, "full-fledged Americans, with all the rights of other American citizens." This did not mean the surrender of racial identity; there were differences which the arts reflected; they would endure. But what those differences were and which among them was most praiseworthy must be determined by Afro-Americans—"reviewed and acclaimed by our own free and unfettered judgment." The danger of the present was that the "criteria of Negro art" were ruled by whites. The exotic was praised to the skies and the young artists were hailed as saviors:

With the growing recognition of Negro artists in spite of the severe handicaps, one comforting thing is occurring to both white and black. They are whispering, "Here is a way out. Here is the real solution of the color problem." The recognition accorded Cullen, Hughes, Fauset, White and others shows there is no real color line. Keep quiet! Don't complain! Work! All will be well! I will not say that already this chorus amounts to a conspiracy. . . . But I will say that there are today a surprising number of white people who are getting great satisfaction out of these younger Negro writers because they think it is going to stop agitation of the Negro question.

It was clear that Du Bois would never join The Six. The following February, *The Crisis* announced the rules for the 1927 prizes. Almost half the $2,035 in prize money had been contributed by Afro-American banks, insurance companies, and the Empire State Federation of Women's Clubs and was to be awarded for works stimulating "general knowledge of banking and insurance in modern life and specific knowledge of what American Negroes are doing in these fields." Amy Spingarn's $600 for literature and a new Chesnutt purse of $350 (although not named for the novelist, at his request) still offered the poet and short story writer reward for effort, but the balance of interest was clear.

McKay's and Du Bois's apprehensions about the politics of patronage were shared by several others who suspected that the price exacted for artistic recognition was too high. But they had not yet dared to speak out loudly, nor were there many in Afro-America who were disposed to listen to them. Because of prestige and personality, Du Bois was free to impose his will on *The Crisis*, but by word and deed Walter White and James Weldon Johnson announced that *their* section of the NAACP was committed to the arts-politics policy more firmly than

ever. April 1926 was another *Opportunity* triumph, though many of
the prizewinners would never be heard from again. Others, like Arthur
Fauset, Joseph Cotter, Jr., John Matheus, and Dorothy West, would
write more and well enough to avoid oblivion. The problem child of
580, Zora Hurston, was present to receive second prize for "Muttsy," a
light short story about romance, renunciation, and venial backsliding
in the wicked city. Arna Bontemps took the Alexander Pushkin first
prize for his indifferent poem "Golgotha Is a Mountain." Once again,
the largely white panel of judges registered surprise at the surge of
competent entrants, predicted an enrichment of American letters, and
went off to Harlem nightspots to celebrate another demonstration of
productive interracialism.

By the close of 1926, then, what McKay called "that NAACP crowd"
had turned itself into a Ministry of Culture for Afro-America. Now that
it was beginning to pay to be creative, the influence of The Six was
becoming decisive. Guided by Locke and George Edmund Haynes,
Afro-American head of the department of race relations of the Federal
Council of Churches, the William E. Harmon Foundation turned its
attention from aid to the blind and student loans to begin funding Afro-
American artists, writers, and professionals. Seven annual prizes were
announced in January 1926 for literature, music, fine arts, industry,
science, education, and race relations, for which only Afro-Americans
were eligible. An eighth prize was reserved for a distinguished Ameri-
can, irrespective of color or vocation. Gold and bronze medals were
struck bearing the inscription "William E. Harmon Award for Distin-
guished Achievement," and the awards were hefty—four hundred
dollars for gold and one hundred for bronze prizes. The gold medal for
race relations carried a five-hundred-dollar purse. The year 1926 had
brought a cascade of bounties. In March, Boni & Liveright announced
a one-thousand-dollar prize for the "best novel on Negro life" by an
author "of Negro descent." Money from individual donors was grate-
fully received at the NAACP and the Urban League: six hundred
dollars from Amy Spingarn for *The Crisis* awards; one thousand dol-
lars from Casper Holstein and a smaller sum from Van Vechten for
Opportunity. Finally, in addition to the Garland Fund and the Louis
Rodman Wanamaker musical composition prizes, there was the parent
of all Afro-American prizes, the NAACP's majestic Spingarn medal,
awarded annually since 1915 "for the highest achievement of an
American Negro." The Spingarn medal was not intended to favor cre-
ative people, but three of eight recipients from 1924 to 1931 were

artists or writers (Roland Hayes, Charles Chesnutt, and actor Richard B. Harrison), and a fourth, James Weldon Johnson, was honored as a man of letters and as a statesman.

Sponsoring talented Afro-Americans was the rage. "Adorable" Zora Hurston had been bundled off by Fannie Hurst after the 1925 *Opportunity* gala to be playmate and private secretary. In her letters, Hurston expressed what most of her fellows must have experienced during this period, if more extravagantly: "I suppose you want to know how this little piece of darkish meat feels at Barnard. I am received quite well. In fact I am received so well that if someone would come along and try to turn me white, I'd be quite peevish at them." Hughes, touted as a "Negro boy friend" by Van Vechten, had been signed by Knopf and offered to *American Mercury* as the "first sophisticated Negro to turn back to the crude and primitive for his inspiration." In November 1926, White applied for a Guggenheim to write a novel about three generations of a southern Afro-American family, a successful application soon to be followed by a similar grant to Eric Walrond.

Two radically dissimilar works of fiction appearing in 1926 were hailed as stunning evidence of the coming of age of literary Harlem and of the national arrival, at center stage, of the Afro-American as subject: Eric Walrond's *Tropic Death* and Carl Van Vechten's runaway best seller *Nigger Heaven*.

Richetta Randolph, James Weldon Johnson's secretary, stayed up much later than usual to finish reading *Nigger Heaven*, and when she closed its covers her depression was so severe that she wrote the vacationing Johnson the following morning:

To the very end I hoped for something which would make me feel that he had done Negro Harlem a service by this work. . . . What Mr. Van Vechten has written is just what those who do not know us think about all of us. . . . I am serious when I say that I think only you can redeem Mr. Van Vechten by writing something to counteract what he has done.

The reaction of Johnson's secretary varied from most Afro-Americans' only in its restraint. She knew that her employer had not only read and enthusiastically approved the final draft of the novel, but had urged Carl Van Vechten to write it in the first place because "no acknowledged American novelist has yet made use of this material." She was keenly aware of the literary conventions that compelled sympathetic

white authors to use derisive prose and regurgitate crude stereotypes before slipping a modest racial compliment between the lines. She knew how necessary it was for distinguished civil rights leaders to hail almost any book or play in which the Afro-American was accorded a semblance of humanity as a giant step forward in racial harmony—as they had sincerely applauded DuBose Heyward's *Porgy* the previous year. But Johnson failed to persuade Richetta Randolph that *Nigger Heaven* was anything other than a copyrighted racial slur. "I believe you feel it is truth. It is truth," Johnson replied to his secretary, "and it is life as you and I know it to be. We could find a counterpart in Harlem life for everything Mr. Van Vechten has pictured in his book."

It was considered bad form among Afro-Americans to be caught reading *Nigger Heaven*, and virtually everyone in Harlem discovered never-before-expressed misgivings about Carl Van Vechten or remembered some telltale incident of his racial insincerity. At the 135th Street library, one Cleveland G. Allen announced that he had petitioned Mayor Walker to prohibit distribution of the book in New York. Walter White had to bring the considerable weight of his office down upon the owner of the Pittsburgh *Courier* before the newspaper rescinded its ban on paid advertisements for the novel. The management of Smalls' Paradise was deaf to all appeals and banned Van Vechten from his favorite Harlem nightspot. Alain Locke and Countee Cullen despised the novel, though neither said so publicly. The awful title confirmed what the women at 580 had always known—that Van Vechten was a literary voyeur, exploiting his Harlem connections in order to make himself even richer. No matter what her respected employer said, Richetta Randolph (and 90 percent of the race) saw the book as Du Bois did—"a blow in the face" and an "affront to the hospitality of black folk and the intelligence of white."

From a distance of more than fifty years, the commotion over *Nigger Heaven* may seem puzzling. Carl Van Vechten is almost as unknown today as his novel is unread. Not only is it not a memorable literary work, it is not even up to Van Vechten's usual polish—to the mordant *Tattooed Countess* and the precious *Blind Bow-Boy*. The plot is sheer melodrama. The boy, Byron Kasson, meets the girl, Mary Love, then deserts her for the amatory ecstasies of the older *femme fatale*, Lasca Sartoris, only to be cruelly cast aside and to fail absurdly in an act of homicidal vengeance upon his replacement, the bolito king Randolph Pettijohn. The only novelty (for 1926) is that all the characters are Afro-Americans. The *Independent*'s verdict—"cheap

French romance, colored light brown"—was harsh but not farfetched. *Nigger Heaven* stirred the public because it was the first fictional treatment of Harlem by a white; and thus the pioneering novel about the condition (high and low) of the urban Afro-American. That it had been done before (and well done), in Paul Laurence Dunbar's *Sport of the Gods* (1902), was ignored by applauding white reviewers. The *Saturday Review* praised it as "a frontier work of enduring order," while *International Book Review* said it was "the truest book he has written and it is the most powerful," for Van Vechten had gotten "beneath the skin of another people." A best-selling book, covering Harlem from Striver's Row to cutthroat cabarets by one of America's most fashionable authors, made James Weldon Johnson almost giddy with delight: "It's all so fine, and so much in fulfillment of what my hopes and wishes were."

By the time *Nigger Heaven* was released by Knopf, in August 1926, Van Vechten ("Carlo," to the inner circle) had become Harlem's most enthusiastic and ubiquitous Nordic. Ever since Walter and Gladys White had escorted him and his wife Fania Marinoff to their first NAACP dance at Happy Rhone's Black and White Club two years earlier, Afro-America had been an addiction. Even *Time* magazine noticed: "Sullen-mouthed, silky-haired Author Van Vechten has been playing with Negroes lately." Arriving from Baltimore with a friend, a shivering Mencken discovered how all-consuming Van Vechten's new passion was when he was turned away into the winter evening so Van Vechten could attend a "black Kosher wedding." He may not have attended every social affair recorded by the *Amsterdam News*, but *The New York Times*'s former music critic became almost as recognizable on Lenox Avenue as Bill "Bojangles" Robinson. The popular "Go Harlem," with lyrics by Harlem's Andy Razaf, sang "Go inspectin' like Van Vechten," and Miguel Covarrubias's drawing of a coal-black Van Vechten was called, appropriately, "A Prediction." With his wobbly walk, piercing eyes and sandy blond hair, protruding jaw and those walrus teeth that had once so disconcerted Mabel Dodge, Van Vechten's weird six-foot presence seemed to be everywhere.

He developed a filial affection for James Weldon Johnson, with whom he shared a birthdate. He introduced Paul Robeson to the man who would become his longtime arranger and accompanist, Lawrence Brown, and arranged Robeson's first recital at Town Hall. He encouraged Rudolph Fisher and Nella Larsen. He praised everything artistically good or promising with enthusiastic good sense, balanced by sympathetic

dismissal of whatever Harlem produced that was clearly mediocre. Once
he found his bearings, the novelist quickly made his way to places quite
unfamiliar to his sponsors—for example, the Rockland Palace trans-
vestite costume balls, for which he and Village artist Robert Chanler
served as judges. He became white America's guide through Harlem,
what Osbert Sitwell described as "the white master of the colored
revels." With Bennett Cerf, he piloted a tipsy William Faulkner from
high-toned clubs to raucous honky-tonks early one morning. (Faulkner's
unvarying slurred request was for "Saint Louis Blues.") With Witter
Bynner, he took Tony Luhan, Mabel Dodge's Indian husband, to
Smalls' one night. The dancing waiters with trays aloft, the madcap
band afire with sound, excited Luhan, who danced between the tables,
wrapping the women's scarves around their men, and finally joined
the band to play drums. Carlo never joined the band. There were many
times when he was too stewed to do more than stagger onto Fifth Ave-
nue and hail a taxi back to his apartment at West Fifty-fifth Street. He
told his biographer that he spent most of the twenties intoxicated by gin
and sidecars.

There were many nights when Van Vechten stayed home with Fania
and invited Harlem to the West Side. These were some of the fabulous
"integrated" parties of Renaissance legend—long, well-lubricated eve-
nings where George Gershwin would play Broadway tunes on the
piano, Tallulah Bankhead let down her hair, Alexander Woollcott
behave charmingly or viperously, Theodore Dreiser sit brooding on the
couch, and Paul Robeson would make everybody weep to a heart-
rending spiritual after the hush induced by James Weldon Johnson
reading from his *God's Trombones*. One Van Vechten party has en-
tered the lore of the twenties—the night Bessie Smith reeled in on the
arm of debonair Porter Grainger, her accompanist, with niece Ruby
Walker and Smith's husband, Jack Gee. Gershwin was there, along
with Fred Astaire's sister, Adèle, Marguerite d'Alvarez, the opera
singer, and a good gathering of other noted New Yorkers. "How
about a lovely, lovely dry martini," Van Vechten minced, whereupon
things went disastrously downhill. "Ain't you got some whiskey,
man . . . ? I don't know about no dry martinis, nor wet ones either."
D'Alvarez tried to help with an aria. "Don't let *nobody* tell you you
can't sing," a momentarily pleased Bessie told the contralto. By then,
though, she was high as a kite, and when Fania Marinoff tried to kiss
the departing singer, Bessie knocked her to the floor, roaring, "Get the
fuck away from me. I ain't never heard of such shit!" Loyalty to Bessie

never wavered, but the Van Vechtens felt much more at ease with her rival, Ethel Waters, who sincerely liked Carlo and was soon obliged to him for showing her Paris. The mix at Van Vechten parties made a popular Harlem joke of the day seem as likely as amusing: "Good morning, Mrs. Astor," says a porter at Grand Central Station. "How do you know my name, young man?" "Why, ma'am," the porter explains, "I met you last weekend at Carl Van Vechten's."

Somehow, after George and Tallulah and Scott Fitzgerald and Pola Negri and Elinor Wylie and Rudolph Valentino and all the other celebrities had left his apartment each morning, Van Vechten would mix a final, steadying sidecar and write for hours—mostly about Harlem and the New Negro Movement. Well before most Afro-Americans associated the name Smith with anything other than cough drops, he was writing critical evaluations of the voices and repertoires of Bessie, Clara, Mamie, and Trixie for *Vanity Fair*. Folk songs, the blues, Billie Holliday, and the theatre—all these he discovered and hailed in half a dozen periodicals. He was utterly oblivious to the "tendency on the part of the Negro to be sensitive concerning all that is written about him, particularly by a white man." If the Afro-American would simply be himself artistically, many social problems—whatever they were— would take care of themselves, he believed. "Moanin' Wid' a Sword in Mah Han' "warned of the willingness of the Afro-American writer to deliver "his great gifts to the exploitation of the white man." Obviously, it never occurred to Van Vechten that what was exotically worthy to him might not strike an Afro-American writer as unusual, or—if so—that it might embarrass or offend the Afro-American deeply. Van Vechten knew he had much to learn about these people, joshing with Mencken, "Ain't it hell to be a Nordic when you're struggling with Ethiopian psychology?"

During the past year he had worked like a man possessed at his Harlem novel, grappling with its protean slang, learning the walk and ways of its sheiks, and insinuating himself into the life of its upper crust. One point of contact was Nora Holt (Ray). She was not really upper crust. Her numerous dalliances and lengthy, noisy divorce from Joseph L. Ray, property owner and holder of the food concession in the Bethlehem, Pennsylvania, steel mills, had been covered, blow and quote, on the front page of the *Defender*. Capitalist Charles Schwab thought highly enough of the lady's cuckolded husband to provide the services of Bethlehem Steel's own law firm, Kirkpatrick, Maxwell, and

Chidsey, but Nora Holt still won a handsome settlement. Van Vechten found himself much taken by this slender, sharp, sophisticated woman. She went into the novel as the beautiful, rich, and unprincipled Lasca Sartoris. On December 21, he wrote the final page of the second draft, sending it off to James Weldon Johnson and Walter White for critical review. Charles Van Duane Van Vechten, his father, was appalled by the working title. "I have, myself, never spoken of a colored man as a 'nigger,'" the old man pleaded. His second and last urgent appeal (Charles Van Vechten died two months later) argued that the title would "not be understood and I feel certain you should change it."

Carl Van Doren wrote Carlo, "Unless my guess is wrong, *Nigger Heaven* ought to break all your records of sales." The outrageous title was commercially perfect, and once Langston Hughes had saved the day by writing, word for word, new lyrics to replace "Shake That Thing" (for the use of which Knopf was being sued because the author had forgotten to negotiate with ASCAP, the American Society of Composers, Authors and Publishers), the novel's sales soared, going through nine printings in four months. The white reading public, well-primed for the vital and the exotic, fascinatedly watched Anatole Longfellow (alias the "Scarlet Creeper") bop and glide down Seventh Avenue:

He wore a tight-fitting suit of shepherd's plaid which thoroughly revealed his lithe, sinewy figure to all who gazed upon him, and all gazed. A great diamond, or some less valuable stone which aped a diamond, glistened in his fuchsia cravat. The uppers of his highly polished tan boots were dove-coloured suede and the buttons were pale blue. His black hair was sleek under his straw hat, set at a jaunty angle. When he saluted a friend—and his acquaintanceship seemed to be wide—two rows of pearly teeth gleamed from his seal-brown countenance.

The prologue ends; the milieu of the Seventh Avenue sheik, with its flavor of sex, savagery, and switchblades, vanishes, to return only at the end of the book almost as abruptly. Book One introduces the world of High Harlem, of plush brownstones and good grammar. Mary Love, who can only have been confected from Jessie Fauset, meets Byron Kasson, University of Pennsylvania graduate and distant cousin to Eric Walrond, at Adora Boniface's country place (A'Lelia's Villa Lewaro). James Weldon and Grace Johnson appear as the cosmopolitan Under-

woods. Van Vechten is there—as novelist Gareth Johns—amazed to
discover people who recite Wallace Stevens, delve into contemporary
French literature and Impressionist paintings, and are bilingual and
well travelled.

"You managed to get what many Negroes will regard as 'family
secrets,'" Charles Johnson wrote the author. The long, eloquent dis-
cussions of "passing," residential segregation, special indignities visited
upon well-bred Afro-Americans, philosophical antagonisms of Du Bois
and Booker Washington, envy of poor blacks and self-hatred of their
betters—all this Van Vechten recorded with striking fidelity. When
Howard Allison, Columbia Law, discourses on the civil rights ambitions
of the New Negro, the message contains a warning from the author:

That won't be successful either, except for the artists. Of course, Paul
Robeson and Roland Hayes and Countee Cullen can go anywhere within
reason. They will be invited to white dinner parties, but I don't see how
that's going to affect the rest of us.
Why not? Olive demanded.
Because the white people they meet will regard them as geniuses, in
other words, exceptions. Yes, they will say to themselves, these are certainly
unusually brilliant and delightful individuals; it's a pity all Negroes aren't
like them. So they will go on neglecting the plight in which our respectable
middle class finds itself.

Afro-Americans who liked *Nigger Heaven* tended to echo the opin-
ion of Richard Barrett, one of Van Vechten's white friends, who wrote,
"As propaganda the book is gorgeous." Actress Edna Thomas, Nella
Larsen the aspiring novelist, Dorothy Peterson the disciple of Toomer
and Gurdjieff, Nora Holt—all praised the novel as a disturbing but
realistic slice of life. Charles Johnson, in an *Opportunity* editorial,
Langston Hughes, and George Schuyler all called attention to the au-
thor's explanation that a "nigger heaven" was the segregated balcony
of a theatre, that Harlem overhung white Manhattan and, as Byron
Kasson declares bitterly,

We sit in our places in the gallery of this New York theatre and watch
the white world sitting down below in the good seats in the orchestra.
Occasionally they turn their faces up towards us, their hard, cruel faces, to
laugh or sneer, but they never beckon. It doesn't seem to occur to them that
Nigger Heaven is crowded, that there isn't another seat, that something has
to be done.

Charles Chesnutt, whose novels are prominently featured in the book, said that the title had shocked him at first (even "Negro" displeased him, as he preferred "colored"), but if the characters "are true to life, that is all that can be asked of the artist."

Not only were they true to life, but Van Vechten's Afro-American defenders argued that he had bent over backward to be more than fair. As James Weldon Johnson said, *Nigger Heaven*'s French-speaking products of Fisk and Harvard were powerful voices for racial betterment. "Has anyone ever written it down—in black and white—that you have been one of the most vital forces in bringing about the artistic emergence of the Negro in America?" Johnson wrote his friend. It is unlikely that Van Vechten told his respected friend that Ralph Van Vechten, his brother, had just remarked in a half-serious letter, "You have done more for the Negro than anyone since Abraham Lincoln. . . ." It was their point of pride, their badge of cosmopolitan tolerance, for Van Vechten's Afro-American partisans to show themselves unruffled by a mere title and a few sordid pages devoted to Harlem's hoi polloi, when emancipated people like themselves were, they thought, flatteringly portrayed. As the actress Edna Thomas wrote the novelist, "Fool the public if you must, darling, but you and I know you've gotten a lot of propaganda off your chest, don't we?"

Van Vechten's own thoughts on Afro-American literature, previously voiced in *Vanity Fair* and *The Crisis*, are placed in the mouth of the editor Russett Durwood (Mencken) and uttered with shocking forthrightness to the racially rootless hero. What Byron Kasson is trying to write, any white mediocrity could do better, says Durwood. But Harlem "is overrun with fresh, unused material. Nobody has yet written a good gambling story; nobody has touched the outskirts of cabaret life; nobody has gone into the curious subject of the divers tribes of the region." Warming to his homily, the editor warns the bewildered Kasson, "If you young Negro intellectuals don't get busy, a new crop of Nordics is going to spring up who will take the trouble to become better informed and will exploit this material before the Negro gets around to it." Of course, that was exactly what Van Vechten and *Nigger Heaven* had done, and the joke was on Claude McKay, still without a publisher.

Whites who were sympathetic to Harlem and believed they knew something of its ways thought the novel was almost perfect. Man-about-town Edward Wasserman (who was known to use Madame Walker's hair compounds) thought *Nigger Heaven* revealed "every detail of [his] life in Harlem." Sinclair Lewis was equally delighted. "No Negro

of my acquaintance," wrote Knopf editor Harry Block, "could have done it, and certainly no other white man." Playwright Avery Hopwood jokingly took Block's logic to the end, informing Van Vechten that his friends were "all so surprised to hear about your negro strain, but I tell them that your best friends always knew." But there were other, more typical, white reactions. Mabel Dodge and F. Scott Fitzgerald adored the novel because, for them, it confirmed the Afro-American grotesqueries produced by civilization and the durability of the peasant—the "unspoiled Negro." Mabel Dodge liked the dénouement—the "archaic real nigger being able to do the deed" (the Scarlet Creeper shooting the bolito king who steals his and Byron's woman) and the hero "spoiled for *action* by thought" (firing into the bolito king's corpse and being arrested for murder)—while Fitzgerald reflected on Harlem's aping of white ways, as if white culture "had been dug out of its context and set down against an accidental and unrelated background." Gertrude Stein told Carlo *Nigger Heaven* was "rather perfectly done," and it is certain that she thought so for reasons different from those of James Weldon Johnson.

What Van Vechten had done was painfully clear to Ethel Fowler, a white acquaintance: "You have certainly made a moving appeal for the educated Negro in his unfair handicap of color. But to me, you have also shown the Negro in such a repulsive light that my opinion of them personally is not enhanced." Van Vechten's motives for writing what amounted to two books in one were a mixture of commercialism and patronizing sympathy. For the sake of sales, he intended *Nigger Heaven* to create a sensation, while not disturbing his white readers' most basic perceptions of the Negro. Moreover, he had plans "to take up the Chinese and the Jews" next. But there were his new friends among the Afro-Americans whose affections and expectations had to be considered—James Weldon Johnson, as dear to him as his own father and possessing greater "tact and discretion"; Walter White, with whom he got on "like a house afire" and who was soon to bestow Van Vechten's name on his son; and Langston Hughes, who was like a son and a colleague. Their help with the manuscript and their approval of it also made a commercially promising novel an even surer bet.

From the point of view of racial uplift, *Nigger Heaven* was a colossal fraud in which the depiction of the Talented Tenth in high baroque barely muffled the throb of the tom-tom. Its unmistakable message is delivered by Lasca Sartoris (the well-bred pleasure principle) to Byron Kasson (the deracinated New Negro): "Negroes aren't any worse off

than anybody else. They're better off if anything. They have the same privileges that white women had before the bloody fools got the ballot. They're considered irresponsible like children and treated with special fondness." Van Vechten portrays the "archaic Negroes" at ease in their skins and able to act decisively. The Scarlet Creeper (the uncouth pleasure principle) is the triumph of phallus over mind. "For Van Vechten," writes one of his most perceptive critics, "each black man has his Creeper running around in his skull." By the same token, each woman has her own Lasca, but Mary Love's is anemic. Mary has "lost or forfeited her birthright, this primitive birthright that all civilized races were struggling to get back to—this fact explained the art of a Picasso or a Stravinsky." Poor Mary Love is too evolved to be saved by her racial heritage:

This love of drums, of exciting rhythms, this naive delight in glowing colour that exists only in cloudless climes—this warm, sexual emotion, all these were hers only through mental understanding. . . .
We are all savages, she repeated to herself, all, apparently, but me!

Eric Walrond's *Tropic Death*, published by Boni & Liveright in October, attracted none of the controversy of *Nigger Heaven* but was widely acclaimed critically. It also represented an achievement for the Urban League, confirming Charles Johnson's early confidence in Walrond, who was now an *Opportunity* employee. The book was one of the truly avant-garde literary experiments of the Harlem Renaissance, a prism so strange and many-sided that even Professor Benjamin Brawley, Afro-America's fatuous literary critic, saw its iridescence: "It is hardly too much to say that in a purely literary way, it is the most important contribution made by a Negro to American letters since the appearance of Dunbar's *Lyrics of Lowly Life*." Like the stories and vignettes in *Cane*, the ten stories in *Tropic Death* tackle themes of cultural disorientation and change in the wake of technology: folk migration, racial assimilation and atavism, technology versus tradition, Oedipus and color complexes, the loss of innocence—all unfolding on a dying archipelago in the margin of modern civilization. West Indian vernacular being neither familiar nor respectable in upper-crust Harlem, *Tropic Death* was hard going for Du Bois. He safely and piously declared that "on the whole, it is a human document of deep significance and great promise." Theophilus Lewis, *The Messenger*'s able new critic, also spoke of significance and promise, in spite of being

uncomfortable with its "exotic and pagan character" and with "unintelligible jargon, disconnected sentences," and the book's other "obvious flaws."

Aside from Toomer, no other Renaissance writer was so consciously certain that what he had to say about his own past was so universally meaningful to the condition of Exiled Africa. *The New Republic* wrote that Walrond was "careless of composition, as the younger writers of the day often are, disdaining unity and coherence in their effort to seize a deep reality." But *Tropic Death* was not all dialect and impressionistic disjunction. "Once catching a glimpse of her, they swooped down like a brood of starving hawks," reads the clean, suspenseful sentence beginning "The Yellow One," one of Walrond's best short stories, about a beautiful, innocent girl whose "skin was the ripe red gold of the Honduras half-breed." A passenger aboard a packed and rotting ship in the tropics, she climbs down into the superheated, stygian galley to get food for her baby, leaving the infant with her indolent husband. The second time she tries it, she is trampled to death in the below-deck frenzy of sex and color-hatred her appearance unleashes among the dark men in the hold. "Me wondah wha' mek she 'tan' so long,' " the lazy, bewildered father St. Xavier Mendez whimpers as the blue hills of Jamaica loom on the horizon and the baby screams in his arms.

Whatever their strong debt to Walrond's literary models Lafcadio Hearn and Pierre Loti, "The Yellow One," "The White Snake," and the title story, "Tropic Death," deserve to rank among the fine Gothic tales of early twentieth-century American literature, while "The Wharf Rats" is a gem of the genre. The story is about two dark-skinned brothers, Ernest and Philip, who dive for the coins thrown from cruise ships. Walrond's message is one of dual fatality here. Philip's rendezvous with a half-caste female cannot be innocent because there is no innocence in a society where everything—color, culture, race, and even destiny—has become indeterminate, where dark-skinned women hate their preening half-caste sisters and invoke nature's vengeance upon their own dark men for approaching them. Ernest and Philip are as doomed in their village as are those other characters who wrench free of their villages to trade in the shark-infested waters of the cities. When the great white ships pass, they leave a spoor of silver and gold, and shark-devoured village boys.

With the sales of *Nigger Heaven* soaring, younger writers like Langston Hughes, Zora Hurston, and Wallace Thurman saw that the

old genteel literary traditions would no longer do. They were not going to deny themselves Van Vechten's privilege of exploring the underside of Afro-American life. Hughes was the first to force the issue into the open, in a declaration of artistic independence appearing in *The Nation* on the eve of *Nigger Heaven*'s publication. In "The Negro Artist and the Racial Mountain," Hughes saw the artist working against "an undertow of sharp criticism and misunderstanding from his own group and unintentional bribes from whites." " 'Oh, be respectable, write about nice people, show how good we are,' say the Negroes. 'Be stereotyped, don't go too far, don't shatter our illusions about you, don't amuse us too seriously. We will pay you,' say the whites." The Afro-American artist must charge up the mountain of misunderstanding:

Let the blare of Negro jazz bands and the bellowing voice of Bessie Smith singing Blues penetrate the closed ears of the colored near-intellectuals until they listen and perhaps understand. . . . We younger Negro artists who create now intend to express our dark-skinned selves without fear or shame. If white people are pleased we are glad. If they are not, it doesn't matter. We know we are beautiful. And ugly too. The tom-tom cries and the tom-tom laughs. If colored people are pleased we are glad. If they are not, their displeasure doesn't matter either. We build our temples for tomorrow, strong as we know how, and we stand on top of the mountain, free within ourselves.

It was much more than a rejection of Du Bois's dictum that art without propaganda was worthless. In affirming the integrity of his vision, Hughes also declared that what was truly worth painting, writing, and singing about was centered mainly in the culture of the common folk: "They furnish a wealth of colorful, distinctive material for any artist because they still hold to their own individuality in the face of American standardizations." A week earlier in *The Nation*, George Schuyler, Harlem's answer to H. L. Mencken, had ridiculed the emergence of a racially distinct art based on the folk as being as "non-existent as the widely advertised profundity of Calvin Coolidge." True, some African elements still permeated black culture in America—"slave songs based on Protestant hymns and Biblical texts known as the spirituals, work songs and secular songs of sorrow and tough luck known as the blues, that outgrowth of rag-time known as jazz"—but they had as little to do with the modern Afro-American as the "music and dancing of the Appalachian highlanders or the Dalmatian peasantry are expressive or characteristic of the Caucasian race." After all, the Afri-

can in America, Schuyler huffed, "is merely a lampblacked Anglo-Saxon."

Whether there is only high or low culture, as Schuyler argued, or whether the common folk are cradle and nursery for arts and letters different from those of the mainstream, as Hughes contended, may be impossible to decide. As a practical, professional matter for the New Negro artist, however, the dilemma presented the option of working within the boundaries prescribed by The Six, and the major civil rights organizations and their black and white allies, or of striking out independently. Langston Hughes had chosen independence with *The Weary Blues*, his first volume of poetry, published by Knopf in spring 1926. Publicly, Afro-America had nothing but praise for the poems. "Quietly and privately, however," according to Wallace Thurman, "certain Negroes began to deplore the author's jazz predilection, his unconventional poetic forms and his preoccupation with the proletariat." When *Fine Clothes to the Jew* was published less than a year later, the dean of Afro-American bluenoses, Professor Brawley, publicly reproved the "sad case of a young man of ability who has gone off on the wrong track altogether." Hughes's latest volume contained wickedly descriptive poems like "Bad Man," "Ruby Brown," "Beale Street," and the earthy "Red Silk Stockings":

Put on yo' red silk stockings,
Black gal.
Go out an' let de white boys
Look at yo' legs.
Ain't nothin' to do for you, nohow,
Round this town,—
You's too pretty.
Put on yo' red silk stockings, gal,
An' tomorrow's chile'll
Be a high yaller.

Brawley, whose literary criticism was somewhat archaic even by NAACP standards, could be ignored. Charles Johnson, James Weldon Johnson, and Walter White could not. White's bouncy optimism about the power of a few cultured Afro-Americans to beat back racism was already notorious. "Most of the physical handicaps under which the Negro labors are to me insignificant," the NAACP secretary once confided. "The greatest handicap he experiences is that he is not permitted

to forget that he is a Negro. . . . The economic and social strictures do not play, in my opinion, so large a part." James Weldon Johnson fully agreed. The upper-class Afro-Americans were gradually becoming lighter in complexion, he noted approvingly in the *American Mercury*. Far more promising, he informed *Harper's* readers, was that, after trying "religion, education, politics, industrial, ethical, economic, sociological" approaches, "through his artistic efforts the Negro is smashing" the race barriers "faster than he has ever done through any other method. . . ." Charles Johnson stood four-square with his NAACP peers, editorializing in *Opportunity* with equal confidence about the abundant signs of civil rights advancement. Johnson's protégé, E. Franklin Frazier, also wrote about "inevitable" progress with the optimism of a Pangloss.

Such sunny forecasts drove a mocking Wallace Thurman to write that "everyone was having a grand time. The millennium was about to dawn. The second emancipation seemed inevitable." Ever since his Labor Day arrival in Harlem in 1925, "Wallie" Thurman had become increasingly distressed by party-line art. Temporarily replacing Schuyler in 1926 as editor of *The Messenger*, he lashed out repeatedly against the Victorian aesthetics of civil rights grandees—those whom he and novelist Zora Hurston later ridiculed as "Niggerati." Before the end of the year, he decided to recruit younger artists and launch a magazine devoted to art for the artist's sake—and for the sake of the folk. His rent-free place on 136th Street—the infamous "267 House" (provided by the owner of a Harlem employment agency, Iolanthe Sydney)—was the cradle of revolt against establishment arts. Thurman and Hurston also mocked themselves by calling 267 House "Niggerati Manor," and all the younger artists called Thurman their "leader"—the fullest embodiment of outrageous, amoral independence among them.

Thurman never doubted that, freed from the prim guidance of the leading civil rights organizations, the artists would recognize the need "for a truly Negroid note" and would go to the proletariat rather than to the bourgeoisie for characters and material. Arthur Fauset, part of the group, also noted his own discomfort with Du Bois and "that crowd" who looked down on people "who didn't dress properly, whose finger nails were dirty, and who didn't eat properly, and whose English was not good." The 267 House artists claimed to be much more in tune with what Hughes described as "those elements within the race which are still too potent for easy assimilation" and which the elites want

"hidden until they no longer exist." Now was the time to feature with artistic honesty those potent, unassimilable elements. Hurston was right: "The way I look at it, *The Crisis* is the house organ at the NAACP and *Opportunity* is the same to the Urban League. They are in literature on the side."

When Thurman left *The Messenger* in October 1926 to become circulation manager of *World Tomorrow*, a white magazine, he devoted every spare hour to raising money for his planned new publication, editing manuscripts with Richard Bruce Nugent, planning format at Aaron Douglas's, holding meetings in Hurston's quarters at Fannie Hurst's, and going so deeply into personal debt that sympathetic editors at *World Tomorrow* gave him a check for a new winter overcoat. Service Bell, the refined Harlem printer, was persuaded to run off the magazine in November, against Thurman's IOU. *Fire!!*, a quarterly "Devoted to the Younger Negro Artists," caught Afro-America by surprise. Professor Brawley found it so disgusting that he predicted, "If Uncle Sam ever finds out about it, it will be debarred from the mails." He saw in its frank treatment of "unseemly" topics the poisonous influence of Van Vechten—"vulgarity has been mistaken for art." A friend wrote Countee Cullen that merely mentioning *Fire!!* to Du Bois hurt the editor's "feelings so much that he would hardly talk to me." At Craig's, the restaurant hangout of literate Harlem, the magazine's contributors were given the silent treatment by all, even the visiting Paul Robesons. "I have just tossed the first issue of *Fire!!* into the fire," snorted the critic for the Baltimore *Afro-American*. The white anthologist Robert Kerlin was ecstatic in Hampton's *Southern Workman*, calling it "original in all its aspects." One of the few white publications to signal its appearance, *The Bookman* was delighted that the Afro-American artist wanted "some journal distinctly under his own editorship and management" that would "let the Negro artist be himself." Afro-American critics generally thought Thurman and his group were being much too much themselves.

Thurman had meant to shock. The "decadent," "primitive" influence of Van Vechten's *Nigger Heaven* was defiantly acknowledged by the editor, who called for the erection of a statue in Van Vechten's honor at the same corner of 135th Street and Seventh Avenue where the author had been so recently hanged in effigy. "Fire," the free-form verse by Hughes and Thurman serving as the quarterly's foreword, set the tone:

FIRE . . . flaming, burning, searing, and penetrating
　　　far beneath the superficial items of
　　　the flesh to boil the sluggish blood. . . .
FIRE . . . weaving vivid, hot designs upon an ebon
　　　bordered loom and satisfying pagan
　　　thirst for beauty unadorned . . . and
　　　flesh is sweet and real . . . the soul
　　　an inward flush of fire . . . Beauty
　　　. . . flesh on fire—on fire in the
　　　furnace of life blazing. . . .
　　　　　"Fy-ah,
　　　　　Fy-ah, Lawd,
　　　　　Fy-ah gonna burn ma soul!"

With Van Vechten listed among its nine otherwise unknown patrons, and Harlemites Gwendolyn Bennett, Harvard undergraduate John Davis, Aaron Douglas, Langston Hughes, Zora Hurston, and Richard Bruce Nugent as associate editors, *Fire!!* was a flawed, folk-centered masterpiece. Aaron Douglas's illustrations evoked unspoiled Africa, while Richard Bruce Nugent's drawings of Nordic-featured figures with Negroid hair were reminders of the limitations of Madame C. J. Walker's hair-straightening compounds. The poetry was memorable: Hughes's "Elevator Boy," Cullen's "From the Dark Tower," Helene Johnson's "Southern Road," Arna Bontemps's "Length of Moon," Waring Cuney's "The Death Bed," Lewis Alexander's "Streets," and Edward Silvera's "Jungle Taste." Gwendolyn Bennett's "Wedding Day," a short story set in Paris about love conquering an expatriate black boxer's hatred for whites, was an effective period piece. Hurston's play *Color Struck*, set in a Jim Crow coach heading for a cakewalk contest, was, for the times, an idea of searing, complex irony.

In "Sweat," Hurston's short story, idea and craft were marvellously wedded. Sykes hides a snake in the bundle of white people's laundry in order to kill his wife, Delia, whose labor and earnings humiliate him; in the dénouement, Sykes returns home to be fatally bitten by the snake the avenging Delia allows to strike without warning. Yet, as "the cold river was creeping up and up to extinguish the eye which must know by now that she knew," Delia realizes that her Old Testament vengeance and Sykes's death offer her no deliverance. Hurston's guilty die innocently, her innocent persecute, and the combat of jobless black manhood versus its working women is everlasting.

Thurman's short story "Cordelia the Crude," with its New Negro protagonist whose myopic compassion for a child prostitute turns out to have confirmed her in the profession, has some of the author's best writing—including prose calculated to scandalize Professor Brawley:

In a short while she had even learned how to squelch the bloated, lewd faced Jews and eager middle aged Negroes who might approach, as well as how to enveigle the likeable little yellow or brown half men, embryo avenue sweetbacks, with their well-modeled heads, sticky plastered hair, flaming cravats, silken or broadcloth shirts, dirty underwear, low cut vests and shiny shoes with metal cornered heels clicking with a brave, brazen rhythm upon bare concrete floor as their owners angled and searched for prey.

In case anybody missed the point of *Fire!!*, Arthur Huff Fauset's essay "Intelligentsia" spelled out the folk-centered goals appropriate to real artisans of the mind.

Fire!! marked the first appearance in print of one of the more interesting minor characters of the Renaissance. Twenty-one-year-old Richard Bruce Nugent was a self-conscious decadent who had shortened his name to Richard Bruce to allay maternal embarrassment about his homosexuality. He bore a striking resemblance to Langston Hughes —a handsomer, more bohemian, Hughes. Nugent had come to Manhattan at thirteen accompanied by his recently widowed mother, bellhopped in a respectable old hotel, and become a mascot of Rudolph Valentino. Peter, his younger brother, became a well-known dancer. Georgia Douglas Johnson believed in Nugent's promise and mothered his neuroses when he returned to Washington in 1924. Alain Locke pursued him, offering Godmother's largesse if the young man would discipline his talents. But it was meeting Hughes at Georgia Johnson's one winter evening in 1925, and walking each other home "back and forth all night," that was the turning point in Nugent's life. He followed Hughes to New York, met Van Vechten, and fashioned his personality (if not his wardrobe) after Van Vechten's libertine Peter Whiffle, moving tieless and sockless from Gay Street to Striver's Row like some Lost Generation version of the medieval holy man.

"Smoke, Lillies and Jade" was like nothing done before by an Afro-American writer. It more than fulfilled Du Bois's worried prediction that Locke's "Beauty rather than Propaganda" could, if taken too far, "turn the Negro renaissance into decadence." Beauty is the name

Richard Bruce Nugent gives the Hispanic Adonis encountered by Alex, Nugent's protagonist, after a Village party. Alex is Nugent himself, and Beauty a composite of Valentino, Miguel Covarrubias, Harold Jackman, nameless Narcissi of the Village, and the Hughes with whom the author once walked back and forth all night:

the street was so long and narrow . . . so long and narrow . . . and blue . . . in the distance it reached the stars. . . . Alex walked like music . . . the click of his heels kept time with a tune in his mind. . . . Alex walked and the click of his heels sounded . . . and had an echo . . . sound being tossed back and forth . . . back and forth . . . someone was approaching. . . . Alex liked the sound of the approaching man's footsteps . . . he walked music also . . . he knew the beauty of the narrow blue. . . .

"Smoke, Lillies and Jade" (Nugent later called it a "precious piece of folderol") closes ("To Be Continued") in a montage of pederasty and androgyny, Beauty metamorphosing into Melva (Alex's fiancée) and Melva into Beauty and prose dissolving into pointillistic soft pornography while Alex, stoned, hears the Hall Johnson Choir singing "Fy-ah, Lawd" in a Harlem church.

Fire!! literally burned itself up. Service Bell, the printer, had released several hundred copies to Thurman to sell door-to-door; they were accidentally destroyed in a basement fire. At one dollar each, Harlemites were noticeably reluctant to dash to Boutté's pharmacy for a copy. Then too, a single *Fire!!*, passed from group to group, spread considerable warmth free of charge. To succeed, Thurman's magazine would have had to run for a year, gain loyal readers among curious whites, and attract a critical mass among the Talented Tenth. After its appearance, however, senior Afro-American notables and their allies found the quarterly distinctly not to their liking. Hughes remembered in *The Big Sea* that "Dr. Du Bois in *The Crisis* roasted it." Actually, Du Bois confined himself to a brief announcement: *Fire!!*, "a beautiful piece of printing," had been received by the editor; it was "strikingly illustrated by Aaron Douglas," and "we bespeak for it wide support." *Fire!!* expired, but in little more than a year Thurman and his group would try again with the review *Harlem*.

7

A Jam of a Party

Robert Kerlin, the southern literary critic, summed up the domi-
nant mind and mood of literary Afro-America in "Conquest By Po-
etry," his account of the May 1927 Urban League competitions. "I
have just finished the poems submitted to *Opportunity* in the 'Pushkin'
and 'Holstein' contests," Kerlin wrote. "Acquainted as I am with Negro
literature, I was not prepared for this abundance of excellence. Who
can doubt that the Negro has arrived?" No one suspected then that
four months later the Urban League would declare the contests sus-
pended. With the "gold-mirrored dining room" of The Fifth Avenue
Restaurant filled with dignitaries, and Charles Johnson rapping for
order after dessert and coffee to introduce John Dewey, civil rights art
seemed more vital and triumphant than ever. But it was in fact the
beginning of the end of the first phase of the Renaissance.

In retrospect, a trailing off of Charles Johnson's enthusiasm was
presaged in remarks about the "too hasty work in certain categories,"
for although there were more contestants now than ever (many from
"beyond the limits of recognized culture centers"), the high quality
and famous names of previous years were missing. One of the white
judges, Professor Daniel Gregory Mason, wrote to a former Urban
League officer of being so disappointed "as to the quality of the work
forthcoming that I must ask to be excused from further service of this
kind." Johnson may have thought that a year's suspension would allow
"potential participants more time for careful work on their manu-
scripts." Even so, some of the 1927 entries were impressive. There was
the long Bontemps poem "The Return" (patterned on Cullen's "Heri-
tage"), which won a second Pushkin prize. "When De Saints Go

Ma'ching Home" by Sterling Brown won the Washington poet a first prize. "Summer Matures" won second prize for Helene Johnson from Boston, and the play "Plumes" by Georgia Douglas Johnson took a first.

The suspension was in fact more a matter of money than of artistic and literary decline. At the beginning of 1927, Van Vechten could write of *Opportunity* itself that it was "no longer fair to merely say that it is better than any Negro periodical. As a matter of fact, it may now be favorably compared with practically any magazine of a similar character published in the United States." Yet, despite its wide influence and impressive standards, *Opportunity* sold a mere eleven thousand copies a month during its peak circulation period—1928—and 40 percent of these were to whites. This was a far cry from the sixty thousand copies monthly of *The Crisis. Opportunity* had been kept afloat largely from funds allocated by the Urban League to Charles Johnson's Department of Research and Investigation. These funds came from a five-year Carnegie Corporation grant of eight thousand dollars annually. At the close of 1927, explaining that the Urban League ought now to be able to support its own publication, Carnegie declined to renew its grant. When his friend Julius Rosenwald refused to fill the breach, Johnson began to ponder returning to academia. Before reaching a final decision, however, he busied himself editing an anthology of Renaissance prose and poetry, *Ebony and Topaz*, published by the Urban League that year. Locke's *The New Negro* had heralded the Renaissance; Johnson's preface to *Ebony and Topaz* stated that its momentum was now assured. He also offered the olive branch to the *Fire!!* rebels. Echoing Hughes's manifesto in *The Nation*, Johnson announced that contributors to his anthology were "much less interested in their audience than in what they are trying to say, and the life they are trying to portray." The movement was well under way, he continued, and its artists were "now less self-conscious, less interested in proving that they are just like white people. . . . Relief from the stifling consciousness of being a problem has brought a certain superiority to it." Johnson's sentiments were as optimistic as they were commendable. In mid-March 1928, having made this notable effort toward the fulfillment of his own prophecies and four years to the month after his first Civic Club invitation, he left the Urban League for Fisk University's sociology department.

Meanwhile, there were problems at *The Crisis*. After Jessie Fauset's resignation, literary matters were handled more and more raggedly.

Langston Hughes was dismayed to see some poems he had been told were lost appearing in the magazine in late 1927. "I don't think they are quite good enough to be there, so please throw them in your waste-basket if there are any more," he begged Du Bois. McKay was out-raged the next summer to see in print three-year-old material that "I beseeched you over a year ago not to publish." Sterling Brown was satisfied with the quality of his *Crisis* poems, but could not imagine how they came into Du Bois's possession. More than the efficient hand of Fauset was missing. The more general cause was Du Bois's deepening aversion to current literary trends—the rising tide of the Van Vechten School. Julia Peterkin's *Black April* and Claude McKay's *Home to Harlem*, best sellers of 1927 and 1928, were biracial lashes that drove Du Bois to agonize about "the Scylla of prudery and the Charybdis of unbounded license." He had nothing against realism in art, no inflexible distaste for fictional characters drawn from Deep South plantations or Black Metropolis tenements, but "other sorts of Negroes do not interest [white readers]," he complained, "because, as they say, 'they are just like white folks.' But their interest in white folks, we notice, continues."

Then, too, as with *Opportunity*, there was a falling off in quality of the 1927 *Crisis* prizewinners and a decline in the renown of the judges. Turning *The Crisis* back to hardheaded coverage of business and poli-tics took time. Mrs. Amy Spingarn's six-hundred-dollar annuity (first in her own name, then in Charles Chesnutt's) was the mainstay of the literary competition. Perhaps the experiment "has already accom-plished the purpose for which it was intended," she suggested in Janu-ary 1928. Perhaps Du Bois "could suggest an equally interesting plan to which I would be sympathetic." Delighted by the opening, Du Bois suggested that the annual prizes, special judges' panels, and Downtown banquet be dropped. Instead, monthly honoraria of fifty dollars would be awarded to the best literary pieces. Amy Spingarn must have been surprised to see white writers Zona Gale and Clement Wood among the first recipients of prizes intended for ambitious Afro-American writers. By the end of the year, Du Bois had moved the literary prize announcements to the bottom of his "Postscript" column. After No-vember 1928, they were never mentioned again, and *The Crisis* left arts and literature altogether.

Meanwhile, Du Bois presented Harlem with two strenuous examples of the union of virtue and art—a novel, *Dark Princess*, and a wedding, his daughter's. Neither was a success. *Dark Princess*, which Du Bois

himself called his favorite book, appeared in September 1928. It was a bouillabaisse of fantasies from Pan-African congresses, Eastern cultures, and Debsian socialism, literary strains from Scott, Carlyle, Zola, and Sutton Griggs, and an utter determination to counteract the moral rot and political irrelevance of the *Nigger Heaven* school. Something, after all, had to be done to stop the young writers from believing that the best course was to follow "the lead of Carl Van Vechten and Knopf and Boni & Liveright and cater to what white America thinks it wants to hear from Negroes."

The protagonists of *Dark Princess*, an Indian princess and a Hampton graduate, pass from Europe to the United States, through improbable experiences with the Garvey movement, Illinois politics, and union organizing, to the final priming of a global conspiracy of the Great Council of the Darker Peoples to overthrow European imperialism. Kautilya, the strong-willed, resourceful princess of Bwodpur, bears a son out of wedlock, Madhu, the new maharaja, and is united at last with Matthew Towns, the noble but manipulated Afro-American. Hero and heroine marry. *Dark Princess* won polite notice in Harlem and beyond. George Schuyler's enthusiasm may have been unique. He thought it was fine literature and "great as a portrayal of the soul of our people." That was exactly what it was not. By statement or example, the novel's characters reiterate Du Bois's doubts about the lack of direction of Afro-America. It is the other darker peoples, from lands where learning is ancient and lineages are royal, who prepare the way for their American cousins—and also for black Africa. Du Bois, now in his sixtieth year and as unrelenting as ever in decrying racism, closed his novel on the less than terrific news that the Great Council of the Darker Peoples has voted to admit Afro-America.

But exegesis of *Dark Princess* was a low priority for Harlem. People were much more interested in the marriage of Yolande Du Bois and Countee Cullen than in the social philosophy of a bulky novel. If there is no character in Du Boisian fiction who is clearly modelled on the real Yolande Du Bois, her fate was, nevertheless, ordained by those exalted ideals of womanhood portrayed in her father's novels—by Zora in *The Quest of the Silver Fleece* and Kautilya in *Dark Princess* —vigorous, intelligent women who dominate and guide their noble, well-meaning mates. Unfortunately, Nina Yolande Du Bois was outstandingly ordinary—a kind, plain woman of modest intellectual endowment. But she was the sole surviving child of one of the country's most accomplished men of color, whose impatience before the

ordinary was legendary. Du Bois loved his daughter deeply, as his letters show; but it is unlikely that he ever truly knew her. In 1914, with assistance from his friend (and the future prime minister) Ramsay MacDonald, he had enrolled Yolande in Bedales School, one of England's finest preparatory academies. Fourteen years old and bewildered, she did her best, while her father outlined her opportunities and diagrammed her duties in lengthy written encouragements. "Above all," she must remember her "great opportunity. You are in one of the world's best schools, in one of the world's greatest modern empires." Millions would "give almost anything" for Yolande's place. He knew she was lonely, the occasional object of curiosity and bigotry, but he commanded her—in the very prose put into the mouths of his fabulous fictional heroines—to succeed:

Take the cold bath bravely. Enter into the spirit of your big bed-room. Enjoy what is and not pine for what is not. Read some good, heavy, serious books just for discipline: Take yourself in hand and master yourself. Make yourself do unpleasant things, so as to gain the upper hand of your soul.

Above all remember: your father loves you and believes in you and expects you to be a wonderful woman.

Later, at Fisk, she coasted along in the fine arts, taking her degree with what her father judged to be "reasonable credit" in 1924. Then she became better acquainted with "Mr. Cullen," whom she had met during the summer of her junior year. "I like to hear him talk," she told Harold Jackman. They read Millay's poetry together, and he seemed "so young"—both he and Jackman—"no other word expresses just what I mean." Whatever she meant, it was not romantic love. Harlem clubwomen knew that Yolande Du Bois was infatuated with bandleader Jimmy Lunceford, one of the young pioneers of swing. Nevertheless, she and Cullen were married by the groom's father on April 9, 1928. Guests arrived from distant states, and Harlem notables trembled at the thought of not being invited to the reception at the Walker Studio. Salem Methodist Church was packed well before six, while the size of the crowd outside suggested a sports event rather than a nuptial. Sixteen bridesmaids beautified the church, while Arna Bontemps, Langston Hughes, Edward Perry, and others ushered such distinguished guests as the James Weldon Johnsons, the Eugene Kinckle Joneses, Charles Johnson, Mary White Ovington, and various Spingarns to their pews. Great waves of sound reverberated as Dr. Melville

Charlton, organist at Union Theological Seminary, rendered *Tann-häuser*, *On Bended Knee* by Harry T. Burleigh, and the *Lohengrin* bridal march. A short, awkward honeymoon in Philadelphia followed.

With a second volume of poetry out within less than a year (*Copper Sun*—dedicated to "The Not Impossible Her"—Yolande) and a Guggenheim fellowship stipend in hand, the new husband sailed for studies in France on June 30. He, his father, and Jackman, his best man, travelled together, leaving the bride to find her own way to Paris later. When she arrived at summer's end, the Cullen marriage broke up promptly, with fact and rumor showering Harlem parties like shrapnel. "I wouldn't stand for all that foolishness," Jackman wrote after learning that Yolande had taken along the phonograph key when she entered the American Hospital for treatment of an undisclosed illness. Du Bois agreed. He knew his daughter was "spoiled and often silly," that their honeymoon had been "trying," but he had expected her—just as at Bedales—to pull herself together. Clearly, she was no Princess Kautilya, but a weakling unworthy of sharing the destiny of Afro-America's poet laureate. "At any rate," Du Bois sighed, "keep her till Christmas if any way possible and then—God show us all the way." Perhaps the problem was "physical and psychological"—a mere matter of sexual compatibility—Du Bois continued to speculate in one distraught letter after another to his daughter's husband. Her mother had so shielded her, he confessed, that Yolande's sexual initiation could not "have failed to have been unpleasant and disconcerting." "Try," he begged, "for the sake of the great love you gave her—try to make this crisis of her broken life as easy as you can." When marriages failed, men of Du Bois's generation first blamed the wife. That his son-in-law was far more ill-suited to the demands of matrimony than his own daughter, he did not allow to cross his mind. By January, it was over, with Jackman clucking, "Well, well, well, I didn't think it would be so soon, really." Du Bois reaffirmed his understanding, promising his ex-son-in-law permanent welcome in the pages of *The Crisis*.

Walter White left New York aboard the S.S. *Carmania* on July 23, 1927, with Gladys, daughter Jane, and two-month-old son Walter Carl Darrow. With a Guggenheim fellowship and an eighteen-month leave from the NAACP, White was off to make a career as a writer. Joel Spingarn was astonished that the associate secretary seemed ready to "give up what I had thought to be your life-work," but writing fiction, as White had half-seriously said to Mencken earlier, was a

"chronic disease." His fellowship proposal of a three-generation novel set in the American South had been intended to prove to himself and the critics that he possessed sufficient imagination and discipline to become a professional writer of fiction. Rebecca West and G. B. Stern had told them about a settlement on the Riviera, "the one place worth living in which British and American tourists haven't invaded." A few days in Paris, one unforgettable night at William Aspenwall Bradley's apartment where Isadora Duncan danced to a Paul Robeson record ("her weight and age seemed to disappear"), and they were away to Villefranche-sur-Mer and the perfect villa—an eight-room hideaway with two balconies, a terrace, servants' quarters, and *chauffage central* "for two-hundred and fifty dollars a year!" They practiced their French, met beautiful, sophisticated people, made shopping and theatre sorties to Nice, and passed languorous hours in sunlight streaming from the Mediterranean. Some of the first letters to James Weldon Johnson and the Spingarn brothers reflected an understandable absence of urgency: "All in all, it is by far the loveliest place we have ever seen." Then, almost overnight, Villefranche was full of tourists and the cost of living skyrocketed. Reluctantly, the Whites broke the lease on Villa Home Sweet Home and moved to Avignon, where they found a comfortable second-floor apartment belonging to a furniture dealer.

Meanwhile, the novel floundered after two chapters. It was to have been woven from a vast tapestry with "a powerful and ruthless man, a Negro," as central, tragic figure. In January 1928, White could still muster enthusiasm in a letter to Arthur Spingarn, describing his protagonist as modelled on an Atlanta friend who was now a well-known lawyer and Marxist:

The clash comes not between him and the whites but with another Negro who plays the game with him for a time but who eventually breaks with him. The main guy, his back against the wall, uses the Klan to get rid of his opponent—but his own son whom he worships and for whom he works and centers his ambitions gets caught. No one knows except himself but the blow is too great and starts a deterioration which at first is slow and then plunges swiftly.

William Aspenwall Bradley had forwarded portions of McKay's novel for criticism, and James Weldon Johnson sent news about forthcoming novels by Du Bois, Fisher, Larsen, and Walrond. "That lineup is stiff competition," White wrote Arthur Spingarn, "so don't hold too much

hope for me." By February 1928, White had shelved his novel. In its place there was a draft of a historical and psychosocial book on lynching, *Rope and Faggot*. "We are too good friends for me to substitute flattery for the honest and frank criticism you ask for," a disappointed Arthur Spingarn wrote after reading the draft. He and James Weldon Johnson urged a large number of helpful revisions, while Charles Johnson offered several cogent analytical improvements. *Rope and Faggot* was the first study of its kind, occasionally perceptive, provocative, critically well-received and widely read when Knopf published it the following year—but not memorable. It was during completion of his first draft that a cablegram arrived from Charles Studin, Arthur Spingarn's law partner, asking White to return from France to play a role in Al Smith's presidential campaign. The appeal of a writer's career had not quite worn off, and White hesitated about official involvement in national politics. One meeting with Governor Smith was all Studin asked; a round-trip ticket was promised; NAACP leadership (except Du Bois) appeared to give its unofficial blessings.

On April 11, the associate secretary of the NAACP hurried down the gangplank of the S.S. *Ile de France* and was whisked off by Studin to the apartment of the remarkable Belle Moskowitz, widow of Henry, prominent philanthropist and a founder of the NAACP. Mrs. Moskowitz was Governor Smith's power broker. Having chosen an Arkansas senator as running mate in order to allay southern horror of a Catholic who favored ending Prohibition, New York's Democratic governor had been advised that the Negro vote was crucial to victory. Smith wanted White to take leave from the NAACP and manage a separate campaign organization, Belle Moskowitz explained in her usual effervescent way. White had already decided that Republicans would make Afro-Americans no promises, that the party took their vote for granted, and that Herbert Hoover would be a calamity for the race. Before leaving Avignon, he had written Studin enthusiastically about backing Smith "without reservations." Smith's enemies, moreover, were "the Negro's enemies, and there has never been so excellent an opportunity to appeal to Negroes to end their chronic Republicanism." The Spingarns agreed, and Belle Moskowitz was of course delighted with their assessment ("When I want to know something about negro movements, I take the liberty of addressing you," she wrote Arthur Spingarn). Moorfield Storey, the president of the NAACP, agreed. With reservations, so did James Weldon Johnson.

The Democrats and the NAACP (over Du Bois's objections) struck

a bargain in Albany. Smith was to declare publicly and unequivocally that he would be president of *all* the people, that he was opposed to racism. Privately, White informed a skeptical board member, "we will be given more specific pledges." It was even probable that the future of the NAACP turned on this election, White suggested. Booker Washington's successor was managing Hoover's campaign in the Afro-American community. If Hoover was elected, Robert Russa Moton "will be practically to him what Booker T. Washington was to Roosevelt. If Smith is elected, the NAACP will be the power behind the throne." White, NAACP's second-in-command, only awaited news from Albany that Al Smith had accepted the agreement before formally requesting the willing board to extend his leave of absence. It never came. Senator Joseph Taylor Robinson, Smith's Arkansas running mate, and several trusted strategists had dissuaded the governor from making any pledges on the racial issue. Smith sent word that he had not changed his heart, only his promises. He wanted White more than ever. Mrs. Moskowitz begged White to take her candidate on faith. Venerable Moorfield Storey urged James Weldon Johnson to "tell White to do what Smith wants him to." The Spingarns struck an attitude of all-purpose wisdom. James Weldon Johnson rapidly reversed himself. For just a few days, White was tempted to work with Smith as the lesser evil, until the weight of his own good sense and firm advice from senior friends like Clarence Darrow and African Methodist Episcopal Bishop John Hurst prevailed.

By the end of July, the Smith flirtation was finished, and so was the Guggenheim fellowship. Sending for Gladys and the children to join him at 409 Edgecombe Avenue, he wrote Moorfield Storey resignedly, "Frankly, I see no solution of the dilemmas which the Negro voter faces." Harlem went for Hoover. Hubert Delany, its Republican candidate for the House of Representatives, lost. What consolation it could the community took from Afro-American Oscar De Priest's Chicago congressional victory.

When DuBose and Dorothy Heyward transformed *Porgy* into a play, and staged it for the first time on the night of October 1, 1927, it was a joyous moment in Harlem. If Brooks Atkinson of *The New York Times* and Countee Cullen of *Opportunity* were less than enthusiastic ("I wonder if we just naturally must sing all the time"), Alexander Woollcott of the New York *World* seemed to speak for everybody else in New York—Uptown and Downtown. The owlish high priest of the-

atre criticism bubbled over his "evening of new experiences, extraor-
dinary interest and high, startling beauty. In a dozen years of first
nights," it was the most innovative production he had seen. Everybody
in Harlem seemed to know someone in the cast—Rose McClendon,
who played Serena; Georgette Harvey, Maria; Evelyn Ellis, Bess;
Leigh Whipper, who doubled as the Crab Man and the Undertaker;
Percy Verwayne, Sportin' Life; Jack Carter, Crown; Frank Wilson,
who played Porgy. Richard Bruce Nugent, Wallace Thurman, and a
goodly percentage of the Dark Tower's bohemians made up the popu-
lation of "Catfish Row." *Porgy* played to Broadway audiences, and
only the swells from Striver's Row could afford the ticket or muster the
self-confidence to see the play at the segregated Guild Theatre. But
Porgy was Harlem's play. Everyone knew that when director Rouben
Mamoulian found the flavor of Catfish Row eluding him, Leigh Whip-
per had brought him to Harlem's storefront churches for a quick study.
The high-stepping music of the Jenkins Orphan Band had been another
Whipper contribution. By the time Paul Robeson replaced Carter in
the role of Crown for a month, before leaving for the London produc-
tion of *Show Boat* in early 1928, Harlemites knew the lines of the play
almost as well as the understudies did.

In February, the Princess Theatre opened another window onto
Harlem. It was said that Frank Wilson's play *Meek Mose* provided
employment for every professional Afro-American actor and a few
relatives besides. Frank Wilson hardly needed work himself; *Porgy*, in
which he played the title role, was to run eight hundred fifty perfor-
mances. *Meek Mose* was not a high point in terms of either drama or
content; even Brooks Atkinson was annoyed by its extreme racial
stereotyping. But Harlem was too gratified at the sight of a "Negro"
play on Broadway by one of its own to be critical. His honor, Mayor
James Walker, addressed the opening night audience; Harlem Alder-
man Fred Moore and Major Moton of Tuskegee shared a box. During
intermission the *Tattler*'s Geraldyn Dismond "caught a glimpse of . . .
Otto Kahn, Max Reinhardt, Alexander Woollcott, Lloyd Thomas,
Nella Imes, Dorothy Peterson, Taylor Gordon, Harry Burleigh, Arthur
and Amy Spingarn," and the abrasive George Schuyler who "displayed
his weakness" by squiring a white female from Texas.

The following month, Harlem was excitedly commenting on the
Hampton Institute concert at Carnegie Hall, sponsored by George
Foster Peabody, Percy Grainger, Walter Damrosch, and other mem-
bers of the Society of the Friends of Music. Professor Robert Nathaniel

Dett's ninety-voice choir sang spirituals and Russian religious songs
with such icy precision that the proud but concerned *Tattler* wrote of a
"restraint which should be divorced from Negro folk songs sung by
Negroes." But the next Carnegie Hall event was a triumph in which
black and white New Yorkers shared equally. With choir and orches-
tra, W. C. Handy gave a concert-lecture on the origins and develop-
ment of Afro-American music. *Blackbirds of 1928*, the musical that
both theatre business circles and informed Harlemites expected to dis-
appear in the long shadow cast by the death of Florence Mills the
preceding November, was also a tremendous success. It capered on
through five hundred delirious curtains, with Bill "Bojangles" Robinson
dancing his Broadway debut and songs like "Diga Diga Doo" and "I
Can't Give You Anything But Love" proving Lew Leslie had been
right to gamble on the show.

Less than three years before, *Variety* had yawned through a nocturnal
Harlem sortie. By late 1929, it found the scene much changed: Har-
lem's "night life now surpasses that of Broadway itself. From midnight
until after dawn it is a seething cauldron of Nubian mirth and hilarity."
"You go sort of primitive up there," Jimmy Durante—certainly an
expert—warned, "with the bands moaning blues like nobody's busi-
ness, slim, bare-thighed brown-skin gals tossing their torsos, and the
Negro melody artists bearing down something terrible on the minor
notes." Comedian Durante added, "The average colored man you see
along the streets in Harlem doesn't know any more about these dumps
than the old maid in North Forks, South Dakota." Lady Mountbatten
knew these "dumps," though. *Variety* said she was a frequent visitor,
and it rejoiced that she could now choose from "eleven class white
trade night clubs" in Harlem. A few of the early cabaret centerpieces
had disappeared or been eclipsed. Ma Theenie's, where comedian Bert
Williams had watered, and the Lybia, which had fascinated Rudolph
Fisher, were gone, while Barron's survived under other names. (Its
aggressive owner had been stabbed to death one morning early in 1926
by "Yellow Charleston," fulfilling, some said, a contract from the mob.)
Almost alone of the old, well-established clubs, Leroy's barred most
white trade. Barron Wilkins's brother was a proud, brooding man
given to piano renditions of classical music in private. Only a few white
friends of the proprietor were welcome at his club, or spendthrift out-of-
towners occasionally brought along by an old, battered ex-boxer,
"Sippi," the only Afro-American horse-and-buggy driver in Central

Park. Persistence, contacts, and money were equally necessary to obtain entry to the transvestite floor shows, sex circuses, and marijuana parlors along 140th Street. Phil Harris, Mae West, and Van Vechten did; for most whites, though, this was unknown country.

Bamville, Connor's, Mexico's, and Tillie's Inn, with their deft mixture of black and tan swank and raunch, were booming—as were most of the clubs in "The Jungle" (133rd Street) and elsewhere that sought white clients enthusiastically, sometimes even fawningly. At the Clam House in The Jungle, a mixed audience came to watch Gladys Bentley, "pianist and torrid warbler." Ed Smalls' Paradise with its steep prices and dancing waiters was now the most prestigious night club owned by Afro-Americans, though the "very luxurious and expensively fitted out" Nest Club probably offered better music and a finer ambiance. Two blocks above, Pod's and Jerry's Catagonia Club had captured Willie "the Lion" Smith from Leroy's. Fascinated and reverent, a young clarinetist named Artie Shaw joined its band without pay. "There I found temporary haven," he wrote gratefully. And there Bix Beiderbecke, Hoagy Carmichael, and Benny Goodman, the Dorsey Brothers, Jack Teagarden, and Paul Whiteman found the music each was making his own. "P & J's" was the early morning watering hole of Mae West, Beatrice Lillie, Lucille Le Sueur (Joan Crawford), Tallulah Bankhead and her Harlem beau George, as well as Texas Guinan, Jimmy Walker, Al Smith, and Fiorello La Guardia.

The Cotton Club—Harlem's gaudiest and best-known nightspot—was virtually unknown territory to Afro-Americans. What began in 1918 as the Douglas Club and turned in 1920 into prizefighter Jack Johnson's Club Deluxe reopened in the fall of 1923 as a white sanctuary. W. C. Handy himself was turned away one evening while the sound of his music blared inside. Now and then, very light Afro-Americans were given the green light by the manager, George "Big Frenchy" Demange. Otherwise, the only Harlemites seen by seven hundred white revellers each night were high-stepping, high-yellow chorines ("Tall, Tan and Terrific") and tuxedoed musicians belonging to Andy Preer's or Duke Ellington's orchestra. Owney Madden and his Chicago mob backers were interested in money, not racial progress, an attitude welcomed by many guests: as Jimmy Durante explained, "Nobody wants razors, blackjacks, or fists flying—and the chances of a war are less if there's no mixing." When the Dusenbergs and Stutzes discharged an Ann Pennington, Emily Vanderbilt, Bobby Coverdale, or

Sailing Baruch under the Lenox Avenue canopy, "brutes" who caused Van Vechten to wince stood ready to pounce upon interracial or even suspiciously swarthy couples.

Cotton Club shows were Ziegfeldian in their gaudiness, and almost too athletic to be sensuous, with feathers, fans, and legs flying in time to Ellington's tornado renditions of compositions like house songwriter Jimmy McHugh's "When My Sugar Walks Down the Street." Bessie Dudley and the freakishly flexible Earl "Snakehips" Tucker gyrated like dervishes by the hour and lovely Edith Wilson sang herself hoarse. Part of the inspiration for those Langston Hughes poems about happy performers weeping as the sun rose must have come from the Cotton Club. Behind the glitter and the musical scores by Harold Arlen and Ted Kohler were gruelling rehearsals, marathon performances, cramped basement dressing rooms, and the gloved fist of Alphonse Capone's mob to make and break contracts. For all its generosity to an Ellington or a Calloway and its Christmas charities, what the Cotton Club offered was barbarism—exotic, explosive, and caged. When Cab Calloway's Missourians temporarily replaced Ellington's orchestra in early 1930, club performances seemed almost to exceed the limits of physical stamina. "Celebrity nights" became panting, jumping spectaculars of costume and cacophony with champagne-soused patrons hoping the bandmaster would repeat his famous fall from the orchestra platform. By then, weekly celebrity nights were radio-broadcast.

Connie's Inn, hard by the Lafayette Theatre on Seventh Avenue, appeared to be somewhat different. Dark faces were almost as scarce there as in the Cotton Club, but the Immerman brothers, Connie and George, were warmer types, stylish high rollers with roots in the community. Before buying and renaming the old Shuffle Inn basement club, the Immermans had run a Harlem delicatessen where Fats Waller worked as delivery boy. They knew and understood Harlem, recognized faces and spoke the argot, and the music at their place was musicians' music—not always as polished as Ellington's or as gymnastic as Calloway's, but sometimes more original. The Immermans opened Connie's to musicians from other clubs for early morning jam sessions, something unknown at the haughtier Cotton Club. Outside the club's door, bestowing upon it a unique communal tie, stood the Tree of Hope, an aging elm that was Harlem's talisman and labor exchange. Mythology held that to rub its bark brought success; the reality was that news of jobs and employers' agents passed that way. At one time or another, almost every actor, singer, or musician in Harlem

found work after a vigil under the Tree of Hope, many just a few steps through the portal at Connie's.

By 1929, the Immermans' club was, for some tastes, superior to the Cotton Club. Connie's *Hot Chocolates*, the show that carried Andy Razaf's lyrics, Fats Waller's music, and Louis Armstrong to Broadway, soon had America humming "Ain't Misbehavin' " and "Can't We Get Together?" The show also featured Harlem's most attractive married couple, the lithe, bronze Bahamian dancers Paul and Thelma Meeres. They were favorites of the *Tattler*, which photographed them, immaculately attired, beside their splendid Packard runabout—"the spiffiest thing lately."A New York *Daily News* article reported that under the red canopy and into the cramped basement of Connie's flowed such celebrities as Mark Hellinger, Jack Pickford, Gertrude Vanderbilt, Harry K. Thaw, and Arthur Flegenheimer, alias "Dutch" Schultz, who may have been the principal investor. "It's merely Texas Guinan's with a colored orchestra," said the *News*. "And the guests . . . are mainly graduates of the Guinan school of spending. All of which is a nice break for Connie." At an average tab of fifteen dollars per person, it was nice.

People rose in Harlem each day to go to work, many of them before the last white revellers had careened homeward. The great majority never saw the interior of a night club. Many would have spurned a free night on the town from religious or moral certainty that the devil himself was the club proprietor. Like any young immigrant community, most of Harlem was sober and hardworking. Those with money and inclination to roam Lenox and Seventh avenues or The Jungle until the crack of dawn probably represented well under 10 percent of the total. Yet it must be said that many who worked hard also played hard, that many of Harlem's memorable nights took place in houses and apartments; that among those who closed Pod's and Jerry's or Smalls' were some of the most popular and prominent Harlemites; and, finally, that no other community has left such a copiously detailed printed record of its daily society life. Almost to the hour, it is possible to reconstruct most of it. And it is certain, from format, quantity, and data, that it was the flashy, party-giving aspect of the news that sent Harlemites to their newsstands. After all, as that elegant high-hatter Harold Jackman complained, "Why, every dance I go to these days I see more people I don't know than those I do know." Reading the *Age*, *Amster-*

dam News, Tattler, and, by spring 1929, *Dunbar News* was a prerequi-
site to a confident stroll down Seventh Avenue.

The soberer architects of the Renaissance were being upstaged by its
exhibitionists, by persons whose lives consisted of going to, or giving,
and recovering from parties. It was the time of Jules Bledsoe and
Taylor Gordon, Afro-Americans who might have been invented by
Van Vechten. Taylor Gordon was a very dark decadent, born in White
Sulphur Springs, Montana, in 1893, perfect subject for Covarrubias
drawings, and the object of affection of Muriel Draper and the Van
Vechtens. When Gordon's autobiography appeared in 1929, Draper
and Van Vechten wrote extravagant prefaces, the former declaring,
"His utterance is as spontaneous as the circulation of blood in the
human body," and the latter comparing Gordon's *Born to Be* with
Twain's *Huckleberry Finn.* Gordon returned Van Vechten's compli-
ment as extravagantly, praising him as "the Abraham Lincoln of negro
art." Taylor Gordon was supposed to be a singer, and he did sing. He
and Rosamond Johnson made a concert tour of America and Europe
together in 1927. But it was much less Gordon's voice than his roguish
personality that captivated white admirers. Spontaneous, amoral, ir-
reverent, yet respectful, always ready with a song or an outrageous
remark about his own race, to much of Park Avenue and the Village
he was everything Roland Hayes or Paul Robeson was—irritatingly—
not. He greatly distressed respectable Harlemites. Yet, they forgave
him and clamored for invitations to his parties. Gordon "gave the best
party that I have been to in some time," Jackman, a connoisseur of
parties, wrote Cullen. "Good music, plenty to eat (this is for you) and
elegant people—the fays couldn't dance worth a cuss—stepped all
over your feet—rhythm, what is rhythm to them?"

Jules Bledsoe was "a dressin' papa these days," Jackman wrote his
best friend in Paris. "His suits are beginning to fit him and he looks
quite English (if you can imagine that Texas bull looking English)."
Each of baritone Bledsoe's parties—and they were numerous—was "a
jam of a party and worthy of the great Jules," testified the *Tattler.* The
one during summer 1928 to christen his lavish new apartment was
attended by Mayor James Walker, theatrical producers Hugo Romberg
and Caroline Regan, Muriel Draper, Taylor Gordon, Harold Jackman,
and newlywed Countee Cullen. When Bledsoe glided by a few months
later in his sky blue Packard, piloted by a uniformed white chauffeur,
Jackman said the Harlem press devoted editorials to the spectacle. The
singer's farewell party for his sister, at summer's end the next year, was

another classic of the genre, with "flowing bowl! Several bowls in fact," Alvin Cobb on saxophone, a "complete musical ensemble," and Walter and Gladys White, A'Lelia Walker, Harold Jackman, Bessye Bearden, "and many another who cannot be recalled at 3:00 a.m."

Dainty Carolyn Hughes Clark, Langston Hughes's mother, was in a different league from the lordly Bledsoe, but she established a reputation for carousals while visiting Harlem. Another visitor who presided over memorable evenings was the Princesse Violette Murat. Jackman had met her the summer he and Cullen sailed away to Paris without Yolande Du Bois. Fascinated by what she heard, this bluest of Bonapartist bluebloods promptly left for New York, commuted to Harlem as regularly as Van Vechten, and dazzled all those whom Jackman, her majordomo, caused to be favored with an invitation. The princess was unattractive (Cullen called her "Princess Muskrat") and perhaps too fond of women for some Harlemites, but after her party for Léonide Massine and the Diaghilev Ballet, Sugar Hill adored her. As for Jackman, he was being sculpted by Alain Locke's newest discovery, Richmond Barthé, lording his new nobility-by-association over Harlem, and "gradually acquiring . . . a French accent." The princess was introduced to the Dark Tower, found its mistress delightful, and Mayme White, A'Lelia's friend, especially attractive. She stayed on until September 1929.

Du Bois's disdain for the frivolous and undignified was so widely known that The Messenger once satirized him as "the well-known astrologer who erstwhile dwelt apart from the world in an ivory tower." It was no secret that in his private life Du Bois was almost rakishly aggressive with women, but the public man was usually stiffly above reproach. Sometimes, nevertheless, obligatory occasions forced him down from the tower, such as the annual rite of integration—the NAACP ball. What he thought of "Bojangles" as master of ceremonies and Earl "Snakehips" Tucker and "Peg Leg" Bates as entertainers was not recorded by the Tattler's account of the 1927 ball. There was one occasion, at least, when even Du Bois was swept up in the mood of the era. The Messenger, his competitor journal, maliciously described a social evening in honor of the Krigwa Players, the dramatics group founded by Du Bois: "Our leader had his beard brushed and his skull well oiled for dancing. When somebody brought in a sugar-fingered mama and introduced her to the piano, [Du Bois] led off the festivities in a manner well-becoming a scholar and a cosmopolite and, I wish I could say, a competent drinker." Even Puritans had loose moments.

With everyone stomping at the Savoy, Harlem, like the rest of the nation, seemed to be heedlessly and happily rising on a wave of good times. When the young English photographer Cecil Beaton arrived in New York, he found most of his friends, including Adèle Astaire, taking dancing lessons in Harlem. The Lindy Hop began at the Manhattan Casino in 1928, and later that year the Alhambra, an architectural jewel with a million-dollar ballroom, opened on 126th Street, vesting Harlem with yet another palace of dance and joy. It was generally occupied by whites and blacks on different nights. That same month (October), after celebrating its first anniversary, the Dark Tower closed. Geraldyn Dismond wept: "The idea of closing the Tower is all wrong," but A'Lelia said she was fed up with the expensive experiment of a private club. For a while, recitals were heard at the Walker Studio. Muriel Draper, Augusta Savage, Richard Bruce Nugent, Taylor Gordon, Porter Grainger, and John W. Work (the latter two, noted musical arrangers) attended a classical piano recital in August. They could have heard the recitalist "many times and yet not been bored," an obviously bored Dismond wrote. After a year, the lights went on again in the Dark Tower. "It will be wise for you to reserve your plates in advance," advised the happy *Tattler*. The following month, it was as though there had never been a hiatus. "A'Lelia Walker, herself, played hostess," Dismond bubbled over. "In addition to the Harlem habitués of the Tower were Fania Marinoff, Carl Van Vechten, Carlo Mills, Eddie Wasserman, Miguel Covarrubias. . . ." A'Lelia's reopening of the Tower came three days after Wall Street's worst hemorrhage—Black Thursday, October 24, 1929.

By the time Marcus Garvey left Atlanta's federal prison in December 1927, even bitter foes like Du Bois had softened toward him, and the Afro-American press was filled with compassionate afterthoughts. He had been a boon to the "dark, dumb masses," *Opportunity* declared in tones solemn enough for an obituary. Pardoned by President Coolidge after serving nearly three years of a five-year sentence for mail fraud, the Black Moses was deported immediately to Jamaica. Garveyites—orthodox and dissident—still marched the streets and congregated at Harlem's Liberty Hall, but the Jamaican's career and great movement had been destroyed by forces in London, Paris, and Washington, and by the gross shortcomings of his own leadership. Harlem's Talented Tenth was much too busy celebrating its uncontested ascendancy to worry much about the implications of the rise and fall of Garvey's UNIA. A class euphoria had enveloped the upper

crust in a warmth as secure as the raccoon coats it wore to Howard-Lincoln football games. The signs of racial progress, though still isolated, were certainly on the increase.

In the legal arena, there had been the much-publicized victory of the NAACP in the Sweet case, early in 1926. On the night of September 9, 1925, Ossian Sweet, a young Detroit physician, and his two brothers opened fire as a mob charged the home just purchased by the doctor in a white neighborhood. A white man was killed. It had taken two trials, nearly eight weeks of actual courtroom drama, almost forty thousand dollars, countless NAACP man-hours, and two of the nation's best trial lawyers—Arthur Garfield Hays and Clarence Darrow—to win acquittal for an upper-middle-class Afro-American family that had dared to exercise a fundamental right. Nevertheless, the NAACP *had* won, and there were other encouraging signs. On March 7, 1927, Justice Oliver Wendell Holmes of the United States Supreme Court delivered the majority opinion denying Texas the right to establish white Democratic primaries. "States may do a good deal of classifying that it is difficult to believe rational," the court declared, "but there are limits." Again, the NAACP had won—at least in the courthouse if not yet in an actual Texas polling booth. At the close of the year, the Atlanta *Constitution* congratulated the state of Georgia for getting through the year without a single lynching. From Virginia came news that, at Governor Byrd's bidding, the legislature had approved a bill requiring any jurisdiction in which a lynching occurred to pay the victim's heirs a fine of twenty-five hundred dollars.

The Afro-American press excitedly monitored the multiplying success stories of bankers, insurance company founders, real estate brokers, and rich professionals. In Indianapolis, construction was well under way on the million-dollar plant of Madame C. J. Walker Manufacturing Company, while in Chicago the race's two largest banks—the Binga State and the Douglass National—were sharing fully in the paper prosperity of pre-Depression days. *The Crisis* and *Opportunity* detailed the astonishing growth of the Colored Merchants Association (CMA). Organized in Alabama under the auspices of Robert Russa Moton's National Negro Business League, CMA stores soon spread to Harlem. Asa Randolph's uphill struggle to win union recognition for Pullman porters was still uncertain in summer 1928, but if fiery editorials in the New York *Evening Telegram* could have decided the issue, columnist Heywood Broun would have deserved the Spingarn medal. "The Pullman Company is a panhandler," the rum-

pled Harlem habitué and friend of James Weldon Johnson and Walter White charged. "Some federal police officer should take away the tin cup from this corporation and confiscate its pencils." Educational bulletins were also heartening. The new Atlanta University—the graduate center—was about to accept its first students. In Nashville, Meharry Medical College had just moved to a new campus built with a two-million-dollar gift from Julius Rosenwald and the General Education Board.

In Harlem, progress seemed as regular as the running of the subway. At the tip of Manhattan Island now stood the largest National Guard armory in the state, home of the much-decorated Fifteenth Regiment. At Harlem General Hospital, the monopoly held by white physicians and nurses had been effectively challenged by the NAACP and the brilliant, young Afro-American surgeon Louis T. Wright, fourth in his Harvard Medical School class and destined to replace Joel Spingarn at the NAACP. Since 1925, five Afro-American physicians had been permanent staff members; there was a new school for nurses, and plans were under way to send scores of Afro-American interns to the hospital. Although the average Harlemite was unlikely ever to use their services, there were two well-equipped private sanitoria by the end of the twenties—the Vincent, financed by Casper Holstein and opened by a former Harlem General Hospital physician, and the Wiley Wilson, built with divorce settlement funds by one of A'Lelia's husbands. Rudolph Fisher's x-ray laboratory was probably the most photographed Harlem medical facility, its metal rods and high-intensity lamps gleaming from the pages of *The Crisis* or *Amsterdam News*.

Real political power continued to elude Harlem, however. The great symbolic breakthrough came in 1928 from Chicago, where Oscar De Priest became the first Afro-American ever to represent a northern constituency and the first in Congress since 1901. Harlem's Republican congressional candidates made strong, unsuccessful runs in 1924 and 1928, and would try again. The ethnic algebra of the Twenty-first Congressional District (factored by Jewish, Irish, and Italian votes) would defeat black Harlem until the Second World War, when the boundaries were redrawn. Harlemites did much better on the state and city level. There had been Afro-American aldermen since 1919 (Fred Moore, owner of the *Age*, was elected in 1928) and state assemblymen since 1917. Harlemites had "learned to play the game in a realistic fashion," one politician observed. Starting out in the Republican Party, they had become Democrats when the rest of New York went Demo-

cratic. Charles W. ("Charlie") Anderson, a legendary figure whose career had advanced with a nod from the mighty Booker Washington, was the "recognized colored Republican leader of New York." A man of considerable culture and kindness, the portly old collector of Internal Revenue for the Third District was less frequently seen on Lenox Avenue as the twenties waned, but the memory of his once considerable patronage and formidable political skills was still bright. Democratic patronage was handled by patrician, Harvard-educated Ferdinand Q. Morton, chairman of the Municipal Civil Service Commission and iron-willed boss of Harlem's United Colored Democracy—"Black Tammany." Morton preached and practiced that politics was a "cold-blooded business proposition." In 1933, he coldbloodedly left the Democratic Party when Fusion candidate La Guardia was elected mayor.

For most Harlem families who were poor, decent housing was difficult to find. For middle-class Harlemites, though, the availability of decent quarters was increasing rapidly. There were several Afro-American–run hotels. Society columns routinely noted the coming and going of distinguished visitors who stopped at the two finest hotels, the Dumas and the Olga. Most people knew that Alain Locke stayed at the Olga. By the end of 1929, Afro-Americans were living in the five-hundred block of Edgecombe Avenue. "Sugar Hill," a citadel of stately apartment buildings and liveried doormen on a rock, soared above the Polo Grounds and the rest of Harlem like a city of the Incas. In the valley below was the five-acre Dunbar Apartments complex, begun in 1927, awarded first prize for design by the New York chapter of the American Institute of Architects, its 511 units ready for occupancy in mid-1928. An oblong block wide and deep, the cocoa-brown brick complex had the appearance of a Florentine palazzo modified to the larger New York scale and the utilitarianism of its Rockefeller benefactor. From Seventh or Eighth Avenue, or under archways pierced along 149th and 150th streets, residents walked through a somewhat forbidding exterior and past stairways leading to apartments, into a grass-carpeted, flower-bordered canyon of a courtyard. Living units were smallish for the times, but well lighted and well equipped. There was a supervised basement nursery and a laundry room. A bank, Dunbar National, offered its depositors the peace of mind of a Rockefeller-backed and -regulated institution. Next door, offering peace of mind to those tenants who worried about untamed hair, was the Madame C. J. Walker Beauty Shoppe. After twenty-two years, the tenants were to

own their apartments. All this for monthly rents ranging from $11.50 per room—paid by occupants whose median monthly income of $148.86 was $40.00 higher than the Harlem family average.

None other than imperious Harvard man Roscoe Conkling Bruce, son of the Afro-American Mississippi senator and almost the double of Theodore Roosevelt, was appointed resident manager by John D. Rockefeller, Sr. Managers of other buildings might accept anyone who could pay the rent. "We let it be widely known," Bruce advised, "that the sporting fraternity, daughters of joy, the criminal element are not wanted, and in fact will not be tolerated." With ten acknowledged unskilled laborers and only fifty-eight domestics in residence, the Paul Laurence Dunbar Apartments were clearly not home for average Harlemites but the preserve of those who wore white collars. "I note that Du Bois, Bob Pickens, Countee Cullen, and several others we know have taken apartments [there]," Walter White wrote to James Weldon Johnson from the south of France.

The Dunbar became home for the Du Boises (installed in two apartments, 5G and J), E. Simms Campbell (illustrator and cartoonist for *Collier's, Esquire, Life,* and *Saturday Evening Post*), Rudolph Fisher (briefly, before moving to Jamaica, Long Island), George Edmund Haynes (president of the apartment complex's board), Fletcher Henderson (at the pinnacle of bandleader fame), Asa and Lucille Randolph (Lucille entertained a great deal), Paul and Essie Robeson (briefly), Leigh Whipper (stage and film character actor), and Clarence Cameron White (noted violinist-composer). It was also home for flashy, prospering families, such as the Enrique Cachemailles and the Lewis H. Fairdoughs and such stylish singles as Sadella Ten Eyck and Ollie Capdeville, their apartment soirées and country retreat weekends reported breathlessly in *Dunbar News* bulletins. There were many more solid, quiet residents who worked at Manhattan's Hotel Taft, stayed out of the limelight, and frugally acquired wealth. Dependable William R. Cogbill (Apt. 6P and "confidential messenger to John D. Rockefeller, Jr., for 32 years"), who retired to his country place in Southampton, Long Island, was one of these. But with its stream of distinguished visitors—Scandinavian architects, French intellectuals, Japanese military delegations, Haitian presidents, mayoral candidates, white philanthropists, and Afro-American college presidents—the Dunbar was decidedly what ordinary Harlemites called "dickty" (ritzy), and the Talented Tenth ballyhoo of the *Dunbar News* made it all the more so: "Dinner guests of Mr. and Mrs. Lester A. Walton (Apt. 5A)

were Dr. Robert Russa Moton of Tuskegee and Alderman Fred R.
Moore"; Colonel Benjamin O. Davis, "highest ranking Negro officer in
the United States Army, is temporarily residing at Apt. 5H." And there
was to be no end of bulletins by the Bruces, apartment by apartment,
week after Late Renaissance week, about Japasequa La Circle, Die
Mädchen, Ne Plus Ultra, and other gloriously named bridge clubs.

The Nigger Heaven syndrome was everywhere. But some com-
munity leaders feared that what was nice for Connie's and the Cotton
Club and good for the entertainment business was not necessarily good
for Harlem. Some observers wondered out loud what a spacious Sugar
Hill apartment or the flair for mixing the races socially had to do with
substantial progress in civil rights. Some with Du Bois's cast of mind
wondered what serious member of the NAACP could salvage any
pride from the *Evening Sun*'s review of *Hot Chocolates*, ending, "And
the harder the dancers danced, the more they smiled and grinned."
When Wallace Thurman's play *Harlem* electrified Broadway, the am-
bivalent critic for the *Defender* despaired, "If, north of 116th Street,
conditions are as disorderly as William Jourdan Rapp and Wallace
Thurman paint them, the white man's burden is, if possible, even heav-
ier than it seems." Harlem was its own worst exploiter, it seemed. "We
are without that civic pride that would drive these hells from among
us," intoned a righteous *Amsterdam News*. "We are without the cour-
age which would make it impossible for even V*ariety* to from time to
time heap ridicule and questionable humor upon us. We are without all
the elements that have seen white men dying if necessary for whole-
some communities which have meant so much in their onward march
to progress. . . ."
Slowly—very slowly—the germ of Harlem's moral blight, of its
preening on form more than substance, was seen to be economic. De-
spite *Crisis* and *Opportunity* covers over the years depicting proud
Harlem business pioneers, Afro-Americans owned little more of Har-
lem, after a fifteen-year occupation, than the restricted right to enjoy
it. By September 1929, even the *Tattler* was beginning to depart from
its usual feature articles to ask, "What Inducements Do Chain Stores
Offer Us?" A list of Jim Crow Harlem businesses followed: Great
Atlantic and Pacific Tea Co., with twenty-four stores and only nine
Afro-Americans—all errand boys—on the payroll; James Butler Co.,
Inc., with twelve stores and nine menials; L. Oppenheimer, Inc., em-
ploying six; United Cigar Store Co., with thirteen branches and not a

single Afro-American employee; Cushman Bakeries. . . . A long list which only a determined and united boycott could hope to shorten, whatever the fears of the "rabbit-hearted gentry."

But even as they pondered the *Tattler's* uncharacteristic revelations, Harlemites were losing control of an authentically local multimillion-dollar growth industry—the policy rackets. The period of bullet-laced candy stores and alley homicides was still to come with the Depression, with deadly consolidation duels between the white gangs. The early signs of organized crime's invasion were, nonetheless, already evident throughout 1928. One after another, the forty or more Harlem policy bankers were mysteriously retiring, leaving fewer than a dozen still in business by autumn. Casper Holstein's paramount position seemed, if anything, even more secure, his philanthropy more robust. In addition to the yearly $2,000 to Virgin Island charities, Holstein had given $1,000 to the 1928 Fisk expansion drive and loaned U. Conrad Vincent, Harlem's society surgeon and Bellevue Hospital staff member, $20,500 to equip his exclusive sanitorium—largesse fully consistent with a $36,000 rescue of the UNIA's Liberty Hall mortgage the previous year. Then, on Sunday morning, September 23, newspapers in Harlem announced that the "Bolito King" had been kidnapped. The ransom was said to be $50,000. Monday, the follow-up story in *The New York Times* reported, "Casper Holstein, wealthy overlord of the Negro sporting world, came home to Harlem early today. His return was as mysterious as his disappearance just after midnight on Thursday."

Holstein denied that a ransom had been paid, could not identify his abductors, and was at a loss to explain their motives. He only knew that as he walked from his apartment to his chauffeured Lincoln, five white men had sprung upon him, bundled him into a car where, before being blindfolded, he saw two women, also white. Three nights later, because they thought he was "getting a raw deal," his captors released him with three dollars for cab fare. It was a confused affair, with police arresting and briefly questioning one Michael Bernstein; an unattributed telephone call to Holstein's Monarch Lodge of Negro Elks ("Tell the police to get out of this case. All they will get will be my dead body"); and discrepancies of detail about time and place of the kidnapping. Yet it is certain that Holstein's fall from the pinnacle of the policy world began with his temporary disappearance. Early in 1928, it developed, "Dutch" Schultz, Harlem's major supplier of Prohibition liquor, had discovered the dollar volume of Harlem's illegal

lotteries. He had moved with deadly speed, eliminating all but six of the largest "bankers"—and they were invited to join his underworld network. One or two would fight back, but most were curiously ill-equipped for a war with the Bronx mob. Holstein, a Talented Tenth gangster, was as distressed by guns and violence as Countee Cullen would have been. He continued his operations on a much reduced scale while the profits of crime became increasingly "integrated."

Harlem's glitter by night and commerce by day were evidence not so much of indigenous vitality but of the magnitude of its exploited wealth. Sometimes *The Messenger* voiced radical solutions. The remedy was "not a change in group control of business on a racial basis," a Marxist contributor argued, "but a fundamental change of ownership and distribution of products on the basis of the class interests of all workers regardless of race." But not even the readers of *The Messenger* were psychologically up to proclaiming Harlem the exploited colony it really was. When social scientists during the Depression poked behind the Harlem facade, they found evidence of decay that had existed, unrecognized, for years. Odd religious movements, for example. "Messiahs," wrote Robert Allerton Parker of Father Divine, "arise out of very special social and psychic conditions—emerging as a rule from the soil of destitution, desperation, or persecution." Harlem was a hothouse of prophets and messiahs offering salvation in the afterlife and jubilation after work.

Inevitably, the migrating peasant had brought his religious fundamentalism and evangelical fervor to Harlem, where they both preserved the old, reassuring ways and served as a psychological safety net in his struggles with the new ways. There was nothing retrograde or unhealthy in this. It was in fact typical of most other immigrant groups, which gained psychological comfort and social stability from various orthodoxies and customs. There came moments, even in the lives of the Talented Tenth, when there was need of the ol' time religion, that enduring syncretism of Protestant liturgy and pagan life. When Helga Crane, the cosmopolitan heroine of Nella Larsen's novel *Quicksand*, blunders into one of Harlem's countless storefront churches, a psychic trapdoor opens beneath her:

Helga too began to weep, at first silently, softly; then with great racking sobs. Her nerves were so torn, so aching, her body so wet, so cold! It was a relief to cry unrestrainedly, and she gave herself freely to soothing tears, not noticing that the groaning and sobbing of those about her had increased,

unaware that the grotesque ebony figure at her side had begun gently to pat her arm to the rhythm of the singing and to croon softly: "Yes, chile, yes chile."

Praising the Lord, vibrating with ecstasy, and glowing in a high of momentary deliverance were what a good Harlem Sunday was all about.

But when the transplanted revivalism of the South went far beyond its traditional boundaries, it created a cultism that was frequently weird, sometimes harmful, and, on occasion, both. These were cults which attracted the socially marginal and spiritually dispossessed. They were much more than Sunday affairs, altering diet, dress, language, and much else. The Black Jews was such a cult. No one knew where it came from, nor exactly when it began. "Funny thing," butcher M. Shapiro was quoted as saying in a 1929 issue of the *Sun*, "some colored people came in this morning and wanted some kosher meat. Real negro people from up in Harlem. They say they are Jews." The butcher would have been surprised to learn that small numbers of Black Jews had lived in Harlem for about a decade. Perhaps, as myth claimed, a few wayfaring Ethiopian Jews—Falashas—had settled in Harlem after the war. Perhaps, in the early years of community flux, there had been a synagogue affiliation—formal or informal—with some Afro-Americans. Strange shadowy holy men like Rabbi Ishi Kaufman and Elder Warren Robinson kept kosher, conducted services in Yiddish and substituted the saxophone, guitar, and tambourine for the kynor, nevel, and tupim.

But it was in 1924 that Harlem really began to notice the Black Jews, with the establishment of the Beth B'nai Abraham congregation at 29 West 131st Street. The leader, Arnold Josiah Ford, was a West Indian who also served as Marcus Garvey's choirmaster. Colorful and charismatic, Ford left the UNIA only after Garvey had made his own lack of interest in Judaism unmistakably clear. He was soon assisted by another man of the Book, Wentworth Arthur Matthew, by his own account bishop, rabbi, D.D., and Ph.D. Rabbi Matthew claimed to have been born in Sierra Leone and, after years of travel and study in the Middle East, to have made his way to New York from Haiti in 1913. It was a matter of record that he had been a professional boxer and wrestler. His theological pronouncements were of a decidedly practical cast. "We think the Jews are a great people," he once explained to the press. "They own all the money in the country. Their religion did

that for them, and maybe it will do the same for us." Ford and Mat-
thew were also drawn to Zionism, preaching to their largely West
Indian disciples that their true destiny lay in Ethiopia. When Congre-
gation Beth B'nai Abraham collapsed financially in 1930, Rabbi Ford
and his common-law wife appear to have sailed for Ethiopia in quest of
the Falashas and just ahead of the creditors. (In Howard Brotz's fas-
cinating book *The Black Jews of Harlem*, the author makes the
astounding suggestion that, instead of leaving for Africa, Arnold Ford
went to Detroit where, tiring of Judaism, he assumed a new identity as
Wallace D. Fard or Farrad—founder of the Nation of Islam, or the
Black Muslims. The very light-skinned Ford physically resembled the
mysterious Fard, but the available evidence fails to substantiate Brotz's
allegation.)

Several years before Rabbi Ford vanished and Rabbi Matthew re-
organized the cult as The Commandment Keepers of the Living God,
or Royal Order of Ethiopian Hebrews, another group of Black Jews
had horrified Harlem. Elder Warren Robinson's flock were thought to
be impeccably orthodox. According to the *Journal of Jewish Ecumeni-
cal Studies*, Robinson "hired a Jewish teacher to instruct these men in
the Yiddish language and in the mannerisms of the Jews." Beards
flowing and in cassocks, they approached Jewish congregations and
business people for contributions, frequently with success. But behind
this facade of derivative Judaism, Elder Robinson had created a hidden
community that was inspired not by the word of Jehovah but by the
perversions of Rasputin. While the older members of the cult chanted
in something like Yiddish and piously studied the Torah, sleek young
men lured women of means to sex hideaways, where many were kept
against their will. Robinson's claims of personal sanctity ballooned
from that of divine inspiration to being the long-awaited Messiah. His
disciples surrendered their personal property to a common pool, tithed
themselves heavily, while secret love dens sprouted in Harlem, upstate
New York, Lawndale, New Jersey, and Chicago. In summer of 1926,
Mary Bedell, once a "slave" in Robinson's love cult and now deaconess
in Saint John's African Methodist Episcopal Church, led law enforce-
ment officers to the Black Jews' orphanage near Lawndale. At Robin-
son's trial, federal authorities presented conclusive evidence of voodoo
rites practiced over four- and five-year-old victims, of a torture cham-
ber operated by Abbey Yancy "the witch," of sexual sadism and
exploitation, and of a personal fortune running into millions. The
leader of the cult drew a three-year sentence for violation of the Mann

Act. He served eighteen months in the same prison in which Garvey had been confined. The scandal had been good for business, though, and Robinson returned to Harlem to find his cult not only intact but larger than ever.

At about the time Warren Robinson was released from Atlanta's federal prison, the Harlem branch of what was to become Afro-America's most famous religious cult opened at 455 Lenox Avenue. Father Divine himself remained at his original "heaven" in Sayville, Long Island, until the end of 1931. Meanwhile, Harlem barely noticed the activities of Divine's disciples—Ellee Lovelace, Sophie Harris, and Bernard Mills—amid so many other similar, competing establishments. Once again, notoriety, trials, and jail sentences would be the making of a society that otherwise might have passed from the Harlem scene with little more than a ripple. But the discovery of Father Divine was still in the post-Depression future, when, for so many Harlemites, the afterlife became a far more certain prospect than regular meals. Already, though—far more than Talented Tenth movers and shakers bothered to suspect—the Harlem subsoil was soaked in religious hysteria.

"Tell me frankly," Harold Jackman wanted to know from Claude McKay, "do you think colored people feel as primitive as so many critics describe them as feeling when they hear jazz?" There was so much "hokum and myth about the Negro these days (since the Negro Renaissance, as it is called) that if a thinking person doesn't watch himself, he is liable to believe it." Jackman already believed much of it. This charming West Indian with an unknown British father and the outsider's special vision seems to have decided that the only fate more benighted than being Afro-American was to be white. Whites were too intellectual, wooden, dry. He saw it at all the best Downtown parties. "They don't seem to have the gayness which our parties do," he wrote Cullen. For all their faults, Jackman argued that "spades have better parties (that is, what you and I call parties) than any other people." Still, he suspected the linkage between the Afro-Americans' deep enjoyment of life and their supposed personification of the id was faulty. "This business of feeling the music so deeply that we almost become intoxicated is beyond me."

If anyone was an expert on primitivism in the spring of 1928 it was the author of *Home to Harlem*, the novel that, said the *Tattler*, "out-niggered Mr. Van Vechten." Harper & Brothers had released Claude

McKay's book in March, and within two weeks it became the first novel by a Harlem writer to reach the best-seller list. Passing along the praise of their friend Max Eastman, Charlotte Osgood Mason, seventy-five and unable to remember when she was not "interested in primitive peoples," rejoiced. *Nigger Heaven* had been "disgustingly terrible," but here was a work in which "life and laughter is ready to burst into such brilliant sunshine," the old lady wrote, "that, in the end, all the world will be robed in beauty, and all the peoples of the world will be forced to recognize the powers of re-creation." In *The New York Times*, John Chamberlain seemed almost as grateful; tapping out his review to a jazz meter about a "book that is beaten through with the rhythm of life that is the jazz rhythm . . . the real thing in rightness. It is the story of a happy negro, of Jake Brown whose life in Harlem and elsewhere is a song of affirmation, of acceptance of the flesh as natural." The *Tattler* stopped far short of ecstasy; Geraldyn Dismond conceded that "although nothing is added to our glory," in the main McKay "has given what is unquestionably a picture of Harlem." But there was only consternation from the *Defender*, which wondered why, given the low opinion of blacks held by whites, McKay wasted "so much time trying to prove it?" "I feel," Du Bois sniffed in *The Crisis*, "distinctly like taking a bath."

Home to Harlem was not the book McKay had originally intended to write. But after the stillbirth of "Color Scheme," the badly flawed novel that never found a publisher, he had not known quite what to do next. He found work in Nice in autumn with Irish film director Rex Ingram, a friend of Max Eastman. Late that summer, 1926, with a six-hundred-franc bonus from Ingram, he went to Marseilles for the lush humanity, literary inspiration, and cheap rents of its Vieux Port. He wrote more short stories there and nearly completed a novel about "an octoroon girl of the Black Belt who can't decide to pass or not." As described in strictest confidence to Arthur Schomburg ("there are no obviously naughty things in it"), the manuscript had the sound of a much reworked, sanitized "Color Scheme," and was no more promising. By the end of August, McKay had abandoned it, written a few more short stories, and become so disillusioned he almost sailed to Singapore as a freighter cabin boy. "In debt and in trouble," he signalled Schomburg, who was in Paris. "Fifty dollars would lift me out of the rut like magic and make me fit for creative work." McKay knew of the Urban League's arranging a ten-thousand-dollar Carnegie gift

to purchase Schomburg's large and unique collection of Negro books and documents for The New York Public Library. The loyal and compassionate Puerto Rican bibliophile probably sent McKay a small sum.

Still desperate, McKay sent some of his poems and stories to his occasional patron, Louise Bryant, John Reed's widow and now diplomat William Bullitt's wife. Bryant had helped six Italian political refugees she "didn't even know" that month; there was a cash flow problem, she wrote from Paris. Moreover, she shared the general low opinion of McKay's current poetry. If he were in Paris, she could show McKay "where each line goes off." But the short stories were different; they had potential. He would have to revise them completely, of course—"Jack Reed often wrote a short story as many as seventeen times!" While McKay dutifully revised, William Bullitt took a hand with his stories. "He writes and edits as carefully as if he were sending a diplomatic message," Bryant assured her protégé, "and you are in luck to have him do this." Bullitt also wrote to Alfred Harcourt of Harcourt, Brace about McKay's stories and suggested a five-hundred-dollar advance for them. By early October, Louise Bryant was in New York with McKay's stories, charging through publishers' offices like an evangelist, preaching McKay's genius and showering desks with manuscript —Harcourt, Harper's, Viking (even the Boni Brothers, despite her conviction that Albert Boni had been a capitalist "spy in Russia"). The publishers were interested, but they all wanted McKay to expand "Back to Harlem," a story about a returning sailor, into a novel. Bryant decided McKay must have a literary agent, and she wrote that no less a personage than William Aspenwall Bradley—Columbia University professor and Ford Madox Ford's agent—had sailed for Paris with an offer from Harper's. With an advance and expense money from Bryant to pump him up, McKay moved in with Max Eastman and his new Russian wife at Antibes. There he finished *Home to Harlem* in the summer of 1927 "and fled to Marseilles."

Home to Harlem was a bombshell. Where Van Vechten had offended by intruding the underclass into a novel about High Harlem, McKay sinned far more grievously by totally ignoring the upper classes. It was as though the residents of Edgecombe Avenue and the Dunbar had drowned in the Harlem River. No graduates of Harvard and Howard discourse on literature at the Dark Tower; there are no easily recognized imitations of Du Bois, Jessie Fauset, or James Weldon Johnson—and no whites at all. When he mentions the unavoidable

fact of class distinctions, McKay draws the illustration from the society of Pullman car cooks and waiters:

The two grades, cooks and waiters, never chummed together, except for gambling. Some of the waiters were very haughty. There were certain light-skinned ones who went walking with pals of their complexion only in stopover cities. Others, among the older men, were always dignified. They were fathers of families, their wives moved in some sphere of Harlem society, and their movements were sometimes chronicled in the local Negro newspapers.

The novel was not entirely about what Du Bois called the "debauched Tenth," but it was ostentatiously plebeian, peopled by crap-shooting, knife-wielding types that not even Daddy Grace could be sure of re-deeming or Leroy's be funky enough to entertain. Primal types who would have both fascinated and frightened Van Vechten:

When you were fed up with the veneer of Seventh Avenue, and Gold-graben's Afro-Oriental garishness, you would go to the Congo and turn rioting loose in all the tenacious odors of service and the warm indigenous smells of Harlem, fooping or jig-jagging the night away. You would if you were a black kid hunting for joy in New York.

McKay denied that he had capitalized on the market largely created by Van Vechten. "I consider this book a real proletarian novel," he wrote James Weldon Johnson, "but I don't expect the nice radicals to see that it is." Still, he *had* followed Van Vechten, and, for critics like Howard University's librarian, the authors of *Nigger Heaven* and *Home to Harlem* were flagrant "filth mongers." There was no question of a crusade of denunciation, however; McKay was selling too well, his praise too widespread, and many of his characterizations too realistic, as even the subjects had to admit. Overwhelmingly, whatever their true reservations, Afro-Americans felt about McKay's sudden fame as they did about use of that electric epithet "nigger"—fine, so long as the user was not white. Much was forgiven success in the twenties. Moreover, one aspect of McKay's novel that rankled many readers deeply was too invidious for frank discussion. All Renaissance writers were preoc-cupied with color, but McKay, to the acute distress of Harlem's elite, was not merely obsessed with "chocolate, chestnut, coffee, ebony, cream, yellow" complexions, his novel (as became the quasi-Garveyite he once was) embraced antimulatto sentiments.

Van Vechten had described the enervation of will and impotence of body that must surely, fatally, overcome the Afro-American unduly exposed to "Nordic civilization." McKay creates a Lenox Avenue edition of the Noble Savage in Jake in order to demonstrate the superiority of the Negro mind uncorrupted by formal learning. Ray, Jake's educated Haitian friend, reads Alphonse Daudet in the original between dining car chores, sleeps with books rather than women, yet is ambivalent both about formal learning and about proletarian naturalness. Modern education "is an anachronism" for the Negro, Ray tells an uncomprehending Jake. "We ought to get something new, we Negroes." Still, Ray reads Barbusse, Joyce, and Lawrence (McKay's favorite modern writer) on the New York–Chicago run and feels he must wrench free of Harlem's dark and unformed and all-consuming dynamism:

Harlem! How terribly Ray could hate it sometimes. Its brutality, gang rowdyism, promiscuous thickness. Its hot desires. But, oh, the rich blood-red color of it! The warm accent of its composite voice, the fruitiness of its laughter, the trailing rhythm of its "blues" and the improvised surprises of its jazz.

Ray symbolizes more than the obvious "other side" of McKay. He is one of Nordic civilization's mental outpatients—the side that pits the black man's brain against his loins and makes a shambles of both.

To the artists who had worked with Wallace Thurman on *Fire!!*, McKay's novel was as much a vindication of their aesthetics as *Dark Princess* was of Du Bois's. Those people "who still retained some individual race qualities and who were not totally white American in every respect save color of skin" were on every page of *Home to Harlem*. Taking heart, planning more carefully, and balancing unconventional pieces by Bruce, Roy de Coverly, and George W. Little with contributions from Locke, Schuyler, and White, Thurman brought out the successor to *Fire!!* in November 1928. *Harlem* lacked the éclat of its prototype but, during its two-issue existence, it nearly achieved its editors' goal of "a wholly new type of magazine, one which would give expression to all groups." There were illustrations by Nugent and Aaron Douglas, political advice from White (no more blind loyalties and no third-party "fantasies"), and Locke's regret that there had been "little sustained art unsubsidized by propaganda." With a plague on

both houses, Nugent ridiculed Afro-Americans who were hypersensitive about ethnic shenanigans in *Porgy* and whites ("Porgy-ites") who uncritically adored everything on stage about Afro-Americans. Twenty-six-year-old Langston Hughes, by now a senior at Lincoln University, contributed "Luani of the Jungles," a polished genre piece on the civilized and the primitive.

What *Harlem* lacked in scandal it more than compensated for in intellectual combativeness. "The time has come now," Thurman declared, "when the Negro artist can be his true self and pander to the stupidities of no one, either white or black." The stupidities *Harlem* had in mind were specific. Privately, Thurman had already lamented Du Bois's inadequacies to Jackman, writing that he "could almost cry over the portions I have read" of *Dark Princess*. Du Bois's review of *The Walls of Jericho*, Rudolph Fisher's first novel, provoked Thurman to public attack. The *Crisis* editor had sadly wondered why Fisher's "glimpses of better class Negroes" were unworthy of the flesh-and-blood types of Fisher's own family? Were Du Bois "a denizen of 'Striver's Row,' scuttling hard up the social ladder, with nothing more important to think about than making money and keeping a high yellow wife," *Harlem* could have laughed "at such nonsense. But Dr. Du Bois is not this." In condemning Fisher's fine novel, Du Bois had unfairly criticized "the first novel written by a Negro which does not seem to be struggling for breath because the author insists upon being heavy handed either with propaganda, as in *Dark Princess*, or with atmosphere, as in *Home to Harlem*. Mr. Fisher keeps his proportions well, almost too well."

"Bud" Fisher wrote one of the most thematically successful and enduring works of the Harlem Renaissance—to say nothing of the most enjoyable—and he did it while establishing a lucrative medical practice and leading a well-paced social life. He was immensely liked by both men and women, not only because he was handsome but because he kept his exceptionally sharp mind from pricking people unnecessarily. Literary teas and "book talk" bored Fisher. Like that of Langston Hughes, with whom he was casually friendly, Fisher's anguish over the race problem fell short of desperation because of personal resiliency and a discerning optimism. *The Walls of Jericho* avoids *Nigger Heaven*'s decadence and *Home to Harlem*'s graceless realism. The hero and heroine—Joshua "Shine" Jones and Linda Young— would never see the inside of the Civic Club; he is a burly, foul-

mouthed piano mover; she, a respectable and ambitious, but slimly educated, maid in the employ of a white Harlem spinster. It is the literary perspective commended by Van Vechten and *Fire!!* and somewhat heavy-handedly executed by McKay—the bottom-up optic through which Afro-American high society is treated as inherently less than satisfactory. But McKay reduced the upper classes to a sterile irrelevancy about which the less written the better, and Van Vechten had them posture their culture and ideals the better to show the ravages of materialistic civilization.

Fisher's satire makes more reasonable and reasoned points, exposing the cleavages within the Afro-American world. There are archetypal whites: Mr. and Mrs. Noel Dunn, who never tire of praising " 'the wealth of material' to be found in Negro Harlem," and Linda Young's employer, Agatha Cramp, transparently modelled from Mrs. R. Osgood Mason ("For fifteen years Miss Cramp had been devoting her life to the service of mankind. Not until now had the startling possibility occurred to her that Negroes might be mankind, too"). In one scene describing the annual General Improvement Association (G.I.A.) Costume Ball at Manhattan Casino, Fisher develops a hilarious—and precise—metaphor:

So swept the scene from black to white through all the shadows and shades. Ordinary Negroes and rats below, dickties and fays above, the floor beneath the feet of the one constituting the roof over the heads of the other. Somehow, undeniably, a predominance of darker skins below, and, just as undeniably, of fairer skins above. Between them, stairways to climb. One might have read in that distribution a complete philosophy of skin-color, and from it deduced the past, present, and future of this people. . . . Out on the dance floor, everyone, dickty and rat, rubbed joyous elbows, laughing, mingling, forgetting differences. But whenever the music stopped everyone immediately sought his own level.

The Walls of Jericho was a social novel with a perfect ending: working-class integrity survives; the best elements of the upper and lower classes ally to oppose an internal foe, symbolized by organized gambling; and lessons in demolishing the walls of class and race are taught.

The only current specimen of the genteel tradition of Afro-American fiction was Knopf's 1927 reissue of James Weldon Johnson's *Autobiography of an Ex-Colored Man*. Cullen's volume of poetry, *Copper Sun*, had been warmly praised by Harlemites in 1927, but

those who bothered to read it detected a decline in powers, a pervasive
moroseness. Its final poem, "Epilogue," ended clammily: "And no man
knows if dead men fade / Or bloom, save those that die." In a few
months, there would be another McKay novel, an even more sensa-
tional Broadway play by Thurman, and the first novel by this persistent
editor of avant-garde magazines. But the genteel tradition was not
ready to vanish. In 1928, Nella Larsen's *Quicksand* was published by
Knopf, and by the following summer another Larsen and a second
Fauset novel would appear.

Nella Larsen Imes, like Rudolph Fisher, found her way to Knopf
through Van Vechten. She was yet another assertive intelligence who
veered into literature from an unrelated background. Like her hus-
band, Elmer Imes, a physicist, she was trained in the sciences, first at
Fisk for a year, then at the University of Copenhagen. For seventeen
years, she lived in New York, working as a nurse in hospitals and for
the Board of Health. Beginning in 1925 she was plagued with poor
health, and it was probably the enforced leisure of convalescence that
led her to begin writing. The *Amsterdam News* described Larsen as "a
modern woman, for she smokes, wears her dresses short, does not
believe in religion, churches, and the like, and feels that people of the
artistic type have a definite chance to help solve the race problem." She
remains, nevertheless, a figure of some mystery, luminous, unconven-
tional, and, in the end, perhaps one of those who found the vagaries of
a white identity preferable to the pain of Africa. Some of her fellow
Virgin Islanders thought she capitalized on her mixed Danish-African
heritage and held aloof from people who were not well-connected. Her
letters to White reveal a quick-witted opportunism, and those to Van
Vechten were often conspiratorially condescending about the race.
What is known with certainty is that Larsen wrote one of the three best
novels of the Renaissance, produced a second in a matter of months,
travelled abroad with a female friend, had an affair with an Englishman,
and followed her philandering husband to Fisk, briefly; then vanished.

She worked hard on *Quicksand*, even junking half of it. "It was
awful," she told Van Vechten. White suggested revisions and volun-
teered his secretary to type the manuscript. When it appeared, in May,
Du Bois finally had a moment of unalloyed critical thanksgiving in *The
Crisis*. He found it, "on the whole, the best piece of fiction that Negro
America has produced since the heyday of Chesnutt, and stands easily
with Jessie Fauset's *There Is Confusion* in its subtle comprehension of

the curious cross currents that swirl about the black American." Locke
agreed. Roark Bradford praised the novel's "delicate achievement in
maintaining for a long time an indefinable, wistful feeling," but found
the second half smacking of the minstrel show. Margery Latimer, writ-
ing for the *World*, was enchanted, without really understanding the
novel.

Quicksand's plot is simple: Helga Crane, Danish-American mother
and Afro-American father, is svelte, educated, taut. Teaching at Naxos
College deep in the South, she feels increasingly alienated by the
school's provincialism and aura of almost grim uplift. Resigning, flee-
ing to her white uncle in Chicago, she finds Uncle Peter has remarried,
that the new Mrs. Nilssen is mortified by Helga's presence. She stum-
bles about Chicago blindly, finds a position with Mrs. Hayes-Rore, a
great-souled YWCA leader suggesting Mary McLeod Bethune, and
eventually travels with her to Harlem. Harlem is heaven. Prosperous,
intelligent people welcome her to Striver's Row and Sugar Hill. She
even meets Naxos's Dr. Anderson again, the all-Afro-American col-
lege president, earnest and fine as ever, fund-raising in the North. A
registered letter brings an apology from Uncle Peter and a check
amounting to the legacy Helga would have received at his death. Helga
suddenly cools to Harlem: "She didn't, in spite of her racial markings,
belong to these dark segregated people." Next comes Copenhagen,
social stardom, a proposal of marriage from rich Axel Olson, and,
inevitably—"it's something deep down inside of me"—ennui. In Har-
lem again, she fails absurdly in her move to conquer Dr. Anderson,
suffers a nervous crisis that inspires religious ecstasy, marries Reverend
Pleasant Green, a migrant evangelist who sanctifies through sex, and
returns to the South, where biology and habitat overwhelm her with
children, drudgery, fatigue, and more children. "And hardly had she
left her bed and become able to walk again without pain, hardly had
the children returned from the homes of the neighbors, when she began
to have her fifth child."

The triumph of *Quicksand* is, first, in the writing—not a word out of
place or a sentence extra. But it is also a considerable allegorical achieve-
ment, with a very modern heroine whose misfortunes and ultimate
destruction are not only racially but personally determined. "Frankly,"
says the author for Helga,

the question came to this: what was the matter with her? Was there,
without her knowing it, some peculiar lack in her? Absurd. But she began
to have a feeling of discouragement and hopelessness. Why couldn't she

be happy, content, somewhere? Other people managed, somehow, to be. To put it plainly, didn't she know how? Was she incapable of it?

Helga's mysterious psyche is more than the sum of its experiences, but these experiences explain much. Being half-white and illegitimate is a heavy cross to bear in Afro-American circles where miscegenation after the Civil War is considered as inexcusable as venereal disease, and veneration of distinguished kin is practiced with an almost oriental seriousness. It was this which drove her from Naxos. Welcomed by Striver's Row, she bypasses the chance to become a "proper Negro," quickly tiring of her closest female friend's stultifying respectability. Helga loves vivid colors, strenuous dancing, dialect. "Towards these things," her friend "showed only a disdainful contempt, tinged sometimes with a faint amusement. Like the despised people of the white race, she preferred Pavlova to Florence Mills, John McCormack to Taylor Gordon, Walter Hampden to Paul Robeson. Theoretically, however, she stood for the immediate advancement of all things Negroid. . . ."

Each situation, each shift of milieu, has its social and racial resonance —is, in large measure, explained by them—and the author's warning emerges with clarity. Those Afro-Americans who capriciously reject their middle-class status risk a fatal fall from grace into perdition, from civilization into atavism—not to master emotions risks being destroyed by them. The novel's superior achievement is that Helga Crane is never reduced to mere illustration of some social problem. Within the contexts of race, place, and class, her fate is ultimately controlled by her own inner flaws of vanity and fantasy.

Writing from Fisk ("rather congenial though lacking in diversity"), Charles Johnson was not hopeful about Renaissance output as the new year began. "So far as my poor eyes observe," the new college professor wrote Cullen, "very little creative work is being done in these United States." He hoped Cullen could "touch off this fast maturing younger generation" when he returned from France. Except to Ethel Nance, who had followed him to Fisk, Johnson said very little about his growing disappointment in his prize candidate for literary greatness, Eric Walrond. Walrond had resigned from *Opportunity* shortly before Johnson had. Boni & Liveright announced his book about the Panama Canal for March 1928. Zona Gale and the Guggenheim Foundation had awarded him fellowships to complete the manuscript, but rumors reached Johnson from Europe that Walrond had squan-

dered the stipends and written nothing. On his way to a weekend in the country with E. M. Forster, Richard Bruce Nugent encountered Walrond in a London railway station in late 1929. That was about the last heard of him.

Reviewing the literary year in the January 1930 *Opportunity*, Alain Locke was also concerned. He was delighted that more books had "been published about Negro life by both white and Negro authors than was the normal output of more than a decade past." DuBose Heyward's second novel, *Mamba's Daughters*, was an astonishing work. It was *Porgy* and *Nigger Heaven* combined, but with more genius and generosity. The sequential tales of Mamba, her daughter, and granddaughter represent an exquisite but powerful account of Afro-American evolution from plantation to ghetto. The Talented Tenth is there, also, and drawn with equal veracity and realism. No other white novelist of the period dealt with the rural and the urban, the primitive and the assimilated quite as successfully and empathetically. Jackman wrote Cullen that the novel was "a great story." Locke, too, admired Heyward's novel, but he also saw clearly the enormous faddism of the "Negrophile movement," and the coming day when popular interest would flag and the movement "will lose thousands of supporters who are now under its spell." His perceptions were sharper than White's, who still clung to two publishing friends' assurances that public interest in Afro-American arts and letters was not "a fad comparable to Coueism, Mah-Jong, and the present cross-word puzzle craze," that it was "destined to develop and flower." In a flash of uncharacteristic candor, Locke conceded the heavy price of artistic advancement: "To get above ground, much forcing has had to be endured, to win a hearing, much exploitation has had to be tolerated. There is as much spiritual bondage in these things as there ever was material bondage in slavery." He concluded with the expectation that the "Umbrian stiffness" (Locke read his Walter Pater religiously) would soon be shed and that the Renaissance would yield a "second hardier and richer crop" of talents.

The 1928 Harmon gold medal for literature had gone to McKay, but, as Charles Johnson had feared, no work of 1929 was judged worthy of more than the foundation's bronze medal. Looking back, at least one contender—Jessie Fauset's *Plum Bun*—fully deserved the positive reviews it received in *The New Republic* and *The New York Times*, although Jackman thought it was "lousy, bad, bad." Mrs. Harris (Jessie Fauset married insurance executive Herbert Harris in April)

produced a much tighter plot and better written novel in this, her
second book, than she had before. It was not as modern in tone as
Larsen's second novel, *Passing*, released in May by Knopf, and its
ending was even more artificial, but it was far more ambitious and
more sociologically intriguing in presenting the dilemmas of floating
racial identity.

Plum Bun has sex, melodrama, and artifice, but its class convictions
overshadow the overwrought prose and romantic development of plot.
Fauset's belief in half-caste superiority is far less nuanced here than in
There Is Confusion. Whites are cruel, violent, vicious; lower-class
blacks are aimless and pitiable types to be uplifted. By contrast, her
protagonists belong to a third world of beauty, breeding, and dignity.
They arise from old families of Boston, Charleston, New Orleans, and
Philadelphia, and are impressively represented by her character Van
Meier (modelled on Du Bois). Equal to whites in every respect (save
money), these brown aristocrats are really superior because of the
tremendous handicaps surmounted. White blood, Fauset speculates,
may in fact pollute:

Her father, her mother and Jinny had always given and she had always
taken. Why was that? Jinny had sighed: "Perhaps you have more white
blood than Negro in your veins." Perhaps this selfishness was what
the possession of white blood meant; the ultimate definition of Nordic
supremacy.

Fauset's heroine Angela Murray (Angèle, when she passes) is equally
alert to the pitfalls of racial solidarity. Van Meier explains them to an
audience at the 135th Street library: " 'Our case is unique,' the beau-
tiful, cultured voice intoned; 'Those of us who have forged forward,
who have gained the front ranks in money and training, will not, are
not able as yet to go our separate ways apart from the unwashed,
untutored herd. We must still look back and render service to our less
fortunate, weaker brethren.' " This was not the alliance between the
classes proposed in *The Walls of Jericho*; it was a parody of the White
Man's Burden, concluding as it does with a formal parcelling-out of
lovers according to the shade of their skins. It was the ultimate mulatto
novel, belonging more to the school of Thomas Nelson Page than to
that of Charles Waddell Chesnutt.

Wallace Thurman knew far better than most artists how prevalent
the hierarchical ideas of *Plum Bun* were. "A man's complexion has

little to do with his talent," he insisted. Intellectually, Thurman knew this was true, but the calamity of his life was that neither whites nor blacks—whether in his hometown of Salt Lake City, Utah, on the campus of the University of Southern California, or in Greenwich Village or in Harlem—ever let him live as though it were. "He was black," Richard Bruce Nugent recalled, "in a way that it's hard for us to recognize that people ever had to be black." Nugent was initially put off by him. "There was this little black boy with a sneering nose. . . . I couldn't eat." Thurman was also somewhat effeminate. In a time when many thought Walter White's greatest asset was his color, Wallace Thurman had no other choice but to be extraordinary to survive. Langston Hughes has left the word profile invariably cited by all students of "Wallie":

He was a strangely brilliant black boy, who had read everything, and whose critical mind could find something wrong with everything he read. . . . He wanted to be a *very* great writer, like Gorki or Thomas Mann, and he felt that he was merely a journalistic writer. His critical mind, comparing his pages to the thousands of other pages he had read, by Proust, Melville, Tolstoy, Galsworthy, Dostoyevski, Henry James, Sainte-Beuve, Taine, Anatole France, found his own pages vastly wanting. So he contented himself by writing a great deal for money, laughing bitterly at his fabulously concocted "true stories," creating two bad motion pictures of the "Adults Only" type for Hollywood, drinking more and more gin, and then threatening to jump out of windows at people's parties and kill himself.

Thurman could read eleven lines at a glance. He was to become the first Afro-American senior editor with a white publishing house. He had already acquitted himself exceptionally as literary critic on *The Messenger*. What he was determined to be, though, was author of the Great Afro-American Novel. Sometimes he thought he would be; sometimes, as after a terrible vision of artists beating their wings "in the luminous void," he doubted, confessing to Jackman once, "If real artists do that—how awful must be the fate of folks like myself not exactly burned by the magic fire of genius, but nevertheless scorched." Thurman concentrated his frustrations of color and intellect in his first novel, *The Blacker the Berry*, published by Macaulay in March 1929.

"For rhythm and pungency [read *Home to Harlem*]," was about all *The New York Times* reviewer cared to say. *Opportunity*'s Eunice Hunton wrote that "the immaturity and gaucherie of the work of this

young man from the West strikes one with a force that is distinctly disheartening." On the other hand, the *Defender* rejoiced. "Here at last is the book for which I have been waiting, and for which you have been waiting, whether you admit it or not." For the first time, the color prejudice within the race was treated not as a regrettable curiosity or vague mutual aversion of light and dark Afro-Americans but as the central theme of a novel. Recessive genes have made Emma Lou, the unfortunate heroine, a very dark member of a Boise, Idaho, family the guiding principle of which is " 'Whiter and whiter every generation,' until the grandchildren of the blue veins could easily go over into the white race." Her odyssey carries her, as Thurman's own did, to college in California and anguish in Harlem. Seldom has so much misery, masochism, and misunderstanding been crammed into one small novel. The reader almost wearies of the heroine's physical and psychic abasement to gain acceptance by the right people, for hers is the double delusion of self-hatred because of color and comic loyalty to "proper" middle-class values. "Had any one asked Emma Lou what she meant by the 'right sort of people,' " Thurman writes, "she would have found herself at a loss for a comprehensive answer. She really didn't know." But she did know that they were seldom as dark as she, that their wives were as white and proud and dignified as Cunard ocean liners.

Emma Lou was obviously Wallace Thurman. But she stands, too, for those Afro-Americans in whom the obsession with respectability extinguishes personality and self-respect—those for whom the least evidence of white influence is revered. The aesthetics of *Fire!!*, in which the real resource of Afro-America resided in honest, noisy common folk and its unconventional artists, inspires Thurman's novel on every page. When Emma Lou is invited to a rent party to meet the lights of the Renaissance (Nugent, Douglas, Hughes, Hurston, Thurman, and Van Vechten, thinly disguised by the author), her first thought is to swallow arsenic wafers to bleach her skin. It is the one occasion in the novel where complete acceptance is hers for the asking, where all the racial and social taboos and ideals are held up for honest, if boozy, scrutiny. "Emma Lou was aghast. Such extraordinary people —saying 'nigger' in front of a white man! Didn't they have any race pride or proper bringing up? Didn't they have any common sense?" Her host, Truman (Thurman), tries to put the intraracial problem in historical perspective:

It was for the mulatto offspring of white masters and Negro slaves that
the first schools for Negroes were organized, and say what you will, it is
generally the Negro with a quantity of mixed blood in his veins who finds
adaptation to a Nordic environment more easy than one of pure blood,
which, of course, you will admit, is, to an American Negro, convenient if
not virtuous.

But Emma's pain is too great for analysis. Her ordeal ends, as the novel
closes, with a tardy understanding that she must save herself by under-
standing herself—not through bleaching creams, arsenic wafers, and
mulatto lovers. Someday, Thurman suggests, even she may come to
believe that familiar folk saying,

> The blacker the berry
> The sweeter the juice. . . .

Jackman and Hughes kept score of Renaissance intramural competi-
tion, and, by their count, the genteel letters team was losing badly by
1929. Relishing the mischief of The Blacker the Berry, Hughes praised
Thurman's "gorgeous book" and predicted it would "complicate things
immeasurably" for all the associations, leagues, and federations, as
well as for the "seal-of-high-and-holy approval of Harmon awards."
Respectable critical reaction to the fiction of Du Bois, Fauset, and
Larsen was no match, in the short term, for the commercial success of
Home to Harlem, the controversy of The Blacker the Berry, or the
controversy and enormous success of Harlem, the Broadway play by
Thurman that opened in February. Loosely based on "Cordelia the
Crude," a Fire!! short story of the corruption by Harlem of a poor
southern family, Harlem's dialogue and plot were sensationalized for
New York audiences by Thurman's white collaborator, William Jour-
dan Rapp, editor of True Story magazine. Gambling, gang warfare,
rent parties, prostitution, and murder rage around and finally consume
the Williams family, scrambling and collapsing in a sardine-packed
railroad flat. "Lawd! Lawd!" moans bewildered Ma Williams as the
curtain falls, "Tell me! Tell me! Dis ain't de City of Refuge?"
 For a season, Thurman was Harlem's best-known inhabitant. Char-
lotte Mason could complain to Locke about "that horrible play" and
"Thurman's Judas Act" (Mason had helped him publish in Dance
magazine), and both Commonweal magazine and the Defender ex-
pressed their dread of what uninformed whites might think, but most

Harlemites agreed with *The Messenger's* Theophilus Lewis that *Harlem* was good for the cause: "It emphasizes 'I will' character instead of the gypsy type of Negro . . . a wholesome swing toward dramatic normalcy." George Jean Nathan was moved to write that "it has the sharp smell of reality; it has a pulse that gallops and it comes as a great relief from the currently promiscuous fakery."

Banjo was the last blast of 1929, appearing a few weeks after *The Blacker the Berry*. "White authors do not need to write against Negroes anymore," Aubrey Bowser lamented in *Amsterdam News*; "the Negroes are writing against themselves." McKay's second novel was fairly bad, although it had fairly good sales. *Home to Harlem* had content, if not much form. *Banjo* had little of either. The central idea was clear enough: European civilization is wholly inimical to the African everywhere, in body, mind, and spirit. But jumbled episode follows jumbled episode as Ray, from *Home to Harlem*, roams with beachboys, plays in a jazz band, discourses interminably, and decides to leave Marseilles's waterfront for Africa. "The truth is," patient William Aspenwall Bradley regretted, McKay had not "made as good a start in *Banjo*" as in the first book.

Home to Harlem and *Banjo* fully answered Jackman's question to McKay about "colored people feeling primitive." McKay saw in those primitive emotions the source of cultural renewal for the African of the diaspora. Yet the Renaissance McKay's success served to advance was contrary to his deepest aesthetic and political ideals, even after allowance was made for much artistic posturing and inverted snobbery. He never really lost sight of certain realities: "The Negroes were under the delusion that when a lady from Park Avenue or from Fifth Avenue, or a titled European, became interested in Negro art and invited Negro artists to her home, that was a token of Negroes breaking into upperclass white society." In Maryland, heading for a vacation on the Eastern Shore after graduating from Lincoln, Langston Hughes sent Thurman a wry letter that would have amused McKay, who was still in France. All the "Niggerati" needed a vacation, their nerves were so high-strung, Hughes wrote. And as for Harlem, alas, all the cabarets have "gone white and Sugar Cane is closed and everybody I know is either in Paris or Hollywood or sick. And Bruce [Nugent] wears English suits!"

8

The Fall of the Manor

The Depression ravaged Harlem, laying waste to the Afro-American workers of the North. In the agricultural South, where conditions had been terrible for so long, they worsened much more gradually, throwing an equal number of blacks and whites out of work—slightly more than 5 percent for males by the end of 1930. Meanwhile in Cleveland, 50 percent of the Afro-American population had no jobs, and in Detroit and Saint Louis 60 percent. Twenty-two out of every one hundred unemployed Chicago workers would be Afro-American by 1935, yet they composed only 8 percent of the municipal labor force. In Harlem, median family income nose-dived 43.6 percent in less than three years. It had been $1,808 in 1929 (the national median was $2,335); in 1932, it would be $1,019. Harlem incomes fell (and so, mercifully, did the national price index for commodities), but not the tide of migrating peasantry; thus, throughout the Depression, rentals above 125th Street would range $12 to $30 a month higher than the rest of Manhattan. Harlem the ghetto was becoming Harlem the slum, the upward movement of its inhabitants pathetically slowing where it did not, as was generally the case, reverse itself.

Charles Johnson's researches at Fisk showed that the professional classes—the Talented Tenth—had grown by an impressive 69 percent between 1920 and 1930. With the notable exception of New York, hardly a major city, North or South, was without its Negro-owned bank. Nearly a dozen aggressive life insurance companies had branched across state lines, displacing or absorbing hundreds of religious or fraternal burial societies founded before the turn of the century. But in the aftermath of Black Thursday, Afro-American fi-

nancial institutions went as suddenly limp as marathon dance contestants at the Savoy. Jesse Binga's Binga State Bank, the largest, led the collapse, in July 1930. Binga's great affluence went up in smoke and the harassed Chicago banker found himself indicted for embezzling a quarter of a million dollars from the institution that was his life and that had been decisive in the lives of hundreds of Chicago property owners. *Opportunity* delivered a baleful obituary on the Binga bank collapse and those that followed, emphasizing that "a Negro bank is more than an institution for financial savings and transactions—it is a symbol of the Negroes' aspirations to enter the commercial life of the nation." For all his early socialist convictions, union leader Asa Philip Randolph found these business failures "baffling."

The fabulous assets of John Nail, of Harlem's Nail & Parker Realty, dwindled pitifully while his brother-in-law James Weldon Johnson vainly interceded with the Rockefellers, and Arthur Schomburg looked for buyers for Nail's remarkable collection of Henry Tanner paintings. The financial reverses of W. E. B. Du Bois, borne with classical stoicism, included the loss of his home and life insurance; and there were not even funds to repay Cullen for Yolande's share of the divorce settlement. "I am sorry that I have not kept my promise of remittances to you," the gallant old man apologized, explaining that the national Depression was so bad that "we have felt it especially in *The Crisis*, and I have not drawn my salary for several months in order to make things go."

Such calamities meant that many Afro-American college graduates and not a few holders of doctorates could look forward to little more than a lifetime of sorting the mail. Yet, Afro-American faith in the free enterprise system and confidence in the role of the race in that system seemed almost as strong as ever. When Broadus Mitchell, the Johns Hopkins University political scientist, addressed the major civil rights organizations in summer 1933, he predicted the "end of the era of individualism" and ventured the gentle admonition that greater boldness was required of "the dominant leadership of the Negro." If he read Lawrence Reddick's "What Does the Younger Negro Think?" in the October *Opportunity*, Mitchell must have realized how rocklike was the orthodoxy of its dominant class, even as mass unemployment showed no signs of abatement. "Most of the students at Howard, Fisk, and Atlanta University have parents who are either doctors, school teachers, or 'business men,'" the article explained (not entirely accurately), "and these same students aspire to be like their parents, but with a finer car and a whiter collar. This deep set faith persists though the present

crisis has stripped the parents clean and plucked most of them to the bone." There were no communists or socialists at these redoubtable institutions, according to Reddick.

Bad as things were, middle-class Afro-American patience and loyalty made a degree of economic sense. Fallback for the Talented Tenth was the United States Post Office. Whatever the wounds to the ego of an Amherst or Atlanta alumnus in the mail room, average annual pay was a viable eighteen hundred dollars. By mid-Depression, median family income in America would barely exceed sixteen hundred dollars. Then there were the two-thousand-dollar social work executives and elementary school principals, the legions of public school and college teachers earning nearly two thousand dollars a year, and the army of Pullman porters and red caps pocketing leaner tips now, but coping on wages often as large as their classroom cousins. These people, whose modest but relatively fixed incomes gave them a real advantage during times of economic constriction, responded with guffaws whenever *New Massses* told them they belonged to the rising proletariat.

In Harlem, now more than ever, the wages of alcohol and amusements paid. The rich ignored or forgot the troubles of Wall Street in the old places like the Cotton Club and Connie's. "Smalls' is quite swank now," Jackman wrote Cullen, as the club made its final transition from a Harlem cabaret to a cabaret in Harlem. "The place has been newly decorated and it looks quite spiffy." But there were more whites now, and more who came without the ready money to finance a night of dancing waiters, high-yellow chorines, and Cab Calloway. They settled instead for small, dark places, the sounds and smells of hard-living flesh, and the oblivion of bathtub gin or abundant cocaine. "The night life in Harlem these days is in the speakeasies," Jackman reported. Many of these places were owned by the Irish, but a good number— Coal Bed, Air Raid Shelter, Glory Hole—were Afro-American. The vast dance halls never shut their doors now, but Jackman found their clientele distinctly disagreeable, half-seriously exclaiming to Cullen about a breakfast dance at the Rockland Palace, "You talk about ugly niggers—they almost frightened me away!" He preferred the speakeasies. Above all, he loved the Clam House, the "little hole" on 133rd Street, where "a black cherub of some mean proportions stomps a piano and sings the blues in a deep contralto voice that is just out of this cosmos." When Gladys Bentley, always in male attire at the Clam House, sang a new blues called the "Saint James Infirmary," Jackman wrote, it "makes you weep your heart out." Less than two years were

left for weeping in speakeasies, though. The end of Prohibition was approaching, and, according to Willie "the Lion" Smith, it was legal liquor that would do to Harlem what scarcer tips and shuttered warehouse of the Depression had failed to do.

The Depression ravaged Harlem, but not totally and not all at once. Destructive, yet capricious, it ran its course with a breadth and ferocity that varied according to class and luck and perspective. There were many molders of opinion like Walter White whose awareness of the Depression remained abstract. They saw the spreading poverty and commiserated with friends who succumbed, but Harlem remained, for them, the great Negro metropolis, fount of arts and letters. When he wrote the *Herald Tribune* to praise a series of Harlem articles by Beverly Smith, White was not merely discharging a routine duty but also conveying a genuine belief that Smith's superficial reporting had "set forth the economic disabilities of Negro Harlem." It made curious reading next to Miss D. J. Small's long *Herald Tribune* letter of February 16, 1930. Orphaned, white, and raised in Harlem by an Afro-American mother, Small wrote with lucid fury of butchers' rotten meat and gouging landlords, of economic exploitation by absentee whites, and of moral decay fostered by those who "do their dirt in Harlem." "If you must write articles about Harlem," she demanded, "learn the truth, the heartaches of mothers, the plea of hungry children, the cry to Almighty God of these struggling people, and then you and your race group will be doing the community a great good."

For most of the Niggerati (an expression that was now current everywhere), the good times rolled onward. Lincoln University met Hampton Institute at the Polo Grounds in early November 1929. It was the first time Afro-American football teams had played there, and there was unmistakable reproach in the *Dunbar News*' disappointment that, because of the severe weather, more Harlemites had not been in the stands to see Lincoln win. No attendance problem detracted from hilarity and ostentation at the annual Kostume Karnival of Kappa Alpha Psi fraternity that same week, at the Renaissance Casino. Downtown, Muriel Draper's parties resembled a Jules Bledsoe gala, although the whites tended to bore Harold Jackman by talking too much and dancing too little. "All we did," Jackman chuckled in one of his weekly letters, "Mac, Lelia, and some of the other spades, was to sit down and eat and drink." Van Vechten's parties were still the best, although the best bartending was done at Heywood Broun's West Fifty-eighth Street penthouse. Now that the *Nigger Heaven* furore had subsided, Van

Vechten seemed to be in competition with the Savoy. He was especially thick those days with one of A'Lelia's permanent houseguests, Mayme White of Philadelphia, the daughter of George H. White, the last nineteenth-century Afro-American congressman—"one of the wittiest" women Geraldyn Dismond ever knew, and, according to Jackman, one of the largest.

Among the most beautiful women on the scene at the time, and the perfect symbol of the Depression-proof side of the Harlem Renaissance, was Blanche Dunn. She was tall, slender, ambiguously beige, with the cool, sculptured, haughty beauty of an Andalusian courtesan. She did nothing, but did it exquisitely. "Blanche," said her friends, "simply exists." Her first "sponsor" was the New York consul general of a Scandinavian country, and her last was a nobleman who married her and took her to Capri. She was what whites and many Harlemites thought the Negro would become in the Golden Age, totally untouched by race prejudice and free of all racial concerns. When the waitress in an elegant Manhattan restaurant explained that Afro-Americans were not served, Blanche Dunn replied composedly, "I don't blame you— now show me the menu, please." She was one of the best-dressed women of the period, and at the Hot Cha, Italian-owned and one of Harlem's most exclusive speakeasies, a table was permanently reserved for her. She and Jackman were inseparable and Van Vechten treated her like a goddess. "This life, which came so easily and unfought for," Richard Bruce Nugent reflected later,

became in reality her career. Her ability to accept the fact that the world was a pleasant place in which to live had never diminished. And why should it? It was during the first of the Depression that she was persuaded that a shopping trip to Paris and a pleasure tour of Europe might prove amusing; and [she] return[ed] to America after having proved to herself that such was the case. Saratoga and the races beckoned, Atlantic City, the football games, the Broadway first nights; and she answered their call. It was all a part of life to her by this time. . . .

At Villa Lewaro, where Blanche Dunn was a frequent guest, A'Lelia's weekends were still glorious, the magnificent, spotlit white mansion glowing at night and rolling laughter and music far up the Hudson. One Monday morning, Geraldyn Dismond reported that five carloads departed Lewaro for Jules Bledsoe's "farm-deluxe" at Roxbury for the day and dinner. "Tuesday found us back in Harlem, but

still dreaming of the perfect weekend" (though not for long: A'Lelia's Harlem "at-homes" were on Wednesdays).

Dropping in unannounced at 409 Edgecombe one evening, Jackman found Walter White "still talking about Walter, and how he can talk about himself, and Carl and Heywood and Res and Clarence and Bernard and all the other big lights." It was a self-important period for White and a turning point for the leading civil rights organization. Since July 1929, he had run the NAACP while an exhausted James Weldon Johnson mended his health and worked on a book through the generosity of the Julius Rosenwald Fund. While Johnson spent that autumn in Japan as a guest of the Institute of Pacific Relations and won dime forfeits from John D. Rockefeller III, and other sailing companions who forgot to speak French, his driven, self-absorbed replacement rapidly fixed his stamp on the NAACP. Because of his heavier duties as acting secretary, White's request for a twelve-hundred-dollar salary raise was granted by the board in early December, over the fierce objections of Du Bois and two other senior officials. On December 10, White's organization made New York society take notice. "Tuesday, the NAACP gave a benefit at the Forrest Theatre (downtown—think of it—downtown)," even blasé Jackman marvelled. "I didn't go—couldn't afford it—but saw many of the audience at the Dark Tower afterwards." Black and white, all the swells were at A'Lelia's that night. James Weldon Johnson had just returned and Charles Johnson was up from Fisk on his way to investigate Liberian peonage for the League of Nations. Jackman failed to disclose White's reaction when A'Lelia punched one of her friends in the face for objecting to the fifty-cent admission charge. "It was a riot. Your people, hmm, hmm!"

In February 1930 there was more excitement on Broadway with the opening of *The Green Pastures*, Marc Connelly's dramatization of Roark Bradford's book of short stories, *Ol' Man Adam an' His Chillun*. A folk play as emotionally fulfilling as it was socially mute, it met with almost universal acclaim. The singing of the Hall Johnson Choir, the rustic dignity of Wesley Hill as the Angel Gabriel, and the believable gravity of Richard B. Harrison as "De Lawd," brought capacity audiences to the Mansfield Theatre for 557 performances. After a tour North and South, it returned to Broadway to run for five years. Brooks Atkinson decreed Connelly's play "a work of ethereal beauty and of compassionate comedy without precedent" deserving to rank with *The Dybbuk*, *Strange Interlude*, and *What Price Glory*. Ster-

ling Brown, in the process of becoming one of Afro-America's severest
critics, pronounced the play a "miracle." If the play was not "accurate
truth about the religion of the folk-Negro," Brown said, it was "mov-
ingly true of folk life." *Lulu Belle, Abraham's Bosom, Porgy, Harlem,*
and King Vidor's controversial talking film *Hallelujah!* had prepared
the way, but Connelly's fable was seen as a breakthrough more historic
than *Shuffle Along,* almost a decade gone. It seemed certain that there
would be more roles and more Hollywood and Broadway productions.
Hall Johnson's folk play, *Run Little Chillun!* (written, directed, and
acted by Afro-Americans), and Paul Green's ecstatically praised
House of Connelly were soon in rehearsal, and James K. Millen's
realistic treatment of lynching, *Never No More,* would follow in Janu-
ary 1932.

Walter White had not been especially taken by Bradford's book, but
to him Connelly's play had "all the poetry and imagination and lyric
loveliness which takes it out of the class of being just a play and lifts it
to the realm of great art." Here, at last, White believed, art and society
were interacting positively, the poet was touching and transforming the
populace. *The Green Pastures* on tour was bringing well-dressed, cul-
tured Afro-Americans to segregated or rarely patronized playhouses and
civic auditoriums where their correct conduct could not fail to impress
"the better class of whites"—whites already moved by the play's por-
trayal of the Afro-American's essential humanity, great gifts of music
and humor, and his noble suffering. White's enthusiasm rivalled Con-
nelly's. In a typical "I-have-just-talked-to" letter to Connelly, he volun-
teered his services to assist the French translator of the play. If some of
the *Fire!!* artists were far less enthusiastic (Hughes, for example, wrote
a wicked piece about "De Lawd's" performance before a segregated
audience in Washington, D.C.), the civil rights establishment was
unanimously enthralled. On March 22, 1931, Lieutenant-Governor
Herbert Lehman presented the NAACP's highest honor, the Spingarn
medal, to the sixty-seven-year-old Richard B. Harrison ("De Lawd")
at the Mansfield Theatre.

As is the usual case with an expiring movement, the beginnings of
the end were either mistaken for more success or only belatedly recog-
nized for what they truly were. The publication of *Black Manhattan*
toward the end of 1930 was one such ambiguous event. James Weldon
Johnson had conceived this first, and still indispensable, history of Har-
lem as both chronicle of past achievements and monument to future

glory. "Harlem," the author wrote, "is still in the process of making." But Johnson's Harlem was fading even as Knopf issued the book, an animated personal and social history written during Johnson's Rosenwald Fellowship year. "The most outstanding phase of the development of the Negro during the past decade," Johnson was certain, "has been the recent literary and artistic emergence of the individual creative artist; and New York has been, almost exclusively, the place where that emergence has taken place." Within a few months, though, Johnson would sever his fifteen-year tie with the NAACP and leave New York for Nashville, Tennessee.

Johnson's sense of organizational accomplishment in 1930 was deservedly immense. He had used his influence as a trustee of the American Fund for Public Service (Garland Fund) to gain a $100,000 appropriation for a permanent NAACP legal counsel. Thanks in part to him, the Urban League and the Brotherhood of Sleeping Car Porters were also needy beneficiaries of Garland Fund generosity. His charter membership on the board of the American Civil Liberties Union had been of great strategic importance to the NAACP. In matters of higher education, his counsels were greatly prized. He was one of the key advisers in the planning of the new Rockefeller-funded Atlanta University. When Anson Phelps Stokes had a friend who wanted to spend a million dollars anonymously on Afro-American education, Phelps Stokes brought the matter to the NAACP secretary.

But Johnson's greatest satisfaction may have been in rallying the Rosenwald Fund to implement its program of Afro-American fellowships. Details had been worked out with Fund president Edwin Embree in Johnson's home one weekend in April 1929. There had been hesitation, Embree wondering whether, "since a Guggenheim foundation has included one or two Negroes in its fellowships," Rosenwald philanthropy might not be more usefully allocated elsewhere. The Afro-American was at the crossroads, Johnson countered eloquently. "Artistic effort and creative achievement among Negroes are just beginning, and so it is not so much a matter of the needs and opportunities of the present moment as it is the fostering and development of these potential powers of the Negro in the five, ten, fifteen, or twenty years to come." On May 17, a relieved Johnson received word from Chicago that the "trustees of the Julius Rosenwald Fund discussed the proposal for fellowships to creative workers and expressed in general a sympathetic attitude." During its remaining twenty-five years of existence, the Fund would award about one thousand fellowships to Afro-Ameri-

cans. Launching the program with the highest standards and maximum publicity, the Rosenwald directors had offered Johnson himself the first fellowship, a generous stipend covering his six-thousand-dollar salary for one year.

With so much achieved, it would have been surprising had Johnson not wondered, during his pleasantly productive sabbatical at age sixty, if he should return to the civil rights war room. As early as the winter of 1923, he had confided to H. L. Mencken that the "job of 'uplifting' any portion of the human race beyond the size of a family takes up all the time and energy the average man possesses." When the sabbatical was up in mid-November 1930, he asked for an extension to "bring near completion a piece of writing that I am now in the midst of," and then finally resigned his NAACP secretaryship for good on December 17. Friends gave him a farewell banquet at Manhattan's Hotel Pennsylvania a few months later. Rosamond Johnson sang and played the songs that had once made the Johnson brothers the lions of Broadway; Heywood Broun, Carl Van Doren, Haitian ambassador Dantes Bellegarde, and the Spingarn brothers spoke of what Johnson meant to them. In a moving toast, Joel Spingarn remembered how he and Johnson had "clicked" on first meeting, and noted that "if a narrow prejudice had not imposed upon him the task of defending a single race, I can imagine him as a shining star among the dim asteroids of the United States Senate." The following September, as Adam K. Spence Professor of Creative Writing, James Weldon Johnson shone on Fisk University.

One by one, those six key personalities of the Harlem Renaissance had reordered their lives until, by the early thirties, White alone sustained the role of active booster. Holstein had become absorbed in the politics of the Elks and his native Virgin Islands; Fauset was a now dedicated housewife; Locke was increasingly busy with Howard University affairs; and both the Johnsons, Charles S. and James Weldon, were in Nashville, where, one by one, Aaron Douglas, Arthur Schomburg, and Arna Bontemps would join them as members of the Fisk community. White's prodigious energy almost made up for the losses. The defeat of North Carolina Judge John J. Parker's nomination to the U.S. Supreme Court in May 1930 was one of the NAACP's greatest political triumphs. After an NAACP-orchestrated national media campaign, alliance with the American Federation of Labor, and White's compelling testimony before the Senate judiciary subcommit-

tee, President Hoover's racist and antilabor nomineee went down to narrow Senate defeat. It was a moment of maximal organizational effort, yet it was also one of Walter White's most active arts and letters periods. Patronage proposals were still launched over lunch at the Algonquin and, as often, consummated at a dinner party at 409 Edgecombe. A formidable volume of letters still went forth from NAACP headquarters to foundations, publishers, and wealthy or well-placed allies to keep the Renaissance on course.

Whether it was that most new creative talent had already been found, or that it now went undiscovered because of the abandonment of the annual awards banquets, there were many fewer new writers and artists for White to promote. Waring Cuney, a young Washington poet whose verse was three parts Hughes and one part Cullen; Richmond Barthé, a Louisianan who would become an outstanding sculptor of his generation; Augusta Savage, another promising but less disciplined sculptor from Florida; Harry Pace, an insurance broker with a yen to write lurid novels; Dorothy Peterson, a Brooklyn schoolteacher who finished a manuscript because Nella Larsen and Jean Toomer, whom she admired, were writers—this was the new crop for which White did as much as high-powered contacts and brisk salesmanship could. For those whose reputations still lagged behind their abilities, he was a tireless self-appointed agent. "I was talking with one of the representatives of the Harmon Foundation," he wrote Arna Bontemps, instructing him to submit his latest work immediately. "Suggest you get manuscript in the mails today, sending it directly to Miss Moriarta," he telegraphed Sterling Brown hours before the Harmon deadline. He nominated Rudolph Fisher for that year's Harmon gold medal. His endorsements of manuscripts did not guarantee a contract, but the publishers routinely told White the reasons for their negative decisions. Blanche Knopf was even willing to reconsider Harry Pace's undistinguished manuscript "Beale Street," explaining that "we knew nothing of your interest in Mr. Pace." There were intercessions—unsuccessful— on behalf of Cullen at the Rosenwald Fund and of Schuyler at the Guggenheim Foundation, and there was the unbroken flow of suggestions, often commencing with typical self-importance (as this one to Hughes): "A few days ago, Nathan W. Levin of the Rosenwald Fund was in to see me...."

When 1930 ended, the vital signs of the Renaissance still appeared remarkably strong. White took his first vacation in years, sailing to Haiti. Alain Locke shared White's optimism, entitling his yearly retro-

spective essay in *Opportunity*, "The Year of Grace." A year that opened with Marc Connelly's *The Green Pastures* and closed with Langston Hughes's *Not Without Laughter* and George Schuyler's *Black No More* surely did not herald the beginning of a decline, Locke thought. Cullen (now styling himself Countée Cullen) had returned from France that summer and, after the restrained reception of *The Black Christ*, was known to be turning to fiction. McKay was rumored to be writing his most serious novel and seriously considering exchanging Paris for New York. Bontemps's *God Sends Sunday* was under contract. Nella Larsen had won a Guggenheim, and was travelling in Europe. She had been almost engulfed by scandal early that year when "Sanctuary," her short story in the January *Forum*, was discovered to bear suspicious similarities to "Mrs. Adis," a 1922 short story by Sheila Kaye-Smith. "But isn't that a terrible thing?" gasped Jackman, who might joke about racial characteristics but never about plagiarism. Van Vechten had rushed to her defense, and Larsen herself seemed much too intelligent (though not, perhaps, too principled) to have stolen another's work. It appeared far more likely to have been coincidence, the editors of *The Forum* concluded, or, as Richard Bruce Nugent believed, something subconsciously filed away from literary banter at Van Vechten's.

Jean Toomer's behavior also puzzled Harlem that year. He was seldom seen by old friends now, as his Chicago activities were given over to the Gurdjieff movement and his occasional stays at the Hotel Brevoort were almost secretive. In mid-July, Toomer had refused to have his work included in James Weldon Johnson's revised *Book of American Negro Poetry*, although, four years earlier, he had not objected to inclusion in Cullen's anthology, *Caroling Dusk*. Since *Cane*, there had been some confusion about his "position," he told Johnson. He did not see things "in terms of Negro, Anglo-Saxon, Jewish, and so on. As for me personally, I see myself an American, simply an American." Harlem wondered if there was a connection between Toomer's new position and, save for one or two curious magazine pieces, his failure to publish.

Whatever the concerns about Larsen's ethics and Toomer's identity, 1930 appeared in the main to have been another vintage year. *Not Without Laughter* helped enormously to make it so. Hughes had written the novel during his senior year at Lincoln, and his aged Park Avenue patron Charlotte Mason had been pleased. Dedicated to Joel

and Amy Spingarn, it was released by Knopf in late summer. Since Toomer, no Harlem writer had written as beautifully about the vices and virtues of ordinary Afro-Americans and the truths governing their lives; (except for *Quicksand*) it would not be equalled or surpassed until Zora Hurston's *Jonah's Gourd Vine* four years later. Hughes's friend Arthur Davis complained, with justice, that it had been padded with "worn-out material," and he particularly attacked one scene in which slavery is sentimentalized. ("They talks about slavery time an' they makes out now like it were de most awfullest time what ever was, but don't you believe it, chile.") But such passages probably resulted from Hughes's awareness of audience demand. Unread writers could hardly hope to have an immediate influence, so *Not Without Laughter* has much "darky" wisdom and not a little minstrelsy to help sales. "It might have been worse," exclaims one character after a storm. "It might have been much more calamitouser!"

Hughes offered far more than entertainment, although he never drummed out a thesis in the manner of McKay or Thurman. Aunt Hager Williams and her family represent Afro-America at the close of the twenties—Harriet, the harlot daughter who succeeds as a blues singer; Annjee, a casualty of the city and its loose ways; Annjee's bewildered son Sandy; and Tempy, materially secure in a small way and deadeningly respectable. Annjee, who lives one day at a time, reasonably expects Sandy to forgo school, run an elevator, and help with the rent on a Chicago slum apartment. " 'Evening's the only time we niggers have to ourselves!' " is the sum of Annjee's counsel to Sandy. " 'Thank God for night . . . 'cause all day you gives to white folks.' " Tempy, on the other hand, with her postal clerk husband, spotless home, and rental property, has the mind and diction of a *Crisis* editorial. " 'White folks will see that the Negro can be trusted in war as well as peace,' " she lectures Sandy. " 'Times will be better after this for all of us.' " Meanwhile, no watermelon, no spirituals, and no consorting with social inferiors for her nephew under her roof. Harriet is too alive to corset herself in Tempy's world, and too smart for the mindless ruination of Annjee. Whites must be beaten on their own terrain, with success, power, brains. " 'All of us niggers are too far back in this white man's country to let any brains go to waste! Don't you realize that?' " she reproaches Annjee and Sandy. Intuiting, even when comforted by them, that his grandmother's simple religious ideals will help him no more than a rabbit's foot when he grows up, Sandy grasps for a destiny.

He remembers the words of Jimboy, his sometimes-present father: " 'White folks get rich lyin' and stealin'—and some niggers gets rich that way, too—but I don't need money if I got to get it dishonest, with a lot of lies trailing behind me, and can't look folks in the face.' "

Not Without Laughter ends before Sandy decides what to do with his life, for Sandy is the Afro-American's future. But Hughes clearly wants it understood that the Afro-American has a special contribution to make, that proving his equality means affirming his distinctive qualities. The vast compassion of Aunt Hager, mother of the black race, the defiant independence of Jimboy—male mind and body at ease with themselves—these are racial attributes that must survive the profiteering and mechanization of white civilization. Aunt Hager, fount of wisdom, puts the matter plainly. She feels sorry for the whites because she knows " 'something inside must be aggravatin' de po' souls. An' I's kept a room in ma heart fo' 'em, cause white folks needs us, honey, even if they don't know it.' " *Not Without Laughter* was not Marxist enough, wrote Walt Carmon of *New Masses*, but it was still "a definite contribution to both Negro and proletarian literature in America. . . . It is the first definite break with the vicious Harlem tradition of Negro literature sponsored by Van Vechten and illustrated by Covarrubias." This novel, which *New Masses* embraced as "our novel," won Hughes the 1930 Harmon gold medal.

If *Not Without Laughter* pleased by appearing to say a good word for everybody, *Black No More* succeeded through broad-gauge mockery. No institution, no personality escaped George Schuyler's Juvenalian irreverence. ("Nothing [is] above a snicker, a chuckle, a smile," Schuyler was fond of saying.) Macaulay's, the same firm that had published Thurman, released the novel in the first weeks of January 1931, but Harlem's civil rights establishment had been passing the manuscript around for months, courtesy of the mischievous author himself. Locke, who somehow escapes being savaged, thought "one of the great new veins of Negro fiction has been opened by this book—may its tribe increase!"

The plot is divertingly preposterous—all the better to allow Schuyler to march in review all the gruesome, absurd, and tedious manifestations of American racism. Dr. Junius Crookman, an Afro-American scientist, invents a process—"by electrical nutrition and glandular control"—which turns dark skin white and crinkly hair straight. One of Crookman's first clients, Max Disher of Harlem, changes his name to Matthew Fisher, pretends to be a noted anthropologist, and moves to

Atlanta, Georgia, where he becomes a ranking officer of the Knights of Nordica. " 'These damn ignorant crackers will fall fer anything fer awhile,' " a redneck sage reassures Fisher about the potential profit of his plans. Such is Fisher's impact upon membership and dues that the Reverend Henry Givens, Imperial Grand Wizard, proudly gives his daughter in marriage to the New York anthropologist. Meanwhile, Afro-Americans vanish by the millions as Crookman's Black-No-More, Incorporated, now a powerful, nationwide enterprise, defies and buys racist politicians, South and North. The racial landscape is transformed:

Gone was the almost European atmosphere of every Negro ghetto: the music, laughter, gaiety, jesting and abandon. Instead, one noted the same excited bustle, wild looks and strained faces to be seen in a war time soldier camp, around a new oil well district or before a gold rush. The happy-go-lucky Negro of song and story was gone forever and in his stead was a nervous, money-grubbing black, stuffing away coins in socks, impatiently awaiting a sufficient sum to pay Dr. Crookman's fee.

White panic is matched by black consternation, as the National Social Equality League (the NAACP) disintegrates, and Madame Sisseretta Blandish's hair-straightening empire goes bankrupt. Finally, as the last transformed Afro-Americans spill forth from Crookman's centers, it is discovered that Black-No-More whites are a shade or so whiter than the genetic variety: "If it were true that extreme whiteness was evidence of the possession of Negro blood, of having once been a member of a pariah class, then surely it were well not to be so white." *Black No More* closes as the nation regains a new racist equilibrium. It is noted that "among the working classes, in the next few months, there grew up a certain prejudice against all fellow workers who were exceedingly pale." Learned books and scientific tests establish the genetic inferiority of the ultra-pale. A Mrs. Sari Blandine "(formerly Mme. Sisseretta Blandish of Harlem), who had been working on a steam table in a Broadway Automat," confects a skin stain desperately sought after by erstwhile Afro-Americans, while the Down-With-White-Prejudice-League is founded by one Karl von Beerde, "whom some accused of being the same Doctor Beard who had, as a Negro, once headed the National Social Equality League."

Schuyler's unsubtle novel was hilarious in 1931, and still amuses. William J. Simmons, the failed evangelist who resurrected the Ku Klux Klan in 1919, is instantly recognizable as Reverend Henry Givens.

Frederick L. Hoffman, senior racist among early twentieth-century so-
cial scientists, appears as Dr. Samuel Buggerie, "the statistician of a
great New York insurance company." Marcus Garvey, as Santop Lic-
orice, had scant reputation left by 1931, of course, and Schuyler
burlesques him brutally. He is somewhat more sparing of Howard Uni-
versity president Mordecai Johnson and Tuskegee Institute principal
Robert Russa Moton, disguised, respectively, as Rev. Herbert Gronne
of Dunbar University ("he very cleverly knew how to make statements
that sounded radical to Negroes but sufficiently conservative to satisfy
the white trustees") and Col. Mortimer Roberts of Dusky River Agri-
cultural Institute, president of the Uncle Tom Memorial Association,
and "acknowledged leader of the conservative Negroes (most of whom
had nothing to conserve)." But the full force of Schuyler's burlesque is
aimed at White (Walter Williams), Du Bois (Dr. Shakespeare
Agamemnon Beard), and the NAACP. Self-serving elitists, the leaders
of the NAACP

began to envision the time when they would no longer be able for the sake
of the Negro race to suffer the hardships of lunching on canvasback duck at
the Urban Club surrounded by the white dilettante, endure the perils of
first-class Transatlantic passage to stage Save-Dear-Africa Conferences or
undergo the excruciating torture of rolling back and forth across the United
States in drawing-rooms to hear each lecture on the Negro problem.

" 'Personally,' " says Walter Williams, " 'I am very proud to be a
Negro and always have been (his great-grandfather, it seemed, had
been a mulatto), and I'm willing to sacrifice for the uplift of my
race.' " Harlem and Afro-America were enjoying their last good laugh
of the Renaissance.

By the end of 1931, the most detached artist and resolute optimist
realized that nothing was any longer quite as it should be, that the
aggravating national chaos could impinge in unexpectedly cruel ways
even upon the lives of distinguished Afro-Americans. In the summer
before the Wall Street crash, there had been portents, isolated indigni-
ties signalling the extreme fragility of racial achievements based upon
arts and letters and philanthropy. Afro-American travel to Europe had
set a record that summer, with the casts of *Blackbirds* and *Porgy*
booked into London theatres, jazz musicians answering the booming
demand of Paris and Berlin night clubs, students and scholars bound
for more serious enterprise, and a few travellers, like the Robert S.

Abbotts, sufficiently affluent to see the globe first class. To the astonishment and distress of many white Americans, dark faces seemed to be everywhere in the summer of 1929—in the swimming pools of the *Normandie* and the staterooms of the *Queen Mary*. But numbers did not mean acceptance. When Robert S. Abbott, founder and publisher of the Chicago *Defender*, arrived with Mrs. Abbott in London in early August, they were asked to leave their hotel after one day because American guests had protested their presence and threatened to blacklist the hotel by word of mouth. They finally found lodging in a London private home.

A noisier scandal occurred when Paul and Essie Robeson were turned away from the Grill Room of the Savoy Hotel after protests by other American tourists. They had gone there often, and were about to return to America for an October concert tour opening at Carnegie Hall. On this evening, however, the management informed Robeson that the hotel "did not permit Negroes to enter the rooms any longer." Until then, England had been Robeson's stage and sanctuary. He had been pleased to learn that his "background at Rutgers and my interest in academic studies" counted for something in England. But now, with a bitterness that would deepen, Paul Robeson learned that the prejudice of white American visitors counted for much more. "It is not in accordance with our British hotel practice," Prime Minister Ramsay MacDonald replied to a question in the Commons, "but I cannot think of any way in which the Government can intervene."

Nineteen-thirty brought the Gold Star Mothers disgrace. Congress had appropriated funds for a tour of the American cemeteries in Europe by mothers whose sons had fallen in the Great War. The War Department gave no thought to the matter of the Afro-American mothers who would be coming too until angry letters began pouring into the White House. It was decided that the mothers could not sail together on the same ship. The white Gold Star Mothers accordingly steamed away in dignity and the Afro-American mothers followed in July aboard a second-rate vessel. James Weldon Johnson was sufficiently distressed to interrupt compilation of his poetry anthology to write a long, ironic poem about the opening of the Arlington tomb of the Unknown Soldier on Judgment Day:

> He, underneath the debris, heaved and hove
> Up toward the opening which they cleaved and clove;

Through it, at last, his towering form loomed
 big and bigger—
"Great God Almighty! Look!" they cried,
 "he is a nigger!"

Viking published "Saint Peter Relates an Incident of the Resurrection Day" in a limited edition of two hundred later that year—at Johnson's own expense.

Charles S. Johnson was denied even the emotional release of poetry, which must have made the predicament he found himself in all the more infuriating. He had been officially deputized by the League of Nations to investigate reports of sales of Liberian boys to Portuguese planters on the island of Fernando Po. Preparing to leave in the first days of 1930, he discovered that no shipping line was willing to sell him satisfactory accommodations. "Three times I have been near these reservations and something queer has happened," he told Schomburg. Because of objections by white Americans, only third-class passage was available.

While the two Johnsons and millions of other Afro-Americans reacted to heightened bigotry, another bit of white insensitivity angered Harlem. The Rosenwald Fund offered to build and endow a segregated medical treatment and training facility in Harlem. Some leaders and physicians were tempted to accept the offer, given the virtual exclusion of Afro-Americans from the municipal hospital system, but, led by Louis T. Wright of integrated Harlem General Hospital, most of the community's physicians and the NAACP flatly opposed the plan. "Mr. Rosenwald," their written response stated, "has not, as far as we know, advocated the segregation of Jewish students at the University of Chicago and the sending of Jewish students to Jewish hospitals for their clinical clerkships and internships." The Rosenwald Fund medical plan was implemented in Chicago, but it was never mentioned again in Harlem.

For Langston Hughes, the winter of 1930–31 was full of bitter surprises from which he emerged greatly altered, emotionally and politically. Not Without Laughter was finished, and Hughes was planning to enjoy himself for the first time without "having to be afraid I might be hungry tomorrow." It was "a strange and wonderful year of economic freedom," thanks to the usual generosity of Charlotte Mason. There was a boat trip to Canada to see the northern lights, a monthly allowance and apartment in Westfield, New Jersey, and a chauffeured

limousine home from Park Avenue, Broadway, or Carnegie Hall. Jackman joked: "I saw Langston escorting a dowager (white) of ninety-eight. . . . Langston was all properly 'tuxed' and the old lady handed him the carriage check and the last I saw of him he was getting into an automobile." But Mason expected Hughes to work as well as to play. At a Jules Bledsoe party in the spring, he had been asked why, among all the plays about Afro-American life submitted to the Dramatists Guild, there had never been a comedy. The question was the genesis of "Mule Bone," a three-act comedy based on one of the numerous folk tales collected by Hughes's Westfield neighbor Zora Hurston. By the end of May, Hughes and Hurston had dictated a rough draft to their friend Louise Thompson, whose stenographic services were paid for by Charlotte Mason. Hurston departed shortly thereafter for Florida, carrying along the second act for more work. Hughes went to Cuba again to find a musician to collaborate on an opera about the African heritage.

Snow was falling on New York when Hughes returned; the daily papers disclosed business disaster and suicide; and bread lines were forming. The Mason millions still appeared to be safe. Miss Chapin, Mason's pleasant private secretary, still anticipated Hughes's needs, and the middle-aged, disapproving white chauffeur still ferried him to dinner and the theatre. The route from Hughes's new Harlem apartment to Mason's took him past the construction site of the new Waldorf-Astoria Hotel—and past subway entrances crammed with apple-peddling beggars. Comfortable, well-tailored, his days devoted to reading and playwriting and the nights to the excitement of theatre and drawing rooms, Hughes was nevertheless forced to remember that he "could very easily and quickly be there, too, hungry and homeless on a cold floor, anytime Park Avenue got tired of supporting me." Park Avenue had recently tired of supporting Hughes's half-brother in a New England preparatory school. The poet's mood began to change. He was outgrowing the folk poetry of his *Weary Blues* period, yet Charlotte Mason wanted her ward to "be primitive." "Unfortunately," Hughes "did not feel the rhythms of the primitive surging" through him. He began, instead, to feel the surge of dialectical materialism. In fact, he felt it so strongly that winter that, when he later wrote about the rupture with Mason in his autobiography, he altered the facts, and claimed it came about because of his long, experimental poem "Advertisements for the Waldorf-Astoria." Mocking the hotel's advertisement in *Vanity Fair*, stanza four is addressed to Harlem:

NEGROES

Oh, Lawd, I dones forgot Harlem!
Say, you colored folks, hungry a long time in 135th Street—
 they got swell music at the Waldorf-Astoria. It sure is a mighty nice
 place to shake hips in, too. There's dancing after supper in a big warm
 room. It's cold as hell on Lenox Avenue. All you've had all day is a
 cup of coffee. Your pawnshop overcoat's a ragged banner on your
 hungry frame. You know, downtown folks are just crazy about Paul
 Robeson! Maybe they'll like you, too, black mob from Harlem. Drop
 in at the Waldorf this afternoon for tea. Stay for dinner. Give Park
 Avenue a lot of darkie color—free for nothing! Ask the Junior Leaguers
 to sing a spiritual for you. They probably know 'em better than you
 do—and their lips won't be so chapped with cold after they step out
 of their closed cars in undercover driveways.
 Hallelujah! Undercover driveways!
 Ma soul's a witness for de Waldorf-Astoria!
(A thousand nigger section-hands keep the roadbeds smooth,
 so investments in railroads pay ladies with diamond
 necklaces staring at Cert murals.)
 Thank God A-mighty!
(And a million niggers bend their backs on rubber plantations,
 for rich behinds to ride on thick tires to the
 Theatre Guild tonight.)
 Ma soul's a witness!
(And here we stand, shivering in the cold, in Harlem.)
 Glory be to God—
 De Waldorf-Astoria's open!

"It's not you. It's a powerful poem! But it's not you," Mason is
supposed to have said, unamused. Hughes said he was reminded of his
father's cold disgust whenever his best had not been good enough. But
Mason could not have said this about "Advertisements for the Waldorf-
Astoria" because the break with her occurred in the winter of 1930,
and the hotel did not open until October 1, 1931. Hughes's poem
appeared in *New Masses* in December 1931. It must have been the
politically explicit, poetically bombastic "Merry Christmas," appearing
in the December 1930 *New Masses*, that riled the old lady. Hughes
never mentioned this poem (just as his autobiography leaves unmen-
tioned the final lines of the Waldorf-Astoria poem), the last three

stanzas of which were as politically shrill as anything the *New Masses*
ever published:

> And to you down-and-outers,
> ("Due to economic laws")
> Oh, eat, drink and be merry
> With a bread-line Santa Claus—
> While all the world hails Christmas,
> While all the church bells sway!
> While, better still, the Christian guns
> Proclaim this joyous day!
>
> While Holy steel that makes us strong
> Spits forth a mighty Yuletide song:
> SHOOT Merry Christmas everywhere!
> Let Merry Christmas GAS the air!

Hughes had become part of Louise Thompson's circle of new friends
for whom the Soviet Union was the model for future societies. Thomp-
son was spirited, attractive, intelligent. She was the first renegade from
the Locke-Mason stable, finding Mason's brand of philanthropy as in-
sultingly patronizing as that of the Hampton Institute, where she had
briefly taught before coming to Harlem. Thompson encouraged
Hughes to break out of his Park Avenue bondage and to become more
political. Locke and Hurston were certain that Thompson alone was
the cause of their friend's rebellion. "What can we do but let him fall,"
Locke sighed to Mason, "—and fall hard enough to wake up but not
break." But it was Mason, not Thompson, who drove away her pro-
tégé. Hughes asked her to release him from her empire, to try to accept
his new ideas, but, above all, "to let me retain her friendship and good
will that had been so dear to me." The old lady reviled him instead,
heaped imprecations upon him, and cast him for all time from her Park
Avenue Eden.*

Hughes was never capable of relating more than the bare details of
that catastrophic morning. He said it was like "that morning in Mexico
when I suddenly hated my father." He stumbled back to Harlem, phys-
ically wretched, and somehow managed to keep a dinner invitation at
Louise Thompson's that evening. By year's end, he was in Cleveland
with his mother, stepfather, and half-brother, living at 4800 Carnegie
Avenue. There, speculating that Hughes's system was being poisoned
by his tonsils, the family physician prescribed the appropriate opera-

* Cf., Rampersad, *Life of Langston Hughes*, I, pp. 185–88, *et passim*.

tion. He had just begun to improve when another emotional and professional blow fell.

On the night of January 15, 1931, Hughes attended a play at Karamu House, home of the Gilpin Players. Chatting afterwards with Rowena Jelliffe, codirector with husband Alexander, of the Afro-American repertory company, he learned that Karamu House was about to stage a promising folk comedy by Zora Hurston, titled "Mule Bone." Reading the script provided by the Jelliffes, it was obvious that, except for minor revisions of the first and third acts, this was the play he and Hurston had dictated to Thompson in Westfield, New Jersey. Hurston had finished the second act from their common notes in Florida. Telephone discussions with Hurston and telegrams between Cleveland and New York only worsened matters. Hurston denied sending the play to the Jelliffes or knowing that a performance was imminent. That much was true. Carl Van Vechten, whom she asked to read it (without mentioning Hughes), had passed it along to the Theatre Guild; from there it had reached Cleveland. During the next two weeks, the "Mule Bone" controversy enveloped much of Harlem's leadership. For once, Walter White may have been relieved that a Haitian vacation kept him from having to intervene. But Arthur Spingarn heard every detail from both sides at least twice; Locke was forced to choose sides; and Van Vechten's unctuous diplomacy failed. It was instantly obvious to Van Vechten, who claimed to fear the quarrel would cost Afro-America a play as potentially popular as *The Green Pastures*, that the work had been a collaboration. To Arthur Spingarn, the coauthorship was as patent as the threats of suits, hysteria by telephone and wire, and tearful depositions were silly. For their sakes, as well as "for the sake of the group," Spingarn warned that "litigation is the last thing either of you should think of...."

A riled Zora Hurston resembled a buzz saw in one of those Florida lumber camps she visited regularly to gather folklore. "It was my story from beginning to end," she insisted to Hughes. "It was my dialogue, my situations." Arriving by car in Cleveland, on February 1, Hurston, Hughes (whose tonsillectomy virtually silenced him), his mother, and the Jelliffes argued and shouted until well past midnight. Hurston refused to allow the play to be mounted under both names. As Van Vechten had feared, "Mule Bone" was not only put aside by the Gilpin Players then, but has never been staged to this day. Only a third act has been published, and copies of the first Afro-American comedy (not minstrel show) by Afro-Americans lie in the vaults of four or five

institutions. It was an almost perfect union of the talents of Hughes and Hurston. In Hughes's hands, Hurston's yarn about two hunters who quarrel over a turkey until one knocks the other cold with a mule's hock bone became a well-knit full-length comedy.

Hurston never came closer to an explanation of her destruction of her deep friendship with Hughes than some comments about "vile" Louise Thompson. Her resentment of Thompson (who left Cleveland just before Hurston arrived) was genuine. But her cavalier attitude about plagiarism and Hughes's fall from Mason's grace had at least as much to do with the break. Once before, Hurston had brazenly taken credit for another person's work—*Historic Sketches of the Old South* by Emma Langson Roche—in her scholarly article, "Cudjo's Own Story of the Last African Slaver," in the October 1927 *Journal of Negro History*. Sensing Hughes's estrangement from Mason and anxious lest it jeopardize her own two-hundred-dollar monthly allowance, the temptation to steal the play, avenge Hughes's and Thompson's alleged ingratitude, and continue pocketing Mason's money may have been irresistible to Hurston. She composed her fawning poem, "To Charlotte Mason," just as her annuity was renewed and on the eve of Hughes's expulsion. With Mason, Van Vechten, and Locke backing her, Hurston must have supposed that Hughes would choose injured silence as the wiser course.

When his throat healed, Hughes took his Harmon prize money and went to Cuba and Haiti. "That spring for me (and I guess, all of us) was the end of the Harlem Renaissance," he decided. "We were no longer in vogue, anyway, we Negroes. Sophisticated New Yorkers turned to Noël Coward." Hughes was understandably depressed, which explains why his medical bulletin on the Renaissance seemed exaggeratedly grave. On the Broadway stage, there was no slackening yet of interest in "Negro" subjects. "Amos 'n' Andy" was still a national pastime on radio. The Pittsburgh *Courier* was calling for a race protest of the radio comedy series as tasteless and demeaning, but Schuyler wrote Mencken that the campaign was probably doomed. Ninety-nine out of one hundred "howling Senegambians" tuned in every night, said Schuyler. Most Afro-American leaders still believed that it was far better for the race to be noticed distortedly—even demeaningly—by stage, radio, and film producers than not to be noticed at all. There was, more remarkably than in the early years of the Renaissance, the notice also being taken of the painters and sculptors. By 1931, they could be counted by the scores—some hundred-odd entering their

works in the annual Harmon Foundation competitions and exhibitions. When William Elmer Harmon died in the summer of 1928, the *Defender* lamented his passing on page one. The Ohio-born philanthropist with one of America's largest real estate fortunes had bequeathed $500,000 two years before to endow the awards for Afro-American achievement. The influence of his foundation in Afro-America had grown until, by 1931, it rivalled that of the Rosenwald Fund. Until 1929, the careful advice of George Edmund Haynes, the Fisk- and Columbia-trained sociologist (and former Urban League director) had guided the Harmon Foundation; Alain Locke continued to play a major advisory role, and Walter White a minor one. To Haynes and Locke was due much of the credit for the enormous success of the first all-Negro art exhibition in January 1928, sponsored by the Harmon Foundation at New York's International House. Eighty-seven items were displayed, signed by most of the painters and sculptors destined to be known at least by discriminating collectors. There had been more entries the next year—paintings by Aaron Douglas, Palmer Hayden, William H. Johnson, Archibald Motley, Jr., James A. Porter, Laura Wheeler Waring, and Hale Woodruff; sculpture by Sargent Johnson, Elizabeth Prophet, and Augusta Savage. The distinguished art critic Edward Alden Jewell fairly raved in *The New York Times* about canvases by Archibald Motley that had "set the art-critical world to wondering and talking." Harmon gold medalist Motley, who claimed the nineteenth-century Frenchman Bouguereau as his master and regretted being unable to "escape the nemesis of my color," was truly a remarkable talent, already recognized by Otto Kahn and the Guggenheim Foundation for his *Mending Socks* and *Syncopation*. A few more years would pass before Palmer Hayden's intriguing still life *Fetich et Fleurs* achieved its full impact, yet it gave back perfectly the ethos of the Renaissance—natural-seeming juxtaposition if not perfect union of refined sensibility and dark powers.

By 1931, as Hughes pushed off for the Caribbean, these and the works of 148 other artists had been gathered into a thick, expensively illustrated catalogue, with text by Locke, and were being shipped to fifty cities in what was now the annual Harmon Travelling Exhibition of the Work of Negro Artists. More than 150,000 people saw what these artists were doing, the vast majority of whom had never known of the existence of an Afro-American painter, photographer, or sculptor. How could it be doubted, as Hale Woodruff gratefully wrote from France, that the foundation was "doing a wonderful piece of work

toward furthering the interests in the achievements of the American Negro"? Congenital ingrates like McKay (a Harmon prize recipient), militant socialists like Frank Crosswaite, or hugely self-confident painters like Romare Bearden might express such doubt, but it seemed increasingly risky to some and plain wrongheaded to most. The role of the Harmon Foundation in Afro-American arts and letters was now far greater than anything Charles Johnson had ever imagined for his *Opportunity* network. Haynes was out of the picture now, in Africa for the Federal Council of the Churches of Christ, then in Washington with the Labor Department; and Locke's influence with the foundation was now shadowy and passive, curiously paralleling his relations with Charlotte Mason. But Miss Mary Beattie Brady, director, and Miss Hannah Moriarta, assistant director, two opinionated women at the Harmon Foundation whose knowledge of art—or literature, for that matter—was open to question, were certainly not deficient as power brokers and salespersons.

The travelling art shows were their work, and they spared no effort to assemble everything, to merchandise it appealingly, and to sell it— whatever its quality. When Motley insisted on withdrawing his paintings from the 1931 travelling show for his own Manhattan one-man show, Brady had her assistant write the young painter that, "while we make no promises or guarantees regarding sale of pictures, we are working very hard to get alumni associations, people of means, colleges, etc., interested and active in the matter of buying outstanding productions for art collections to be placed particularly in Negro colleges and universities." The mighty philanthropy in Nassau Street began to bear a striking resemblance to other addresses in Wall Street. The line between a foundation in the business of rewarding creative art and a business serving as clearinghouse for a foundation's artwork grew thinner. Still, what its directors were doing was in the purest tradition of The Six, as Aaron Douglas must have realized years later when he described the Harmon Foundation's vacuum-cleaner approach to the arts:

Neither streets, houses nor public institutions escaped. When unsuspecting Negroes were found with a brush in their hands they were immediately hauled away and held up for interpretation. They were given places of honor and bowed to with ceremony. Every effort to protest their innocence was drowned out with big-mouthed praise. A number escaped and returned to a more reasonable existence. Many fell in with the game and went along

making hollow and meaningless gestures with brush and palette, but . . .
the Negro artists have emerged.

While the Harmon financed, advertised, and sold Afro-American
fine arts, the publishing houses continued to be interested. Two white
writers had well-received novels about Afro-America during 1931.
Maxwell Bodenheim's *Naked on Roller Skates* offered another white
sophisticate's view of Harlem, mainly from taxis to and from tables in
Happy Rhone's now extinct Black and White Club. Nan Bagby
Stephens's unmemorable *Glory*, a melodramatic story about evil Rev-
erend Cicero Brown ravishing a credulous parishioner's daughter,
James Weldon Johnson considered remarkably good, musing how
strange it was that "in most cases the Southern white writers can dig
so deep down into Negro life, often a good deal deeper than the Negro
writers themselves." Johnson was obviously unaware that *Glory* owed
characters and plot to a brilliant 1924 silent film, *Body and Soul*, star-
ring Paul Robeson and written, produced, and directed by Oscar
Micheaux. There was even a second novel by George Schuyler that
year, a badly done work commissioned by publisher George Putnam
himself. Hoping his new firm of Brewer, Warren & Putnam could capi-
talize on public indignation aroused by Charles Johnson's report on
Liberian peonage, the publisher and his friend aviatrix Amelia Earhart
had invited Schuyler for drinks in mid-January to propose a secret trip
to West Africa. *Slaves Today* was the result.

For the moment, Harlem gossip was so spiced by news of Afro-
Americans in Europe that the Depression and its attendant racial
stresses still seemed tolerably remote—although a judicial travesty in-
volving nine Afro-American teenagers in Scottsboro, Alabama, was
duly and indignantly noted in early April. In Edward Perry's "Impres-
sions" column, *Tattler* readers were given details of Jules Bledsoe's
Paris concert debut at the Salle Gaveau, under the high patronage of
Princesse Violette Murat, Princes Michel Soumbatov and Touvalou
Houénou, Madame Eva Gautier, and Lady Cook. In the *Defender*,
they read of Nora Holt's triumph as hostess in London's most exclusive
café, the Coventry Street Restaurant. The *Amsterdam News*, the *De-
fender*, the Pittsburgh *Courier*, and the *Tattler* gave front-page coverage
to Ethel Waters's appearance at the London Palladium and her show at
the Café de Paris, which the Prince of Wales was reported to have seen
three times in one week. The private lives of the Robesons, subject of
perennial fascination for Harlemites, were of special interest that season

because of Essie Robeson's recent biography, *Paul Robeson, Negro*. In what was certainly an excess of candor, if nothing worse, Essie Robeson suggested that her famous husband owed his success to her. "Paul was very lazy," she told her readers. "He was not the person to think out what he would do or wanted to do and then go do it." There were rumors of separation, fervid speculation that, after critical acclaim for his London *Othello* the previous summer, the actor-singer resented his domineering wife's superior airs more than ever and was in love with Lady Mountbatten. "The word here," Mason alerted Locke, "is that he was so incensed at Essie's writing that book which made him so ridiculous that he told her what he thought of her and left."

Abruptly, on Monday, August 17, Harlem received a shocking prefiguration of its mortality. "Mme. Lelia [sic] Walker Robinson, only daughter of the late Mme. Sarah [sic] J. Walker, inventor of a preparation designed to remove the kink from Negro hair," *The New York Times* announced, "died suddenly early today at the home of friends in Lippincott Avenue, Long Branch. Her age was 46 years." To maintain her lifestyle, A'Lelia had mortgaged Villa Lewaro. Her parties had become more sumptuous, more tasteful, as she allowed herself to be guided by Clara Novello-Davies, voice teacher and mother of the Welsh actor, composer, and playwright Ivor Novello. A'Lelia's last large party had been in honor of Novello. The dinner party in Long Branch, New Jersey, was a small but elaborate birthday celebration for one of her intimates, May Fain. Around midnight, accompanied by Mayme White, A'Lelia departed for her cottage and went immediately to bed. At four that morning, her companion heard her cry out, "Mayme, I can't see; get me some ice." A'Lelia had paid no heed to her physicians' warnings about high blood pressure and overeating.

The Reverend Adam Clayton Powell, Sr., stirringly eulogized her at the exclusive funeral parlor on Seventh Avenue. Langston Hughes sat with Negrotarian stalwarts Muriel Draper, Rita Romilly, and Mrs. Roy Sheldon. Carl Van Vechten was too upset to attend. Hughes, who left a memorable description of the occasion, was struck by Reverend Powell's resemblance to Richard B. Harrison, the actor who portrayed De Lawd in *The Green Pastures*:

He had the same white hair and kind face, and was later offered the part of De Lawd in the film version of the drama. Now, he stood there motionless in the dim light behind the silver casket of A'Lelia Walker.

Soft music played and it was very solemn. When we were seated and the chapel became dead silent, De Lawd said: "The Four Bon Bons will now sing."

A night club quartette that had often performed at A'Lelia's parties arose and sang for her. They sang Noel Coward's "I'll See You Again," and they swung it slightly, as she might have liked it. It was a grand funeral and very much like a party. Mrs. Mary McLeod Bethune spoke in that great deep voice of hers, as only she can speak. She recalled the poor mother of A'Lelia Walker in old clothes, who had labored to bring the gift of beauty to Negro womanhood, and had taught them the care of their skin and their hair, and had built up a great business and a great fortune to the pride and glory of the Negro race—and then had given it all to her daughter, A'Lelia.

Then a poem of mine was read by Edward Perry, "To A'Lelia." And after that the girls from the various Walker beauty shops throughout America brought their flowers and laid them on the bier.

Villa Lewaro fell under the auctioneer's gavel; the Dark Tower was eventually leased to the city; the Walker Manufacturing Company was divided (but, by the terms of A'Lelia's will, to be perpetually headed by a female); and A'Lelia's adopted daughter received real estate valued at half a million dollars.

Hughes was recovering from his misery, and A'Lelia's was over. Now it was the turn of Jean Toomer and Walter White. Toomer's transcendental experience on an elevated platform of the New York rapid transit in 1926 had lifted him to the "broad way" of Gurdjieff, and he who had been "wrapped around was unwrapped; who had been closed was opened. . . . Questions I would never have asked while in the waking state, now came to me, increasing my sense of mystery and the unknown." Since then, Toomer had lectured on Gurdjieff, raised funds for the movement and Gurdjieff's 1930 American tour, travelled between Chicago and the center at Fontainebleau, and written little. A peculiar short story for The Dial, "Mr. Costyve Duditch," and an interesting fragment for The Second American Caravan, "Winter on Earth" —both appeared in 1928. Several other short pieces with a transcendental bias went unpublished. That same year, he wrote a publisher about a trilogy that would need ten years "to lay the foundations of," and of which "Gallonwerps" was the beginning. By 1929, though, "Gallonwerps" had become a play which publishers unanimously rejected despite "some unusual and interesting material."

By 1931, Toomer had decided that the publishing world was hope-

lessly misguided. His book of aphorisms, called "Essentials," and the long poem "Blue Meridian" had also been rejected by Farrar, Knopf, Harcourt, Harper's, and a number of others. Yet he was certain that if he wished "to devote the time and energy to it," he could now be one of the strongest forces in American literature. To that end, Toomer published one hundred copies of *Essentials* at his own expense in March 1931. Walter White noticed, and sent a delighted message. More congratulations followed when Toomer married the white novelist Margery Latimer in late October. Latimer, a lineal descendant of poet Anne Bradstreet, was an intense feminist, fascinated by Gurdjieff, by civil rights and Afro-Americans, sexual unorthodoxy, Zona Gale, and Jean Toomer. She had known Toomer casually for several years, but when he arrived in Portage, Wisconsin, to take charge of her small commune, she glowed. She experienced "wholeness for the first time, so complete, so strangely in the body. Jean was magnificent looking this time." Declining Mabel Dodge Luhan's invitation to come to Taos, the couple left Portage the following March for Carmel, California, where Toomer wrote an overly analytical account of the Portage commune and awaited arrival of his first-born in August.

The idyll was shattered on March 28, 1932, when *Time* magazine printed "Just Americans" on its third page, a long, sarcastically prurient piece about the Wisconsin commune which also disclosed that "Bridegroom Toomer has few negroid characteristics." There was hate mail, outrage from deceived white friends, incessant telephone interrogation, and journalists at the door. Toomer was in addition frustrated by his troubles with "Caromb," a formless, broodingly symbolic novel-in-progress. Margery claimed to be "more happily married than before —yes, even with this horrible publicity." But why was Jean not allowed to call himself simply "an American?" she wondered. Because his grandfather "had negro blood in addition to English, Spanish, and Scotch" they were being crucified by the press. Margery Toomer concentrated on the last pages of her own novel and tried to ignore paranoid fears. She did not live to see it published; in August, after giving birth to a healthy baby girl in Portage, she died. The news of Toomer's marriage and his wife's death was virtually the last Harlem would have of him.

"Yes, truly words were inadequate," Toomer replied to Walter White's letter of condolence. Behind conventional words of compassion lay White's own recent instruction in racism and senseless death. It was as though the fates chose these two racial sports to illustrate in

reality the cruel paradox of George Schuyler's fiction: punishment for desertion of the race could be as condign as the retribution for believing in its progress. As 1931 ended, a physically exhausted White continued to play his part as resident impresario of Harlem arts and letters. The Scottsboro cause célèbre, competition from communist front organizations, and preparation of voting rights litigation took most of his time and demanded ever deeper reserves of energy. He managed to send material on race relations to Nancy Cunard, the steamship heiress, for her huge collation, *Negro*. Guggenheim and Rosenwald officials were updated on worthy applicants. President John Hope of the new Atlanta University was asked to find space in his music department for J. Rosamond Johnson. Bontemps was dissuaded from immediate hope that he could escape from his miserable teaching job in rural Alabama, but promised support for a position at the new Dillard University in New Orleans.

On November 20, 1931, Walter White received a telegram from his brother George. Their father was dying. George White, Sr., had spent forty-three years delivering and collecting mail in Atlanta. Only once, during the blizzard of 1888, had he failed to report for work precisely at 5:30 a.m. Since his retirement in 1921, the senior White had devoted himself to his church, the First Congregational, and to the children of his daughters Helen and Olive. Walking home from an evening with his grandchildren on Thursday, November 19, he stepped from the curb into the path of a car running the traffic light. The driver, a white physician from the municipal hospital, carefully placed the victim in his car and sped to the new, well-equipped medical facility for white Atlantans, where George White was placed in the intensive care unit and given expert treatment. He had been badly injured. After searching the crowded wards of the "colored" hospital building, one of his dark-skinned sons-in-law finally enquired at the new Henry Grady pavilion. Horrified when they realized their patient's race, the medical staff promptly ceased its labors and sent Walter White's father bumping across the street in driving rain to the dilapidated building reserved for Afro-Americans.

His father regained consciousness shortly after Walter arrived. He and his brother George kept vigil in the crowded, putrid ward. "Dinginess, misery, and poverty pressed so hard on one from every side," White grimaced, "that even a well person could not avoid feeling a little sick in those surroundings." His frame and stamina annealed by two-score years of walking outdoors, the old man forestalled the inevitable

for seventeen days. "Huge cockroaches came out of hiding places and scampered about the wards and corridors" when the lights were dimmed, White recalled. "The pattern of nocturnal nausea they made was occasionally varied by the appearance of a rat." As George White died on Sunday night, December 7, 1931, with his family by his side, the vermin-infested ward with its scabrous paint suddenly resounded with Christian hymns as a band of white church people entered on a "mission." Poised self-governance had always been Walter White's professional catechism—the head of the NAACP must be the most responsible emissary of the race—"but the strain and bitterness were too great." Walter White heard himself screaming at these white pilgrims, ordering them to "go away and at least let my father die in peace."

Meanwhile, Langston Hughes was having a happier time of it in the South. The flower of southern white womanhood turned out for his readings. At Chapel Hill, Paul Green had thrown a marvellous party after a dramatic reading at the University of North Carolina (with police guarding the proceedings from irate rednecks); and Andrew Mellon's nephew had "opened a million bottles of home brew" in his honor. In South Carolina, old Dr. E. C. L. Adams, author of Afro-American folk stories and Hughes's idea of "what a true Southern gentleman should be," invited the poet to his plantation for talk and drink. But at Auld Lang Syne plantation, Julia Peterkin had confined her courtesy to a chat at the plantation gate. Passing through Alabama, Hughes read poetry at Tuskegee and visited the Scottsboro Boys. The Boys stared listlessly through bars, obviously having no idea who he was or why he had come to read poetry. He arrived in Nashville a few weeks after James Weldon Johnson had delivered his first lecture at Fisk, and both he and Johnson were the unwitting cause of an incident that illustrated with sad clarity the sort of racism still to be found among intellectuals.

In Nashville there was growing social and professional intercourse between the faculties of Fisk and Vanderbilt universities. It was mutually understood that a certain discretion was required of such biracial affairs, that they were exceptions to the local tradition of apartheid, and that only the exceptional should participate in them. When Thomas Mabry, a young member of Vanderbilt's English department, sent out invitations for a small party for Johnson and Hughes in late January 1932, he was surprised to receive a mordant refusal from his colleague Allen Tate. Tate was just establishing his reputation as a

member of Vanderbilt's so-called Fugitives, a group of writers espousing southern agrarianism. He would gladly meet these "very interesting writers" in New York, London, or Paris, Tate declared, but he agreed with "the colored man who milks our cow" that there should be no racial intercourse in the South, "unless we are willing for that to lead to intermarriage." Tate went on to say that he was sure these people were his "intellectual equals," that Mabry was "disinterested and fine," but common sense dictated accepting the position of Aristotle, "who defined man as a social animal; I do not believe he defined him as an artistic animal."

Mabry was appalled at the poet-critic's "moral lassitude" and furious when he learned that Tate had sent copies of his "vacuous and insulting" letter to members of the Vanderbilt English department and to a New York magazine. "We invited people who are presumably civilized," Mabry protested. Civilized, but not principled, apparently, for there was a flood of turn-downs and a summons from Mabry's chairman, who informed the young instructor that his position at Vanderbilt would become untenable (as it did) and there would be no recommendation "to a position anywhere" unless the party for Hughes and Johnson was cancelled. When Mabry apologized to James Weldon Johnson for calling off the party, later handing over Tate's letters as requested, Afro-America's senior statesman was far angrier than he let on. Not long afterward, in the privacy of his study, he wrote: "The South as an institution can sink through the bottom of the pit of hell." A few years later, when a speaking engagement was mooted for Tate at Fisk, Johnson persuaded the Fisk president to drop the idea.

Fania Marinoff was quoted as saying at the beginning of 1932 that she had "tasted all the drinks in all the speakeasies." She had "memories of hundreds of parties in apartments, night clubs, honky tonks, speakeasies" in Harlem and the Village. It had been "a phase in the life of this generation. It was all very hollow," and the wife of Carl Van Vechten concluded, "I never liked it." The biggest surprise was her claim that Van Vechten was equally weary of that life. "He does not drink at all. He does not smoke." Let that be a warning "to Negroes who bow and scrape to patronizing whites," the Pittsburgh *Courier* announced. "Mr. Van Vechten got the material for *Nigger Heaven*, which sold up to $70,000 according to one book seller. Now he and his wife are through. Well they might be!" On the heels of Marinoff's interview, Julia Peterkin, another friend, spoke superciliously of the

community in *The New York Times.* Many of its unemployed had
grown up "in her yard," Peterkin drawled. "Harlem is just discovering
the Depression, and the Negroes are trying to sing themselves out of
trouble, just as they always do." Harlem knew Peterkin had in mind
the multiplying storefront churches and the chiliastic empires of Rev-
erend Becton and Father Divine, but her truths hurt and were insult-
ingly stated. The *Afro-American* had a typical, braggart response: on
her next Harlem visit she should ask to be taken to "some homes and
ridden in paid-for-autos that would make her wish to extend her 'plea-
suring.' "

As economic conditions worsened, a larger minority of the race decided
to vote for the Democrats in the 1932 elections, but its leadership
tended to be deeply suspicious of those who spoke of the demise of
capitalism and called for the building of a workers' society. Addressing
the twenty-second annual NAACP conference the previous summer,
Walter White had seen Marxism as a purely negative force that might
compel America to choose between abandoning racism or leaving "the
Negro open to communist propaganda." His audience understood fully
that White was horrified by communism. Yet even NAACP sympathiz-
ers began to doubt the wisdom of leaders who succumbed to panic
whenever communists approached. Communist advice and numbers
promised to advance significantly the racial cause célèbre of the early
thirties—the Scottsboro case. Nine Afro-American youths, ranging in
age from thirteen to nineteen, had been sentenced to death in early
April 1931 for the alleged rape of two white prostitutes aboard a train.
The two young women were dressed in men's clothing, had indulged in
sex with white hoboes earlier, and were hitching free rides aboard the
boxcar, as were the Afro-American teenagers. Honest uncertainty
about the boys' innocence, garbled communications with its nearest
local branch, and the proven wisdom of using local white attorneys in
the South had cost the NAACP vital time in entering the Scottsboro
case. But the main reason for the organization's relative ineffectiveness
had been the lightning intervention of the communist International
Labor Defense Fund (ILD).

When the ILD's chief legal officer, Joseph Brodsky, invited Clarence
Darrow to enter the case, White urged his old friend not to do so. He
had "no objection to the ILD because it is a communist organization,"
he claimed, but the NAACP had found that it was "impossible to
cooperate with them in any legal case" because they were only inter-
ested in propaganda. Moreover, Darrow was assured, the NAACP had

the situation well under control. Not even the NAACP field secretary William Pickens believed that; the volatile, vain old man had caused a storm within his organization by sending the *Daily Worker* a letter praising the ILD for mobilizing "more speedily and effectively than all the other agencies put together." In *New Masses*, Eugene Gordon of *Opportunity* banquet days sneered that the NAACP was now revealed as the "Nicest Association for the Advantage of Certain People." Even the *Defender* had regretted the Association's refusal to try to find a *modus vivendi* with the ILD.

The Scottsboro business was personally and politically simply too distasteful for White. He was far from charmed by these sullen, backward, inarticulate black boys who had understood very little of what he had told them in Kilby prison and, hours later, when ILD lawyers turned up, had disavowed even that. He found their parents equally prickly and ignorant, and had virtually said so to the press. He must have winced that July, in 1931, when a Scottsboro mother retorted at a rally, "Well, we are not too ignorant to know a bunch of liars and fakers when we meet up with them and are not too ignorant to know that if we let the NAACP look after our boys, that they will die." When White gave his former superior his reasoning for minimizing the ILD role in the case, James Weldon Johnson was genuinely disappointed and annoyed. White had written glibly, "If they lose, they lose, and if they win, they lose," for everyone would understand that an ILD victory had been made possible because of the 1919 U.S. Supreme Court ruling on fair trials won by the NAACP. Nonsense, Johnson replied. There was not "one person in a thousand [who] would either hear of or understand the basis on which the victory might be won, that is, on the decision we won on the Arkansas cases."

White's complacency, as the communists monopolized a case with the potential drama of the Sacco-Vanzetti affair, was emphasized by the way his letter to Johnson moved along without pause to: "I do wish you had been here Wednesday. I attended a tea in the sky salon of the St. Moritz for Escudero, the great Spanish dancer, pictures of whom appear in the January *Vanity Fair*. Miguel Covarrubias and Rose Rollanda gave the tea. I have never seen such an aggregation of celebrities, among them being movie stars like Ramon Navarro." Yet it was not that the NAACP secretary was intellectually insensitive to the plight of the Scottsboro Boys, or that he failed to draw the fundamental connection between elementary justice for sharecroppers and progress for the middle classes. The communists *were* as unscrupulous as he

A crowd collects outside the Lafayette Theatre at 132nd Street and Lenox Avenue to hear Johnny Hudgins and the Cotton Club Band.
(Schomburg Center, NYPL)

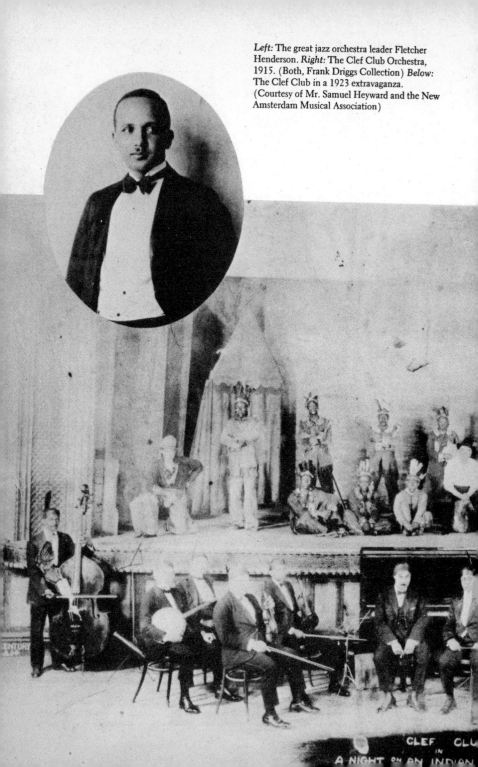

Left: The great jazz orchestra leader Fletcher Henderson. *Right:* The Clef Club Orchestra, 1915. (Both, Frank Driggs Collection) *Below:* The Clef Club in a 1923 extravaganza. (Courtesy of Mr. Samuel Heyward and the New Amsterdam Musical Association)

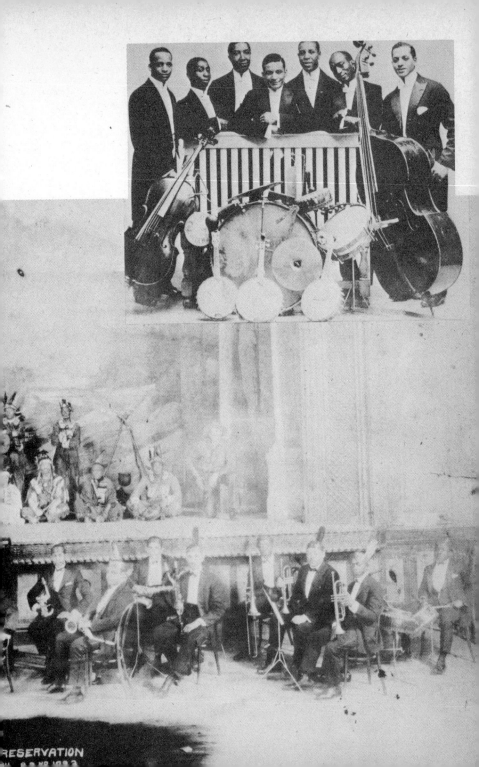

OPPORTUNITY
JOURNAL OF NEGRO LIFE

INVITES YOU TO BE
PRESENT
AT THE
AWARD DINNER OF
ITS FIRST LITERARY
CONTEST
AT THE
FIFTH AVE. RESTAURANT
FIFTH AVE. BLDG. 24TH ST.
SIX THIRTY P.M. MAY 1ST 1925
2.75 A PLATE

Invitation designed by Winold Reiss for the Award Dinner of the first *Opportunity* contest, 1925. (Williamson Collection, Moorland-Spingarn Research Center)

Novelist and playwright Wallace Thurman, founder of the short-lived radical magazine *Fire!!* (Collection of American Literature, Beinecke Rare Book and Manuscript Library, Yale University)

Poet Sterling Brown, author of *Southern Road*. (Williamson Collection)

Winold Reiss's drawing,
"A College Lad"—actually a portrait
of Harold Jackman—appeared in
Survey Graphic's special edition
for March 1925: "Harlem:
Mecca of the New Negro."
(Williamson Collection)

Poet Georgia Douglas Johnson, whose
parties made her Washington home an
outpost of the Harlem Renaissance.
(Courtesy of Henry Lincoln Johnson)

Richard Bruce Nugent, photographed in the
1930s with his wife, Grace. (Courtesy
of Richard Bruce Nugent)

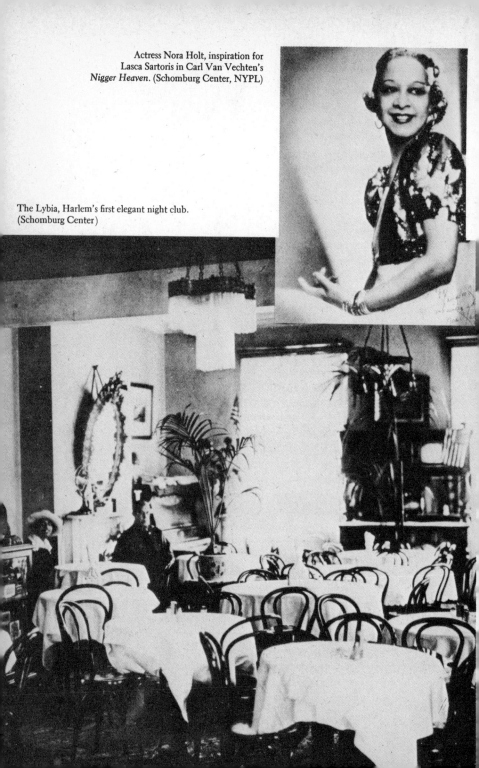

Actress Nora Holt, inspiration for
Lasca Sartoris in Carl Van Vechten's
Nigger Heaven. (Schomburg Center, NYPL)

The Lybia, Harlem's first elegant night club.
(Schomburg Center)

Left: Van Vechten with Fania Marinoff, Venice, 1914. (Estate of Carl Van Vechten, and Bruce Kellner) *Below:* Three sketches from *Negro Drawings* (1927) by Miguel Covarrubias, whose career as a caricaturist was launched by Van Vechten. (Moorland-Spingarn Research Center)

"Flapper"

"The Stomp"

"Strut"

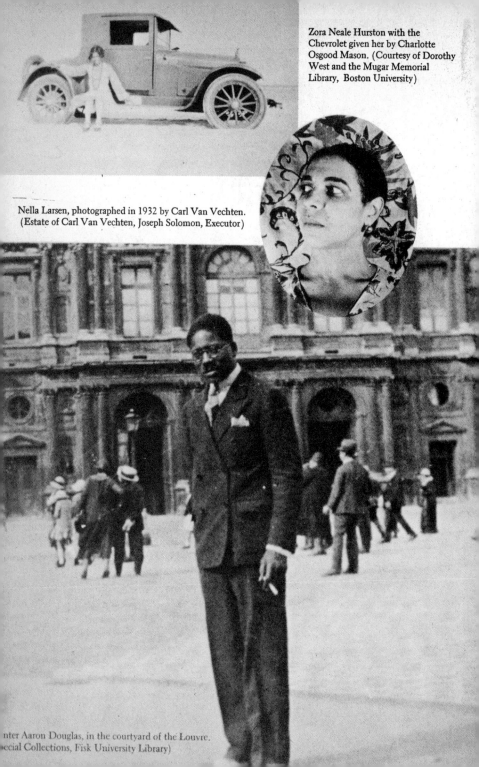

Zora Neale Hurston with the Chevrolet given her by Charlotte Osgood Mason. (Courtesy of Dorothy West and the Mugar Memorial Library, Boston University)

Nella Larsen, photographed in 1932 by Carl Van Vechten. (Estate of Carl Van Vechten, Joseph Solomon, Executor)

nter Aaron Douglas, in the courtyard of the Louvre. ecial Collections, Fisk University Library)

Above: Yolande Du Bois and Countee Cullen during their brief marriage. (Trevor Arnett Library, Atlanta University) *Right:* George Schuyler, satirical reporter to *The Messenger*, author of *Black No More*, photo by Van Vechten. (Estate of Carl Van Vechten and McClendon–Van Vechten Collection)

Langston Hughes and Wallace Thurman. (Trevor Arnett Library, Atlanta University)

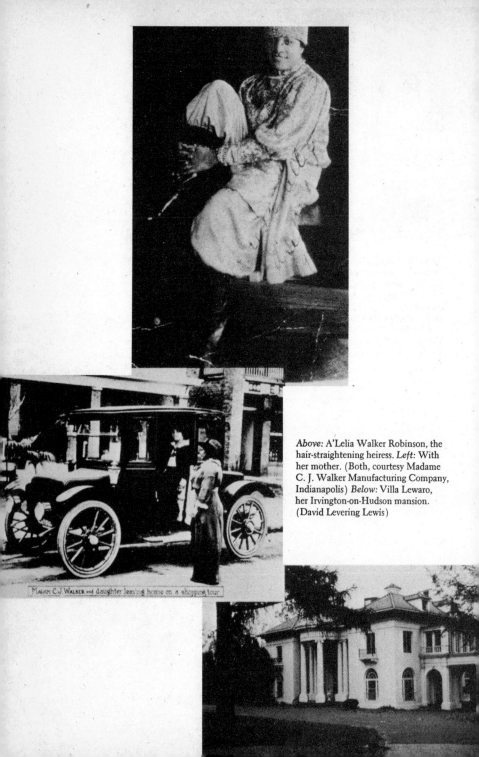

Above: A'Lelia Walker Robinson, the hair-straightening heiress. *Left*: With her mother. (Both, courtesy Madame C. J. Walker Manufacturing Company, Indianapolis) *Below*: Villa Lewaro, her Irvington-on-Hudson mansion. (David Levering Lewis)

Madam C. J. Walker and daughter leaving home on a shopping tour

Baritone Jules Bledsoe, one of Harlem's great party-givers. (Schomburg Center, NYPL)

Geraldyn Dismond of *The Inter-State Tattler*, Afro-America's most frivolous newspaper. (Schomburg Center)

Earl "Snakehips" Tucker.
(Schomburg Center, NYPL)

Lulu Belle opened on Broadway in February 1926. Its success brought unprecedented numbers of whites to Harlem for a taste of the "real thing." (Program from Channing Pollock Theatre Collection, Howard University; production photo from Billy Rose Theatre Collection, New York Public Libary at Lincoln Center, Astor, Lenox and Tilden Foundations)

Belasco Theatre
West 44th Street, near Broadway.
UNDER THE SOLE MANAGEMENT OF DAVID BELASCO

WEEK BEGINNING MONDAY EVENING, OCTOBER 11, 1925
Matinees Thursday and Saturday

DAVID BELASCO
Presents

LENORE ULRIC
AS
LULU BELLE

In a Play in Four Acts
By Edward Sheldon and Charles Mac Arthur
Supported by HENRY HULL
And an Exceptional Cast
Settings by Joseph Wickes Smith

BETWEEN
THE ACTS
Little Cigars

Opposite, above: Connie's Inn, one of Harlem's whites-only night clubs. *Opposite, center:* Connie and George Immerman, the owners. *Opposite, below:* "High-yaller" chorines in "primitive" garb. (Schomburg Center)

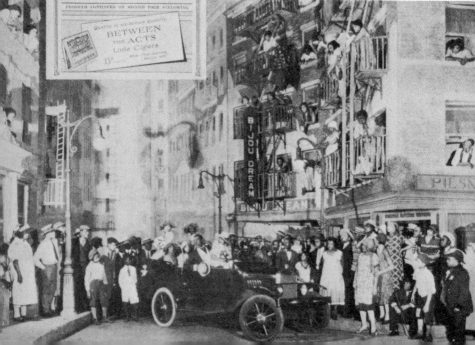

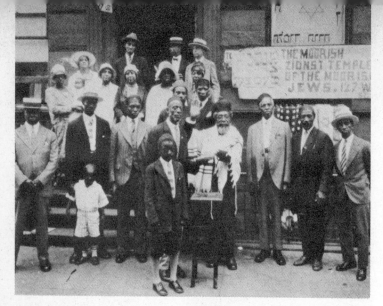

Moorish Jews, 1929,
photographed by Van Der Zee.

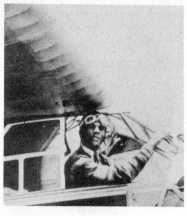

* "Lieutenant" Herbert Julian,
"The Black Eagle." (UPI)

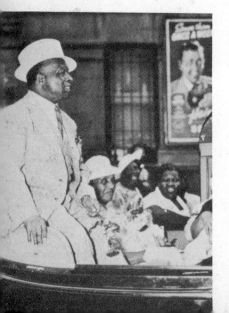

Father Divine, religious leader of Harlem
throughout the Depression. (UPI)

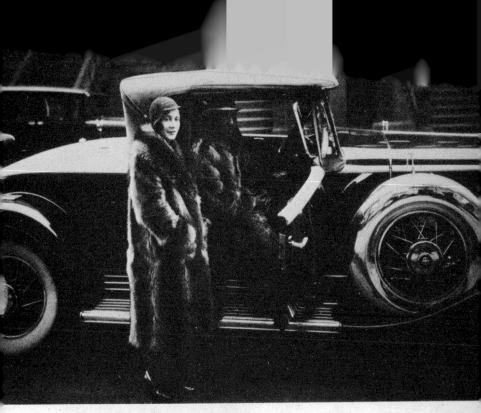

Couple in Racoon Coats, 1932,
photographed by Van Der Zee.

The Dunbar National Bank was one of the amenities
of the luxurious Dunbar Apartment complex, which
opened in 1928. (The Bettman Archive)

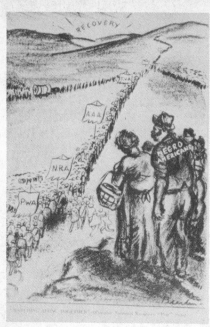

"Marching Along Together"—cartoon
from *The Crisis*, March 1925.
(Moorland-Spingarn Research Center)

At the height of the Depression.
Outside the Emergency Unemployment
Relief registration offices in
New York City, October 1931. (UPI)

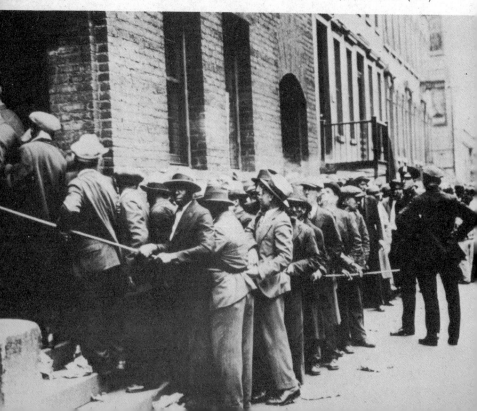

alleged; nor could the NAACP risk becoming confused in the public mind with the party of revolution; but the secretary's judgment in this crucial affair was, to say the least, organizationally and racially myopic. He had come to trust overly much in allegiances struck at the St. Moritz, become too jealous of his monopoly over civil rights advocacy, and too Talented-Tenth in his perception of race progress. "He was convinced the latent canker of prejudice could easily be removed," the astonished publisher George Oppenheimer discovered on meeting White at lunch—possibly at the Saint Moritz.

Walter White's personal life was in crisis at this time. Walter White the Negro found he needed someone who could help him forget, from time to time, that he was "Mr. N-double-ACP," who could appreciate him simply as being witty, charming, and complex. He concealed the personal toll of his father's death—much of it even from Gladys, his wife—yet the day George White died in that dilapidated ward, a secret Walter White came of age. Returning to New York in a Jim Crow coach, his wallet stolen, he had gone that morning to the apartment of Poppy Cannon, a white South African. "That day Walter wept in my arms," and he showed "himself to me—vulnerable," she remembered. It was another emotional milestone in a long, secret affair that would eventually drive Gladys out of his life and end in marriage to Poppy Cannon.

Most of the other Renaissance figures continued to believe, with White, in lobbying for civil rights in places like the Civic Club. Once again, at the end of 1931, Jessie Fauset had given her public yet another novel about an upper-class mulatto family, *The Chinaberry Tree*. Zona Gale's preface spoke of how strange it was that many Americans were ignorant of "a great group of Negroes of education and substance who are living lives of quiet interests and pursuits." Fauset added that she wanted to depict (in 1931) the Afro-American "who is not being pressed too hard by the Furies of Prejudice, Ignorance, and Economic Injustice." It was hardly without significance, she remarked, that, though they came as slaves, the ancestors of her characters had arrived a full year before the *Mayflower*. The reviewer for *The Nation* delighted in the novel's "amber-tinted elegance," and deplored the modest advertising budget of her publisher, Frederick A. Stokes. There are passages that read convincingly and some that admirably capture bygone times; Arthur Davis's judgment is unassailable, that, "as a source of information about the way Northern middle-class Negroes lived and thought in the 1920's, the book is valuable." For respectable newspapers like the

Amsterdam News and the Pittsburgh *Courier*, the high praise for Fauset was a consideration more of class than of craft—she was, after all, the first Renaissance novelist to autograph her books at Macy's department store. Theophilus Lewis thought she was still Harlem's most popular writer "because her novels give the truest picture of Negro life," and the *Courier's* Aubrey Bowser agreed. Once again, as the *New Republic* critic would say of her last novel three years later, Fauset had shown how like other people Afro-Americans were—"only more so, and also that they are different and superior; that they are at the same time more primitive and vital and more refined and sensitive, subtler and more intelligent and simpler and more kind-hearted." As literature, however, *The Chinaberry Tree* disappointed even Fauset's most loyal critic, William Braithwaite.

The Godfather of the Renaissance agreed. He repeated his message in his annual *Opportunity* retrospective that the most effective social propaganda for the Afro-American was purely and simply good and honest literature. Where a Du Bois invariably preferred Fauset over McKay because of the neighborhoods in which her novels lived, Locke faulted both evenhandedly whenever they grossly distorted either Striver's Row or The Jungle. Locke was being more harshly didactic than usual partly because he had before him a superb illustration of his own artistic canons—Sterling Brown's collection of poetry, *Southern Road*, "true in both letter and spirit to the idiom of the folk's own way of feeling and thinking." Transported by Brown's unaffected, first-person vigor—"I laks yo' kin' of lovin', / Ain't never caught you wrong, / But it jes' ain' nachal / Fo' to stay here long;"—Locke hailed "a new era in Negro poetry, for such is the significance of this volume." Compared to this, he saw little value in Fauset's nice book; it was time to move beyond the Jane Austen phase of Renaissance literature. Locke's harshness and Fauset's bristling response also reflected the collapse of what had survived of New Negro etiquette after the shock of *Fire!!* Secretly less than enchanted with "her Herbie" (who seems to have been boorishly resentful of his wife's literary success), Fauset poured out her dislike of Locke—a dislike "dating from the time years ago when you went out of your way to tell my brother that the dinner given at the Civic Club for *There Is Confusion* wasn't for me." She knew he had never cared for her or her art, and she had never liked his *New Negro* essays— "stuffed with a pedantry which fails to conceal their poverty of thought" —and, furthermore, his role as literary critic was dictated by his "failure

as a writer"—a role he had filled "with utmost arrogance and obsequi-
ousness to whites."

There may have been malice in Locke's appraisal of Fauset's novel
(as two Old Philadelphians they knew much about one another's pri-
vate lives), but his general literary distress was certainly warranted. It
had been Fauset herself who became the first Afro-American to pub-
lish a Renaissance novel because she wanted to present a deeper view
of her race than white authors had. But now, nearly nine prize-laden
years later, the contemporary problems of the race were more likely to
be featured in novels by whites about Afro-Americans. McKay's offer-
ing for 1932, *Gingertown*, a collection of short stories about porters,
prostitutes, and blue-collar stalwarts trapped by and rebelling against
menial degradation and color prejudice, was the outstanding excep-
tion; but the subject matter was too limited to carry a large message.
Rudolph Fisher achieved a Renaissance breakthrough that year with
The Conjure Man Dies, the first detective story by an Afro-American.
"Above average," "a plot of classic suspense," Sterling Brown and
Arthur Davis thought; "much better than most white fictioneers," the
critic for *Time* magazine wrote. Fisher's technique owed something to
the master of thrillers, S. S. Van Dine, but the interest of *The Conjure
Man* is largely its Harlem setting and its overworking of Amos 'n'
Andy dialogue to play to white (and, secretly, black) readers.

For white novelists concerned with Afro-America, 1932 was a year
of realism and large social issues: Roy Flannagan's *Amber Satyr* and
Welbourn Kelly's *Inchin' Along*, treating miscegenation and serfdom
as socioeconomic rather than personal tragedies; Scott Nearing's *Free-
Born*, hemorrhaging from arson, rape, murder, labor conflict, and
prison heaped upon its proletarian hero in order to preach, through
Jim, that mass misery is economic in origin rather than racial; John
Spivak's Marxist classic, *Georgia Nigger*, exposing southern peonage in
the manner of a slightly fictionalized government white paper; and
Myra Page's *Gathering Storm*, a reprise of the populist themes in Du
Boisian fiction, but stretching socialist realism until it becomes a politi-
cal tract. These were not great novels, or even outstanding for prose
style or delineation of character. On the first count, Hughes was su-
perior, and on the second, Larsen. Nevertheless, the white novels that
year appealed, at least to Locke and Sterling Brown (now reviewing
for *Opportunity*), because of relevancy, because works of fiction de-
nouncing penal slavery and heralding the victory of united black and

white workers had political value. By comparison, the preoccupation in Renaissance literature with color, drawing room diction, cultural and class identity, and enduring vitality of simple folk began to seem stale in a revolutionary era. Locke was not surprised to see Afro-American writers "lean backward, away from [political] propaganda and problem fiction," but he was pained that "the flight from propaganda" was so seldom compensated for by true art. Where, in the fiction of the Renaissance, was there a character portrait to equal Joe Christmas in William Faulkner's *Light in August*, another 1932 offering? Who would be the Renaissance novelist to present the Afro-American counterpart to Erskine Caldwell's *Tobacco Road*?

By 1932, neither Countee Cullen nor Wallace Thurman wore success comfortably. Since Cullen's publication of *The Black Christ* three years earlier, while he was in Paris, he had not quite found his bearings. Dedicated to Jackman, that volume, with its tone of bleating doubt and intellectualized faith, had been Cullen's farewell to original poetry. Not only had Afro-American critics been cool to *The Black Christ*, their teeth set on edge by its sighing and pouting and Sunday-school ardor, but Witter Bynner, the white mentor whose opinion Cullen valued so highly, had dismissed it as "a book which almost anyone might have written." Its stylized piety oppressed him. "Be the man you were headed toward being," Bynner challenged Cullen. Contrite, the poet promised to "do better next time," sportingly adding, "but I really did try my darndest this time." By 1932, though, Cullen must have suspected that there would never be a next time, and, in retrospect, one of the poems had forecast this. In "A Wish," he expressed the hope that when he had sung his "rounds," he would be "Content that silence hold her sway."

Cullen turned to fiction because he found he had nothing more to say in poetry. His novel was called *One Way to Heaven*, and its first ninety pages are very well done. Sam Lucas is an itinerant, one-armed confidence man who regularly shouts his salvation in revival meetings, dramatically flinging to the foot of the altar the symbols of his corruption, a deck of cards and a razor. Mattie Johnson of Harlem, also saved, is much impressed by Sam and marries him, promptly undertaking Sam's economic redemption—finding him a job. It was this portion of the novel that had excited Charles Johnson—Cullen's realistic, sympathetic treatment of Mattie—for Johnson had long been pained "both by the general public and the Negro public" which demanded

of writers that "they produce a snicker every time a black girl comes into the picture." Cullen had made Mattie "actually charming, and you have done it rather well." If the author avoided "too many adjectives and didn't spoil Sam's honest, rough" portrait ("too many references to the electric current of Sam's eyes, especially since it was not on the strength of his eyes that he won Mattie"), his first novel would have been good fiction and (always the right civil rights aspect) "a distinct step."

Even so, *One Way to Heaven* has many serious failings as a novel. The whole central portion is occupied with extremely heavy-handed satire of the diction, drawing rooms, and fixations of Sugar Hill, which clashes with the story of Sam and Mattie. It is as if Cullen had combined two separate manuscripts. The novel might have borne the weight of two worlds if Sam and Mattie's active and living voices had not been drowned out by the Van Vechtenesque chatter of such weak jokes as the Duchess of Uganda, Lady Hyacinth Brown, Mrs. De Peyster Johnson, and a gaggle of thinly disguised members of the Harlem literary nobility. Returning at the end to Sam and Mattie, the book closes with philandering Sam obliging a weeping, fanatically pious Mattie by pretending to embrace Christ before expiring of pneumonia. It was a conclusion that echoed the message of Cullen's fine poem from *Color*, "Pagan Prayer":

> Our Father, God; our Brother, Christ,
> Retrieve my race again;
> So shall you compass this black sheep,
> This pagan heart. Amen.

"He had enjoyed living and loving," says the narrator of Sam, "and what was there to fear in dying?"

Thurman's *Infants of the Spring* appeared in February, and Locke wrote that it "also misses fire, with a capital theme to make the regret all the keener." It might be true that Harlem novels were "somehow in a class by themselves," *The New York Times* noted, but *Infants of the Spring* was "a pretty inept book" by any standards. "It is clumsily written. Its dialogue, which ranges from elephantine witticisms to ponderous philosophizing, is often incredibly bad." The novel is so poorly done it hardly seems possible that the best-read, most brilliant, and most uncompromising of the Harlem artists could have written it. In his "Notes to a Stepchild," Thurman had spelled out the highest stan-

dards for himself. "He would be labelled a *Negro* artist, with the emphasis on the Negro rather than on the artist, only as he failed to rise above the province of petty propaganda," only as he failed to escape "the stupefying *coups d'état* of certain forces in his environment." He told his friend and collaborator William Jourdan Rapp that he still held fast to the theory "that a Negro who achieves personal success could fight his way past racial barriers. I still believe in that despite my own disillusionment on many occasions."

Taken to its logical extreme (which he did), failure to become a great artist meant failure to transcend being a Negro. Thus Thurman strove almost ridiculously at times to divorce what he saw as the conventional misfortunes of people of his race from what was proper for an artist of great potential. Stoically, he accepted the refusal of a Los Angeles theatre to sell him a center aisle ticket (on five occasions— "including opening night") to *Harlem*, his own successful Broadway play, now on tour. Instead, he complained to Rapp about ending up "on the side in a little section where any other Negro who happened to buy an orchestra seat was also placed." Wanting to buy a ticket on the "crack" train to Los Angeles from New York, Thurman had been told none was available. The messenger he sent an hour later returned with the ticket. Thurman pretended he was "sure it was just the particular ticket agent," just as he appreciated "the customs and phobias which make such things seem advisable" in the theatre. His luck with Afro-Americans was occasionally no better. A Pullman porter on the Los Angeles–Salt Lake City train condemned *Harlem* when he learned Thurman's identity, and a delegation of Salt Lake City church people prayed "over me for almost an hour, beseeching the Almighty to turn my talents into the path of righteousness."

Occasions for disillusionment had come hard on the heels of Thurman's first novel. The most unforgiving critic of *The Blacker the Berry* was its author. Theophilus Lewis had written that it was a book "of which [Thurman] ought be proud, but isn't." His play *Harlem* had shock value and realistic touches, but Thurman never mistook it for durable drama. Meanwhile, his marriage to Louise Thompson had only aggravated his chronic alcoholism, just when neither Nugent nor Hughes was in New York to help. A few benefactors kept him upright with friendship and loans. But this was the time, still remembered by Harlem hostesses, when Thurman's appearance inspired dread. He would begin brilliantly, slur into outré remarks, then reel and lurch about, often causing expensive breakage of glassware, only to end up

comatose. Before *Harlem* left Broadway on tour, Thurman and his new wife had become bitter enemies, battling through lawyers in an ignoble alimony fight. She must have felt justified in offering homosexuality as the reason for incompatibility (Thurman had been arrested in a subway lavatory days after arriving in Harlem), but her husband wrote that the real incompatibility was one of personality.

Then he had made himself scarce, seeking refuge with Theophilus Lewis and his family in Jamaica, Long Island. "Harlem holds no more charms for me," he wrote Jackman in August 1930. "Liquor I will always like, but my motto is now civilized tippling." He worked on a novelized version of *Harlem*, considered doing an Afro-American rhapsody ("Gershwin's stuff [was] thin and unimaginative"), finished a play, "Jeremiah" (now lost), about Garvey, and polished the novel he called *Infants of the Spring*. (Louise Thompson accepted a twenty-five-hundred-dollar annuity and a Reno divorce—then backed out of the agreement in order to be with her dying mother.) Thurman hated the "world in general, Negroes, all my friends, save you," he wrote William Rapp during his first California sojourn among the "oh, so dumb" cinema moguls. He met his mysterious father for the first time in California, one of Thurman's mother's six husbands, who turned out to be suffering horribly from what appeared to be tertiary syphilis. Thurman began to feel "an immense discouragement, a sensation of unbearable isolation, a perpetual fear of some remote disaster, an utter disbelief in my capacity, a total absence of desire, and an impossibility of finding any kind of interest."

The publication of *Infants of the Spring* did not relieve his depression; the last novel about—though not of—the Harlem Renaissance was recognized as the mediocre work of a writer who no longer believed in himself as a man, an Afro-American, or an artist. Yet, in an odd historical sense it succeeded. The congratulatory telegram from Hughes, on March 12, 1932, conveyed much more than loyalty of friendship. Thurman had written, he said, a "swell book," brave, provoking, "and very true." Most of the novel takes place in "Niggerati Manor," a house very like the one at 267 West 136th Street donated by Iolanthe Sydney, the owner of the employment bureau. The place is crowded with two-thirds of the cream of the Renaissance, disguised so as to invite ready discovery. The action of the novel is in the ideas of the inhabitants. They talk and talk—about themselves, Booker Washington, Du Bois, racism, and Afro-American destiny. Caustic and superior, Raymond Taylor (Thurman) pontifically comments on the

comédie humaine over which he presides. Raymond, who is not " 'the least bit self-conscious' " about his race, prefers " 'brutal frankness to genteel evasion at any time.' " He may be the only Afro-American who is not self-conscious, for Thurman's title is taken from the lines in *Hamlet*, "The canker galls the infants of the spring / Too often before their buttons be disclosed," by which he means that the Renaissance is terminally ill from the cancer of race consciousness. Raymond even doubts that Afro-America can produce a great writer now, "any more than can America." He knew of only one Afro-American "who has the elements of greatness, and that's Jean Toomer." Sweetie May Carr (Hurston) understands. " 'It's like this,' she had told Raymond. 'I have to eat. I also wish to finish my education. Being a Negro writer these days is a racket and I'm going to make the most out of it while it lasts. Sure I cut the fool.' "

The canker had taken two forms: those writers (Fauset and White?) " 'who had nothing to say and who only wrote because they were literate and felt they should appraise [*sic*] white humanity of the better classes among Negroes,' " whom Raymond dismisses as sociologists or propagandists; and those writers (Cullen, even Thurman's revered Toomer?) " 'who contended that should their art be Negroid, they, the artist, must be considered inferior,' " for whom Raymond has only contempt. This time, too, Locke is not spared, for the fustian speech to the artists of Dr. Parkes might have been transcribed from one of Locke's lectures: " 'Because of your concerted storming up Parnassus, new vistas will be spread open to the entire race. The Negro in the South will no more know peonage, Jim Crowism, or the loss of the ballot, and the Negro everywhere in America will know complete freedom and equality.' " This was hardly the stuff of a good novel, but it was a valuable first intellectual statement of the malaise of the Renaissance. *Infants of the Spring* rejects both sociological and supraracial literature and sweeps aside, along with it, that unrealistic belief that favorable reviews in *The New York Times* were a blow against the abuses of sharecropping.

Thurman never surrenders his faith in the power of the arts to ennoble and transfigure the individual of genius, but he now knows that "talent was not a sufficient springboard to guarantee his being catapulted into the literary halls of Valhalla. . . . He needed genius and there was no assurance that he had it." Having failed, Raymond-Thurman leaves his readers to ponder, in embarrassment, the painful contradiction born of his failure. Is there no way out? a white friend

asks. " 'What is to be done about anything? Nothing,' " snaps Raymond. " 'Negroes are a slave race and a slave race they'll remain until assimilated. Individuals will arise and escape on the ascending ladder of their own individuality. The others will remain where they are.' " The novel's ending is conceptually well done and exhibits its most skilled, unencumbered prose. Paul Arbian (Richard Bruce Nugent) commits suicide in a dilapidated Village apartment, after donning a "crimson mandarin robe" and slashing his wrists "with a highly ornamental Chinese dirk" in a full tub of water. He had made a carpet of his manuscript, every page but one no longer legible because of the overflow from the tub. On the remaining legible page is the book's title, "Wu Sing: The Geisha Man."

Beneath this inscription, he had drawn a distorted, inky black skyscraper, modeled after Niggerati Manor, and on which were focused an array of blindingly white beams of light. The foundation of this building was composed of crumbling stone. At first glance it could be ascertained that the skyscraper would soon crumple and fall, leaving the dominating white lights in full possession of the sky.

9
It's Dead Now

By summer 1932, F. Scott Fitzgerald, golden boy of the Lost Generation, had discovered the writings of Karl Marx and was predicting that "to bring on the revolution, it may be necessary to work inside the Communist party." Two years before, the jovial columnist Heywood Broun (his campaign managed by Alexander Woollcott) had unsuccessfully run for Congress on the Socialist party ticket; since then, leftist politics—leftist political rhetoric, certainly—had made considerable progress in New York literary circles. Malcolm Cowley would soon speak for many of the same white writers who had befriended the Renaissance in its infancy—Anderson, Dos Passos, Dreiser, Mumford, Steffens—when he insisted that the revolutionary movement "can and will do more for writers than the writers can do for the revolutionary movement." Countee Cullen thought so, too, and he surprised Harlem with a new-found political seriousness, declaring, "The Communist party alone is working to educate and organize the classes dispossessed by the present system." The poet laureate of Negro America, joined by Langston Hughes, formally endorsed the Communist party candidacy of William Z. Foster and James W. Ford (the first Afro-American to run for the vice presidency of the United States).

Richetta Randolph, now Walter White's overworked secretary, was certainly not going to vote the Communist ticket in 1932. But with factories padlocked, "Hoovervilles" ringing northeastern urban centers, and gaunt figures stalking the land like flagellants before a medieval plague, she now knew that it was senselessly optimistic to expect a policy of national recovery from the Republican party and Wall Street. The budget of her own organization, sixty thousand dollars in 1930, would slide to half that by 1934. *Opportunity* magazine was

expected to fold by the end of 1932 and the fate of *The Crisis* was as bleak. "Yes," Richetta Randolph wrote to James Weldon Johnson, "the 'depression' has us; and no matter how one tries to ignore it it won't be downed." The economic meaning of the word was as novel as the sounds of the coming stampede of Afro-America to the Democratic party. At the beginning of the year, sociologist E. Franklin Frazier's wife, Marie, had amused Cullen with her maid's reaction to the "depression": "She says, 'Mrs. Frazier, everybody is talking about the depressure, de depressure. I don't know nuthin' 'bout no depressure. I ain't seen nuthin' but hard times all my life.' " That winter, though, "depression" entirely lost its novelty and Fisk faculty wives lost much of their sense of humor.

Harlem, too, was becoming serious. The Lincoln Theatre had already closed, reopening, with obvious symbolic significance, as Mount Moriah Baptist Church. The majestic Alhambra folded a few weeks after the national elections. Nineteen thirty-two was a lethal year for institutions bound up with the manic glamor of the Jazz Age. Texas Guinan and Flo Ziegfeld died broke. John Gilbert, thought to have a voice too high for the talkies, committed suicide. And Clara Bow went to a sanitarium. Julius Rosenwald, representing the positive side of the bold enterprise of that age, also died. When the *Tattler* presented its readers with a *"Tattler* Platform," a six-point political program the editors hoped to see adopted by the Democratic party, it was unmistakably clear that Dark Tower days were over. The *Tattler* wanted repeal of the Eighteenth Amendment; a Negro congressman from Harlem and a Negro magistrate for the Washington Heights court of Manhattan; employment of Negro clerks and workers in all businesses in Negro communities; better living conditions and normal rents; fair racial hiring and promotion in public utilities corporations; and a federal department of education. Hard times could even bring about solidarity with the West Indian community; early that same year, *Tattler* added a regular section on economics and politics in the Caribbean.

"Go home and turn Lincoln's picture to the wall," exhorted the owner-editor of the Pittsburgh *Courier*, once a rock-ribbed Republican. "The debt has been paid in full." They had done so, and now most of the men and women who had made the Harlem Renaissance clung to the hope that the racial policies of the new administration would be as fair as the encouraging words of Franklin Roosevelt before his inauguration. Walter White shared the uplift of the new president's

inaugural address with millions of humble folk who had voted against the party of Lincoln for the first time. Alain Locke wrote Charlotte Mason of the thrill of hearing FDR "speak some of your thoughts," for the husband of one of her ladies-in-waiting, Francis Biddle, was one of the president's wealthy backers and advisers. There were a few paltry gestures suggesting better rewards to come, with the appointment of a federal judgeship (Virgin Islands) and some forty minor federal positions for "eminent Negroes." Some were reassured by the special closeness of the president's wife and the Afro-American college president, Mary McLeod Bethune, eventually designated "special advisor for minority affairs." But after the intoxication of the "Hundred Days," it was clear enough that the New Deal intended to bypass the Afro-American.

Relief and public works programs under the National Industrial Recovery Act widely discriminated against Afro-Americans, and, in the South, when exclusion was not complete, there were inequalities in pay. When the names of Charles Johnson and Asa Randolph were forwarded to Washington for appointment to the board of the National Recovery Administration (NRA), they were rejected. The vast Tennessee Valley Authority project disbursed but a nominal portion of taxpayers' money to Afro-American labor. It seemed self-evident to NAACP board member Oswald Garrison Villard that the Afro-American worker should not even expect that his lot would be improved until the New Deal "raised the standard of work among the whites." Meanwhile, the lynching rate began to rise again, with twenty-eight lynchings by the end of 1933. As they had in 1919, the NAACP's allies on Capitol Hill introduced antilynching legislation, and civil rights leaders made it clear to the president that, on this moral issue, they expected the support of the White House. But southerners controlled the committees in Congress. One "warm spring Sunday in 1935," FDR remorsefully confided the realpolitik about lynching and jobs and elementary racial justice to White. If he supported the antilynching bill, "they will block every bill I ask Congress to pass to keep America from collapsing. I just can't take that risk." A few of the younger intellectuals already understood. They saw that as far as Afro-America was concerned, Roosevelt's New Deal meant as little as Wilson's New Freedom of 1912; there was only the relative absence of presidential Negrophobia and greater presence of economic misery now.

It seemed inevitable that leftist ideals would be earnestly studied by the younger Afro-American intellectuals—that they would eventually

collaborate with one or another mode of Marxism. How could a race victimized as much by the Depression's putative cures as by its causes lose anything through social revolution? E. Franklin Frazier had tried to solve that puzzle in *"La Bourgeoisie noire,"* a 1928 article that would be the basis for his classic book on Afro-American elites. He concluded that for a race whose ladies were wont to remark that "only an educated gentleman with culture could be a Pullman porter," the rousing peroration of the Communist *Manifesto* was meaningless. In his forgotten poem "Elderly Race Leaders," Hughes ascribed Talented Tenth conservatism to venality:

> Wisdom reduced to the personal equation:
> Life is a system of half-truths and lies,
> > Opportunistic, convenient evasion
>
> > > Elderly,
> > > Famous,
> > > Very well-paid,
>
> > They clutch at the egg
> > Their master's
> > Goose laid:
> > $$$$$$$$
> > $$$$$$$
> > $$$$$$
> > $$$$$

There were leaders who were bought, who fully justified Hughes's cynicism. But George Streator, leader of the 1925 Fisk University student strike and recently of the *Crisis* staff, worried much more about leaders whose services to the race's oppressors were available free of charge. The paradox was that, somehow, his unmistakable proletarian status made the Afro-American all the more determined to defy the dialectic of the class struggle. "The Negro is nine-tenths a laborer, or ninety-nine-one-hundredths economically insecure," Streator wrote. "Yet, the sympathies of his intellectuals have been with the few who exploit this world for the good of the few."

In its most pathetic manifestations, the psychological bond between Negro and Nordic notables led Benjamin Brawley to rejoice to James Weldon Johnson that President Hoover had preserved law and order by unleashing the army on Washington's Bonus Marchers. At its most bizarre, it led a towering intellect like Du Bois to publish a tortuously

reasoned *Crisis* essay, "Marxism and the Negro Problem," which might well have been written by someone who had not read the major works of Marx. It was evident that the future of the darker races throughout the world lay with the forces of revolution, but "the black proletariat is not part of the white proletariat," Du Bois contended. Its circumstances and goals were not merely different, they were inimical. Capitalism was brutal, concluded this socialist whose two novels had preached labor solidarity, but, for the Afro-American proletariat,

the lowest and almost fatal degree of its suffering comes not from capitalists but from fellow white laborers. It is white labor that deprives the Negro of his right to vote, denies him education, denies him affiliation with trade unions, expels him from decent houses and neighborhoods, and heaps upon him the public insults of open color discrimination.

Perhaps Du Bois's protégé George Streator was right in suggesting that having to please the political nonentities, retired businessmen, and misplaced literary people who comprised the Board of the NAACP "took its toll." Finally, there was the amnesia of James Weldon Johnson, writing *Negro Americans, What Now?* and having to be reminded by Arthur Spingarn that no modern political breviary could ignore even the mention of communism. Heeding Spingarn and revising his manuscript to include a trenchant discussion of communism, Johnson concluded that "the wholesale allegiance of the Negro to Communistic revolution would be second in futility only to his individual resort to physical force."

Wholesale allegiance and outright violence were out of the question. Out of its national membership of perhaps fifteen thousand, there were probably never more than two hundred Afro-Americans enrolled in the Communist party of the U.S.A. The potential sympathy of the masses of Afro-Americans and vocal support by a few of their leading artists and writers were more likely concerns. They concerned Joel Spingarn greatly. Spingarn was an economic liberal who hated communism, but as chairman of the board and president of the NAACP he knew that the organization was losing the younger intellectuals, and that to remain preeminent in civil rights the NAACP had to broaden its base. But his and Du Bois's plan for a second policy conference in August 1932 (like the first one in 1916 at his Troutbeck estate near Amenia, New York) never took place because White and his new assistant, Roy Wilkins, stalled the preparations. Nor were its prospects any better for summer 1933, until Joel Spingarn summarily resigned his

offices that March. When they had joined the Association, there had
been a "thrilling programme, revolutionary for its time," Spingarn la-
mented to Mary White Ovington. "Now we have only cases, no pro-
gramme, and no hope." And Walter White "ignored or thwarted" him
at every turn. Meanwhile, the parlous finances of *The Crisis* had con-
strained Du Bois himself to accept a professorship at Atlanta Univer-
sity, leaving Streator and Roy Wilkins to run the magazine with his
remote guidance. Feuding bitterly with Wilkins, Streator warned
James Weldon Johnson and the Spingarns that if White was "allowed
to get his hands on *The Crisis* the whole movement may as well fold
up."

A national program of literature, litigation, and lynching legislation
no longer seemed suited to deal with the problems thrown off by eco-
nomic chaos. "The dismal decade of the thirties grew more and more
dismal," White recorded with annoyance. He found himself "with less
and less time for the theater, baseball, parties, writing, or any of the
other diversions." The NAACP had not yet regained its balance after
the Scottsboro misadventure when another case invited new confronta-
tion with the International Labor Defense Fund, just as the Associa-
tion's own internal dissensions were rising. Angelo Herndon, an
eighteen-year-old Mississippi coal miner, was (in spite of white fears to
the contrary) an exception—a militant Afro-American communist. In
January 1933, a court in Atlanta, Georgia, found him guilty of inciting
insurrection (attempting to organize local labor), a crime punishable
under state law by death. In its mercy, the court imposed a sentence of
twenty years. The son of one of Atlanta's most prominent families had
sped home to volunteer his legal services. Benjamin J. Davis was a
graduate of Amherst and Harvard Law. His father, a newspaper pub-
lisher, was also Georgia's Republican National Committeeman. Rising
to address the court, young Ben Davis heard the presiding judge drawl,
"Well, nigger, go ahead and say what you have to say." Herndon's trial
was a travesty. As for Davis, "instant joining of the Communist party
was the only effective reply" he could think of. Unlike the Scottsboro
Boys, Herndon was more than battered flesh; he was a photogenic
ideologue. On his behalf, the ILD held Angelo Herndon rallies coast to
coast, saturated Afro-American ghettoes with propaganda, and ulti-
mately won an acquittal, leaving the NAACP to explain lamely why it
had applauded but was not a party to the cause.

In Washington, Alain Locke watched the galloping disarray as it
spread to the artists. His trip to Europe the past summer had depressed

him greatly, despite the pleasant surprise of discovering that Josephine Baker and Aaron Douglas truly possessed "genius," and tasting the delights of Bricktop's night club in Place Pigalle. "The younger Negroes here," he wrote wearily to Charlotte Osgood Mason, "they're all about on their last legs." New York was almost as bad. The professor conceded the exception of Richard Bruce Nugent, another "genius," who had written the scenario for the choral ballet "Sahdji" (music by William Grant Still), first performed in the summer of 1932 at the Eastman School of Music. But Cullen was being spoiled by praise of his mediocre novel. Hughes was "burnt out and trading on the past." He "might as well give up" on Arthur Fauset, Locke's gifted intimate who had taken a wife. Roland Hayes and Paul Robeson seemed determined to prostitute their art. Somehow, though, the race would come through, Locke promised Mason. How and when he could not now see, "but do let us hold together the silent hope of the future." "Eventually," his voices told him, "there must be true Negroes—really free Negroes." But he was certain they would not be communists, and, as for Hughes, Louise Thompson, the young Californian Loren Miller, and the others posing as communists, Locke dismissed their performance as a "melodramatic burning of broken bridges—to disguise the fact that they were already broken before." Zora Hurston had already written Mason about the root of the problem, sounding a wide-eyed warning: "Godmother, as I see it, unless some of the young Negroes return to their gods, we are lost."

In 1919, the Harlem Renaissance had sprung to life with the measured tread of New Negroes in uniform returning from the World War. Its last days were symbolically so appropriate and the characters who filled them so well cast that what transpired in mid-June of 1932 might well have been a Wallace Thurman film scenario rather than reality. On June 14, at Brooklyn Pier, twenty young Afro-Americans began boarding the German ship *Europa* for the first leg of their trip to the Soviet Union. The group leader, Louise Thompson (soon known as "Madame Moscow"), stayed topside until late that evening, marking off arrivals—Mat Crawford, a friend from Berkeley; Taylor Gordon, the Van Vechten singing favorite; Allen MacKenzie, the sole acknowledged Communist party member; Henry Moon and Ted Poston, journalists; Wayland Rudd, professional actor; Homer Smith, a University of Minnesota journalism graduate turned postal clerk; Mollie Lewis, pharmacist; and Dorothy West, the Boston poet—until all but two

were accounted for and assigned berths in third class. Then came the frantic last-minute arrival of Hughes and Loren Miller who had driven six days nonstop from the West Coast. With his typewriter and big box of Louis Armstrong, Bessie Smith, Duke Ellington, and Ethel Waters records (and the soap and toilet paper Lincoln Steffens had warned him to take along), Hughes was the last passenger up the gangplank on June 15. Expenses for the trip were being paid by Meschrabpom Film Corporation of Moscow, which had sent an invitation through James Ford, the CPUSA's Afro-American candidate for vice-president. A sponsoring committee made up of Malcolm Cowley, W. A. Domingo, Rose McClendon, Will Vodery, and several more handled publicity. The Russians intended to make a film about "the exploitation of the Negro in America from the days of slavery to the present," to be called *Black and White* and set in Birmingham, Alabama. Only two of Thompson's group knew much about acting, but no one at Meschrab-pom knew anything at all about racial discrimination in the American South.

At the same time, shortly before he was to sail to Europe with a young Howard colleague, Ralph Bunche, Alain Locke discovered to his dismay that he had been booked on the same ship carrying the Russian film group. Locke and Bunche were quartered in first class. On the second day at sea, urged along by "waves of curiosity," Locke descended, fully expecting to find the ship's third class awash with Marxist revivalism. Leonard Hill and Henry Moon, former Howard students, spoke darkly about Thompson and Hughes and their in-tention—along with MacKenzie and Mildred Jones—to stay in Russia after the film was finished. Descending again the following day, Locke introduced the group to Ralph Bunche, the twenty-eight-year-old UCLA Phi Beta Kappa political scientist and Harvard doctoral can-didate. Bunche and Hughes were ceremonially affable under Locke's mischievous eye. Later, Bunche wagered that "most of that crowd don't even know what communism is." Locke smugly noted in his daily report to Mason that by Sunday, June 18, many of the twenty-two were in open rebellion against Hughes and Thompson.

Professors Locke and Bunche left the film cast at Bremerhaven. On June 20, after a tragicomedy of missing visas and botched train sched-ules, the twenty-two arrived at Moscow's Nikolayevsky Station and were riotously welcomed by the city's Afro-American expatriate com-munity. The Soviet citizens' welcome was even more frenzied (al-though some grumbled that Hughes, Miller, Thompson, and most of

the others were not "genuine Negroes," presumably because they were not dark enough). The group was housed in the Grand Hotel. In the midst of a famine, they were served caviar and sturgeon and rivers of vodka; and when they asked, instead, for ham, eggs, and even grits, the Russian hosts somehow obliged. Russian women found the men magnificent and their dancing intoxicating. Russian men found the women intoxicating and their dancing magnificent. Konstantin Ousmansky, future ambassador to the United States, kept Mildred Jones constantly at his side. Foreign Commissar Maxim Litvinov, Ousmansky's superior, and his English wife opened their home to Hughes, Miller, and Thompson.

Meschrabpom paid each of the twenty-two actors four hundred rubles monthly—"more money to spend than we had ever had in our young lives," Thompson wrote. "Most of it was spent in having a good time— wining, dancing, and dining at the Hotel Metropol, parties, and of course there was always the theatre." There was also the legendary Emma Harris, whom Hughes called "The Mammy of Moscow," a sixty-year-old Afro-American actress from Kentucky who had been the mistress of a nobleman before the Revolution and who still managed to live in the grand manner and to preside over elaborate parties. Even Stalin was believed to have heard Emma's boast that if she could be his cook "she'd put enough poison in his first meal to kill a mule." Emma hated communism but she loathed the world of Scottsboro more, although she attended the numerous Moscow rallies for the nine Alabama boys in company with the *Black and White* twenty-two, a few of whom, said Dorothy West, learned the details of the case from the Russians on whose backs they were invariably hoisted.

Long after the first pleasure and excitement of the Russian experience had worn off, Henry Moon's *Nation* article conveyed its residual fascination: He had never "felt more at home among a people than among the Russians" who had taught him that the roots of racism "are essentially economic. Race prejudice cannot flourish when its roots are destroyed." But for Hughes, the Soviet Union meant a great deal more than color-blind dances at the Metropol and being lionized in Moscow's Park of Rest and Culture. His march leftward had been signalled by a steady output in *The Negro Worker, New Masses,* and *Negro Liberator,* such as the one-act play "Scottsboro, Limited," and the poem "The Same." His poem "A New Song" appeared a few months after the *Europa* sailed—"I speak in the name of the black millions / Awakening to Communism. / Let all others keep silent a moment." Then, in

December, *The Negro Worker* published his unprecedented "Goodbye, Christ," the first avowedly atheistic poetic statement by an Afro-American. James Weldon Johnson, who was almost certainly an atheist, had delighted the worldly and moved the common folk of the race with *God's Trombones.* Cullen's voluble paganism always danced about on the hot coals of Puritan guilt. Nearly twenty years had gone by since Hughes had been ashamed of not finding the holy spirit beside his grandmother in a Lawrence, Kansas, revival meeting. "Goodbye, Christ" brought the news that, even for the deeply religious Afro-American, there was no longer a God to bring shame:

> Listen, Christ,
> You did alright in your day, I reckon—
> But that day's gone now.
> They ghosted you up a swell story, too,
> Called it Bible—
> But it's dead now
>
> ──────────
>
> Goodbye Jesus Lord God Jehova,
> Beat it on away from here now.
> Make way for a new guy with no religion at all—
> A real guy named
> Marx Communist Lenin Peasant Stalin Worker Me—

Black and White was never filmed. The twenty-two could not act and most were unable to carry a tune. The gifted German director was hamstrung by an ideologically correct script so intractably awful as to defeat Hughes's editorial surgery. But it was international politics that in the end killed the movie. The United States was about to grant diplomatic recognition to the Soviet Union; on August 11, 1932, the Paris *Herald-Tribune* announced cancellation of *Black and White.* "Comrades, we've been screwed," journalist Ted Poston bellowed as the unsuspecting cast relaxed in Odessa. "And they didn't even have the courtesy to tell us." Meschrabpom offered travel fare and expenses to those wanting to leave immediately and a tour of the Soviet South for the others. Much amused, Locke reported to Charlotte Mason from Berlin the disintegration of the group.

The breakup was an ideograph of Afro-American politics in the thirties. As the old entente cordiale of Jewish notables, Negrotarian publishers, and civil rights grandees fell apart, more artists and intellectuals would turn, with more or less enthusiasm, to communism.

Many would find their high hopes poisoned by political exploitation, arrant racism, and intellectual tyranny often far surpassing that of their erstwhile capitalist patrons. Others—the overwhelming majority—controlled their disillusionment and tried to find a place in the new order. For artists and writers, this often meant a place with a patron better endowed than Casper Holstein, Boni & Liveright, or even the Rosenwald Fund—the Works Project Administration (WPA) of the United States government. Most of the writers of the next generation—William Attaway, Ralph Ellison, Margaret Walker, Richard Wright, Frank Yerby—and most of the artists—Romare Bearden, Jacob Lawrence, Charles Sebree, Charles White—would pass that way. There were a few who came out of the Harlem Renaissance with enough momentum to succeed on their own, to retain easy access to major publishing houses, and to turn misfortune to advantage. Bontemps and Hughes succeeded. For a time, so did Hurston. McKay and Toomer never stopped trying, but never approached their first triumphs. In any case, when the *Europa* weighed anchor and steamed east, those on board would never return to the Renaissance.

Three never returned at all. Lloyd Patterson the artist, Wayland Rudd the actor, and Homer Smith the postal clerk became Russian citizens of some significance. Hughes stayed on for a time, at last angrily leaving the rump group at a railroad stop deep in Uzbekistan. In a dusty city called Ashkhabad, he met the writer Arthur Koestler, then still a few years away from his apostasy in *Darkness at Noon*. It was a meeting of two singularly different mental cultures. Hughes was very "likeable and easy to get on with," Koestler recalled, "but at the same time one felt an impenetrable, elusive remoteness which warded off all undue familiarity." Koestler, the unsentimental Jewish intellectual, held the Russian Revolution accountable for the expediency of all its deeds. Hughes, the sentimental Afro-American intellectual, ignored and excused the Revolution's defects, explaining that he "observed the changes in Soviet Asia through *Negro* eyes. To Koestler, Soviet Turkmenistan was simply a *primitive* land moving into twentieth-century civilization. To me it was a *colored* land moving into orbits hitherto reserved for whites." It was Hughes who told Koestler of the purge trial (one of the earliest) of Atta Kurdov, a local official. Hughes thought the man looked like "a portly bull-necked Chicago ward boss," and he readily left Kurdov to the imperatives of revolutionary justice. For Koestler, the strange proceedings in the Ashkhabad courtroom pointed the way to his own inevitable disillusion. "I thought he might come

back to listen to some jazz," Hughes recalled, after their argument over Kurdov. "But he didn't come back. The trial disturbed him."

In October, Hughes returned to Moscow, where he read D. H. Lawrence short stories and Thomas Mann, wrote articles for Russian and American magazines, and became romantically involved with a Natasha. Meanwhile, Knopf had published *The Dream Keeper*, his fourth volume of poetry, a slender effort devoid of protest and, Van Vechten wrote him, "lacking in any of the elementary requisites of a work of art." Going eastward again, Hughes reached Shanghai just as Nora Holt was leaving. Then he sailed to Japan; after a weird game of cat and mouse surveillance, the Japanese expelled him as a political undesirable. He sailed under the Golden Gate bridge on a "sunny summer morning" in 1933. At the dock, he was met by a liveried chauffeur and driven up Russian Hill to a mansion that had once belonged to Robert Louis Stevenson. His host was a rugged, shy bachelor whose family was one of San Francisco's oldest and richest. Noel Sullivan was the Carl Van Vechten of the Pacific Coast, although, unlike his counterpart, he had no literary talent. "It was," Hughes admitted, "fun to get back to capitalism."

During the next few months, living in Carmel in a cottage loaned him by Sullivan, Hughes wrote harder than ever before in his life—long ten- to twelve-hour daily stretches—occasionally broken by dinners with his neighbors the Robinson Jefferses and Lincoln Steffenses and visits from Nora Holt, Wallace Thurman, and Mabel Dodge with Tony Luhan. The result was *The Ways of White Folks*, fourteen short stories dedicated to Noel Sullivan (and greatly influenced by D. H. Lawrence) which *The New York Times* found to contain "more latent hatred" than *Not Without Laughter*. "One hopes that Mr. Hughes will not let bitterness betray his art into monotony." He travestied Godmother, the Van Vechtens, and the Renaissance.

And as for the cultured Negroes who were always saying art would break down color lines, art could save the race and prevent lynchings! "Bunk!" said Oceola. "Ma ma and pa were both artists when it came to making music, and the white folks ran them out of town for being dressed up in Alabama."

"Father and Son," the last story, an unsentimentalized tale about a suicidally defiant mulatto lad and his caste-ridden white planter father, Hughes was to adapt for the Broadway stage as *Mulatto*.

* * *

While Hughes was writing at Carmel, the custodian of the Renaissance was witnessing Europe disintegrating once more. His beloved Italy saddened Locke with its fascist buffoonery, while the Germany of his postgraduate years—the Germany he and his mother had known—was now a steel gymnasium in which, he wrote Mason, "all Germans live with one arm extended in the air." He heard chilling accounts of Nazi psychopathy from Wilhelm Reich, became ill—drained. Like a character in Thomas Mann's fiction, he sought Alpine refuge and cure. But to no avail. "Wind, rain, hail, all sorts of queer atmospheric lights" drove him back to Vienna, and then back to New York. "I know it isn't the end of the world, but it is the end of an era," he complained to Charlotte Mason.

Locke knew by now that the movement which had been given structure and guidance in the Civic Club some nine years earlier awaited only a proper burial. Yet, as in the final scene of some grand opera, a few of the dying could still sing with gusto. *The Crisis* proudly announced the creation of a Du Bois literary prize of a thousand dollars, donated by a Mrs. Edward Roscoe Mathews and awarded to James Weldon Johnson for *Black Manhattan*. Escaping extinction through last-minute donations, *Opportunity* gamely announced the resumption of the annual prize banquets, and Sterling Brown, John Day, president of John Day Publishing Company, and Fannie Hurst were among the judges. Only a hundred or so contestants entered, less than a tenth of the 1927 number. First prize went to Bontemps for the short story "A Summer Tragedy," with Marita Bonner and Henry B. Jones winning honorable mention. Pearl S. Buck was guest of honor at the banquet on May 5, 1933, and spoke with what must have been moving sincerity of the psychological burdens of racism. "Let me be of your blood and your race and try to think as one of you," pleaded this woman who held such extraordinary powers of empathy. The Urban League would mount one more annual literary gala before concluding that the money and interest to sustain the tradition were lacking.

It was in 1933 that Jessie Fauset's final novel, *Comedy: American Style*, appeared. A student of this literature has judged it "the most penetrating study of color mania in American fiction," but plodding through the yeasty plots and Antillean prejudices of pigment only strains the reader to care about Fauset's characters and compels the certainty that the author is no less a victim of their mania. A sarcastic Schuyler might have been tempted to retitle the novel "Very Light Brown No More" and to see in its tragic ending a lamentable logic

determined by Fauset's elevation of the superficial into a metaphysic.
Three years after *Comedy: American Style*, with the death of her sister
Helen, Fauset and her husband moved to a neat little house in Mont-
clair, New Jersey, where she lived silently and not very happily there-
after.

McKay's last novel, *Banana Bottom*, also appeared in 1933. As
literature, Sterling Brown found it superior to *Banjo*, far less preachy
and less exaggerated in character depiction. Despite a soporific flatness
of prose, *Banana Bottom* presents McKay's most plausible and en-
grossing character. Bita Plant, a dark-skinned Jamaican girl, educated
in Europe but rooted in Afro-Jamaica, is obviously based on the au-
thor himself. Through Bita, McKay makes a long-overdue distinction
in his fiction between the knowledge of Europe and the values of Eu-
rope:

A white person is just like another human being to me. I thank God that
although I was brought up and educated among white people, I have
never wanted to be anything but myself. I take pride in being colored and
different, just as any intelligent white person does in being white. I can't
imagine anything more tragic than people torturing themselves to be
different from their natural, unchangeable selves.

But McKay's heroine is emotionally far healthier than he was, still
living in Paris. Max Eastman notified James Weldon Johnson and
Charlotte Osgood Mason in May that their friend was "too lonely and
isolated over there," and that the risk was great of losing "one of the
few lyrical geniuses we have." Once again, the hat was passed. Joel
Spingarn contributed. James Weldon Johnson believed Henry Allen
Moe of the Guggenheim Foundation had made a commitment for a
fellowship. In early February 1934, after a twelve-year absence, the
Jamaican novelist-poet came home to Harlem, but, oddly, not to the
promised Guggenheim. Johnson had been certain it was McKay's for
the asking; Moe had invited McKay along for a pleasant office chat. "It
was a bitter disappointment," McKay complained to Johnson, while
Eastman speculated that *Home to Harlem* had soured the white lib-
erals.

McKay had brought two almost completed novels from North
Africa. "Harlem Glory," a raggedly written jumble of Parisian epi-
sodes revolving around the expatriate widow of Harlem's numbers
king, Millinda Rose, a character inspired by A'Lelia Walker. Its aban-

donment is probably not to be regretted. But the second manuscript, "Romance in Marseilles," could have been his best, once the incredibly awkward prose had been fixed. Lafala, a little West African stowaway whose frozen legs were amputated in a New York hospital, sues the steamship company for his imprisonment in a toilet—but only after "Black Angel," an Afro-American, puts him in contact with a Jewish lawyer. From his court victory to Marseilles, where two prostitutes contend for his affection (and his money), to his return to Africa, Lafala betrays everyone he meets—friend, lawyer, lover—not by initiating actions but by docile adherence to an alien European code of conduct. McKay, who had written the first Afro-American best seller, now found himself as unwanted as a silent film star in the age of talkies. "If only I could find a publisher that would be willing to give an advance," he wrote Johnson, but Saxton told McKay he was part of an expired fad. Alfred Knopf agreed, telling Van Vechten it would be difficult "to do anything with [McKay] without being willing to risk and probably lose a good deal of money."

Three white writers published works—two of them major—on the Afro-American during 1933, and both illustrated the double-edged nature of the material of the Renaissance, the ever-present problem of the right thing said by the wrong person or the wrong thing well said by the right person. At her best, Julia Peterkin belonged to the former group. Walter White dashed off an enthusiastic note to Peterkin about *Roll, Jordan, Roll,* her book of photographs and text about the people on her South Carolina plantation. "It is a superb accomplishment and I am strongly recommending that the Book-of-the-Month Club choose it." In her preface, Peterkin took pains to note the absurdity of placing "all Negroes in one great social class." She knew about Charleston's three hundred colored antebellum families who had been taxpayers. Yet Doris Ulmann's camera and Peterkin's pen were devoted to folk who "do not build or run machines, they have no books or newspapers to read, no radios or moving pictures to entertain, but they have leisure to develop faculties of mind and heart and to acquire the ancient wisdom of their race." No doubt Julia Peterkin was a kindly mistress, Sterling Brown granted in *Opportunity,* but her laborers paid "for their quaintness by their—at best—semi-enslavement. And even for quaintness this is too much to ask."

An even more curious development was White's unequivocal refusal to endorse a friend's novel, Clement Wood's *Deep River.* Wood's *Nigger* had helped launch the Renaissance, and *Deep River* was to be

widely regarded as a socially useful potboiler, realistically treating marriage between a famous Afro-American singer and a white woman. But White disliked the novel's sexual explicitness. A misunderstanding led Wood's publisher to include an endorsement by White in its advertisement. When the dust cleared in early 1934, the publisher had apologized to White, rejacketed the book, and cancelled its contract with the novelist. This controversy foreshadowed White's objection many years later to the Bontemps-Cullen Hollywood script for *St. Louis Woman*. They were "my friends," White explained, but the proposed film "pictured Negroes as pimps, prostitutes, and gamblers with no redeeming characteristics. Even one role supposed to portray a decent person—that of a pious churchgoing woman—represented her as having had several children, each without benefit of clergy." Lena Horne, who had been offered the leading part, came to embrace the NAACP position.

The third book, Fannie Hurst's *Imitation of Life*, was the hugely acclaimed contribution of an *Opportunity* judge and civil rights sympathizer. Afro-American officialdom generally applauded the work: only Sterling Brown had the courage to break ranks and deeply anger Hurst with an *Opportunity* review, "Imitation of life—Once a Pancake," indicating the novel's stereotype "of the contented mammy, and the tragic mulatto; and the ancient ideas about the mixture of the races."

The literary event of the year was James Weldon Johnson's magisterial autobiography, *Along This Way*. Here was the adroit politician mellowed into elder statesman, the aristocrat who proved the natural tendency of some men to rise above all others. Locke was right to call *Along This Way* the "history of a class and also of a generation," the story "of the first generation of Negro culture." It was easily more than that, and, for once, Van Vechten was free of exaggeration in recognizing *Along This Way* as one of the great American autobiographies. Yet it had the serious and ineradicable flaw of its author's unique life and values. In a period when his people were being stretched on the economic rack, Johnson concluded that it was "possible to observe that faster and faster the problem is becoming a question of mental attitudes towards the Negro rather than of his actual condition." The following year Johnson stated the issue still more forcefully in *Negro Americans, What Now?* He would not allow "one prejudiced person or one million or one hundred million" to blight his life, he wrote. He would not let prejudice "or any of its intended humiliations or injustices bear him down to spiritual defeat." To which another patrician leader of vast

culture, Du Bois, sadly observed, "Mr. Johnson fails to realize the vast economic changes through which the world is going today." And Du Bois added, "As for myself, I am perfectly aware that Negro prejudice in America has made me far less a rounded human being than I should like to have been."

In an all-but-final throw of the dice against the James Weldon Johnson sort of psychological elitism, Du Bois had helped Joel Spingarn force the second Amenia conference on August 18, 1933, at which thirty-three of Afro-America's senior leaders and Young Turks gathered at Spingarn's Troutbeck estate a hundred miles north of New York City. The old caution, limited strategies, special relationships, and case-by-case litigation must give way to bold policies and largeness of vision, the delegates agreed. Du Bois pushed for an evaluation of the role of Afro-Americans in the global strivings of peoples of color. It was agreed that a broad base with labor was necessary—white as well as black labor (though not with white labor as currently organized). "The primary problem," the majority stated, "is economic." Yet, when the Amenia conference ended, its resolutions vanished into briefcases, never to be referred to again.

Harlem watched with surprise and amusement now as its traditional leadership turned upon itself. The innovative young painter Romare Bearden savaged the Harmon Foundation in *Opportunity*, deploring its attitude that "from the beginning has been of a coddling and patronizing nature." Arthur Fauset attacked the problem from a more generalized perspective in a trenchant economic and political *Opportunity* essay, "Educational Procedure for an Emergency," warning that unless bold strategies were embraced the "Negro masses must suffer a socio-political-economic setback from which it may take decades to recover." One thing was certain, Fauset went on to say—it was suicidally unrealistic "to believe that social and economic recognition will be inevitable when once the race has produced a sufficiently large number of persons who have properly qualified themselves in the arts. . . ." For Loren Miller the straightforward solution to the racial and national crisis was obvious—"One Way Out—Communism."

Du Bois had a different, much more outrageous solution—outrageous to most of his Talented Tenth disciples. At the beginning of 1934, he had written the first of two *Crisis* essays on the advantages of what he provocatively called "segregation." "Not only shall we be compelled to submit to much segregation," the second essay explained, but sometimes "it will be necessary to our own survival and a step

toward the ultimate breaking down of barriers, to increase by volun-
tary action our separation from our fellow men." Rivers of ink would
flow over this apparent reversal by Du Bois of beliefs that had caused
him to clash with Booker Washington a generation gone by. For Wal-
ter White, this was the last straw; Du Bois must recant, accept censor-
ship, or leave the NAACP. He left on May 21. The irony of Du Bois's
parting accusation against White surely escaped the old editor. He
spoke of White as he himself had been spoken of by Garvey. "He has
more white companions and friends than colored," Du Bois fumed.
"He goes where he will in New York City and naturally meets no
Color Line, for the simple and sufficient reason that he isn't 'colored.' "

There were no theoretical and confusing racial policy disputes in the
kingdoms of George Baker, alias Father Divine. The weary and down-
trodden, along with a good number of the upwardly mobile, were
fascinated by the man who called himself God at 20 West 115th Street.
Among the Talented Tenth, Divine's appeal was limited, but even
there it was by no means negligible. Two mysterious deaths had en-
couraged the cult's rapid growth. The judge who sentenced Father
Divine to a year in jail for creating a public nuisance died suddenly, in
May 1932. One year later, the first of Harlem's big business messiahs
was kidnapped and murdered in Philadelphia. The Reverend George
Wilson Becton had been one of the Lord's most graceful, mellow-
voiced, and colorful instruments. Cullen's father had yielded his pulpit
to Becton because of poor health, and the preacher had taken the
community by storm. Becton's church became the "World's Gospel
Feast," where gorgeously caparisoned pages maintained the rule of
hushed silence, a mighty choir and orchestra thrilled worshippers at
paced intervals, and Becton, radiating animal magnetism and divine
revelation, would lead his flock in a great outpouring of "consecrated
dimes." Becton's translation from this world shook Harlem as little else
had in recent years, leaving a void that Father Divine hastened to
fill.

To the educated, Divine's sermons recalled "Kingfish" of *Amos 'n'
Andy*. "As I aforesaid," the messiah would intone, "when you realize
that which was in you, I retake and reincarnate. I reproduce, reiterate,
and rematerialize your human intelligence, your human skill and abil-
ity. . . . I reincarnate them." To the no longer "debaucherated" devout,
these were eternal verities to be grasped in a gnostic trance. The re-
porter from the *Tattler* pronounced his sermons a "masterpiece as

sermons go." The Garveyite *Negro World* (now the property of Father Divine) carried the good news of Divine's fifteen kingdoms, spread from Harlem to California. The faithful were guaranteed everlasting life on earth and instant erasure of racial status, for the word "Negro" was banned. From Australia, China, Switzerland, cards and letters reached Divine simply addressed to "God–Harlem–New York City."

Divine's kingdom was not politically timid. He condemned fascism, anti-Semitism, and the Scottsboro injustice. This was before the perniciousness of fascism was clearly understood by many Afro-Americans, and at a time when communist tactics had alienated many churchmen from Scottsboro. He criticized the New Deal and made flirtatious remarks about communists standing "for social equality and justice in every issue, and this is the principle for which I stand." He summoned President Roosevelt and Pope Pius XI to an international Righteous Government Convention at Harlem's Rockland Palace, and actually succeeded in securing the presence of mayoral candidates Fiorello La Guardia and John P. O'Brien. Divine's greatest achievement, however, was economic rather than spiritual or political. His mostly female disciples surrendered their worldly goods. After expenditures for extensive real estate investments, for a mansion near FDR's Hyde Park, and a fleet of Cadillacs, there was enough money left to support hostels and cafeterias where board and bed were had for a minimal cost. In Divine's kingdoms they sang, "The abundance of the fullness of all good things / Is wheresoever I am!"

While the disciples of Father Divine danced themselves into trances, Bishop Amiru Al-Minin Sufi Abdul Hamid, originally of Lowell, Massachusetts, led his followers through the streets of Harlem to boycott white businesses guilty of discrimination. Sufi Abdul Hamid had come to Harlem in 1930 and founded his Universal Holy Temple of Tranquility on Morningside Avenue. Like Divine, he abolished usage of the term "Negro," and like Divine, he offered Harlem a political program. Sufi Abdul Hamid claimed he had tried without luck to work through Harlem's established leadership, the NAACP, Urban League, and the Baptist Ministerial Conference. His boycott of Chicago's South Side merchants had been fairly successful, but there he had enjoyed community support. In early 1934, with a small band of followers, Sufi's newly formed Negro Industrial and Clerical Alliance chose the large Five & Ten Cents store at 125th Street, still a white stronghold, as its first target. Booted, bearded, beturbaned, Sufi Hamid's heavy six-foot-three frame harbored a powerful speaking voice and piercing chestnut

eyes. Overnight Harlem was electrified—and deeply divided. As thousands of young men joined his movement, as the streets of Harlem became parade grounds for Sufi's troops chanting, "Live and Let Live! Share the Jobs!" the owners of Blumstein's department store formed the white Harlem Merchants' Association. Well-bred Harlem organized the Citizens' League and joined Sufi's people on the picket lines.

The collaboration was uncomfortable and brief. Hamid's bombastic personality ruffled the Talented Tenth, and his strong-arm tactics appalled. The Negro Industrial and Clerical Alliance exacted dues, increased them, and demanded contributions from laborers, ministers, and merchants. It refused to defer to the NAACP or the Urban League. Charges flew that Hamid was running a shakedown operation, victimizing Afro-American and West Indian merchants as readily as white. Fred Moore, owner of the New York *Age*, called him a blasphemer, a faker, and a fleecer. Stunned by his success, the communists denounced the movement through Ben Davis's *Negro Liberator*. By late 1934, the Negro Industrial and Clerical Alliance had thoroughly alienated Harlem's elite and driven the Citizens' League into separate, moderate, and more dignified forms of protest. Watching and writing about post-Depression Harlem years later, McKay saw the white merchants exploit these divisions. "They promoted an interracial banquet to which they invited representative Negroes who," McKay claimed, "made good-will speeches and denounced the activities of irresponsible troublemakers in Harlem."

Jewish merchants claimed they were being intimidated, that Sufi Hamid had praised Hitler for his persecution of German Jews, and they demanded Mayor La Guardia order an investigation. A Jewish Minutemen's organization was formed, while the *Daily News* called the Afro-American street leader "The Black Hitler" and "The Führer of Harlem." For a moment in early November, establishment Harlem (black and white) held its breath as the forces of Father Divine and Sufi Hamid joined in a monster rally at Rockland Palace to end discrimination in hiring and housing. The moment passed, though, and, after an extortion indictment and trial, so did the founder of the Universal Holy Temple of Tranquility from the forefront. Yet his boycott campaign paved the way for the young Reverend Adam Clayton Powell, Jr., and subsequent boycott campaigns.

On Sugar Hill, in Striver's Row, and at the Dunbar (where 60 percent of the original tenants still resided), the new messiahs were

objects of mild sarcasm, and the white Marxists (now almost as numerous as the Negrotarians of the twenties) were spoken of as passing aberrations. There was mild interest in the changing character of aristocratic foreign visitors, the new generation of titled travellers with ideologies as unmistakable as their pedigrees. The Swedish Crown Prince, Lady Mountbatten, the Rothschilds, and Princesse Murat were supplanted by Prince Yasuichi Hikida, apologist for Japanese imperialism, and Nancy Cunard, convert to communist revolution. Yale-educated Prince Hikida was a pleasant, shadowy Japanese nobleman who courted Afro-American leaders with increasing success. He found considerable sympathy for his cause among people like Locke and Schomburg and Dunbar Apartment dwellers (who were visited by Japanese army and navy delegations and given the same cherry trees that blossomed along Washington's Tidal Basin). But if there was considerable sympathy, there was as much ignorance and suspicion of the Japanese. Hikida complained to James Weldon Johnson of a recent trip South during which he met fifty leaders "who asked him how Negroes were treated in Japan!" A friend warned NAACP field secretary William Pickens that communists were going to attack Hikida and the Japanese as "seeking Negro friends to serve imperialist purposes and that you are aiding them." No matter, Pickens replied; he would go to see Japan for himself, "even if I have to resign for a year, or permanently." Another Hikida recruit, an officer of the Associated Negro Press (ANP), confided to Pickens that the race must learn to become superior to whites, like the Japanese: "Things can be done better than white people do them and it is for Negroes to seek these superior standards."

Nancy Cunard, comfortably wealthy English artistic and political revolutionary, found the notables of the community insufferably narrow and feudal. Since the Hotel Theresa had not yet dropped its ban on Afro-Americans, Cunard raised headlines and respectable eyebrows in May 1932 by renting a two-room suite in a St. Nicholas Avenue hotel favored by musicians, writers, and even more questionable lodgers. She had rocked London society with her pamphlet *Black Man and White Ladyship*, reproving her socially prominent mother in the most savage and personal way for objecting to her public love affair with an Afro-American; now Cunard was in Harlem to study her lover's people firsthand. More than that: she had come to disabuse Harlemites of all delusions that the cultured rich—people of her mother's class—cared about their welfare in the slightest.

From her first no-nonsense note ("Dear Mr. Spingarn, I am now here. . . ."), Nancy Cunard made her purpose and her expectations of undivided Talented Tenth attention brusquely clear. In a strange repetition of the collective excitement inspired by Locke's *Survey Graphic* edition, her presence and her summons for contributions to the massive anthology *Negro* galvanized the veterans of the Renaissance. McKay and Eric Walrond refused to contribute unless paid, and Toomer, about to marry Margery Content, daughter of one of Wall Street's most respected brokers, informed Cunard that he had put the question of Negro ancestry behind him. Most of the others were delighted to do what came naturally, to write again, still clinging to the hope, as they were, that American racial prejudice was a matter solely of ignorance and misunderstanding which forceful prose by honor college graduates could do much to attenuate. Cunard's contempt could not have escaped their notice. She spoke openly of Harlem's terrifying "snobbery around skin color." Her low opinion of the NAACP and the Renaissance was no secret. Yet, when she chastised James Weldon Johnson ("Am I to expect your article or not?") or upbraided Schomburg for historical sloppiness ("I can't believe either that you wrote this as a joke"), she usually got results. When *Negro* appeared in 1934, there were contributions from Sterling Brown, Du Bois, Frazier, Locke, Rayford Logan, Schomburg, White, Taylor Gordon, and others. But it also carried Cunard's major article on Du Bois and the NAACP: "A Reactionary Negro Organization." The only worthwhile Harlemites, said Nancy Cunard, were those who wrote for or subscribed to the *Negro Liberator*, the communist paper.

"I'll someday have to write out for my own satisfaction—and absolution, the inside story of the 'Negro renaissance' and how it was scuttled from within," Locke promised Godmother. Instead, Afro-America's first Rhodes scholar continued to swing between despair and exhilaration. Because Godmother had let him "into the sanctum of her life" and because she had taught him that "Alain must be true to his real self," it was somewhat easier to carry on. On the other hand, he saw no other course (or so he wrote Mason) than to write off Hughes, Toomer, and Robeson. Seeing the West African opera *Kykunkor* on Broadway, revived his faith completely for an hour or so: "Here it is, at last, Godmother—as you have dreamed and prophesied—and though it will not take root immediately—it is here and cannot be denied." He greeted Roosevelt's November 1934 appointment of Francis Biddle to the NRA as though it were a coup d'état engineered

by Mason: "This brings your principles within shooting-range of prac-
tical affairs—although I know they have their underground channels
already." The New Deal, the New Negro, and Mrs. Mason were ready
to reform America.

Others shared Locke's moodiness. "So suddenly I am serious and
entirely grown-up," Dorothy West wrote James Weldon Johnson, "and
I know that the promise we, the New Negroes, were so full of is enor-
mously depleted. And now there are newer voices that are younger and
surer." Among those younger, surer voices was Richard Wright, one of
West's communist collaborators, along with Jackman, on *Challenge*
(then *New Challenge*), a pale echo of Thurman's *Fire!!* "Scold us a
little," she begged, "I [sic] and my contemporaries who did not live up
to our fine promise. Urge us to recapture." Fallen on hard times, an-
thologist William Stanley Braithwaite told James Weldon Johnson that
"the race collectively is not intelligent [or else it would have bought
enough books to save the Renaissance]."

The last novel of the Renaissance, Hurston's *Jonah's Gourd Vine*,
was either ignored or disparaged by many of the Niggerati. Charles
Johnson and James Weldon Johnson admired the work, and Locke
was so pleased when Lippincott released it in May 1934 that he sent
Mason a copy of the glowing *New York Times* review from Europe (a
dispatch he hoped would be as heartening to his hospitalized patron as
the photograph of the young Trotsky sent later that month). Yet *Op-
portunity* sneered that "in plot construction and characterization, Miss
Hurston is a disappointment." Hurston's novel, her first, was about her
immediate family—especially her father—and the life of an auton-
omous Afro-American polity called Eatonville, Florida. Although the
plot is sometimes distended by melodrama and the characters distorted,
the novel is enormously satisfying. Hurston's biographer has accurately
described *Jonah's Gourd Vine* as "less a narrative than a series of
linguistic moments representing the folklife of the black South." But
linguistic moments in Afro-American folklife were almost as irrelevant
in 1934 as the passions of Fauset mulattoes.

Two writers from whom much more should have come, Rudolph
Fisher and Wallace Thurman, died maddeningly avoidable deaths
within days of each other. Fisher fell victim to intestinal cancer caused
by exposure to his own x-ray equipment, on the day after Christmas,
1934. Bledsoe sang at his funeral, and officers of the 369th Infantry
Regiment, along with Cullen, Jackman, and Noble Sissle, escorted the

cortege. Thurman died four days earlier. Just back from Hollywood, he defied his physician's orders to abstain from alcohol and laughingly invited a crowd to a drink with him in his apartment. Dorothy West saw the surprised expression on Thurman's face when he hemorrhaged at 2 a.m. and knew he was going to die. His widow, Louise Thompson, Aaron and Alta Douglas, Countee Cullen, Richard Bruce Nugent, Harold Jackman, Dorothy Peterson, Dorothy West, Walter White, and William Rapp attended the Harlem funeral. Thurman was buried in Silver Mount Cemetery on Staten Island. Locke was devastated, writing Godmother, "It is hard to see the collapse of things you have labored to raise on a sound basis."

The Depression accelerated a failure that was inevitable, for the Harlem Renaissance could no more have succeeded as a positive social force, whatever the health of Wall Street, than its participants could have been persuaded to try a different stratagem of racial advancement. As different as each of The Six was, as unalike as were Toomer and Thurman, Cullen and Hughes, or Larsen and Hurston, they were all creatures in the margin of a rigidly divided, racist society. They knew that not to be white in their America was to be something less than human, whatever their valedictorian achievements. They recognized that, by the laws of the South and the customs of the North, the fundamental distinction drawn by most white Americans was between good and bad Afro-Americans. In this dehumanized scheme of things, neither culture nor color could alter the pariah status of those whose ancestors had been African slaves. Uncle Tom and Frederick Douglass were social equivalents, while the illiterate redneck was the superior of W. E. B. Du Bois. Or at least so the ancient law of race relations ran.

In reality, nevertheless, the Talented Tenth knew also that those who were culturally and physically more assimilated to white America were, more often than not, beneficiaries of some slight humane and material consideration. The Talented Tenth also recognized—however much it evaded or denied—that a chasm of culture separated it from its peasant origins. Objectively, of couse, it might have tried to pursue a path that more nearly corresponded to the political and institutional needs and aspirations of the masses of Afro-Americans. Realistically, by emotions and convictions, there was never much chance of that happening. The architects of the Renaissance believed in ulimate victory through the maximizing of the exceptional. They deceived themselves

into thinking that race relations in the United States were amenable to the assimilationist patterns of a Latin country. Allowance could be made for Van Vechten writing to James Weldon Johnson, after publication of *Along This Way*, "A little bit more here and a little bit more there and the dam will break and the waters will no longer be segregated," but it was grievously misconceived for Johnson to believe this.

What was about to break was not the dam of segregation but the long-suffering patience of those Harlemites who never read *Opportunity* and no longer derived vicarious pride from Walter White's presence at the Saint Moritz. The superstitious had long seen impending calamity in the poor health of the Tree of Hope outside Connie's Inn. The sophisticated discerned the pervasive wrongness of things in Duke Ellington's refusal to perform for a reasonable fee at the 1934 annual NAACP ball, just as, earlier, Roland Hayes had ignored pleas not to sing before segregated audiences. The one-for-all ethos of Harlem was clearly a thing of the past as suffering in these six square miles reached truly terrible dimensions, and signs of further deterioration became unmistakable. Much of this had been foretold by the *Report of the Committee on Negro Housing*, presented to President Hoover in 1931. "One notable difference appears between the immigrant and Negro populations," the investigators stated. "In the case of the former, there is the possibility of escape, with improvement in economic status in the second generation." For Afro-American urban dwellers, the more things changed, the more they worsened. Despite its vaunted Renaissance and distinguished residents, Harlem was no exception. In this "city within the city," almost 50 percent of the families were out of work, yet a mere 9 percent of them received government relief jobs. The community's single public medical facility, Harlem General Hospital, with 273 beds and 50 bassinets, served 200,000 Afro-Americans. The syphilis rate was nine times higher than white Manhattan's; the tuberculosis rate was five times higher; pneumonia and typhoid rates were twice as high; two black mothers and two black babies died for every white mother and infant.

On the evening of March 19, 1935, the riot awaiting its immediate cause swept down Lenox Avenue with ten thousand angry Harlemites destroying two million dollars in white-owned commercial property. A sixteen-year-old Puerto Rican lad, Lino Rivera, had been roughed up by white store clerks who saw him shoplift a pocketknife in the West 135th Street five-and-dime. Rumor spread that the teenager had been beaten to death. The Young Communist League incited people against

the police. By the following morning, three Afro-Americans were dead, thirty people were hospitalized, and more than one hundred were in jail. Less than a year before, Roscoe and Clara Bruce had sadly informed Talented Tenth readers of the *Dunbar News* that changing times compelled them to "lay their scissors and their pens aside." It was time to do so.

Notes

ABBREVIATIONS

WB-CC/HU Witter Bynner–Countee Cullen Letters/Special
 Collections: The Houghton Library, Harvard University.
CA-MY/SCRBC ("The Negro in America") Carnegie-Myrdal Study/Special
 Collections: Schomburg Center for Research in Black
 Culture, New York Public Library.
CCMC/AU Countee Cullen Memorial/Special Collections: Trevor
 Arnett Library, Atlanta University.
CCP/ARC Countee Cullen Papers: Amistad Research Center, Dillard
 University.
FWP/SCRBC ("Negroes of New York") Federal Writers Program/Special
 Collections: Schomburg Center for Research in Black
 Culture, New York Public Library.
WFC/UP Waldo Frank Collection/Special Collections: Van Pelt
 Library, University of Pennsylvania.
HFR/LC Harmon Foundation Records: Manuscript Division,
 Library of Congress.
ZNH/UF Zora Neale Hurston Collection/Special Collections:
 University of Florida.
JWJMC/YU James Weldon Johnson Memorial Collection/Collection of
 American Literature: Beinecke Rare Book and Manuscript
 Library, Yale University.
ALLP/HU Alain Leroy Locke Papers: Moorland-Spingarn Research
 Center, Howard University.
CMP/SCRBC Claude McKay Papers/Special Collections: Schomburg
 Center for Research in Black Culture, New York Public
 Library.
HLMC/NYPL H. L. Mencken Collection: Manuscript Division, New York
 Public Library.
OHP/CU Oral History Project: Nicholas Murray Butler Library,
 Columbia University.
WPRG/SCRBC William Pickens Record Group/Special Collections:
 Schomburg Center for Research in Black Culture, New York
 Public Library.

AASP/SCRBC	Arthur A. Schomburg Papers/Special Collections: Schomburg Center for Research in Black Culture, New York Public Library.
ASP/HU	Arthur Spingarn Papers: Moorland-Spingarn Research Center, Howard University.
JSC/NYPL	Joel Spingarn Collection: Manuscript Division, New York Public Library.
JTC/FU	Jean Toomer Collection/Special Collections: Fisk University.
CVVC/NYPL	Carl Van Vechten Collection: Manuscript Division, New York Public Library.
WWC/LC	Personal Correspondence of Walter White/National Association for the Advancement of Colored People Collection: Manuscript Division, Library of Congress.
TRI	Tape recorded interviews by David Levering Lewis

 Abdul, Raoul (September 1974)
 Adams, Wilhelmina (March 1975)
 Andrews, Regina (July 1975)
 Bundles, A'Lelia (May 1977)
 Cook, Mercer (April 1978)
 Cullen, Ida Mae (September 1974)
 Daniels, James (March 1978)
 Davis, Arthur P. (March 1977)
 Dewitt, Miriam (Hapgood) (October 1976)
 Diggs, Irene (September 1976, not taped)
 Dodson, Owen (May 1977)
 Douglas, Aaron (July 1974)
 Fauset, Arthur Huff (May 1977)
 Fisher, Ivy (Mrs. Rudolph) (March 1975)
 Fisher, Pearl (March 1975)
 Fleming, G. James (June 1976)
 Harper, Emerson (September 1974)
 Hutson, Jean Blackwell (September 1974)
 Immerman, Aida (Mrs. Connie) (April 1978)
 Jackman, Ivy (September 1974)
 James, C. L. R. (April 1976)
 Jarbaro, Caterina (April 1975)
 Johnson, Grace Nail (Mrs. James Weldon)
 (September 1974, not taped)
 Johnson, Henry Lincoln, Jr. (March 1977)
 Johnson, Mildred (May 1977)
 Kellner, Bruce (November 1975)
 Knopf, Alfred (September 1974)
 Logan, Rayford (October 1974)
 Major, Gerri (Geraldyn Dismond) (May 1977)
 Moon, Henry Lee (May 1977)
 Nelson, A'Lelia Ransom (September 1974)
 Nugent, Richard Bruce (September 1974, May 1977)
 Patterson, Louise (July 1974, April 1978)
 Peck, Mae Wright (September 1976)
 Redd, George N. (July 1974)
 Rogers, Helga (Mrs. Joel A.) (March 1975, not taped)
 Russell, Maurice (May 1975)

Schuyler, George (September 1974)
Sebree, Charles (April 1977)
Spady, James (November 1975)
Spingarn, Amy (Mrs. Joel) (May 1977)
Sullivan, Mae Miller (April 1977)
Toomer, Marjorie (Mrs. Jean) (September 1974)
Wesley, Charles S. (April 1975)
West, Dorothy (October 1976)
Whipper, Leigh (September 1974)
Wilson, Edith (October 1976)
Wright, Corinne (Mrs. Louis T.) (May 1977)

CHAPTER 1 : WE RETURN FIGHTING

Page

3 THE NATION'S MORES: Vernon and Irene Castle, *Modern Dancing* (New
York: Harper & Bros., 1914): Irene (Foote) Castle, *Castles in the Air: As
Told to Bob and Wanda Duncan* (Garden City, N.Y.: Doubleday, 1958),
pp. 118–20; Frederick Lewis Allen, *Only Yesterday: An Informal History
of the 1920's* (New York: Harper & Row, 1959; orig. pub., 1931), esp.
chap. 5; Samuel B. Charters and Leonard Kunstadt, *Jazz: A History of the
New York Scene* (Garden City, N.Y.: Doubleday, 1962); Lloyd Morris,
Postscript to Yesterday, America: The Last Fifty Years (New York: Ran-
dom House, 1947); Eileen Southern, *Music of Black Americans* (New
York: Norton, 1971); Margaret Just Butcher, *The Negro in American
Culture*, rev. ed. (New York: Mentor Books, 1971), pp. 59–60.

3–4 MARCH TO THE RHINE: Arthur W. Little, *From Harlem to the Rhine*
(New York: Covici Friede, 1936). Charles Holston Williams, *Negro Sol-
diers in World War I: The Human Side* (New York: AMS Press, 1979;
orig. pub., 1923); Emmett Scott, *Scott's Official History of the American
Negro in the World War* (New York: n.p., 1919); Jack D. Foner, *Blacks
and the Military in American History* (New York: Praeger, 1974), chap. 6.

4 "GET ANOTHER JOB": New York *Age*, Feb. 22, 1919.

4 "THESE FIGHTING MEN": "Fifth Avenue Cheers Negro Veterans," New
York *Times*, Feb. 18, 1919.

5 "WAR AND COME BACK": New York *Age*, Feb. 22, 1919.

6 "NO ANGLO-SAXON": W. E. B. Du Bois, *Darkwater: Voices from Within
the Veil* (New York: Schocken, 1969; orig. pub., 1920), p. 9. "SHADOW
SWEPT ACROSS ME": W. E. B. Du Bois, *The Souls of Black Folk: Essays
and Sketches* (Greenwich, Conn.: Fawcett, 1961; orig. pub., 1903), p. 16.

6–7 "THE ISLANDS OF THE SEA": *Ibid.*, p. 23. "CENTRAL THOUGHT OF ALL HIS-
TORY": W. E. B. Du Bois, "The Conservation of Races," cited in
Wilson J. Moses, *The Golden Age of Black Nationalism, 1850–1925*
(Hamden, Conn.: Archon, 1978), p. 134. BOOKER T. WASHINGTON:
August Meier, *Negro Thought in America, 1880–1915: Racial Ideologies
in the Age of Booker T. Washington* (Ann Arbor: The Univ. of Michigan
Press, 1964), p. 192. ON THE MASSES: W. E. B. Du Bois, *The Auto-
biography of W. E. B. Du Bois: A Soliloquy on Viewing My Life from
the Last Decade of Its First Century* (New York: International Pub-
lishers, 1968), p. 236.

7 "READ IT OFTEN ALOUD": Elliott M. Rudwick, W. E. B. *Du Bois: Propagandist of the Negro Protest* (New York: Atheneum, 1968). Mary White Ovington, *The Walls Came Tumbling Down* (New York: Harcourt, Brace, 1947), p. 108; Daniel Walden, ed., W. E. B. *Du Bois: The Crisis Writings* (Greenwich, Conn.: Fawcett, 1972); Francis L. Broderick, W. E. B. *Du Bois: Negro Leader in Time of Crisis* (Stanford, Calif.: Stanford Univ. Press, 1959); Charles Flint Kellogg, *NAACP* (Baltimore, Md.: Johns Hopkins Univ. Press, 1967), vol. 1., esp. chaps. 5, 11.

8 "UNITED STATES OF EUROPE": *The Crisis*, 16 (July 1918): 111.

9 "WITH CLEAN HANDS": Quoted by Stephen R. Fox, *The Guardian of Boston: William Monroe Trotter* (New York: Atheneum, 1971), p. 217. On this debate: William H. Harris, *Keeping the Faith*, A. *Philip Randolph* (Urbana: Univ. of Illinois Press, 1977); Jervis Anderson, A. *Philip Randolph, A Biographical Portrait* (New York: Harcourt Brace Jovanovich, 1972); Florette Henri, *Black Migration: Movement North, 1900–1920* (Garden City, N.Y.: Doubleday, 1976), chap. 9; Kellogg, *NAACP*, vol. 1, chap. 11; Rudwick, *Du Bois*, chap. 8.

9 UNFITNESS . . . TO COMMAND: Henri, *Black Migration*, chap. 8. Fox, *The Guardian of Boston*, p. 218; Williams, *Negro Soldiers*, p. 45.

9–10 SPOKE FOR THEM: Roi Ottley and William J. Weatherby, eds., *The Negro in New York: An Informal Social History, 1626–1940* (New York: Praeger, 1969), pp. 199–200; Elliott Rudwick, *Race Riot at East St. Louis* (New York: Atheneum, 1972); Kellogg, *NAACP*, vol. 1, p. 226.

11 "NOT A SINGLE MAN": Spingarn to H. L. Mencken, n.d.; HLMC/NYPL. B. Joyce Ross, *J. E. Spingarn and the Rise of the NAACP* (New York: Atheneum, 1972). On Spingarn: Alfred Kazin, *On Native Grounds, An Interpretation of Modern American Prose Literature* (New York: Reynal and Hitchcock, 1942).

11 "YOU WERE NEVER MISTAKEN": Quoted by Herbert Aptheker, ed., *The Correspondence of W. E. B. Du Bois, Selections 1877–1934*, 2 vols. (Amherst: Univ. of Massachusetts Press, 1973), 1: 200. Ross, *Spingarn*, p. 64.

11–12 "TRAINING MAY BE OBTAINED": Quoted by Ross, *Spingarn*, p. 85. "WRITE US FOR INFORMATION!" *The Crisis*, 14 (June 1917): 60. Ross, *Spingarn*, pp. 84–85; Rudwick, *Du Bois*, p. 203; Kellogg, *NAACP*, pp. 250–51.

12 "OFFICERS INTO SHAPE": Young to Du Bois, *Corr. of Du Bois*, 1: 222. For archival evidence of Young's unfair treatment: Henri, *Black Migration*, pp. 218–83.

12–13 "A RANK QUITTER . . . " CONFIRMED: Quoted by Fox, *Guardian of Boston*, p. 219. On captaincy furore: Byron Gunner to Du Bois, July 25, 1918, *Corr. of Du Bois*, 1: 228; Kellogg, *NAACP*; Rudwick, *Du Bois*; Ross, *Spingarn*; Henri, *Black Migration*.

13 "BEFORE THE WAR": Quoted by Williams, *Negro Soldiers*, pp. 220–21. Henri, *Black Migration*, p. 305.

13 STATIONED ABROAD WROTE: Williams, *Negro Soldiers*, p. 62. "APPEARANCE OF SABOTAGE": George Schuyler, *Black and Conservative: The Autobiography of George S. Schuyler* (New Rochelle, N.Y.: Arlington House,

1966), p. 87. NOTED FOR INDUSTRIAL TRAINING: Williams, *Negro Soldiers*, pp. 165–95; Foner, *Blacks and the Military*, p. 118.

13–14 DANGER OF ANOTHER HOUSTON: André Kaspi, *Le Temps des américains: Le concours américain à la France en 1917–1918* (Paris: Publications de la Sorbonne, 1976), pp. 181–86.

14–15 "ADMIRATION OF THE WHOLE NATION": Quoted by Robert T. Kerlin, *The Voice of the Negro, 1919* (New York: Arno Press, 1968; orig. pub., 1920), p. 40. "PRESENCE OF WHITE AMERICANS": Quoted by Lerone Bennett, *Before the Mayflower* (Baltimore: Penguin Books, 1962), p. 369. HOURLY CHECKS: Williams, *Negro Soldiers*, p. 75.

15 REMAIN ABROAD INDEFINITELY: TRI/Rayford Logan. "HAVE BEEN SUBJECTED": Quoted by Foner, *Blacks and the Military*, p. 122.

15 "OR KNOW THE REASON WHY": "Returning Soldiers," *The Crisis*, 17 (May 1919): 13–14.

15–16 LIKE ALEXANDER BERKMAN: Robert K. Murray, *Red Scare: A Study in National Hysteria* (Minneapolis: Univ. of Minnesota Press, 1955); John Higham, *Strangers in the Land: Patterns of American Nativism* (New York: Atheneum, 1963); Justin Kaplan, *Lincoln Steffens: A Biography* (New York: Simon & Schuster, 1974), chap. 12; Robert A. Rosenstone, *Romantic Revolutionary: A Biography of John Reed* (New York: Knopf, 1975), chap. 16.

16 HISTORIAN OF THE PERIOD WRITES: William Leuchtenburg, *The Perils of Prosperity, 1914–1932* (Chicago: Univ. of Chicago Press, 1958), p. 78.

17 "ELLIS ISLAND": Reproduced in Andrew Buni, *Robert L. Vann of the Pittsburgh Courier* (Pittsburgh: Univ. of Pittsburgh Press, 1974), p. 10. See Editorial, *The Messenger*, 6, no. 7 (July 1924): 247. ARTICLES CHARGED AGAINST THEM: *United States Attorney-General, Investigation Activities of the Department of Justice* (U.S. Senate Documents, Nov. 17, 1919), p. 162. Anderson, *Randolph*, chap. 3; Theodore G. Vincent, ed., *Voices of a Black Nation: Political Journalism in the Harlem Renaissance* (San Francisco: Ramparts Press, 1973).

17–18 POLICEMAN WERE INJURED: Arthur I. Waskow, *From Race Riot to Sit-in: 1919 and the 1960s* (Garden City, N.Y.: Anchor Books, 1966), chap. 2.

18 GOOD MEASURE, SHOT HIM: William M. Tuttle, Jr., *Race Riot: Chicago in the Red Summer of 1919* (New York: Atheneum, 1970), p. 23.

18–19 JONES AND DAVIS . . . TO ESCAPE: Tuttle, *Race Riot*, pp. 25–29; Waskow, *Race Riot*, pp. 16–17.

19 "BE LYNCHED MYSELF": Carter G. Woodson Affidavit Concerning Events of July 20, 1919.

19 "PALE INTO INSIGNIFICANCE": Waskow, *Race Riot*, chap. 3. Constance McLaughlin Green, *The Secret City: A History of Race Relations in the Nation's Capital* (Princeton, N.J.: Princeton Univ. Press, 1967), pp. 190–93. INTELLIGENCE TO THEIR COMMUNITIES: Constance McLaughlin Green, *Washington: A History of the Capital* (Princeton, N.J.: Princeton Univ. Press, 1962), pp. 266–67.

19–20 1,000 HOMELESS: The Chicago Commission [Charles S. Johnson], *The Negro in Chicago: A Study of Race Relations and a Race Riot in 1919* (New York: Arno Press, 1968; orig. pub., 1922); Tuttle, *Race Riot*, pp. 74–107; Emmett J. Scott, *Negro Migration During the War* (New York: Oxford Univ. Press, 1920); T. J. Woofter, *Negro Problems in the Cities* (New York: Negro Universities Press, 1969; orig. pub., 1928); Louise Venable Kennedy, *The Negro Peasant Turns Cityward* (New York: AMS Press, 1968; orig. pub., 1930).

20 LEFT THE SOUTH BEFORE 1920: Henri, *Black Migration*, chap. 2; Tuttle, *Race Riot*, p. 76; Scott, *Negro Migration*, pp. 15–56.

20 FOR THEIR CHILDREN: Scott, *Negro Migration*, p. 26. "WITHIN TWO WEEKS": T. Arnold Hill, in Tuttle, *Race Riot*, pp. 85–86.

20–21 "WERE MADE AT ALL": Tifton *Gazette*, in Scott, *Negro Migration*, pp. 79–80.

21 BAKER . . . WAS TOLD: Ray Stannard Baker, *Following the Color Line* (New York: Doubleday, 1908), p. 133. "FOR SEVERAL DECADES": Louise Kennedy, *The Negro Peasant*, pp. 49–50.

21 "WAH'S GOIN' ON": Unascribed quote in Henri, *Black Migration*, p. 51.

21 EDITION OF THE DEFENDER: Tuttle, *Race Riot*, pp. 87–90. FOR A NINE-HOUR DAY: *Ibid.*, p. 87; Henri, *Black Migration*, p. 55; Scott, *Negro Migration*, p. 16.

21–22 "ECONOMIC ADVANTAGE TO HIMSELF": Du Bois, "The AFofL and the Negro," *The Crisis*, 36 (July 1919): 241. On union friction: Tuttle, *Race Riot*, pp. 108–56; Philip Foner, *History of the Labor Movement in the United States* (New York: International Publishers, 1964), vol. 3, chap. 9.

22–23 CONTROL OF PHILLIPS COUNTY: Waskow, *Race Riot*, chap. 7. AT HELENA: Walter White, " 'Massacring Whites' in Arkansas," *The Nation*, Dec. 6, 1919: 715–16.

23 "DEMANDING ECONOMIC EQUALITY": Carter G. Woodson, *A Century of Negro Migration* (New York: Ames Press, 1918), p. 180.

23 "FIGHTING BACK!": *Selected Poems of Claude McKay* (Harcourt, Brace, 1953), p. 36.

23–24 "DOUBLE-BARREL SHOT GUNS": Kerlin, *Voice of the Negro*, pp. 22, 25, 67–68, 77, 146. See also Vincent, *Voices of a Black Nation*.

CHAPTER 2 : CITY OF REFUGE

Page

25 CHARGE THE AFRO-AMERICANS MUCH MORE: Jacob Riis, *How the Other Half Lives* (New York: Sagamore Press, 1957; orig. pub., 1890), p. 113. On Afro-American Harlem: Roi Ottley and William J. Weatherby, eds., *The Negro in New York: An Informal Social History, 1626–1940* (New York: Praeger, 1967), pp. 183–87; James Weldon Johnson, *Black Manhattan* (New York: Atheneum, 1972; orig. pub., 1930), chap. 13; Claude McKay, *Harlem: Negro Metropolis* (New York: Harcourt Brace Jovanovich, 1968; orig. pub., 1940), pp. 15–20; Clyde V. Kiser, *Sea Island to City: A Study of St. Helena Islanders in Harlem* (New York: Atheneum,

1969; orig. pub., 1932); Gilbert Osofsky, *Harlem, The Making of a Ghetto: Negro New York, 1890–1930* (New York: Harper & Row, 1966).

26 "BEEN FORCED UPON US": Quoted by Osofsky, *Harlem*, p. 110.

26 A DAZZLING DEAL: Quoted, *ibid.*, p. 96. On this incident: Wilbur Young, "Sketch of James C. Thomas," in "Negroes of New York": Reel no. 2 FWP/SCRBC.

26 "FILL THE AIR ON A SUNDAY": Quoted by Konrad Bercovici, *Around the World in New York* (New York: The Century Co., 1924), p. 215.

26–27 TOTAL HARLEM POPULATION: "Thirty-four Hundred Negro Families in Harlem: An Interpretation of the Living Conditions of Small Wage Earners," New York Urban League, 1927, p. 5; Osofsky, *Harlem*, p. 135; Kiser, *Sea Island to City*, pp. 28–30.

27 "VARIETY OF BUSINESS ENTERPRISES": Quoted by Osofsky, *Harlem*, p. 32. AFRO-AMERICAN REALTY COMPANY: Bercovici, *Around the World*, p. 216. "CAPITAL OF THE WORLD": Johnson, *Black Manhattan*, p. 59.

28–29 FAITHFUL TO THE PLACE: On Tenderloin culture, clubs, personalities: Johnson, *Black Manhattan*, chap. 8; Margaret Just Butcher, *The Negro in American Culture*, rev. ed. (New York: Mentor Books, 1971), chap. 4; Willie "the Lion" Smith (with George Hoefer), *Music on My Mind: The Memoirs of an American Pianist* (Garden City, N.Y.: Doubleday, 1964); Samuel B. Charters and Leonard Kunstadt, *Jazz: A History of the New York Scene* (Garden City, N.Y.: Doubleday, 1962), chaps. 1–5; Eileen Southern, *Music of Black Americans* (New York: Norton, 1971), chaps. 10, 11, 12; Ann Charters, *Nobody: The Story of Bert Williams* (New York: Macmillan, 1970); James Weldon Johnson, *Along This Way: The Autobiography of James Weldon Johnson* (New York: Viking, 1961; orig. pub., 1933); Lawrence W. Levine, *Black Culture and Black Conciousness* (New York: Oxford University Press, 1977), chap. 4. "AND WORLD OF MUSIC": Johnson, *Along This Way*, pp. 152, 172–73.

29–30 JOHNSON WROTE DELIGHTEDLY: Johnson, *Black Manhattan*, p. 97.

30 "NOTHING DID FOR A DECADE": Quoted by Southern, *Music of Black Americans*, p. 295.

31 DURING ITS BEST YEARS: Johnson, *Black Manhattan*, p. 123; Irene (Foote) Castle, *Castles in the Air: As Told to Bob and Wanda Duncan* (Garden City, N.Y.: Doubleday, 1958), p. 58.

31–32 "DIFFERENT AND DISTINCTIVE": Quoted by Charters and Kunstadt, *Jazz*, p. 31.

32 "WHO WERE AGAINST IT": Castle, *Castles in the Air*, p. 85. Frederick Lewis Allen, *Only Yesterday: An Informal History of the 1920's* (New York: Harper & Row, 1931, 1959), chap. 5.

32 "ALL FANTASTIC DIPS": Quoted by Vernon and Irene Castle, *Modern Dancing* (New York: Harper & Bros., 1914), p. 20.

32–33 "COME TO AN END": Castle, *Castles in the Air*, p. 90.

33 "ONLY TWO COUPLES LEFT": *Ibid.*, p. 120.

33 "LAID ASIDE FOR A TIME": Charters and Kunstadt, *Jazz*, p. 111.

34 "BE THAT WHITE!": John Henrik Clarke, ed., *American Negro Short
Stories* (New York: Hill & Wang, 1966), p. 22.

34–35 "SENTIMENT IN AMERICA": Quoted by Jervis Anderson, *A. Philip Ran-
dolph: A Biographical Portrait* (New York: Harcourt Brace Jovanovich,
1972), p. 123. On this incident: (A. Philip Randolph): OHP/CU.
"LISTEN TO HIS STORY": Quoted by Anderson, *Randolph*, p. 122. BEEN
HEARD IN AMERICA: On Garvey's ideological antecedents, personality,
and politics: Edmund David Cronon, *Black Moses: The Story of Marcus
Garvey* (Madison: Univ. of Wisconsin Press, 1969); Tony Martin, "The
Emancipation of a Race: Being an Account of the Career and Ideas of
Marcus Mosiah Garvey" (Michigan State Univ. Ph.D. diss., 1973; pub.
by Greenwood Press [Westport, Conn., 1976] as *Race First: The Ideologi-
cal and Organizational Struggles of Marcus Garvey and the Universal Negro
Improvement Association*); John Henrik Clarke, ed., *Marcus Garvey and
the Vision of Africa* (New York: Vintage Books, 1974); Amy Jacques-
Garvey, ed., *Philosophy and Opinions of Marcus Garvey* (New York:
Atheneum, 1969); Wilson J. Moses, *The Golden Age of Black National-
ism, 1850–1925* (Hamden, Conn.: Archon Books, 1978); Edwin S. Red-
key, *Black Exodus, Black Nationalist and Back-to-Africa Movements* (New
Haven, Conn.: Yale Univ. Press, 1969); August Meier, *Negro Thought in
America, 1880–1915* (Ann Arbor: Univ. of Michigan Press, 1966, 1978).

35 AND WILLIAM H. FERRIS: Martin, "Emancipation"; Cronon, *Black Moses.*

35–36 "HELP TO MAKE THEM": Quoted by Clarke, *Garvey*, p. 73.

36 "NEGRO IMPROVEMENT ASSOCIATION": Quoted, *ibid.*, p. 74. "THE HIGH
GOD": Martin, "Emancipation," p. 10.

36 "OF SCATTERED ETHIOPIA": Quoted, *ibid.*, p. 89. HEADQUARTERS "DUMB-
FOUNDED": Jacques-Garvey, ed., *Philosophy and Opinions*, p. 57.

37 AFRICA AND THE UNIA: Martin, "Emancipation," p. 89. On the 369th Inf.
Regt.: *Ibid.*, p. 18.

37–38 "UGLIEST NEGROES IN AMERICA": TRI/Arthur P. Davis, G. James Flem-
ing, James Spady. "CONDITIONS OF MY RACE": Quoted by Cronon, *Black
Moses*, p. 56.

38 VESSEL AS SEAWORTHY: Quoted, *ibid.*, p. 64. "REGULAR AND PROPER EN-
TRIES": Quoted by Clarke, *Garvey*, p. 143. TWENTY-THIRD STREET PIER:
Cronon, *Black Moses*, p. 56.

38–39 STATUE OF LIBERTY FOR HAVANA: Clarke, *Garvey*, pp. 131–32. "SYSTEM TO
HIS DISHONESTY": Quoted, *ibid.*, pp. 141, 142–46.

39 BLACK STAR LINE'S LIABILITY: Quoted, *ibid.*, pp. 133–35.

39–40 "BEFORE OR SINCE": Quoted, *ibid.*, p. 135. "BEAUTIFUL LAND": Mary
White Ovington, *Portraits in Color* (New York: Viking, 1927), p. 24.
"A FREE IRELAND": Clarke, *Garvey*, p. 64. IMMINENT BLACK DOMINION:
Cronon, *Black Moses*, pp. 63–70; Martin, "Emancipation," p. 21.

40–41 "AUTHORITY OF THE PEOPLE": Jacques-Garvey, ed., *Philosophy and
Opinions*, p. 72. "LEADING TO WAR": *Ibid.* "SCHEME OF THINGS": *Ibid.*,
p. 70. "THE FIRST FASCISTS": Quoted by Martin, "Emancipation," p. 105.
Jacques-Garvey, ed., *Philosophy and Opinions*, pp. 72–73; Cronon, *Black
Moses*, pp. 189–90.

41 OUT OF WORK: TRI/G. James Fleming. Afro-American attitudes vis-à-vis West Indians: Adam Clayton Powell, Sr., *Marching Blacks* (New York: Dial, 1973; orig. pub., 1945), pp. 80–81; Ira De A. Reid, *The Negro Immigrant: His Background, Characteristics and Social Adjustment* (New York: Arno Press, 1969; orig. pub., 1939); Harold Cruse, *The Crisis of the Negro Intellectual* (New York: William Morrow, 1967), pp. 130–35; McKay, *Harlem*, pp. 132–42; Bercovici, *Around the World*, pp. 238–39; Osofsky, *Harlem*, pp. 131–35.

41 FINISHED, HE WARNED: Jacques-Garvey, *Philosophy and Opinions*, p. 57. Theodore G. Vincent, *Voices of a Black Nation: Political Journalism in the Harlem Renaissance* (San Francisco: Ramparts Press, 1973).

41–42 "THE NEGRO RACE": "Back to Africa," *Century*, 105: 547: "A Lunatic or a Traitor," *The Crisis*, 28, no. 1 (May 1924): 8–9. " INTO TWO GROUPS": *Negro World*, May 10, 1924, p. 1. WAS GENUINE: Jacques-Garvey, *Philosophy and Opinions*, p. 37. "ARE THE BLACK MAN'S": Quoted by Martin, "Emancipation," p. 176.

42–43 "BETWEEN US IN POWER": *Quoted, ibid.,* p. 122. "BY THE WHITE MAN": Quoted, *ibid.,* p. 54; other quotes, pp. 361, 399, 403. DYER'S SAINT LOUIS DISTRICT: Quoted, *ibid.,* p. 103.

43 "HAS BEEN DOING": Quoted, *ibid.,* p. 193. UNIA HEADQUARTERS: Quoted, *ibid.,* p. 215. On FBI activities: *Ibid.,* pp. 221–35. WAS HIGHLY SUSPICIOUS: *Ibid.,* pp. 19–20; Cronon, *Black Moses,* pp. 44–45. MADISON SQUARE GARDEN CONVENTION: Martin. "Emancipation," p. 242; Robert F. Murray, *Red Scare: A Study in National Hysteria* (Minneapolis: Univ. of Minnesota Press, 1955), p. 85.

43–44 TOWARD NATURALIZATION: Martin, "Emancipation," p. 27. PRESENCE IN WEST AFRICA: *Ibid.,* p. 82. ENEMIES EVER COULD HAVE: *Ibid.,* p. 27; Anderson, *Randolph,* pp. 132–34; Theodore Kornweibel, Jr., *No Crystal Stair: Black Life and the Messenger* (Westport, Conn.: Greenwood Press, 1975), pp. 137–42.

44–45 "IMITATION OF A WHITE MAN": Quoted by Martin, "Emancipation," p. 59. "PURPOSE TOWARD THE NEGRO": Quoted, *ibid.,* p. 401. AND ON AND ON: "The Madness of Marcus Garvey," *The Messenger,* 5, no. 3 (Mar. 1923): 638, 648; A. P. Randolph, "The Only Way to Redeem Africa," *The Messenger,* 5, no. 1 (Jan. 1923): 568–70; Kornweibel, *No Crystal Stair,* pp. 140–42. "DISGRACE OF GARVEYISM": *The Messenger,* 5, no. 3 (Mar. 1923): 639–40. "THIS VICIOUS MOVEMENT": Quoted by Clarke, *Garvey,* p. 228. Kornweibel, *No Crystal Stair,* p. 142.

45 "THE WORST OF THEM ALL": Edwin Embree, *Thirteen Against the Odds* (New York: Viking, 1944), p. 55. "PUNISHMENT OF THE VICTIM": C. S. Johnson to White, Oct. 31, 1929 (C-98): WWC/LC.

45–46 "THAT CAUSE IT": Embree, *Thirteen Against the Odds,* p. 54. On Charles S. Johnson: Patrick J. Gilpin, "Charles S. Johnson: Entrepreneur of the Harlem Renaissance," in *The Harlem Renaissance Remembered, Essays Edited with a Memoir,* ed., Arna Bontemps (New York: Dodd, Mead, 1972); James E. Blackwell and Morris Janowitz, *Black Sociologists: Historical and Contemporary Perspectives* (Chicago: Univ. of Chicago Press, 1974); Ralph L. Pearson, "Charles S. Johnson: The Urban League Years,

A Study of Race Leadership" (Johns Hopkins Univ. Ph.D. diss., 1970);
August Meier, "Black Sociologists in White America (Review)," *Social
Forces,* 1, no. 56: 259–68; S. P. Fullinwider, *The Mind and Mood of
Black America: 20th Century Thought* (Homewood, Ill.: The Dorsey
Press, 1969), pp. 111–13.

46 PARK'S PAPERS REVEALED: Quoted by Stanford M. Lyman, *The Black
 American in Sociological Thought* (New York: Capricorn Books, 1973),
 p. 35. "REVERSE IT": Quoted, *ibid.,* p. 28.

46 "LADY OF THE RACES": Quoted, *ibid.,* p. 42. TO THE CORE: Quoted, *ibid.,*
 p. 46. FELLOWSHIP AMONG THE RACES: Johnson, "The Balance Sheet,
 Debits and Credits in Negro-White Relations," *The World Tomorrow,*
 Jan. 1928: pp. 13–16.

47 FUNDAMENTAL NOR PERMANENT: Arthur I. Waskow, *From Race Riot to
 Sit-in: 1919 and the 1960s* (New York: Atheneum, 1970), chap. 5; Gilpin,
 "Johnson," pp. 218–20.

47–48 TO MAKE IT BEARABLE: Quoted by Fullinwider, *Mind and Mood,* p. 113.
 "WILL BE CORRECTED": Quoted by Gilpin, "Johnson," p. 221.

C H A P T E R 3 : S T A R S

Page

50 "ENTIRE SOLAR SYSTEM": Gwendolyn Bennett to Countee Cullen, Aug.
 28, 1925: CCP/ARC.

50–51 "MOST ALIEN RACE AMONG US": Claude McKay, *Harlem Shadows* (New
 York: Harcourt, Brace, 1922).

51 "ACID HAUTEUR OF SPIRIT": Claude McKay, *A Long Way from Home*
 (New York: Harcourt, Brace & World, 1970; orig. pub., 1937), p. 110.
 WITHOUT REALLY TRYING: *Ibid.,* pp. 114–15.

52 "OF LONDON WALK": Quoted by Wayne Cooper, ed., *The Passion of
 Claude McKay: Selected Prose and Poetry, 1912–1948* (New York:
 Schocken, 1973), p. 5.

52 "POET OF HATE": Jean Wagner, *Black Poets of the United States: From
 Paul Laurence Dunbar to Langston Hughes* (Urbana: Univ. of Illinois
 Press, 1973), p. 225.

52 "INCREASINGLY TO WIN": "Mulatto," in Cooper, *Passion of McKay,* p. 126.

52–53 REVOLUTIONARY FIRES RAGED: McKay, *Long Way from Home,* p. 69.
 DREADNOUGHT WAS PRINTED: *Ibid.,* pp. 78–79. "FINER SYSTEM OF SOCIAL-
 ISM": Quoted by Cooper, *Passion of McKay,* p. 54. Harold Cruse, *Crisis
 of the Negro Intellectual* (New York: William Morrow, 1967), pp. 46–48.

53 CHASTISED HIS PATRON: McKay to Eastman, May 18, 1923, in Cooper,
 Passion of McKay, p. 89. "THE CONTINENT OF AFRICA": *Liberator,* 5 (Apr.
 1922): 8–9, in Cooper, *Passion of McKay,* p. 67; also p. 15. On McKay's
 feelings for Garvey: McKay, *Long Way from Home,* p. 109; "Marcus
 Aurelius Garvey," in Claude McKay, *Harlem: Negro Metropolis* (New
 York: Harcourt, Brace & World, 1968; orig. pub., 1940).

53–54 OF HARLEM SHADOWS: McKay to J. Spingarn, Dec. 18, Dec. 31, 1934: JSC/NYPL. "DANGER AHEAD": Quoted by Cooper, *Passion of McKay*, pp. 84, 88. McKay, *Long Way from Home*, p. 139; Cruse, *Crisis of Negro Intellectual*, pp. 49–53.

54 "FIND SUCH MASTERPIECES": McKay, *Long Way from Home*, p. 139. "HAD MORE PEP": Quoted by Cooper, *Passion of McKay*, p. 79.

54 "URGED COMPROMISE": McKay, *Long Way from Home*, p. 144.

54 "DREAM OF THE JUNGLE": *Ibid.*, p. 145.

54–55 "SOJOURN AND A REST?": "The Negro's Friend," in *Selected Poems of Claude McKay* (New York: Harcourt Brace & World, 1953), p. 51. QUICKLY AS IT CAME: "The City's Love," in *Selected Poems*, p. 66. "AND OUT OF TIME": Cooper, *Passion of McKay*, p. 121. "AND HUMAN PITY": "Desolate City," in *Selected Poems*, p. 52. "HEAD AND WEPT": "The Tropics in New York," in Cooper, *Passion of McKay*, p. 117. "THESE HARSH DAYS": "Rest in the City," in *Selected Poems*, p. 77. "STREET TO STREET": *Ibid.*, p. 60.

55–56 "THAT STRANGE PLACE": *Ibid.*, p. 61.

56 "BOUNCERS ON YOU-ALL": McKay, *Long Way from Home*, p. 132. "SACRIFICES FOR ME": *Ibid.*, p. 150. "COLOR CONSCIOUSNESS": *Ibid.*

56–57 "NO MISTAKE ABOUT IT": *Ibid.*, p. 168. "THE WALLS OF THE CITY": *Ibid.*, p. 170.

57 "COMMUNISTS OF AMERICA": Quoted by Cooper, *Passion of McKay*, p. 93. A SPECIAL COMMITTEE: Theodore Draper, *American Communism and the Soviet Union* (New York: Viking, 1960), p. 353; Cruse, *Crisis of Negro Intellectual*, pp. 54–58; G. Zinoviev to McKay, May 8, 1923 (C-90): WWC/LC.

57 FOR THE HIERARCHY: Cooper, *Passion of McKay*, pp. 22–25, 41–44; Theodore Draper, *The Roots of American Communism* (New York: Viking, 1957), pp. 386–87; Draper, *American Communism and the Soviet Union*, chap. 15.

57–58 AN AMERICAN REVOLUTION: McKay, *Long Way from Home*, p. 193. "A DIFFERENT ROAD": *Ibid.*, p. 177. WAS THE REPLY: Quoted by Claude McKay, "My Green Hills of Jamaica," unpub. autobiography: CMP/SCRBC, p. 86.

58 "AND LACKING UNITY": McKay to Toomer, Dec. 6, 1921, Box 6, Fol. 10: JTC/FU. THE SOVIET UNION: McKay to Toomer, July 11, 12; Sept. 12, 1922, Box 6, Fol. 10: JTC/FU. Joseph Freeman (*Liberator*) to Toomer, Sept. 25, 1922, Box 6, Fol. 10: JTC/FU; Gorham Munson, *Destinations: A Canvass of American Literature Since 1900* (New York: AMS Press, 1970; orig. pub., 1928), chap. 12.

58–59 "RACE IN LITERATURE": Quoted by Darwin T. Turner, *In a Minor Chord: Three Afro-American Writers* (Carbondale: Southern Illinois Univ. Press, 1971), p. 2. "I LIKE CANE": Cullen to Toomer, Sept. 29, 1923, Box 1, Fol. 12: JTC/FU. WASHINGTON OR NEW YORK: Allen Tate to Toomer, Nov. 7, 1923, Box 9, Fol. 1. Robert Littell to Toomer, May 19, 1923, Aug. 30, 1923, Oct. 10, 1923, Box 7, Fol. 12; Munson to Toomer, Oct. 29,

1922, Feb. 22, 1923, Box 7, Fol. 12: JTC/FU; Munson to Frank, Aug. 16, 1923: WFC/UP.

59 "POWER TO YOUR ELBOW": Sherwood Anderson to Toomer, 1922, Box 1, Fol. 1: JTC/FU. "REALLY NEW": Anderson to Toomer, Dec. 22, 1922, Box 1, Fol. 1: JTC/FU. "IT DANCES": Anderson to Toomer, Jan. 3, 1924, Box 1, Fol. 1: JTC/FU.

59-60 "WHITE AND NEGRO WORLDS": "Outline of the Story of the Autobiography," Box 14, Fol. 1: JTC/FU. GRANDFATHER'S NEWSPAPER: "The Book of Washington and Bacon Street, Autobiography," Box. 14, Fol. 3: JTC/FU.

60 "A BIG HEART": "Nathan and Nina" (Fragment), Box 14, Fol. 9: JTC/FU. EVERYONE WHO MET HIM: W. E. B. Du Bois, *Black Reconstruction in America, 1860–1880* (New York: Meridian Books, 1964; orig. pub., 1935); August Meier, *Negro Thought in America, 1880–1915* (Ann Arbor: Univ. of Michigan Press, 1966, 1978); Maurice Christopher, *America's Black Congressmen* (New York: Crowell, 1971), chap. 10; Joe Gray Taylor, *Louisiana Reconstructed, 1863–1877* (Baton Rouge: Louisiana State Univ. Press, 1975); James Haskins, *Pinckney Benton Stewart Pinchback* (New York: Macmillan, 1973).

61 "COLORED WORLD," TOOMER WROTE: "Rochelle" (fragment), "Story of Autobiography," Box 15, Fol. 6: JTC/FU.

61 "HAVE NEGRO BLOOD": "A Fiction and Some Facts," Box 1, Fol. 12: JTC/FU. PART AFRICAN: "Story of the Autobiography," "William and Eliza" (fragment), Box 14, Fol. 2: JTC/FU; Toomer, *Cane* [Intro. by Arna Bontemps] (New York: Harper & Row, 1962; orig. pub., 1923); Turner, *Minor Chord*, p. 7; Wagner, *Black Poets*, chap. 7; Robert Bone, *The Negro Novel in America* (New Haven, Conn.: Yale Univ. Press, 1958), chap. 4; Robert Bone, *Down Home: A History of Afro-American Short Fiction* (New York: Putnam's, 1975), chap. 8; Nathan I. Huggins, *Harlem Renaissance* (New York: Oxford Univ. Press, 1971), chap. 4; Mabel Dillard, "Jean Toomer: Herald of the Negro Renaissance" (Ohio Univ. Ph.D. diss., 1967).

62 "ROOTED TO AIR": Quoted by Bone, *Down Home*, p. 236.

62 "THOUSAND YEARS OLD": "Story of the Autobiography," p. 17.

62-63 "A LITERARY CAREER": *Ibid.*, p. 19. "KNOWN IN WASHINGTON": *Ibid.* READ BOOKS CRITICALLY: "Robert Bismarck Pinchback" (biographical fragment), Box 14, Fol. 7: JTC/FU.

63 "WITH LITERARY NEW YORK": "Story of the Autobiography," p. 36. "SLEEPING WITH WOMEN": *Ibid.*, p. 42.

63-64 "SPEAK THEIR LANGUAGE": *Ibid.*, p. 45. "OF MY APPRENTICESHIP": *Ibid.*

64 "RICH AND BEAUTIFUL": *Ibid.*, p. 58. "SO TOUCHED ME": Toomer to Frank, Aug. 21, 1922: WFC/UP. W. E. B. Du Bois, *The Autobiography of W. E. B. Du Bois* (New York: International Publishers, 1968), chap 8.

64-65 IN HIS LIFE: Toomer to Anderson, Dec. 18, 1922, Box 1, Fol. 1: JTC/FU. "READ WINESBURG, OHIO": *Ibid.*

65 HIS RELATIVES: "Nathan and Nina": JTC/FU. "I'M DONE WITH IT": Toomer to Samuel Pessin, May 25, 1923, Box 8, Fol. 5: JTC/FU.

65–66 WALDO FRANK WROTE: Frank to Toomer, n.d. 1922, Box 1: JTC/FU. CRISIS, WANTED TO KNOW: Fauset to Toomer, Feb. 17, 1922, Box 3, Fol. 1: JTC/FU. LATEST PASSAGES: Munson to Frank, Nov. 23, 1922: WFC/UP. COLLEGE IN NEW ENGLAND: TRI/Mae Wright Peck. Toomer to Mae Wright, July 22, Aug. 4, Aug. 16, Aug. 21, 1922, Box 10, Fol. 10: JTC/FU; Toomer to Anderson, Dec. 22, 1922; Toomer to Frank, July 25, 1922; Toomer to Munson, Oct. 8, 1922, Box 1: JTC/FU.

66 ENCOUNTER IN A DECADE: Alan Trachtenberg, ed., *Memoirs of Waldo Frank* (Boston: Univ. of Massachusetts Press, 1973), p. xv. HUMANISM OVER MATERIALISM: Oscar Cargill, *Intellectual America: Ideas on the March* (New York: Macmillan, 1941); Arthur Frank Wertheim, *The New York Little Renaissance: Iconoclasm, Modernism, and Nationalism* (New York: New York Univ. Press, 1976); Paul J. Carter, *Waldo Frank* (New York: Twayne Publishers, 1967). "ORGAN AS ITS CENTER": Quoted by Trachtenberg, *Waldo Frank*, p. 6. "WITH EXCOMMUNICATION": Quoted, *Ibid.*, pp. xix–xx.

66–67 "RARE, REAL," FRANK WROTE: Frank to Toomer, Apr. 25, 1922, Box 6: JTC/FU. "NO DOUBT OF THAT": Frank to Toomer, n.d., No. 836: JTC/FU. "IN ONE'S LOINS": Frank to Toomer, July 22, 1926, Box 6: JTC/FU. "MY FRIEND": *Ibid.* "BOND BETWEEN US": Toomer to Frank, Dec. 12, 1922, Box 6: JTC/FU.

67 "DEEPER THAN THE OTHERS": Quoted by Trachtenberg, *Waldo Frank*, p. 107. Moorland to Toomer, July 31, 1922, Oct. 7, 1922; Toomer to Moorland, July 28, 1922, Box 7, Fol. 10: JTC/FU.

67 "THE BOOK IS DONE": Toomer to Frank, Dec. 12, 1922, Box 6: JTC/FU. "IMPRESSIONIST SYMPHONY": Wagner, *Black Poets*, p. 265.

68 "SOUL SOON GONE": Toomer, *Cane*, p. 21.

68 "SENSE OF FADING": Toomer to Frank (fragment), 1922, Box 6: JTC/FU. "SOFTLY SOULS OF SLAVERY": *Cane*, p. 21.

68–69 "WHEN HE GOES DOWN": *Ibid.*, p. 75.

69 "RUSTY WITH TALK": *Ibid.*, p. 20.

69 "AMERICAN CHAOS": Toomer to Frank (fragment), 1922, Box 6: JTC/FU,

69 "KABNIS IS ME": *Ibid.*

69 "THE WATERMELON": Quoted by Alfred Kreymborg et al., eds., *The New American Caravan* (New York: Macaulay, 1929), p. 636.

70 "GATHER PETALS": *Cane*, p. 153. For interpretations of Toomer: Wagner, *Black Poets*, chap. 7; Bone, *Down Home*, chap. 8; Munson, *Destinations*, chap. 12; Turner, *Minor Chord*, chap. 1; S. P. Fullinwider, *The Mind and Mood of Black America: 20th Century Thought* (Homewood, Ill.: The Dorsey Press, 1969), pp. 137–43; Arthur P. Davis, *From the Dark Tower: Afro-American Writers* (Washington, D.C.: Howard Univ. Press, 1974), pp. 44–51; Huggins, *Harlem Renaissance*, pp. 179–87.

70 "IMPORTANT FOR LITERATURE": Quoted in Bontemp's introduction to *Cane*, p. xvi. PROVINCETOWN PLAYERS: Frank to Toomer, 1922, No. 836,

Box 6: JTC/FU; Frank to Toomer, n.d. (1923?), Box 1, Fol. 6: JTC/FU; Matthew Josephson to Toomer, Oct. 12, 2 n.d.'s, 1923, Box 1, Fol 6: JTC/FU. PARIS IN 1926: Robert Coates, *The Eaters of Darkness* (New York: Putnam's, 1959; orig. pub., 1926), pp. 54–55. "DANCE AND MUSIC": Paul Rosenfeld, *Men Seen: Twenty-four Modern Authors* (New York: Dial, 1925), p. 233. For appreciation by Toomer's contemporaries: Malcolm Cowley, *Exile's Return: A Narrative of Ideas* (New York: Norton, 1934), pp. 188–90; Brom Weber, ed., *The Letters of Hart Crane, 1916–1932* (Berkeley: Univ. of California Press, 1965), pp. 149, 150, 162, 185, 195; Munson, *Destinations*, chap. 12: Alfred Kreymborg et al., eds., *The Second American Caravan: A Yearbook of American Literature* (New York: Macaulay, 1928), pp. 170–77.

70–71 HE WROTE LIVERIGHT: Toomer to Liveright, Sept. 5, 1923, Box 1, Fol. 5: JTC/FU. "SUCH A THOUGHT AGAIN": *Ibid.* "LOSE A DIMENSION": Frank to Toomer, 1922, Box 1, Fol. 7: JTC/FU ("For an analogous reason, when the Jews were first liberated from the Ghettos, they produced second rate books and music and pictures"). "DURING RECONSTRUCTION": Toomer to Frank, Apr. 26, 1922: WFC/UP.

71–72 HEMOPHILIAC HEIR: J. G. Bennett, *Gurdjieff: Making a New World* (New York: Harper & Row, 1973), p. 116; Thomas de Hartmann, *Our Life with Mr. Gurdjieff* (New York: Cooper Square Publishers, 1964); P. D. Ouspensky, *In Search of the Miraculous: Fragments of an Unknown Teaching* (New York: Harcourt, Brace, 1945). "EATEN BY THE MOON": Quoted by Ouspensky, *In Search of the Miraculous*, p. 57. EXERCISES AT FONTAINEBLEAU: Emily Hahn, *Mabel: A Biography of Mabel Dodge Luhan* (Boston, Houghton Mifflin, 1977), p. 177.

72 SO MUCH NONSENSE: Gorham Munson to Frank, May 25, 1924: WFC/UP; Toomer to A. R. Orage, Jan. 30, July, Dec. 8, 1924, Jan. 9, 1925, Box 8, Fol. 2: JTC/FU. "THAT IS JUST?": Frank to Toomer, Feb. 18, 1924, Box 6, Fol. 7: JTC/FU. "BE ANALYZED": Margaret Naumberg to Frank, Jan. 4, 1924, Box 6: WFC/UP. "DAY AND NIGHT" ABOUT TOOMER: Naumberg to Toomer, July 31, 1924, Box 7, Fol. 17: JTC/FU.

72–73 COMING TO HEAR HIM: TRI/Aaron Douglas, Richard Bruce Nugent; Langston Hughes, *The Big Sea: An Autobiography* (New York: Hill & Wang, 1975; orig. pub., 1940), pp. 241–43. EDNA ST. VINCENT MILLAY: TRI/Richard Bruce Nugent, Henry Lincoln Johnson. LOST GENERATION PEERAGE: Weber, *Hart Crane*, p. 195.

73–74 STOMPED AND BELLOWED: Mabel Dodge, *Intimate Memories* (New York: Harcourt, Brace, 1936), vol. 3, pp. 79–80. "HAS BECOME MODIFIED": Mabel Dodge Luhan to Toomer, "Sunday," n.d. (1925?), Box 7, Fol. 2: JTC/FU. "PREPARATION FOR IT": Luhan to Toomer, "Wednesday," n.d. (1925?), No. 2329, Box 7, Fol. 2: JTC/FU. "WE LIKE EACH OTHER": Luhan to Toomer, "Sunday," n.d. (1925?), Box 7, Fol. 2: JTC/FU.

74 "SINS OF GOD EITHER": Luhan to Toomer, "Monday," n.d. (1925?), Box 7, Fol. 2: JTC/FU. "NO LONGER INTERESTED": Luhan to Toomer, n.d. (1926?), Box 7, Fol. 2: JTC/FU. HER ESTATE: Luhan to Toomer, "Wednesday," n.d. (1925?), No. 2329, Box 7, Fol. 2: JTC/FU. FOR "THE WORK": Toomer to Luhan, Nov. 26, 1934, No. 2342, Box 7, Fol. 2;

Luhan to Toomer, Jan. 8, n.d. (1926?), Box 7, Fol. 2: JTC/FU ("If you hear anything from Gurdjieff will you wire me?").

74–75 IMPORTANT AMERICAN DISCIPLE: No mention is made of Toomer in the literature of the Gurdjieff movement. Gurdjieff to Luhan, n.d. (1926?), Box 4, Fol. 3; Olga de Hartmann to Toomer, Feb. 11, 1926, Box 4, Fol. 3; de Hartmann to Toomer, Mar. 1927, Box 4, Fol. 3; Orage to Toomer, Jan. 5, 1926, May 5, 1928, Feb. 2, 1929, Box 8, Fol. 2: JTC/FU. "THE KERNEL INDELIBLY": Quoted by Turner, *Minor Chord*, p. 37. "ALL THEIR WRITERS": Hughes, *Big Sea*, p. 242.

75 EARLY POEMS: Wagner, *Black Poets*, p. 287 (footnote 20). "HAVE A COPY?": Kittredge to Hyde E. Rollins, Dec. 1923, Box 5, Fol. Ro-Rz: CCP/ARC. CULLEN FIRST PRIZE: Bynner to Cullen, Nov. 5, 1923, Box 1, Fol. "Bynner": CCP/ARC. OF THE THREE JUDGES: See enthusiastic coverage in *The Messenger*, 6 (Jan. 1924): 5. "BID HIM SING": Cullen, *Color* (New York: Harper & Bros., 1925).

76 SURVIVORS OF THE PERIOD: TRI/Regina Andrews, Ida Mae Cullen, Owen Dodson, Ivy and Pearl Fisher, Gerri Major, Richard Bruce Nugent; Wagner, *Black Poets*, p. 287. "LAY HIM LOW": Cullen, *Color*. "ME NO MORE": *Ibid.* IT WAS MORBID: Hughes to Cullen, Jun. 27, 1924, Box 3, Fol. "Hughes": CCP/ARC. "BOX OF GOLD": Cullen, *Color*.

76–77 "ANYTHING" FOR HIM: TRI/Ida Mae Cullen, Jean Blackwell Hutson; Wagner, *Black Poets*, pp. 284–87. TO BE FOUND: Cullen, *Color*. AND AGAINST GOD: "Fruit of the Flower," quoted by Wagner, *Black Poets*, p. 294.

77 "AND SILVER LUTE": "The Touch," *The Crisis*, 26 (May 1923): 22. On this poem: Wagner, *Black Poets*, pp. 293–301; Turner, *Minor Chord*, chap. 2; Huggins, *Harlem Renaissance*, pp. 205–14. GRAND CENTRAL STATION: Cullen, *Color*. REMEMBERED NOTHING ELSE: *Ibid.* "I CAN DO": Quoted by Du Bois, "Opinion," *The Crisis*, 27 (Nov. 1923): 103.

78 "IN KANSAS": Hughes, *Big Sea*. On Hughes's family and early years: Thurman B. O'Daniel, ed., *Langston Hughes, Black Genius: A Critical Evaluation* (New York: William Morrow, 1971); Wagner, *Black Poets*, pp. 386–89; Bone, *Down Home*, pp. 241–47; Donald C. Dickinson, *A Bio-Bibliography of Langston Hughes*, 2d ed., (Hamden, Conn.: Archon Books, 1972).

78–79 "HATED HIMSELF": Hughes, *Big Sea*, p. 40. "TEN THOUSAND STRANGE BEDS": "Ten Thousand Beds," in Langston Hughes, ed., *The Langston Hughes Reader* (New York: Braziller, 1958), pp. 489–90. "ALGER BOY TRIUMPHED": Hughes, *Big Sea*, p. 16.

79 BE A WRITER: Hughes, *Big Sea*, pp. 33–34. "SPEAKS OF RIVERS": Langston Hughes, ed., *Selected Poems of Langston Hughes* (New York: Vintage Books, 1974; orig. pub., 1959). "FROM FEELING WORSE": Langston Hughes, *I Wonder as I Wander: An Autobiographical Journey* (New York: Hill & Wang, 1964; orig. pub., 1956), p. 3. Hughes, *Big Sea*, pp. 55–56.

80 "LIKE THE RIVERS": Hughes, *Selected Poems*, p. 4.

80 MOTHERABLE YOUNG MAN: Hughes, *Big Sea*, pp. 93–94.

80–81 "DULLEST HUMOR": Hughes to Cullen, n.d. (1923?), Box 3, Fol. "Hughes": CCP/ARC. Hughes, *Big Sea*, p. 32.

81 "LIKE THE POEM": Hughes to Cullen, Mar. 4, 1923: CCP/ARC. "MOTHER TO SON": Ibid. MOSCOW ART PLAYERS: Hughes to Cullen, Mar. 4, 1923, Box 3, Fol. "Hughes": CCP/ARC; Hughes to Locke, Feb. 6, 1923: ALLP/HU. HUGHES IN THE CRISIS: Hughes, *Big Sea*, pp. 92–93. Hughes to Cullen, Mar. 4, 1923, Box 3, Fol. "Hughes": CCP/ARC; Hughes to Locke, Feb. 6, 1923: ALLP/HU.

81–82 "BE FRIENDS WITH": Hughes to Locke, Feb. 6, 1923: ALLP/HU. "ANY OF MY POEMS": Hughes, *Big Sea*, p. 92. "GLIMPSE OF LIFE": Hughes to Locke, Apr. 6, 1923: ALLP/HU. TOLD CULLEN: Hughes to Cullen, Mar. 4, 1923, Box 3, Fol. "Hughes": CCP/ARC. "OFFER THEM TO ME": Hughes to Locke, Feb. 3, Apr. 6, 1923: ALLP/HU. "IN THOSE DAYS": Hughes to Cullen, Mar. 4, 1923: CCP/ARC. Hughes, *Big Sea*, p. 93.

82 "IN NEW YORK": Hughes to Locke, Feb. 6, 1923: ALLP/HU. "TOUCH OF BOOKS": Hughes to Locke, Apr. 6, 1923: ALLP/HU.

82 "NECESSITY NOT YOUR OWN": Hughes, *Big Sea*, p. 98.

82–83 COCONUT TREE GROVES: Hughes to Cullen, July 21, 1923, Box 3, Fol. "Hughes": CCP/ARC. GLISTENING IN THE SUN: Hughes, *Big Sea*, p. 102.

83 "DANCE": *Selected Poems*, p. 1.

83–84 "WE ARE LIARS": Quoted by Wagner, *Black Poets*, p. 398.

84 "THE COLONIAL PROBLEM": Hughes, *Big Sea*, p. 102. "SAIL IN ALWAYS": Quoted by Wagner, *Black Poets*, p. 397 (footnote 28). "YOU WHITE MAN!": Hughes, *Big Sea*, p. 103. "YOU NO BLACK MAN, NEITHER": "Burutu Moon," *The Crisis*, 30, no. 2 (June 1925): 65.

84–85 "DRIVES ME MAD": "Luani of the Jungles," in Nathan 1. Huggins, ed., *Voices from the Harlem Renaissance* (New York: Oxford Univ. Press, 1976): p. 152.

85 IN EARLY FEBRUARY: Hughes to Locke, Feb. 2, 1924: ALLP/HU. "AND KNOW YOU": Hughes to Locke, Feb. 1924: ALLP/HU. "THEY DO NOT!!!": Hughes to Cullen, Mar. 11, 1924, Box 3, Fol. "Hughes": CCP/ARC.

85–86 "GO BACK HOME": Hughes, *Big Sea*, p. 146. "WAS NOT ENOUGH": Ibid., p. 157. CURRENCY SPECULATION: TRI/Rayford Logan; Hughes, *Big Sea*, p. 157. "LIKE THE MISSISSIPPI": Hughes, *Big Sea*, p. 162.

86 "STARTS BEFORE MIDNIGHT": Hughes to Cullen, Mar. 11, July 4, 1924, Box 3, Fol. "Hughes": CCP/ARC.

86–87 "TOGETHER, AT ALL": Hughes, *Big Sea*, p. 166. "THINK ABOUT HER SO MUCH": Ibid., p. 170.

87 FAVORITE ARMCHAIR: TRI/Arthur P. Davis, Mercer Cook, Henry Lincoln Johnson, Jr., Richard Bruce Nugent, Maurice Russell. "TO INCLUDE HIM": Locke to Cullen, n.d. (1923?), Box 3, Fol. Locke: CCP/ARC. "LONGER SO COLD": Hughes to Locke, May 27, 1924: ALLP/HU. "ALAIN LOCKE": Hughes, *Big Sea*, p. 184.

87–88 "AMERICAN ITALIANS LIVED": Hughes, *Big Sea*, p. 189.

88 "LIKE ME": *Selected Poems*, p. 51.

CHAPTER 4: ENTER THE NEW NEGRO

Page

89 APPEARED TOOMER'S CANE: Robert Bone, *The Negro Novel in America*, rev. ed. (New Haven, Conn.: Yale Univ. Press, 1965; orig. pub., 1958); Sterling Brown, *Negro Poetry and Drama and the Negro in American Fiction* (New York: Atheneum, 1969; orig. pub., 1937); J. Saunders Redding, *To Make a Poet Black* (Chapel Hill: Univ. of North Carolina Press, 1939); Vernon Loggins, *The Negro Author: His Development in America* (New York: Columbia Univ. Press, 1931); Hugh M. Gloster, *Negro Voices in American Fiction* (New York: Russell & Russell, 1965); Robert T. Kerlin, ed., *Negro Poets and Their Poems* (Washington, D.C.: Associate Publishers, 1935).

90 "YOUR NEXT BOOK": Charles S. Johnson to Toomer, Mar. 6, 1924, No. 1352, Box 4, Fol. 11: JTC/FU. On the Civic Club: TRI/Rayford Logan, Richard Bruce Nugent, Arthur Huff Fauset. Mary White Ovington, *The Walls Came Tumbling Down* (New York: Harcourt, Brace, 1947), pp. 193–95.

90 "ONLY TO BEAUTY": Quoted by Arna Bontemps, ed., *The Harlem Renaissance Remembered: Essays Edited with a Memoir* (New York: Dodd, Mead, 1972), p. 9. "The Debut of the Younger School of Negro Writers," *Opportunity*, 2, no. 17 (May 1924): 143–46.

90–91 "THINGS" IN AMERICA: Harold Stearns, *America and the Young Intellectuals* (New York: Doran, 1921), pp. 11–12. "SUBSTANTIAL BEGINNING": Quoted by William Leuchtenburg, *The Perils of Prosperity, 1914–1932* (Chicago: Univ. of Chicago Press, 1958), p. 147. "BEING OVEREDUCATED": Malcolm Cowley, *Exile's Return: A Narrative of Ideas* (New York: Norton, 1934), p. 230. On white expectations of the "New Negro": Van Wyck Brooks, *The Confident Years, 1885–1915* (New York: Dutton, 1952); Frederick J. Hoffman, *Freudianism and the Literary Mind* (Baton Rouge: Louisiana State Univ. Press, 1945); George M. Frederickson, *The Black Image in the White Mind: The Debate on Afro-American Character and Destiny* (New York: Harper & Row, 1971); Kerlin, *Negro Poets*; Gorham Munson, *Destinations: A Canvass of American Literature Since 1900* (New York: AMS Press, 1970; orig. pub., 1928), chap. 12.

91–92 THEATRE MAGAZINE WROTE: Edith Isaacs, *The Negro in the American Theatre* (New York: Theatre Arts, 1947), p. 56. INCLINED TO AGREE: Marie Seton, *Paul Robeson* (London: Dennis Dobson, 1958), p. 24.

92 "BACK OF A CROCODILE": George Schuyler, "Black Genesis," *The Modern Quarterly*, 5 (Spring 1929): 571–72. "THE HIGHER LINES": Brawley to J. W. Johnson, May 9, 1922, Ser. 1, Fol. 57: JWJMC/YU.

92–93 "GROUP OF NEGROES": Quoted by Patrick J. Gilpin, "Charles S. Johnson: Entrepreneur of the Harlem Renaissance," in *Harlem Renaissance Remembered*, chap. 11, p. 224. AFRO-AMERICAN LETTERS: "The Debut of the Younger School of Negro Writers," *Opportunity*, 2, no. 17 (May 1924): 143–44. "YOUNGER GROUP": *Ibid.*

93–94 "KNOW WHAT AMERICANS ARE": *Ibid.*, p. 145.

94 "SONGS OF BIRTH": *Ibid.*, pp. 143–44.

94–95 "STARTED INTO MY OFFICE": Quoted by Bontemps, "The Awakening: A Memoir," in *Harlem Renaissance Remembered*, p. 11.

95 JONES'S EDITORIAL PROPOSED: " 'Cooperation' and 'Opportunity,' " *Opportunity*, 1, no. 1 (Jan. 1923): 5. RURAL AND URBAN DEMOGRAPHY: Alain Locke, "The Black Watch on the Rhine," *Opportunity*, 1, no. 13 (Jan. 1924): 6–9; Monroe N. Work, "Taking Stock of the Race Problem," *Opportunity*, 2, no. 14 (Feb. 1924): 41–46; E. Franklin Frazier, "A Note on Negro Education," *Opportunity*, 2, no. 15 (Mar. 1924): 75–77); Joseph A. Hill, "The Recent Northward Migration of the Negro," *Opportunity*, 2, no. 16 (Apr. 1924): 100–105; Horace M. Bond, "What the Army 'Intelligence' Tests Measured," *Opportunity*, 2, no. 19 (July 1924): 197–202; Melville Herskovits, "Preliminary Observations in a Study of Negro-White Crossing," *Opportunity*, 3, no. 27 (Mar. 1925): 69–74; Guichord Parris and Lester Brooks, *Blacks in the City: A History of the National Urban League* (Boston: Little, Brown, 1971), pp. 159–60, 171–75.

95 "I SEE THEIR FUTURE": Locke, "Max Rheinhardt [sic] Reads the Negro's Dramatic Horoscope," *Opportunity*, 2, no. 17 (May 1924): 145.

96 "TICKET FOR NEW YORK CITY": Bontemps, "The Awakening," p. 15. "I WANT TO DO THAT": Hurston to Pickens, n.d.: WPRG/SCRBC. "FILLED WITH HOPE": Quoted by Robert Hemenway, *Zora Neale Hurston: A Literary Biography* (Urbana: Univ. of Illinois Press, 1977), p. 9.

96–97 AFRO-AMERICAN DISCIPLE: Ethel Ray Nance transcript, Fisk Oral History Program: Fisk University, pp. 25–26; TRI/Aaron Douglas.

97 "PROPAGANDA AND PROTEST": "An Opportunity for Negro Writers," *Opportunity*, 2, no. 21 (Sept. 1924): 258.

97–98 CRISIS LITERARY COMPETITION: "The Amy Spingarn Literary Prizes," *The Crisis*, 28 (Sept. 1924): 199. "YOUR OFFER WAS MADE": Du Bois to J. Spingarn, Sept. 16, 1924, Box 1, Fol. 10 (Small Collections): JWJMC/YU. Charles F. Cooney, "Forgotten Philanthropy: The Amy Spingarn Prizes" (unpub. monograph courtesy the author), pp. 1–25. THROUGH THE ARTS: Quoted by Gilpin, "Johnson," p. 238.

98–99 "TOO IN TIME": Van Vechten to Mencken, May 29, 1925: HLMC/NYPL.

99 "PERHAPS WOULD BE": Anderson to Mencken, June 25, 1922: HLMC/NYPL.

99 PROFESSIONAL SELF-INTEREST: Hughes to Locke, n.d.: ALLP/HU.

99–100 "USE WHAT I HAD": Ovington to J. Spingarn, Oct. 13, n.d. (1918 or 1919): JSC/NYPL.

100–101 MANY TIMES REPEATED: B. Joyce Ross, *J. E. Spingarn and the Rise of the NAACP* (New York: Atheneum, 1972), pp. 116–17; Nancy J. Weiss, *The National Urban League, 1910–1940* (New York: Oxford Univ. Press, 1974), pp. 53–54. MOTHER WAS JEWISH: Hasia Diner, "In the Almost Promised Land: Jewish Leaders and Blacks, 1915–1935" (Univ. of Illinois Ph.D. diss., 1975; published by Greenwood Press [Westport, Conn., 1977] under same title), p. 76. COLLABORATION WAS CONSID-

ERABLE: *Ibid.*, pp. 150–53; Steven Bloom, "Interaction Between Blacks and Jews in New York City, 1900–1930, As Reflected in the Black Press" (New York Univ. Ph.D. diss., 1973).

101 "FIVE PERCENT ABILITY": Quoted by Edwin P. Embree and Julia Waxman, *Investment in People: The Story of Julius Rosenwald* (New York: Harper & Bros., 1949), p. 11. Alfred Q. Jarrette, *Julius Rosenwald: Son of a Jewish Immigrant* (Greenville, S.C.: Southeastern Univ. Press, 1975). OVERSIGHT . . . AS WELL: Diner, "Almost Promised Land," p. 170; Jarrette, *Rosenwald*, p. 21. AFRO-AMERICANS IN THE SOUTH: Embree, *Investment in People*, pp. 31–33.

101–2 ATLANTA VENTURE: Robert H. Rutherford, "What I Think of the Standard Life Episode," *The Messenger*, 7, no. 2 (Mar. 1925): 121–22, 142; "Standard Life Insurance Co. Taken Over by Whites," *Chicago Defender*, Jan. 4, 1925, p. 1. ABRAHAM LINCOLN: Jarrette, *Rosenwald*, p. 10. "OTHER PERSECUTED PEOPLES": Embree, *Investment in People*, p. 25. "IN SLAVERY": Quoted by Bloom, "Interaction Between Blacks and Jews," p. 35.

102–3 THE AFRO-AMERICAN: *Ibid.*, p. 28. "THE NEGRO PROBLEM": Quoted by Diner, "Almost Promised Land," p. 51. MURDER-RAPE: Bloom, "Interaction Between Blacks and Jews," pp. 28, 30, 32–33; Leonard Dinnerstein, *The Leo Frank Case* (New York: Columbia Univ. Press, 1968); Harry Golden, *A Little Girl Is Dead* (New York: World Publishing, 1965).

103 TO AFRO-AMERICANS: John Higham, *Strangers in the Land: Patterns of American Nativism* (New York: Atheneum, 1963); E. Digby Baltzell, *The Protestant Establishment: Aristocracy and Caste in America* (New York: Random House, 1964); David M. Chalmers, *Hooded Americanism: The First Century of the Ku Klux Klan* (Garden City, N.Y.: Doubleday, 1968); Leonard Dinnerstein, *Antisemitism in the United States* (New York: Holt, Rinehart & Winston, 1971); Robert G. Weisbord and Arthur Stein, *Bittersweet Encounter: The Afro-American and the American Jew* (Westport, Conn.: Negro Universities Press, 1970). "EVEN ON THE BENCH": Quoted by Diner, "Almost Promised Land," p. 200. "ALSO SERVES JUDAISM": *Ibid.*, p. 199. "AND LARGE MONEY": Quoted by Bloom, "Interaction Between Blacks and Jews," p. 82.

103–4 "THE BROAD AVENUES": Arna Bontemps, "Harlem the Beautiful," *Negro Digest*, 15, no. 3 (Jan. 1965): 62. "MILLER AND LYLES": Arthur P. Davis, "Harlem During the New Negro Renaissance," *The Oracle* (Summer 1971): p. 4. "BE ALIVE THEN": TRI/Arthur P. Davis.

104 STAFF LECTURER: Louise Bryan, "Brief History of the Life and Work of Hubert Harrison," Reel No. 1: FWP/SCRBC, p. 2; Roi Ottley and William J. Weatherby, eds., *The Negro in New York: An Informal Social History* (New York: Praeger, 1967), p. 223.

104–5 "NOTHING HAD HAPPENED": Quoted by Seton, *Robeson*, p. 23.

105–6 ETHEL WATERS: Richard Bruce Nugent, "On Arthur (Happy) Rhone," Reel No. 1: FWP/SCRBC; TRI/Edith Wilson. On early Harlem cultural life: George S. Schuyler, *Black and Conservative: The Autobiography of George S. Schuyler* (New Rochelle, N.Y.: Arlington House, 1966); Maxwell Bodenheim, *Naked on Roller Skates* (New York: Liveright, 1931). "THE JUNGLE" OF 133RD STREET: Willie "the Lion" Smith

(with George Hoefer), *Music on My Mind: The Memoirs of an American Pianist* (Garden City, N.Y.: Doubleday, 1964), pp. 157–58; Charles G. Shaw, *Night Life: Vanity Fair's Intimate Guide to New York After Dark* (New York: John Day, 1931), pp. 74–76. "LYBIA AT NIGHT": Rudolph Fisher, "The Caucasian Storms Harlem," *American Mercury*, Aug. 1927, p. 393. Smith, *Music on My Mind*, p. 90.

106–7 "WELL-PRINTED PROGRAM": "Fashion Show," *The Messenger*, 6, no. 6 (June 1924): 198.

107 "PLAYED IN THEIR HOMES": Smith, *Music on My Mind*, p. 101. ARTHUR DAVIS: Davis, "New Negro Renaissance," p. 7. Langston Hughes, *The Big Sea: An Autobiography* (New York: Hill & Wang, 1975; orig. pub., 1940), p. 231.

107–8 "GET ACQUAINTED": Smith, *Music on My Mind*, p. 156. AFTER-HOURS VOLUME: *Ibid.*, p. 154. "THE SAME PLACE": Wallace Thurman, *The Blacker the Berry . . .* (New York: Collier Books, 1970; orig. pub., 1929). pp. 149–51.

108 INCOME OF $1,570: "Twenty-four Hundred Negro Families in Harlem: An Interpretation of Living Conditions of Small Wage Earners" (New York: Urban League, 1927), p. 23. "THESE APARTMENTS": Quoted by Gilbert Osofsky, *Harlem: The Making of a Ghetto* (New York: Harper & Row, 1966), p. 135. "AS A SLUM": *Ibid.*

109 "SMALL-WAGE EARNERS" STATED: "Twenty-four Hundred Negro Families," p. 14. LIQUIDATION OVER INTEGRATION: Osofsky, *Harlem*, p. 121.

109– "DESIGNED HERSELF": Odette Harper, "Sketch of Pig Foot Mary," Reel
10 No. 1: FWP/SCRBC, p. 2. $375,000: *Ibid.*, p. 3. "DAMN QUICK": *Ibid.*

110– VERSAILLES PEACE CONFERENCE: Stephen R. Fox, *The Guardian of Bos-*
11 *ton: William Monroe Trotter* (New York: Atheneum, 1971), p. 223; Tony Martin, "The Emancipation of a Race, Being an Account of the Career and Ideas of Marcus Mosiah Garvey" (Michigan State Univ. Ph.D. diss., 1973; published by Greenwood Press [Westport, Conn, 1976] as *Race First: The Ideological & Organizational Struggles of Marcus Garvey and the Universal Negro Improvement Association*), p. 18. PROFITS TO CHARITY: "Madame C. J. Walker Beauty Culturist Dies," *Chicago Defender*, May 31, 1919, p. 1; George Schuyler, "Madame C. J. Walker," *The Messenger*, 6, no. 6 (July, 1924): 251, 254–58; TRI/ A'Lelia Ransom Nelson.

111– 139TH AND 140TH STREETS: John Peer Nugent, *The Black Eagle* (New
12 York: Bantam, 1972), p. 19.

112 GREENLAND, AND CANADA: *Ibid.*, p. 27. POSTAL OFFICIAL APPEARED: Quoted by Morris Markey, "The Black Eagle," *The New Yorker*, July 11, 1931, p. 25. "A SCHEDULED STOP": Quoted by Nugent, *Black Eagle*, p. 35.

112– THE PROFESSIONALS: Pollard, "Harlem As Is: Sociological Notes on Har-
13 lem Social Life" (The College of the City of New York B.B.A. diss., 1936), p. 1.

113 "SPIRIT OF NEW YORK": "Harlem: The Cultural Capital," *The New Negro*, ed. Alain Locke: Atheneum, 1974; orig. pub., 1925), pp. 309–10.

113 "DIFFERENT SHADE": Melville Herskovits, *ibid.*, p. 353.

114 "O BLUES!": Langston Hughes, ed., *Selected Poems* (New York: Vintage Books, 1974; orig. pub., 1959), pp. 33–34.

114 "CONTRACT FOR IT FIRST": Van Vechten to Alfred Knopf, May 5, 1925 (correspondence courtesy of Alfred A. Knopf).

114– "MERIT OF HIS WORK": Quoted by Stephen H. Bronz, *Roots of Negro*
15 *Racial Consciousness: The 1920's* (New York: Libra Publishers, 1964), p. 14. "USUALLY BRING OUT": Quotes about the *Opportunity* banquet from "Comments on the Negro Actor," *The Messenger*, 7, no. 1 (Jan. 1925): 20; Editorial, *Opportunity*, 3, no. 29 (May 1925): 130–31; "Casper Holstein," *Opportunity*, 3, no. 31 (July 1925): 220. "THE FUTURE": Quoted by Gilpin, "Johnson," p. 231. Charles S. Johnson, "The Negro Renaissance and Its Significance," in Rayford W. Logan, Eugene C. Holmes, G. Franklin Edwards, eds., *The New Negro Thirty Years Afterward: Papers Contributed to the Sixteenth Annual Spring Conference of the Division of Social Work, Howard University* (Washington, D.C.: Howard Univ. Press, 1955), pp. 80–88.

115– "THE NEW NEGRO": Paul Kellogg to William E. Harmon, Nov. 20, 1925,
16 Box 1: HFR/LC. ("We sold 42,000 of our Harlem number, which ran into two editions. . . .") "NEW CZECHOSLOVAKIA": Alain Locke, "Harlem," *The Survey Graphic*, 6, no. 6 (Mar. 1925): 630. "RACE GROUPS": Alain Locke, "Enter the New Negro," *The Survey Graphic*, 6, no. 6 (Mar. 1925): 632. "WERE DESIRABLE": *Ibid.*, p. 633.

116– "A NEGRO RENAISSANCE": "A Negro Renaissance," New York *Herald*
17 *Tribune*, May 7, 1925. "SILKEN GOLD": "Jazzonia," *The Survey Graphic*, 6, no. 6 (Mar. 1925), p. 712. DOUANIER ROUSSEAU: Countee Cullen, *Color* (New York: Arno Press, 1969; orig. pub., 1925), pp. 36–37.

117 "PAST AND PROSPECTIVE": Locke, *New Negro*, p. 15. "LACQUERED DILL PICKLE": George Schuyler, "Shafts and Darts," *The Messenger*, 6, no. 6 (June 1924): 183.

117– "TWENTIETH CENTURY CIVILIZATION": Locke, *New Negro*, p. 14. "CLEAR
18 ENOUGH": Locke, "Harlem," p. 629. "THE NEW NEGROES": Quoted by Robert Hayden in Locke (preface), *New Negro*, p. xi.

118 "WE MARCH!": Langston Hughes, *New Negro*, p. 142.

CHAPTER 5: THE SIX

Page

119 "UNCOMMON IN HARLEM": Langston Hughes, *The Big Sea: An Autobiography* (New York: Hill & Wang, 1975; orig. pub., 1940), p. 227.

119– "DILAPIDATED SLUM PROPERTY": Reprinted in *Opportunity*, 4, no. 40
20 (Apr. 1926): 113. "THE COMMON EXPERIENCE": S. P. Fullinwider, *The Mind and Mood of Black America: 20th Century Thought* (Homewood, Ill.: The Dorsey Press, 1969), pp. 119–22. Arthur Frank Wertheim, *The New York Little Renaissance: Iconoclasm, Modernism, and Nationalism in American Culture* (New York: New York Univ. Press, 1976), chap. 1; Van Wyck Brooks, *The Confident Years: 1885–1915* (New York: Dutton, 1952).

120 AFRO-AMERICAN ARTS AND LETTERS: J. Spingarn to George Edmund Haynes, Oct. 21, 1926: HFR/LC.

120– "NEGRO LITERATURE INTO BEING": Hughes, *Big Sea*, p. 218. David Lever-
21 ing Lewis, "The Politics of Art: The New Negro, 1920–1935," *Prospects: An Annual of American Cultural Studies*, 3 (1977): 237–61.

121 TO BE SURE: TRI/Arthur Huff Fauset, Mae Miller Sullivan; Carolyn Wedin Sylvander, "Jessie Redmon Fauset: Black American Writer: Her Relationships, Biographical and Literary, with Black and White Writers, 1910–1935" (Univ. of Wisconsin Ph.D. diss., 1976), pp. 71–73. AWARDED HER IN 1919: Sylvander, "Fauset," p. 72; J. Fauset to Arthur Spingarn, Feb. 28, 1926, Box 3: ASP/HU ("I should like to be a publisher's reader [if remunerative enough]).

121– DU BOIS HIMSELF: TRI/Mae Miller Sullivan, Arthur P. Davis, Rayford
22 Logan.

122 "I WERE DEAD": Reproduced by Langston Hughes and Arna Bontemps, eds., *The Poetry of the Negro, 1746–1970* (Garden City, N.Y.: Doubleday, 1970; orig. pub., 1949), p. 67.

122 ANOTHER KEY ASSISTANT: Sylvander, "Fauset," pp. 165–71; TRI/Arthur Huff Fauset. "AND WITHOUT PROPAGANDA": J. Fauset to Arthur Spingarn, Jan. 20, 1923, Box 3: ASP/HU. IN FOREIGN LANGUAGES: J. Fauset to Toomer, Feb. 17, Feb. 24, Aug. 22, 1922, Box 3, Fol. 2: JTC/FU.

122– "CONSIDERED RESPECTABLE AGAIN": J. Fauset to J. Spingarn, Jan. 25,
23 1922: JSC/NYPL.

123 "TRY TO DO SO": Quoted by Marion L. Starkey, "Jessie Fauset," *Southern Workman*, 61, no. 5 (May 1932): 217–20, pp. 218–19. Hiroko Sato, "Under the Harlem Shadow: A Study of Jessie Fauset and Nella Larsen," in *The Harlem Renaissance Remembered: Essays Edited with a Memoir*, ed. Arna Bontemps (New York: Dodd, Mead, 1972); Sylvander, "Fauset," p. 108.

123– "ASPIRATIONS OF THE RACE": *The Messenger*, 6 (May 1924): 145–46,
24 p. 146. REALLY EXISTED: Quoted by Sylvander, "Fauset," p. 110. "NEGROES TO BE LIKE THIS": *Ibid.*, p. 112.

124– "FREE FROM FETTERS": J. Fauset to Arthur Spingarn, Feb. 10, 1925, Box
25 3: ASP/HU.

125 "ANYONE ELSE IN AMERICA": Hughes, *Big Sea*, p. 218. "TO MANY OTHERS," SHE WROTE: Zora Neale Hurston, *Dust Tracks on a Road: An Autobiography* (Philadelphia: Lippincott, 1971; orig. pub., 1942), p. 168. "SET OUT TO EXPLOIT IT": "Arna Bontemps Talks About the Harlem Renaissance," in "The Harlem Renaissance Generation: An Anthology," 2 vols., comp. and ed. L. M. Collins (unpub. manuscript, 1972, Fisk Univ. Library), 1: 207–19, p. 216. Patrick J. Gilpin, "Charles S. Johnson: Entrepreneur of the Harlem Renaissance," in *Harlem Renaissance Remembered*; David Levering Lewis, "Dr. Johnson's Friends: Civil Rights by Copyright," *The Massachusetts Review*, 20, no. 3 (Autumn 1979): 501–19. "DIDN'T MOLD ANYTHING": "Aaron Douglas Chats About the Harlem Renaissance," in "The Harlem Renaissance Generation," 1: 180–203, pp.

181–82, 184. NEW ARTISTIC FERMENT: Charles S. Johnson to Arthur Schomburg, Apr. 21, 1937, Reel No. 2, Box 3: AASP/SCRBC.

125– JOHNSON'S GO-BETWEEN, WROTE SCHOMBURG: Eric Walrond to Schom-
26 burg, Nov. 3, 1924, Reel No. 4: AASP/SCRBC. Eileen Des Verney Sin-
nette, "Arthur Alfonso Schomburg, Black Bibliophile and Curator"
(Columbia Univ. Ph.D. diss., 1977), p. 111. IN FOUNDATION MATTERS: For
example: Schomburg to C. S. Johnson, 1935, Reel No. 5; Jan. 24, 1934,
Reel No. 2: AASP/SCRBC. Sinnette, "Schomburg," p. 102.

126 "AND RICHARD BRUCE NUGENT": G. Dismond, "Social Snapshots," *The
Inter-State Tattler*, Feb. 10, 1928, p. 4. TRI/Gerri (Geraldyn Dismond)
Major.

126 "HAD A BALL": Hughes, *Big Sea*, p. 247.

126 "ON A BOARD": Ethel Ray Nance transcript, Fisk University Oral History
Program, p. 43.

126– "I SALUTE YOU": Johnson to Angelina Grimké, Jan. 6, 1925, Box 3: An-
27 gelina Weld Grimké Papers, Moorland-Spingarn Research Center, How-
ard University. TO ANGELA GRIMKE: H. G. Wells to Grimké, Jan. 6, 1925,
Box 3: Angelina Weld Grimké Papers. Abby and Ronald Johnson, "For-
gotten Pages: Black Literary Magazines in the 1920's," *American Studies*,
8, no. 31: 363–82. TRI/Henry Lincoln Johnson, Jr., Mae Miller Sullivan,
Richard Bruce Nugent.

127– "580 ST. NICHOLAS AVENUE": Nance transcript, p. 28. "HE WAS SO IM-
28 PRESSED": *Ibid.*, p. 17.

128 UNDER PRIVATE TUTORS: Robert Bone, *Down Home: A History of Afro-
American Short Fiction* (New York: Putnam's, 1975), chap. 7; Nance
transcript, p. 14.

128– INNOVATIVE ANTHROPOLOGIST: Hughes, *Big Sea*, p. 239; Nance transcript,
29 p. 26. "SHE WAS OFF": Nance transcript, p. 40. Robert E. Hemenway, *Zora
Neale Hurston: A Literary Biography* (Urbana: Univ. of Illinois Press,
1977), chap. 1. IMITATION OF LIFE: Hemenway, *Hurston*, p. 24.

129– "THE NUMBERS GAME THERE": Nance transcript, p. 16. "FARM LAND IN
30 VIRGINIA": J. Saunders Redding, "Playing the Numbers," *North American
Review*, 238 (Dec. 1934): 533–42, p. 534; Sadie Hall, "Caspar [*sic*]
Holstein," Reel No. 1: FWP/SCRBC; Claude McKay, *Harlem: Negro
Metropolis* (New York: Harcourt, Brace & World, 1968; orig. pub., 1940),
pp. 114–16.

130 OCTOBER 1925 ISSUE: "The Virgin Islands," *Opportunity*, 3, no. 34 (Oct.
1925): 304–6. See also, Holstein, "American Role in the Virgin Islands
[Letter to editor]," *The Nation*, 115 (Aug. 23, 1922): 189.

130– "THE HARLEM NIGHT CLUBS": Edwin Embree, *Thirteen Against the Odds*
31 (New York: Viking, 1944), p. 68.

131 "IN POVERTY AND IGNORANCE": *A Man Called White: The Autobiography
of Walter White* (Bloomington: Indiana Univ. Press, 1970; orig. pub.,
1948), p. 11. Embree, *Thirteen Against the Odds*; Edward E. Waldron,
Walter White and the Harlem Renaissance (Port Washington, N.Y.:

Kennikat Press, 1978), chap. 1. TRI/Corinne (Mrs. Louis T.) Wright, George Schuyler.

131– PLANS FOR THE TRIP: White, *A Man Called White*, pp. 54–55. "CREATE
32 A SENSATION": Quoted, *ibid.*, 65. Charles F. Cooney, "Walter White and the Harlem Renaissance," *The Journal of Negro History*, 57, no. 3 (July 1972): 231–40, p. 231.

132– "LIKE A VERITABLE FLOOD": White to McKay, Aug. 15, 1924 (C-91):
33 WWC/LC. "PROBLEM WILL BE SOLVED": Walter White, *The Fire in the Flint* (Westport, Conn.: Negro Universities Press, 1969; orig. pub., 1924), p. 47.

133 IN TWELVE DAYS: White to McKay, Aug. 15, 1924 (C-91): WWC/LC;
White, *A Man Called White*, p. 66.

133– "BAD MATTERS WORSE": Saxton to White, July 23, 1923 (C-90): WWC/
34 LC. White to Saxton, Aug. 23, 1923 (C-90): WWC/LC; White, *A Man Called White*, pp. 66–67. "THAT HORRIBLE BOOK": Irwin Cobb interview in Savannah, Ga., newspaper (June 24, 1925), C-92: WWC/LC. *A Man Called White*, p. 67. "SETTING IT FORTH": Saxton to White, Aug. 16, 1923 (C-90): WWC/LC.

134 A MAN CALLED WHITE: White, *A Man Called White*, p. 67. Charles F. Cooney, "Mencken's Midwifery," *Menckeniana: A Quarterly Review*, no. 43 (Fall 1972): 1–4.

134 "NEVER BEEN ADEQUATELY GIVEN": White to Saxton, Aug. 19, 1923 (C-90): WWC/LC.

134– PUBLICATION MIGHT STILL BE POSSIBLE: Saxton to White, Aug. 21, 1923
35 (C-90): WWC/LC. "DECIDES TO PUBLISH IT": Will Alexander to White, Oct. 1, 1923; White to Arthur Spingarn, Aug. 22, 1923; Saxton to White, Aug. 30, 1923 (C-90): WWC/LC. "TRUE TO LIFE": White to Saxton, Aug. 23 (C-90): WWC/LC. DORAN REFUSED PUBLICATION: Saxton to White, Oct. 28, 1923 (C-90): WWC/LC.

135 "AS YOU ENCOUNTERED WITH DORAN": Mencken to White, Oct .16, 1923 (C-90): WWC/LC. "NIGGER IN HIS PLACE": White to Mencken, Oct. 17, 1923 (C-90): WWC/LC.

135– CONCENTRATED PASSION OF THE WORK: Carl Van Doren to White, Jan.
36 10, 1924 (C-90); T. S. Stribling to White, Sept. 8, 1924 (C-91); Mencken to White, Oct. 16, 1923; Blanche Knopf to White, Dec. 18, 1923 (C-90): WWC/LC. HIGHLY SUCCESSFUL: Mencken to White, Dec. 24, 1923 (C-90): WWC/LC. "PROFESSIONAL CONFEDERATES": White to Mencken, Oct. 16, 1924 (C-91): WWC/LC. "WAS DRIVING AT": White to Van Vechten, Aug. 7, 1924 (C-91): WWC/LC. CRUSTY BALTIMORE EDITOR: White to Mencken, Aug. 30, 1924 (C-91): WWC/ LC.

136 "FELT RATHER ANEMIC": Charles F. Cooney, "Walter White and Sinclair Lewis: The Story of a Literary Friendship," *Prospects: An Annual of American Cultural Studies*, 1 (1975): 63–79. White to J. Spingarn, Oct. 22, 1924; Sinclair Lewis to White, Nov. 12, 1924 (C-91): WWC/LC. "FOR SOME MUSIC": White to Van Doren, Jan. 13, 1925 (C-92): WWC/ LC. "YOUR PRESENCE": White to Hayes, Jan. 5, 1925 (C-92): WWC/

LC. AUTHOR OF NIGGER: Wood to White, Feb. 23, 1923 (C-90): WWC/LC.

136– "SUNLIT GLOWING PARK": Van Vechten to White, May 3, 1925 (C-92):
37 WWC/LC.

137 READING ALL THE OFFICE MAIL: Richetta Randolph to J. W. Johnson, Jan. 19, 1931, Ser. 1, Fol. 386: JWJMC/YU. TO THE GREEN PASTURES: Embree to White, May 19, 1930 (C-98): WWC/LC. "NEXT MONDAY NIGHT": White to Blanche Knopf, Sept. 30, 1926 (C-95): WWC/LC. DIXIE TO BROADWAY: White to Mills, Dec. 8, 1924 (C-92): WWC/LC. "MY LINDY LOU": White to Hayes, June 13, 1924 (C-91): WWC/LC.

137– OF THE INSTITUTION: White to John D. Rockefeller, Sr., Feb. 3, 1925
38 (C-92): WWC/LC. "OVER THE COUNTRY": White to Nathan, Oct. 27, 1924 (C-91): WWC/LC. "MONEY FOR COPIES" OF COLOR: White to Cullen, Jan 4, 1925 (C-92): WWC/LC. ON HIS ADVICE: White to Jim Tully, May 7, 1926 (C-94): WWC/LC.

138 "WHITE RACE, TOO": Hayes to White, May 31, 1924 (C-91): WWC/LC. "MRS. WHITE HAVE GIVEN": Bledsoe to White, 1925 (C-92): WWC/LC. "TO SEE WHAT I CAN DO": Chesnutt to White, Dec. 28, 1926 (C-94): WWC/LC.

138– EXCELLENT IDEA: J. W. Johnson to White, 1923 (C-90): WWC/LC.
39 "WISH YOU WERE A HEN": Locke to White, Mar. 10, 1923 (C-90): WWC/LC.

139 "REVOLUTIONIZE CONDITIONS IN THE UNITED STATES": White to William S. Nelson, Jan. 15, 1924 (C-91): WWC/LC.

139 "YOUR ATLANTIC MONTHLY STORY": White to Fisher, Feb. 6, Mar. 12, 1925 (C-92): WWC/LC. Charles F. Cooney, "Walter White and the Harlem Renaissance," *Journal of Negro History*, 57, no. 3 (July 1972): 231–40.

140 LARSEN'S MANUSCRIPT: *Ibid.*, p. 238; White to Sol Hurok, May 26, 1929 (C-92): WWC/LC; Waldron, *Walter White*, chap. 5. TWO YEARS OF EUROPEAN STUDY: White to McKay, Jan. 26, 1924 (C-91): WWC/LC. White to George E. Haynes, Sept. 17, 1928, Box 43: HFR/LC. White to Otto Kahn, July 18, 1927 (C-95): WWC/LC.

140 MCKAY SHOULD DO THE SAME: Louise Bryant Bullitt to McKay, Sept. 27, 1926, Dec. 2, 1927 (McKay uncat. corr.): JWJMC/YU. Claude McKay, *A Long Way from Home* (New York: Harcourt Brace & World, 1970; orig. pub., 1937), p. 254. "DISTINCTLY SECOND-RATE": White to Hughes, Dec. 18, 1925 (C-92): WWC/LC.

140– "WHATEVER I CAN" FOR MCKAY: Lewis to White, Oct. 15; White to
41 Lewis, Oct. 15, 1924 (C-91): WWC/LC. "A SON-OF-A-BITCH": McKay to White, Dec. 4, 1924 (C-91): WWC/LC. "SCRAP THE WHOLE THING": Grace Hegger Lewis, *With Love From Gracie* (New York: Harcourt, Brace, 1955), p. 291.

141 HARLEM'S BIBLIOPHILE: McKay to Schomburg, 1925; Aug. 1, 1926, Reel No. 3: AASP/SCRBC. MCKAY RECOUNTED: McKay, *Long Way from Home*, p. 257. PAUSING TO READ IT: McKay to Schomburg, Apr. 28, 1925, Reel No. 3: AASP/SCRBC.

141– OPPENHEIM AND HAROLD GUINZBURG: White to Viking, May 22, 1925
 42 (C-92): WWC/LC. "WILL NOT SHOCK HIM": McKay to Schomburg,
 1925, Reel No. 3: AASP/SCRBC. McKay to White, June 5: White to
 McKay, July 8, 1925 (C-92): WWC/LC. "CONTRARY TO THE AIMS OF
 THE NAACP": McKay to Schomburg, July 17, 1925, Reel No. 3: AASP/
 SCRBC. VAN VECHTEN'S BOOK ON HARLEM: McKay to Schomburg, Aug. 3,
 1925, Reel No. 3: AASP/SCRBC: McKay to White, Aug. 8, Sept. 25;
 White to McKay, Aug. 18, 1925 (C-92): WWC/LC. AND WORRIES:
 McKay to White, Nov. 25, 1925 (C-92): WWC/LC.

142 POSSIBILITIES AS A MUSICAL: O'Neill to White, Oct. 12, Oct. 24, 1924
 (C-90); White to O'Neill, Oct. 28, 1924 (C-90): WWC/LC. "FEELING
 OF TRUTH": Maugham to White, Jan. 1, 1927 (C-95); Lewis to J. Spin-
 garn, Sept. 6, 1924 (C-91): WWC/LC.

142– LIFE INTO THE CHARACTERS: White to Spingarn, Sept. 9, 1925 (C-91):
 43 WWC/LC. Lewis to Blanche Knopf, Oct. 6, 1925 (C-91): WWC/LC
 (But Lewis declined "to do a blurb" for the book because the public
 would "believe that this was entirely a matter of friendship, which would
 be of advantage to neither him nor me"). "CAN EASILY BE MISUNDER-
 STOOD": C. S. Johnson to White, Aug. 5, July 22; White to C. Johnson,
 July 28, 1926 (C-94): WWC/LC. Frank Horne, "Our Book Shelf,"
 Opportunity, 3, no. 4 (July 1926): 227; Nella Larsen Imes, Correspon-
 dence, *Opportunity*, 4, no. 46 (Oct. 1926): 326; Wallace Thurman, "A
 Thrust at Eve with an Atavistic Wound," *The Messenger*, 8, no. 5 (May
 1926): 154; Waldron, *White*, pp. 100–107.

143 AFRO-AMERICA'S SENIOR STATESMAN: Eugene Levy, *James Weldon John-
 son: Black Leader, Black Voice* (Chicago: Univ. of Chicago Press, 1973),
 chap. 12; Mary White Ovington, *The Walls Came Tumbling Down* (New
 York: Harcourt, Brace, 1947).

143– AS DID WALTER WHITE: James Weldon Johnson, *Along This Way: The
 44 Autobiography of James Weldon Johnson* (New York: Viking, 1961: orig.
 pub., 1933), p. 9. Edwin Embree, *Thirteen Against the Odds* (New York:
 Viking, 1944), pp. 71–72.

144 "A GENTLEMAN SHOULD BE": Johnson, *Along This Way*, p. 98.

145 "UNDER THE BAMBOO TREE": *Ibid.*, pp. 149–55. Levy, *Johnson*, chap. 4.

145 "AND DOING THEM NO BETTER": Johnson, *Along This Way*, p. 161. James
 Weldon Johnson, *Black Manhattan* (New York: Atheneum, 1972; orig.
 pub., 1930), p. 109; Levy, *Johnson*, chap. 4.

145– OF A SPECIAL KIND: Johnson, *Along This Way*, pp. 229–51; Levy, *Johnson*,
 46 p. 111. CONSERVATIVE RACIAL PHILOSOPHY: Levy, *Johnson*, p. 151.

146 "POETRY OR ANYTHING ELSE": Quoted, *ibid.*, p. 147. TEN BEST SELLERS:
 Mary White Ovington, *Portraits in Color* (New York: Viking, 1927), p. 2.

146 "AMERICANS AND CITIZENS": Quoted, Levy, *Johnson*, p. 143.

146– FOR WARREN HARDING: *Ibid.*, pp. 204–7; Johnson, *Along This Way*, pp.
 47 149–59. "PUSHING HIMSELF FORWARD": Ovington, *Portraits*, p. 2.

147 A CANAL ACROSS THE ISTHMUS: Johnson, *Along This Way*, pp. 286–88.
 LAISSEZ-FAIRE CAPITALISM: Levy, *Johnson*, p. 159. "DARKY" TRADITION OF

AMERICAN LETTERS: *Ibid.*, pp. 145, 150; Jean Wagner, *Black Poets of the United States: From Paul Laurence Dunbar to Langston Hughes* (Urbana: Univ. of Illinois Press, 1973), pp. 358–59; Addison Gayle, Jr., *The Way of the New World: The Black Novel in America* (Garden City, N.Y.: Anchor Press, 1975), pp. 90–97. "CHOSEN THE LESSER PART": J. W. Johnson, *The Autobiography of an Ex-Colored Man* (New York: Knopf, 1966; orig. pub., 1912): p. 211.

147– "THE FIRST MODERN": Fullinwider, *Mind and Mood of Black America*,
 48 p. 91; Levy, *Johnson*, p. 20; Wagner, *Black Poets*, p. 364; Gayle, *Way of the New World*, pp. 90–91. "MODERN CIVILIZATION": James Weldon Johnson, "The Negro's Place in the New Civilization" (speech delivered to Bordentown, N.J., NAACP Branch, Aug. 12, 1920), p. 5.

148– "FIGHT FOR OURS ALSO": Quoted by Levy, *Johnson*, p. 158. "THAN OF
 49 ACTUAL CONDITIONS": Johnson, *Along This Way*, p. 374. Johnson, *Negro Americans What Now?* (New York: Viking, 1935), p. 103.

149 "PRODUCTION OF LITERATURE AND ART": James Weldon Johnson, *The Book of American Negro Poetry* (New York: Harcourt, Brace, 1959; orig. pub., 1922), p. 9.

149 "A CERTAIN DEGREE OF THIS": Alain Locke, "The Ethics of Culture," *Special Articles: Howard University Records*, 17 (Feb. 1923): 178–85, p. 181. MUCH TOO DARK: Locke to Mason, Sept. 8, 1931, Box 56: ALLP/HU.

149– DUPLICATE THE EUROPEAN PATTERN: Recollections of Karl Karstens and
 50 Eugene C. Holmes, in Rayford Logan, Eugene Holmes, G. Franklin Edwards, eds., *The New Negro Thirty Years Afterward: Papers Contributed to the Sixteenth Annual Spring Conference of the Division of Social Sciences, April 20, 21, 22, 1955* (Washington, D.C.: Howard Univ. Press, 1955), pp. 4, 16–17.

150– "WHENEVER I AM WITH YOU": Walrond to Locke, Apr. 23, 1924, n.d.
 51 (1925?) (M-Z): ALLP/HU.

151 "BEEN MY PATRON": Langston Hughes, *I Wonder As I Wander: An Autobiographical Journey* (New York: Hill & Wang, 1964; orig. pub., 1956), p. 5. SPEAKING OF HER IN WHISPERS: Hurston, *Dust Tracks on a Road*, pp. 175–77.

151 "WORK DURING THE VACATION": Hughes, *Big Sea*, pp. 313–14.

152 THE NEW BARNES FOUNDATION: Actually, Douglas returned to Mason's payroll after a little more than a year. TRI/Aaron Douglas. On this incident: Alfred Knopf to Van Vechten, May 28, 1919: Corr. courtesy of Alfred Knopf; Van Vechten to Knopf, June 28, 1930: Corr. courtesy of Alfred Knopf; Mason to Locke, July 12, 1929, Box 59: ALLP/HU. "THE METROPOLITAN OPERA HOUSE STAGE": Mason to Locke, Apr. 8, 1919, Box 59: ALLP/HU.

152– HER BROWN BOY: Mason to Locke, Mar. 11, 1927, Box 59: ALLP/HU.
 53 GLORIES OF AFRICA'S PAST: Mason to Locke, July 28, 1927, Box 59: ALLP/HU. "FROM HIS OWN VISION": Mason to Locke, Aug. 1, Aug. 16, 1927, Box 59: ALLP/HU. TO OFFER IT: Mason to Locke, Aug. 26, 1929; Apr. 23, 1931, Box 59: ALLP/HU. MISS CORNELIA CHAPIN: TRI/Louise Patter-

son Thompson, Arthur Huff Fauset; Mason to Locke, July 12, 1929, Nov. 22, 1931, Box 59: ALLP/HU.

153 HIS LIFE HAD BEEN SAVED: Hughes, *Big Sea*, p. 219; Mason to Locke, July 28, 1927, Box 59: ALLP/HU. ACADEMY IN THE PENNSYLVANIA WOODS: Mason to Locke, Apr. 1, 1927, Aug. 26, 1929, Box 59: ALLP/HU.

153– "PUSSY-FOOTING PROFESSOR": McKay to Locke, Mar. 1, 1925: ALLP/HU.
54 McKay to A. Schomburg, Sept. 25, 1923, Reel No. 3: AASP/SRCBC; McKay, *Long Way from Home*, p. 312. "WAS DESTROYED": McKay to Locke, Mar. 1, 1925; Apr. 18, June 4, 1927: ALLP/HU. LIFE IN NORTH AFRICA: McKay to Mason, Dec. 1, 1928: ALLP/HU.

154 "WAITING IN THE BEYOND": Mason to Locke, Apr. 20, 1920: ALLP/HU. THE GARLAND FUND FOR SUPPORT: Locke to White, Mar. 10, 1923 (C-90): WWC/LC. "COMES TO BUYING": Locke to Mason, Jan. 30, 1929: ALLP/HU.

154– "ALL AFRICA'S STRENGTHS": Mason to Locke, Mar. 4, 1928, Box 56:
55 ALLP/HU. MORIBUND WHITE WORLD: *Ibid.*, "SUCH INSPIRING STORIES": Locke to Mason, Feb. 27, 1929, Box 56: ALLP/HU. SIMILAR PREJUDICES: Locke to Mason, Feb. 6, 1928, Box 56: ALLP/HU.

CHAPTER 6: NIGGER HEAVEN

Page

156– HARLEM APPEAR MORE ATTRACTIVE: Langston Hughes, "Our Wonderful
57 Society: Washington," *Opportunity*, 5, no. 8 (Aug. 1927): 226–27; Brenda Ray Moryck, "I, Too, Have Lived in Washington," *ibid.*, pp. 228–31, 243.

157 "ALIKE BY OLD AND NEW": W. E. B. Du Bois, *The Souls of Black Folk: Essays and Sketches* (Greenwich, Conn.: Fawcett, 1964; orig. pub. 1903), p. 87.

157– 105 PHI BETA KAPPAS: *Opportunity*, 11, no. 12 (Dec. 1933); Harry W.
59 Greene, "The Number of Negro Doctorates," *School & Society*, 38 (Sept. 16, 1933): 375; Harry W. Greene, "The Ph.D. and the Negro," *Opportunity*, 6, no. 9 (Sept. 1928): 267–69; Charles H. Thompson, "The Socio-Economic Status of Negro College Students," *Journal of Negro Education*, 2, no. 1 (Jan. 1933): 26–27. ACADEMICS AND ADMINISTRATORS: Carter Woodson, *The Negro Professional Man and the Community* (Washington, D. C.: Association for the Study of Negro Life and History, 1934), pp. 30, 31.

158– "EDUCATED BEYOND HIS ENVIRONMENT": Quoted by Raymond Wolters,
59 *The New Negro on Campus: Black Colleges and Rebellions in the 1920's* (Princeton, N.J.: Princeton Univ. Press, 1975), p. 11. "USED IN NEW ENGLAND": Quoted, *ibid.*, p. 6. Louis R. Harlan, *Booker T. Washington: The Making of a Black Leader* (New York: Oxford Univ. Press, 1972), p. 275. CRIPPLING POVERTY: Wolters, *New Negro on Campus*, pp. 278–79. SEEMED BEYOND HOPE: *Ibid.*, p. 15.

159 "TWENTY OR THIRTY—NO": Quoted, *ibid.*, 325–26. Steven Bloom, "Interaction Between Blacks and Jews in New York City, 1900–1930, As

Reflected in the Black Press" (New York Univ. Ph.D. diss., 1973), p. 82; E. Digby Baltzell, *The Protestant Establishment: Aristocracy and Caste in America* (New York: Random House, 1964), pp. 210–11; W. E. B. Du Bois, "Higher Training," *The Crisis*, 24 (Aug. 1922): 151–55. KEEP HIS ROOM: Editorial, *The Messenger*, 6, no. 5 (May 1924): 137.

159–
60 "THEIR LACK OF ABILITY": Quoted in Wolters, *New Negro on Campus*, pp. 11–12. "A MILLION DOLLARS": Editorial, *The Crisis*, 28, no. 6 (Oct. 1924): 251–52. "PHELPS-STOKES FUND WILL GET YOU": "Gifts of Education," *The Crisis*, 29 (Feb. 1925): 151–52.

160 MORDECAI JOHNSON, SUCCEEDED HIM: Wolters, *New Negro on Campus*, pp. 128–29.

160–
61 "NO NEGRO PROFESSORS": Langston Hughes, "Three Students Look at Lincoln in 1929": CCMC/AU, p. 2.

161 LASTING FRIENDSHIP WITH LANGSTON HUGHES: TRI/Louise Thompson Patterson; Wolters, *New Negro on Campus*.

161–
62 "AGAINST OPPRESSION": "Negro Students," *The Messenger*, 8, no. 2 (Feb. 1926): 46. "OUR OWN SOULS": "Fisk," *The Crisis*, 29 (Apr. 1925): 247–51, p. 251.

162–
63 "IN THE FIELD OF ART": New York *Herald Tribune*, May 7, 1925. BELLHOP: *Opportunity*, 3, no. 31 (June 1925): 190–91. For Garland Anderson: Doris Anderson, *Nigger Lover* (London: Fowler, n.d.); Doris Abramson, *Negro Playwrights in the American Theatre* (New York: Columbia Univ. Press, 1969).

163 "SPIRIT UPON THE CROSS": Mary White Ovington, *Portraits in Color* (New York: Viking, 1927), p. 237. "ALL THE WORLD KIN": Herbert Seligman, "Race Prejudice," *Opportunity*, 3, no. 26 (Feb. 1925): 37–40, p. 37. "WITH AFRO-AMERICAN SINGING": New York *Sun*, Apr. 21, 1924. "THE NEGRO SPIRITUAL": Eileen Southern, *Music of Black Americans* (New York: Norton, 1971), chap. 14. "NOT YET MASTER": Samuel Charters and Leonard Kunstadt, *Jazz: A History of the New York Scene* (Garden City, N.Y.: Doubleday, 1962), p. 40.

163–
64 "SOCIOLOGICAL EL DORADO": Eric Walrond, "The Black City," *The Messenger*, 6, no. 1 (Jan. 1924): 13–14. "INTERESTING PEOPLE": Ethel Ray Nance transcript, Oral History Program: Fisk University, p. 9.

164 "VULGARITY" AND "STEREOTYPING": White to Mills, Dec. 8, 1924 (C-90): WWC/LC. "WHITE SUPREMACY": "Dixie to Broadway," New York *World*, Oct. 30, 1924. "COLORED SHOW AT ALL": *Opportunity*, 2, no. 23 (Nov. 1924): 342.

164–
65 TASTE OF THE REAL THING: Edith Isaacs, *The Negro in the American Theatre* (New York: Theatre Arts, 1947), p. 80. "BLACK AND TANS OF HARLEM": "Black-Belt," *Variety*, 82, no. 1 (Feb. 17, 1926): 4, 8, p. 8. "HOUSE OF ASSIGNATION": Walrond, "Black City," p. 14. "TURNED WHITE": *American Mercury*, 11, no. 44 (Aug. 1927): 393–98, p. 393.

165 EXTENDED TO HARLEM: Osbert Sitwell, "New York in the Twenties," *Atlantic Monthly*, Feb. 1962, pp. 38–43, p. 39. LOUIS XVI FURNITURE: New York *Amsterdam News*, Aug. 26, 1931; Langston Hughes, *The Big Sea:*

An Autobiography (New York: Hill & Wang, 1975; orig. pub., 1940), p. 246.

165– USUALLY QUITE CREDITABLE: TRI/Owen Dodson, Richard Bruce Nugent,
66 Henry Lincoln Johnson, Jr., Ivy and Pearl Fisher, Wilhelmina Adams, Gerri Major, George N. Redd.

166 "SOUTH, EAST, AND NORTH": Richard Bruce Nugent, "On the Dark Tower": FWP/SCRBC.

166– PULLMAN CORPORATION: Ibid. SOCIETY LEGEND: TRI/Henry Lincoln John-
67 son, Jr. THE CROWN PRINCE: Hughes, Big Sea, pp. 244–45. "OUGHTN'T TO MINGLE": Sitwell, "New York in the Twenties," p. 41.

167– "BUT NOT TRUTHFUL": Walker to White, Nov. 10, 1924 (C-92): WWC/
68 LC. BORDERED BY STATUARY: "Wealthiest Negro Woman's Suburban Mansion," New York Times Magazine, Nov. 4, 1917, p. 6.

168 A'LELIA'S GOOD WILL: TRI/Gerri Major, A'Lelia Ransom Nelson.

169 "AND HOT NIGHT CLUB": Nugent, "On the Dark Tower," p. 4.

169– MAGIC OF NUMBERS: TRI/George Schuyler, Leigh Whipper, Richard
70 Bruce Nugent, G. James Fleming.

170– HALF-DOZEN OTHER COMPETITORS: Myrtle Evangeline Pollard, "Harlem As
71 Is: Sociological Notes on Harlem Social Life," 2 vols. (City College of New York B.B.A. thesis, 1936), 1: 160. SHIFT ON ITS FOUNDATIONS: Charters and Kundstadt, Jazz, chap. 15.

171 BALM OF PERSPECTIVE: Sterling Brown, "The Negro in American Culture," Reel No. 1: CA-MY/SCRBC; Alain Locke, The Negro and His Music (New York: Arno Press, 1969; orig. pub., 1936), chaps. 9, 10.

171– A GREATER STORYVILLE: Mezz Mezzrow, Really the Blues (Garden City,
72 N.Y.: Anchor Books, 1972; orig. pub., 1946), p. 99: Willie "the Lion" Smith (with George Hoefer), Music on My Mind: The Memoirs of an American Pianist (Garden City, N.Y.: Doubleday, 1964), p. 124; Brown, "Negro in American Culture," p. 157. "PAUL BARBARIN": Ibid. BENNY GOODMAN: Mezzrow, Really the Blues, p. 99. "OUT ACROSS THE ROOM": Ibid., p. 97.

172 "THE WAY FREDDIE WAS": Sidney Bechet, Treat It Gentle (London: Cassell, 1960), p. 112. "NO WAY TO SAY IT": Ibid., pp. 140–41. LESS THAN REMARKABLE: Ibid., p. 141.

173 CATHOUSES THAT SPAWNED IT: Ibid.

173 A MUSIC DEMONSTRATOR: Charters and Kunstadt, Jazz, chap. 14. JOHNSON PIANO ROLL: Ethel Waters, His Eye Is on the Sparrow: An Autobiography (Garden City, N.Y.: Doubleday, 1951), p. 142.

173–4 IN LESS THAN ONE MONTH: Charters and Kunstadt, Jazz, chap. 7.

174 FROM CHESTER, PENNSYLVANIA: Ibid., p. 97. "CULTURAL NUMBERS": Waters, His Eye Is on the Sparrow, p. 141. UNMISTAKABLE NITTY-GRITTINESS: Chris Albertson, Bessie (New York: Stein & Day, 1974), p. 37. THE RIGHT DECISION: Waters, His Eye Is on the Sparrow, p. 141.

175 UPGRADE THE CATALOGUE: Charters and Kunstadt, *Jazz*, p. 140. "GRAND OPERA COMPANY": *The Crisis*, 24, no. 1 (May 1922): 44. EDITH WILSON: TRI/Edith Wilson.

175– "PROPAGANDIST INTELLIGENTSIA": Claude McKay, "Negro Life and Negro
76 Art," n.d. (1926?), NAACP Collection (C-421): LC. DU BOIS SHOUTED: "Criteria of Negro Art," *The Crisis*, 32, no. 6 (Oct. 1926): 290–97, p. 296.

176– "A DROP OF VITALITY REMAINS?": *The Crisis*, 32, no. 11 (Mar. 1926):
77 219. On this incident: Arnold Rampersad, *The Art and Imagination of W. E. B. Du Bois* (Cambridge, Mass.: Harvard Univ. Press, 1976), chap. 9.

176 "AFRICA ON EUROPE IN AMERICA": W. E. B. Du Bois, *The Gift of Black Folk: The Negro in the Making of America* (Boston: The Stratford Co., 1924), p. 320.

177 REPAY THE FAUSET SISTERS: Fauset to J. Spingarn, June 8, 1926: JSC/ NYPL. "LABOR MOVEMENT IN THE MODERN WORLD?": Editorial, *The Crisis*, 30, no. 1 (May 1925): 8–9. Rampersad, *Art and Imagination of W. E. B. Du Bois*, pp. 196–97. "I AM A BOLSHEVIK": Editorial, *The Crisis*, 33, no. 1 (Nov. 1926): 8. W. E. B. Du Bois, *The Autobiography of W. E. B. Du Bois: A Soliloquy on Viewing My Life from the Last Decade of Its First Century* (New York: International Publishers, 1968), pp. 289–90; Elliott M. Rudwick, *W. E. B. Du Bois: Propagandist of the Negro Protest* (New York: Atheneum, 1968), p. 255.

177–8 "SLAVES AND BLACK TO DO WITH ART?": "Criteria of Negro Art," p. 294.

178 "STOP AGITATION OF THE NEGRO QUESTION": *Ibid.* "NEGROES ARE DOING IN THESE FIELDS": Quoted by Charles F. Cooney, "Forgotten Philanthropy: The Amy E. Spingarn Prizes" (unpub. monograph courtesy the author): 1–26, p. 15.

178– "GOLGOTHA IS A MOUNTAIN": *Opportunity*, 4, no. 41 (May 1926): 148–
79 49.

179–80 AUTHOR "OF NEGRO DESCENT": *The Crisis*, 31, no. 5 (Mar. 1926): 217.

180 "QUITE PEEVISH OF THEM": Hurston to Connie, June 5, 1926: ZNH/UF. "PRIMITIVE FOR HIS INSPIRATION": Van Vechten to Mencken, Dec. 9, 1925: HLMC/NYPL.

180 "COUNTERACT WHAT HE HAS DONE": Randolph to Johnson, Sept. 1, 1926: JWJMC/YU.

180– "USE OF THIS MATERIAL": Johnson, quoted by Bruce Kellner, *Carl Van
81 Vechten and the Irreverent Decades* (Norman: Univ. of Oklahoma Press, 1968), p. 219. PORGY THE PREVIOUS YEAR: C. S. Johnson to Countee Cullen, Oct. 3, 1926, Box 3: CCP/ARC ("John Farrar has asked particularly that we give 'Porgy' our best attention"). "PICTURED IN HIS BOOK": J. W. Johnson to Randolph, Sept. ("Saturday") 1926: JWJMC/ YU.

181 DISTRIBUTION OF THE BOOK IN NEW YORK: "Novel About Harlem Called Unfit," *Chicago Defender*, Nov. 6, 1926, p. 4. FAVORITE HARLEM NIGHT-SPOT: Lewis F. Baer to Van Vechten, Sept. 28, 1926: CVVC/NYPL;

White to Robert L. Vann, Aug. 16, 1926 (telegram) (C-95): WWC/ LC. "THE INTELLIGENCE OF WHITE": *The Crisis*, 33, no. 2 (Dec. 1926): 15, 199, p. 15. Ethel Ray Nance transcript, p. 12; TRI/Ida Mae Cullen, Maurice Russell.

181– NOT FARFETCHED: Quoted by Kellner, *Van Vechten*, p. 213. "HOPES AND 82 WISHES WERE": Johnson to Van Vechten, Aug. 28, 1926: CVVC/NYPL. Reviews cited in Kellner, *Van Vechten*, pp. 220–24.

182 "PLAYING WITH NEGROES LATELY": Quoted by Kellner, *Van Vechten*, p. 195. "BLACK KOSHER WEDDING": Van Vechten to Mencken, Jan. 26, 1924: CVVC/NYPL.

182– SERVED AS JUDGES: Kellner, *Van Vechten*, p. 201. "MASTER OF THE COL- 83 ORED REVELS": Sitwell, "New York in the Twenties," p. 41. "SAINT LOUIS BLUES": "The Reminiscences of Carl Van Vechten": OHP/CU, p. 207; Kellner, *Van Vechten*, p. 199. GIN AND SIDECARS: Kellner, *Van Vechten*, p. 219.

183– GOD'S TROMBONES: *Ibid.*, 201; Hughes, *Big Sea*, pp. 251–55; Taylor Gor- 84 don, *Born To Be* (Seattle: Univ. of Washington Press, 1975; orig. pub., 1929), chap. 17; Edward Leuders, *Carl Van Vechten and the Twenties* (Albuquerque: Univ. of New Mexico Press, 1955), chap. 7. "HEARD OF SUCH SHIT": Quoted by Chris Albertson, *Bessie*, p. 143. Kellner, *Van Vechten*, p. 200. "WEEKEND AT CARL VAN VECHTEN'S": Quoted by Kellner, *Van Vechten*, p. 201.

184 WOULD TAKE CARE OF THEMSELVES, HE BELIEVED: "Moanin' Wid a Sword in Mah Hand," in Bruce Kellner, ed., *"Keep A-Inchin' Along": Selected Writings About Black Arts and Letters by Carl Van Vechten* (Westport, Conn.: Greenwood Press, 1979). "EXPLOITATION OF THE WHITE MAN": *Ibid.* "STRUGGLING WITH ETHIOPIAN PSYCHOLOGY": Van Vechten to Mencken, 1925: HLMC/NYPL.

184– WON A HANDSOME SETTLEMENT: "Nora Holt Ray Bares Divorce Secrets," 85 Chicago *Defender*, Feb. 6, 1926, p. 1; Dec. 17, 1927, p. 1; Hughes, *Big Sea*, p. 254. UNPRINCIPLED LASCA SARTORIS: Van Vechten to Mencken, 1925: HLMC/NYPL; Kellner, *Van Vechten*, p. 218. "YOU SHOULD CHANGE IT": C. D. Van Vechten to Carl Van Vechten, Nov. 28, 1925; Dec. 7, 1925: CVVC/NYPL.

185 "YOUR RECORDS OF SALES": Van Doren to Van Vechten, Aug. 11, 1926: CVVC/NYPL. NINE PRINTINGS IN FOUR MONTHS: Kellner, *Van Vechten*, p. 213.

185 "HIS SEAL-BROWN COUNTENANCE": Carl Van Vechten, *Nigger Heaven* (New York: Harper & Row, 1971; orig. pub., 1926), p. 3.

186 JOHNSON WROTE THE AUTHOR: Quoted by Kellner, *Van Vechten*, p. 217.

186 "MIDDLE CLASS FINDS ITSELF": Van Vechten, *Nigger Heaven*, p. 50.

186 "BOOK IS GORGEOUS": Burnett to Van Vechten, Aug. 16, 1926: CVVC/ NYPL.

186 "SOMETHING HAS TO BE DONE": *Nigger Heaven*, p. 149. Editorial, *Opportunity*, 4, no. 45 (Sept. 1926): 270–71; George Schuyler, "Carl Van Vechten," *Phylon*, 12 (1951): 362–68; Kellner, *Van Vechten*, p. 209.

187 "ALL THAT CAN BE ASKED OF THE ARTIST": Chesnutt to Van Vechten, Sept. 7, 1926: CVVC/NYPL.

187 VOICES FOR RACIAL BETTERMENT: James Weldon Johnson, *Along This Way: The Autobiography of James Weldon Johnson* (New York: Viking, 1961; orig. pub., 1933), pp. 380–81; James Weldon Johnson, "Nigger Heaven," *Opportunity*, 4, no. 46 (Oct. 1926): 316, 330. "NEGRO IN AMERICA?": Quoted by Kellner, *Van Vechten*, p. 223. "ABRAHAM LINCOLN": Quoted, *ibid.*, p. 220. "OFF YOUR CHEST, DON'T WE?": Thomas to Van Vechten, Aug. 8, 1926: CVVC/NYPL.

187 "DIVERS TRIBES OF THE REGION": Van Vechten, *Nigger Heaven*, p. 222. "GETS AROUND TO IT": *Ibid.*

187– "LIFE IN HARLEM": Edward Wasserman to Van Vechten, Aug. 2, 1926:
88 CVVC/NYPL. EQUALLY DELIGHTED: Sinclair Lewis to Van Vechten, Aug. 6, 1926: CVVC/NYPL. "NO OTHER WHITE MAN": Block to Van Vechten, n.d.: CVVC/NYPL. "BEST FRIENDS ALWAYS KNEW": Hopwood to Van Vechten, Sept. 22, 1926: CVVC/NPYL. "UNRELATED BACKGROUND": Luhan to Van Vechten, Aug. 11, 1926: CVVC/NYPL; Fitzgerald to Van Vechten, 1926: CVVC/NYPL. JAMES WELDON JOHNSON: Kellner, *Van Vechten*, p. 221.

188 "IS NOT ENHANCED": Fowler to Van Vechten, Aug. 13, 1926: CVVC/ NYPL. "CHINESE AND THE JEWS": Van Vechten to Mencken, 1926: HLMC/NYPL. A SON AND A COLLEAGUE: "Reminiscences of Carl Van Vechten," pp. 266–73; Johnson, *Along This Way*, pp. 380–81; Langston Hughes, *The Weary Blues* (New York: Knopf, 1926), preface by Carl Van Vechten; Kellner, *Van Vechten*, p. 204.

188– "WITH SPECIAL FONDNESS": Van Vechten, *Nigger Heaven*, p. 235. "RUN-
89 NING AROUND IN HIS SKULL": Addison Gayle, Jr., *The Way of the New World: The Black Novel in America* (Garden City, N.Y.: Doubleday, 1975), p. 87.

189 "ALL, APPARENTLY, BUT ME!": Van Vechten, *Nigger Heaven*, pp. 89–90.

189– LYRICS OF LOWLY LIFE: Benjamin Brawley, "The Negro Literary Ren-
90 aissance," *The Southern Workman*, 56, no. 4 (Apr. 1927): 177–84, p. 179. "AND GREAT PROMISE": "Tropic Death," *The Crisis*, 33, no. 3 (Jan. 1927): 152. "OBVIOUS FLAWS": "Books," *The Messenger*, 9, no. 1 (Jan. 1927): 27–28.

190 "A DEEP REALITY": Quoted by Robert Bone, *Down Home: A History of Afro-American Short Fiction* (New York: Putnam's, 1975), p. 195.

190 GEM OF THE GENRE: Eric Walrond, *Tropic Death* (New York: Collier Books, 1972; orig. pub., 1926).

191 "FREE WITHIN OURSELVES": Langston Hughes, "The Negro Artist and the Racial Mountain," *The Nation*, 122, no. 3181 (June 28, 1926): 692–94, p. 694.

191– "AMERICAN STANDARDIZATIONS": *Ibid.*, p. 693. "LAMPBLACKED ANGLO-
92 SAXON": George Schuyler, "The Negro Art Hokum," *The Nation*, 122, no. 3180 (June 16, 1926): 662–63, p. 662.

192 "WITH THE PROLETARIAT": Wallace Thurman, "Negro Artists and the Negro," *New Republic*, 52 (Aug. 31, 1927): 36–39. "WRONG TRACK ALTOGETHER": Brawley, "Negro Literary Renaissance," p. 182.

192 "BE A HIGH YALLER": Langston Hughes, *Fine Clothes to the Jew* (New York: Knopf, 1927), p. 73.

192– "SO LARGE A PART": White to L. M. Hussye, Jan. 19, 1925 (C-92):
93 WWC/LC. "THROUGH ANY OTHER METHOD": Johnson, "Race Prejudice and the Negro Artist," *Harper's*, 157 (Nov. 1928): 769–76, p. 776. OPTIMISM OF A PANGLOSS: E. Franklin Frazier, "Social Equality and the Negro," *Opportunity*, 3, no. 30 (June 1925): 165–68.

193 "SECOND EMANCIPATION SEEMED INEVITABLE": Thurman, "Negro Artists and the Negro," 37. Wallace Thurman, "Nephews of Uncle Remus," *The Independent*, 119 (Sept. 24, 1927): 296. REVOLT AGAINST ESTABLISH-MENT ARTS: TRI/Richard Bruce Nugent, Dorothy West, Aaron Douglas.

193– FOR CHARACTERS AND MATERIAL: Thurman, "Negro Artists and the
94 Negro," pp. 37–38; Mae Gwendolyn Henderson, "Portrait of Wallace Thurman," in *The Harlem Renaissance Remembered: Essays, Edited with a Memoir*, ed. Arna Bontemps (New York: Dodd, Mead, 1972), p. 151. "ENGLISH WAS NOT SO GOOD": TRI/Arthur Huff Fauset. "UNTIL THEY NO LONGER EXIST": Thurman, "Negro Artists and the Negro," pp. 37–38. "IN LITERATURE ON THE SIDE": Hurston to Locke, Oct. 11, 1927: ALLP/HU.

194 "MISTAKEN FOR ART": Brawley, "Negro Literary Renaissance," p. 184. "HARDLY TALK TO ME": Fred Bair to Cullen, Apr. 18, 1927, Fol. Corr. Ba-Bo: CCP/ARC. VISITING PAUL ROBESONS: TRI/Richard Bruce Nugent. AFRO-AMERICAN: Quoted by Hughes, *Big Sea*, p. 237. "ALL ITS ASPECTS": Robert Kerlin, "Conquest by Poetry," *The Southern Workman*, 56, no. 6 (June 1927): 282–84, p. 284. "NEGRO ARTIST BE HIMSELF": "Challenge to the Negro," *Bookman*, 54, no. 3 (Nov. 1926): 258–59, p. 259.

195 "FY-AH GONNA BURN MA SOUL!": *Fire!!*, 1, no. 1 (Nov. 1926), 1.

196 "ANGLED AND SEARCHED FOR PREY": Wallace Thurman, "Cordelia the Crude," *Fire!!*, 5–7, p. 6.

196– "NEGRO RENAISSANCE INTO DECADENCE": "Our Book Shelf," *The Crisis*,
97 31 (June 1926): 141.

197 "BEAUTY OF THE NARROW BLUE": Richard Bruce Nugent, "Smoke, Lillies and Jade," *Fire!!*, 33–39, p. 36.

197 "THE CRISIS ROASTED IT": Hughes, *Big Sea*, p. 237. "WIDE SUPPORT": "The Looking Glass," *The Crisis*, 33 (Jan. 1927): 158. Robert Hemenway, *Zora Neale Hurston: A Literary Biography* (Urbana: Univ. of Illinois Press, 1977), p. 48.

CHAPTER 7: A JAM OF A PARTY

Page

198 "THE NEGRO HAS ARRIVED?": *The Southern Workman*, 56, no. 6 (June 1927): 282–84, p. 283.

198– PREVIOUS YEARS WERE MISSING: Patrick J. Gilpin, "Charles S. Johnson:
99 Entrepreneur of the Harlem Renaissance," in *The Harlem Renaissance
Remembered: Essays Edited with a Memoir*, ed. Arna Bontemps (New
York: Dodd, Mead, 1972), p. 235; "The Opportunity Dinner: An Im-
pression," *Opportunity*, 5, no. 7 (July 1927): 208–9. "FURTHER SERVICE
OF THIS KIND": G. E. Haynes to M. B. Brady, July 8, 1927, Box 22: HFR/
LC. "CAREFUL WORK ON THEIR MANUSCRIPTS": Nancy J. Weiss, *The Na-
tional Urban League, 1910–1940* (New York: Oxford Univ. Press, 1974),
p. 230.

199 "PUBLISHED IN THE UNITED STATES": Letter, *Opportunity*, 5, no. 1 (Jan.
1927): 6. 40 PERCENT . . . TO WHITES: Weiss, *National Urban League*,
p. 221. DECLINED TO RENEW ITS GRANT: *Ibid.*, p. 157. "A CERTAIN SUPERIOR-
ITY TO IT": Charles Johnson, ed., *Ebony and Topaz: A Collectanea* (New
York: National Urban League, 1927), pp. 11–13.

199– INTO DU BOIS'S POSSESSION: Quoted by Carolyn Wedin Sylvander, "Jessie
200 Redmon Fauset: Black American Writer, Her Relationships, Biographical
and Literary, with Black and White Writers, 1910–1935" (Univ. of Wis-
consin Ph.D. diss., 1976), p. 162. "WHITE FOLKS, WE NOTICE, CONTINUES":
Du Bois, "Mencken," *The Crisis*, 34, no. 8 (Oct. 1927): 276. "The Cri-
teria of Negro Art," *The Crisis*, 32, no. 6 (Oct. 1926): 290–97; Ar-
nold Rampersad, *The Art and Imagination of W. E. B. Du Bois*
(Cambridge, Mass.: Harvard Univ. Press, 1976), pp. 196–97.

200 "I WOULD BE SYMPATHETIC": Amy Spingarn to Du Bois, Jan. 17, 1928,
quoted by Charles F. Cooney, "Forgotten Philanthropy: The Amy E.
Spingarn Prizes" (unpub. article courtesy the author): 1–26, p. 17.

200– OF THE NIGGER HEAVEN SCHOOL: Arthur P. Davis, *From the Dark Tower:
201 Afro-American Writers, 1900–1960* (Washington, D.C.: Howard Univ.
Press, 1974), p. 23; Rampersad, *Art and Imagination of W. E. B. Du
Bois*, p. 201. "TO HEAR FROM NEGROES": Du Bois to Amy Spingarn, Jan.
19, 1928, in *The Correspondence of W. E. B. Du Bois: Selections, 1877–
1934*, ed. Herbert Aptheker (Amherst: Univ. of Massachusetts Press,
1973), vol. 1, p. 372.

201 "SOUL OF OUR PEOPLE": Schuyler to Du Bois, Oct. 11, 1928, *ibid.*, p. 382.
ALSO FOR BLACK AFRICA: Rampersad, *Art and Imagination of W. E. B.
Du Bois*, pp. 206, 210.

202 "TO BE A WONDERFUL WOMAN": W. E. B. Du Bois to Yolande Du Bois,
Oct. 29, 1914, in *Corr. of Du Bois*, vol. 1, pp. 207–8.

202–3 "REASONABLE CREDIT" IN 1924: Du Bois to J. Spingarn, July 16, 1924, in
ibid., vol. 1, pp. 291–92. "JUST WHAT I MEAN": Yolande Du Bois to Jack-
man, "Thursday" (Aug. 2, 1922?), unprocessed Jackman papers: CCMC/
AU. YOUNG PIONEERS OF SWING: TRI/Mae Wright Peck, Jean Blackwell
Hutson. PHILADELPHIA FOLLOWED: "Cullen-Du Bois Nuptials," *The
Inter-State Tattler*, Apr. 13, 1928, p. 4; W. E. B. Du Bois to Cullen, Jan.
31, 1928, Box 21: CCMC/AU; Du Bois to Cullen, Feb. 11, 1928, Box 2:
CCP/ARC.

203 UNDISCLOSED ILLNESS: Jackman to Cullen, Nov. 19, 1928, Box 3: CCP/
ARC. "SHOW US ALL THE WAY": Du Bois to Cullen, Feb. 11, 1928: CCP/
ARC. "LIFE AS EASY AS YOU CAN": Du Bois to Cullen, Sept. 18, Oct. 11,

1928, Box 2: CCP/ARC. For interesting reflections on sex and marriage: W. E. B. Du Bois, *The Autobiography of W. E. B. Du Bois: A Soliloquy on Viewing My Life from the Last Decade of Its First Century* (New York: International Publishers, 1968), pp. 279–81. "SO SOON, REALLY": Jackman to Cullen, Jan. 3, 1929, Box 3: CCP/ARC.

203–4 "A CHRONIC DISEASE": White to Mencken, Aug. 30, 1924 (C-91): WWC/LC. Spingarn, quoted by B. Joyce Ross, *J. E. Spingarn and the Rise of the NAACP, 1911–1939* (New York: Atheneum, 1972), p. 128. "HAVEN'T INVADED": Walter White, *A Man Called White: The Autobiography of Walter White* (Bloomington: Univ. of Indiana Press, 1948), p. 92. "TWO-HUNDRED AND FIFTY DOLLARS A YEAR!": *Ibid.*, p. 93. "LOVELIEST PLACE WE HAVE EVER SEEN": White to Johnson, Aug. 16, 1927, Ser. 1, Fol. 539: JWJMC/YU. White to Arthur Spingarn, Aug. 16, 1927, Box 6: ASP/HU. White, *Man Called White*, p. 93.

204 "THEN PLUNGES SWIFTLY": White to Arthur Spingarn, Jan. 9, 1928, Box 6: ASP/HU.

204–5 "TOO MUCH HOPE FOR ME": *Ibid.* READING THE DRAFT: Arthur Spingarn to White, Mar. 6, 1928, Box 6: ASP/HU. ANALYTICAL IMPROVEMENTS: J. W. Johnson to White, Mar. 1, 1928 (C-95): WWC/LC; C. S. Johnson to White, July 31, 1928 (C-97): WWC/LC. ITS UNOFFICIAL BLESSING: Studin to White, Mar. 7, Mar. 28, 1928: White to Studin, Mar. 7, Mar. 28 (C-97): WWC/LC; White, *Man Called White*, p. 99.

205 SMITH'S POWER BROKER: Robert A. Caro, *The Power Broker: Robert Moses and the Fall of New York* (New York: Knopf, 1974), pp. 91–93, 98–100. "THEIR CHRONIC REPUBLICANISM": White to Studin, Mar. 7, 1928 (C-97): WWC/LC. WROTE ARTHUR SPINGARN: Moscowitz to Arthur Spingarn, Aug. 14, 1925, Box 5: ASP/HU.

205–6 "GIVEN MORE SPECIFIC PLEDGES": White to John Hurst, July 20, 1928 (C-97): WWC/LC. "BEHIND THE THRONE": *Ibid.* "SMITH WANTS HIM TO": Moorfield Storey to J. W. Johnson, July 25, 1928 (C-97): WWC/LC. JOHN HURST PREVAILED: Darrow to White, July 30, 1928; Hurst to White, July 21, 1928; Storey to White, July 28, 1928 (C-97): WWC/LC; White, *Man Called White*, chap. 13.

206 "WHICH THE NEGRO VOTER FACES": White to Storey, July 31, 1928 (C-97): WWC/LC.

206–7 MOST INNOVATIVE . . . HE HAD SEEN: N.Y. *World*, Oct. 11, 1927. AS THE UNDERSTUDIES DID: TRI/Leigh Whipper; Rose McClendon Scrapbook, vol. 1: SCRBC/NYPL.

207 TO BE CRITICAL: Doris E. Abramson, *Negro Playwrights in the American Theatre, 1925–1959* (New York: Columbia Univ. Press, 1969), pp. 56, 58; Fannin S. Belcher, "The Place of the Negro in the Evolution of the American Theatre, 1767 to 1940" (Yale Univ. Ph.D. diss., 1945), pp. 235–36. FEMALE FROM TEXAS: "Social Snapshots," *The Inter-State Tattler*, Feb. 10, 1928, p. 4.

207–8 "SONGS SUNG BY NEGROES": "Social Snapshots," *The Inter-State Tattler*, Apr. 27, 1928, p. 4. "GAMBLE ON THE SHOW": Edith Isaacs, *The Negro in the American Theatre* (New York: Theatre Arts, 1947), p. 69.

208–9 "NORTH FORKS, SOUTH DAKOTA": Jimmy Durante and Jack Kofold, *Night Clubs* (New York: Knopf, 1931), p. 113. "TRADE NIGHT CLUBS" IN HARLEM: "Black Belt's Night Life," *Variety*, Oct. 16, 1929, p. 12. A CONTRACT FROM THE MOB: Willie "the Lion" Smith (with George Hoefer), *Music on My Mind: The Memoir of an American Pianist* (Garden City, N.Y.: Doubleday, 1964), p. 135. DRIVER IN CENTRAL PARK: *Ibid.*, p. 96; Ethel Waters, *His Eye Is on the Sparrow: An Autobiography* (Garden City, N.Y.: Doubleday, 1951), p. 131. UNKNOWN COUNTRY: Smith, *Music on My Mind*, p. 138; Robert Sylvester, *No Cover Charge: A Backward Look at the Night Clubs* (New York: Dial, 1956), p. 46; Charles G. Shaw, *Night Life: Vanity Fair's Intimate Guide to New York After Dark* (New York: John Day, 1931), p. 73.

209 A FINER AMBIANCE: Konrad Bercovici, *Around the World in New York* (New York: The Century Co., 1924), p. 237; Shaw, *Intimate Guide to New York After Dark*, pp. 74, 76. EACH WAS MAKING HIS OWN: Artie Shaw, *The Trouble with Cinderella: An Outline of Identity* (New York: Farrar, Straus & Young, 1952), pp 223–24; Smith, *Music on My Mind*, pp. 171–72. LA GUARDIA: Smith, *Ibid.*, p. 172.

209–10 HIS MUSIC BLARED INSIDE: *Ibid.*, 136; TRI/Jean Blackwell Hutson, Leigh Whipper, Edith Wilson. SUSPICIOUSLY SWARTHY COUPLES: Jim Haskins, *The Cotton Club* (New York: Random House, 1977), p. 36; Alan Schoener, ed., *Harlem on My Mind: Cultural Capital of Black America, 1900–1968* (New York: Random House, 1968), p. 83; Bruce Kellner, *Carl Van Vechten and the Irreverent Decades* (Norman: Univ. of Oklahoma Press, 1968), p. 200.

210 "SUGAR WALKS DOWN THE STREET": Haskins, *Cotton Club*, p. 36.

211 "SPIFFIEST THING LATELY": "Social Snapshots," *The Inter-State Tattler*, May 31, 1929, p. 5. "NICE BREAK FOR CONNIE": "Socialites Mix in Harlem Club," New York *Daily News*, Nov. 1, 1929. TRI/Ida (Mrs. Connie) Immerman.

211–12 "THOSE I DO KNOW": Jackman to Cullen, Nov. 19, 1928, Box 3: CCP/ARC.

212 "LINCOLN OF NEGRO ART": Taylor Gordon, *Born to Be* (Seattle: Univ. of Washington Press, 1975; orig. pub., 1929), p. 185. *Ibid.*, Draper and Van Vechten preface and foreword, xiv, xlix. "WHAT IS RHYTHM TO THEM?": Jackman to Cullen, Jan. 27, 1930, Box 3: CCP/ARC.

212–13 EDITORIALS TO THE SPECTACLE: Jackman to Cullen, May 17, 1929, Box 3: CCP/ARC. "RECALLED AT 3:00 A.M.": "Social Snapshots," *The Inter-State Tattler*, Sept. 13, 1929, p. 5.

213 WHILE VISITING HARLEM: "Social Snapshots," *The Inter-State Tattler*, Oct. 18, 1929, p. 10. SUGAR HILL ADORED HER: Jackman to Cullen, May 10, 1929, Box 3: CCP/ARC. UNTIL SEPTEMBER 1929: Jackman to Cullen, Mar. 29, Apr. 26, 1929, Box 3: CCP/ARC.

213–14 "AN IVORY TOWER": Theophilus Lewis, "The Theater," *The Messenger*, 8, no. 6 (June 1926): 182–83. THE 1927 BALL: "Social Snapshots," *The Inter-State Tattler*, Mar. 22, 1929, p. 5; TRI/Wilhelmina Adams, Corinne (Mrs. Louis T.) Wright, Ivy and Pearl Fisher; Du Bois, *Autobiography*,

pp. 281–83. "A COMPETENT DRINKER": Theophilus Lewis, "The Theater," *The Messenger*, 9, no. 3 (Mar. 1927): 85.

214 DANCING LESSONS IN HARLEM: Cecil Beaton, *The Wandering Years: Diaries: 1922–1939* (London: Weidenfeld and Nicholson, 1961), p. 215. EXPERIMENT OF A PRIVATE CLUB: "Social Snapshots," *The Inter-State Tattler*, Oct. 19, 1928, p. 4. BORED DISMOND WROTE: *Ibid*. ADVISED THE HAPPY TATTLER: *Ibid*. BLACK THURSDAY, OCTOBER 24, 1929: "Social Snapshots," *The Inter-State Tattler*, Aug. 2, 1929, p. 5.

214– SOLEMN ENOUGH FOR AN OBITUARY: "The Passing of Garvey," *Opportu-*
15 *nity*, 3, no. 27 (Mar. 1925): 66. "Social Snapshots," *The Inter-State Tattler*, Oct. 25, Nov. 22, 1929.

215 A FUNDAMENTAL RIGHT: White, *Man Called White*, pp. 155–56. FINE OF TWENTY-FIVE HUNDRED DOLLARS: *Opportunity*, 6, no. 3 (Mar. 1928): 68.

215– PRE-DEPRESSION DAYS: *Opportunity*, 5, no. 7 (July 1927): 216; *The Dun-*
16 *bar News*, Oct. 16, 1929, p. 2. SPREAD TO HARLEM: Albon L. Holsey, "The C.M.A. Stores for the Chains," *Opportunity*, 7, no. 7 (July 1929): 210–13. "CONFISCATE ITS PENCILS": New York *Evening Telegram*, June 11, reproduced in *The Inter-State Tattler*, June 15, 1928, p. 3. GENERAL EDUCATION BOARD: Chicago *Defender*, Feb. 23, 1929, p. 1.

216 ONE OF A'LELIA'S HUSBANDS: "The Guardians of Health in Harlem," *The Inter-State Tattler*, Feb. 10, 1928, p. 8.

216– ONE POLITICIAN OBSERVED: Gilbert Osofsky, *Harlem: The Making of a*
17 *Ghetto: Negro New York, 1890–1930* (New York: Harper & Row, 1963), p. 172. TRI/Corinne (Mrs. Louis T.) Wright. LA GUARDIA WAS ELECTED MAYOR: Osofsky, *Harlem*, p. 173.

218 "WILL NOT BE TOLERATED": *The Dunbar News*, Oct. 16, 1929, p. 1. SOUTH OF FRANCE: White to J. W. Johnson, Jan. 1, 1928 (C-96): WWC/LC.

218– LONG ISLAND, WAS ONE OF THESE: *The Dunbar News*, June 17, 1930.
19 "RESIDING AT APT 5H": *The Dunbar News*, Jan. 29, 1930, p. 3; July 16, 1930.

219 "MORE THEY SMILED AND GRINNED": Quoted in "Hot Chocolates Hit Broadway with a Bang," Chicago *Defender*, June 29, 1929, p. 7. "HEAVIER THAN IT SEEMS": Robert Garland, "Harlem Opens," Chicago *Defender*, Mar. 9, 1929, p. 6. "ONWARD MARCH TO PROGRESS": "Is This Really Harlem," New York *Amsterdam News*, Oct. 23, 1929.

219– RESTRICTED RIGHT TO ENJOY IT: Lester A. Walton, "Negro's Failure to
20 Enter Trade Seen as Mistake," New York *World*, Aug. 10, 1924; Osofsky, *Harlem*, chap. 6. "RABBIT-HEARTED GENTRY": "What Inducements Do Chain Stores Offer Us," *The Inter-State Tattler*, Sept. 13, 1929, p. 1.

220 THE PREVIOUS YEAR: *Opportunity*, 1, no. 2 (Feb. 1927): 61; 6, no. 5 (May 1928): 140; Sadie Hall, "Caspar [sic] Holstein," Reel No. 1: FWP/ SCRBC. "AFTER MIDNIGHT ON THURSDAY": "Casper Holstein Seized: $50,000 Ransom," *New York Times*, Sept. 23, 1928, p. 1.

220– PLACE OF KIDNAPPING: "Kidnapped Negro Freed by Captors," *New York*
21 *Times*, Sept. 24, 1928, p. 1. CRIME BECAME INCREASINGLY "INTEGRATED": Smith, *Music on My Mind*, pp. 175–76; Helen Lawrenson, *Stranger at the*

Party: *A Memoir* (New York: Random House, 1972), chap. 9; Henry Lee Moon, "Stephanie St. Clair, Policy Queen," Reel No. 1: FWP/SCRBC.

221 "REGARDLESS OF RACE": Thomas L. Dabney, "Can Negro Business Survive?" *The Messenger*, 10, no. 4 (Apr. 1928): 75–76, 92, p. 92. "DESPERATION, OR PERSECUTION": Robert Allerton Parker, *The Incredible Messiah: The Deification of Father Divine* (Boston: Little, Brown, 1937), ix–x.

221– "YES, CHILE": Nella Larsen Imes, *Quicksand* (New York: Collier Books,
22 1971; orig. pub., 1928), p. 186.

222 "THEY SAY THEY ARE JEWS": "Negro Sect in Harlem Mixes Jewish and Christian Religions," New York *Sun*, Jan. 29, 1929. KYNOR, NEVEL, AND TUPIM: *Ibid*. "Head of Black Jewish Cult Dies of Burns," *Afro-American*, Aug. 1, 1936; Albert Ehrmann, "Black Judaism in New York," *Journal of Ecumenical Studies*, 8, no. 1 (Winter 1971): 103–14.

222– "IT WILL DO THE SAME FOR US": Ehrmann, "Black Judaism," p. 110.
23 "Black Israel," *News-Week*, Sept. 29, 1934, p. 25. JUST AHEAD OF THE CREDITORS: Ehrmann, "Black Judaism," p. 106. BROTZ'S ALLEGATION: *Ibid*., p. 106; Howard Brotz, *The Black Jews of Harlem: Negro Nationalism and the Dilemmas of Negro Leadership* (Glencoe, Ill.: Free Press of Glencoe, 1964), p. 12.

223– "MANNERISMS OF THE JEWS": Ehrmann, "Black Judaism," p. 105. GARVEY
24 HAD BEEN CONFINED: "Elder Robinson," *Afro-American*, Aug. 19, 1931; Ehrmann, "Black Judaism," p. 105.

224 LITTLE MORE THAN A RIPPLE: Parker, *Incredible Messiah*, p. 20.

224 "LIABLE TO BELIEVE IT": Jackman to McKay, Apr. 22, 1928, Uncat. Corr.: JWJMC/YU. "THAN ANY OTHER PEOPLE": *Ibid*. "INTOXICATED IS BEYOND ME": *Ibid*.

224– "OUT-NIGGERED MR. VAN VECHTEN": "Lady Nicotine," *The Inter-State
25 Tattler*, Mar. 16, 1928. THE BEST-SELLER LIST: McKay Obituary, New York *Herald Tribune*, May 24, 1948. "THE POWERS OF RE-CREATION": Mason to McKay, Mar. 11, 1928, Box 56: ALLP/HU. "THE FLESH AS NATURAL": John Chamberlain, "When Spring Comes to Harlem," New York *Times*, Mar. 11, 1928. "A PICTURE OF HARLEM": *The Inter-State Tattler*, Mar. 6, 1928. "TRYING TO PROVE IT?": Quoted by Wayne Cooper, ed., *The Passion of Claude McKay: Selected Prose and Poetry, 1912–1948* (New York: Schocken Books, 1973), p. 29. "DISTINCTLY LIKE TAKING A BATH": Quoted by Michael B. Stoff, "Claude McKay and the Cult of Primitivism," in *The Harlem Renaissance Remembered*, p. 131.

225– NO MORE PROMISING: McKay to Schomburg, Aug. 1, 1926, Reel No.
26 3: AASP/SCRBC. Claude McKay, *A Long Way from Home* (New York: Harcourt, Brace & World, 1970; orig. pub. 1937), chap. 25. "FIT FOR CREATIVE WORK": McKay to Schomburg, Aug. 28, 1926, Reel No. 3: AASP/SCRBC. NEW YORK PUBLIC LIBRARY: Elinor Des Verney Sinnette, "Arthur Alfonso Schomburg, Black Bibliophile and Curator: His Contribution to the Collection and Dissemination of Materials About Africans and People of African Descent" (Columbia Univ. Ph.D. diss., 1977), p. 143.

226 "EACH LINE GOES OFF": Louise Bryant Bullitt to McKay, Dec. 2, 1927: JWJMC/YU. "AS SEVENTEEN TIMES!": *Ibid.* "LUCK TO HAVE HIM DO THIS": Louise Bullitt to McKay, June 20, 1926?: JWJMC/YU. "SPY IN RUSSIA": Louise Bryant Bullitt to McKay, Dec. 18, 1926: JWJMC/YU. "FLED TO MARSEILLES": McKay, *Long Way from Home,* p. 283.

227 "LOCAL NEGRO NEWSPAPERS": Claude McKay, *Home to Harlem* (New York: Cardinal, 1965; orig. pub., 1928), p. 67.

227 "JOY IN NEW YORK": *Ibid.,* p. 16.

227 "TO SEE THAT IT IS": McKay to J. W. Johnson, Apr. 30, 1928, Ser. 1: JWJMC/YU. FLAGRANT "FILTH MONGERS": E. C. Williams, New York *News,* May 19, 1928. ANTIMULATTO SENTIMENTS: Davis, *Dark Tower,* p. 40.

228 "SURPRISES OF ITS JAZZ": McKay, *Home to Harlem,* pp. 128, 141.

228- EVERY PAGE OF HOME TO HARLEM: Mae Gwendolyn Henderson, "Por-
29 trait of Wallace Thurman," in *The Harlem Renaissance Remembered,* p. 152. "TO ALL GROUPS": Wallace Thurman, Editorial, *Harlem: A Forum of Negro Life,* 1, no. 1 (Nov. 1928): 21–22.

229 "EITHER WHITE OR BLACK": Thurman, "Book Reviews," *Harlem: A Forum of Negro Life,* pp. 31–35, p. 31. OF DARK PRINCESS: Thurman, "Book Reviews," *ibid.* "DR. DU BOIS IS NOT THIS": Thurman to Jack-man, May 17, 1928, Box 1, Fol. 1, "Small Collection": JWJMC/YU. "ALMOST TOO WELL": Thurman, "Book Reviews," pp. 31–35, p. 31.

229- BORED FISHER: TRI/Ivy and Pearl Fisher, Corinne (Mrs. Louis T.)
30 Wright.

230 "NEGROES MIGHT BE MANKIND, TOO": Rudolph Fisher, *The Walls of Jericho* (New York: Arno Press, 1969; orig. pub., 1928), p. 61.

230 SOUGHT HIS OWN LEVEL: *Ibid.,* p. 74.

230- "SAVE THOSE THAT DIE": Countee Cullen, *On These I Stand* (New York:
31 Harper & Bros., 1947), p. 72.

231 "SOLVE THE RACE PROBLEM": Thelma E. Berlack, "New Author Un-earthed Right Here in Harlem," New York *Amsterdam News,* May 23, 1928. CONDESCENDING ABOUT THE RACE: Larsen to Van Vechten, ("Monday 6th") 1922: CVVC/NYPL; Larsen to White, Mar. 12; ("Monday Nov.") 1922 (C-95): WWC/LC; TRI/G. James Fleming; Larsen, *Quicksand,* introduction by Adelaide Cromwell Hill, pp. 9–17, p. 15.

231- SHE TOLD VAN VECHTEN: Larsen to Van Vechten, "Wednesday 6th,"
32 1926: CVVC/NYPL. "SWIRL ABOUT THE BLACK AMERICAN": *The Crisis,* 35, no. 5 (June 1928): 97. OF THE MINSTREL SHOW: Roark Bradford, "Quicksand," New York *Herald Tribune,* May 13, 1928. REALLY UNDER-STANDING THE NOVEL: New York *World,* July 22, 1928. R. Bradford, New York *Herald Tribune,* May 13, 1928.

232 "HAVE HER FIFTH CHILD": Larsen, *Quicksand,* p. 222.

232-3 "WAS SHE INCAPABLE OF IT?": *Ibid.,* p. 140.

233 "OF ALL THINGS NEGROID": *Ibid.,* p. 93.

233 BEING DESTROYED BY THEM: Addison Gayle, Jr., *The Way of the New World: The Black Novel in America* (Garden City, N.Y.: Doubleday, 1975), p. 114.

233– WHEN HE RETURNED FROM FRANCE: C. S. Johnson to Cullen, Jan. 16,
34 1929, Box 3: CCP/ARC. CANAL FOR MARCH 1928: "Social Snapshots," *The Inter-State Tattler*, Mar 30, 1928, p. 4. THE LAST HEARD OF HIM: TRI/Richard Bruce Nugent.

234 "A DECADE PAST": Alain Locke, "1928: A Retrospective Review," *Opportunity*, 7, no. 1 (Jan. 1929): 8–11, p. 8. "A GREAT STORY": Jackman to Cullen, Jan. 8, 1929, Box 3: CCP/ARC. "TO DEVELOP AND FLOWER": White to Fisher, Mar. 12, 1924 (C-92): WWC/LC. "RICHER CROP" OF TALENTS: Locke, "1928," p. 8.

234–5 "LOUSY, BAD, BAD": Jackman to Cullen, Jan. 31, 1929, Box 3: CCP/ARC.

235 "NORDIC SUPREMACY": Jessie Fauset, *Plum Bun: A Novel without a Moral* (New York: Frederick A. Stokes, 1928), p. 277.

235 "WEAKER BRETHREN": *Ibid.*, p. 218.

235– "HIS TALENT," HE INSISTED: Quoted by Mae Gwendolyn Henderson, "Portrait of Wallace Thurman," in *The Harlem Renaissance Remembered*,
36 p. 153. "EVER HAD TO BE BLACK": TRI/Richard Bruce Nugent.

236 "AND KILL HIMSELF": Hughes, *Big Sea*, p. 235.

236 "NEVERTHELESS SCORCHED": Thurman to Jackman, May 17, 1928, Box 1, Fol. 4, "Small Collection": JWJMC/YU.

236– CARED TO SAY: "Harlem Negroes," New York *Times*, Mar. 17, 1929.
37 "DISTINCTLY DISHEARTENING": Eunice Hunton Carter, "The Blacker the Berry," *Opportunity*, 7, no. 5 (May 1929): 162. "WHETHER YOU ADMIT IT OR NOT": Dewey R. Jones, "The Bookshelf," Chicago *Defender*, Mar. 2, 1929. "INTO THE WHITE RACE": Wallace Thurman, *The Blacker the Berry . . . A Novel of Negro Life* (New York: Collier Books, 1970; orig. pub., 1929), p. 12. "REALLY DIDN'T KNOW": *Ibid.*, p. 46.

238 "CONVENIENT IF NOT VIRTUOUS": *Ibid.*, pp. 144–45.

238 "OF HARMON AWARDS": Hughes to Thurman, July 29, 1929, Box 1, Fol. 3: JWJMC/YU. TRUE STORY MAGAZINE: Theophilus Lewis, "Wallace Thurman Is Model Harlemite," New York *Amsterdam News*, Mar. 4, 1931; Abramson, *Negro Playwrights*, pp. 32–38. "DE CITY OF REFUGE?": Quoted, *ibid.*, p. 37.

238– "PROMISCUOUS FAKERY": Reviews quoted by Belcher, "The Place of the
39 Negro," pp. 237–39. Mason to Locke, 1929, Box 59: ALLP/HU; Abramson, *Negro Playwrights*, p. 38.

239 "WRITING AGAINST THEMSELVES": Aubrey Bowser, "Banjo," New York *Amsterdam News*, May 8, 1929. AS IN THE FIRST BOOK: Bradley to McKay, Oct. 30, 1927: JWJMC/YU.

239 "UPPER-CLASS WHITE SOCIETY": McKay, *Long Way from Home*, p. 321. "WEARS ENGLISH SUITS!": Hughes to Thurman, July 29, 1929, Box 1, Fol. 3: JWJMC/YU.

CHAPTER 8 : THE FALL OF THE MANOR
Page

240 END OF 1930: Charles S. Johnson, *The Economic Status of Negroes: A Summary and Analysis of the Materials Presented at the Conference on the Economic Status of the Negro, Held in Washington, D.C., May 11–13, 1933, Under the Sponsorship of the Julius Rosenwald Fund* (Nashville, Tenn.: Fisk Univ. Press, 1933), p. 19; Robert C. Weaver, *The Negro Ghetto* (New York: Harcourt, Brace, 1948), p. 52. REST OF MANHATTAN: Weaver, *Negro Ghetto*, pp. 53, 60; Raymond Wolters, *Negroes and the Great Depression: The Problem of Economic Recovery* (Westport, Conn.: Greenwood Press, 1970), pp. 91–92; Clyde W. Kiser, "Diminishing Family Income in Harlem: A Possible Cause of the Harlem Riot," *Opportunity*, 13, no. 6 (June 1935): 171–73.

240– BETWEEN 1920 AND 1930: C. S. Johnson, *Economic Status of Negroes*,
41 p. 47. TURN OF THE CENTURY: August Meier and Elliott Rudwick, *From Plantation to Ghetto*, 3d ed. rev. (New York: Hill & Wang, 1976), chap. 5. CHICAGO PROPERTY OWNERS: "Banker Binga in Jail Hospital," *Chicago Defender*, Mar 14, 1931. "COMMERCIAL LIFE OF THE NATION": *Opportunity*, 8, no. 9 (Sept. 1930): 264. BUSINESS FAILURES "BAFFLING": A. P. Randolph, "The Economic Crisis of the Negro," *Opportunity*, 9, no. 5 (May 1931): 145–49, p. 145.

241 TANNER PAINTINGS: J. W. Johnson to J. D. Rockefeller 3d., June 21, 1931, Ser. 1, Fol. 406: JWJMC/YU; John E. Nail to Schomburg, Aug. 5, 1933, Reel No. 1: AASP/SCRBC. "TO MAKE THINGS GO": Du Bois to Cullen, June 28, 1930, Box 2: CCP/ARC.

241– "LEADERSHIP OF THE NEGRO": Broadus Mitchell, "The Future of the
42 Negro in America," *Opportunity*, 11, no. 8 (Aug. 1933): 248–51. ACCORDING TO REDDICK: Laurence D. Reddick, "What Does the Younger Negro Think?" *Opportunity*, 11, no. 10 (Oct. 1933): 312.

242 VIABLE EIGHTEEN HUNDRED DOLLARS: Weaver, *Negro Ghetto*, p. 60. THE RISING PROLETARIAT: *Ibid.*, pp. 56–60.

242– "LOOKS QUITE SPIFFY": Jackman to Cullen, Mar. 17, 1931, Box 3: CCP/
43 ARC. "WEEP YOUR HEART OUT": Jackman to Cullen, Apr. 25, 1930, Box 3: CCP/ARC. HAD FAILED TO DO: Willie "the Lion" Smith (with George Hoefer), *Music on My Mind: The Memoir of an American Pianist* (Garden City, N.Y.: Doubleday, 1964), p. 139.

243 "ECONOMIC DISABILITIES OF NEGRO HARLEM": Walter White, Letter, New York *Herald Tribune*, Feb. 12, 1930. "A GREAT GOOD": D. J. Small, Letter, New York *Herald Tribune*, Feb. 16, 1930.

243– TO SEE LINCOLN WIN: *The Dunbar News*, Nov. 13, 1929, p. 1. "EAT AND
44 DRINK": Jackman to Cullen, Nov. 8, Dec. 12, 1929, Box 3: CCP/ARC. ONE OF THE LARGEST: TRI/Richard Bruce Nugent, Ivy and Pearl Fisher, Gerri Major, Regina Andrews. Richard O'Connor, *Heywood Broun: A Biography* (New York: Putnam's, 1975), p. 72.

244 "THE MENU, PLEASE": TRI/Henry Lee Moon.

244 "BY THIS TIME": Richard Bruce Nugent, "Blanche Dunn": FWP/
SCRBC, p. 3.

244– WERE ON WEDNESDAYS: "Social Snapshots," *The Inter-State Tattler*, Sept.
45 5, 1930.

245 "THE OTHER BIG LIGHTS": Jackman to Cullen, Sept. 20, 1929, Box 3:
CCP/ARC. TWO OTHER SENIOR OFFICIALS: Robert W. Bagnall to Wil-
liam Pickens, Oct. 19, Dec. 11, 1929, Box 1–2: WPRG/SCRBC. "YOUR
PEOPLE, HMM, HMM!": Jackman to Cullen, Dec. 12, 1929, Box 3:
CCP/ARC.

245– WHAT PRICE GLORY: Brooks Atkinson, quoted by Fannin S. Belcher, "The
46 Place of the Negro in the Evolution of the American Theatre, 1767 to
1940" (Yale Univ. Ph.D. diss., 1945), p. 242. "TRUE OF FOLK LIFE":
Sterling Brown, *Negro Poetry and Drama and the Negro in American
Fiction* (New York: Atheneum, 1969; orig. pub., 1937), pp. 119–20.

246 "REALM OF GREAT ART": White to Aaron Bernd, Mar. 10, 1930 (C-98):
WWC/LC. TRANSLATOR OF THE PLAY: White to Arthur Spingarn, Apr.
3, 1930, Box 6: ASP/HU. UNANIMOUSLY ENTHRALLED: Hughes, "Trouble
with Angels," *New Theatre*, July 1935, pp. 6–7.

246– "PROCESS OF MAKING": James Weldon Johnson, *Black Manhattan* (New
47 York: Atheneum, 1972; orig. pub., 1930), p. 281. "EMERGENCE HAS TAKEN
PLACE": *Ibid.*, p. 260.

247 THE NAACP SECRETARY: Phelps Stokes to J. W. Johnson, Jan. 8, 1929, Ser.
1, Fol. 463: JWJMC/YU; Walter White, *A Man Called White: The
Autobiography of Walter White* (Bloomington: Univ. of Indiana Press,
1948), p. 141; Eugene Levy, *James Weldon Johnson: Black Leader, Black
Voice* (Chicago: Univ. of Chicago Press, 1973), chap. 14.

247– "TWENTY YEARS TO COME": Embree to J. W. Johnson, Apr. 4, Apr. 24,
48 1929; J. W. Johnson to Embree, Apr. 27, 1929; Embree to J. W. Johnson,
May 17, 1929, Ser. 1, Fol. 414: JWJMC/YU. FELLOWSHIPS TO AFRO-
AMERICANS: Edwin P. Embree and Julia Waxman, *Investment in People:
The Story of Julius Rosenwald* (New York: Harper & Bros., 1949), pp.
157–61. SALARY FOR ONE YEAR: J. W. Johnson to Embree, June 18, 1924,
Ser. 1, Fol. 414: JWJMC/YU.

248 "AVERAGE MAN POSSESSES": J. W. Johnson to Mencken, Dec. 19, 1923:
HLMC/NYPL. DECEMBER 17: Levy, *Johnson*, p. 290. "UNITED STATES
SENATE": "James Weldon Johnson Dinner" (Spingarn Misc.): CCMC/
AU. White, *Man Called White*, p. 115.

248– NARROW SENATE DEFEAT: White, *Man Called White*, p. 106; John Hope
49 Franklin, *From Slavery to Freedom: A History of Negro Americans*, 5th
ed. rev. (New York: Knopf, 1980), pp. 385–86.

249 LATEST WORK IMMEDIATELY: White to Bontemps, Aug. 8, 1930 (C-102):
WWC/LC. HARMON DEADLINE: White to S. Brown (telegram), Sept. 2,
1930 (C-104): WWC/LC. GOLD MEDAL: White to Harmon Foundation,
Oct. 22, 1930 (C-102): WWC/LC. "INTEREST IN MR. PACE": Blanche
Knopf to White, Mar. 22, 1933 (C-104): WWC/LC. "TO SEE ME":
White to Hughes, May 5, 1931 (C-100): WWC/LC.

249– "THE YEAR OF GRACE": *Opportunity*, 9, no. 2 (Feb. 1931): 48–51. ABOUT
 50 PLAGIARISM: Jackman to Cullen, Jan. 27, Mar. 13, 1930, Box 3: CCP/
 ARC. BANTER AT VAN VECHTEN'S: TRI/Richard Bruce Nugent.

250 "SIMPLY AN AMERICAN": Toomer to J. W. Johnson, July 11, 1930, Box 4,
 Fol. 11: JTC/FU.

250– "MUCH MORE CALAMITOUSER!": Langston Hughes, *Not Without Laughter*
 51 (New York: Collier Books, 1969; orig. pub., 1930), pp. 7, 178.

251– "GIVES TO WHITE FOLKS": *Ibid.*, p. 65. "FOR ALL OF US": *Ibid.*, p. 256.
 52 REPROACHES ANN JEE AND SANDY: *Ibid.*, p. 303. "LOOK FOLKS IN THE FACE":
 Ibid., p. 119.

252 "IF THEY DON'T KNOW IT": *Ibid.*, p. 181. "ILLUSTRATED BY COVARRU-
 BIAS": Walt Carmon, "Away from Harlem," *New Masses*, Oct. 1930,
 pp. 17–18.

252 SCHUYLER WAS FOND OF SAYING: Quoted by Jervis Anderson, A. *Philip
 Randolph: A Biographical Portrait* (New York: Harcourt Brace Jovano-
 vich, 1972), p. 144. MISCHIEVOUS AUTHOR HIMSELF: Schuyler to White,
 Aug. 20, 1930 (C- 102): WWC/LC. "ITS TRIBE INCREASE": Alain Locke,
 "We Turn to Prose," *Opportunity*, 10, no. 1 (Jan. 1932): 40–44, p. 43.

252– PROFIT OF HIS PLANS: George Schuyler, *Black No More: Being an Ac-
 53 count of the Strange and Wonderful Workings of Science in the Land of
 the Free, A.D. 1933–1940* (New York: Collier Books, 1971; orig. pub.,
 1931), p. 72. Compare Schuyler's novel with Paul Morand, *Black Magic*
 (New York: Viking, 1929).

253 "DR. CROOKMAN'S FEE": Schuyler, *Black No More*, p. 87.

253 "NOT TO BE SO WHITE": *Ibid.*, p. 219. "EXCEEDINGLY PALE": *Ibid.* "NA-
 TIONAL SOCIAL EQUALITY LEAGUE": *Ibid.*, p. 220.

253– "NEW YORK INSURANCE COMPANY": *Ibid.*, p. 155. "NOTHING TO CON-
 54 SERVE": *Ibid.*, p. 95.

254 "ON THE NEGRO PROBLEM": *Ibid.*, p. 89.

254 "UPLIFT OF MY RACE": *Ibid.*, p. 94.

254– A LONDON PRIVATE HOME: "London Hotel Bows to American Prejudice,"
 55 Chicago *Defender*, Sept. 7, 1929, p. 4.

255 "THE ROOMS ANY LONGER": Quoted in "Prejudice Stirs Up England,"
 Chicago *Defender*, Oct. 26, 1929, p. 1. Marie Seton, *Paul Robeson* (Lon-
 don: Dennis Dobson, 1958), p. 51; Dorothy Butler Gilliam, *Paul Robe-
 son: All-American* (New York and Washington, D.C.: The New Republic
 Book Co., 1976), p. 55. "GOVERNMENT CAN INTERVENE": Quoted by
 Seton, *Robeson*, p. 178.

255 SECOND-RATE VESSEL: "Gold Star Mothers Sail for France," *Variety*, July
 19, 1930: 1.

255– "HE IS A NIGGER!": J. W. Johnson, *Saint Peter Relates an Incident
 56 of the Resurrection Day* (New York: Viking, 1935; orig. pub., 1930),
 p. 18.

256 THIRD-CLASS PASSAGE WAS AVAILABLE: C. S. Johnson to Schomburg, 1930,
 Box 3, Reel No. 2: AASP/SCRBC.

256 MENTIONED AGAIN IN HARLEM: Myrtle Evangeline Pollard, "Harlem As Is: Sociological Notes on Harlem Social Life," 2 vols. (City College of New York B.B.A. thesis, 1936), 2: 55–56.

256– "BE HUNGRY TOMORROW": Langston Hughes, *The Big Sea: An Autobiog-*
57 *raphy* (New York: Hill & Wang, 1975; orig. pub., 1940), p. 317. "GET-TING INTO AN AUTOMOBILE": Jackman to Cullen, Jan. 3, 1929, Box 3: CCP/ARC. NEVER BEEN A COMEDY: Hughes to Arthur Spingarn, Jan. 21, 1931, Box 13: ASP/HU.

257 "TIRED OF SUPPORTING ME": Hughes, *Big Sea*, pp. 230, 324. "SURGING" THROUGH HIM: *Ibid.*, p. 325.

258 "DE WALDORF-ASTORIA'S OPEN!": Quoted by Faith Berry, ed., *Good Morning Revolution: Uncollected Social Protest Writing by Langston Hughes* (New York: Lawrence Hill & Co., 1973), pp. 19–22.

258–59 BEEN GOOD ENOUGH: Hughes, *Big Sea*, p. 323.

259 "GAS THE AIR!": *New Masses*, Dec. 1930, p. 4.

259 "BUT NOT BREAK": Locke to Mason, Mar. 5, 1930, Box 56; Hurston to Mason, Jan. 20, 1931, Box 180: ALLP/HU. TRI/Louise Thompson Patterson. "SO DEAR TO ME": Hughes, *Big Sea*, p. 325.

259–60 "HATED MY FATHER": *Ibid.*, p. 327.

260 HAD BEEN A COLLABORATION: Robert E. Hemenway, *Zora Neale Hurston: A Literary Biography* (Urbana: Univ. of Illinois Press, 1977), p. 143. "SHOULD THINK OF": Arthur Spingarn to Hughes, Jan. 24, 1931, Box 48: ASP/HU.

260– "MY DIALOGUE, MY SITUATIONS": Hurston to Hughes, Jan. 18, 1931, Box
61 48: ASP/HU. UNDER BOTH NAMES: Hughes, *Big Sea*, p. 333; Rowena Jelliffe to Arthur Spingarn, Jan. 30, 1931, Box 48: ASP/HU; Hughes to Van Vechten, Feb. 4, 1931, Fol. 14 ("Joel Spingarn"): JWJMC/YU. FULL-LENGTH COMEDY: Hemenway, *Hurston*, p. 149.

261 JOURNAL OF NEGRO HISTORY: *Ibid.*, p. 96. HUGHES'S EXPULSION: Zora Neale Hurston, "Wind in De Banjo," 1930, Box 56: ALLP/HU.

261– "TURNED TO NOEL COWARD": Hughes, *Big Sea*, p. 334. SAID SCHUYLER:
62 Schuyler to Mencken, June 16, 1931: HLMC/NYPL. AND EXHIBITIONS: Cedric Dover, *American Negro Art* (Greenwich, Conn.: New York Graphic Society, 1960), pp. 31–33.

262 AFRO-AMERICAN ACHIEVEMENT: "Harmon Will," Chicago *Defender*, July 21, 1928. ELIZABETH PROPHET AND AUGUSTA SAVAGE: Dover, *American Negro Art*, p. 31; Beattie Brady to Hannah Moriarta, June 11, 1931, Box 78: HFR/LC. SYNCOPATION: Archibald Motley, Box 78: HFR/LC.

262– "ACHIEVEMENTS OF THE AMERICAN NEGRO?": Woodruff to Brady, Mar. 20,
63 1929, Box 19: HFR/LC.

263 "COLLEGES AND UNIVERSITIES:" Brady to Moriarta, June 11, 1931, Box 78: HFR/LC.

263– "NEGRO ARTISTS HAVE EMERGED": Quoted by Dover, *American Negro Art*,
64 p. 31.

264 BLACK AND WHITE CLUB: Maxwell Bodenheim, *Naked on Roller Skates* (New York: Horace Liveright, 1931), p. 116. "NEGRO WRITERS THEMSELVES": J. W. Johnson to Brawley, Mar. 28, 1932, Ser. 1, Fol. 57: JWJMC/YU. Nan Bagby Stephens, *Glory* (New York: John Day, 1931). BY OSCAR MICHEAUX: Thomas Cripps, *Slow Fade to Black: The Negro in American Films, 1900–1942* (New York: Oxford Univ. Press, 1977), pp. 191–93. WAS THE RESULT: George Schuyler, *Black and Conservative: The Autobiography of George S. Schuyler* (New Rochelle, N.Y.: Arlington House, 1966), pp. 174–81.

264– AND LADY COOK: "Jules Bledsoe," Schomburg Vertical Files: SCRBC.
65 COVENTRY STREET RESTAURANT: "Nora Holt," Chicago *Defender*, Sept. 7, 1929, p. 7. IN ONE WEEK: "Prince of Wales at Café de Paris," Chicago *Defender*, Feb. 22, 1930, p. 6. "AND THEN GO DO IT": Eslande Goode Robeson, *Paul Robeson, Negro* (New York: Harper & Bros., 1930), p. 73. LOVE WITH LADY MOUNTBATTEN: TRI/Wilhelmina Adams, Poppy Cannon, Ivy and Pearl Fisher, Dorothy West. "AND LEFT": Mason to Locke, Mar. 1, 1931, Box 59: ALLP/HU.

265 "AGE WAS 46 YEARS": "Mme. Lelia W. Robinson," *New York Times*, Aug. 17, 1931. "GET ME SOME ICE": Quoted in "Death Follows Hearty Dinner at Longbranch," *Afro-American*, Aug. 22, 1931.

265– "LAID THEM ON THE BIER": Hughes, *Big Sea*, pp. 246–47. "Three Hun-
66 dred at Farewell of Heiress," Chicago *Defender*, Aug. 29, 1931.

266 HALF A MILLION DOLLARS: "A'Lelia Walker's Will," New York *Age*, Sept. 5, 1931.

266 "MYSTERY AND THE UNKNOWN": Toomer, "The Second River, or From Exile into Being: A Record of Experience," Box 37: JTC/FU. S. P. Fullinwider, *The Mind and Mood of Black America: 20th Century Thought* (Homewood, Ill.: The Dorsey Press, 1969), pp. 141–42. "UNUSUAL AND INTERESTING MATERIAL": Janet Cohn to Toomer, Mar. 1, 1928; Toomer to Miss Baumgarten, Sept. 4, 1928, Box 1, Fol. 4; Faber and Faber to Toomer, Feb. 23, 1931; Clifton Fadiman to Toomer, Jan. 22, 1932, Box 3; Farrar & Rinehart to Toomer, May 6, 1930, Box 3; Harcourt, Brace to Toomer, Mar. 6, 1928, Box 4, Fol. 4; Harper & Bros. to Toomer, July 15, 1931, Box 4, Fol. 4; Knopf to Toomer, Dec. 1, 1930, Box 4: JTC/FU.

266– IN AMERICAN LITERATURE: Toomer to Carey, Sept. 20, 1927, Box 3,
67 Fol. 4: Toomer to Josephine Beardsley, Nov. 1, 1930, Box. 1, Fol. 1: JTC/FU. ZONA GALE AND JEAN TOOMER: Latimer to Shirley Grove, Jan. 6, 1931, Box 5, Fol. 12; Latimer to Carl Rakosi, Mar. 1931, Box 5, Fol. 17; Latimer to Meridel Le Sueur, June 1931, Box 6, Fol. 2: JTC/FU. "MAGNIFICENT LOOKING": Latimer to Meridel Le Sueur, June 1931, Box 6, Fol. 2: JTC/FU. FIRST-BORN IN AUGUST: Mabel Dodge to Toomer, Nov. 17, 1931, Apr. 23, 1932, Box 7, Fol. 1: JTC/FU.

267 "NEGROID CHARACTERISTICS": "Races—Just Plain Americans," *Time*, Mar. 28, 1932, p. 19. Toomer to *Time*, 1932, Box 9, Fol. 2: JTC/FU. SYMBOLIC NOVEL-IN-PROGRESS: Darwin T. Turner, *In a Minor Chord: Three Afro-American Writers and Their Search for Identity* (Carbondale: Southern Illinois Univ. Press, 1971), p. 51. CRUCIFIED BY THE PRESS: Latimer to Meridel Le Sueur, Mar. 1932, Box 6, Fol. 2: JTC/FU.

267– LETTER OF CONDOLENCE: Toomer to White, Aug. 31, 1932 (C-103):
 68 WWC/LC. UNIVERSITY IN NEW ORLEANS: White to Bontemps, Nov. 16,
 1931; White to John Hope, Nov. 12, 1931; White to John Troustine,
 Sept. 3, 1931; Cunard to White, Sept. 2, 1931 (C-101): WWC/LC.

268– "SICK IN THOSE SURROUNDINGS": White, *Man Called White*, p. 136. "DIE
 69 IN PEACE": *Ibid.*, pp. 136–37.

269 "BREW" IN HIS HONOR: Hughes to White, Dec. 8, 1931 (C-101): WWC/
 LC. Langston Hughes, *I Wonder As I Wander: An Autobiographical
 Journey* (New York: Hill & Wang, 1964; orig. pub., 1956), p. 46. TALK
 AND DRINK: *Ibid.*, p. 49. THE PLANTATION GATE: Julia Peterkin to Mencken,
 1932: HLMC/NYPL ("Our Black people are different from Waldo Frank
 and Jean Toomer"). TRI/Arthur P. Davis. COME TO READ POETRY:
 Hughes, *I Wonder*, p. 61.

269– "AN ARTISTIC ANIMAL": Tate to Mabry, Jan. 20, 1932 (C-102): WWC/
 70 LC.

270 HUGHES AND JOHNSON WAS CANCELLED: Mabry to Tate, Jan. 22, 1932;
 Tate to Mabry, Jan. 25, 1932; Mabry to White, Aug. 30, 1932 (C-102):
 WWC/LC; Levy, *Johnson*, p. 328. TO DROP THE IDEA: Levy, *Johnson*,
 p. 328.

270–"WELL THEY MIGHT BE!": Floyd G. Snelson, "Van Vechtens Desert 'Gay
 71 Spots' of Harlem," Pittsburgh *Courier*, Jan. 23, 1932. "EXTEND HER PLEA-
 SURING": "Harlem Attacks Ofay Julia," *Afro-American*, Apr. 23, 1932.

271 "COMMUNIST PROPAGANDA": "Walter White," *The Union*, July 16, 1931.

271– "INTERESTED IN PROPAGANDA": White, quoted by Dan T. Carter, *Scotts-
 72 boro: A Tragedy of the American South* (New York: Oxford Univ. Press,
 1969), p. 53. "AGENCIES PUT TOGETHER": *Ibid.*, p. 60. "CERTAIN PEO-
 PLE": *Ibid.*, p. 86. VIVENDI WITH THE ILD: *Ibid.*, p. 89.

272 TO THE PRESS: *Ibid.*, p. 72. "THEY WILL DIE": *Ibid.*, p. 91. BY THE NAACP:
 White to J. W. Johnson, Jan. 15, 1932, Ser. 1, Fol. 540: JWJMC/YU.
 "ON THE ARKANSAS CASES": J. W. Johnson to White, Jan. 25, 1932, Ser. 1,
 Fol. 540: JWJMC/YU.

272– "STARS LIKE RAMON NAVARRO": White to Johnson, Jan. 15, 1932, Ser. 1,
 73 Fol. 540: JWJMC/YU. AT THE SAINT MORITZ: George Oppenheimer, *The
 View from the Sixties: Memories of a Spent Life* (New York: McKay,
 1966), p. 50.

273 "VULNERABLE," SHE REMEMBERED: Poppy Cannon, *A Gentle Knight: My
 Husband, Walter White* (New York: Rinehart, 1953), p. 9. TRI/Poppy
 Cannon.

273– "INTERESTS AND PURSUITS": Zona Gale, Introduction to *The Chinaberry
 74 Tree: A Novel of American Life* (Frederick A. Stokes, 1931), p. vii. "ECO-
 NOMIC INJUSTICE": Fauset, in Foreword to *Chinaberry*, p. ix. FREDERICK A.
 STOKES: Gerald Sykes, "Amber-Tinted Elegance," *The Nation*, July 27,
 1932. "BOOK IS VALUABLE": Arthur P. Davis, *From the Dark Tower: Afro-
 American Writers, 1900–1960* (Washington, D.C.: Howard Univ. Press,
 1974), p. 93. AUBREY BOWSER AGREED: Theophilus Lewis, "Harlem Sketch
 Book," New York *Amsterdam News*, Jan. 19, 1932; "First Time in
 History," Pittsburgh *Courier*, May 21, 1931; Aubrey Bowser, "New

Books," New York *Amsterdam News*, June 19, 1932. "SIMPLER AND MORE KIND-HEARTED": Martha Gruening, "Black Is White," *New Republic*, Feb. 14, 1934.

274- OR THE JUNGLE: Alain Locke. "Black Truth and Black Beauty," *Oppor-*
75 *tunity*, 11, no. 1 (Jan. 1933): 14–18. "SIGNIFICANCE OF THIS VOLUME": Quoted by Sterling Stuckey in Preface to Sterling A. Brown, *Southern Road* (Boston: Beacon Press, 1974: orig. pub., 1932), p. xvi. "OBSEQUIOUS- NESS TO WHITES": Jessie Fauset to Locke, Jan. 9, 1933, Box 149: ALLP/HU.

275 TO CARRY A LARGE MESSAGE: Brown, *Negro Poetry*, pp. 134–35. TIME MAGAZINE WROTE: "Conjure Man," *Time*, Aug. 1, 1932; Brown, *Negro Poetry*, p. 136; Davis, *Dark Tower*, p. 103.

275- BECOMES A POLITICAL TRACT: Brown, *Negro Poetry*, chap. 11. COMPEN-
76 SATED FOR BY TRUE ART: Alain Locke, "Black Truth," p. 16. Sterling Brown, "Georgia Nigger," *Opportunity*, 11, no. 2 (Feb. 1933): 59.

276 FAREWELL TO ORIGINAL POETRY: Jackman to Cullen, Oct. 20, 1929, Box 3: CCP/ARC ("I bet the niggers will start talking now"). Jean Wagner, *Black Poets of the United States: From Paul Laurence Dunbar to Langston Hughes* (Urbana: Univ. of Illinois Press, 1973), p. 290. BYNNER CHAL- LENGED CULLEN: Bynner to Cullen, Nov. 22, 1929: WB-CC/HU. "MY DARNDEST THIS TIME": Cullen to Bynner, Dec. 11, 1929: WB-CC/HU. "HOLD HER SWAY": Quoted by Wagner, *Black Poets*, p. 290.

276- "DONE IT RATHER WELL": C. S. Johnson to Cullen, May 18, 1931, Box 3:
77 CCP/ARC.

277 "AMEN": Wagner, *Black Poets*, p. 338.

277- "REGRET ALL THE KEENER": Locke, "Black Truth," p. 116. "OFTEN IN-
78 CREDIBLY BAD": "Harlem Bohemia," *New York Times*, Feb. 28, 1932. "DISILLUSIONMENT ON MANY OCCASIONS": Thurman, quoted by Mae Gwendolyn Henderson, "Portrait of Wallace Thurman," in *The Harlem Renaissance Remembered: Essays Edited with a Memoir*, ed. Arna Bon- temps (New York: Dodd, Mead, 1972), p. 157.

278 "THE PATH OF RIGHTEOUSNESS": Thurman to Rapp, "Thursday," 1929, Box 1, Fol. 7; n.d. (1929?), Box 1, Fol. 7; "Tuesday," n.d., Box 1, Fol. 7, "Small Collections": JWJMC/YU.

278- "PROUD, BUT ISN'T": T. Lewis, quoted by Henderson, "Thurman," p. 158.
79 END UP COMATOSE: TRI/Aaron Douglas, Richard Bruce Nugent, Dorothy West. ONE OF PERSONALITY: Thurman to Rapp, May 7, 1929, Box 1, Fol. 7: JWJMC/YU.

279 "CIVILIZED TIPPLING": Thurman to Jackman, Aug. 30, 1930, Box 1, Fol. 3: JWJMC/YU. HER DYING MOTHER: Thurman to Rapp, three undated let- ters, Box 1, Fol. 7; Thurman to Jackman, Aug. 30, 1930, Box 1, Fol. 3: JWJMC/YU. "ANY KIND OF INTEREST": Thurman to Rapp, "Tuesday," n.d.; May 7, 19, 1929, Box 1, Fol. 7: JWJMC/YU.

279- OR AN ARTIST: Henderson, "Thurman," p. 165. "AND VERY TRUE":
80 Hughes to Thurman, n.d., Box 1, Fol. 3: JWJMC/YU. THE EMPLOY- MENT BUREAU: TRI/Richard Bruce Nugent, Arthur P. Davis, Dorothy West. "EVASION AT ANY TIME": Wallace Thurman, *Infants of the Spring*

(New York: Books for Libraries Press, 1972; orig. pub., 1932), p. 16. "THAT'S JEAN TOOMER": *Ibid.*, p. 221. "CUT THE FOOL": *Ibid.*, p. 230.

280 "FREEDOM AND EQUALITY": *Ibid.*, pp. 234, 91.

280–1 "WILL REMAIN WHERE THEY ARE": *Ibid.*, pp. 141–42, 145.

281 "POSSESSION OF THE SKY": *Ibid.*, p. 284.

CHAPTER 9: IT'S DEAD NOW

Page

282 "COMMUNIST PARTY": Fitzgerald, quoted by William E. Leuchtenburg, *The Perils of Prosperity, 1914–1932* (Chicago: Univ. of Chicago Press, 1958), p. 261. Richard O'Connor, *Heywood Broun: A Biography* (New York: Putnam's, 1975), pp. 162–64. "REVOLUTIONARY MOVEMENT": Cowley, quoted by Michael Gold, *The Hollow Men* (New York: Internationl Publishers, 1941), p. 38. "THE PRESENT SYSTEM": "Cullen Supports Communists!" *The Union*, Sept. 22, 1932.

282– "IT WON'T BE DOWNED": Richetta Randolph to J. W. Johnson, Apr. 18,
83 1932, Ser. 1, Fol. 386: JWJMC/YU. *Opportunity*, 10, no. 12 (Dec. 1932): 68. Nancy J. Weiss, *The National Urban League, 1910–1940* (New York: Oxford Univ. Press, 1974), pp. 244–45; Elliott M. Rudwick, *W. E. B. Du Bois: Propagandist of the Negro Protest* (New York: Atheneum, 1968), pp. 269–70. "HARD TIMES ALL MY LIFE": Marie Frazier to Cullen, Feb. 13, 1932, Box 2: CCP/ARC.

283 FEDERAL DEPARTMENT OF EDUCATION: "Tattler Platform," *The Inter-State Tattler*, Mar. 26, 1932, p. 4. POLITICS IN THE CARIBBEAN: *The Inter-State Tattler*, Feb. 25, 1932.

283– "PAID IN FULL": Quoted by Leslie Fishel, "The Negro in the New Deal
84 Era," in *The Negro in the Depression and War: Prelude to Revolution, 1930–1945*, ed. Bernard Sternsher (Chicago: Quadrangle Books, 1961), p. 8. BACKERS AND ADVISERS: Locke to Mason, Mar. 4, 1933, Box 57; Nov. 1, 1934, Box 58: ALLP/HU.

284 THEY WERE REJECTED: Raymond Wolters, *Negroes and the Great Depression: The Problem of Economic Recovery* (Westport, Conn.: Greenwood Press, 1970), pp. 137–38. "WORK AMONG THE WHITES": Oswald G. Villard, "Guest Editor," *Opportunity*, 12, no. 2 (Feb. 1934): 39. "CAN'T TAKE THAT RISK": Walter White, *A Man Called White: The Autobiography of Walter White* (Bloomington: Univ. of Indiana Press, 1970; orig. pub., 1948), pp. 169–70.

284– MANIFESTO WAS MEANINGLESS: E. Franklin Frazier, "La Bourgeoisie
85 noire," *The Modern Quarterly*, 5, no. 1 (1928–30): 78–84, p. 80.

285 "$$$$": Langston Hughes, ed., "Elderly Race Leaders," in *Race: Devoted to Social Political & Economic Equality, 1935–1936*, (Westport, Conn.: Negro Universities Press, 1970), p. 87.

285 "THE GOOD OF THE FEW": George Streator, "In Search of Leadership," in *Race*, pp. 14–20, p. 20.

285– BONUS MARCHERS: B. Brawley to J. W. Johnson, Sept. 6, 1932, Ser. 1,
86 Fol. 54: JWJMC/YU.

286 "COLOR DISCRIMINATION": W. E. B. Du Bois, "Marxism and the Negro Problem," *The Crisis,* 40, no. 5 (May 1933): 103–4, 118, p. 104.

286 "TOOK ITS TOLL": Streator, "In Search of Leadership," p. 12. E. Franklin Frazier, "The Du Bois Program in the Present Crisis," in *Race,*" pp. 11–13. "RESORT TO PHYSICAL FORCE": J. W. Johnson, *Negro Americans, What Now?* (New York: Viking Press, 1935), p. 11. J. W. Johnson to Arthur Spingarn, Sept. 15, 1934, Ser. 1, Fol. 450: JWJMC/YU.

286– COMMUNIST PARTY OF THE U.S.A.: Wilson Record, *The Negro and the*
87 *Communist Party* (Chapel Hill: Univ. of North Carolina Press, 1951), p. 26. AT EVERY TURN: J. Spingarn to Ovington, Mar. 28, 1933: JSC/NYPL. B. Joyce Ross, *J. E. Spingarn and the Rise of the NAACP, 1911–1939* (New York: Atheneum, 1972), p. 173. "MAY AS WELL FOLD UP": Streator to J. Spingarn, Dec. 16, 1933: JSC/NYPL.

287 "THE OTHER DIVERSIONS": White, *Man Called White,* p. 141. "YOU HAVE TO SAY": Quoted by Murray Kempton, in *Part of Our Time: Some Monuments and Ruins of the Thirties* (New York: Dell, 1967; orig. pub., 1955), p. 254. "REPLY" HE COULD THINK OF: Benjamin J. Davis, "Why I Am a Communist," *Phylon,* 8 (1947): 105–16, p. 109. PARTY TO THE CAUSE: "NAACP Betrayal of Peterson Evokes Mass Anger in Birmingham," *Liberator,* July 29, 1933, p. 1.

287– "ON THEIR LAST LEGS": Locke to Mason, July 10, 1931, Box 56: ALLP/
88 HU. EASTMAN SCHOOL OF MUSIC: Locke to Mason, May 24, 1931, Box 56: ALLP/HU. Maude Cuney Hare, *Negro Musicians and Their Music* (Washington, D.C.: Associate Publishers, 1936), p. 335. TO PROSTITUTE THEIR ART: Locke to Mason, Mar. 10, May 22, 1931, Box 56; Mar. 7, Apr. 25, 1932, Box 57: ALLP/HU. "ALREADY BROKEN BEFORE": Locke to Mason, July 7, 1932, Box 57: ALLP/HU. "WE ARE LOST": Hurston to Mason, Oct. 15, 1931, Box 180: ALLP/HU.

288– GANGPLANK ON JUNE 15: Langston Hughes, *I Wonder As I Wander: An*
89 *Autobiographical Journey* (New York: Hill & Wang, 1964; orig. pub., 1956), p. 69. Louise Thompson Patterson, "With Langston Hughes in the USSR," *Freedomways: A Quarterly Review of the Negro Freedom Movement,* 8, no. 2 (Spring 1968): 152–58. TRI/Louise Thompson Patterson. BIRMINGHAM, ALABAMA: Locke to Mason, Mar. 26, 1932, Box 57: ALLP/HU. Homer Smith, *Black Man in Red Russia: A Memoir* (Chicago: Johnson Publishing Co., 1964), pp. 23–24.

289 AGAINST HUGHES AND THOMPSON: Locke to Mason, June 16, 1932, Box 57: ALLP/HU.

289– NOT DARK ENOUGH: Smith, *Black Man in Red Russia,* p. 25. HOSTS SOME-
90 HOW OBLIGED: Thompson, "With Langston Hughes," p. 154. HUGHES, MILLER, AND THOMPSON: Hughes, *I Wonder,* p. 123; Smith, *Black Man in Red Russia,* pp. 28–29.

290 "ALWAYS THE THEATRE": Thompson, "With Langston Hughes," p. 155. WERE INVARIABLY HOISTED: TRI/Dorothy West; Smith, *Black Man in Red Russia,* p. 35; Hughes, *I Wonder,* pp. 82–86.

290– "ITS ROOTS ARE DESTROYED": Henry Lee Moon, "A Negro Looks at Soviet
91 Russia," *The Nation,* Feb. 28, 1934, pp. 244–46, p. 246. "KEEP SILENT

FOR A MOMENT": Langston Hughes, "A New Song," *Liberator*, Oct. 15, 1932, p. 5. Hughes, "The Same," *The Negro Worker*, 2, nos. 9–10 (Sept./Oct. 1932): 31; Hughes, "Scottsboro, Limited: A One Act Play," *New Masses*, Nov. 1931, pp. 18–21. GOD'S TROMBONES: Jean Wagner, *Black Poets of the United States: From Paul Laurence Dunbar to Langston Hughes* (Urbana: Illinois Univ. Press, 1973), p. 361.

291 "STALIN WORKER ME": Langston Hughes, "Goodbye Christ," *The Negro Worker*, 2, nos. 11–12 (Nov./Dec. 1932): 32.

291 EDITORIAL SURGERY: Hughes, *I Wonder*, pp. 89–90. "COURTESY TO TELL US": Hughes, *I Wonder*, p. 95; TRI/Louise Thompson Patterson, Dorothy West, Henry Lee Moon. DISINTEGRATION OF THE GROUP: Locke to Mason, Aug. 11, 1932, Box 57: ALLP/HU.

291– WOULD PASS THAT WAY: Jerre Mangione, *The Dream and the Deal: The* 92 *Federal Writers' Project, 1935–1943* (New York: Avon Books, 1972), chap. 4.

292– "ALL UNDUE FAMILIARITY": Arthur Koestler, *The Invisible Writing,* 93 *Being the Second Volume of Arrow in the Blue: An Autobiography* (New York: Macmillan, 1954), pp. 111–12. IMPERATIVES OF REVOLUTIONARY JUSTICE: Hughes, *I Wonder*, pp. 116–17. "THE TRIAL DISTURBED HIM": *Ibid.*, p .117.

293 "WORK OF ART": Van Vechten to Hughes, Mar. 20, 1934, cited by Bruce Kellner, ed., "Selected Writings of Carl Van Vechten About Negro Arts and Letters" (Manuscript published as *"Keep A-Inchin' Along"* [Westport, Conn.: Greenwood Press, 1979]). "BACK TO CAPITALISM": Hughes, *I Wonder*, p. 282.

293 "HIS ART INTO MONOTONY": *New York Times*, June 28, 1934. Hughes, *I Wonder*, p. 213; D. H. Lawrence, *The Lovely Lady* (New York: Vintage Books, 1971; orig. pub., 1933), p. 110.

• 293 "DRESSED UP IN ALABAMA": Langston Hughes, *The Ways of White Folks* (New York: Vintage Books, 1971; orig. pub., 1933), p. 110.

294 BECAME ILL—DRAINED: Locke to Mason, Aug. 28, 1933, Box 57: ALLP/HU. TO CHARLOTTE MASON: Locke to Mason, Aug. 28, 1933, Box 57: ALLP/HU.

294 FOR BLACK MANHATTAN: Herbert Aptheker, ed., *The Correspondence of W. E. B. Du Bois: Selection 1934–1944*, 2 vols. (Amherst: Univ. of Massachusetts Press, 1976), 2:4. POWERS OF EMPATHY: Pearl S. Buck, "The Road to the Future," *Opportunity*, 9 no. 6 (June 1933): 170–73, pp. 171–72. TRADITIONS WERE LACKING: *Opportunity*, 13, no. 1 (Jan. 1935): 7.

294– NOT VERY HAPPILY THEREAFTER: TRI/Ida Mae Cullen, Mae Wright 95 Peck.

295 IN CHARACTER DEPICTION: S. Brown, "Banana Bottom," *Opportunity*, 11, no. 7 (July 1933): 217–22.

295 "UNCHANGEABLE SELVES": Claude McKay, *Banana Bottom* (New York: Harcourt, Brace & World, 1961; orig. pub., 1933), p. 169.

295 "GENIUSES WE HAVE": Max Eastman to J. W. Johnson, May 24, 1933,
Ser. 1, Fol. 140: JWJMC/YU. FOR A FELLOWSHIP: J. W. Johnson to
McKay, Jan. 9, 1934, Ser. 1, Fol. 140: JWJMC/YU. SOURED THE WHITE
LIBERALS: McKay to J. W. Johnson, May 31, 1935, Ser. 1, Fol. 140:
JWJMC/YU.

295– BY A'LELIA WALKER: Claude McKay, "Harlem Glory" (unpub. manu-
96 script, SCRBC); Claude McKay, "Romance in Marseilles" (unpub.
manuscript, SCRBC). EXPIRED FAD: Wayne Cooper, ed., *The Passion of
Claude McKay: Selected Prose and Poety, 1912–1948* (New York:
Schocken, 1973), p. 36. "LOSE A GOOD DEAL OF MONEY": Knopf to Van
Vechten, July 9, 1934: Correspondence courtesy of Alfred A. Knopf.
Cooper, *The Passion of Claude McKay*, p. 36.

296 "CLUB CHOOSE IT": White to Peterkin, Nov. 16, 1933 (C-104): WWC/
LC. "WISDOM OF THEIR RACE": Julia Peterkin and Doris Ulmann, *Roll,
Jordan, Roll* (New York: Robert O. Ballou, 1933), p. 22. "TOO MUCH TO
ASK": Sterling Brown, "Arcadia, South Carolina," *Opportunity*, 12, no. 2
(Feb. 1934): 59–60, p. 60. Jay Saunders Redding, *To Make a Poet Black*
(Chapel Hill: Univ. of North Carolina Press, 1939), p. 113.

296– CONTRACT WITH THE NOVELIST: White to Arthur Spingarn, Feb. 28, 1934;
97 Wood to White, Mar. 24, Mar. 27, 1934 (C-104): WWC/LC; Sterling
Brown, *The Negro in American Fiction* (New York: Atheneum, 1969;
orig. pub., 1937), p. 148. "WITHOUT BENEFIT OF CLERGY": White, *Man
Called White*, pp. 338–39. TRI/Ida Mae Cullen, Corinne (Mrs.
Louis T.) Wright.

297 "MIXTURE OF THE RACES": Sterling Brown, "Imitation of Life—Once a
Pancake," *Opportunity*, 13, no. 4 (Apr. 1935): 87–88.

297– "GENERATION OF NEGRO CULTURE": Alain Locke, "The Saving Grace of
98 Realism," *Opportunity*, 12, no. 1 (Jan. 1934): 8–11, 36, p. 9. GREAT
AMERICAN AUTOBIOGRAPHIES: Van Vechten to Johnson, Oct. 11, 1933,
Ser. 1, Fol. 501: JWJMC/YU. "HIS ACTUAL CONDITION": James Weldon
Johnson, *Along This Way: The Autobiography of James Weldon Johnson*
(New York: Viking, 1961; orig. pub., 1933), p. 410. "SPIRITUAL DEFEAT":
Johnson, *Negro Americans, What Now?*, p. 103. "SHOULD LIKE TO HAVE
BEEN": Du Bois, "Negro Americans, What Now?," New York *Herald
Tribune Book Review*, No. 18, 1934, pp. 23–24.

298 REFERRED TO AGAIN: Ross, *J. E. Spingarn and the Rise of the NAACP*,
pp. 182–85; Ralph Bunche, "The Programs, Ideologies, Tactics and
Achievements of Negro Betterment Interracial Organizations," Reel No.
1: CA-MY/SCRBC, pp. 145–48.

298 "PATRONIZING NATURE": Romare Bearden, "The Negro Artist and Mod-
ern Art," *Opportunity*, 12, no. 12 (Dec. 1934): 371–72. "IN THE ARTS":
Arthur Huff Fauset, "Educational Procedure for an Emergency," *Op-
portunity*, 11, no. 1 (Jan. 1933): 20–22, p. 20. "COMMUNISM": Loren
Miller, "One Way Out—Communism," *Opportunity*, 12, no. 7 (July
1934): 214–17.

298– "SEPARATION FROM OUR FELLOW MEN": W. E. B. Du Bois, "Integration,"
99 *The Crisis*, (Apr. 1934): 117. W. E. B. Du Bois, "Segregation," *The

Crisis, (Jan. 1934): 20. "HE ISN'T COLORED": Quoted by Rudwick, W. E. B. Du Bois, p. 278.

299 DIED SUDDENLY, IN MAY 1932: Robert Allerton Parker, *The Incredible Messiah: The Deification of Father Divine* (Boston: Little, Brown, 1937), p. 27. DIVINE HASTENED TO FILL: Nancy Cunard, "Harlem Reviewed," *Negro: An Anthology Made by Nancy Cunard, 1931–1933* (New York: Negro Universities Press, 1969; orig. pub., 1934), p. 72; Sara Harris, *Father Divine* (New York: Collier Books, 1971; orig. pub., 1953), p. xii.

299– "AS SERMONS GO": Clarence A. H. Abbott, "Divine Draws Mob to 300 Church," *The Inter-State Tattler,* Feb. 4, 1932, p. 3. "GOD-HARLEM-NEW YORK CITY": Parker, *Incredible Messiah,* pp. 121–54.

300 "WHERESOEVER I AM!": Quoted by Parker, *Incredible Messiah,* p. 14.

300– BAPTIST MINISTERIAL CONFERENCE: Wilbur Young, "Activities of Bishop 301 Amiru Al-Mu-Minin Sufi A. Hamid," Reel No. 1: FWP/SCRBC, p. 2; Claude McKay, *Harlem: Negro Metropolis* (New York: Harcourt, Brace & World, 1968, orig. pub., 1940), pp. 181–222, p. 191.

301 NEGRO LIBERATOR: "Sufi Racket Fans Race Hatred," *Liberator,* Oct. 6, 1934, p. 1. *New York Age,* Jan. 19, 1935, p. 1. "TROUBLEMAKERS IN HARLEM": McKay, *Harlem,* p. 195.

301 HIRING AND HOUSING: "Father Divine Tells Meeting He Will Defeat False Leaders," *New York Times,* Nov. 10, 1934.

301–2 "WERE TREATED IN JAPAN!": Hikida to J. W. Johnson, Sept. 26, 1933, Ser. 1, Fol. 206: JWJMC/YU. *The Dunbar News,* Apr. 20, 1936. "ARE AIDING THEM": P. Prattis to Pickens, Mar. 8, 1934, Box 2: WPRG/SCRBC. "OR PERMANENTLY": Pickens to Prattis, Jan. 30, 1934, Box 2: WPRG/SCRBC. "THESE SUPERIOR STANDARDS": Prattis to Pickens: Apr. 27, 1934, Box 2: WPRG/SCRBC.

302 QUESTIONABLE LODGERS: "Cunard Heiress Is Living Among Negroes," *New York American,* May 2, 1932.

303 BRUSQUELY CLEAR: Cunard to Arthur Spingarn (postcard), 1932, Box 3: ASP/HU. ANCESTRY BEHIND HIM: Toomer to Cunard, Feb. 8, 1932, Box 1, Fol. 12: JTC/FU. "AROUND SKIN COLOR": Cunard, *Negro,* p. 73. USUALLY GOT RESULTS: Cunard to Schomburg, Apr. 15, 1935, Reel No. 3: AASP/SCRBC; Cunard to J. W. Johnson, Aug. 2, 1932, Ser. 1, Fol. 110: JWJMC/YU. "REACTIONARY NEGRO ORGANIZATION": Cunard, *Negro,* pp. 142–47.

303–4 LOCKE PROMISED GODMOTHER: Locke to Mason, Apr. 25, 1934, Box 58: ALLP/HU. EASIER TO CARRY ON: Locke to Mason, *Ibid.* "CHANNELS ALREADY": Locke to Mason, May 1, Nov. 21, 1934, Box 58: ALLP/HU.

304 "URGE US TO RECAPTURE": Dorothy West to J. W. Johnson, Oct. 23, Oct. 30, 1933, Ser. 1, Fol. 533: JWJMC/YU. "TO SAVE THE RENAISSANCE": Braithwaite to Johnson, Sept. 6, 1934, Ser. 1, Fol. 55: JWJMC/YU.

304 "A DISAPPOINTMENT": Estelle Fulton, "Jonah's Gourd Vine," *Opportunity,* 12, no. 8 (Aug. 1934): 253. Locke to Mason, May 5, 1934, Box 58: ALLP/HU. "FOLKLIFE OF THE BLACK SOUTH": Robert E. Hemenway,

Zora Neale Hurston: A Literary Biography (Urbana: Univ. of Illinois Press, 1977), p. 192.

304–5 ESCORTED THE CORTEGE: "Clergy, Professionals and Artists at Dr. Fisher's Rites," *Afro-American*, Jan. 5, 1935. HE WAS GOING TO DIE: TRI/Dorothy West: Thurman, Box 3, Fol. 56, "Small Collection": JWJMC/YU. "ON A SOUND BASIS": Locke to Mason, Dec. 29, 1934, Box 58: ALLP/HU. Thurman, Box 3: JWJMC/YU; "Death Claims Noted Writer," New York *Amsterdam News*, Dec. 29, 1934.

305–6 TO BELIEVE THIS: Van Vechten to J. W. Johnson, n.d., Ser. 1, Fol. 502: JWJMC/YU.

306 OUTSIDE CONNIE'S INN: " 'Tree of Hope' Loses Prestige as Job Getter," New York *Herald Tribune*, June 8, 1930. SEGREGATED AUDIENCES: "Duke Fails to Draw Crowd at Savoy," *The Inter-State Tattler*, May 19, 1932, p. 2; Locke to Mason, Nov. 15, 1934, Box 58: ALLP/HU. "THE SECOND GENERATION": Quoted by Gilbert Osofsky, Harlem *The Making of a Ghetto: Negro New York, 1800–1930* (New York: Harper & Row, 1966), p. 131. GOVERNMENT RELIEF JOBS: Roi Ottley and William J. Weatherby, eds., *The Negro in New York: An Informal Social History, 1626–1940* (New York: Praeger, 1967, p. 271. WHITE MOTHER AND INFANT: James W. Ford, *Hunger and Terror in Harlem* (New York: Published by Harlem Section of the C.P., 1935).

306–7 WERE IN JAIL: Claude McKay, "Harlem Runs Wild," *The Nation*, Apr. 3, 1935, pp. 382–83; "The Harlem Riot," *Opportunity*, 13, no. 4 (Apr. 1935): 103. "THEIR PENS ASIDE": "Au Revoir," *The Dunbar News*, May 2, 1934, p. 1.

P E R M I S S I O N S A C K N O W L E D G M E N T S

Grateful acknowledgment is made to the following for permission to reprint from previously published, and previously unpublished, material:

Alfred A. Knopf, Inc.: Excerpts from "The Negro Speaks of Rivers," "*Danse Africaine*," "Waterfront Streets," and "The Weary Blues" by Langston Hughes, from *Selected Poems of Langston Hughes*, copyright 1926 by Alfred A. Knopf, Inc., copyright renewed 1954 by Langston Hughes. Reprinted by permission of Alfred A. Knopf, Inc.

Liveright Publishing Corporation: Excerpts from *Cane* by Jean Toomer, Liveright Publishing Corporation, New York, N.Y. Copyright 1923 by Boni & Liveright. Copyright renewed 1951 by Jean Toomer.

The Estate of Claude McKay: Three lines of poetry beginning "I've a longing . . ." in *Dialect Poetry*, Books for Libraries, 1972; poetry excerpt beginning "There is a searing hate within . . ." from "Mulatto," *Selected Poems of Claude McKay*, Bookman Associates, 1953; excerpts beginning "Although an International Socialist . . ." ("Workers Dreadnaught, 1/31/20"), "Bananas ripe and green . . . ," "My spirit is a pestilential city . . . ," "For I was born far from my native clime . . ." ("Outcast"), "Upon her swarthy neck . . . ," "Halting footsteps of a lass . . ." ("Harlem Shadows"), and "The ugly corners . . ." ("Rest in

Peace") from *Selected Poems of Claude McKay*, Harcourt Brace & World, 1953; excerpt from autobiography, *My Green Hills of Jamaica*, Heinemann, Kingston, Jamaica, 1979, reprinted by permission of the Estate of Claude McKay. Excerpts from letters from Claude McKay to Walter White (the Personal Correspondence of Walter White, NAACP Collection, Library of Congress), from Claude McKay to Arthur A. Schomburg (The Arthur A. Schomburg Collection, The New York Public Library), from Claude McKay to Alain Locke (Locke Papers, Moorland-Spingarn Research Center, Howard University), excerpt from previously unpublished manuscript, "Negro Life and Negro Art" (NAACP Collection, Library of Congress), reprinted by kind permission of Hope McKay Virtue.

The National Urban League: Excerpt from "The Debut of the Younger School of Negro Writers" by Gwendolyn Bennett. Reprinted from *Opportunity Magazine*, May, 1924, courtesy of the National Urban League.

Harold Ober Associates, Inc.: Excerpt from "Two Poems" by Langston Hughes, *Fine Clothes for a Jew*, published by Alfred A. Knopf, Inc., copyright 1927 by Alfred A. Knopf, Inc., renewed 1955 by Langston Hughes. Excerpts from *The Big Sea* by Langston Hughes, published by Alfred A. Knopf, Inc., copyright 1940, 1963 by Langston Hughes. Excerpt from "Goodbye Christ" from *The Negro Worker* by Langston Hughes, published by Alfred A. Knopf, Inc., copyright 1932 by Langston Hughes. Excerpt from "Elderly Race Leaders" from *The Panther & The Lash* by Langston Hughes, published by Alfred A. Knopf, Inc., copyright © 1967 by Langston Hughes. Excerpts from "Merry Christmas" by Langston Hughes, published in 1930 in *New Masses*, and "Advertisement for The Opening of the Waldorf Astoria" by Langston Hughes, published in *New Masses*, copyright 1935 by Langston Hughes. Excerpt from "The Negro Artist and the Racial Mountain" by Langston Hughes, published in *The Nation*, June, 1926, copyright 1926 by Langston Hughes. Excerpt from "We Have Tomorrow" by Langston Hughes, from *The New Negro*, published by Boni Publishers in 1925, and by Atheneum in 1974, copyright 1925 by Albert & Charles Boni, Inc. Excerpts from "The New Song" and "Luani of the Jungles" by Langston Hughes. Excerpt from "Liars" by Langston Hughes, published in *Opportunity*, March 1925. All rights reserved. All of the above reprinted by permission of Harold Ober Associates, Inc.

The Estate of Amy E. Spingarn: Excerpt from "Heloise sans Abelard" by Joel E. Spingarn. Reprinted by permission of the Estate of Amy E. Spingarn.

The Estate of Carl Van Vechten: Excerpts from *Nigger Heaven* and two letters by Carl Van Vechten reprinted courtesy of the Estate of Carl Van Vechten, Joseph Solomon, Executor.

The Viking Press: Excerpts from "Under the Bamboo Tree" in *Along This Way* by James Weldon Johnson. Copyright 1933 by James Weldon Johnson, copyright renewed 1961 by Grace Nail Johnson; excerpts from *Saint Peter Relates an Incident of the Resurrection Day* by James Weldon Johnson, copyright 1935 by James Weldon Johnson, copyright renewed 1963 by Grace Nail Johnson. Reprinted by permission of The Viking Press.

Index

Urban League (*continued*)
 prizes, see *Opportunity* (maga-
 zine): prizes
 and Walrond, 189
USSR, *see* Russia

Van Doren, Carl, 99
 and White, 136
 "Younger Generation of Negro
 Writers, The," 93–4
Van Vechten, Carl, 98, 114, 136,
 182–5
 financial support of Harlem
 Renaissance, 179, 195
 and T. Gordon, 212
 as Harlem "tour guide," 183
 and N. Holt, 184–5
 and Hughes, 188
 and J.W. Johnson, 182, 188
 and Larsen's *Quicksand*, 231
 and Mencken, 182
 on mulattos, 228
 at "Negro in Art" *Crisis* symposium,
 176–7
 Nigger Heaven, 177, 180–2, 184–9,
 225, 227
 and White, 188
Villa Lewaro, 110–11, 165–6, 167–8,
 244–5, 265–6
Villard, Oswald Garrison, 99, 284

wages, *see* income
Walker, A'Lelia (Robinson), 105,
 110–11, 165–70, 244–5
 death and funeral of, 265–6
Walker, David: *Appeal in Four
 Articles*, 24
Walker, Sarah Breedlove (Madame
 C.J.), 110, 167
Waller, "Fats," 33, 108, 120, 171,
 210, 211
Walls of Jericho, The (novel, Fisher),
 151, 229–30
Walrond, Eric, 125, 233–4
 at Civic Club dinner (March
 1924), 89
 and "580," 128
 and Garvey, 44
 as Harlem "tour guide," 164
 and C.S. Johnson, 233–4
 and Locke, 150

"Miss Kenney's Marriage," 128
Tropic Death, 189–90
"Voodoo's Revenge," 114
"Wharf Rats, The," 190
"Yellow One, The," 190
Wanamaker (Louis Rodman) musical
 composition prizes, 179
Washington, Booker T., 23
 and Du Bois, 47–8
 on education, 158
 elitism of, 7
 and Garvey, 36
 and J.W. Johnson, 146
Washington, D.C., race riot (July
 1919), 19
Wasserman, Edward, 187, 214
"Waterfront Streets" (poem,
 Hughes), 88
Waters, Ethel, 120, 127, 184, 264
 and F. Henderson, 173–5
Ways of White Folks, The (short
 stories, Hughes), 293
"Weary Blues, The" (poem, Hughes),
 81, 114, 169
"Wedding Day" (short story, G.
 Bennett), 195
Wells, Herbert George, 127
West, Dorothy, 139, 179, 288, 304
"Wharf Rats, The" (short story,
 Walrond), 190
When Africa Wakes (Harrison), 104
"When My Sugar Walks Down the
 Street" (song), 210
White, Mayme, 167, 213, 244, 265
White, Walter Francis
 and P. Cannon, 272
 death of his father, 268–9
 and the Depression, 243
 elitism of, 192–3
 in Europe (1927–28), 203–5
 financial support of, 180
 Fire in the Flint, The, 94, 132–6
 Flight, 142
 on *Green Pastures, The*, 246
 and Helena, Ark., racial violence, 23
 influence on Harlem Renaissance,
 130–43, 248–9, 267
 and S. Lewis, 136, 140, 142
 and McKay, 140–1
 and Mencken, 132–6 *passim*
 and F. Mills, 164

A NOTE ABOUT THE AUTHOR

David Levering Lewis was born in Little Rock, Arkansas, in 1936. He received a bachelor's degree from Fisk University, a master's degree in American history from Columbia University, and a doctorate in French history from the London School of Economics. He is currently a fellow at the Center for Advanced Study in the Behavioral Sciences at Stanford University. His previous books are *King*, a biography of Martin Luther King, Jr., *Prisoners of Honor*, a study of the Dreyfus Affair, and a history of the District of Columbia. He is married and has three children.